Presidio, Mission, and Pueblo

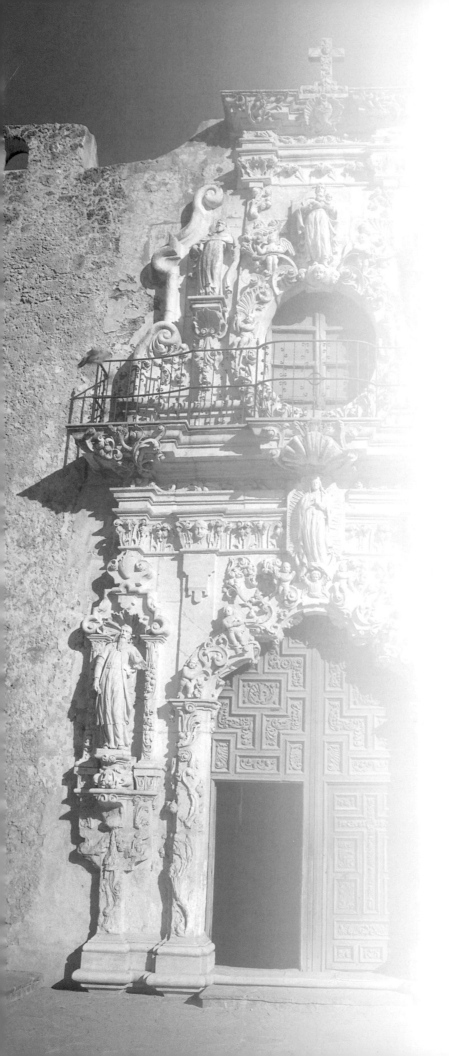

Also by James Early

Romanticism and American Architecture
The Making of Go Down, Moses
The Colonial Architecture of Mexico

PRESIDIO, MISSION, AND PUEBLO

Spanish Architecture and Urbanism in the United States

❧

JAMES EARLY

*Published in cooperation with the
William P. Clements Center for Southwest Studies*

SOUTHERN METHODIST
UNIVERSITY PRESS
Dallas

For William B. Taylor and David J. Weber

Copyright © 2004 by James Early
First Southern Methodist University Press edition, 2004
All rights reserved

Requests for permission to reproduce material from this
 work should be sent to:
Rights and Permissions
Southern Methodist University Press
PO Box 750415
Dallas, Texas 75275-0415

Cover photo: San Xavier del Bac, Tucson area, by James Early
Jacket and text design by Tom Dawson

LIBRARY OF CONGRESS CATALOGING-IN-PUBLICATION DATA

Early, James, 1923-
 Presidio, mission, and pueblo : Spanish architecture and
urbanism in the United States / James Early.—1st Southern
Methodist University Press ed.
 p. cm.
 Includes bibliographical references and index.
 ISBN 0-87074-482-8 (cloth : alk. paper) —
1. ISBN 0-87074-484-4 (pbk. : alk. paper)
 Architecture, Spanish Colonial—Southwestern States.
 I. Title.

NA727.E372003
720'.976'0903—dc22 2003057338

Printed in the United States of America on acid-free paper

10 9 8 7 6 5 4 3 2 1

Contents

	Preface	x
I	Spanish Settlement and Construction in North America	1
II	Florida	11
III	New Mexico	46
IV	Texas	96
V	Louisiana	122
VI	Arizona	137
VII	California	154
VIII	Hispanic Architecture in the United States after 1846	209
	Plates	213
	Notes	229
	Glossary	233
	Bibliography	235
	Index	246

Illustrations

Chapter II, Florida

2.1. Pedro Menéndez de Avilés. **11**
2.2. Seven settlements of sixteenth-century Florida. **13**
2.3. St. Augustine during Drake's raid, 1586, detail of a map of Baptista Boazio. **16**
2.4. Buildings of St. Augustine c. 1593, detail of a map of the area. **17**
2.5. Charlotte Street, St. Augustine, in 1886. **19**
2.6. Plan of St. Augustine, published by Thomas Jefferys in 1762. **21**
2.7. Guardhouse and plaza of St. Augustine with lookout tower on Anastasia Island, drawing, 1764. **22**
2.8. Governor's house in St. Augustine, drawing, 1764. **23** and **213**
2.9. Façade of the parish church, incorporated into the cathedral of St. Augustine. **24**
2.10. "The Map of the Town, Fort and Neighborhood of St. Augustine," c. 1593. **26**
2.11. Castillo de San Marcos, aerial view. **27**
2.12. Fort Matanzas, a gun platform near the mouth of the Matanzas River. **29**
2.13. Castillo de San Marcos, view from the southwest. **30**
2.14. Castillo de San Marcos, west side with moat and outer fortifications. **30**
2.15. Map of Mission Santa Catalina de Guale, dated 1691. **35**
2.16. Mission San Luis de Talimali, reconstruction of the central plaza. **37**
2.17. Map of Pensacola, c. 1779, showing the Durnford plan. **43**

Chapter III, New Mexico

3.1. Church of San Esteban of Ácoma Pueblo, plans and section. **53**
3.2. Detail of a painting uncovered on a wall of the sanctuary of the church at Awatovi, Arizona. **54**
3.3. Retablo of the church of San José, Laguna Pueblo. **56**
3.4. The Martínez Hacienda, Taos. **59**
3.5. Front patio of the Martínez Hacienda. **59**
3.6. Pecos, Mission of Nuestra Señora de los Angeles de Porciúncula in 1680, reconstruction drawing. **61**
3.7. Pecos in 1846, drawing by John M. Stanley. **63**
3.8. Remains of the eighteenth-century church at Pecos. **63** and **214**

3.9. Church of San José de Giusewa, view from the southwest. **64**
3.10. Interior of the church of San José de Giusewa. **65**
3.11. Plan of the church and *convento* of San Gregorio at Abó. **66**
3.12. Exterior wall of the church of San Gregorio at Abó from the west-southwest. **67**
3.13. San Gregorio at Abó from the east. **67** and **215**
3.14. Plan of the church and *convento* of Purísima Concepción at Quarai. **68**
3.15. Interior of the church of Purísima Concepcíon at Quarai in 1890. **69**
3.16. Drawings of Las Humanas in 1877 by Lt. Charles P. Morrison. **71**
3.17. Ácoma, the church and the pueblo on the rock. **72**
3.18. The church and convento of San Esteban at Ácoma. **74**
3.19. Interior of the church at Ácoma, facing the choir loft and entrance in 1940. **75**
3.20. Illustration of the interior of the church at Ácoma in the 1880s. **75**
3.21. Plan of the presidio, incorporating the governor's palace, of Santa Fe in 1791. **78**
3.22. Plan of Santa Fe in 1766 by Joseph de Urrutia and a rendering of its central area in a painting by Wilson Hurley. **79**
3.23. Plan of Santa Fe in 1766 by Joseph de Urrutia and a rendering of its central area in a painting by Wilson Hurley. **79**
3.24. Interior of church of San Miguel. **81**
3.25. Church of San Miguel in the 1870s. **81**
3.26. Parish church of Santa Fe in 1849, watercolor by Richard Kern. **82**
3.27. Stone altar screen from chapel of La Castrense. **83**
3.28. East San Francisco Street from the plaza to the parish church, photograph c. 1868. **84**
3.29. Palace of the Governors in 1868. **84**
3.30. Palace of the Governors, reconstruction designed by Jesse Nusbaum. **85**
3.31. Detail of a plan of El Paso del Norte, now Ciudad Juarez, by Joseph de Urrutía in 1766. **87**
3.32. The church of Nuestra Señora de Guadalupe, c. 1851. **88**
3.33. Interior of the church of Nuestra Señora de Guadalupe. **88** and **216**
3.34. Interior of the church of San José de Gracia, Las Trampas. **90**
3.35. Church of San José de Gracia, Las Trampas, in 1881, watercolor by John G. Bourke. **91**
3.36. The church of San José de Gracia with Penitente *morada* on the right. **91** and **217**
3.37. Chimayó, Plaza del Cerro in the 1960s. **92**
3.38. West range of Plaza del Cerro with the Ortega Chapel. **93**
3.39. Chimayó, Santuario del Señor de Esquipulas in the early twentieth century. **93**
3.40. Santuario del Señor de Esquipulas showing alterations of the 1920s. **93**
3.41. Chancel of the Santuario with altar screen painted by Molleno. **94**
3.42. Retablo of the nave of the Santuario painted by Molleno. **95**

Chapter IV, Texas

4.1. Mission church of San Antonio de Valero, the Alamo, in 1847, watercolor by Edward Everett. **99**
4.2. The "Governor's Palace" in San Antonio. **100**
4.3. Detail of the Plan of San Antonio in 1767, Joseph de Urrutia. **103**
4.4. Main plaza and parish church in San Antonio in 1849, watercolor by Seth Eastman. **104**
4.5. Mission Concepción, church and part of the *convento*. **110** and **218**

| Illustrations

4.6. Mission Concepción, portal of the church. **110**
4.7. Mission Concepción, the interior of the church in the 1860s. **111**
4.8. Mission Concepción, plan. **111**
4.9. Mission Concepción, mural painting of the crucifixion and decorations in the baptistery. **112**
4.10. Room in the *convento* of Mission Concepción. **112** and **219**
4.11. Bird's-eye view of Mission San José, drawing based on a model by H. L. Summerville. **115**
4.12. Interior of the sacristy of Mission San José. **116**
4.13. "Rose window" of the sacristy of Mission San José. **116**
4.14. Church of Mission San José from the southwest. **117**
4.15. Plan of Mission San José. **117**
4.16. Façade of the church of Mission San José. **118**
4.17. Frontispiece of the church of Mission San José. **119** and **220**

Chapter V, Louisiana

5.1. French plan of New Orleans, published in 1764, after Louisiana had been ceded to Spain. **123**
5.2. Plan of St. Louis in 1796. **126**
5.3. Spanish plan of New Orleans in 1794 showing Baron de Carondolet's fortifications. **128**
5.4. "Madame John's Legacy," New Orleans. **130**
5.5. The buildings facing the Place d'Armes (Jackson Square) in 1815. **131**
5.6. Portrait of Andrés Almonester y Roxas, as Knight of the Order of Carlos III. **131**
5.7. Façade of the Cathedral of St. Louis in New Orleans, based on a drawing by Benjamin H. Latrobe, 1819. **132**
5.8. Aisle of the Cathedral of St. Louis, drawing by Latrobe, 1819. **133**
5.9. The Cabildo, New Orleans, drawing by Benjamin H. Latrobe, 1819. **134**
5.10. The Cabildo, New Orleans, after the addition of the mansard roof and the lantern in 1847. **135**

Chapter VI, Arizona

6.1. Detail of the map of the Presidio of Tubac in 1766, by Joseph de Urrutia. **139**
6.2. Church of San José de Tumacácori. **141**
6.3. Tucson, the presidio in 1782, reconstruction drawing. **143**
6.4. Tucson, ruins of the *convento*, c. 1880. **143**
6.5. Plan of the church of San Xavier del Bac. **146**
6.6. Interior of San Xavier del Bac facing the sanctuary. **147** and **221**
6.7. Interior of San Xavier del Bac facing the choir balcony and the entrance. **147** and **222**
6.8. Vault of a bay of the nave, San Xavier del Bac. **148**
6.9. Angel of pier of the crossing, San Xavier del Bac. **148**
6.10. Main retablo, upper level, San Xavier del Bac. **149**
6.11. Retablo of the east transept chapel of San Xavier del Bac, with the incised cross, upper level center. **149**
6.12. The choir balcony, San Xavier del Bac. **150**
6.13. The façade of San Xavier del Bac. **150** and **223**
6.14. Upper level of the frontispiece, San Xavier del Bac. **151**
6.15. West side of San Xavier del Bac. **151**

Chapter VII, California

7.1. Interior of the church of Mission San Miguel Arcángel decorated by Estebán Munras. **165**

7.2. Painting of the thirteenth Station of the Cross, from Mission San Fernando Rey, now on display at Mission San Gabriel. **166** and **224**

7.3. Plan of the Monterey Presidio c. 1771. **166**

7.4. Monterey presidio chapel, design for the façade, Manuel Ruiz. **169**

7.5. Monterey presidio chapel in 1847, drawing by W. R. Hutton. **169**

7.6. Carmel, interior view of Mission San Carlos, c. 1794. **171**

7.7. Mission San Carlos, view from the rear in 1837. **171**

7.8. Mission San Carlos, façade of the church. **172** and **225**

7.9. Interior of the church of Mission San Carlos facing the entrance, about 1880. **173**

7.10. Interior of the church of Mission San Carlos, baptistery, with gothic ribs decorating the vault. **173**

7.11. Present interior of the church of Mission San Carlos. **174**

7.12. Church of Mission San Gabriel, plan and section. **179**

7.13. Mission San Gabriel. **180**

7.14. Reconstruction, cross section facing entrance, Mission San Gabriel. **180**

7.15. *Campanario*, Mission San Gabriel. **181**

7.16. Mission San Gabriel in 1828, painting by Ferdinand Deppe, 1832. **181** and **226**

7.17. Los Angeles, layout of house and field lots, 1793. **182**

7.18. Los Angeles, Plaza Church before 1860. **184**

7.19. Central Los Angeles in 1847. **185**

7.20. Mission San Juan Capistrano, plan. **187**

7.21. Mission San Juan Capistrano, plan of the stone church. **188**

7.22. Remains of the stone church of San Juan Capistrano, c. 1880. **188**

7.23. The remains of the stone church of San Juan Capistrano in 1850, drawing by H. M. T. Powell. **189**

7.24. Mission San Luis Rey in 1848, drawing by W. R. Hutton. **192**

7.25. Mission San Luis Rey, façade of the church and part of the arcade of the restored quadrangle. **194** and **227**

7.26. Interior of the church, Mission San Luis Rey. **194**

7.27. Plan of the church, Mission San Luis Rey. **195**

7.28. Mission San Luis Rey, San Francisco Chapel in 1870. **195**

7.29. Chapel of San Antonio de Pala, interior in the 1890s. **195**

7.30. Santa Barbara presidio chapel in 1855, painting by J. N. Alden. **199**

7.31. Mission Santa Barbara in 1856, drawing by Henry Miller. **201**

7.32. Part of the water system of Mission Santa Barbara in 1847, drawing by W. R. Hutton. **203**

7.33. Layout of Mission Santa Barbara. **203**

7.34. Mission Santa Barbara, rebuilt façade of the church. **204**

7.35. Detail of rebuilt upper façade of the church of Mission Santa Barbara. **205** and **228**

7.36. Mission Santa Barbara, interior of the church, c. 1905. **207**

7.37. Mission Santa Barbara, interior, sanctuary, about 1911. **208**

Preface

General studies of American architecture have concentrated on the development of the English colonial building types along the Atlantic seaboard which led directly into the architecture of the early republic. Even Marcus Whiffen allocated only ten pages of text to Spanish structures in his admirable portion of *American Architecture 1607-1976*. Studies of Hispanic buildings within the present territory of the United States have customarily centered on particular areas, notably California and New Mexico.

My concern in this book is to provide a comprehensive account of Hispanic building and urban development in parts of the United States that once belonged to Spain. These activities lasted almost three centuries, beginning in Lucas Vázquez de Ayllón's short-lived town on the Georgia coast in 1526 and concluding after 1821 when Mexico gained independence and Florida was ceded to the United States.

In addition to examining Spanish design and construction of buildings, both ecclesiastical and domestic, defensive fortifications, town planning, and urban development, I am concerned with the institutional, social, and religious forces which shaped them.

In this study I extend the range of my earlier book, *The Colonial Architecture of Mexico*, from the central sites and major monuments of New Spain to its remote northern regions, reachable only by months of arduous travel from the viceregal capital and inhabited by indigenous peoples much more resistant to Europeanization and Christianization than were the sedentary and sophisticated peoples of the central plateau who were already accustomed to complex forms of civic polity. Distance and the nature of the native societies shaped architectural and urban development in the north, forcing a concentration on the institutions of the mission and the presidio, or fortification, and its satellite town.

Writers of general works depend heavily upon the scholarly labors of others. Among the architectural studies I found most helpful were three comprehensive works: George Kubler's Yale dissertation, *The Religious Architecture of New Mexico*; Bainbridge Bunting's *Early Architecture of New Mexico*; and Marc Treib's more recent *Sanctuaries of Spanish New Mexico*. Other essential New Mexican studies include E. Boyd's *Popular Arts of Spanish New Mexico*; Fray Francisco Atanasio Domínguez's *The Missions of New Mexico, 1776*; John L. Kessell's general study of

the missions since 1776 and his account of Pecos, *Kiva, Cross and Crown*. James E. Ivey's *In the Midst of a Loneliness* is a striking study of the remarkable abandoned stone missions of the Salinas region. Chris Wilson's *The Myth of Santa Fe* is valuable for insight into the processes of restoration, free re-creation, and marketing for tourists of Spanish and Indian structures.

The scholarly literature on Spanish California is voluminous, if not of the quality of that on New Mexico. Still useful are older studies of George Wharton James, *In and Out of the Old Missions*; Rexford Newcomb, *Old Mission Churches and Historic Houses of California*; and Frances Rand Smith, *The Architectural History of Mission San Carlos Borromeo*. Edith Buckland Webb's *Indian Life at the Old Missions* is the most valuable single architectural study of Hispanic California. *The California Missions* from Sunset Books provides plans and historic drawings and photographs. The many books of the Franciscan students of the missions of their order, Zephyrin Engelhardt, Maynard Geiger, and Francis J. Weber, are important sources of information. Mardith K. Schuetz-Miller has recently compiled an important study, *Building and Builders in Hispanic California, 1769-1850*.

Catholic writers were the most assiduous pioneers in the study of the Spanish and Mexican past of Texas. Carlos E. Castañeda's multivolume *Our Catholic Heritage in Texas* remains indispensable. As in California, Franciscan writers have been leaders in chronicling the achievements of their order. Marion A. Habig's *The Alamo Chain of Missions* is essential and Benedict Leutenegger's work has been useful, especially his translations of important documents. More secular studies include William Corner's still valuable 1890 guidebook to San Antonio. Two important collaborative works are *The Spanish Missionary Heritage of the United States*, edited by Howard Benoist and Maria Carolina Flores, and *An Archeological Investigation of Mission Concepción*, written primarily by Dan Scurlock and Daniel E. Fox. Jesús F. de la Teja's study, *San Antonio de Béxar: A Community on New Spain's Northern Frontier*, is admirable. Jacinto Quirarte's *The Art and Architecture of the Texas Missions* stresses the decorative art of the missions and its meaning.

Valuable books on Spanish Arizona include John L. Kessell's *Mission of Sorrows* and *Friars, Soldiers and Reformers*, Henry F. Dobyns's *Spanish Colonial Tucson*, and James E. Officer's *Hispanic Arizona*. In addition to Father Eusebio Kino's own works, Herbert E. Bolton's biography, *The Rim of Christendom*, and several works of Ernest J. Burrus provide valuable insight into the career of that remarkable Jesuit. Important monographs on San Xavier del Bac in the Tucson area include one by Prent Duell of 1919 and Richard E. Ahlborn's *The Sculpted Saints of a Borderland Mission*. Bernard L. Fontana is the outstanding contemporary authority on that superb structure.

The architecture of Spanish Louisiana has been perceptively studied by two friends, the architect Samuel Wilson, Jr., and the historian and collector Leonard V. Huber.

Architectural construction in the extensive area the Spaniards called Florida, long neglected, has in recent decades been perceptively studied. Among the leaders in this work have been Albert Manucy, for many years a member of the National Park Service. His two books on the houses of St. Augustine and his work with Luis R. Arana on the Castillo de San Marcos are outstanding. Among other scholars who have done important work on Spanish Florida are the archeologists Kathleen Deagan, David Hurst Thomas, Bonnie G. McEwan, and Gary Shapiro, and the historians John H. Hann, Eugene Lyon,

Preface

Amy Turner Bushnell, and Paul E. Hoffman. Elsbeth K. Gordon's recent *Florida's Colonial Architectural Heritage* provides a valuable account of both Spanish and British architecture in Florida and is notable for superb illustrations.

Essential studies of urban development in formerly Spanish areas include several works of John W. Reps, especially *The Making of Urban America* and *Cities of the American West*. *Spanish City Planning in North America* by Dora P. Crouch, Daniel J. Garr, and Axel I. Mundigo is helpful, especially regarding the royal ordinances on the laying out of cities. Oakah L. Jones, Jr.'s *Paisanos* is a comprehensive account of Spanish town dwellers.

A general historical work of Bernard L. Fontana, *Entrada*, and two works of my friend and colleague David Weber, *The Mexican Frontier, 1821–1846* and *The Spanish Frontier in North America*, are valuable in supplying much of the context for architectural and urban development and are models of broad-gauged, sympathetic, yet critical thinking and writing.

I have benefited from the assistance of the staff of the De Golyer library of Southern Methodist University and its directors, David Farmer and Russell L. Martin. Jill Bagwell and Lynn Dickson turned my writing into legible typescript. I gained from the intelligence and tact of my editor, Kathryn Lang. The text benefited greatly from the sharp eye of Freddie Jane Goff. The index was created by Laura Moss Gottlieb. This book is substantially better because of the searching readings of W. Eugene George, James Ivey, Mardith Schuetz-Miller, Susan Parker, and David Weber. The knowledge and generosity of such readers provides cheering reassurance of the existence of a mutually sustaining scholarly community. Ann Early's role in exploring the sites and improving the text was essential.

CHAPTER I

Spanish Settlement and Construction in North America

Walt Whitman wrote in 1883 regarding the 333rd anniversary of the founding of Santa Fe that "Spanish character will supply some of the most needed parts" of the future composite national identity based no longer entirely on English origins "as America, from its many far back sources . . . entwines [and] faithfully identifies its own."[1]

Despite the survival of imposing Hispanic structures in all the former Spanish territories, ranging across the southern tier of American states from Florida to California, there was little sympathetic interest in the Spanish past before the 1880s. Until well after the Civil War anti-Hispanic and anti-Catholic feelings, fueled by memories of the Spanish Armada and the slaughter at the Alamo, persisted in the people of the United States, who were largely British in origin and overwhelmingly Protestant.

Spanish architectural remains are most evident in New Mexico. Many buildings survive from the Spanish and Mexican periods and, in addition, many modest village structures built during the century and a half since the American take-over reflect authentic Hispanic building traditions. At least thirty churches were in use in Indian pueblos before the Spanish were driven from New Mexico in the revolt of 1680. Seventeen churches are still in use in New Mexican pueblos. Four of these originated in the seventeenth century and were rebuilt after the revolt, and seven are new constructions of the twentieth century. In addition to the pueblo churches, twenty or more churches remain from the Spanish and Mexican periods which served the mixed populations living in Santa Fe and the other New Mexican towns. Over three hundred village churches built before 1940, and reflecting to some degree persisting Hispanic building practices, exist in the northeastern portion of New Mexico alone.

In St. Augustine, Florida, little but the great stone fortress, the Castillo de San Marcos, and portions of some houses survive from the first two hundred years of Spanish occupation, and there is only archeological or written evidence for the existence of the 128 sites identified by John H. Hann as places in the American Southeast where missionary activity took place. Spanish Texas, which contained thirty-seven missions, eleven presidios, and at least half a dozen villages, is now marked by five restored missions, a governor's residence in San Antonio, and a restored mission and presidio at Goliad. The miraculously well-preserved church of San Xavier del Bac and the preserved remains of the church at Tumacácori survive south of Tucson in Arizona in

Chapter I

what was once the missionary region of northern Sonora. Buildings constructed during the forty years of Spanish Louisiana remain, to the surprise of many, as the major monuments of the French Quarter at New Orleans. In California twelve missions (out of twenty-one) and two chapels survive, most of them heavily restored. Examples of the adobe-walled houses remain in San Diego, in the Los Angeles area, and in Santa Barbara, now commonly roofed with tiles instead of the tar usual in California in Hispanic times.

Because of the concentration in our historical writing upon the English colonial roots of the American republic, the remains of Spanish architecture are more prominent in our national consciousness than the people responsible for the spread of Spanish settlement north into the present territory of the United States. The leaders of that enterprise, which endured for almost three hundred years, are less generally known than earlier explorers such as Juan Ponce de León, Hernando de Soto, and Francisco Vázquez de Coronado. Those responsible for settlement were strikingly diverse. Many were born in Spain, others in Mexico, and still others were from regions as different as Ireland and the Tyrol. They were missionaries, soldiers, explorers, sailors, engineers, bureaucrats, and people of wealth and influence.

Junípero Serra may be the only one of these widely known to Americans; he represents California in Statuary Hall in the national capitol. The doughty, combative, masochistically pious Franciscan was over fifty when he struggled on legs lamed by varicose ulcers some six hundred miles from Loreto in Baja California to found his first mission in San Diego in 1769. But Serra was not the most interesting of the Spaniards who lived in North America. Preeminent, perhaps, was Pedro Menéndez de Avilés, maritime strategist and favorite naval commander of Philip II, *adelantado* or proprietor of a Florida that extended north along the Atlantic coast toward Newfoundland and west along the gulf to northeastern Mexico. Menéndez obliterated the French who threatened the Spanish sea lanes and founded the first enduring European settlement in North America but failed in his ambition to become a second Hernán Cortés.

The most remarkable scholar of New Spain, Carlos Sigüenza y Góngora, was a frequent visitor to the great poet and prodigy Sor Juana Inéz de la Cruz, and he publicly confuted the pious interpretations of astronomical phenomena of the noted Jesuit missionary and explorer Eusebio Kino. Sigüenza y Góngora was a historian and an investigator of Aztec civilization as well as professor of mathematics and astronomy. He was also an expert map maker and an engineer. Sent on an expedition to Pensacola Bay, he provided the viceroy with an enthusiastic report and an accurate map that led to the settlement of western Florida.

An important military figure was the Irish-born Lt. General Alejandro O'Reilly, who had reformed the Spanish army and shored up the defenses of Havana after its capture by an English fleet in 1762. In 1769 he quashed a revolt in formerly French New Orleans and secured Spanish control of Louisiana up to St. Louis and beyond. Accompanying O'Reilly was Andrés Almonester y Roxas, who made a great fortune as a real estate investor and building contractor in New Orleans and, in quest for royal honors, personally rebuilt one hospital, founded another, and then paid for the construction of both the Cabildo and the Cathedral.

The greatest landowner of northern New Spain, the Marqués de San Miguel de Aguayo, possessor of a chain of haciendas encompassing an area larger than Denmark, hundreds of thousands of sheep, and vineyards famous for wine and brandy, led a personally financed expedition that rescued Spanish Texas from the threat of obliteration by the French. Aguayo refounded the missions and the presidio in East Texas, which had been abandoned

in 1719. In addition he reinforced the presidio in San Antonio and constructed the presidio of Los Adaes, the capital of Texas for its first half century, located in present-day Louisiana.

New Mexico was settled in 1598 by another *adelantado*, "the last conquistador," Juan de Oñate, son and heir of Cristóbal de Oñate. His father had been a lieutenant of Nuño de Guzman, the ruthless conqueror of western Mexico, and later was a founder of Zacatecas, first of the great silver cities of Mexico. Almost two centuries later New Mexico was prudently governed for a decade by Juan Bautista de Anza the younger, who had led two remarkable expeditions from Tubac in Arizona through deserts and mountains to San Gabriel and Monterey. The second expedition doubled the Hispanic population of California and led to the founding of San Francisco and San José. In New Mexico Anza defeated and then established a permanent peace with the long feared Comanches.

The most remarkable of the missionaries in Texas was Fray Antonio Margil de Jesús, one of the earliest members of the *Colegio de Propaganda Fide* (College for the Propagation of the Faith) of Querétaro. He established the Mission of San José in San Antonio and other missions in Texas. Before arriving in that region, he had spent thirteen years in central America, ranging from Chiapas to northern Panama, and had survived an attempt to burn him alive. Although formidably energetic, he signed himself "La Misma Nada," insignificance itself.

Notable among the Jesuits in Arizona was the Tyrolian-born explorer and scientist Eusebio Kino, the founder of Mission San Xavier del Bac and two other missions in that state. Kino had declined a position in mathematics in a German University, offered to him by the Duke of Bavaria, because of his eagerness to be a missionary. San Xavier was later served by another intrepid and restless explorer, Francisco Garcés, a Franciscan, who was killed by Yuma Indians at the junction of the Colorado and Gila Rivers in the assault that permanently closed off the land supply route to Spanish California.

The most effective of Spanish governors of California was a military officer, Felipe de Neve. The energetic founder of both San Jose and Los Angeles and refortifier of the region's presidios was frustrated, however, in his effort to reform the mission system by his persistent opponent, Junípero Serra.

The most prominent of Spaniards to visit America in the eighteenth century was José de Gálvez, Visitor General of King Carlos III and later Minister of the Indies. Gálvez was prevented from traveling north into the present United States but conceived and organized in Baja California the occupation of Upper California by Governor Gaspar de Portolá and Father Serra. Gálvez expressed his concern for the success of the Portolá expedition by helping Serra to pack his equipment. An important member of the expedition was the military engineer Miguel Constansó, a gifted cartographer and architect who directed the construction of the first Spanish buildings in Monterey and whose diary provides the most interesting account of the expedition. Constansó later became an important engineer and architect in Mexico who provided viceroys with knowledgeable and prudent advice about California.

In the sixteenth century Florida and New Mexico were granted to wealthy men who contracted with the king to explore and settle the regions at their own expense in exchange for the hereditary title *adelantado*, plus carefully defined but substantial privileges. But Spanish colonial policy was much more consistently formulated and administered than the English pattern of grants to chartered corporations and to royally favored individual proprietors or groups of proprietors. As early as 1524 a Council of the Indies was separated from the powerful Council of Castile to issue laws for the American dominions, to act as an appellate judicial

court for colonial cases, and to make nominations for important civil and religious appointments. The American territories were conceived as kingdoms, like the separate kingdoms of the Iberian Peninsula, united under the Spanish monarch with viceroys ruling as substitutes for the king. The viceroy of New Spain, living in Mexico City, was responsible for almost the whole North American continental area and the islands north of the Isthmus of Panama, for the portion of northern South America now constituting Venezuela, and for the Philippines. Viceroyalties also had judicial and advisory bodies, *audiencias*, chaired in their most important deliberations by the viceroy. As settlement spread westward and northward from Mexico City, a second *audiencia* was created in Guadalajara with the governor and captain general of the northwest region presiding. Further subdivisions were made into jurisdictions such as Florida, New Mexico, and the Californias with ruling governors. Florida's reported to the Council of the Indies, the others were subordinate to the viceroy of New Spain.

In the Americas the king was head of the church as well as the state because of the *Patronato Real de Indias*, founded by papal bulls of the early sixteenth century and designed to foster the conversion of native peoples. He paid the expenses of the missionary and secular clergy, administered ecclesiastical jurisdictions and revenues, appointed bishops, and had the power to nullify papal bulls. Spanish monarchs were pious Christians, supporters of the church, but they used missionary activities to further their secular aims. Their delegation of their authority as patron of the church to colonial viceroys and governors led to never-ending disputes between ecclesiastical and civil authorities, the best known in the United States being Father Serra's squabbles with governors of California.

Royal funds provided critical support for the missionary work of the regular orders active in northern New Spain. The Jesuits pioneered in Florida but left after six years, with nine of their number killed by Indians and having achieved very few conversions. The Franciscans succeeded the Jesuits in Florida and, for a time, in Baja California, and were active in New Mexico, Texas, Arizona, and Alta California. The Jesuits later worked with great success in northwestern regions of New Spain, in the mountains of Sonora, in Baja California, and in Arizona until their summary expulsion in 1767, ordered by Carlos III and directed by José de Gálvez.

In the early years Franciscan missionary activity was directed through their regular provincial organization. Florida was the only region in the United States to achieve provincial status with the establishment of the Province of Santa Elena de la Florida in 1612. New Mexico was organized in 1616 as a *custodia* subordinate to the Province of Santo Evangelico, headquartered in the Convento of San Francisco in Mexico City. In the other areas within the present United States the Franciscan missions were established and regulated by the colleges for the propagation of the faith, which were new institutions created, after the creation in Rome in 1622 of the Congregation for the Propagation of the Faith, to train missionaries for the field. The first in New Spain was the College of Santa Cruz of Querétaro, founded in 1682. The College of Guadalupe of Zacatecas followed in the first decade of the eighteenth century. These colleges shared the work of evangelization in Texas. Not until 1734 did the vicegeral capital get a college for the propagation of the faith, San Fernando, the training place for Junípero Serra and other California missionaries.

In addition to the members of the regular orders, secular priests (ordained to serve in a diocese) served in northern New Spain as parish priests and as chaplains of presidios. Secular priests had accompanied Pedro Menéndez de Avilés in 1565 and were soon established as parish priests in St. Augustine. They, like the members of the regular orders, were nominally subject to bishops who lived

in distant cities and very rarely made visits of inspection. The bishop of Santiago de Cuba was responsible for Florida, and on two occasions in the seventeenth century an auxiliary bishop was appointed for the area. In 1621 the newly created Bishop of Durango took over the responsibility for New Mexico from the Bishop of Guadalajara, and later California was placed in his huge diocese. Near the end of the colonial period new bishoprics were created in the northern cities of Monterrey and Arispe, Sonora.

Soldiers and settlers were as important in Spanish North America as the more celebrated missionaries. Soldiers were not usually members of the Spanish army but armed civilians who were part-time settlers, part-time soldiers. The contract of Pedro Menéndez de Avilés for the first permanent settlement in the United States required him to bring to *La Florida* one hundred farmers and close to four hundred additional armed settlers whom he recruited and trained. Juan de Oñate was forced to raise an additional eighty armed settlers because the five hundred he had originally recruited for New Mexico dwindled below the specified two hundred during the years his *entrada* was delayed by a change in viceroys. Characteristically, soldiers assigned to the fortified presidios were delegated to defend the missions and to help enforce mission discipline on the often recalcitrant "neophyte" Christian Indians.

In the eighteenth century the defensive effectiveness of the far-flung presidios became a royal concern. In Florida only the Castillo in St. Augustine withstood the depredations of the English Carolinians and Georgians and their Indian allies. In the West, Brigadier Pedro de Rivera in the 1720s, and Field Marshal the Marqués de Rubí in the 1760s, made tours of inspection lasting years and covering several thousand miles. Both tours resulted in well-intended sets of regulations that did little to improve the effectiveness of soldiers operating over harsh American terrain against mobile Indian opposition. Rubí also recommended a retreat, a pulling back of presidios excepting those in Santa Fe and San Antonio, to a line along the 30th parallel in order to concentrate defense in areas actually settled, rather than merely claimed as Spanish territory. Rubí's advice led to the abandonment of the posts in East Texas and adjacent Louisiana.

Accompanying both Rivera and Rubí were military engineers, specially trained officers important to Spanish architecture and urban development in North America. The Spanish Royal Corps of Engineers, founded in 1711 by a Fleming, the Marqués de Verboom, required officers to pursue rigorous mathematical, scientific, and technical studies, in schools like those already established in Brussels and Paris, to prepare them for work in cartography, civil engineering, and architecture. No more than eleven members of the Corps served at one time in New Spain; therefore much work was done by regular officers who had acquired some training in engineering. One of the first members of the Corps to arrive in New Spain, Francisco Alvarez Barreiro, accompanied the Alarcón expedition which reinforced Spanish Texas in 1718 and then joined Brigadier Rivera on his eight thousand mile inspection tour between 1724 and 1728. Another member of the Corps, Nicolás de Lafora, marched with Rubí between 1766 and 1768, keeping a diary of the journey and drafting maps. Drawings of twenty-two presidios, now the most valuable source of information regarding the layout and extent of Spanish communities in northern New Spain in the eighteenth century, were made by Joseph de Urrutia, an able map maker who was not a member of the Corps, and who later became an important Spanish general. Gilberto Guillemard, who learned engineering on campaign with Bernardo de Gálvez against British posts on the Mississippi and against Mobile and Pensacola, designed the cathedral and the still existing flanking buildings the Cabildo and the Presbytère in New Orleans.

Chapter I

As early as 1566 a military engineer, Captain Pedro de Redoban, was in Florida directing the construction of a fort to replace one that Indians had burned down. In 1587 Philip II had in his own living quarters plans for fortifications in Florida and, possibly, in the area of the English colony at Roanoke Island. The great military engineer of the Americas, the Italian-born Juan Bautista Antonelli, had made those plans. In the late nineties, Antonelli visited Florida on a tour of inspection before returning to Spain after designing great stone fortifications for the defense of San Juan, Puerto Rico; Cartagena; Vera Cruz; and Havana. Another engineer who worked in Havana, Ignacio Daza, made the original plans of 1672 for the Castillo de San Marcos, constructed of local coquina stone. In the eighteenth century the defenses of St. Augustine were assessed by a third engineer from Cuba, Antonio de Arredondo. Strengthening the Castillo was begun a few years later in 1738 under the direction of Pedro Ruiz de Olana from Venezuela and completed in 1756 under Pedro de Brozas y Garay, a military engineer who had been posted at Ceuta in Morocco. Two military engineers from Havana, Pablo Castelló and Juan de Cotilla, were in St. Augustine in the 1760s mapping the city and appraising its buildings in preparation for its transfer to England. Another engineer, Mariano de la Rocque, designed the parish church after the city was restored to Spain. An Austrian-born engineer, Jaime Francke, led the construction of the earliest fortification of Pensacola.

The Castillo was unique among Spanish fortifications in the United States for its sturdy stone construction. Proposals for such a fortification were initiated in St. Augustine as early as 1586, after Drake's destructive assault, but the town had to make do with wooden forts, roofed with slabs of concrete, for more than eighty years. Then another English sack in 1668 and the establishment of an aggressive English outpost at Charleston in 1670 persuaded Spanish officials to authorize a costly stone structure. Before that, massive fortifications of stone had been provided only for ports essential to the protection of silver fleets and for Acapulco, the port used by galleons bringing treasures from Asia. Nine or ten rapidly decaying wooden structures had preceded the Castillo in St. Augustine, and wood and sun-dried mud bricks were used for almost all the Spanish fortifications in the United States. These were surprisingly numerous. Roughly thirty sites have been identified for presidios or lesser forts, and in several of these places structures were from time to time reinforced or completely rebuilt.

The condition of the forts and the overall defensibility of the very extensive northern frontier of New Spain was of recurring concern. Inspecting officers such as Brigadier Rivera and Field Marshall Rubí were critical, troubled by the state of the defenses and their cost to the royal treasury. In addition to finding the forts inadequate to repel attacks, Rivera and Rubí found the soldiers ill-trained and exploited for personal profit by their officers. At best the fortifications consisted of rectangular enclosures of wood or adobe, sometimes amplified by a palisade and, at one or two corners of the rectangle, by a pointed or circular bastion. The unusually strong presidio at San Sabá in central Texas was a fully enclosed rectangular structure of rubble stone, with round bastions at two opposite corners and outlying parapets and a ditch. Suggestive of the state of most presidios was the report in 1777 of the new governor of California, Felipe de Neve, that three of his four presidios were "without any defense other than their garrisons." A decade earlier Joseph de Urrutia had portrayed the presidio of San Antonio as a very loosely rectangular, in no sense enclosed, aggregation of structures including the house of the governor, the guardhouse, and strips of houses for the soldiers. The plan of Santa Fe showed the governor's

house but no suggestions whatever of a defensible rectangular enclosure.

Presidios such as San Antonio and Santa Fe had in the later eighteenth century become almost indistinguishable from the houses of settlers and of the families of soldiers and of retired soldiers which surrounded them. Their appearance probably resembled that of the earliest communities of Spanish North America. We know little about the layout of the first settlement, Lucas Vázquez de Ayllón's San Miguel de Gualdape of 1526 in coastal Georgia, except that it had a church and temporary houses for its hundreds of armed settlers. Vázquez de Ayllón's contract authorized fortified structures, but we do not know if any were built. Santa Elena, capital of Pedro Menéndez de Avilés' *La Florida*, founded on Parris Island in South Carolina in 1566, had a church, at least eighty houses, many with flat concrete roofs and elaborately furnished, and three different forts during its twenty-one years of existence, but there is no information regarding its plan.

For St. Augustine, founded by Pedro Menéndez, contrary to his original intention, a year earlier than Santa Elena, we have two slightly differing engraved views made by a gifted Italian, Baptista Boazio, who was a member of Sir Francis Drake's fleet that destroyed St. Augustine in 1586. His remarkable engravings are the earliest pictorial representations of any North American city. They portray progressive stages of Drake's attack, a hexagonal wooden fort on the north with nine cannon, and at a considerable distance to the south, separated by two streams, a carefully laid out town. Eleven rectangular blocks, primarily of one-story houses, are placed in three rows south of an open area containing a watchtower, a "town house," and a church. Along the shore, just east of the rectangular blocks, are two less ordered groups of structures bordering narrow lanes. Boazio's image of St. Augustine resembles one half of the type of ordered town plan prescribed for new settlements as early as 1513 and given full expression in Ordinances for the Discovery, New Settlement, and Pacification of the Indies, issued by Philip II in 1573 and later incorporated into Laws of the Indies.

The provisions for ordered urban design prescribed in the royal Ordinances were still determinative in 1781 when Governor Neve gave directions for the laying out of the new pueblo, Los Angeles. The Ordinances descend from classical ideas of planning enunciated in *The Ten Books of Architecture* of Vitruvius and reformulated in the Renaissance by the great architect and theorist Leon Battista Alberti. Of initial concern was the selection of a site. It should be elevated and healthy with fertile land and good access to waterways or, if inland, to roads. It should also be close to settlements of Indians, the object of Christian evangelism. Of essential importance was the initial preparation of an overall plan dividing the site "into squares, streets, and building lots, using cord and ruler, beginning with the main square from which the streets are to run to the gates and principal roads and leaving sufficient open space so that even if the town grows it can always spread in the same manner."

The crowning element of the town, the plaza, was to be placed at the center of inland towns and at the landing of coastal ones. Plazas, like forums in Vitruvius, were to be rectangular with the longer side at least half again the length of the shorter side. Such a shape was regarded as most suitable for the town's fiestas. The sides of the plaza, and the four principal streets, which ran out from the midpoints of its sides, were to be provided with colonnades for protection against sun, wind, and rain. The plaza, and the town as a whole, was oriented to make each corner face a cardinal direction in order to minimize exposure to the principal winds.

A prominent site on the plaza was to be chosen for the church, making it visible from the sea in a

coastal town. In inland towns it was to be elevated upon a raised base apart from other structures, so that it could be seen with its striking decoration from all sides and would appear impressively authoritative. Places on the plaza were specified for the structures of the royal and municipal governments, for the custom house, for the hospital, and for the arsenal. Houses for merchants, in which business was transacted, were also given preferred sites on the plaza.

An overall gridiron layout of streets was implicit in the Ordinances and two streets were specified to run out in different directions from each of the corners of the plaza. Building lots for prominent citizens, *caballerías*, were approximately two hundred feet in depth and one hundred feet across. Those for ordinary individuals, *peonarías*, were one hundred by fifty feet. Larger additional allocations of land for cultivation and for pasturing livestock were assigned beyond the built-up area of the town. Distribution of lots was determined by lottery. Essential to the Spanish conception of a community was the reservation of a tract of land for a commons sufficient for recreation and pasturage even if the town grew substantially in population. The other unallocated land was retained by the royal government for assignment of future settlers.

With the exception of the prominence of the church, a classical orderliness in appearance was desired in the structures of the town as well as in the geometrical pattern of the layout. The final Ordinance on the design of towns urged officials to "try as much as possible to have all the buildings of one type in order to enhance the beauty of the town."[2]

The domestic buildings and all but a few of the churches constructed along the northern fringe of Spanish America were relatively uniform in appearance, primarily because they were built inexpensively of materials readily available in their region, and suggested little of the aspiration for grandeur evident in the more imposing structures of central New Spain. Both houses and churches were designed by Europeans as modest versions of remembered European structures, but Indian building techniques were frequently adapted, in part because the labor force was indigenous.

In Florida the dwellings of ordinary settlers, and many of the churches, were constructed of frameworks of poles filled in with lesser vertical elements interwoven with horizontals of willow branches, vines, and twigs plastered with clayey earth mixed with Spanish moss. Roofs, like Indian ones, were of woven palm thatch. More pretentious houses were covered with planks resembling rural structures in the Basque region. A quarry of coquina stone was discovered near St. Augustine before 1581, but poverty and the lack of stonemasons delayed its exploitation. Tabby (*tapia*), a concrete made from oyster shells, was in use in the 1580s. We know it was used for roofs and for a church floor. There may have been some tabby walls for the lower stories of particularly ambitious houses. Finally in 1672, nearly a century after its discovery, coquina stone was put to use with construction of the Castillo de San Marcos.

In New Mexico timbers were used to support flat earthen roofs. The primary construction material used for the walls was the earth itself in the form of adobe, sometimes reinforced by stones scavenged from exposed ledges. In a few areas unshaped ledge stone, embedded in mud mortar, was used. The friars, who usually acted as architectural designers and construction foremen, taught their Indian workers to make bricks of adobe, which formed walls more durable than those constructed by the puddling technique of piling up successive layers of mud dribblings generally prevalent among the Pueblo Indians at the end of the sixteenth century. No effort was made in poor, remote, and thinly settled New Mexico to teach the Indians European methods of quarrying and cutting stone.

In Texas structures of wood were characteristic

in the heavily wooded eastern section, and shelters called *jacales*, using vertical logs with the gaps filled with brush or stones and often plastered with mud, were common in the central area. Adobe was widely used in more substantial houses, and in sumptuous structures, stone. Craftsmen from central New Spain were brought to the region by the friars to design and oversee the construction of several vaulted stone churches.

In California and Arizona similar techniques were used, *jacales* for humble structures, adobe for larger houses and most churches. Stone and fired brick were rarely used. San Juan Capistrano and San Gabriel missions had churches with vaults of stone, short-lived because of earthquakes. Two other California missions had and have stone façades and walls. San Xavier del Bac, near Tucson, still stands with a prominent, Moorish-looking, white-painted dome and handsomely decorated oval vaults covering its nave and transepts, constructed of fired adobe bricks set in lime mortar with a core of stone rubble.

The architectural remains of Spanish North America constitute a fraction of the mission and urban churches, houses, and forts constructed during the centuries of Spanish occupation. The use of rapidly perishing materials, wood and adobe, in almost all buildings contributed to their disappearance, as did the fragility of settlements on the extreme northern fringe of Spanish America, months away from the urban centers of central Mexico and far beyond the rich mining communities of northern Mexico. Indigenous populations were sparse, relatively poor, and in many regions migratory, lacking the complex urban civilizations and dense populations of the Aztecs and other peoples of the central region, characteristics which had made relatively easy their conversion to Christianity. Sizable subsidies from the chronically impoverished royal treasury were required to sustain the northernmost settlements and, except in New Mexico, the primary justification of the settlements and their expense was imperial defense. In the sixteenth century Florida was settled to stave off French incursions into Spanish America and to protect the Bahama Channel, critical to the safe return of fleets carrying the treasure of Mexico and Peru. At the end of the next century Texas was first settled to form a bulwark against the French threat of La Salle on the Gulf Coast and, later, in the Mississippi Valley. The final Spanish *entrada* in North America, to Upper California in the second half of the eighteenth century, was stimulated by reports of the presence of Russian and English mariners and fur traders on the northern Pacific coast.

In all three regions, Florida, Texas, and California, presidios and soldiers were essential, but the primary agency of Spanish occupation was the relatively inexpensive mission. The immense, well-intentioned missionary efforts of the Spaniards produced thousands of conversions to Christianity and brought to indigenous peoples many elements of European technology and some rudiments of Spanish culture. But for the Indians the effort to convert them was catastrophic. European diseases for which they had no immunity, and the demoralizing effect of relocation in almost penal mission communities where much of their cultures were disparaged and they were treated as children of adult size, devastated native peoples. In mission after mission, region after region, populations did not replenish themselves despite constant efforts to replace the human losses by drawing in new prospects for conversion. Instead, the Indians frequently lost spirit, often fled, and in massive numbers they died.

Settlements centered upon what in Florida was a progressively failing missionary enterprise were especially vulnerable to distant political changes and the constant pressure of English and, later, American frontiersmen hungry for Spanish land. By 1705 viable Spanish Florida had shrunk to the St. Augus-

| Chapter I

tine area defended by the Castillo de San Marcos and a small military community on Pensacola Bay. A century later the forty years of Spanish Louisiana ended with a transfer back to France and, almost immediately, to the United States. The upheavals of the Napoleonic invasion of Spain and the rising against Spanish authority in Mexico after 1810 deprived the remaining missions and communities in Texas, New Mexico, Arizona, and California of the royal support critical to their operation. After Mexican independence, decrees of secularization of the new government terminated the missions, although a few survived as parish churches. By 1846 when the remains of Spanish North America were seized from Mexico by the United States, little was left outside New Mexico of the tenuous and remarkable effort to extend Spanish civilization into the extreme north except a few dusty, struggling towns like San Antonio and Los Angeles and the already crumbling remnants of the architecture that is the subject of this book.

CHAPTER II

Florida

In 1565 the land of *La Florida* was granted by King Philip II to his formidable naval commander and strategist, Pedro Menéndez de Avilés, because of French intrusions threatening the returning treasure fleets passing through the Bahama Channel along the Florida coast (Fig. 2.1). Originally believed to be another West Indian Island, Florida was the first area in North America visited by the Spaniards and the area in which they expended the greatest effort, resources, and people. Five major expeditions, beginning with the second visit of Juan Ponce de León in 1521, preceded the fleet of Menéndez. The best remembered, the brutal *entrada* led by Hernando de Soto, had enlisted six hundred men, half of them mounted, and hundreds of pigs and other livestock. It had lasted from 1539 till 1543 and had ravaged the American Indian south from Tampa Bay to the Tennessee Valley and across the Mississippi into Arkansas and Texas. After the devastating failure in 1561 of the last of these expeditions, a massive undertaking led by Tristán de Luna y Arellano and involving five hundred armed men and a thousand settlers, Philip II questioned continuing the efforts in Florida.

News of a briefly existing French settlement of 1562 in South Carolina and apprehensions regarding the probable French return to the South Atlantic coast had prompted Philip's authorizing the appointment of Pedro Menéndez as *adelantado* of *La Florida*, an immense area conceived as extending south from the neighborhood of Newfoundland down around the Florida Peninsula and west along the Gulf toward the most northerly settlements of New Spain.

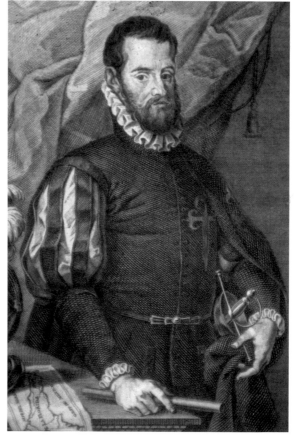

2.1. Pedro Menéndez de Avilés, from *Retratos de los Españoles Ilustres* (Madrid, 1791), reproduced in Elsbeth K. Gordon, *Florida's Colonial Architectural Heritage*, fig. 3.1

Chapter II

Several specifications of his contract as *adelantado* followed recommendations Menéndez had been requested to make to the king in the late winter of 1565. He was directed to take at his cost and under his commission "five hundred men, one hundred of them farmers and one hundred sailors, and the rest of them naval and military men and officials, stone-cutters, carpenters, sawyers, smiths, barbers, locksmiths, all of them with their arms, arquebuses, and helmets and bucklers and other offensive and defensive weapons which you may see fit."[1] He was subsequently to bring approximately five hundred settlers, farmers and workmen, two hundred of them married. Four parish priests, ten or twelve members of a regular religious order chosen by Menéndez, and four Jesuits were to be included to minister to the members of the expedition and, especially, to speed the conversion of the pagan natives of Florida. In addition, one hundred horses and mares, two hundred calves, four hundred swine, four hundred sheep and some goats and all the other cattle and livestock Menéndez judged appropriate were to be transported to spread European agriculture. Within three years, three towns with at least a hundred inhabitants each were to be built and protected with a fortified building, constructed of nearby stone, or adobe, or wood. Because of the strategic importance of Florida to Spain, the king provided 15,000 ducats from the royal treasury, and after the existence of a new French settlement was confirmed, he added three hundred soldiers to the expedition at Cádiz with additional funds for their support. Between 1565 and 1568 the royal treasury contributed 200,000 ducats to the settlement of Florida, approximately 70 percent of the complete amount expended on the land defenses of the Caribbean in these years. This dwarfed the very considerable investment of 75,000 ducats provided by the *adelantado* and his associates.

Menéndez had convinced himself of immense possibilities in the land of Florida, ranging from control of the great fishing area of the Grand Banks in the north to opening a road to the recently discovered mines of Zacatecas in the south. An internal waterway slicing through the continent connecting these regions and leading toward the Pacific and the way to China was reported to be reachable from Chesapeake Bay. Menéndez was granted a substantial personal domain in his contract and promised the title of Marqués after the completion of his settlement. He fancied himself as another Cortés developing the immense resources of a huge portion of the American continent.

Once in Florida Menéndez acted with characteristic energy and decisiveness. Within three months in 1565 he founded St. Augustine and another port two hundred miles to the south, captured Fort Caroline at present Jacksonville, and butchered virtually the entire French force, extinguishing the threat to vital Spanish maritime operations. Most prominent among his victims was the great explorer and corsair Jacques Ribault, admired by Menéndez but killed without apparent compunction. "The King of France," wrote Menéndez to Philip, "could do more with fifty thousand ducats using him than with five hundred thousand using others; and [Ribault] could do more in one year than another in ten."[2]

When Menéndez returned in 1566 after a winter working on the maritime defenses of the Caribbean, he established an outpost in an Indian community in southwest Florida. In October he was able to write to the king that he had left relatives and close associates as deputies in charge at St. Augustine, at San Mateo (the former Fort Caroline), and at Santa Elena, his recently established capital on Parris Island, close to the site of the 1562 French colony in South Carolina (Fig. 2.2). He mentioned his explorations up the St. John's River from San Mateo in search of an internal waterway to the southern gulf coast, and stressed the necessity of establishing three fortified ports to the north,

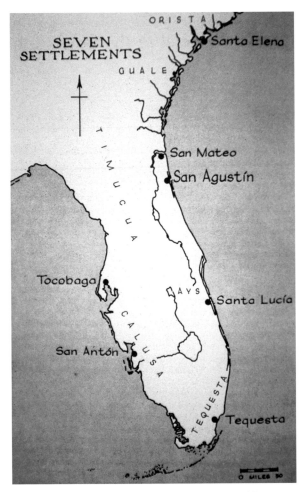

2.2. Seven settlements of sixteenth-century Florida, from Albert Manucy, *Menéndez*, p. 84.

the most important of these in the Chesapeake Bay area.

Subsequently Menéndez dispatched his nephew Pedro Menéndez Marqués on explorations of the bays and rivers of the Atlantic coast northward to Newfoundland, and of the Gulf of Mexico westward at least along most of the Texas coast. Land expeditions extended from Santa Elena across the Carolinas and the mountains into Tennessee and Alabama. Fortified posts, some with a Jesuit missionary, were established on the Florida gulf coast from Tampa Bay south to the Charlotte Harbor region and around the tip of the peninsula to the Miami area.

Menéndez's expansive optimism continued through 1567 despite his being forced by other responsibilities to limit his time in Florida to no more than a few months a year, and despite recurring mutinies among his irregularly supplied troops, and constant uprisings of the Indians caused by the Spanish dependence on native agriculture. His subordinates lacked the diplomacy in Indian relations characteristic of Menéndez which had led him to be called "Mico Santa María," Mary's great chief, by the Indians of Guale in Georgia. By 1569 Menéndez was forced by native hostility to abandon south Florida and by fiscal distress to reduce his remaining garrisons to a level at which they could be supported with a subsidy he was able to secure from the King.

Menéndez had returned to Spain for an extended stay in 1567 and had been honored by Philip II. Work on royal assignments in the following years prevented more than brief visits to Florida, although his wife and family established a home in Santa Elena in 1571. In 1574 Pedro Menéndez died at Santander on his native northern Spanish coast while preparing to lead a large armada against corsairs who had been harassing Spanish shipping on the sea lanes to Flanders in the Bay of Biscay and in the English Channel. Nine days before his death he expressed the poignant hope that after his upcoming voyage the King would free him "to go at once to Florida, not to leave it for the rest of my life; for that is the sum of my longings and happiness."[3]

La Florida after the death of Menéndez was a land of diminished hope, lessened resources, and shrinking territory. His able nephew Pedro Menéndez Marqués served as governor between 1577 and 1589. He was forced to take to the woods when Drake's huge raiding party of two thousand burned the fort and town of St. Augustine in 1586. In the following year he had to close down Santa Elena. Spanish resources in the year of preparation for the great armada were insufficient to support more than one fortified town in Florida. As a result

of the abandonment of Santa Elena, the immense *La Florida* of Pedro Menéndez's ambitions contracted to coastal Georgia and a portion of northeast Florida.

The region was organized as a captain generalcy and subsequent governors were military or naval officers. One, Gonzalo Méndez de Canzo, rebuilt St. Augustine after the fire and storm of 1599 and made many improvements, dreaming of an expanded Florida, but was forced to defend its continued existence in an official inquiry and was dismissed before the inquiry results reached Spain. The government continued to provide support for the St. Augustine garrison and to underwrite the repair and rebuilding of the fort, finally in stone, but it increasingly shifted from its original military emphasis in attempting to pacify the area to less expensive missionary activities. The friar replaced the soldier as the most significant Floridian. When the Jesuits withdrew from *La Florida* after the 1571 slaughter of eight of their number in a Virginia post between the James and York rivers, they were replaced by Franciscans. Florida became a Franciscan *custodio* in 1608, and a full province in 1612. By 1655 seventy Franciscans were stationed in Florida serving, they stated, twenty-six thousand Indians, Timucuans of northeast Florida and Guales of coastal Georgia. In the following decades, before they were routed by the English and their Indian allies, they expanded the missionary effort 250 miles west to the provinces of Apalachee and Apalachicola. Pensacola was established in 1698 to oppose the French threat to the central Gulf, but in the eighteenth century Spanish Florida on the Atlantic coast contracted to a modest area around St. Augustine, defended by the formidable Castillo de San Marcos. In 1763 Florida was transferred to British control, and twenty years later back to Spain. The second Spanish period, marked architecturally by the construction of a stone church in St. Augustine, concluded with cession of Florida to the United States in a treaty negotiated by John Quincy Adams in 1819 and ratified in 1821.

St Augustine and Santa Elena

The foundation of the oldest city in the United States was accidental. Pedro Menéndez intended to center *La Florida* farther north at Santa Elena on Port Royal Sound, the area celebrated in the Spanish imagination since the reports of Lucas Vázquez de Ayllón in the 1520s as the fabulously fertile Chicora, and settled briefly by the French in 1562. Making landfall in mid-August 1565 near present-day Cape Kennedy, Menéndez's fleet sailed north seeking the French fort on the St. John's River. Delayed by a strong head wind, they discovered an Indian village, a river, and a harbor. After skirmishing with part of Ribault's fleet at the mouth of the St. John's, they returned for protection to the harbor they had discovered. Here they unloaded men and supplies, sent two larger vessels to Santo Domingo, and fortified Chief Seloy's large communal building in the Indian village before formally founding St. Augustine on September 8. On that day Menéndez and the main body of his fleet landed with banners flying, trumpets blaring, and cannon resounding. They were met by the chaplain carrying a cross and singing *Te Deum Laudamus*. All knelt on the North American earth, kissed the cross, and took possession of *La Florida* for the King of Spain. A Spanish type municipal government was created with a *cabildo*, or city council, consisting of Menéndez's brother Bartolomé as *alcalde*, or mayor, and two captains as *regidores*, or municipal judges. Similar governments were set up at San Mateo and Santa Elena. *Cabildos* were expanded to include royal treasury officials, resident clerics, attorneys and supply masters. In 1566 Menéndez issued ordinances for the provinces of Florida, the first European code of laws in North America, in an attempt to prevent recurrence of the earlier mutinies that

year and to insure the regular functioning of the *cabildos*.

St. Augustine was originally located close to the communal lodge which the soldiers had fortified in Chief Seloy's village. After Indians burned that structure in early 1566, the fort and the town were moved away from them to a site on Anastasia Island close to the harbor's entry bar. That fort was undermined by water and rebuilt farther inland, and in 1571 the site of the fort and the town was moved permanently back to the mainland, south of the Indian village.

Also in 1571 Menéndez's wife and family arrived in Santa Elena, founded a year after St. Augustine but designated as the capital of *La Florida*, its principal settlement and center for exploration of the interior and of the Chesapeake area to the north. As in St. Augustine, the early years had been difficult, marked by delays in the arrival of supplies and wages, a mutiny, and by hostility of the native inhabitants who were pressed to provide food.

Menéndez had anticipated a Florida rich in cash crops, perhaps gold and pearls and furs, and certainly dried fish, as well as material for naval stores such as hemp, tar, pine trees for masts, and wood for planking, both pine and oak. He planned on silk production, like that in the Caribbean Islands, for mills he intended to erect. He sent to Santa Elena Asturian farmers, good solid people from his part of Spain, "raised up with gazpacho, garlic, and onion"[4] and unacquainted with fancy inns and banquets, but they complained of the infertile sandy coastal soil and were too intimidated by native hostility to move inland.

Forty modest houses were reported in Santa Elena in 1569, many consisting of one or two rooms. With the arrival of the Menéndez family some of the houses, and their furnishings, became more elaborate. Among the Menéndez household goods unloaded at the dock were sixty-three pipes of wine; a lady's bed in the Turkish style with fringed canopies and lace and taffeta coverlets; embossed leather wall hangings; a "great rug" and four carpets, two large and two small; two pounds of silk and immense quantities of linen for tablecloths and napkins of different qualities; various types of ceramic tableware and thirty-six pewter plates of varying types and sizes; serving implements of silver; and a hamper with five copper kettles. Modern excavations have not located the site of the Menéndez house or the church. They were probably in the half of the town that has been lost to erosion. The largest house that has been excavated measured forty-two feet by eleven, but fragments of expensive Ming porcelain and decorated Majolica were found.

Social activity in the town included religious gatherings in the church with its daily Masses and prayer services and its open-air processions and fiestas for particular holy days. A confraternity of laymen assisted the priest in caring for the church and in visiting the sick and burying the dead. The church was a modest structure of wood but amply decorated with a painted altarpiece of Christ crucified, a gilded image of Santa Clara, an embossed leather canopy, costly altar vessels and linens, and richly embroidered vestments.

After Menéndez's death Santa Elena was evacuated by his son-in-law, Hernando de Miranda, in the face of Indian assault in 1576. The town was rebuilt under the governorship of his nephew, Pedro Menéndez Marqués, who in 1579 brought lumber and carpenters 150 miles up the coast from St. Augustine. In the following year he wrote to King Philip that reconstruction of the houses was proceeding well with over sixty completed. Thirty of these had walls "of wood and adobe, covered with lime (tabby) inside and out with roofs of lime" so that they appeared fortified to the Indians, who had "lost their mettle" for attacks.[5] Drake's fleet lacked a pilot to enable it to reach Santa Elena after destroying St. Augustine, but the town was evacu-

| Chapter II

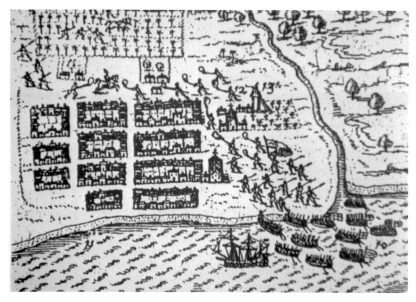

2.3. St. Augustine during Drake's raid, 1586, detail of a map by Baptista Boazio, reproduced in Elsbeth K. Gordon, *Florida's Colonial Architectural Heritage*, fig. 3.2.

ated the next year, 1587, at the recommendation of Menéndez Marqués, who had shifted his capital to St. Augustine and saw no way to sustain two towns in Florida.

The earliest representation of St. Augustine, Baptista Boazio's rendering of its appearance in 1586 under attack by Drake, presents a stylized array of houses arranged in eleven rectangular blocks placed parallel to the waterfront in four tiers and south of an open area containing a large governmental structure, a modest church, and a tall watchtower (Fig. 2.3). Presumably the layout of the town when it was rebuilt in the years after 1586 continued to resemble Boazio's representation. Albert Manucy, the careful student of St. Augustine architecture, believed that "the same eleven block nucleus [that existed in 1586] exists today."[6]

A fire, which consumed the Franciscan friary, the parish church, and much of the southern part of the town, and a storm surge, which demolished part of the fort and several houses in the northern section, devastated St. Augustine in 1599. Upon his arrival in 1597 Governor Gonzalo Méndez de Canzo had repaired the church, built a second small hospital that had a chapel and was tended by an elderly black nurse, and also set up a public market and a horse-drawn grist mill. Then he re-created the town after 1599. He laid out additional lots south of town and, to expand the agricultural land, drained a swamp called "El Gran Mosquitero." He rebuilt a wooden church, "one of the neatest and best finished of its kind in the Indies."[7] To the north he created a plaza sizable enough to serve as a parade ground and erected on its sides a governor's house, a warehouse-treasury, and a guardhouse. The filling out with streets and houses of the northern section of the town, reaching up to the area of the fort, was delayed. No more than five hundred Europeans lived in the St. Augustine area in the early seventeenth century, and growth was slow throughout the century. By the mid-eighteenth century the city layout resembled that prescribed in the royal Ordinances of 1573 with a central plaza facing the harbor and an approximate gridiron of streets equally balanced between south and north.

The first work of construction in Florida was performed by soldiers, but later most forms of arduous labor were performed by natives or by black slaves. Indian labor gangs, organized by their chiefs under the *repartimiento* system, served in St. Augustine and Santa Elena. They worked in the fields clearing, spading, sowing, cultivating, and harvesting, and they unloaded ships at the town dock and paddled canoes. They provided the principal means of transportation by land in the region, staggering under oppressive loads as baggage bearers. As construction workers they built and repaired houses and public buildings and worked on the fort. A normal term of service for a work crew in St. Augustine was two weeks. European Floridians considered Indian labor light, involving no labor as arduous as the work in mines required elsewhere in Spanish America. They were puzzled that the Indian death rate was comparable to that of other regions. Florida Indians, wrote one governor, "are the least worked and best treated in the Indies."[8]

Pedro Menéndez had been granted in his con-

tract the privilege of importing five hundred slaves "in order that the town may be built and the lands cultivated and for planting sugar."[9] Perhaps fifty slaves were brought to Florida in the early years. In 1581 the king's government ordered officials in Havana to send royally owned slaves to Florida to replace those who had died. Two years later a report was sent to Spain describing royal slave labor assisting in clearing land for planting, sawing timber, and constructing a church, a blacksmith shop, and a gun platform for the fort. After this work was finished in St. Augustine, ten slaves were sent to Santa Elena for work on the fort there.

By the 1650s the neat wooden church constructed by Governor Mendez de Canzo was leaking, termite ridden, and in danger of collapse, but it was not replaced for a quarter of a century. In 1678 Governor Hita Salazar built the first church constructed of stone and mortar in Florida. A bell tower of imported ashlar stone was later added to this church. These structures were destroyed in 1702 when English forces, led by Governor James Moore of Carolina, failed to capture the Castillo but destroyed everything in the town except some twenty houses and the hospital and chapel of Nuestra Señora de la Soledad, which was partially burned. Royal funds for the reconstruction of the church were diverted to pay for additional defenses, and the replacement church remained unfinished when Florida passed to Great Britain in 1763. The hospital chapel served as the city church but it was so small that overflow parishioners had to stand outside during Mass, and Auxiliary Bishop Francisco de San Buenaventura wrote after his arrival in St. Augustine in 1735 "when it rains [being inside the church] . . . is the same as being outside."[10]

Four secular priests had accompanied Pedro Menéndez to Florida to minister to members of the expedition on the ships and in the towns he planned to found. One was the chaplain of the fleet, Francisco López de Mendoza Grajales, who wrote a memoir of the expedition and was installed as parish priest of St. Augustine. Support for the parish came directly from the king, from a share of church tithes, and from fees paid for particular religious services, such as marriages and funerals. Gradually the clerical staff expanded to a second priest and then a third, replacing a soldier who served as sacristan. By 1697 the parish priest, who was the university graduate Alonso de Leturrondo, had as clerical staff members a chaplain as well as a chief and an assistant sacristan. The next year another priest, an organist, was added. The lay staff comprised a housekeeper, four slaves, and a boy for sweeping. By 1730 two acolytes, boys in clerical dress, had joined them.

The dramatic calamities of St. Augustine's long history, destruction by powerful invaders and raging fires, the slower processes which undermined wooden structures through erosion and decay, and the demolition of ruined stone chapels for building material, have deprived us of the remains of any religious structure before the church which was completed in 1797 and incorporated into the present cathedral. Public buildings and houses fared only slightly better. Virtually nothing survives unaltered from two hundred years of the first Spanish period, but recent studies of Albert Manucy and Kathleen Deagan have provided considerable information about houses in St. Augustine of the sixteenth century and later. Deagan's *Spanish St. Augustine* is primarily the report of archeological work, and Manucy's *Sixteenth Century St. Augustine* depends considerably upon the careful study of maps, notably one associated with Ensign Hernando de Mestas, emissary of the governor in St. Augustine to the Spanish court in 1595. Manucy examined carefully the map's representations of the town pier, the nearby guardhouse with eight cannon, the church, and the large "*casa de general*" (Fig. 2.4). But he was primarily concerned with the layouts and the materials and methods of construction of the houses. He quoted, partly in confirmation of the renderings of de Mestas's map, Fray Andrés de San Miguel's

2.4. Buildings of St. Augustine c. 1593, detail of a map of the area (see fig. 2.10), reproduced in Elsbeth K. Gordon, *Florida's Colonial Architectural Heritage*, fig. 3.3.

description of St. Augustine in 1595, "all the walls of the houses are wood, . . . the principal ones of board, [and] "the roofs are palm. . . . The fort is wood and terreplained [has gun platforms]. . . . Now they have told me they have built a small room of lime and stone in the middle of it, brought at so much cost, for keeping the powder. . . . The Spaniards make the walls of their houses with . . . red cedar because the part of it in the ground does not rot."[11]

Manucy believed that house lots in St. Augustine generally conformed to the standard smaller lot defined in the urban Ordinances of 1573, the *peonaria*, fifty by one hundred Spanish feet, or forty-four by eighty-eight English feet. He endorsed Kathleen Deagan's finding that a common layout was characteristic of these lots throughout the whole period 1565 to 1763. The short side of the lots faced the streets. Ordinary houses were placed directly along the street with a porch attached to one of their sides at right angles to the street. Larger houses extended from the street back into the lots. A freestanding kitchen and utility structure was often placed in a rear corner of the lot and a garden wall ran down one of its long sides. One or more wells, originally lined with superposed barrels to prevent the sandy soil from dissolving, were placed near the kitchen.

Manucy suggested that the first shelters in St. Augustine consisted of walls supported by unworked branches and thatched with palm. Sometimes these walls were elaborated into a woven mesh of twigs or vines (a wattle) and smeared with mud (a daub). He devoted separate chapters to hypothetical houses of people of three different levels of wealth, humble houses of the poor, more substantial houses of the middle class, and relatively elaborate houses of the community leaders such as Pedro Menéndez Marqués. The houses of the poor were lightly framed to support walls of palm thatch. More substantial versions were thickened with wattle and daub.

Both middle- and upper-class houses were substantially framed in wood and had walls of sawed boards like those of rural northern Spain. The frames were constructed with sills of cedar or cypress which were placed upon beds of shells. Cypress and cedar were also used in the upper portions of the frame for ridgepoles and rafters because of their superior resistance to rotting. Posts and beams of pine formed the intermediate section of the frame. Walls of middle-level houses were made of planks of cedar and cypress, and roofs, like those of the ordinary houses, were of palm thatch. Some upper-class houses of the sixteenth century, Manucy believed, were of two stories with their first-story walls constructed of tabby. Most other scholars believe that widespread use of tabby walls began in St. Augustine only after Moore's invasion at the beginning of the eighteenth century. Manucy thought that roofs of elaborate sixteenth-century houses had planking to support tiles made of tabby.

The soil of coastal Florida was unsuitable for adobe construction, and the climate shortened the durability of buildings of wood. Therefore efforts to make use of concrete and masonry began early. Limestone was ordered from Havana in 1577, and lime for mortar and concrete was soon manufactured by burning the plentifully available oyster shells. Father San Miguel mentioned a masonry powder magazine in the fort in 1595, and fifteen years earlier Pedro Menéndez Marques had described concrete roofs and lime-coated walls in Santa Elena. Use of tabby had probably spread to St. Augustine before Santa Elena was evacuated in 1587, and certainly it reached St. Augustine then. Its use was probably limited in the early years to the foundations of buildings and to special structures like powder magazines.

A report submitted just after the British took possession in 1762 provides important information about housing in St. Augustine at the end of the first Spanish period. Of 342 houses recorded, 140 had walls of tabby, 124 had walls of stone, and 78

had walls of wood. Most two-story houses had upper stories of wood above lower ones of tabby or of stone. The grandest houses had two stories of stone with flat roofs of tabby slabs concealed behind parapets. The use of tabby for walls probably began about 1700 and stopped about sixty-five years later during the British period. Wall construction with tabby was slow, requiring the tamping of oyster shell mortar into framing boards of wood in layers which had to harden thoroughly before another layer could be laid in. Months were needed to construct a wall. Sometimes vertical posts were inserted at five-foot intervals to make slightly speedier construction possible.

The principal result in housing of the twenty-year British occupation was the loss of nearly a hundred structures, most of them tabby. Walls of tabby, frequently covered by roofs of palm thatch with smoke holes open to the sky, were not durable. John Bartram, a visitor in 1766, described the tendency of poorly built tabby walls to swell and crack, and the pulling down of abandoned houses, nearly half those in the town, by British soldiers seeking firewood. During British occupation wooden shingles became normal in roofing and the number of wooden frame houses, some showing traces of Charleston types of construction, increased dramatically, from 49 reported in 1764 to 114 in 1788.

There was some loss of coquina stone houses, but nearly a hundred stood when the Spanish returned in 1783. Even the largest of the Spanish houses before 1783 lacked chimneys and glass. Windows were usually small and limited in number. They were protected by gratings of lathe-turned spindles, and large ones sometimes projected from the walls on the street side, affording the occupants views of the activities in the town without being visible themselves.

A new quarry for coquina was discovered on Anastasia Island to replace the old one which had been depleted, and the British found stone nearer to town, close to the inlet. Normally walls of one-story

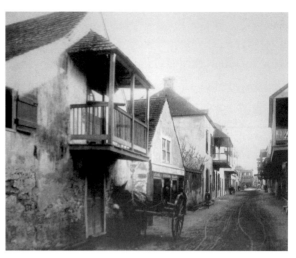

2.5. Charlotte Street, St. Augustine, in 1886, still reflecting its appearance in the second Spanish period, with balconies overhanging the street, photograph by George Barker.

houses were just under one foot thick and those of two-story houses about a foot and a half.

Shaded side and rear porches, sometimes with roofs adjusted to admit the winter sun, were a standard feature of St. Augustine houses for well over two centuries. The front balcony extending over the street, now characteristic of many houses in the city, was first recorded in a description of the governor's house in 1713 (Fig. 2.5). The overhanging balconies were supported by extensions of the timbers holding up the second floor, by extensions pegged into those timbers, or by wooden corbels.

Stone walls enclosed gardens to the side and rear of substantial eighteenth-century houses, and the entrances in most instances faced the side gardens. More elaborate entrances had roofs supported by arches or pillars of stone. Interior stairs were rare. Steps, sometimes constructed of slabs of tabby, gave access from the garden side of the house to the upper story.

A remarkable number of stone houses built before 1821 survive in St. Augustine, thirty-six in all, twelve from the period before 1763.

Spanish St. Augustine was, for most of its long history, a modest sized, relatively poor community. After the death of Pedro Menéndez de Avilés it was viewed by the royal government which sustained it as a defensive military outpost and, until Governor Moore's devastating attack, a center for bringing

Christianity to the indigenous population of Florida through an extended network of missions. The earliest mission, named Nombre de Dios by the Spaniards, was established in the Indian community of Chief Seloy north of town when the fort and town were reestablished on the mainland after a brief period on Anastasia Island. The Mestas map of the 1590s pictures that village with eleven structures, several with thatched walls and others possibly with walls of wattle and daub. The central structure may have been the great communal lodge. Four structures, probably churches and granaries, have crosses. Another Indian village, San Sebastian de Yaoconos, with seven structures appears on the map. At least ten communities were located close to St. Augustine and its fortification after the English and their Indian allies drove Christian Indians south from the Georgia coast and east from the Apalachee region of west central Florida. By 1714 the Indian population of the immediate St. Augustine area reached four hundred. Twelve years later it had increased to over eleven hundred before dwindling greatly in the final decades of Spanish occupation.

St. Augustine, though small, unimposing in appearance, and poor, was surprisingly self-sufficient, apart from the royal subsidy. Not until the late seventeenth century did the population pass one thousand, and an estimate places the income of two-thirds of the people below 200 pesos a year, with less than 5 percent having more than 400. In *The King's Coffer* Amy Turner Bushnell gives an account of the uses the city made of the resources available nearby. She writes: "The timber, stone, and mortar for construction were available in the vicinity, nails, hinges, and other hardware were forged in the town. Boats were built in the rivers and inlets. There was a gristmill, a tannery, and a slaughterhouse. Fruit, vegetables, and flowers grew in the gardens; pigs and chickens ran in the streets. Although it was a while before cattle ranching got started, by the late seventeenth century beef was cheap and plentiful. The swamps and savannahs provided edible roots, wild fruit, and game; lakes and rivers were full of fish; oysters grew huge in the arms of the sea. Indians paddling canoes or carrying baskets brought their produce to market on the plaza: twists of tobacco, pelts, painted wooden trays, packages of dried cassina tea leaves, rope and fishnets, earthenware and baskets, dried turkey meat, lard and salt pork, saddles and shoe leather, charcoal, and fresh fish and game, but especially they brought maize."[12] Imported goods, sold by a dozen or so merchants most of whom were moonlighting soldiers, were less plentiful and more expensive. They were a necessity for members of the local upper class and their cost strained that group's fiscal resources.

St. Augustine had from its origin a hierarchical social arrangement of the Spanish type. The Menéndez family and their relatives constituted the original ruling class. A celebrated early incident rose from the actions of Lt. Governor Diego de Velasco, a Menéndez son-in-law. He verbally insulted and dismissively pushed aside a tailor's daughter who had dared to assume the honorific title of *Doña*. The woman's father, Alonso de Olmos, sued Velasco and presented papers supporting the claim of his family to caballero standing. Even in the sixteenth century, as Albert Manucy demonstrated, housing differed according to class standing, and the differences grew throughout the next century. After Moore's destruction of the town, 149 property owners claimed losses totalling 62,570 pesos. The most modest houses were valued between 50 and 80 pesos and middling houses between 200 and 500. Eight families claimed losses over 1,000 pesos and one structure was valued at 6,000. Upper-class families were forced to spend in order to demonstrate their social standing. An important man had a patronage network which might include free blacks, mulattos, and Indians, as well as poor Spaniards. Households included poorer relatives, servants and, on the average, four or more slaves costing about 500 pesos and requiring clothing and food. Salaries in the fort remained constant during the seventeenth century but the costs of

maintaining a household constantly increased. Majolica tableware, white bread, and wine, at 160 pesos a barrel, were normal expenses. Much clothing could be made by local tailors and most shoes by town cobblers, but impressive dress for great occasions had to be imported and was very expensive. Boots of cordovan leather, silk stockings, shirts with lace collars and cuffs, breeches, cloak, and doublet of lace all cost substantially more than in Havana or Mexico City. Horses, essential to upper-class status, were relatively few and high in price until after the middle of the seventeenth century.

Despite the destructiveness of Governor Moore's siege and later invasions by Colonel John Palmer of Carolina in 1728 and by General James Oglethorpe, founder of Georgia, in 1740, St. Augustine almost tripled in population in the eighteenth century and became larger than any cities in the present United States south of Philadelphia, except Charleston and Norfolk. A comprehensive account of St. Augustine at the end of the first Spanish period was written in 1759 in a report to the king by Juan Joseph Solano, chaplain of the presidio (Fig. 2.6). The town was laid out longitudinally, Solano wrote, about two thousand yards long and less than seven hundred wide. "The houses that constitute it are 303, of stone and flat roofs 23, roofed of shingles or boards of the same material 26, and . . . some of a second story. Those of one story covered with thatch are 190, and the rest are of board or palm thatch." The population, including Spaniards, Indians, Negroes, and Mulattos, consists of "462 families that between children and adults form the number of 2,446 persons" who live in the 303 houses mentioned. In addition to these are "124 forced laborers; 26 soldiers detached to the lookouts of Picolata, Matanzas, Santa Anastasia and the Pueblo of Mose, 50 men that garrison the fort of San Marcos de Apalachee including a subaltern and a superior engineer, 23 forced laborers exclusive of those assigned to that fort by the Governor of Havana, and 40 Islander families that live outside the enclosure of this city in 26 huts that compose the number of 171 persons. There are 35 free Negroes in the Pueblo of Mose and 79 Indians that form the Pueblos of Tolomato and de Leche [Nombre de Dios]. These compose 2954 persons."

Solano lamented the inadequate state of reli-

2.6. Plan of St. Augustine, published by Thomas Jefferys in 1763, revealing a layout in accord with the royal Ordinances. The central plaza faces the water and contains the guardhouse, the uncompleted church, and, at its inner edge, the governor's house. The Castillo de San Marcos is on the water at the upper corner of the town. The "parish church," the small and leaky chapel of the hospital, is in the older lower half of the town and the Franciscan convent at its lower fringe. Reproduced in Elsbeth K. Gordon, *Florida's Colonial Architectural Heritage*, fig. 5.

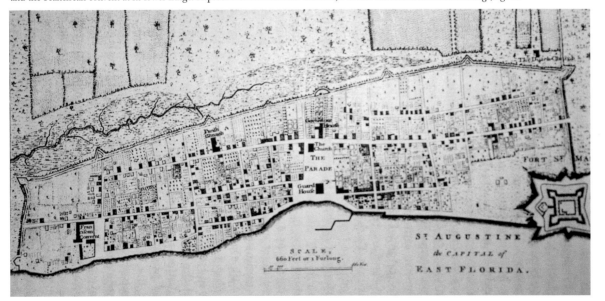

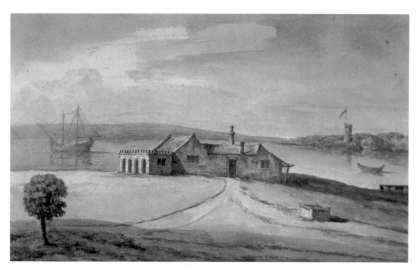

2.7. Guardhouse and plaza of St. Augustine with lookout tower on Anastasia Island, drawing 1764, British Library.

gious and hospital facilities in St. Augustine. The recently relocated hospital had neither a physician nor a surgeon and the presidio's apothecary shop lacked sufficient medical supplies. Royal grants totaling 40,000 pesos had not secured the completion of the long anticipated new parish church. It stood empty in the plaza with four stone walls but no roof or interior furnishings. Like Bishop de San Buenaventura more than three decades earlier, he complained about the chapel of the old hospital which still served as the principal church in town. Its inadequate size forced the overflow congregation to stand outside, enduring rain or the hot Florida sun. Three stone arches had recently been constructed to replace rotting wooden supports, but the roof and its framing were so deteriorated that rain fell directly on the altar. Improvements had belatedly begun in the Franciscan *convento*. A stone church structure was built which was later expanded and used by the British as a barracks and by the Americans as a jail, but some friars were still living in shelters copied from the Indians.

Solano then went on to describe recent works of construction, "the principal guard barracks . . . newly constructed of stone, roofed in board, with a shed roof to exterior portico construction, covered with the same material," which "faces the Plaza de Armas, and . . . the hospital [which] is a house that was the dwelling of the Accountant Don Francisco Menéndez Marquez, newly rebuilt (Fig. 2.7). It has two large rooms, one above the other, ample for 12 beds each one, and two interior rooms below, used for treatment by unctions of mercury. . . . The Governor's house, newly rebuilt, is of stone covered by board. The Episcopal Palace was built with 4000 pesos that were intended . . . for the church, and on which the illustrious Señor Don Francisco de San Buenaventura y Texada [Auxiliary Bishop, 1735–1745] expended 1726 pesos of his own to complete. . . . It has a flat roof. Outside the main salon and oratory it has seven rooms, a dining room [of] running arches with sufficient capacity."

Solano mentioned the total lack of stone in the region except that of a single quarry on Santa Anastasia Island opposite the city, and criticized the streets as poorly arranged but praised the drinking water from wells easily dug in the sandy soil. He went on to a glowing description of the available fruits. "These are many . . . as in Spain, such as white and black figs, peaches, quince, mulberries, other berries, and plums. Inside the city are arbors where very mellow grapes are gathered. In the woods they are abundant where they grow wild, and there are also sweet and sour oranges."[13]

More information about St. Augustine architecture can be found in the appraisals made of property at the time of the British takeover. The governor's house, which had been rebuilt frequently during St. Augustine's early history, had been burned along with most of the structures in town during Governor James Moore's invasion in 1702. It was rebuilt before 1713 and rebuilt again, as Solano stated, shortly before 1759. A drawing of this structure dated 1764 is now in the British Museum, and its appraisal provides interesting information (Fig. 2.8). The most valuable parts of the establishment were the walls surrounding the property and the observation tower, appraised at 2523 pesos. Next most valuable were the walls of the structure itself

and the kitchen, 1397 pesos. Other parts of the building itemized under masonry construction included a large door in the Doric style of architecture, sixteen columns and their capitals, the chimneys and the flat roofs. The most valuable items listed under carpentry were the frame of the building and the wooden shingles, a balcony, doors, and beams for the principal floor. Outside were twelve wells faced with masonry and many fruit trees. The most valuable were nineteen Chinese orange trees, but there were many more of the ordinary sour orange trees, as well as a grapevine and a number of peach and fig trees. The scattering of other trees included six pomegranates, a quince, and a cherry. The total appraisal value was 9062 pesos.

The guardhouse was appraised at 3466 pesos, and the value of the appraisals of private houses ranged from 8504 pesos, almost that of the governor's house, down to 758 pesos for a "second" house. The most valuable portion of the most expensive house was "hewn buttress stone," at over 3600 pesos.

After Spanish control was restored special efforts were made to attract back to Florida people who had been forced to evacuate in 1763. Stipends and compensation for the loss of former estates, and promises of more land and loans of farm implements and of slaves, induced only 123 to return by 1786 and fewer than 375 more in later years. Some were disappointed in the Florida they had left twenty years earlier and returned to Cuba and to other places in Spanish America. Roughly three hundred British stayed on in Florida, agreeing to swear allegiance to the King of Spain and to adopt the Catholic religion. Many settled on landed estates in the St. Augustine area. Later Florida was officially opened to settlement by "aliens and heretics."

An important source of people for St. Augustine was a failed agricultural project of the British period, New Smyrna. A Scot, Dr. Andrew Turnbull, had recruited 1403 laborers from Greece and Italy,

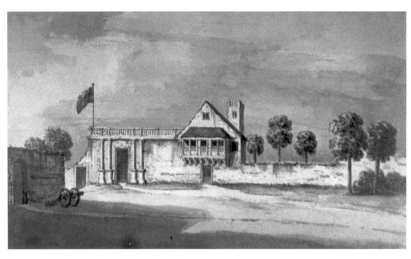

2.8. Governor's house, St. Augustine, drawing 1764, British Library, reproduced in Elsbeth K. Gordon, *Florida's Colonial Architectural Heritage*, plate B. Also see Plate I.

and especially from the island of Minorca, to grow Mediterranean crops. The colony collapsed because of widespread disease, many deaths, and working conditions resembling slavery. In 1786 Minorcans constituted more than half the population of St. Augustine, numbering 469 and clustered in makeshift houses in the northeast part of town. The population in the second Spanish period never exceeded 1600 and was remarkably diverse. In addition to the Minorcans, Greeks, and Italians from New Smyrna, the returning old Floridians, and the remaining English, Scottish, and Irish, there were people from Spain and Spanish America and Canary Islanders from Pensacola. There were also people from the United States, both white and black, Indians, and a scattering of people from Germany, Switzerland, and France.

St. Augustine, like Pensacola, remained dependent upon imported foodstuffs and upon sugar, rum, and coffee from Cuba. Increasingly, manufactured goods came from the United States and Britain. Of forty-two ships docking in 1806, five were from Havana and thirty-seven form the United States.

Architecturally the period after the Spanish return was marked by important construction, including two notable monuments of present-day

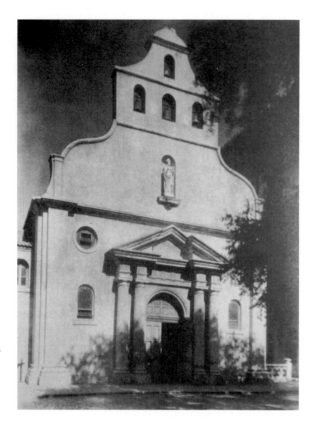

2.9. Façade of the parish church, incorporated into the cathedral of St. Augustine, photograph by Frances Benjamin Johnston.

St. Augustine, the City Gate and the façade of the Cathedral. The first structure completed, in 1793, was a new hospital located south of the plaza along the harbor where it could be ventilated by ocean breezes. Reconstruction of an adequate parish church for the city was delayed from the time of Moore's invasion in 1702 until the Spanish were forced to leave the city in 1763. Shortly after the restoration of Spanish control, the King decreed in 1786 that a new structure be built. Designs of the royal engineer, Mariano de la Rocque, were approved in 1790, but concerns regarding costs and funding delayed the laying of the cornerstone until 1793. To minimize costs, coquina stone was salvaged from two ruined Indian chapels for reuse on the selected site on the north side of the plaza. The dimensions of the planned structure were increased by governmental order from approximately 108 by 36 feet to 124 by 41. De la Rocque's design for the façade of coquina covered with lime stucco, now incorporated into the present cathedral, was slightly altered in construction (Fig. 2.9). The principal feature of the ground story is a neoclassical porch with paired Doric columns at the sides, and a frieze of triglyphs and plain metopes and a layered pediment above. The upper façade, rising into a false front above the gabled roof, contains a plain niche set over the portal and enclosed by the swinging baroque double curves of the outer edges of the wall, which come together to support a belfry at the top. The belfry has four small niches for bells, three below and one above, an ensemble more complicated than de la Rocque's conception. One of the bells is dated 1682 and is inscribed with a cross and the inscription "Sancta Joseph Ora Pro Nobis."

The roof of the church was supported by timber trusses so that the interior was open from wall to wall except for two stone pillars which supported a double balcony inside the entrance. During Mass, seating was segregated by gender and by race. White women sat on rugs spread over the central floor, white men sat on a double row of benches lining the side walls, and blacks crowded into the lower balcony. The upper balcony was reserved for the choir. Near the entrance a crucifix was placed which had been retrieved from the ruined church of Mission Nombre de Dios, north of town.

Mariano de la Rocque was also the designer of a new powder magazine located outside the town to the south. Another engineer, Manuel de Hita, was responsible for the impressively simple City Gate of 1808.

St. Augustine endured slow, steady decline after the United States took possession of Florida. Tallahassee became the political center of the state, and Jacksonville developed into the transportation and commercial center of the eastern part of the state. A brief revival came in the 1880s when Henry Flagler developed St. Augustine as a winter resort. But in 1887 a yellow fever scare and a fire, which destroyed all but the façade of the parish church and many other structures north of the plaza, depressed the

tourist business, which suffered again during the depression of 1893. Flagler's activities shifted south and the city relapsed as northern vacationers flocked to new resorts in South Florida.

Concern for the preservation of remnants of the city's Spanish past crystallized in the organization of the St. Augustine Preservation Society early in the twentieth century. In the 1930s Mayor Walter B. Frazer promoted a Williamsburg-like wholesale re-creation of colonial St. Augustine. John C. Merriam, president of the Carnegie Institution, a principal source for funding, counseled selective restoration based upon careful historical and archeological study and convinced Verne E. Chatelain, who had just resigned as chief historian of the National Park Service, to lead the St. Augustine project. Chatelain recruited Albert Manucy, an architectural historian who had grown up in the city, and W. J. Winter, who had worked in excavating Jamestown. Support from the WPA was helpful but funding from the State of Florida to supplement that of the Carnegie Institution was delayed and the Second World War interrupted work in St. Augustine. Albert Manucy and Kathleen Deagan, in particular, have greatly added to our knowledge of Spanish St. Augustine in the decades after the war.

The Castillo de San Marcos and other Fortifications

Florida was founded for Spanish territorial defense and its people were constantly building and rebuilding forts. At least nine wooden forts preceded the construction of the stone Castillo in St. Augustine in the 1670s, and three forts were constructed during the twenty or so years of Santa Elena's interrupted existence. Numerous fortified structures were built elsewhere in Florida beginning with the rebuilding of the French Fort Caroline, after Menéndez's daring assault, as Fort San Mateo.

Later forts include the many log and sand structures built and rebuilt by the Spaniards between 1698 and 1817 to defend Pensacola.

Fortification began in St. Augustine a day before Pedro Menéndez landed when his soldiers worked with bare hands to construct ditches and earthworks to make the communal lodge of Chief Seloy more defensible against the threat of French attack. After that structure was partly destroyed by Indian fire arrows in 1566, Menéndez moved the site away from the possibility of another hostile Indian attack to a place off the mainland on Anastasia Island at the bar to the harbor. Two wooden forts were constructed there, the second somewhat inland after the earlier one was washed away. Soldiers built the earlier fort, 170 men working in four squads from three to nine A.M. and from two to six P.M. daily for ten days. A soldiers' mutiny substantially damaged the second fort and led to relocating the fort and the town to the mainland south of the Indian village in the general vicinity of their present locations.

Fully five more forts were built in that general area in the sixteenth century, and another followed in the seventeenth century before work was begun on the Castillo in 1671. The third of the five, and the sixth of the entire series of St. Augustine forts, begun in 1586 and nearly finished at the time of Drake's raid, was described by a member of his force as "built of timber, the walls being none other than whole masts or bodies of trees set up close together in the manner of a pole, without anie ditch as yet made. . . . The platforms wheron the ordinance lay [comprising the front portion of the hexagonal structure], was whole bodies of long pine trees, whereof there is a great plentie [in the area], layd a crosse one on another, and some little earth amongst. There was in it thirteene or fourteene great pieces of brasse ordinance."[14]

Drawings of two forts have been found in papers associated with the visits to Spain in the

1590s of Ensign Hernando de Mestas as emissary seeking funding for a new fortification. One is an irregularly shaped four-sided structure identified as "the old fort . . . called San Marcos. It is entirely of wood, . . . [is] in danger of collapsing, inside and out, . . . [and is] propped up by thirty-two supports [diagonally placed timbers] which are indicated. . . . The guns on its wall are not to be fired because it is feared all the curtains will tumble down."[15]

This fort, which had replaced the orderly hexagon destroyed in the Drake raid, bears no resemblance to the sort of design for fortifications in Florida which Juan Bautista Antonelli had prepared for study by Philip II himself. The other fort is included in a "Map of the Town, Fort, and Neighborhood [Caño] of St. Augustine"[16] (Fig. 2.10). The representations at the left edge of the map of the church, guardhouse, a large communal building, and other structures seem based on actual edifices. They have been fruitfully studied by Albert Manucy for indications of late sixteenth-century building materials and techniques. The prominently placed fort, redrawn by Manucy to represent the type of forts built in 1566 on Anastasia Island, is not related by him or by other students of Florida fortifications to any of the forts built in St. Augustine after 1593. Instead, its plan seems to have been sent to Spain to suggest the type of fort officials in St. Augustine would build if they could secure sufficient funding. It may possibly be based on one of the designs prepared by Antonelli.

The fort, defended by a circling moat fed by water from the bay, is striking in its regularity. It is perfectly triangular with curtain walls each eighty feet long and expertly designed four-sided bastions at the corners. The four sides of the bastions equal the eighty feet of the curtain walls in length. Guns placed on the inner faces of the bastions could protect the curtain walls from assault. There is no indication on the map of the material of the fort, but we know that a stone fort had been requested for St. Augustine soon after Drake's raid and that Mestas had secured its approval. A grant for 10,000 ducats was awarded, and permission was given for the use of twenty blacks from Havana, including a master stonecutter, an apprentice, and three masons. Coquina stone had been available since its discovery on Anastasia Island in 1580. But the building craftsmen were not sent and an elaborate two-story fortified timber frame structure (a *casa fuerte*) with a roof of oyster shell concrete was built in 1596. This fort was damaged in the storm of 1599 and repaired. A new structure of stone was considered early in the seventeenth century when no one in St. Augustine was capable of cutting stone corners. An expert, Comendador Tiburcio Spanoqui, consulted by officials in Madrid, made extensive comments upon questions submitted by Governor Ybarra regarding plans for the structure. Spanoqui recommended that a military engineer be sent from Havana and expert stonecutters from Spain to insure competent con-

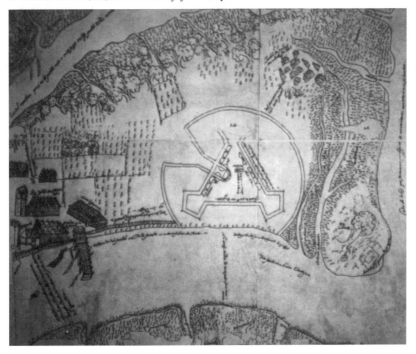

2.10. "The Map of the Town, Fort and Neighborhood of St. Augustine," c. 1593, contains at the left the structures portrayed in fig. 2.4 and at the right a perfectly regular triangular fort. Two Indian villages, Nombre de Dios and San Sebastián de Yoacos, are portrayed, Nombre de Dios near the fort and San Sebastián across the creek above the buildings of the town. The map is reproduced in Michael Gannon, ed., *The New History of Florida*, p. 67.

struction. But again nothing was done and the wooden structure endured, gradually deteriorating until mid-century, the longest enduring of St. Augustine's wooden forts. The final wooden structure was erected some time after 1647.

Within a decade, Governor Diego de Rebolledo renewed the argument for a stone fort, citing the plentiful availability of coquina locally, and suggesting buying a dozen slaves skilled in stonecutting and masonry and bringing an engineer from Cartagena. The Council of the Indies decided against proceeding without more information, and St. Augustine had to put up with the wooden structure until a pirate raid of 1668 convinced the government of the Queen Regent, Mariana, to proceed at last with a stone fortification for St. Augustine. The decision to build, made in 1669, was confirmed by the news in 1670 of increased danger from the north with the founding of Carolina by the English.

In the 1670s the number of places in the St. Augustine garrison, which had long numbered 300 and had included the friars of Florida who were supported by the military budget, was raised to 350 with the stipulation that they be reserved for soldiers, with the expenses of the friars shifted to another account. The number of regular infantry companies was also increased to three. There were also regular companies of cavalry and artillery and militia companies of both Spanish civilians and free blacks. The support staff included caulkers, interpreters, masons, a blacksmith, an armorer, a surgeon, a barber-surgeon, and a pharmacist.

Sergeant Major (a rank equivalent to a modern major) Manuel de Cendoya, the new governor, arrived in St. Augustine on August 8, 1671, after stopping in Mexico City to secure the initial year's funding for the construction of a stone fortress, 12,000 pesos, from the viceroy and *audiencia* of New Spain, and in Havana to pick up an engineer, Ignacio Daza, and several masons and lime burners. Almost immediately kilns were set up near the old

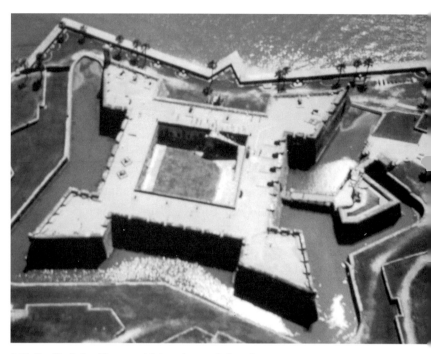

2.11. Castillo de San Marcos, aerial view, photograph from the National Park Service.

fort for burning oyster shells to make lime, and Indian workers were sent to Anastasia Island to clear the ground around the quarry of scrub oak and palmetto. The soft coquina was cut, pried from the quarry, and rafted, in blocks ranging up to four feet long and two feet thick, requiring six men to lift, over the Matanzas River to a site just north of the existing fort. The air would harden the stone into a substance effectively resistant to artillery projectiles. Ground was not broken until October and the first stone not laid until November 9, 1672. More than a year had elapsed in accumulating and grading the stone (both rough and hewn), familiarizing the Cuban stonecutters with the qualities of coquina, and training local cutters.

The plan of the fort was a standard square with pointed, four-sided bastions at the corners like the old wooden one (Fig. 2.11). It was larger in order to provide more space in the interior for living quarters, chapel, wells, storerooms, and powder magazine, and the bastions were lengthened on the recommendation of engineer Daza. The overall

length of each side from bastion tip to bastion tip was almost 300 feet. The curtain walls, approximately 125 feet in length, were designed to taper as they rose 20 feet from a width of 13 at the base to 9 at the top. Both Governor Cendoya and Ignacio Daza died in early 1673 after only seven months of construction. Except for one brief visit of another engineer from Cuba, work continued under master masons, without expert engineering advice, until the Castillo was completed in 1695. One result was extensive miscalculation of levels. Cendoya's successor, Pablo de Hita Salazar, arrived in St. Augustine in the spring of 1675 and made the Castillo defensible in six weeks. By the time he was replaced in late 1680 all the walls were up to parapet level, and the parapet of one bastion was nearly complete. Progress was twice interrupted by shortage of funds and was generally slower in the concluding stages of the twenty-three-year building campaign.

Virtually all the 138,375 pesos expended in construction of the stone fort between 1671 and 1695 was paid in wages. Approximately 150 ordinary laborers were needed to keep 15 artisans supplied with construction materials. Roughly a third of the force worked in the quarries or in transporting the coquina on oxcarts or rafts. A similar number were busy gathering oyster shells and burning charcoal in the lime kilns. Another contingent was originally needed for digging the foundation trenches and carrying away the earth in baskets. Later, mortar had to be mixed and wood furnished.

Repartimento drafts sent by Indian communities for two-week periods provided most of the workers, but poor Spaniards, black slaves, local convicts, and English prisoners of war also served. A Catholic pirate, Andrew Ransom, who had been saved from garroting by the Franciscans after the silk strangling cord broke, proved adept as a carpenter, maker of "artificial fires," and gunner.

The Indians were housed in camps and required supervisors or interpreters fluent in the languages of the areas from which the labor drafts came, Timucua in northeastern Florida, Guale in coastal Georgia, and Apalachee in north central Florida. Wages were four *reales* a day for an ordinary Spanish worker, and one *real* and meals for an Indian. Master craftsmen, masons and carpenters, were paid as much as twenty *reales* a day. A few Indians progressed to become artisans. An "Andrés" was paid as a stonecutter for more than fifteen years.

The Castillo was tested by Governor Moore's ambitious two-pronged attack in 1702. One force ascended the St. John's River and moved in from the west. A sortie from the fort destroyed nearby houses to improve the lines of fire. Moore's main force came by sea. It destroyed most of the city but found its artillery ineffective against the coquina walls of the Castillo, which absorbed the projectiles. Moore then sent to Jamaica for mortars and shells to bombard the populace who had taken refuge within the walls, but he was blocked in the harbor by a Spanish fleet and forced to burn his ships and retreat overland.

The city was then made less vulnerable by the construction of surrounding earthworks and palisades stiffened at critical points by redoubts. A force under Colonel John Palmer destroyed the village and chapel at Nombre de Dios in 1728 but did not assault the fort or the city. Subsequently blockhouses, Fort Picolata and Fort San Francisco de Pupo, were built on the east and west banks of the St. John's river at the crossing of the road west to Apalachee. The new colony of Georgia, founded in 1732, added to English pressure from the north. As a result, an inspection of the defenses was made by another engineer from Havana, Antonio de Arredondo.

In Arredondo's expert judgment, St. Augustine in 1736 was "defenseless" with an earthen wall "composed of cactus and plants" and a fort incapable of surviving a siege of twenty-four hours. He found the exterior wall still "thick and strong" but the interior "much deteriorated," and too small "to shelter all the neighborhood in the event of an approach by

the enemy."[17] The outer defenses of the Castillo, consisting primarily of a moat, seemed to Arredondo inadequate to resist assault by land.

Improvements began in 1738 under the direction of an engineer from Venezuela, Pedro Ruiz de Olana. The walls were raised five feet and, following Arredondo's recommendation, coquina vaults replaced the rotting timbers of the interior rooms. Three layers of concrete were poured on top of the vaults to create a roof six feet thick to serve as a gun deck, and a domed watchtower was constructed on the northeast bastion facing the ocean. Substantial improvements were also made to the defenses on the three land sides.

General James Oglethorpe arrived on June 13, 1740 from Savannah with seven warships and a force of fourteen hundred, including the sailors and the Indian allies. Scots Highlanders captured Fort Mose two miles to the north, which was staffed by free blacks who had escaped from slavery in the English colonies, but lost it to Spanish counterattack. After twenty-seven days the firing from the English batteries had killed only two in the Castillo. Cannonballs damaged the parapets but could penetrate the coquina walls only a foot and a half. Oglethorpe wished to attempt an attack by land, but threatened by mutiny and stymied by his naval commander who feared the hurricane season, he was forced to withdraw. Governor Montiano, who had feared for the survival of St. Augustine's garrison, wrote, "I cannot comprehend the conduct, or rules of this general."[18]

Making St. Augustine more defensible was urgent. As early as the 1560s, a lookout had been stationed near the tip of Anastasia Island where the Matanzas River met the Atlantic. In 1742, Governor Montiano erected a coquina gun platform, backed by fortified living quarters for the members of the battery, on the west bank of the river near its entrance to the ocean (Fig. 2.12). He also acted to repair the Castillo, but extensive renovation was delayed until termite damage caused part of the roof

2.12. Fort Matanzas, a gun platform near the mouth of the Matanzas River.

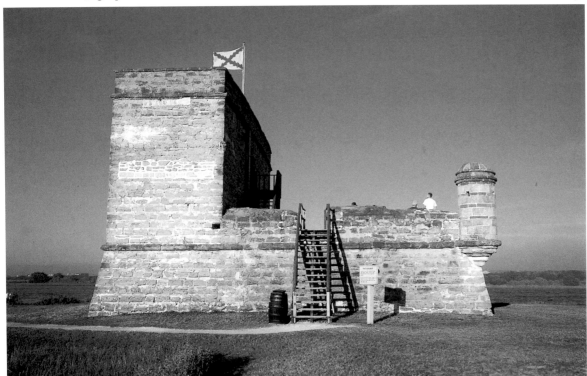

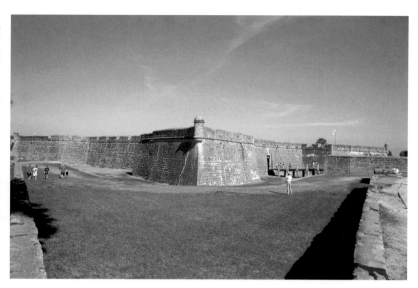
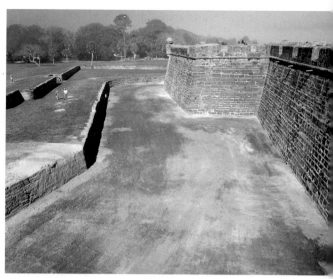

2.13. Castillo de San Marcos, view from the southwest.

2.14. Castillo de San Marcos, west side with moat and outer fortifications.

to collapse in 1749. A building campaign directed by an engineer from Ceuta in Africa, Pedro de Brozas y Garay, which culminated in 1756 with the placing of an inscription over the entrance, led to important changes. The interior quarters were approximately doubled in size, and the walls were raised to thirty feet from their bases to the crowns of their parapets. Substantial improvements were made to the land defenses. Two earthwork lines were constructed as the city's outermost barrier. For the Castillo an upward sloping earth glacis was built to protect the covered way, which shielded men with small arms posted outside the moat behind a six-foot stone parapet; the earth glacis also served to shield the walls of the Castillo (Fig. 2.13 and Fig. 2.14). The old ravelin, a triangular outwork defending the entrance, was to be increased to a height proportionate to the new walls, but this construction, begun in 1762, was stopped when news of the cession of Florida to Britain reached St. Augustine.

The British anglicized the structure's name to Fort St. Marks but did not increase the height of the ravelin or make other significant changes. They did ship more than sixty revolutionary Carolinians to St. Augustine, four of whom were imprisoned in the fort. After the Spanish returned in 1783 the military engineer Mariano de la Rocque added a neoclassical entrance to the chapel. Four years after taking over in 1821 the American government gave the fort the name it was to bear for over a century, Fort Marion, in honor of South Carolina's revolutionary general Francis Marion, "the swamp fox." Less than a decade later the action of the bay in eroding the fort's foundations became disturbingly apparent. Repair was begun on the seawall in 1834, and subsequently Lt. Francis L. Dancy wrote to the chief of the Corps of Engineers urging more extensive repairs, arguing that the judicious expenditure of a few thousand dollars would preserve for the ages a monument of Spain and of events memorable in the history of our country. The positive response of the government saved the already more than 150 year old fortress.

In addition to the Carolinian patriots Fort Marion housed other notable prisoners. Seminole leaders tricked under a flag of truce, including the famous Osceola, were held in the fort in 1837. The prominent chief, Coacooche, and the medicine man, Talmus Hadjo, escaped that year by squeezing their way through a narrowing light and air shaft at least thirteen feet above the floor of a small room in the southwest bastion in which they had been kept.

Four decades later prominent leaders of tribes

of the plains, Comanches, Kiowas, and Cheyennes, were sent to the fort in 1875, and in the late 1880s a number of Apaches, including all three of Geronimo's wives, were sent there. The commandant in 1875, Captain Richard Pratt, became concerned for the Indians who were occupying themselves entertaining white visitors in the fort and in neighboring hotels with demonstrations of tribal songs and dances, with target shooting with bow and arrow, and with warwhoops. Pratt, who later founded the Carlisle Indian School in Pennsylvania, wished to teach those under his charge to speak English and to perform useful industrial trades. Some young Indians were sent to the Hampton Institute in Virginia, and on two different occasions a school was operated by women of St. Augustine in the fort's chapel.

In 1924 Fort Marion, which had been occupied by the St. Augustine Historical Society for ten years, was designated a national monument, together with Fort Matanzas. Both forts were transferred from the War Department to the National Park Service in 1936. The original Spanish name, Castillo de San Marcos, was restored by an Act of Congress in 1972.

The Missionary Effort: Santa Catalina de Guale and San Luis de Talimali

The first missionaries in Florida were Jesuits, recruited by Pedro Menèndez de Avilès. They arrived in 1566, initially working in south Florida, and left in 1572 after a slaughter in tidewater Virginia. In those six years ten missions were established but only six dying Indians were converted, all but two of them children. The Jesuits' discouraging failure reflects the daunting difficulty of what they were trying to do. A single unarmed priest or brother, thousands of miles of ocean from comforting familiar surroundings, would venture into a native community knowing almost nothing of its language or culture, in hope of persuading its people to abandon their central beliefs and customs and to adopt those of an alien European Christianity.

The Franciscans, who replaced the Jesuits as the principal missionary order in Florida and in all Spanish North America, were more successful but they rarely succeeded in their primary aim of wholly obliterating native religious beliefs and practices and substituting those of Christianity. In addition to the immensity of their undertaking, other factors added to the difficulty of making conversions. These were identified by the missionaries themselves. The offensive behavior of Spanish soldiers dismayed the natives and made them hostile to all Europeans. The Jesuits were blamed, with some truth, for the epidemic diseases devastating Indian communities. Indian patterns of living which made conversion difficult were denounced by Father Juan Rogel, who wrote in 1570 that no admonitions of the Jesuits could break through an Indian barbarity based on liberty unrestrained by reason. This barbarity consisted largely of the Indian migratory pattern of living. Rogel continued, "In order to obtain fruit in the blind and sad souls of these provinces, it is necessary first of all to order the Indians to come together, and live in towns and cultivate the earth, collecting sustenance for the entire year; and after they have thus become very settled, then to begin the preaching. Unless this is done, although the religious remain among them for fifty years, they will have no more fruit than we in our four years, which is none at all, nor even a hope."[19]

Franciscans came to Florida in 1573, but five years later the only two remaining were serving as chaplains to Spaniards in St. Augustine and Santa Elena. In 1584 Fray Alonso Reinoso landed at St. Augustine with seven other friars, some of whom were assigned to mission posts. Another twelve came in 1587. But few of these many Franciscans stayed long. By 1592 only three or four priests and two lay brothers remained. Sustained missionary effort began in 1595 with the arrival of a new group of twelve. Nine missions were operating in 1596 ranging from Nombre de Dios, just north of St.

Augustine, to five Guale missions on the coast of Georgia, the northernmost on St. Catherine's (Santa Catalina's) Island.

But in 1597 a revolt terminated missionary activity on the Georgia coast for several years. Fray Pedro de Corpa was offended by the existence of several wives of a leading Indian, Don Juanillo, and attempted to block his inheritance of an important chiefdom extending south from Guale into Tolomoto. Juanillo smashed Father Corpa's head and then displayed it impaled on a lance. He next enlisted seven other chiefs in a general attack, urging them, as transcribed by Spanish informants, to "restore our liberty of which these friars deprive us. We, who are called Christians, experience only hindrances and vexations. They take away from us our women, allowing us but one, and that in perpetuity, forbidding us to exchange them for others. They prohibit us from having our dances, banquets, feasts, celebrations, games and wars, in order that being deprived of these we might lose our ancient valor and skill . . . They persecute our old men, calling them wizards. They are not satisfied with our labor for they hinder us from performing it on certain days. . . . All they do is reprimand us, treat us in an injurious manner, oppress us, preach to us and call us bad Christians. They deprive us of every vestige of happiness which our ancestors obtained for us, in exchange for which they hold out hope of the joys of Heaven. In this deceitful manner they subject us, holding us bound to their wills. What have we to hope for except to become slaves."[20]

The Guale revolt, which destroyed five missions and murdered five Franciscans, led to punitive attacks by Spanish soldiers in 1598 and 1601 which alienated the Indians more. Juanillo's grievances would be echoed through the remaining centuries of Spanish North America as other mission Indians in other areas from Florida to California felt oppressed by the regimen of the friars.

Despite the shock of the 1597 revolt and its retributive aftermath, missionary activity slowly gained momentum. A visitation of the Bishop of Santiago de Cuba, Juan de las Cabezas de Altamirano, encouraged the friars by showing recognition of the importance of their efforts. The missions of Guale were reconstituted and missionaries began work among the inland Timucua as far as a hundred miles from the coast in the areas of Gainesville and the Suwannee River. But missionary labor in poor, primitive, and recalcitrant Florida was never easy. In 1612 four friars wrote to the crown expressing their discouragement. Conversion seemed to them virtually impossible with Indians accustomed to living in the woods, "as free as deer." Florida Indians, the friars wrote, were unlike the peoples "of New Spain, who are much more subdued and have houses and property to lose, and these people nothing at all." Resisting European-style sedentary agriculture, the Indians supplemented the scanty products of their traditional agriculture with animals they hunted or with plants they found in the woods, dates, acorns, and roots. The Indians, the letter continued, converted the doctrine taught by the friars "into hatred and abhorence against us, the service of Your Majesty, and Spaniards in general, and against the livestock we tried to introduce exterminating them like vermin, and they did the same to the trees and seeds [we planted] wishing to leave no trace or smell of us."[21]

Headquarters for Franciscan missionary activity, formally organized as the Custodia of Santa Elena de la Florida in 1606 and as a full province six years later, was the *convento*, or friary, of the Immaculate Conception in St. Augustine, now generally known as the Convento de San Francisco. Initial construction, at the southern end of town, was in 1588. Both the living quarters and the chapel were built of vertically set red cedar logs, faced with boards and covered with a roof of palm thatch. There may have been lesser structures completing a quadrangle. Fire destroyed the buildings in 1599. A new chapel was completed by 1606 and new living quarters by 1610. When Bishop Gabriel Díaz Vara

Calderón arrived in 1674 for his tour of inspection, the staff consisted of only the Father Superior, another priest who served as preacher, and a lay brother, but Queen Regent Mariana had authorized the addition of three curates for the three principal languages of these provinces, Guale, Timucua, and Apalachee, to further the teaching of Christian doctrine and administering the sacraments to the Indians. Half a century earlier Fray Francisco Pareja had constructed a dictionary and a grammar of the Timucuan language, and he had written devotional works in that language, including a *Confessionario* published in Mexico City in 1613. Works in at least one other Indian language were also written.

In the middle of the seventeenth century the Franciscan *convento* was rebuilt with two or three post-supported wooden structures. Governor Moore's destruction of the city in 1702 necessitated another reconstruction. Although funds were appropriated by the royal government in the 1720s, only a small stone chapel was built and the friars lived in wooden huts. In 1737 new living quarters containing twenty-five cells were constructed of coquina set on an oyster shell concrete base. Ultimately the stone *convento* consisted of rectangular structures arranged, as pictured in the Castello and de la Puente maps of 1764, to form an open quadrangle and a half.

Nombre de Dios, just north of St. Augustine at the Indian village which had welcomed the Spaniards in 1565, had, in 1587, a resident priest, Fray Alonso Escobedo, author of a verse narrative *La Florida*, but by the time of Bishop Díaz's tour of inspection had been reduced to a *visita*, served periodically by a priest from the Franciscan headquarters. In order to gain the most from their limited cadre of priests, the Franciscans surrounded each mission, or *doctrina*, with a circle of ten or so *visitas*, villages where Mass would be said weekly, or even less frequently, by a priest from the central mission.

Franciscans visited the people of the third great missionary area of Florida, Apalachee, as early as 1607, but the first resident priest did not arrive until 1633. This section of north central Florida, west of the Aucilla River and including the present state capital, Tallahassee, had the greatest density of Indian population and the most productive agriculture. By the 1630s the Franciscans had had half a century's experience with the Florida Indians and had developed effective means of conversion. Native peoples were regarded as members of the "Republic of Indians" and were allowed to retain much of the structure and many of the customs of their societies. The Franciscans had learned the hard lesson of the Juanillo confrontation. Frequently local chiefs of the Timucuans and the Apalachees would journey over two hundred miles on foot to St. Augustine to seek alliance with the Spaniards against their Indian enemies and would invite friars to their towns. The Spanish authorities would recognize the chiefs with elaborate ceremonies and gifts which were greatly valued. When they arrived in the villages, the friars were careful to work with the traditional headmen and to recognize the pattern of inheritance through the matrilineal line. Upper-class Indians were guaranteed sovereignty over their traditional lands and honored with the title "*don*," like upper-class Spaniards. They were granted the right to ride horses and to carry swords and were exempted from labor drafts, corporal punishment, and taxation. The chiefs were visited annually by the governor, or his deputy, who responded to their grievances and bestowed gifts. An important chief was able to force the recall of a friar or even of a deputy governor. Special privileges were also given to medicine men and even to star players in the Indian ball game, frequently deplored by missionaries. James Axtell, the perceptive historian of the Indians of the eastern United States, described the initiation of a Franciscan mission: "Accompanied by a troop of Indians shouldering arquebuses and a banner emblazoned with the Holy Cross, a friar typically announced his intentions by throwing down and burning native religious images in the central plaza. This bold act

cleared the stage for the building of a standardized Catholic mission and the enrollment of the town in the independent but allied 'Republic of the Indians' under the Spanish crown."[22]

The layout of the mission buildings varied with the existing configuration of Indian towns. A common pattern was quadrangular like that in St. Augustine, with the church on one side of a courtyard, the living quarters of the friar on another, and the kitchen and another structure on the remaining sides. In Apalachee three structures were sometimes arranged to form a right triangle. The earliest buildings were often of thatch, rectangular rather than round as was traditional in Indian structures. Walls of wattle and daub were common, supported by vertical posts, sometimes anchored in clay-filled postholes. Wooden churches were prized and Spanish observers praised the craftsmanship of the Indian carpenters. Fray Francisco Alonso de Jesús wrote that the Indian timber churches were "constructed with as much perfection as those of the Spaniards and as well decorated and adorned with ornaments that the religious provide from the alms of the king."[23] The value of religious articles in the missions was substantial. By one calculation the average per village in Apalachee in the 1680s was 2,500 pesos.

The missionary enterprise in Florida had expanded greatly during the first half of the seventeenth century. In the first decade growth was slow because of the lingering distress caused by the Guale uprising, but in the three years following the establishment of the Franciscan province of *La Florida* in 1612, twenty-three friars arrived and a dozen new *doctrinas* were founded, bringing the total to twenty. In 1633 a major push two hundred miles westward from St. Augustine brought the rich and populous area of Apalachee into the mission fold. By 1655 there were seventy friars and thirty-eight *doctrinas*. A major revolt of the Apalachee and Timucua in the following year broke the friars' momentum. At the time of Bishop Díaz's visitation of 1674–1675, there were nearly as many missions as twenty years earlier, three of them farther west in Apalachicola, but by 1670 there were only forty friars. Twenty-three new missionaries arrived in 1679 but placing them was difficult. The population of Christian Indians was declining sharply and the pagan Indians were increasingly resistant to the friars. In the next quarter of a century, the most ambitious missionary effort among the Indians of North America would be reduced to a cluster of villages in the immediate area of St. Augustine, protected by its great stone fortress.

Santa Catalina de Guale

As in other areas of Florida, the Spaniards applied to the people of the whole region of the Georgia coast the name of the dominant chief (the *mico*), Guale, who was resident on what was probably St. Catherine's (Santa Catalina's) Island. Pedro Menéndez had passed along the Georgia coast on his way to found Santa Elena in 1566. The Guale seemed less resistant to Spaniards and to Christianity than the Indians who surrounded Santa Elena, and Menéndez left five or six soldiers as lay catechists to initiate the process of conversion. Before sailing back to Spain in 1567, Menéndez ordered a blockhouse, garrisoned by fifty soldiers, constructed beside Chief Guale's village, and the next year a Jesuit lay brother, Augustín Vaez, reported to have prepared a dictionary for the Indians, may have spent some time with them. Fray Antonio Sedaño and three lay catechists resided in the village for fourteen months without evangelical success before being recalled in 1570. The Franciscans who first ministered to the Spaniards in Santa Elena and St. Augustine staged a quick, "in-and-out" mission to Guale in 1575 during which a celebrated preacher, Fray Juan Cordero, converted the *mico* and his wife. A *doctrina* may have existed on the island as early as 1587. A church was begun after the arrival of substantial Franciscan reinforcements in 1595, but it was destroyed in the revolt led by Juanillo in 1597.

David Hurst Thomas has led a team of archeologists in the excavation of the sub-soil remains of Mission Santa Catalina de Guale since their discovery in 1981. Among the most interesting of the findings of Thomas's team is that the entire mission complex was organized on the grid pattern prescribed by the royal Ordinances of town planning of 1573, with a rectangular plaza measuring roughly forty by twenty-three meters at the center. The plaza and the mission buildings were surrounded by and separated from the structures of the Guale village. Both the church and the living quarters of the friar, which were burned in 1597, were larger than the buildings reconstructed after 1604. When Governor Ybarra visited Santa Catalina that year, the church had already been rebuilt but not until the next was a permanent missionary, Fray Pedro Ruy, assigned to the village which became regional headquarters for the Spaniards as it was for the Guales. The seventeenth-century church, occupying the same site as its predecessor, faced southwest with a tall, possibly gabled and false-fronted façade, constructed of wattle and daub anchored on four upright poles, double the size of those supporting the sidewalls, and set in shell-filled postholes. The building was rectangular of a size characteristic of Florida mission churches, twenty by eleven meters. The side walls were also constructed of wattle and daub until they reached the sanctuary area, four meters from the rear wall. The symbolic importance of that section of the church, which may have been raised internally above the nave, was expressed by a shift to wooden construction, pine planking supported by a frame. Remains of figures sculpted in clay have been found in the nave, and the sanctuary may have been ornamented by a fixed *retablo*, or altar screen, of painted metal panels. Wheat for communion wafers has been discovered in the sacristy, adjoining the church on the left. In front was a modest-sized square *atrio*, or plaza, with fifteen meters to each side. The *atrio* was paved with marine shells and probably surrounded by a low wall. It could have been used on Sundays for open-air services if the modest-sized church was insufficient to shelter the whole community.

Two superposed *conventos* have been located on the plaza placed parallel to the church and about forty meters to the east. They share a wall but only partially overlap. The sixteenth-century *convento* was as long and nearly as wide as the church. It was constructed entirely of wattle and daub, coarser than that of the church. The interior, divided into at least three rooms, probably included the living quarters of the friar, a kitchen and place to eat, and space for storage. After the rebuilding about 1604, the *convento* had 15 percent less space, and a separate kitchen was built twenty meters to the north. Such a separate kitchen was normal in Florida.

A map of 1691, sent to the king by the governor, purports to represent the Mission of Santa Catalina after it was removed to Amelia Island (Fig. 2.15). It shows two large and two smaller rectangular structures, identified as "the church, the convento of the doctrina, a barracks for the infantry,

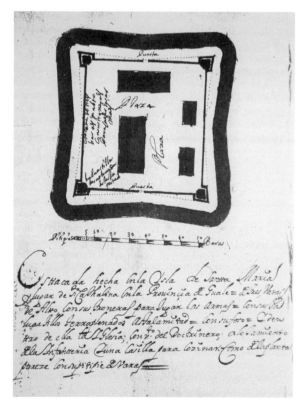

2.15. Map of Mission Santa Catalina de Guale, dated 1691, reproduced in Bonnie G. McEwan, ed., *The Spanish Missions of La Florida*, fig. 2.3.

and a small house for cooking." These four buildings surround a space labeled "plaza" and are surrounded by a square bastioned palisade about eight feet high which is enclosed by a moat. This elaborate layout corresponds with neither the excavations on St. Catherine's Island nor the remains at the mission's later site on Amelia Island. Instead it seems to represent an ideal defensible mission complex which the Franciscans aspired to in the 1690s after the whole province of Guale had been abandoned in 1686.

During most of its seventy-five years of existence after its 1604 reoccupation, the mission on Santa Catalina Island was the northernmost Spanish outpost. It was an important source of shipments of maize for St. Augustine and of *repartimiento* drafts of labor for communal projects and agricultural work in the citizens' personal gardens. An attack by three hundred Indians allied to the English and armed with muskets led to the abandonment of the mission in 1680, even though the attack was successfully withstood. Pressure from the English and their armed Indian cohorts rendered a coup de grace to the Florida missions, but the *doctrinas* east of Apalachee had been declining in effectiveness since mid-century. Mission populations had withered. One cause was the harsh retributive campaigns of the Spaniards after the periodic Indian revolts. More important were epidemic diseases. In 1657 Governor Diego de Rebolledo wrote that the Guale and Timucua had been wiped out by the plague (*pesta*) and smallpox. And two years later his successor, Francisco de Córcoles y Martínez, reported ten thousand deaths from measles. Losses to diseases were augmented by Indian departures to the pagan interior, which was increasingly under English influence.

Indian disillusionment with missions was caused partly by feuding among the Spaniards. Friars and the governors, who claimed the right to exercise the king's *patronato real* and direct the missionaries, accused each other of oppressing the Indians. Friars also accused civil authorities of depriving the missions of funds and supplies by diverting them to support St. Augustine's defenses and its soldiers. Early in the century Fray Francisco Pareja, noted for his works in the Timucuan language, wrote that St. Augustine officials believed "that the soldiers are the necessary ones, and that we are of no use. . . . But we are the ones who bear the burden and the heat, we are the ones who are conquering and subduing the land."[24]

Mission Indians were accustomed to sowing separate communal fields, one to support the priest and religious activity and the other to support the military detachment and the indigent, the widows and the poor. In 1680 Governor Juan Márques Cabrera accused the Franciscans of forcing the natives to stock the friars' granaries and to transport the maize without pay. In the following year his subordinate on the northern frontier, Captain Francisco de Fuentes, who had defended the mission on Santa Catalina's Island, wrote that Indians were repudiating the Spaniards because of their harsh treatment from the Franciscans. He accused a friar, Juan de Uzeda, stationed on neighboring Japelo Island to which the Santa Catalina community had fled, of making Indians shell maize on Sunday and ordered soldiers to remove maize from Uzeda's granary. He wrote that another friar, Domingo Santos of the mission at Asao, "had publicly whipped Chief Ventura in church for missing Mass one day because he had gone to the mainland with some of his vassals . . . to get sticks or saplings to fence the convento."[25] Ten years later another secular Spaniard reported that three hundred Indians had taken to the woods to avoid the whip of Fray Domingo. Tension between the friars' demands and traditional Indian sense of protocol was evident in the *mico* of Guale's report to the governor that Father Uzeda had forced his daughter to work like ordinary girls at chores in the convent and at shelling seafood.

In 1686 the former mission of Santa Catalina de Guale was relocated on Amelia Island off the Florida coast just south of the St. Mary's River, the boundary with Georgia. The chiefs of the four mission com-

munities on Japelo Island had preferred Amelia Island to a site on the south bank of the St. John's near Jacksonville where the landing was poor and cattle threatened their crops. The *convento* and the cemetery beneath the church of Santa Catalina have been excavated on Amelia Island. The community there lasted sixteen years until it was burned by Governor Moore in 1702 on his way to St. Augustine. Population continued to dwindle. There were only two hundred Indians on the entire island in 1700. The final move of the remaining Christian Indians of Santa Catalina de Guale was to Nombre de Dios where, as Amy Bushnell explained, in refugee pueblos close to the guns of the fort, they would lose their self-respect and, ultimately, their identity.

San Luis de Talimali

Apalachee, the third of the principal missionary areas of Florida to be evangelized, was by the second half of the seventeenth century the most populous and the richest. Poverty was a persistent periodic problem in St. Augustine and the missions of eastern Florida. Bishop Altamirano had found the parish church of St. Augustine without a single candle in 1606, and Mass could not be celebrated in 1673 because of the lack of wine and of wheat flour for the hosts. In Guale two priests made a chalice of lead because there were none of silver. Apalachee, visited early by Panfilo de Narváez and Hernando de Soto, was inhabited by Indians who were sedentary farmers descended from the creators of the impressive mound-building culture of the southeastern United States. They were known for their crops of maize before the arrival of the first Spanish explorers, and after the development of missions in the 1630s, their productivity was, for Florida, remarkable. Besides producing maize for their own use—indeed, Indian health suffered from their almost total dependence on it in their diets—mission Indians, under the direction of the friars, produced surpluses for marketing. Indian bearers

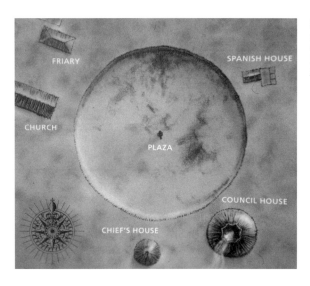

2.16. Mission San Luis de Talimali, reconstruction of the central plaza, *The Apalachee Indians and Mission San Luis*, p. 72.

carried agricultural products and deerskins to St. Augustine, but the preferred market was Cuba. A port, San Marcos de Apalachee, was developed on the eastern end of the gulf south of Tallahassee, and both the missions and civilian ranches, such as those of the prominent Florencia family, supplied the city of Havana and the Indies fleets with maize and beans, hams, chickens, dried turkey meat, cowhides, and tallow. Governor Pedro Benedit Horruytiner, who initiated the large-scale Spanish movement into Apalachee in part because of his own agricultural interests, reported in 1633 that the Indians were building churches and *conventos* for the friars. The principal chief of Apalachee relocated his village "to be where the Spaniards were."[26]

San Luis de Talimali was placed by the Spaniards on an extensive flat hilltop a few miles west of the center of modern Tallahassee. It served as residence of the lieutenant governor and a garrison of as many as forty-five soldiers as well as a mission and an Indian village. Excavations of the village have revealed a low embankment enclosing a circular area 125 meters across. At opposite sides of this open plaza area, which probably was used for the ball game, were located the Franciscan church complex and the Indians' large communal house, the *bujio*, similar to the house of Chief Seloy which Pedro Menéndez's soldiers had converted into the first of St. Augustine's many forts (Fig. 2.16).

Bishop Díaz Vara Calderón described the *bujio* as central to each Indian village, "constructed of wood and covered with thatch, round, and with a very large opening at the top. Most of them can accommodate from 2,000 to 3,000 persons. They are furnished all around the interior with niches called *barbacôs*, which serve as beds or seats for the chiefs, and as lodgings for soldiers and transients. Dances and festivals are held in them around a great fire at the center. The missionary priest attends these festivities in order to prevent indecent and lewd conduct, and they last until the bell strikes *las animas*."[27]

The paired and opposed locations of the large round council house and the sizable rectangular wooden-framed church expressed an uneasy equipoise in the village between Indian and Franciscan patterns of living and patterns of belief. The church, supported by posts set in the ground, was sided by vertical planks and roofed with thatch. Measuring about 110 by 50 feet, its dark and mysterious interior was divided into a nave and side aisles and contained an area greater than that of the stone-walled parish church in St. Augustine not completed until 1797. A smaller wattle and daub friary was placed parallel to the church and a Spanish village comprising some fifty structures was nearby. The much larger Indian village seems to have encircled the central area of the plaza and in turn been encircled by the extensive agricultural fields.

The first soldiers had come to Apalachee in 1638, but nearly twenty years later the chief argued against a plan to increase the garrison to twelve. He did offer to have a blockhouse constructed, probably the fortified "country house" inhabited by the deputy governor at the time of Bishop Díaz's 1675 visit. A few years later the threat of English and Indian depredations led to the increasing of garrison strength to forty-five. A map of 1705, made after the abandonment of San Luis, places a palisaded blockhouse which was constructed in the middle 1690s to the east of the village. The palisade was rectangular, approximately 230 by 130 feet, with angled bastions at the corners. Its curtain walls were nearly 12 feet high and were surrounded by a dry moat. The blockhouse inside measured approximately 70 by 40 feet and was described as faced with palm posts, backed with adobe bricks, and sheathed by boards three inches thick, but archaeological excavations suggest the walls were constructed of wattle and daub. On the roof were placed four cannons of four pounds, and four stone mortars. Cannons or stone mortars were also placed in the bastions and at the fort's gate.

At the time of Bishop Díaz's visit, San Luis was the most populous mission in Florida and the center for missionary activity in Apalachee, comprising fourteen or fifteen missions, more than forty settlements, and over eight thousand baptized Christian Indians. The fourteen hundred neophytes of San Luis Mission were divided between the main village and several satellite villages served by friars from San Luis.

The prosperity of Apalachee and its capital, San Luis, endured for half a century until the early 1680s. But earlier it was diminished by the widespread departures of Indians from their villages to the pagan north, and by the revolt led by non-Christian chiefs in 1647 which caused the deaths of three of the eight friars in Apalachee and of the deputy governor and his family in San Luis, and the destruction of seven of the eight missions. As in Guale and in St. Augustine itself, the friars and the royal authorities blamed each other for mistreating the Indians. Fray Alonso Moral wrote that Indians from all the mission provinces had to carry loads to the fort in St. Augustine. "Each year from Apalachee alone more than three hundred are brought to the fort at the time of planting of the corn, carrying their food and merchandise for the soldiers on their shoulders for more than eighty leagues [roughly 220 miles] with the result that some of them die and those who survive do not return to their homes because the governor and other officials detain them at the fort so they

may serve them."²⁸ Fray Juan Gómez de Engraba protested Apalachees being loaded like pack animals and even nobles being commandeered as *cargadores*. During the term of Governor Horruytiner, only ten of two hundred Indians returned to Apalachee from one year's long trek to St. Augustine. The friars relocated Christian Indians from several villages in Timucua at sites along the route to Apalachee to protect river crossings and maintain the pathway.

Governor Rebolledo, no friend of the Franciscans, visited eleven Apalachee villages to question the Indians in order to learn what had provoked the 1647 revolt. The grievances reported to him included the hated service as bearers, for friars as well as soldiers, and work as stevedores on frigates at San Marcos de Apalachee. The Indians also complained that the friars forbade them to trade directly with the soldiers or with the frigates at the dock. They particularly resented the friars' prohibitions of their traditional dances and the fiestas associated with their ball game, played by village teams of forty to fifty. The game had religious importance for the Indians and dismayed the friars by its violence and by its pagan significance. The governor ordered the Franciscans to pay for native labor, to allow direct trading, and to permit the game and the dances. Subsequently the friars renewed their campaign against the ball game, finally getting it prohibited by the royal government. Their protests against Rebolledo were a cause of his condemnation by the Council of the Indies and removal from office. Disaffection of the Indians was increased in the 1680s by the irrational brutality of a deputy governor, Antonio Matheos, who increased the already heavy burden of the labor *repartimiento* for shipbuilding projects and explorations and put two important chiefs in irons.

Spanish Apalachee came to an abrupt end in 1704 when Colonel James Moore, who had been repulsed at the Castillo San Marcos two years earlier and lost his governorship, invaded the province with fifty whites, many of them slavers, and a thousand Creek Indians. Neither Moore's force nor a second invading band of Creeks attacked San Luis, but the mission was abandoned by the Spaniards and by the Indians and destroyed. Large numbers of the Apalachee were carried into slavery. Others moved north and returned to traditional customs. A few of the most Christian went to St. Augustine and more fled to the west, especially to the French outpost, Mobile. The four hundred refugees from Apalachee were well received by the French, who regarded them as decent hard-working Catholics and were delighted by their civilized European clothes. Their language, an odd mixture of Apalachee and Spanish, did surprise the people of Mobile. These refugees to French territory from the collapse of the great missionary endeavor of Florida exemplified the Franciscan aim, to develop Native Americans who would adopt the Christian religion and the work habits and social patterns of good Europeans.

In 1983 the State of Florida purchased the site of Mission San Luis and initiated a program of archeological and historical research. Gary Shapiro and Bonnie G. McEwan have served as the archeologist at the site. San Luis is now an outdoor museum and the church, the *convento*, the Indian *bujio* or communal house, and the chief's house have been reconstructed. The block house will be rebuilt next.

Pensacola

The attempt in 1559 to plant a settlement on Pensacola Bay, like the successful campaign of Pedro Menéndez de Avilés which began six years later, was a response to the threat of French intrusion into Spanish territory. In 1557 Philip II had directed Viceroy Luis de Velasco II to appoint a governor of *La Florida* and *Puente de Santa Elena*. The viceroy chose his friend Tristán de Luna y Arellano, a former officer of the Vázquez de Coronado *entrada* to New Mexico two decades earlier. Luna was an older man who had recurring periods of physical

and mental illness that limited his ability to provide strong and consistent leadership. The viceroy's directions were to place one settlement on the Gulf and another on the Atlantic in the area of the Point of Santa Elena.

The town established on Pensacola Bay after Luna's arrival on August 14, 1559 was, according to the viceroy's instructions, to have gates in four directions visible from its central plaza. There were to be 140 house lots and the structures were to include a church, a friary, and a royal building to provide a residence for the governor, administrative offices, and a warehouse. One hundred heads of families were to form a garrison of farmer-soldiers for this second Spanish town established in North America.

Luna's expedition was crippled by a hurricane that struck a few days after the landing and destroyed ten of the thirteen ships and most of the provisions. Despite persistent efforts of Viceroy Velasco, food was scarce for Luna's approximately fifteen hundred men and the horses. The sandy soil did not support agriculture and the area was without a substantial Indian population. The expedition's headquarters and all but fifty of its personnel were moved temporarily to the vicinity of a sizable Indian community north of Mobile Bay in hopes of securing desperately needed food. Ultimately the bulk of the expedition returned to Pensacola Bay.

An urgent order from Philip II led Luna to dispatch ships to Santa Elena but a hurricane forced them to abandon the voyage. In early 1561 Luna was replaced as governor by Angel Villafañe and sailed back to Spain with the annual fleet. Villafañe fulfilled the royal order to reach Santa Elena by ship but was unable to establish a settlement there. Before the end of the year the town on Pensacola Bay was abandoned. The *La Florida* established by Pedro Menéndez de Avilés less than a decade later became primarily an Atlantic colony centered in St. Augustine and, for a brief period, in Santa Elena in South Carolina.

Spanish concern for the northern shore of the Gulf of Mexico was revived a century and a quarter later by shocking reports of the presence of the Sieur de La Salle's fleet which, failing to locate the mouth of the Mississippi from the Gulf, had landed on the mid-Texas coast. Juan Enríquez Barrota, a former student of New Spain's leading scholar and scientist, Carlos Sigüenza y Góngora, led the first of the searches for La Salle in 1686. Sailing west along the shore Barrota discovered the entrance to a large bay called by the Indians Panzacola. The enthusiasm of the mariners for the bay spread to official circles after their return to the viceregal capital. Their reports, charts, and maps intrigued Sigüenza y Góngora, the royal cosmographer. A memorial drafted by Sigüenza y Góngora and signed by Captain, subsequently Admiral, Andrés de Pez was presented to the new viceroy, the Conde de Galve, urging that Pensacola Bay be occupied immediately to forestall the French and that costly and stagnant St. Augustine be abandoned after blocking its harbor with sunken ships.

Pez was dispatched to Spain in 1689 to seek the authorization needed for an action of grave importance for Florida and all New Spain. The ministers of the Council of the Indies opposed the abandonment of St. Augustine and were reluctant to assume the costs of establishing and fortifying a new remote post. After delaying indecisively for nine months, the mentally unbalanced last of the Hapsburg monarchs, Carlos II, unexpectedly overruled his ministers and enabled Pez to return with royal approval of the Pensacola project.

In the following March a preliminary expedition, insisted upon by the Council of the Indies, set out to explore the bay and the entire Gulf coast as far as the mouth of the Mississippi River, known to the Spaniards as Rio de la Palizada because of the multitude of logs blocking entry to its several mouths. Pez was the commander and Sigüenza y Góngora accompanied him to prepare a report on the preferred place for the settlement, the building materials available, "the nature and disposition of

the Indians . . . and everything else that grows and multiplies." He was also to provide "a drawing of the fortifications necessary for the protection of the entrance, and to decide the most suitable site" and to "make a chart and drawing of the entire bay and its channel."[29] Sigüenza drew a handsome and accurate map of the bay named Bahía de Santa María de Galve in honor of the viceroy and wrote a glowing account of the fruits, animals, and fish abundantly available to settlers, extravagantly telling of "extensive fields and near-by woods . . . suitable for small farms and stock raising on a large scale."[30] He described the bay as "the finest jewel possessed by his majesty . . . not only in America but in all his kingdom"[31] and assured the viceroy that it could be defended from any foreign power by a pentagonal fort on the bluff to the west of its entrance and two batteries to the east at the tip of a barrier island which they named Point Sigüenza.

Little was done for five years despite Sigüenza's promotional enthusiasm. But in 1698 reports reached Spain of preparations in France for an expedition led by Pierre Le Moyne, Sieur d'Iberville, which was to extend the activities in the Gulf initiated by La Salle. Captain Jordán de la Reina, then in Spain, was ordered to Havana to gather troops and supplies and to sail to Pensacola Bay, which he had visited with Captain Barrota. He arrived on November 17 with two ships and 60 soldiers, and four days later the main force of three ships and 357 men joined them from Vera Cruz under the command of Andrés de Arriola, famous for a voyage from Acapulco to Manila and back in only ten months. Most of Arriola's hastily assembled force were the scourings of the slums of Mexico City and of Vera Cruz, impressed soldiers, former beggars and convicts. Their leader and his military engineer Jaime Francke found in wintry Pensacola few of the charms which had delighted Sigüenza y Góngora during his spring visit five years earlier. The sixty-year-old Franck rescued most of his belongings from a devastating fire set by careless gamblers early in January. But, he wrote to a member of the Council of the Indies, "I was robbed aplenty," losing four jugs of wine, six flasks of brandy, many of his clothes, and 100 pesos in cash. He had "never had such a sorry job," he wrote, "shoved into a wretched hut" and always fearful of another fire.[32]

Despite his discontents, Franck directed the construction of what ultimately became the harborside wall of a bastioned structure of logs and sand which was christened San Carlos de Austria in honor of the heir to the Hapsburg throne in Vienna. Franck's hastily built partial fort was defended by sixteen cannon and was sufficient to enable the motley garrison to bar Iberville's fleet from entering the bay when it arrived on January 26. Having beaten the French to Pensacola Bay by just over two months, the Spanish were able to divert them westward and to consolidate control of a portion of the Gulf's northern shore.

But Spanish Pensacola remained throughout its over one hundred year history a poor remote outpost dependent upon the unpredictable arrival of supplies from New Spain. The sandy region could not support agriculture sufficient to sustain the garrison. In 1705 the Sieur de Bienville, brother and assistant of d'Iberville, wrote of Pensacola to the French Minister of Colonies that "during half the year they are reduced to living on Indian corn, and they come . . . [to Mobile Bay] to get merchandise to trade for it. They would have been forced to abandon their fort several times, if we had not helped them. There are two hundred persons in their garrison in addition to whom there are those of mixed blood and convicts. Their fort is made of four bastions of upright poles. . . . The houses are of poor frame work, roofed with straw."[33] Florida was regarded in New Spain as a place to be avoided and Pensacola was particularly dreaded by potential settlers. Spanish women were few; sexual relations with Indian women were common. Arriola had written to the viceroy suggesting that some women for Pensacola might be found in the brothels of Mexico City, but the pro-

posal seemed to the authorities there a threat to the morality of the new community. Another proposal, made by the viceroy himself, was that women criminals might be sentenced to Pensacola. The *audiencia*, his supreme administrative judicial court, was opposed. Because of the frequency of illness and death in Pensacola, they could not imagine a woman committing a crime sufficiently despicable to deserve to be sentenced to go there.

During much of the eighteenth century Spain and France were allied in a "family compact" of Bourbon monarchs which restrained their rivalry in the Gulf, but in 1719 the War of the Quadruple Alliance broke out uniting France, Britain, Austria, and Holland against Spain. The Sieur de Bienville, now governor of Louisiana, surprised the Pensacola garrison in May 1719, easily capturing both the new battery which had been constructed on Point Sigüenza at the tip of Santa Rosa Island and Fort San Carlos de Austria on the opposite bank. A Spanish fleet from Havana recaptured Pensacola in August, but it was lost again in September and remained in French hands until June 1722, over a year after its return to Spain was mandated by the treaty ending the war.

Lt. Colonel Alejandro Wauchope, a Scot who had served in Spain's Irish Brigade, then arrived in Pensacola Bay with an infantry company aboard three ships. His orders mandated the digging of a canal across Santa Rosa Island in order to lower the level of the bay so that large enemy ships could not enter. If that project proved unworkable, as it did, he was to relocate the presidio across the channel on Santa Rosa Island near Point Sigüenza, where it remained until after it was devastated by a hurricane in 1752.

During the 1740s a small blockhouse named San Miguel was constructed on the mainland at the center of the site of the present city of Pensacola to protect a mission of Yamasee-Apalachino Indians from attacks by the Creeks of the interior, who were allied with the British. Although some progress had been made in rebuilding the presidio on Santa Rosa Island after the storm of 1752, the viceroy ordered that the presidio be transferred to the mainland site of Fort San Miguel. A royal *cédula* of 1757 changed its name to Presidio San Miguel de Panzacola. The presidio's walls of vertical timbers, pointed at their tips, measured 700 by 365 feet and enclosed an administrative building, barracks, warehouses, a church, and an ample house for the governor, all designed by royal engineer Felipe Feringan Cortés. Outside the stockade were huts for the living quarters of civilians, officers, and married soldiers. A hurricane destroyed half the stockade in 1760 and decimated the thatched roofs. Because cypress bark essential for roofing could not be obtained, the garrison endured the winter of 1760–1761 exposed to the elements. Relief from the constant Indian pressure was finally secured in September 1761 when a representative of the French governor of Louisiana achieved peace between the Creeks and Spaniards.

Florida was transferred to British control in 1763 in exchange for Havana, which had been captured a year earlier after Spain had belatedly entered the Seven Years War as an ally of France. Pensacola was evacuated by 772 persons, including military personnel and civilians and 209 Yamasee-Apalachino Christian Indians. At the same time just over 3,000 people left St. Augustine.

The British appreciated the strategic importance of holding Pensacola Bay after having been kept out of the Gulf by the Spanish and French for sixty-five years, since the voyages of Arriola and d'Iberville. But they were unimpressed by the steadily deteriorating wooden fortifications which collectively had cost the Spanish government 4,565,820 pesos to maintain since 1698. Almost all the funds had gone for salaries and supplies, under 5 percent for the fortifications themselves.

The British divided Florida into two colonies and Pensacola became the capital of West Florida. Commanding engineer and surveyor Elias Durnford drew up a town plan to guide the hoped-for

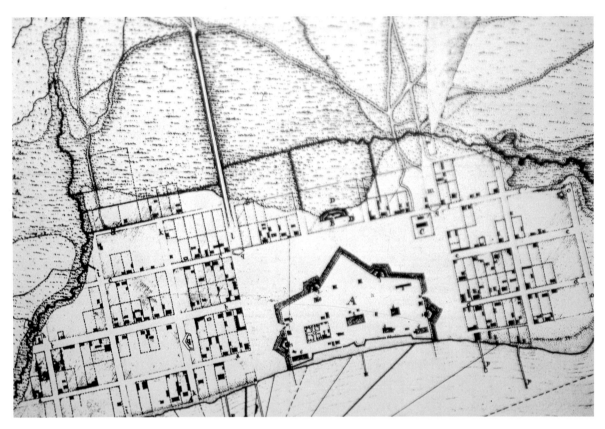

2.17. Map of Pensacola by Joseph Purcell, c. 1779, showing the Durnford plan, reproduced in Judith A. Bense, ed., *Archaeology of Colonial Pensacola*, p. 162.

future development (Fig. 2.17). He retained the central area near the fort and the area just to the north for public buildings. Residential lots were laid out on both east and west sides in rectangular grids of three streets with three or four blocks each. Garden plots were placed in a grid to the rear, a section of four blocks to the west was reserved for naval purposes, and block houses were projected on both the east and the west. A visitor, Lord Adam Gordon, gave a characteristic appraisal of the town the English took over. The fort, he wrote, was "an oblong square with a double stockade and a very narrow Ditch dug in the Sand. Four bastions are intended. The Governor's is the only tolerable House in the place. It is . . . [roofed] with shingles and has a balcony both ways up one pair of stairs. All the other houses are on the ground and . . . [are roofed] with Palmetto leaves. It is a very poor place, the Soil a deep white Sand for Many Miles around."[34]

The British improved Pensacola's bay-side fort and its buildings. In 1778 William Bartram described the stockade as "a tetragon with salient angles at each corner, where there is a block-house or round tower, one story higher than the curtains, where are light cannon mounted: it is constructed of wood."[35] A new Fort George, with two redoubts and two batteries, was constructed on the high ground behind the town.

In 1779 Spain went to war against England in support of France, which was providing forces essential to the success of the rebelling English colonists. Bernardo de Gálvez, future viceroy of New Spain and nephew of José de Gálvez, Secretary of the Indies, was governor of Louisiana, which had been ceded by France to Spain in compensation for Spanish losses in the Seven Years War. His uncle wrote to him that "the king has determined that the principal object of his arms in America during the present war will be to drive [the British] from the Mexican Gulf and the neighborhood of Louisiana."[36] In August and September 1779

Chapter II

Bernardo de Gálvez cleared the Mississippi of the British forts on its east bank at Manchac, Baton Rouge, and Natchez. The fort on Mobile Bay was captured in March 1780. Pensacola was more difficult. Galvez began his operations in the following autumn but a hurricane struck his fleet just after it sailed from Havana, and he had to begin again in March 1781. After a sixty-one-day siege Pensacola surrendered on May 8. The Spanish had agreed not to shell the town or the fort by the bay so that the battle was concentrated on Fort George and its redoubts on the upper slope. The outcome was decided when a Spanish grenade blew up the powder magazine in the northernmost Queen's Redoubt and made Fort George vulnerable to fire from above.

The Spanish took over a town more substantial than the one they had evacuated eighteen years before. But though life was easier and more pleasant than it had been in the earlier part of the century, Pensacola did not greatly prosper in the final forty years of Spanish possession. These years were marked by an influx of people from other parts of Spanish America such as Cuba and New Spain, from France and Britain, and from the United States. But the size of the population was modest. The transfer of Louisiana to the United States led to a dramatic increase in Pensacola's inhabitants, who totaled nearly fourteen hundred in 1805, but by 1820 the free population sank to just under seven hundred, approximately the number of 1803. Protestants had reached close to 25 percent of the population by 1801. Of the 695 people counted in 1820, 441 were white and 254 were free blacks. Slaves were not included.

The prosperous Scottish-led trading firm of Panton, Leslie and Company established its headquarters in Pensacola in 1784, three years after Spain regained control of the town. The firm shipped hides of cattle from Florida ranches, but its primary trading was with Indians who were customarily kept as debtors. British goods, notably muskets, shot, and powder, were exchanged for deerskins and the furs of beavers, foxes, and other animals. The company's posts extended from St. Augustine to New Orleans and up the Mississippi River as far as the Memphis area. With the support of Spanish officials who shared in its profits, it dominated trade in West Florida.

The three-story brick house of William Panton, head of the firm, was a dominant landmark on Pensacola's waterfront. Most of the houses of the moderately prosperous were one-and-a-half-story frame structures of wood which were raised above the ground and had broadly sloping roofs extending forward to cover the four- or five-posted verandas which provided shade and were open to breezes from the bay. Their walls were filled with clayey mud and moss, often mixed with lime mortar, which hardened like concrete.

The French visitor C. C. Robin provided a diverting account of life in Pensacola in 1703. He was charmed by the friendly women who, favoring French fashions, were "slender waisted and short sleeved. They show off the figure without embarrassment." There were thirteen taverns but much of the town's male social activity took place in the pool room. Robin wrote that it was "the general meeting place of everyone from the governor down to the laborer and the humblest clerk. Here the shoemaker considers himself as good as the highest military officer. Here . . . equality reigns not that of the debased coarseness of the lowest elements of the population but the equality which raises people to the honest customs of sociability. . . . Here people play billiards, drink punch and other refreshments and talk purely for the sake of talking."[37]

Pensacola was always primarily a military outpost and efforts continued to improve its defenses. The fortifications of the British above the town were allowed to deteriorate but new works were constructed at the entrance of the bay. A battery was

placed on the island near Point Sigüenza. On the opposite shore the water-level Battery of San Antonio was built of brick, and for its defense higher up the bluff, near where San Carlos de Austria had stood, Fort San Carlos de Barancas was constructed. Both these fortifications have been restored in their later American forms. A substantial portion of the brick battery is the only surviving Spanish masonry construction in Pensacola.

The new fortifications made the bay no more secure than it had been in the past. The British took over the town during the War of 1812. In November 1814 General Andrew Jackson drove them away, but they destroyed Fort San Carlos Barancas and the battery on Santa Rosa Island as they left. Jackson again invaded Pensacola four years later because he believed the town was supplying Indians who were raiding settlements in Alabama. American control lasted for nine months until February 1819. Jackson's last invasion convinced Spain of the impossibility of retaining Florida and led to the signing later that month by John Quincy Adams and Luis de Onís of the treaty for cession to the United States. A ceremony two years later on July 17, 1821 marked the end of Spanish Florida. In Pensacola's plaza General Jackson, the first governor of the American Territory of Florida, supervised the lowering of the Spanish flag and replaced it with the Stars and Stripes.

CHAPTER III

New Mexico

The exploration and ultimate settlement of New Mexico was a byproduct of the effort to settle Florida. In 1536 reports by Alvar Núñez Cabeza de Vaca, a shipwrecked survivor of the disastrous third effort to colonize Florida who wandered through a huge area of Texas and northern Mexico, aroused a great interest in the unknown northern interior of the continent. Both Hernán Cortés and Viceroy Mendoza sent expeditions from central New Spain to the north. The viceroy's emissary, Fray Marcos de Niza, probably reached New Mexico and returned with secondhand accounts of the City of Cíbola "bigger than the City of Mexico" and merely one of seven fabulously wealthy cities of the north.

Wild enthusiasm for the riches available in the seven cities led Mendoza in 1540 to commission Francisco Vázquez de Coronado, the governor, in Guadalajara, of Nueva Galicia (then the northwesternmost area of New Spain), to take command of an expedition of more than three hundred mounted Spaniards, six Franciscans, and over a thousand Indians. Finding Cíbola a mud-walled Zuñi Pueblo village, Vázquez de Coronado's men moved west through the Hopi area of Arizona to the edge of the Grand Canyon and east through the Rio Grande pueblos and beyond them to central Kansas. The disillusioned Spaniards, who antagonized the Pueblo Indians and found no riches in New Mexico nor in Quivira to the east on the buffalo-crowded grasslands of the Great Plains, returned to Mexico City in 1542. Their failure delayed for half a century further large-scale exploration of the northern interior.

Prodded by Philip II, whom the Franciscans had interested in the possibility of massive conversions of Indians to Christianity, Viceroy Luis de Velasco II signed a contract in 1595 with Juan de Oñate to settle New Mexico. Oñate was the wealthy son of Cristóbal de Oñate, government official, energetic entrepreneur, and leading figure among the founders of Zacatecas, the first of Mexico's great silver mining centers. Juan had been active in mining and in fighting hostile Indians, had organized the city government of another mining center, San Luis Potosí, and had married Isabel Tolosa Cortés Montezuma, granddaughter of Cortés and great-granddaughter of the Aztec ruler. He was to acquire the title of *adelantado* when New Mexico was settled.

Oñate had recruited some five hundred armed settlers, many more than the two hundred specified in his contract, but protracted delay caused by misgivings of a new viceroy and by second thoughts of Philip, himself, reduced the expedition substantially before it set out in 1598 from Santa Bárbara, Chi-

huahua, then the northernmost outpost of New Spain. A new route was cut, the future *Camino Real*. The expedition marched directly north past the future site of the city of Chihuahua to the Rio Grande, at the place where the twin cities of Ciudad Juárez and El Paso would be built. The force moved on up the river, leaving it when it curved west to trudge for five parched days over the harsh desert terrain of the *Jornada del Muerto*. The party then followed the river north again, stopping finally at the Pueblo of Okhe, renamed by them San Juan de los Caballeros, which was located about twenty miles north of the future Santa Fe, near the junction with the Chama River.

On his way north in late April, Oñate had camped at "the pass of the river and the ford" and had formally taken possession of New Mexico for Spain. The El Paso area would always be part of Spanish New Mexico. Oñate claimed the land "from the leaves of the trees in the forests to the stones and sands of the river."[1] High Mass was said, trumpets sounded, and a play written by an officer was performed portraying the joyful conversion of the New Mexican Indians.

After he reached San Juan de los Caballeros, Oñate explored the interior of the continent even more extensively than Vázquez de Coronado, reaching "Quivira," an agricultural town of some twelve hundred round, thatched houses in central Kansas, in 1601 and believing himself only a short distance from the Atlantic. Four years later he followed the Colorado River to its mouth at the head of the Gulf of California and thought he'd reached the shore of the main body of the Pacific. But Oñate found no riches and was discredited by rebellious followers and their reports to the viceroy of his cruelty to Indians, especially to those of Ácoma Pueblo. Removed from his position as proprietor of New Mexico and replaced by a regular royal governor, Oñate rebuilt his shattered fortune in Zacatecas and died in a Spanish mine in 1626 while serving as the chief inspector of mines for the king.

Oñate had planned to found a Spanish city in New Mexico, the City of Our Father, San Francisco, but his party first settled in a section of the pueblo they called San Juan, then later took over a nearby pueblo located west of the Rio Grande on the left bank of the Chama, which had been evacuated by the Indians and which they named San Gabriel. The auditor of the expedition wrote in 1601 that "the governor wanted a town established, an *alcalde* named and houses built, but the Spaniards refused," reluctant to expend more effort in a land they wished to abandon.[2] The occupation of San Gabriel provided the needed housing for a Spanish community without requiring much Spanish work. A church, probably of *jacal* construction (branches plastered with mud), had been erected in the late summer of 1598 near San Juan Pueblo and dedicated to San Juan Bautista.

Excavations of San Gabriel Pueblo have revealed a substantial plaza area with portions of the foundations of a T-shaped church at its opening. This church dedicated to San Miguel had a nave forty-two feet long and approximately thirty feet wide and a transept twenty-five feet deep which extended just over fifteen feet beyond the nave walls on either side, constituting a building sixty-seven feet long and nearly sixty feet wide at the transept. Within a pueblo houseblock, foundations of two multiroom "apartment" complexes have been discovered, probably once having additional living rooms above them. One complex may have been the kitchen and living quarters of some of the friars of the expedition and the other the command center of Oñate. The walls of block were constructed by women in the method traditional since the fourteenth century, coursed adobe, which was poured sequentially in layers upon narrow foundations of cobblestones. Walls were as much as a foot thick, stiffened by an intermix of stones, and had few lateral openings. Passage between the rectangular rooms, which ranged between eight and ten feet long and six and seven feet wide, was primarily ver-

tical by internal ladders. Roofs were supported by timbers which were laid by Pueblo men.

The conversion of the Indians had been a prime concern of the Spanish government as it stimulated the settlement of New Mexico. Ten Franciscans had accompanied Oñate, their expenses paid by the government rather than by the contractor. Philip II's Ordinances for the Discovery, New Settlement, and Pacification of the Indies of 1573 had stated that "preaching the holy gospel . . . is the principal purpose for which we order new discoveries and settlements to be made."[3] The comprehensive Ordinances, which were intended to protect American natives from arbitrary cruelty of individual Spaniards, went so far as to ban the use of the word "conquest" and to designate the missionaries as the principal representatives of the royal government in Christian pacification.

The government committed substantial funds to supporting the evangelization of Indians. The annual amount provided to support a missionary after 1671 was a modest 330 pesos for a priest and 230 for a Franciscan lay brother. But the cost of transporting a friar from Spain to New Mexico was substantial. The passage from Seville to Vera Cruz by ocean came in the seventeenth century to more than 50 pesos, and the trip by land to Mexico City involved an additional expense. A 1631 contract reveals the very considerable cost of preparing a friar for service in New Mexico. Outfitting him to depart on one of the supply trains, which left the viceregal capital every three years, cost 875 pesos. Expenses for the six-month-long journey added another 325 pesos, and the costs of freight, and two mules and a wagon for every two friars, brought the total to nearly 1400 pesos.

Like Florida, New Mexico was threatened with abandonment by Spain in the first decade of the seventeenth century. Unlike Florida, New Mexico was from its beginning subordinate to the viceroy of New Spain, and Viceroy Velasco II, troubled by the lack of progress in the Oñate years, recommended in the spring of 1608 the withdrawal of the Spaniards and the few hundred Indians who had been converted. His recommendation was forwarded by the Council of the Indies to the King for a final decision. While he delayed his decision for many months, the New Mexican Franciscans, belatedly aware of the threat to their missionary enterprise, sent one of their number over fifteen hundred miles to Mexico City to report seven thousand conversions in the summer and thousands more Indians miraculously eager for Christianity. Both viceroy and king were elated by the reports. New Mexico was saved and in 1609 Pedro de Peralta was appointed its first royal governor.

In 1630 Fray Alonso de Benavides wrote a *Memorial* to the king describing Franciscan missionary work in New Mexico; it was published in Madrid and soon translated into French, German, Dutch, and Latin. Fray Alonso described the arrival of thirty new priests in Santa Fe after nine months and over fifteen hundred miles on the long, dry, rough road from Mexico City, and he gave a glowing account of Franciscan accomplishments. He urged the crown to support the conversion of all the Indians of the continent, and claimed that five hundred thousand Indians had already been pacified and eighty thousand converted. Enthusiastically he wrote that "more than fifty churches have been constructed with amazing ceilings, ornately carved in filigree patterns, and with handsomely painted walls"; they were built by the Indian women assisted "by the church-school boys and girls."[4]

As elsewhere in Spanish America, the Franciscans made a special effort to initially convert the Indian rulers and their children. Ceremonious gift-giving often initiated the process. The friars destroyed as many of the masks, statues, and other images of the native religions as they could, and worked to replace the traditional seasonal patterns of religious observances with Christian ones.

Dances, processions, and plays were staged and the sights, sounds, smells, and colors of Christian festivals were put to use. Candles in the dark, clouds of incense, bright vestments, and solemn music added to the emotional appeal of Christianity. Plays for the Indians reinforcing the Christian year were a specialty. They dramatized the Christmas story, the failure to find an inn in Bethlehem, and the visit of the three kings. For Holy Week, from Palm to Easter Sunday, there was much to present: crowd-pleasing entry to Jerusalem, betrayal, bloody whippings, crowns of thorns, processions with Indians carrying crosses, and the empty tomb.

Franciscan missions were supported by extensive agricultural operations. Important pueblos controlled districts approximately eleven miles in diameter. Within the districts were both pueblo agricultural tracts and larger areas of common land. Missions as well as settlers operated farms. By the early 1640s the twenty-five known mission farms more than doubled the number of secular ones, and in 1773 at least sixty mission farms were in operation. Substantial surpluses of cattle and grain were available for sale to the military and to the settlers. The revenue made possible the purchase in Mexico of expensive things for the churches and *conventos*, such as carved *retablos* and figures of saints, musical instruments, luxurious vestments, gold and silver vessels, and even chocolate for the friars. In periods of drought and famine, distribution of mission surpluses helped ease suffering among the Indians and the Spanish residents and provided seeds for planting and crops.

The Franciscans dominated New Mexico until the great Pueblo revolt of 1680, which expelled the Spaniards from almost all of New Mexico and forced them to take refuge in the El Paso area for more than a decade. Four hundred were killed including twenty-one missionaries. In all, forty-nine Franciscans were killed in New Mexico in the seventeenth century, nearly half of those who served in the area. In 1616 New Mexico was organized as the Franciscan Santa Custodia de la Conversión de San Pablo de Nuevo México, subordinate to the Province of Santo Evangelio de México headquartered in Mexico City, and unlike Florida never attained the status of a province. But the great distance from the authorities in New Spain afforded the New Mexican Franciscans virtual ecclesiastical autonomy. They regarded themselves as masters of a godly kingdom of Christian Indians and doggedly resisted the civilian authorities, quarreling with them over the exploitation of Indian labor, the major source of wealth in the area. They had the power of the Holy Office of the Inquisition and the taxing power of the *Santa Cruzada*, and also used the power of excommunication freely. They fought with almost every governor, intimidated most, and of the few who stood up to them sent one back to Mexico City in manacles and helped provoke the murder of another.

Among the causes of the great revolt of 1680 were increasing pressure on the Indians for labor services as their population, ravaged by epidemics and starvation from drought, dropped from approximately eighty thousand in 1598 to about seventeen thousand in 1679, and intensified Spanish effort to stamp out Indian religious practices which had been revived when frightening numbers of deaths suggested that the new Christian beliefs were ineffective. Many Indians believed that the old gods were angry and had to be appeased to restore rain, health, and happiness.

After the reconquest of 1692–1696, led by a Spanish nobleman, Diego de Vargas, who marched north with a statue of Our Lady of the Rosary, *La Conquistadora*, the Franciscans softened their opposition to Indian religious practices. Some chose to regard the omnipresent pueblo kivas, sacred to the Indians, as merely council chambers. Mission churches were rebuilt in most of the pueblos which had been occupied in 1680, and four remained in the

El Paso area, three of them constructed for refugee Christian Indians. The Spanish type government of the pueblos, originally established in 1621 and controlled by the friars, was permitted to come under the domination of the chiefs and medicine men.

Religious Architecture

More Spanish religious structures survive in New Mexico than in any other region of the United States. Father Benavides, with possible exaggeration, mentioned fifty in 1630. George Kubler's classic study of *The Religious Architecture of New Mexico* lists forty-nine Indian pueblos and Spanish towns that had churches erected during the years before American occupation in 1846 and eight structures within Santa Fe itself. Additional churches of Spanish New Mexico were outside the present state of New Mexico, such as those on the Hopi Mesas of Arizona and in the El Paso and Ciudad Juarez area. Many of these buildings do not survive. Little remains of construction before the revolt of 1680, and frequent rebuilding characterized the two and a half centuries of Hispanic rule and the century and a half since New Mexico came under the jurisdiction of the United States.

A striking characteristic of this architecture is conservative continuity of form and material. Building in the eighteenth century was less ambitious than in the period before the Pueblo revolt, and the traditional types of church continued to be built of the traditional materials in the traditional ways throughout the entire Hispanic period and in one instance even into the twentieth century.

New Mexican religious architecture resembles the buildings of the Indian pueblos more than the churches of New Spain. Unlike the churches the friars designed for Indians in the sixteenth century in central Mexico or in the eighteenth century in Texas, Arizona, or in their more ambitious efforts in California, New Mexican churches show little evidence of the influence of European traditions of church construction. Vaults, domes, and even walls of cut stone or rubble stone in mortar construction were unknown in colonial New Mexico, and arches of adobe were very rare. In marked contrast to Florida, limestone was readily available in many places for cutting and finishing and clay soil for fired bricks and tiles was plentiful, but in New Mexico the friars made no effort to have the Indians taught how to use European building materials and techniques. George Kubler attributed the friars' failure to push an ambitious European-style building program in New Mexico to the absence of a native population dense enough to support more laborious and time-consuming types of construction, to the resistance of the Pueblo Indians to foreign influences, and to the provisional nature of Spanish civilization at its remote northern edge in the formative early seventeenth century.

Friars who were directed to construct churches were provided with tools unavailable in New Mexico when they joined the supply train. It left the capital every three years with thirty-six wagons, over five hundred mules, and a variety of other animals, and took six months, averaging ten miles a day. A contract of 1631 specified that for the construction of a church a friar should be given ten axes, three adzes (for trimming logs), ten hoes, a medium-sized saw, a chisel with collar and handle, two augurs, a plane with a box to contain it, nearly three thousand nails of various sizes, eight hundred tacks, and fixtures such as latches, hooks, braces, hinges, and locks. Expenses for these items and for bells, altar cloths, and vestments were covered by a special royal grant of 1000 pesos. Once in New Mexico the friars negotiated with a pueblo's leaders regarding the location of the church and related *convento* buildings which were placed close to the existing structures of the pueblo. Sometimes the church was given a central place in the plaza; more often in the seventeenth century it was located off to the side.

The only known use of trained artisans of construction in New Mexico is the early importation of

carpenters to teach their skills to the Indians of Pecos, who became celebrated throughout the region for their carpentry. The lack of written records may be due to the destruction of most collections of documents in the revolt of 1680.

Were the Franciscan friars entirely responsible for the design and construction of such buildings as the great six-towered seventeenth-century church at Pecos, traditionally attributed to Fray Andrés Juárez, and the expanded church at Abó with its daringly thin stone walls, traditionally attributed to Fray Francisco de Acevedo? I share Mardith Schuetz-Miller and Eugene George's skepticism of the traditional belief in the omni-competent friar designer. If the Franciscans were wholly responsible for churches such as Pecos and Abó, New Mexico was the only province of Spanish North America without significant assistance in construction from lay professionals.

In construction it was first necessary to determine the placement of the church and the *convento* buildings. The site had to be leveled, involving in most cases both digging and filling to insure proper drainage. Churches were normally placed to face east so that light from a transverse clerestory would light the altar. An outline of the structures would probably first be drawn on paper or board, and then marked off by cord on the ground or bedrock before trenching began for the bottoms of the walls. Cords with knots spaced at equal intervals, normally a *vara* (approximately two feet, eight inches), were used. The lines were anchored by stakes or by iron pins. A twelve-space cord, known since Medieval times as an "Egyptian" cord, was used to determine right angles by forming a basic three/four/five right-angle triangle with the cord. Use of measured cords allowed the dimensions of the various sections of a building to be related as multiples of the basic module, such as the *vara*.

The friars were shocked by the role of women in constructing and finishing pueblo walls. Father Benavides wrote, "If we force some man to build a wall, he runs away from it, and the women laugh."[5] The men did collect, make, and assemble the materials needed for construction. A majordomo usually acted as superintendent of building operations, sometimes an Indian, sometimes a Spaniard such as a lay brother.

The principal materials were those the Indians used on their pueblo structures: adobe, *terreones* (dried sods), randomly shaped ledge stones gathered from outcroppings, and timber, brought with effort from the distant tree-covered mountains. The friars taught the Indians an improved technique for adobe construction, replacing their traditional method of pouring clay mud in sequential layers with the manufacture of sun-dried bricks, a practice known in the Mediterranean world since ancient Mesopotamia and probably introduced to Spain by the Moors. Pre-Hispanic adobe bricks have been discovered in Arizona but not in New Mexico. Seventeenth-century New Mexican bricks were large, weighing as much as fifty pounds and measuring approximately twelve by eighteen by five inches, heavy loads for the female Indian wall-builders, even with the assistance of ropes and pulleys to raise the bricks in baskets or wooden tubs to elevated places. The mud of clay and sand mixed with water and, in some places, with straw to hasten drying, was poured into wooden frames and allowed to dry. The frames were then removed, leaving the adobe bricks on the ground. After two days of additional drying, the bricks were turned on end and within a week or so they could be stacked for a month of curing. In the construction of walls, the bricks were laid in a mortar of clay and sand with joints sometimes nearly as wide as the bricks themselves. Plumb lines were used to keep the walls straight, and scaffolding of vertical poles and thong-tied horizontal elements made it possible to lay adobes above the height of four feet. After a wall was laid, the Indian women finished their work by applying one or more layers of adobe mud to smooth the surface, using sheepskins to brush the mud onto the wall.

Heavy buttresses added to support the side and rear walls, especially where they meet at the corners, are a striking feature of many New Mexican churches. Ranchos de Taos, memorably painted by Georgia O'Keeffe and photographed by Paul Strand, is a notable example. Buttresses were a response to the threat of structural failure but, as George Kubler noted, their design also reflected a concern for esthetic effect. More ample than structural needs demanded, they filled out and softened the silhouette of the church.

Stone from outcroppings, available in many locations, was used to face or reinforce adobe brick construction and in several notable seventeenth-century mission complexes was laid in adobe mortar as an alternative to mud bricks. Unlike the refined stone masonry of the prehistoric Pueblo Indians in Chaco Canyon and on Mesa Verde, these stones were unworked, of random shape and size. Yet walls of these rough stones were more durable than those of mud bricks, especially when the sand and clay mortar was forced into the joints after the wall had been erected.

In adobe construction, timbers were sometimes placed horizontally at the top of walls to strengthen their bearing capacity. Tapering was usual, increased by weathering as wind and water removed material from the upper wall and some of the eroded material adhered to the slanting lower section. Width of wall can vary suprisingly from one side of a church to the other. A thick wall facilitated the hoisting of the roof-supporting *vigas*.

Floors were usually of packed dirt or of adobe clay. Some stone churches also had floors of stone flags perhaps measuring two by one and a half feet. Preliminary preparation of floors preceded the construction of walls, and normally there was an upward slant from the entrance to the steps leading to the raised sanctuary.

Roofing, like other operations of construction, changed little from the pre-Spanish period until after American occupation. Work crews went to the sometimes distant wooded mountains to harvest logs of spruce, ponderosa pine, fir, or cottonwood. The logs, large enough to provide a finished *viga*, or roof beam, averaging thirty-five feet long and a foot thick and weighing about 1750 pounds, were sometimes left to season for a year before any preliminary carpentry began but lengthy seasoning was not essential. Trimming into *vigas*, rectangular or rounded, probably preceded transportation to the mission site. Wheels, removed from carts, may have been used, but carrying *vigas*, so that they would not be damaged by dragging, was the work of teams of Indians. Additional carpentry to cut, carve, and decorate the *vigas* and the associated corbels and lintels began after the timbers reached the mission. Wall construction, especially in stone churches, took as long as five or six years.

Lifting the heavy *vigas* to their places just under the tops of the walls was laborious and difficult. The Spanish may have introduced the Indian workers, accustomed to building with shorter and lighter roof timbers, to the use of European construction devices such as blocks and tackle and shear legs.

A low parapet extended around the structure at the top of the walls above the *vigas* and the roof which they supported. Roofs were flat and the water which collected on them was drained off by wooden *canales*, or spouts. The *vigas* were usually supported by wooden corbels set in the walls and frequently decorated with ornamental carving. *Vigas* were placed at intervals ranging from a foot and a half to over three and a half feet, and supported a layer of thin poles of juniper or aspen laid diagonally or in a herringbone pattern. An alternative was a bed of split lengths of cedar. Then came a layer of bark, brush, or other vegetative material. Earth at least six inches thick formed the upper level of the roof. This was sometimes made of packed adobe and sometimes merely of loose earth.

Windows were few and small, wider than they were high, and topped by lintels of rough-hewn logs. They were present in only one of the side walls

and ranged in number from one to three, averaging two. A single window in the façade, placed over the entrance, brought light into the choir loft. Glass was rare. More usual were sheets of mica or selenite set in gridiron-like frames of wood.

A transverse clerestory window, the principal source of light for the interior, was a structural form known only in New Mexico, but possibly invented elsewhere. A wide opening was created above the roof of the nave by raising the walls of the sanctuary a few feet above the nave's walls so that a broad band of light could illuminate the area of the altar. This simple structural innovation enabled the friars to secure much of the dramatic light characteristic of baroque churches without the complex methods of construction required for domes, almost universal in the seventeenth- and eighteenth-century churches of central New Spain.

Façades of New Mexican churches were essentially unornamented, dependent for esthetic effect upon simple massing. Most often they were towerless, culminating in a curving parapet with openings for one or two bells. Flanking towers were common in Spanish towns, rare in pueblo churches. When present, the towers rose in a continuous mass to a belfry stage above the central façade; some extended the line of the façade, others were set in front of that line. Buttresses placed at the front corners of some churches served to suggest towers. An ornamental feature of several churches was a balcony over the entrance, supported by timbers projecting from the choir loft and extending from tower to tower, or buttress to buttress. Mardith Schuetz-Miller has suggested that these balconies may have been used like the open chapels of central Mexico, to provide Mass outside the church for congregations too large for its interior capacity. Single towers, either freestanding, or placed at the center of the façade or behind the sanctuary, were rare. An exceptional church, built in the seventeenth century at Pecos, was described as having six towers.

Single-nave plans were normal in the churches

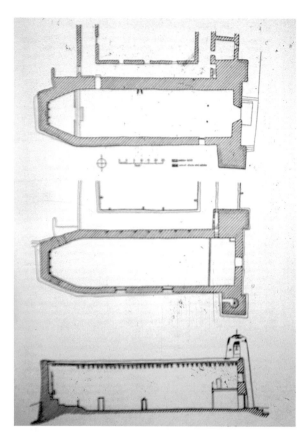

3.1. Church of San Esteban of Ácoma Pueblo, plans showing the ground level (top) and window level (middle), and a longitudinal section showing the choir balcony (right) and the raised sanctuary with a *retablo* at its rear (left), from George Kubler, *The Religious Architecture of New Mexico*, fig. 32.

of the pueblos. Cruciform plans were adopted in a few notable stone pueblo churches of the seventeenth century and were normal in the churches built in Spanish communities. Aisles were not known in colonial New Mexican churches. Sanctuaries were raised above the level of nave or transept floor and were rectangular, trapezoidal, or, rarely, curved in form to constitute an apse (Fig. 3.1).

As was frequent in Spain and normal in sixteenth-century Mexico, the choir was separated from the sanctuary and placed in a balcony at the opposite end of the church over the entrance. Lit by the façade window, the choir loft was ample, frequently extending from wall to wall and covering as much as a fifth of the entire interior.

The width of New Mexican churches was limited by the length of tree trunks available for use as *vigas*. Few, with the exception of the great church at Pecos, were much more than 30 feet wide. Naves were long, narrow, and dark. Overall interior lengths

| Chapter III

3.2. Detail of a painting uncovered on a wall of the sanctuary of the church at Awatovi, Arizona, simulating a three-dimensional decoration in tile, from Ross G. Montgomery, *Franciscan Awatovi*, fig. 60.

frequently reached 100 to 130 feet, and Ácoma extended close to 150 feet.

Franciscans believed the Pueblo Indians were spiritually moved by the "decency, ornamentation and ritual" of their churches, and Alonso de Benavides has left us an enthusiastic description of their amazing ceilings and handsomely painted interior walls. But except in Ciudad Juarez, no seventeenth-century church interior survives because no roof and ceiling has survived. Most of the churches extant in 1680 were destroyed in the Pueblo Revolt.

The elements of the ceiling of the church of Nuestra Señora de Guadalupe in Ciudad Juarez are more elaborately decorated than in any other church now standing in the territory of Spanish New Mexico. Small, deeply cut flowers cover both corbels and *vigas*, set in rectangles on the corbels and in diamonds on the *vigas*. A delicately carved triple molding runs high along the length of the nave walls just below the *vigas*. Such moldings are rare in present-day New Mexico. In most interiors whitewashed walls set off the strong, simple, curving forms of the barely ornamented corbels, and these shapes contrast with the plain, roughly carpentered *vigas*.

Some sense of the decoration of seventeenth-century interiors was provided by excavations directed by John O. Brew in the late 1930s at Awatovi in the Hopi territory. The principal church was named San Bernardo de Aguatubi by the friars. The archeologists discovered that in the initial construction the interior walls were treated with a layer of adobe clay and a layer of sandy plaster to smooth the irregularities. Then a third layer of fine white gypsum was added to prepare the surface for painting. As in sixteenth-century New Spain, the murals were not true frescoes but were painted on the surface of the plaster after it had dried.

Unlike the largely monochromatic murals of the sixteenth century, these wall paintings were done in a variety of colors. At Awatovi yellow, blue, green, pink, vermilion, maroon, and orange were found, in addition to black and white. Dados along the base of the walls were painted in panels of different solid colors. Areas farther up were decorated with a wide variety of stylized floral and geometric designs, suggestive in their charming patterns and sprightly colors of the majolica decorative tiles manufactured in Puebla. One interesting design, discovered on a wall of the sanctuary, was painted to create the illusion of three-dimensional blocks decorated on their ends with daisylike petals (Fig. 3.2). The main and side altars, constructed of adobe blocks, were decorated with continuous bands of floral decoration. Flowers were white, yellow, black, blue, and red, the colors varying from altar to altar. These bands were reminiscent of the stylized floral mural decoration of churches and *conventos* in Mexico. A somewhat similar fleur-de-lis design was discovered on an altar at San José de Giusewa near Jémez Springs in an excavation of 1921. The paintings at Awatovi were made with stiff brushes which left traces of their work. Indians trained by friars seem to have been the painters, and their work, following European designs, showed less assurance than their execution of their own designs in the kivas.

In many New Mexican churches, niches were hollowed out of the sanctuary wall above the altar to hold painted and gilded wooden statues of Christ,

the Virgin, and a variety of saints, and painted representations also adorned the churches. The 1627 supply caravan brought to New Mexico eighteen diverse images, seven statues of Christ, and eighteen pairs of tall candlesticks. The congregations stood, and sometimes kneeled and sat on blankets, but there were no chairs or pews so that the pulpit stood alone in the nave. Painted wooden pulpits rose in gobletlike shapes from adobe stems. They were reached by ladderlike steps and were topped by sounding boards.

After the reconquest of the 1690s, restored and newly built church interiors, like all ecclesiastical designs, were conservative, less ambitious and experimental than those of the earlier period. New Mexico, unlike the San Antonio and Tucson areas, was virtually untouched by the dazzling baroque of eighteenth-century Mexico. The region was poor, distant from central New Spain and sharing none of its affluence. A new economical way of ornamenting New Mexican churches was by painting on animal hides, using the hides of deer, elk, and buffalo. Favored subjects were the Crucifixion, other scenes and persons from the life of Christ, and some Franciscan saints. Figures were stiff, reflecting older Renaissance modes of design rather than the baroque. An altar frontal painted on bison skin remains in the Church of San José of Laguna Pueblo, though freshened by synthetic colors in 1964. Three lily plants rise and spread charmingly from urns and are framed by a loosely painted vegetative border. Extensive areas of mural painting from the late eighteenth or early nineteenth century survive on the side walls of the sanctuary at Laguna and behind the wooden altarpiece at Las Trampas. At Laguna the painting suggests textiles decorated by flowing, leafy forms. At Las Trampas there are fragmentary remains of bands of diagonal blocks, some enlivened with flakes of mica and above them flowers and birds, all framed by a great painted arch.

By the time of a visitation of Fray Francisco Atanasio Domínguez in 1776, many New Mexican churches had new wooden altar screens which replaced the niches above the altar characteristic of many earlier interiors. A painted stone reredos made for the Church of Nuestra Señora de la Luz, La Castrense, in Santa Fe in 1761 may have stimulated the desire for altar screens in other churches. The Castrense altarpiece, the only stone reredos ever constructed in New Mexico, was brilliantly painted and contains six large *estípite*-type columns with the sharply faceted outlines popular in metropolitan Mexico City. It was flat and not advanced in design by contemporary Mexican standards but so outstanding in remote New Mexico that Fray Domínguez described it as seemingly copied from "the façades now used in famous Mexico [City]."[6]

The wooden altar screens were brilliantly painted quasi-architectural compositions which framed representations of Christ, the Virgin, and various saints, both colored wooden statues and paintings on canvas, that were already in the churches before the altar screens were constructed. Normally an altar screen contained seven or more images arranged in three or four tiers with three images in the two lower tiers. If a church lacked the requisite number of images, representations of the religious figures were painted on the altar screen itself.

The outstanding surviving wooden altar screen in New Mexico is in the Church of San José at Laguna Pueblo. It was not present at the time of Fray Domínguez's visit and was probably constructed and painted shortly after 1800. The work attributed to "the Laguna Santero" contains no preexisting paintings or statues, only images painted on the altarpiece itself.

Such compositions required the labors of a carpenter and a woodcarver, as well as a painter-designer. The Laguna Santero is believed to have been a provincial artist from northern Mexico who worked on altarpieces of several other churches,

Chapter III

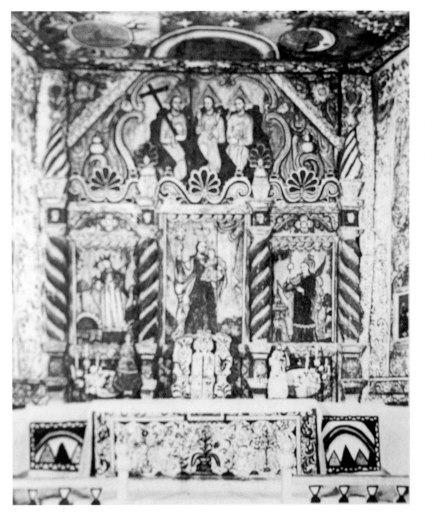

3.3. *Retablo* of the church of San José, Laguna Pueblo, photograph from Sandak Inc.

including that of Ácoma Pueblo and San Miguel in Santa Fe. A wooden canopy above the altarpiece of the San José church is attached to the *vigas* of the ceiling to protect it from falling dust and other debris (Fig. 3.3). Painted Indian symbols adorn it, a red sun and a white fragment of a moon at the sides and a modest-sized rainbow at the center. The altarpiece is organized architecturally in two tiers by orders of blue and red painted twisting salomonic columns, a baroque type more than half a century out of date in Mexico City. The principal, lower, level contains at its center a painting of San José holding the infant Jesus, flanked by similarly primitive renderings of San Juan Nepomuceno and Santa Bárbara. The upper level contains, framed by curving baroque scrolls, a triple representation of the Christian Trinity as three seated men in red, the one on the left holding a large cross.

In the wake of the Laguna Santero, a remarkable school of native *santeros* developed in New Mexico. They decorated a large number of village churches, particularly in the area north of Santa Fe during the last years of Spanish rule and especially in the Mexican and American periods. Their paintings were simpler, more primitive than those of the Laguna Santero, more abstract, and at their best more decorative. Many of these artists also carved *bultos*. These folk statues were usually modest in size and strikingly colored. They are consistently charming and in some instances powerfully expressive.

Initially the friars were given a few, usually previously abandoned, rooms in a pueblo and allowed to have them modified into suitable spaces for their sleeping, cooking, eating, and other daily activities. Later they had *conventos* built by Indians who adapted their accustomed building techniques to create a New Mexican equivalent of the Franciscan *conventos* of Spain and central Mexico. In the larger establishments buildings were arranged around two patios. Roofs, supported by *vigas* and wooden posts, ran along the four sides of the principal patio to provide a protected cloister walk. Off it opened a reception room and several cells, with the principal one connecting to an office for the friars and the others serving as a refectory, a kitchen, an infirmary, and one or more rooms for storage for Indian members of the staff. A second patio contained space for secular activities, for workshops, and for animals.

Secular Architecture

Little of Spanish secular architecture survives in New Mexico, even in the many times reconstructed Palace of the Governors in Santa Fe. But Spanish building traditions continued well into the period of American occupation. Methods usually resembled those of ecclesiastical construction: walls made of

adobe bricks, flat dirt roofs supported by large cross-timbers, *vigas*, and diagonally placed smaller poles or split lengths of wood. *Jacal* construction, vertical poles interwoven with brush and coated with adobe plaster on both sides, similar to the wattle and daub work of Florida, was used in the seventeenth century for provisional housing and throughout much of new Mexican history for animal and storage shelters.

In mountainous areas of northern New Mexico timbers of pine, fir, spruce, and aspen were available for the building of log structures for houses, barns, sheds, and corrals in the centuries after 1700. The logs were stripped of bark and often hewn to a squared-off shape to produce smoother interior and exterior walls. They were held together at the corners of buildings by projecting double-notch joints. Charles F. Gritzner identified the sites of approximately fifty water-driven gristmills which were housed in crib structures of logs. He believed that probably more than twice that number were operational in the nineteenth century. The mills were simple, without gears, and of modest productivity. Water drove a horizontal waterwheel which was fused with the axel and the upper millstone. The rotation was counterclockwise.

Houses in the seventeenth century were modest. Except for a few *estancias* of as many as ten rooms, most consisted of one to three rooms, about fifteen feet wide and at most eighteen feet long. They were for living, sleeping, eating, cooking in winter, and other purposes. In the many single-room houses the door was often the only source of light. In larger houses there were few windows, most often wooden framed to support panels of mica, selenite, or pieces of treated cloth. Glass was virtually unknown in New Mexico until the middle of the nineteenth century. Poverty and fear of Indian attack led to the minimal fenestration.

A Pennsylvanian, W. W. H. Davis, who served as United States Attorney in territorial New Mexico in 1853, wrote in *El Gringo* (1857) that there were only two two-story houses in Santa Fe and that neither was erected "by the Mexicans." Davis described the interior walls of New Mexican houses as whitewashed with *yezó* (or *jaspe*) by women who spread the layer of native gypsum with their hands and pieces "of sheep skin with wool on it," instead of brushes. They also prepared the floors by spreading on the ground a coating of soft mud "which when dry makes a comfortable floor."[7] Walls were not always white. Earth colors, ranging from pink to warm brown, could be mixed with the jaspe and in some instances a sparkling effect was produced by using *tierra amarillo*, yellow-tan clay containing flakes of mica. Chairs were few. Benches when present along the walls could be used for sleeping. Most often people folded the mattresses they had slept on against the walls and covered them with blankets. Davis found these a satisfactory substitute for a sofa.

Fireplaces, frequently placed in a corner, were a standard feature of New Mexican rooms. Father Domínguez had described one in the buildings of Nambé Mission in 1776 as "a brazier on the floor with a wooden hood plastered with mud."[8] Such fireplaces and chimneys were Spanish innovations in New Mexico, where the traditional European upward-sloping chimney hood was frequently modified into a dual structure, with a vertically sloped hood over the small firebox combined with a flat, plastered shelf supported by wooden posts. These shelves, called "shepherds' beds," could provide a warm place to sleep. Other New Mexican fireplaces had profiles like bells. In summer cooking was normally done outside in igloo-shaped ovens called *hornos*, which like the adobe brick were of Moorish derivation.

Defensibility was a concern in New Mexican domestic architecture because the nomadic tribes of the plains were a recurring threat to lives in the scattered settlements. Juan Bautista de Anza II, governor of New Mexico after he completed his long expeditions from present-day Arizona to the coastal settlements of California, in 1779 urged settlers to

consolidate their houses in fortified plazas for protection against Comanche raiders. Houses joined together to form a contiguous structure closed on the outer sides except for one well-defended opening would have some of the effectiveness of the Indian pueblo structures which provided a model for defensible domestic structures. Their two- and three-story houses, joined together to form plazas with all the houses having portable ladders that could be pulled up in time of invasion and with the roofs and upper and lower terraces having embrasures in the parapets for their defense, had been studied by the Spaniards.

The plaza of El Cerro de Chimayó, founded half a century before Anza, survives, though decayed and modified, in enclosed rectangular form. Similar fortified communities existed in Ranchos de Taos, at Las Trampas in the mountains north of Santa Fe, and at several communities on the edge of the plains on the eastern frontier.

Torreones, towers usually round, sometimes square, were incorporated into some of the fortified plazas and were built to defend isolated farmsteads. The royal government proposed a chain of *torreones* for the *Camino Real* from upper New Mexico to El Paso, spaced a day's travel apart. Only one round tower of adobe bricks survives, in Talpa near Ranchos de Taos, and ruins of two are at Dixon, once the fortified plaza of San Antonio del Embudo.

Torreones were constructed of either adobe bricks or stone and had interiors about fifteen feet across. They were usually two-storied with a single strong door and, high in the walls, peepholes or a few small, barred windows. Walls were close to three feet thick. A trapdoor allowed access to the parapeted roof so that defenders could fight off attackers while keeping the women and children safe in the upper room and the animals in the lower room.

In settlements less vulnerable to Indian attack, houses were more open, sometimes incorporating covered porchlike structures called *portales*. A *portal* was usually placed in the center of the front of a house. The roughly fifteen-foot-long beam at the top, which supported the *vigas* under the roof, was sustained by two or more posts. A carved length of wood constituting a sort of corbel, or capital, and called a *zapata*, was set between the top of a post and the horizontal beam. In some instances both the beam and the *zapatas* were cut from a single large log. The *zapata* is another instance of the persistence in Spanish colonial architecture on the American continent of elements of Moorish building methods. The carving of the *zapata* and, in some instances, incising it with minimal decoration made it a cruder version of the corbel of the church interior and the only ornamental form known in New Mexican domestic architecture.

In Santa Fe *portales* were extended across the fronts of structures facing the plaza, including the Palace of the Governors, and along some of the nearby streets. These crude quasi colonnades provided welcome protection from the sun and from water during the rainy season. The town market was sheltered under the *portal* of the Governor's Palace in the 1850s, and Indian crafts are now sold to tourists in the same traditional place.

Relatively few New Mexican houses in towns like Santa Fe and in the countryside were large multiroom buildings constructed around one or more interior patios. The restored building of the Martínez Hacienda in the Taos area is an outstanding example of the type. The property was purchased by Severino Martínez, who moved to Taos from Abiquiú with his wife and the first three of their six children in 1803. The present structure may have grown from a modest three- or four-room building belonging to the Indians of Taos Pueblo. Martínez's eldest son, Antonio José, became the most influential New Mexican clergyman of his time, the famous Padre Martínez of Taos who was excommunicated by Bishop Jean Baptiste Lamy for resisting his authority.

The structure, which gradually grew to close to twenty rooms, has been restored with few openings in the exterior walls in order to suggest its early fortresslike state (Fig. 3.4). At one time it had no exterior windows and only two massive, gated openings, *zaguans*, to permit entry into its front and rear patios. At the top of its high walls indentations were cut in the parapets to provide protected stations for defensive fire. In a later era less concerned about Indian attacks, the hacienda acquired an exterior *portal*.

The front patio, or *placita*, was surrounded by a dozen rooms of varying length, ranging from the nearly thirty-foot principal *sala* to a corner room approximately ten feet square (Fig. 3.5). Doors and windows opening on the patio were numerous, and a *portal* provided protected circulation between the rooms along all four sides. These rooms included another *sala*, several places for both sleeping and working, a chapel and a kitchen, and rooms for storage and trade. Seven or eight rooms placed around the back patio probably provided quarters for servants, places for workshops, and stables for animals. A well was located near the southeast corner of the front patio and one or more external ovens, *hornos*, were also located there.

The hacienda provided living and sleeping quarters for the Martínez family and their servants, and it also served as a place of trade and of manufacture. Local agricultural products and items bartered from the Indians were sold, as well as special goods manufactured in Mexico. A gristmill was operated nearby and a workshop for processing wool. Spinning, knitting, and weaving were probably also carried on. Woolen garments, blankets, and rugs would have been among the products, as well as leather garments and shoes made from locally tanned and prepared hides. Among the items in the will of Severino Martínez, in addition to many horses, mules, cattle, oxen, goats, and a thousand sheep, were "one hundred and twenty-four

3.4. The Martínez Hacienda, Taos.

3.5. Front patio of the Martínez Hacienda.

buffalo hides, twenty-five deer hides [and] forty-four pairs of woolen stockings."[9]

Pecos

"When the roof caught and began burning furiously a strong draft was created through the tunnel of the nave from the clearstory window over the chancel thereby blowing ashes out of the door. It was like a giant furnace. When the fire died down,

the blackened walls of the monster still stood. To bring it low, Indians . . . clambered all over it, like Lilliputians over Gulliver, laboriously but jubilantly throwing down adobes, tens of thousands of them. Unsupported by the side walls the front wall toppled forward façade down, covering the layer of ashes blown out the door. With an explosive vengeance the Pueblos had reduced the grandest church in New Mexico to an imposing mound of earthen rubble."[10] Thus John L. Kessell described the destruction of the second church of Pecos in 1680 in his fine history, *Kiva, Cross, and Crown*.

Pecos Pueblo, southeast of Santa Fe at the downward slope of the high country of New Mexico, had been visited by a scouting party of Vázquez de Coronado in 1540. A year later the Pueblo, in the hope that the Spaniards and their horses would starve to death, had been responsible for luring Coronado into embarking on his futile five-hundred-mile trip to Kansas in search of the fabulous golden land of Quivira. Some forty years later Pecos was described by another exploring Spaniard as "the best and largest of all the towns discovered by . . . Coronado. . . . The houses, of from three to four stories are whitewashed and painted with very bright colors and paintings. Its fine appearance can be seen from far off."[11] Pecos served as a gateway, a place of war and of trade, between the pueblos and the nomadic Indians of the plains.

The first missionaries to attempt the evangelization of the Pecos Indians were a Franciscan lay brother, Fray Luis de Ubeda, who had remained after the departure of the Coronado expedition, and Fray Francisco de San Miguel, who spent a few months at the pueblo in 1598, the year of Oñate's arrival. With San Miguel was Juan de Dios, an Indian from central New Spain who had learned the language of Pecos from a native brought as captive to Mexico City by an earlier expedition. A modest rectangular adobe church, measuring about eighty by twenty-five feet and placed slightly more than three hundred yards northeast of the principal pueblo block, may have been begun by Indians under the direction of Fray San Miguel and Juan de Dios or, more likely, under the direction of the next Franciscan at Pecos, Fray Pedro Zambrano Ortiz, who was probably in residence from 1617 until 1620. The church was dedicated to Nuestra Señora de los Angeles de Porciúncula, a century and a half before the founding of the city in California similarly dedicated.

Whenever its construction was begun, this first adobe church was used for only a brief period. In October 1622 Fray Andrés Juárez, recently assigned to Pecos, wrote to the viceroy that work was underway on an urgently needed church. It had probably been started in late 1620 under his predecessor, Fray Pedro de Ortega, because there was "no place to say Mass except for a *jacal* in which not half the [nearly two thousand people of the pueblo] . . . will fit." Fray Juárez asked that an altarpiece "featuring the Blessed Virgin of the Angels, advocate of this pueblo . . . [and] a child Jesus to place above the chapel" be sent from Mexico City. He stressed to the viceroy the importance of Pecos to the evangelization of the Indians of greater New Mexico. Every year, he wrote, "heathens, called the Apache nation . . . come to this pueblo to trade, and the items they bring are very important both to the natives and to the Spaniards." The pagan Indians, he continued, would enter the church and be moved by the altarpiece and other religious images and "the Lord will enlighten them so that they [will] want to be baptized and converted to Our Holy Catholic Faith."[12]

The church of Fray Juárez, his Indian workers, and probably an unknown craftsman designer was completed in 1625. It was praised in Alonso de Benavides's *Memorial* of 1630 as "a most splendid temple of singular construction and excellence on which a friar expended great labor and diligence." Franciscans in far-off Mexico City knew of its fame. Agustín de Vetancurt, chronicler of Franciscan achievements, described it in his *Teatro Mexicano*

nearly twenty years after its destruction as "a magnificent temple . . . adorned with six towers, three on each side" with walls "so thick that services were held in the recesses."[13] An approximation of the appearance of the church described by Vetancurt has been provided in a reconstruction drawing by Lawrence Ormsby and a painting by a modern Franciscan, Hans Lentz[14] (Fig. 3.6). Alden C. Hayes in *Four Churches of Pecos* has summarized the archeological findings of William B. Witkind and of Jean M. Pinkley, who identified the foundations of the church. Hayes continued the investigations after Pinkley's death.

The church was placed at the southern end of the mesa on which the pueblo was located, at the point of access. The surrounding area was level, suitable for construction of the *convento* and auxiliary buildings, but some leveling of the bedrock with adobe was necessary to provide a flat floor. The walls were constructed on a massive rubble-filled foundation which was faced with randomly sized pieces of local sandstone. The church ran 146 feet from the entrance to the rear wall of the sanctuary with its nave walls narrowing slightly from a remarkable width of nearly 41 feet, ten more than the New Mexican norm, to $37\frac{1}{2}$ at the opening into the relatively small sanctuary. The ceiling was at least 45 feet above the floor.

The walls varied in thickness from 8 to 10 feet and were supported by ten buttresses on the outer side and a lesser number on the side where the *convento* building provided some support. Total wall thickness through the buttresses ranged from just over 11 to $13\frac{1}{2}$ feet. Small rooms at the eastern corners of the church served as bases for the front towers and at the rear corners massive constructions, resembling transepts and approximately 22 feet thick, provided bases for the four other towers, two on each side. John L. Kessell estimated that the construction of the church required three hundred thousand bricks of gray adobe, each about $9\frac{1}{2}$ by 18 by 3 inches in size, and containing pieces of bone,

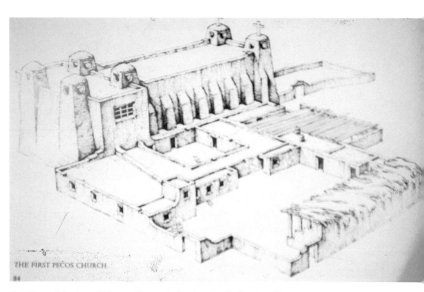

3.6. Pecos, Mission of Nuestra Señora de los Angeles de Porciúncula in 1680, reconstruction drawing by Lawrence Ormsby.

pottery, and charcoal, suggestive of their source in the pueblo's long accumulated trash mounds.

Construction of the church was an immense labor for the Indians of the pueblo even though most of the building activities were familiar to them. Even the earlier church had magnified their conception of interior space. Accustomed to building cubelike blocks of rectangular apartments with interiors measuring little more than ten feet long and eight feet high, and circular kivas about twenty feet in diameter and eight feet deep, they were asked to construct European-type church interiors. The interior of Father Juárez's church must have seemed astonishingly vast to its Pecos parishioners.

Seventeenth-century Pecos had, in addition to a resident friar supported at times by a lay brother, two nonresident *encomenderos*, individuals to whom the community owed tribute. This was limited in New Mexico to goods, not goods and services as in central New Spain. Pecos was the richest *encomienda* in New Mexico. Collection was made in both spring and fall. The principal *encomendero* after mid-century was Francisco Gómez Robeledo, *Maese de Campo* of New Mexico, owner of *encomienda* grants in four other pueblos, including Abó, Ácoma, and Taos. He was a principal ally of Governor Bernardo

López de Mendizabal and, like him, was arrested by the Franciscans in the name of the Inquisition, imprisoned for five months, and then sent in shackles on a four months' journey to Mexico City for trial; but, unlike the governor, he was speedily acquitted of the charges, which included being a secret Jew. From 170 Pecos households, Gómez Robeledo received his tribute in buckskins, woven mantas, buffalo hides, and light and heavy buffalo or elk skins. Most of these goods had been secured by barter from the Apaches of the plains at the annual Pecos trade fair.

Some Pecos Indians had warned Gómez Robeledo in Santa Fe of the impending revolt in 1680 despite the alienation of much of the community by Governor Otermín's assistant, Francisco Javier, who had captured a group of Apaches who were peacefully camped for trading at Pecos and sold them into slavery. Such action had threatened the economic well-being of the pueblo. Governor Otermín ignored the warning transmitted to him, and a sizable contingent of Indians from Pecos joined the assault on Santa Fe. At Pecos, Indians killed a Spanish family and a Franciscan lay brother, and an effort to spare the venerable minister, Fray Fernando de Velasco, by sending him away, was unsuccessful. Later the people of Pecos attempted to blame the destruction of their church on Tewa-speaking Pueblos from the area north of Santa Fe, but it seems that the majority of the pueblo was caught up in the anti-Christian frenzy which led elsewhere to the widespread smashing of Christian images, desecration of chalices with human excrement, slaughter of Spaniards, and destruction of churches.

The reconqueror, Diego de Vargas, was welcomed at Pecos on his initial foray into New Mexico in 1692, but he left no description of the ruins of the church. Two years later Vargas installed the secretary of the Franciscan *Custodia* of New Mexico, Fray Diego de Zeinos, as missionary. Zeinos remained only about a year, but in that time he directed the construction of a temporary church using a still-standing wall of the *convento*. It was about half the length and width of the demolished structure and was placed on the same site but with reversed orientation, the façade facing west.

By this time the population of the pueblo had dropped below 750 residents, a little more than half what it had been before the rebellion. Nevertheless a substantial church, the fourth and final one at Pecos, was begun about 1705 and completed approximately a decade later. This church, triple the size of Zeinos's and about two-thirds the size of the great church, had lost its roof but was otherwise largely standing when Pecos was visited in 1846 by an artist attached to Stephen Watts Kearny's Army of the West, John Mix Stanley. The church sketched by Stanley had paired bell towers set well in front of the façade and joined by a balcony over the doorway, supported by diagonally placed timbers (Fig. 3.7). The transept, indicated by Stanley, and the apse survive today in a great mass of reddish brown adobe (Fig. 3.8). A photograph taken in the early 1870s by H. T. Hiester shows some of the *vigas* and corbels still in place at the end of the nave and in the sanctuary, and a clerestory window containing ten vertical ribs which had held translucent pieces of selenite. A rectangular *viga* and a corbel, removed in 1869, are now in the Museum of New Mexico. They are carved with the skill characteristic of Pecos carpenters, the beam with delicate subtlety and the corbel with powerful plasticity in order to be seen from below in the dark interior. A carving of a Franciscan cord is at the center of the corbel, flanked by other ropelike undulating forms.

In the late 1740s the Comanches threatened Pecos, perhaps resenting its earlier role as center for trade with the Apaches. Governor Tómas Vélez Cachupín reported to the viceroy in 1750 that he had fortified Pecos and the neighboring pueblo of Galisteo with trenches and towers (*torreones*). The

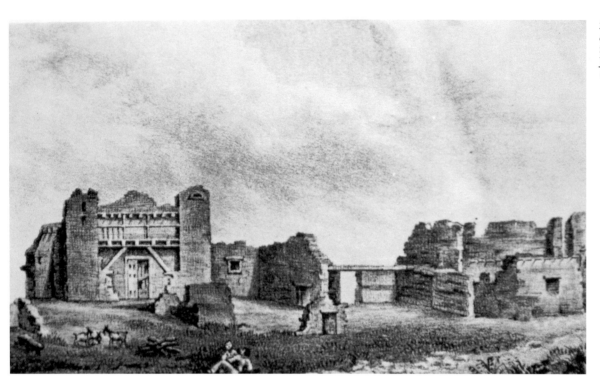

3.7. Pecos in 1846, drawing by John M. Stanley, reproduced in John L. Kessell, *Kiva, Cross, and Crown*, p. 470.

four or five towers at Pecos were placed to guard the four entrances to the pueblo. Comanche incursions persisted for more than thirty years, but in 1786 Governor Juan Bautista Anza concluded a peace at Pecos which preserved New Mexico from further depredations.

The decline of the Pecos population, evident early in the eighteenth century, continued and the pueblo was displaced as gateway to the eastern plains by new racially mixed communities farther down the Pecos River, San Miguel and San José del Vado. Franciscan concern shifted from the dwindling remnant in the old pueblo to the growing populations of the new towns. Friars became scarce and in 1829 they were forced to abandon their more than two century old ministry to the Pecos Valley. Secular priests riding out from Santa Fe provided periodic religious services for the towns.

Occupation of the pueblo concluded about 1838 when the seventeen to twenty survivors left for a Towa-speaking pueblo in the Jémez mountains, eighty miles to the west. In September 1839 an actor-journalist, Matthew C. Field, slept in the Pecos church. He later described in the *New Orleans Picayune* the deserted town of "Pécus" with its houses unroofed, their walls crumbling, and only the church remaining almost intact.

3.8. Remains of the eighteenth-century church at Pecos. Also see Plate II.

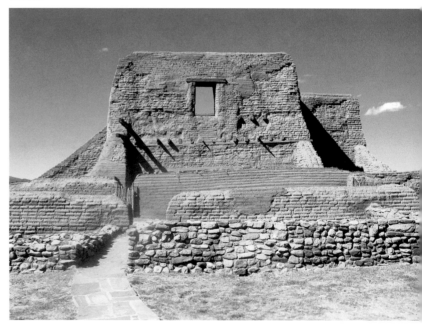

3.9. Church of San José de Giusewa, view from the southwest.

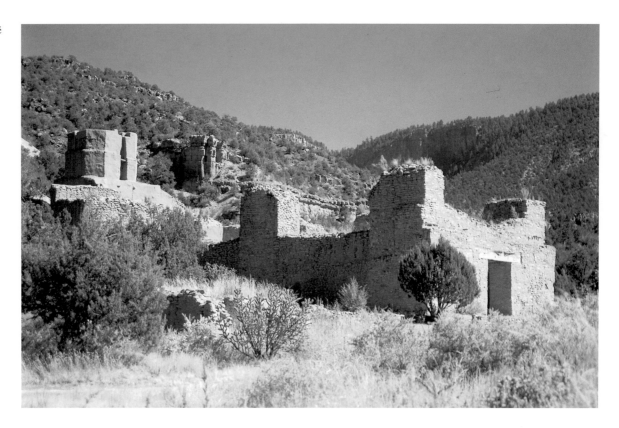

Stone Churches: the Salinas Region and Jémez

"A huge and mysterious edifice, an edifice in ruins, it is true, but so tall so solemn, so dominant in that strange, lonely landscape, so out of place in that land of adobe box-huts, as to be overpowering. On the Rhine it would be superlative; in the wilderness of the Manzano it is a miracle."[15] So wrote the flamboyant promoter of the Hispanic Southwest Charles Fletcher Lummis of the ruined stone Church of Quarai in *The Land of Poco Tiempo*.

Several important stone churches and their *convento* buildings were erected and abandoned before the Pueblo Revolt of 1680. All were constructed in pueblos distant from the Rio Grande Valley, in places where stone was readily available and Indians were accustomed to building in stone, so memorably worked by their ancestors in Chaco Canyon.

The first built and the first abandoned, San José de Giusewa, near Jémez Springs some fifty miles west of Santa Fe, was described about 1630 by Father Benavides as a most sumptuous and interesting church and *convento* (Fig. 3.9). The church's huge walls, measuring up to eight feet thick on the east side and extending about five feet above the roof line, possibly for defensive purposes, were constructed of local sandstone set in adobe-mud mortar.

A sizable church, 111 feet from the entrance to the end wall of the sanctuary and approximately 34 feet wide, San José was placed in a cramped site between two streams so that digging into a hillside was necessary at the northern, sanctuary end. An extraordinary feature of its construction was the filling of a gap between segments of the floor of the nave with charred wood and other burned material. George Kubler suggested that the builders used water-repelling charcoal to avoid difficulties with moisture likely to result from the seepage of water from the excavated hillside. Most striking visually was the quasi-octagonal stone tower placed behind the sanctuary at the base of the hill. The tower may have loomed as much as fifty feet above the church

with a doorway leading out onto the roof. The interior walls, constructed of unworked but relatively flat-faced stone, were leveled with mud plaster, finished with gypsum plaster, and painted with mural decoration in true fresco technique (Fig. 3.10). A fragment of fleur-de-lis ornamentation painted on wet plaster, unique in New Mexico, was discovered in an excavation of the early twenties directed by Lansing B. Bloom.

The immense labor devoted to constructing this imposing church in five or six years in the early and mid-1620s must have ultimately seemed fruitless to its Indian builders. After barely a dozen years' use, it was abandoned when missionary activity shifted to another site in the Jémez area.

Three other impressive ruins of stone religious structures are east of the Rio Grande Valley, separated from it by the Manzano mountains, and close to the Salinas salt beds deposited by prehistoric lakes. The area is a dry and stony grassland but was relatively heavily populated when the first Franciscans passed through in 1581 and Juan de Oñate's men arrived in 1598. The largest pueblo, though located on the driest terrain, was named by the Spaniards Las Humanas and is now popularly known as Gran Quivira because of attempts in the late eighteenth and nineteenth century to find there legendary buried treasure. Las Humanas was reported to have two thousand residents when the Spaniards first visited it, and as late as 1672 it was reported to have more than five hundred families when Abó Pueblo had somewhat more than three hundred and Quarai more than two hundred.

Abó

Serious Franciscan Mission activity began in the Salinas area as early as 1614, but no construction at Abó preceded the middle 1620s when a simple stone structure with a single nave was built, possibly under the direction of Fray Francisco Fonte, who had at first been allowed to take over some unused

3.10. Interior of the church of San José de Giusewa.

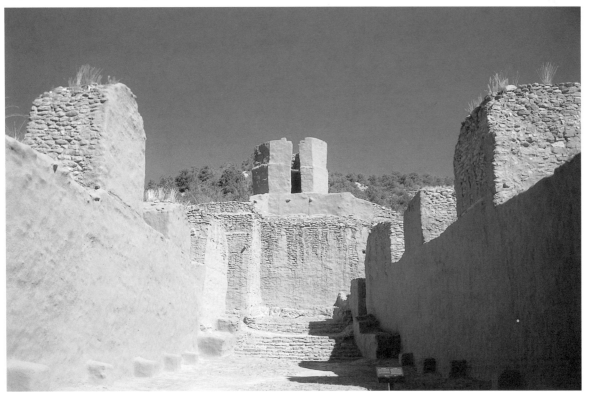

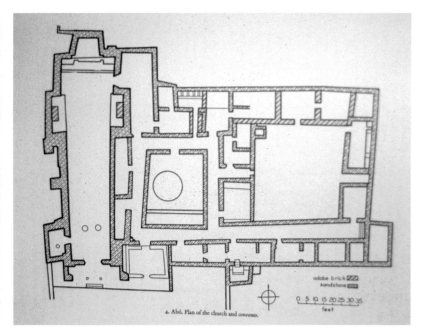

3.11. Plan of the church and *convento* of San Gregorio at Abó, from George Kubler, *The Religious Architecture of New Mexico*, fig. 4.

rooms in the pueblo. Twenty years after the completion of the first church, Fray Francisco de Acevedo began a massive program of alteration and expansion of the church of San Gregorio. The unknown artisan designer who probably assisted him decided to minimize additional construction by retaining most of the earlier church. This campaign, which lasted several years in the 1640s, began with the demolishing of the old square apse so that the nave could be extended farther north with shallow transept-like structures, with space only for side chapels, two-thirds of the way along the side walls (Fig. 3.11). These structures, approximately twenty feet long and five feet deep, were sufficient to contain side altars but did not significantly affect the sense of the nave as a single space broadening slightly, like that of many other New Mexican stone churches, as it approached the small polygonal sanctuary. The side chapels contained unusual railed balconies, or tribunes. They seem to have been connected to a unique feature of the church, what James E. Ivey, the notably perceptive archeologist and historian of the Salinas missions, called a "catwalk" running across the interior of the church in front of the sanctuary at a height of twenty-two feet. Access to the bell platform at the top of the west wall was possible only from the tribune of the western chapel.

Another unusual feature of Abó, and of Quarai, is the existence of an underground kiva in the middle of the principal patio of the *convento*. Ivey wrote of the kiva at Abó in *In the Midst of a Loneliness:* "Since it appears to have been built during the . . . construction . . . [of] the church, Fonte must have approved of it. It may have served as the temporary church during the construction . . . , helping the Indians in transition from their kivas to the above ground churches typical of Catholicism."[16]

The new reddish brown sandstone walls of Father Acevedo's expanded church were thicker than those of Father Fonte's original structure (Fig. 3.12). Two buttresses were added to the old west wall in preparation for its unroofing and the demolition of its original apse which had helped to support it. The walls of the expanded church were over forty feet high in the sanctuary end, nearly double that of most adobe churches, and daringly thin by New Mexican standards. The designer of this church was most sparing in the use of building materials and most courageous in his approximation of European efficiency in construction technique. At San José de Giusewa the west wall reached a thickness of six feet and the massive east wall a thickness of eight (Fig. 3.13). The taller walls at Abó are remarkably consistent in thickness, approximately three feet thick in the older section and four feet in the newer, with the facing stones attached loosely on a rubble core. The east wall was built about a foot higher than the west so that water would drain across the roof in that direction.

San Gregorio was a large church, approximately 132 feet in interior length and gradually widening from about 22 feet at the entrance to close to 32 feet at the opening into the sanctuary. That made it about 15 feet shorter than the seventeenth-century church at Pecos and over 10 feet longer than the

church at Giusewa. A sudden contraction of space in the sanctuary created particular optical emphasis upon that sacred area.

The roof structure was unusual. Instead of being supported by relatively closely spaced *vigas*, it was supported by nine widely separated compound beams. Two massive one-foot-square timbers were laid together to constitute the beam. These beams, handsomely carved and resting on similarly massive long and short carved corbels, were placed more than seven feet apart.

Another unusual feature of the construction of Father Acevedo's church was the laying of long beams, approximately a foot square, along the tops of the walls to diffuse the weight of the great compound crossbeams evenly along the whole wall. The ends of the corbels and crossbeams were fastened to the longitudinal beams to form what James E. Ivey called "a series of box frames around the tops of the walls bracing them against the effects of . . . [wind] pressures and shifting foundations."[17]

The interior of the church had a concentration of light in the sanctuary area which was provided by two windows in the east wall and the transverse clerestory. A platform supported subsidiary stone altars at the sides, and the principal altar, also of stone, was placed in the polygonal apse and was reached by a short flight of steps. At the other end of the church the choir loft, lit by a window reconstructed in the façade, occupied the first twenty feet of the nave and was supported by a beam resting on vertical posts set upon stone foundations.

Joseph H. Toulouse found traces of gypsum plaster and fragments of colored paint everywhere in the church and *convento* at Abó in the 1930s, but he was unable to suggest the nature of the decorative patterns except for the likelihood of there having been a red dado in the church. He also found fragments painted in white enamel with gilt and green trim suggestive of a painted *retablo*, or altar screen.

In addition to the five altars in the church, three in the sanctuary and two in the chapels set back from

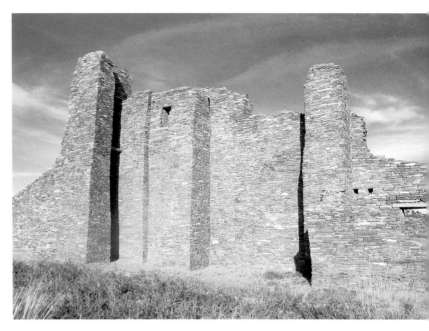

3.12. Exterior wall of the church of San Gregorio at Abó from the west-southwest.

3.13. San Gregorio at Abó from the east, photograph by David Wakely. Also see Plate III.

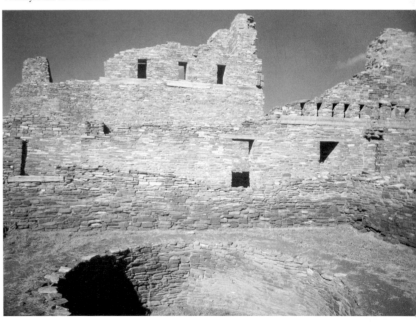

the nave, a sixth altar was placed behind the baptismal basin in the baptistery, which was located outside the front end of the west wall of the church and was reachable through a door under the choir loft.

Father Acevedo's tall stone church was impressive when it was completed about 1651. The understated façade had an unroofed porch supported by *vigas* extending out from the choir balcony but no

flanking towers. The walls, over thirty feet high in the nave and over forty in the new north section, were smoothed by adobe plaster and ornamented by three-stage crenellations to provide a striking, exotic, slightly Moorish appearance.

Like the other missions in the Salinas pueblos, Abó suffered from drought, famine, and disease in the 1660s and 1670s. The carefully accumulated food supplies of the missions were distributed to stave off starvation. In the summer of 1672 Fray Gil de Àvila slaughtered thirty-seven sheep and twelve head of cattle and distributed from the mission granary more than two tons of corn in addition to the seed corn, which shriveled after sprouting. In the next year the friar left and the pueblo was abandoned. The final years of the Salinas missions were also marked by increasing pressure from the Apaches of the plains to the east. The *convento* at Abó was burned by Apaches soon after it was abandoned, but the church survived substantially intact until the nineteenth century.

Quarai

Nuestra Señora de la Purísima Concepción de Quarai, called Cuarac or Cuara by the Spaniards, is after substantial restoration in the 1930s the best preserved of the stone churches in the Salinas region. The site, a few miles east of the Manzano mountains and watered by springs, was inhabited as early as 1300 and abandoned probably after less than a century. Reoccupation began about 1500. Fray Juan Gutiérrez de la Chica arrived at Quarai in 1626. He purchased several rooms in an end of one of the pueblo's houseblocks and had them modified for his living quarters, storage space, and a temporary church.

The next year he initiated construction of a *convento* and church on a mound of ruins near the northeast corner of the pueblo. First it was necessary to have a retaining wall built around the mound and to have the site leveled by excavation of the high

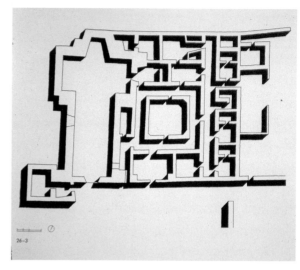

3.14. Plan of the church and *convento* of Purísima Concepción at Quarai, from Marc Treib, *Sanctuaries of Spanish New Mexico*, fig. 26.3.

places and filling of the low ones with rubble, packed earth, and sand. As at Abó a kiva was placed in the patio of the *convento*. Unusually, the principal rooms did not open off the covered corridors surrounding the patio but off another corridor to the east (Fig. 3.14). The *convento* was finished after about three years but the church took twice as long.

James E. Ivey estimated that a church and *convento* like those at Quarai would require almost a hundred thousand cubic feet of masonry and that less than twenty thousand could be laid annually by a work crew of forty, which included eight masons working on the scaffolds, eight helpers who brought them the raw stone and mortar, and twenty-four laborers who collected and prepared the materials. He estimated that the site preparation, trenching, and foundation construction would require three months and that the roof construction, woodwork, plastering, finishing, and painting would take an additional nine months after the walls were completed. Six years' work would be required, five of them in constructing the stone walls. Quarai is believed to have been under construction from 1627 until 1633.

The church was designed with thicker walls than the first church at Abó, about four feet thick

for the façade and four feet eight inches for the other walls. Six tower buttresses gave additional stability, a pair about thirty-nine feet high at the corners of the façade, a pair forty-three feet high at the points of juncture between the nave and the shallow transepts, and a pair forty-five feet high flanking the polygonal apse. Ivey believed that the towers were capped by four-sided pyramids to ease the shedding of water and to minimize damage from frost. The exterior walls were plastered and may have been whitewashed like those at Pecos.

The constructors of Quarai used squared compound *vigas*, or beams, to support the roof, similar to those that would be used in the amplification of the church at Abó in the 1640s. Quarai is smaller than the final structure at Abó but considerably more ambitious than the earlier church built there by Fray Francisco Fonte. Beams fully fifty-six feet long were needed to support the clerestory window where the roof of the transept was lifted six feet above that of the nave. The small polygonal apse had two features of special interest, a lowered, "false" ceiling to provide emphasis, and beams set in the rear wall to support a *retablo* expected to arrive from central Mexico in the supply train (Fig. 3.15).

Resident at Quarai while the church was still under construction was Fray Estevan de Perea, the scourge of New Mexican governors. Perea was twice named *custodio* of the Franciscans and was responsible for persuading the authorities in Mexico City to grant the powers of the Inquisition to the friars in New Mexico. Perea made Quarai his headquarters during much of his term as Commissary of the Inquisition in the 1630s.

Quarai suffered from the drought which ravaged the Salinas area in the 1660s and 1670s. Probably because of its relatively well-watered situation, it was not abandoned until 1677, three years before the great revolt. The church and *convento* survived throughout the entire eighteenth century, substantially intact if desolate "in a loneliness." Water damage caused part of the roof to collapse, and beams and other wooden elements began to rot and give way. The church was burned out during an

3.15. Interior of the church of Purísima Concepcíon at Quarai in 1890, photograph by Charles F. Lummis.

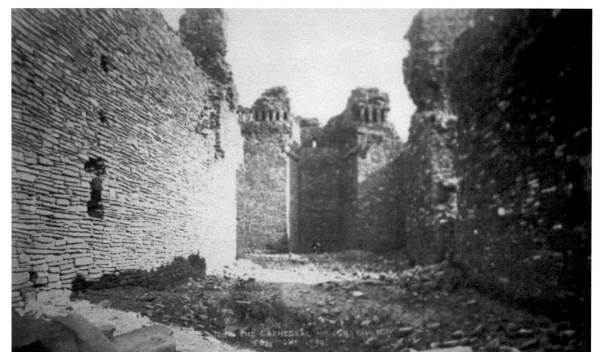

Apache raid in 1829. Two decades later settlers removed stone for house building and travellers took wood to build fires. In 1853 the military expedition of Major James H. Carleton found "one room here, probably a cloister attached to the church which was in a good state of preservation. The beams that supported the roof were square and smooth and supported under each end by shorter pieces of wood [corbels], carved into regularly curved lines and scrolls. The earth upon the roof was sustained by small straight poles, well finished and laid in herringbone fashion on the beams."[18] The room was probably the sacristy of the church.

As late as the winter of 1882–1883 the Swiss-born archeologist Adolf F. Bandelier found some rooms in the *convento* still roofed. But disintegration progressed rapidly. By 1916 the whole central façade had disappeared. The impressive remains that are visible today are in part the work of ardent restorers who, especially during 1939–1940, stabilized the structure, added as much as ten feet to the then existing stone wall, and re-created the façade.

Las Humanas

The well-populated pueblo the Franciscans called Las Humanas, which is popularly known as Gran Quivira, was able to exist on a dry and stony mesa on the southern rim of the Estancia Basin because its people devised methods of catching surface water, built cisterns, and dug wells in order to grow corn, beans, squash, and cotton. They also subsisted on hunting and on goods procured in trade with the Indians of the plains. An early houseblock, constructed about 1300, was circular, built around an oval plaza with a kiva at its center. A new houseblock built about fifty years before Oñate's arrival in New Mexico was loosely rectangular, but it retained in its U-shaped plaza the old kiva.

Fray Alonso de Benavides, *custodio* of the Franciscans, preached in that plaza in 1627 and confuted, as he explained in his *Memorial* to Pope Urban III, an "old sorcerer," or native religious leader, who had attacked the Christians for insanely flagellating themselves. Benavides dedicated the pueblo to San Isidro, the scholarly archbishop of Seville of the early middle ages, and in 1629 Fray Francisco de Letrado started the construction of the first of the two churches of Las Humanas in the name of San Buenaventura. This church was incomplete in late 1631 when Father Letrado was assigned to Zuñi in western New Mexico, where he was soon murdered by hostile Indian arrows. Las Humanas became for nearly thirty years a *visita*, without a resident priest, dependent on Abó for periodic clerical visitations. The church, possibly completed under the direction of Fray Francisco de Acevedo, resident at Abó, was single naved and longer, but otherwise similar to the first church constructed at Abó a few years earlier.

Las Humanas, like Pecos, was vulnerable to Apache raiding parties. A raid in the 1650s seriously damaged the church and carried off seventeen Indian women and children. When a priest, Fray Diego de Santander, was assigned to Las Humanas in 1659, he found the church in poor shape and initiated the construction of a new *convento* and church.

By the middle of the next decade, two friars were normally assigned to each mission and mission staffs had become sizable. Indian sacristans wore cassocks while assisting at the celebration of Mass. Additional assistants at Mass included a choir leader, an organist, other musicians, and a bell ringer. The *convento* required a porter, a cook, an interpreter, a horse tender, waiters, and gardeners. Still more Indians were needed to serve as herdsmen, shepherds, farmers, woodcutters, and millers. Schools enrolled as many as seventy Indian students. Such an establishment required a substantially expanded *convento* and a larger church at Las Humanas, despite a steady decline in the pueblo's population from approximately two thousand in 1627 to roughly one thousand in the 1660s.

All seven kivas in the pueblo show signs of having been damaged, probably a result of the 1661 effort of the Franciscan *custodio* to get the friars to confiscate native religious objects and prohibit native ceremonies. The secular official responsible for the Salinas region, *alcalde major* Nicolás de Aguilar, an appointee of anti-clerical Governor Bernardo López de Mendezábal, enjoyed Kachina dances and opposed the repressive measures, muttering that the religious chants of the Indians "had no more effect than the Gregorian chants of the padres."[19] Word spread that Aguilar forbade the Indians to work on Fray Santander's new church but he and the governor denied it.

The construction material at Las Humanas was bluish gray limestone rather than the reddish brown sandstone of Abó and Quarai. The church was intended to resemble the general form of the churches of Abó and Quarai, but drought forced Father Santander to abandon construction before the roof was completed (Fig. 3.16). We know from the report of the party of Major Carleton that the choir loft was well preserved in 1853. The author of the report praised the skill and "exquisite taste" of the carvers and declared that "the beams . . . would have been an ornament to any edifice. . . . We have cut one of the beams in three parts, to take back with us."[20] In 1669 Fray Juan Bernal had reported: "For three years no crop has been harvested. Last year . . . a great many Indians perished of hunger, lying dead along the roads, in the ravines, and in their huts. There were pueblos, like Las Humanas, where more than 450 died of hunger. The same calamity prevails because there is no money, there is not a *fanega* of maize or wheat in all the kingdom. As a result the Spaniards, men as well as women, have sustained themselves for two years on the cowhides they have in their houses to sit on.

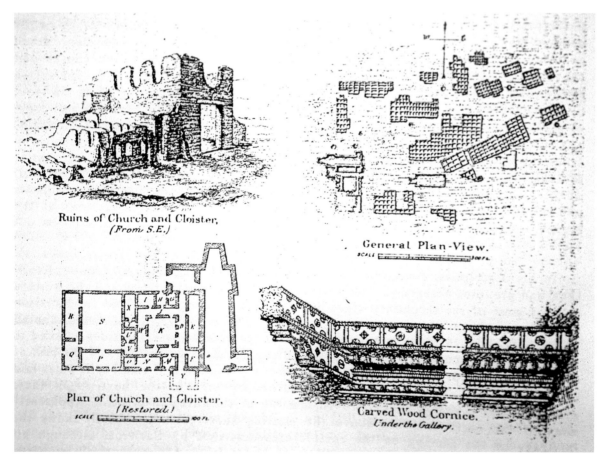

3.16. Drawings of Las Humanas in 1877 by Lt. Charles P. Morrison showing the existing ruins of the church and the cloister and their plan on the left. The layout of the pueblo and the carved structure for the support of the choir balcony are on the right. The drawings are reproduced in James E. Ivey, *In the Midst of a Loneliness*, p. 288.

They roast them and eat them. And the greatest woe of all is that they can no longer find a bit of leather to eat."[21]

At Las Humanas the community tried to resist the drought. Small dams were built to collect water from the channels which ran off the mesa, herds of cattle and sheep were moved to Abó, and fields of wheat were planted for Las Humanas at Quarai. But after two years approximately 450 Indians had died, and Apache pressure made conditions worse. Some time after a raid in September 1670 which shattered the partially completed church, the driest of the mission sites in the Salinas region was abandoned.

ÁCOMA

The first Europeans to see the famous "Sky City," "built on a high rock" and "the greatest stronghold ever seen in the world," were members of the Vázquez de Coronado expedition (Fig. 3.17). The people of Ácoma descended to greet the Spaniards, "although they could have spared themselves the trouble and stayed on their rock and we could not have been able to trouble them." Like other Pueblos they provided supplies, "cloaks of cotton, cattle and deer skins, turquoises, chickens, and some of the rest of their food."[22]

Some forty years later Ácoma was visited by Antonio de Espejo, who was impressed by the precipitous stairs cut in the rock up to the pueblo, by the natural cisterns on the top, and by the provisions stored in the buildings. Again the Indians were generous; they gave cotton textiles, "deerskins and strips of buffalo-hide, topped as they tan them in Flanders, and many provisions, consisting of maize and turkeys." A few miles from the rock Espejo noted fields near a river where water was diverted in small streams from a marsh for irrigation, and Castilian roses and wild onions grew nearby. The Ácomas entertained the Spaniards with "a very ceremonious *mitote* and dance, the people coming out in fine array. They performed many juggling feats, some very cleverly done with live snakes,"[23] but later a part of Espejo's expedition, thinking themselves angrily shouted at, set fire to some huts and ruined two fields of maize.

Relations deteriorated after Oñate's visit in 1598, during which there may have been an attempt to trap him in a kiva. Battles with the Ácomas are featured in Captain Gaspar Pérez de Villagrá's epic verse narration, *Historia de la Nuevo México, 1610.* Shortly after Oñate's stop, his nephew, Juan de Zaldívar, pressed the Ácomas too insistently for food already bargained for. Violence broke out and at least eleven Spaniards were killed, including the leader. After consulting with the Franciscans regarding Spanish law, Oñate dispatched a force led by his younger nephew, Vicente de Zaldivar, to retaliate and make Ácoma an example for other pueblos tempted to resist Spanish authority. When the Indians refused to surrender, war without quarter was declared. By cunning and great daring, attackers secured control of a portion of the rock and in three days of desperate fighting conquered and destroyed the pueblo. At least eight hundred

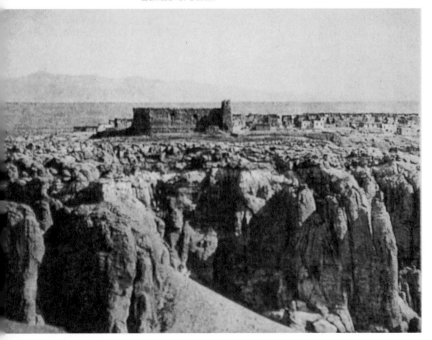

3.17. Ácoma, the church and the pueblo on the rock, photograph by Edward S. Curtis.

Indians were killed, about five hundred in the fighting, the remainder put to the knife individually or burned to death collectively in the kivas. Some eighty men and about five hundred women and children were carried away as prisoners to San Juan. Their sentences, later questioned and carefully investigated by authorities in Mexico City, were for males over twenty-five to have a foot amputated, and for males between the ages of twelve and twenty-five and females over twelve to serve at least twenty years of servitude. Children under twelve were judged to be innocent and free but were taken from their people. The girls were given to the Franciscan leader for distribution to *conventos* so that they would gain knowledge of the Christian God and salvation for their souls, and the boys were given to Vicente de Zaldivar to obtain "the same goal."

The surviving Ácomas reconstructed their pueblo, and Fray Jerónimo de Zárate Salmerón may have been received as missionary between 1623 and 1626. But evangelism really began when Fray Juan Ramírez was escorted to Ácoma by thirty soldiers led by Governor Francisco Manuel de Silva Nieto and Fray Estevan de Perea. The *Memorial* of Alonso de Benavides reports that "in the past year of [16]29 God was pleased that we should reclaim [the Ácomas] in peace, and today they have a Religious who is catechising them and baptizing"[24] and that his efforts had been enhanced by the miraculous recovery of a dying infant who had been baptized.

Father Ramírez may have directed the construction of the church whose foundations have been discovered in the four-foot-thick adobe platform underneath the present church. A kiva has also been detected below the church, under the altar. A report of 1664 described the church as the most handsome in New Mexico with abundant paraphernalia for worship and six hundred souls under its care.

About eight years later the church of San Esteban was reported to have "a gilded retablo in three sections with images in the round and paintings, the handiwork of the best artists in Mexico, and two side altars . . . , also made in Mexico, one of the Immaculate Conception and the other of our Seraphic Father San Francisco." There were also "a beautiful Crucifix, and more canvases, all the handiwork of great artists and brought from Mexico. Also, a very fine silver gilt tabernacle . . . [and] a most excellent large organ, one of the best in this Holy Custodia . . . [and] a set of flutes with their bassoon and trumpets."[25] We know nothing of possible mural decorations, but the splendid furnishings must have enlivened the church interior, which is rather bare today.

In the revolt of 1680 the Ácomas killed the resident friar. Diego de Vargas offered the people of Ácoma pardon when he first came to New Mexico in 1692 and patiently coaxed them down from the great rock. Invited to inspect the church, he found it "very large . . . even larger than the convento church of San Francisco in . . . [Mexico City] in its extent and the height of its walls which are almost five feet in thickness; they stand firm in spite of the heavy rains which break the windows and skylights of the church."[26] Vargas's description seems to confirm that the church which existed in 1664 survived the revolt substantially intact, the only major church above the El Paso area in Spanish New Mexico, except the abandoned Quarai, to remain. His account of broken windows and "skylights" suggests that the church had a transverse clerestory and that it had undergone damage. Some reconstruction was completed between 1696 and 1700, possibly the roof was rebuilt, and in 1705 Fray Antonio Miranda was repairing the church by himself.

The dimensions of San Esteban of Ácoma accord in general with Vargas's journal entry. The pewless church is single naved and at just under 150 feet even longer than the seventeenth-century church at Pecos. The walls of adobe reinforced by stone are twice as thick as Vargas reported, nearly ten feet wide, and close to fifty feet high. The interior width is thirty-three feet, requiring roof *vigas* forty feet long and fourteen inches in diameter.

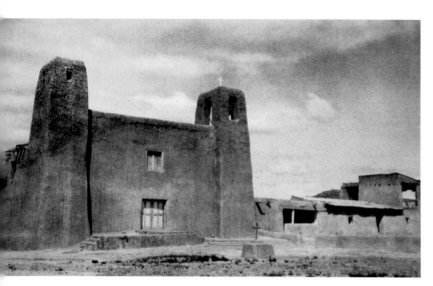

3.18. The church and *convento* of San Esteban at Ácoma, photograph from Historic American Buildings Survey.

The work of construction was much more arduous than for any other church in New Mexico. The great rock on which the pueblo rests is approximately four hundred feet above the nearby ground and was accessible only by a few narrow and dangerous "stairs" cut in the rock. The broken but relatively flat top contains cisterns for collecting rainwater but no soil or fragments of rock for building. The *vigas* were transported twenty miles from the San Mateo Mountains. The stone had to be collected and the adobe bricks made and seasoned and slowly and laboriously carried to the top in baskets or atop the heads of Indians. The total weight of materials required to be brought up the steep rock steps approximated twenty thousand tons, and according to John L. Kessell's estimate required, for the walls and towers alone, ninety thousand climbs up to the top.

Remarkably arduous also was the creation of a *campo santo* for Christian burial in front of the church. Local tradition attributes forty years to filling with dirt a huge boxlike rectangular area in front of the church; this area was enclosed on three sides by a massive stone wall which reaches a height of forty-five feet in some places.

Bishop Pedro Tamarón y Romeral of Durango visited Ácoma in 1760. He praised the pueblo's streets and substantial "stone" houses, the *campo santo*, and the missionary of twenty years' service, Fray Pedro Ignacio del Piño, for his efforts in instructing the Indians in Christian doctrine and his requiring that they attend Mass. The friar was obliged to use the whip to keep the Indians in order and to use seven interpreters to make himself understood by them because, although he understood much of their language, he could not speak it. Bishop Tamarón was amazed to see "a swarm of women and children emerge with pots and jars of water on their heads" as if from "a narrow and deep well," or "a kind of steps in which the feet barely fit." He couldn't comprehend how given "the tremendous depth, the ascent through so narrow a tube is managed."[27]

Another visitor, Fray Francisco Atanasio Domínguez, stopped at Ácoma on his inspection tour of the New Mexican missions in 1776. He noted the orientation of the church with the façade facing east and admired the good adobe of the walls (Fig. 3.18). He mentioned the tower buttresses jutting out from the front corners with their upper bell towers and noted the absence of a balcony like those he'd seen elsewhere. In the right bell tower he noticed that two bells, the gift of the king, were cracked.

Bells for New Mexican churches were normally made in Mexico. Hernán Sánchez, *maestro de campañero*, who cast a great bell for the Cathedral of Mexico City, cast six large bells for New Mexican Franciscans in 1710. The bells at Pecos and at the Hopi church at Awatovi in Arizona were cast in the same mold as a bell for Ácoma.

Domínguez described the interior of the church at length, mentioning the choir loft "supported by fourteen wrought *vigas*" and extending some eighteen feet into the nave (Fig. 3.19 and Fig. 3.20). "The whole roof consists of fifty well-wrought and corbelled *vigas*," he wrote, but, modified since Vargas's visit in 1692, it had a single level, "because there is no [transverse] clearstory." He found the

interior "pleasant, although bare" and described the sanctuary, which was ornamented but less sumptuous than in the seventeenth century. The central feature, in an ordinary painted wooden niche, was a medium-sized statue of San Esteban, which had been bought by the Indians. Above it was "a large old painting on buffalo hide of San Esteban's martyrdom and above this was another buffalo skin with a gilt paper cross on it . . . all spangled with little flowers made of painted paper." Arches painted with earth colors by Indians framed the central area and the areas on the sides contained venerable oil paintings of San Antonio de Padua and San Pedro.

Domínguez went on to describe the *convento*, mentioning "an enclosed cloister, lighted by good windows on each side" and "a well-arranged mirador . . . on the flat roof of the room at the corner . . . [facing] north and east with railings and pillars. It has an earthen floor, but hard, and on the south and east walls are seats of well-wrought boards resting on small corbels." He praised "a beautiful salon" and wrote that "Father Pino made it all."[28]

After he recorded his description of the missions, Father Domínguez made a discouraged assessment of the state of Indian Christianity in New Mexico. He remarked that the continuing use of the term "neophyte" for the Indians reflected their failure to progress in the Christian faith in the long decades since the reconquest, "their condition now . . . almost the same as it was in the beginning for they have preserved some very indecent, and perhaps superstitious customs." He noted the failure of the Indians to use among themselves their Hispanicized Christian names and their joking when these names were used by the friars. He believed that they showed a general "repugnance and resistance to most Christian acts" and that they performed "the duties pertaining to the church," such as annual confession, only under compulsion, if at all. Their love of crosses, reliquaries, and other religious objects was a result of the love of ornament, not devout feelings. He mentioned the omnipresent

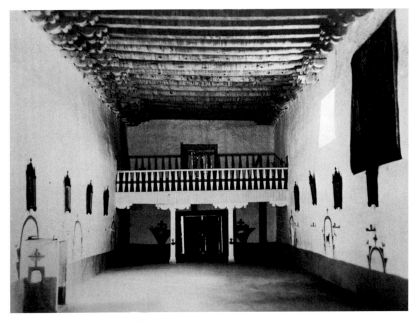

3.19. Interior of the church at Ácoma, facing the choir loft and entrance in 1940, photograph, George Kubler, *The Religious Architecture of New Mexico*, fig. 180.

3.20. Illustration of the interior of the church at Ácoma in 1880s, drawing by Charles Graham.

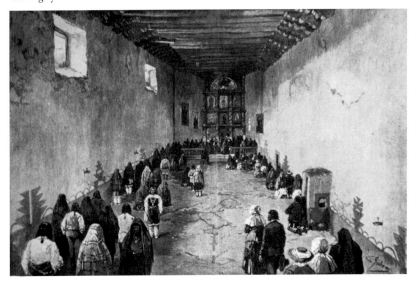

kivas but seemed to resist acknowledging their full implications, calling them "chapter, or council rooms" and stressing their use for affairs of Indian government, stating finally that they were used to rehearse the Indian dances, "or sometimes for other things."[29]

A few years after the visit of Father Domínguez, Ácoma lost its resident friar and became a *visita* of the mission at Laguna. The pueblo of Laguna had

been founded in the late seventeenth century by Keresan-speaking Indians, many of them from Ácoma. Unlike remote Ácoma, Laguna was on the main route between the Rio Grande communities and Zuñi in the west. San Esteban gradually decayed. Water damaged both the massive walls and the roof. Early photographs reveal rotting and sagging *vigas*. An altar screen created by the Laguna Santero was gradually destroyed by moisture. By 1902 the belfry stage of the left tower buttress had almost disappeared; the entire façade above the level of the doorway, where it could be conveniently repaired from the ground, was disintegrating badly; and the south wall was also in very poor shape. Repairs were made in the following years, and in the 1920s large-scale restoration was made possible by the Committee for the Reconstruction and Preservation of New Mexico Mission Churches, headquartered in Santa Fe. The architect John Gaw Meem drove to Santa Fe and was greeted by Father Fridolin Schuster and the Ácomas. Meem was troubled by a proposal to roof the church in concrete, by the condition of the exterior where "great canyons had been gouged into the sidewalls by runoff water from the roof," and by the state of the towers. What "seemed to be a central column of a wooden stairway leading to the upper story" of one of the towers fascinated Meem. Excavation later revealed that each step had "a stub which engaged with the stub above it to form the central column."[30] Meem recruited Lewis Riley, later replaced by B. A. Reuter, to supervise the work of reconstruction which slowly progressed through the summers beginning in 1924 and extending into 1927.

Before this work two large *vigas* had been replaced, brought like the originals by the Ácomas from the distant San Mateo Mountains, and the roof was the first part of the church to be reconstructed in 1924. A two-inch-thick concrete slab was constructed above the traditional roof of *vigas*, boards, and adobe. Above the slab was poured a covering of asphalt roofing composition and, finally, another layer of adobe was spread over that. The modern restorers found impressive the amount of material which they had to have brought up to the site and hoisted to the roof of the church: "50,000 pounds of water, 24,000 pounds of cement, 72,000 pounds of sand, 35,000 feet boards of scaffolding, 5,000 pounds of felt roofing, and 5,000 pounds of asphalt."[31] The work was an Ácoma communal enterprise. The pueblo governor agreed that "the entire Ácoma people would assemble for the purpose of bringing dirt up the mountain [for the repair of the walls], that they would carry and pack dirt for three days, and then . . . [the construction superintendent] was to be given fifteen men for the job, a new gang each week."[32] Scaffolding for repair of the badly eroded south side was 140 feet long and nearly 42 feet high.

In the 1970s the exposed southwest corner of the church, the apse, and the western end of the south wall were encased in masonry and the *convento* was reroofed. Under the whitewashed wall of one side of the cloister, traces of colored decoration were found, with images of animals, vegetation, and rainbows. Later the roof of the church was repaired.

In recent years the deterioration of San Esteban has again become seriously troubling. In 1992 the church was listed in a Save America's Treasures Project, and ten year later it appeared on the 2002 World's Monuments Watch of 100 Endangered Sites. In 1995 the pueblo sought assistance from the Cornerstone Community Partnerships. Dennis Playdon was appointed program manager and George Salvador was selected by the pueblo's governor to lead the construction crew. An Ácoma historic preservation office for the restoration was funded with $75,000 and a preservation grant of $400,000 was awarded in 2001. The program which will secure endangered parts of the structure such as the south tower and teach young Ácomans the proper way of making adobe blocks and other traditional construction methods is estimated to need six years and six million dollars for completion.

Ácoma Pueblo on its high rock, with its church of San Esteban preserved by the cooperative work of its people and sensitive, knowledgeable outsiders, is a Monticello of the West, a monument of Native America, independent, with a past both bloody and, for two centuries, peaceful.

Santa Fe

Juan de Oñate reluctantly put up with an abandoned pueblo as his capital because his colonists proved unwilling to construct a Spanish "City of Our Father, San Francisco."[33] As early as 1607 he was aware of the movement of some settlers twenty miles south to a narrow valley called Santa Fe which had no active pueblo, and he informed the viceroy in 1608 that a new *villa* and capital was being planned. Oñate's successor, Governor Pedro de Peralta, was directed by Viceroy Luis de Velasco II in 1609 "first of all to found and settle a villa . . . so that they may begin to live with some order" in proper Spanish fashion, and specifically to mark out six districts and "a square block for government buildings and other public works." Peralta's layout of Santa Fe did not strictly follow the Ordinances for the Discovery, New Settlement, and Pacification of the Indies. The plaza was a long rectangle extending about as far east as the present cathedral. Its corners did not face the cardinal points of the compass, and no streets were laid out from midpoints of its shorter east and west sides. The earliest church was probably placed just to the east, and a structure combining a residence for the governor and offices, the *casas reales*, was probably located on the north side where the Palace of the Governors now stands.

Peralta was also ordered to establish a municipal government for the *villa*, which was authorized to grant "each resident two lots for house and garden, two contiguous fields for vegetable gardens, two others for vineyards and olive groves, and in addition four *caballerías* of land [more than 130 acres], and for irrigation, the necessary water."[34]

In the Laws of the Indies, Spanish colonial policy defined water as a resource common to all inhabitants and colonial officials were directed to provide water and to supervise irrigable lands in consultation with local councils in order to promote the public welfare. Two *acequias* (irrigation ditches) were constructed on either side of the Santa Fe river; the northern one, later called the Acequia de la Muralla, brought water to the plaza and the governmental building.

The municipal government established by Governor Peralta consisted of a *cabildo* of four elected *regidores* (councilmen), who elected annually from their membership two *alcaldes ordinarios* to judge civil and criminal cases and chose an *alguacil* (constable) to enforce the laws, and a notary to record official matters.

Ten years after its founding Santa Fe was an unpromising village of about fifty people, but in the later 1620s, according to Fray Alonso de Benavides, its Spanish citizens possibly totaled 250, "most of them married to Spanish or Indian women or to their descendants. With their servants they number almost 1000 persons." Benavides wrote that he constructed "a very fine church." He was assisted by the inhabitants, "their wives, and children [who] aided me . . . by carrying the materials and helping build the walls with their own hands. . . . The most important Spanish women pride themselves on coming to sweep the church and wash the altar linen, caring for it with great neatness, cleanliness, and devotion."[35]

In 1680 the population of Santa Fe was approaching three thousand when, in August, hundreds of Indians from Pecos and a few other pueblos swept from the south to capture the Barrio of Analco near the Church of San Miguel and for nine days laid siege to the fortified inner town around the plaza. A Spanish counterattack drove off the Indians after they had cut off the water supply and captured a corner of the plaza, but Governor Antonio Otermín decided to abandon his surrounded capital

and led some thousand men, women, and children down the *Camino Real* toward El Paso.

The Indians took over the Spanish capital for a dozen years, building on top of the *casas reales* a multistory pueblo reportedly capable of housing a thousand, digging two circular kivas in patios on the north side of the plaza and constructing a defensive wall. In an exploratory reconnaissance of 1692, Diego de Vargas's forces cut off the Santa Fe pueblo's water supply and brought up small artillery. After a long day's stand-off the Indian leaders chose to welcome the Spaniards. But a year later two days of hard fighting were needed to capture the Indian citadel. Seventy who had refused to surrender were executed and four hundred who had stopped resisting were sentenced to ten years' service to the armed settlers.

Vargas formally organized a presidio and brought regular soldiers to Santa Fe in 1693. Before 1680, modest one-story adobe military structures, including a barracks and a guardhouse, had been constructed north of the plaza near the *casas reales*. Towers had been added to the *casas* at the southeast and southwest corners, which served as a chapel for the soldiers and a storehouse for gunpowder. In 1715 the presidial structures, which had been built after the reoccupation of Santa Fe, were expanded to form some sort of quadrangle north of the *casas reales* in order to accommodate a hundred soldiers. The adobe structures disintegrated, and in 1760 Bishop Pedro Tamarón reported that there was no fortification in Santa Fe nor any presidial building to house the garrison of eighty mounted soldiers.

The first plan of Santa Fe, drawn in 1766, was one of the remarkable series of renderings of presidios made by Lt. Joseph de Urrutia, a member of the party of inspection of northern defenses led by the Marqués de Rubí. Urrutia subsequently became Captain General of Catalonia and of the Spanish Army. After the deaths of Alejandro O'Reilly and another general he took command of the army which held off French revolutionary forces north of

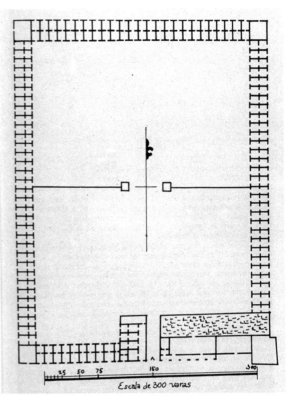

3.21. Plan of the presidio, incorporating the Governor's Palace, of Santa Fe in 1791, drawn by Jack Mills on the basis of a map by Juan de Pagasaurtundua.

Barcelona in 1795. His admirable portrait in the Prado was painted by Goya at the request of the Duke of Osuna.

Urrutia's plan showed only three small structures behind the "Casa de Governador" which occupied the western portion of the north side of a very wide plaza, more than twice as long from east to west as from north to south.

In 1780 Governor Juan Bautista Anza requested that a new presidio be constructed as part of his plan to make Santa Fe more defensible by relocating it on the south side of the river in the Barrio de Analco. The residents blocked his plan and nothing was done until 1789. After three summers of work, delayed by rain which ruined eighty thousand stacked adobes, a large one-story presidial structure was completed north of the plaza (Fig. 3.21). Together with the existing *casas reales* it formed an immense quadrangle measuring almost 1225 feet from north to south and about 1000 feet

from east to west. Living quarters and their attached stables lined the perimeters, with larger quarters for sergeants placed in three of the corners. An angled bastion occupied the southeast corner, a replacement for one of the towers which had flanked the *casas reales*. Living quarters were provided for 106 of the 120 soldiers then constituting the garrison.

Little sense of the ordered Spanish colonial community prescribed in the royal Ordinances is conveyed by Joseph de Urrutia's map of Santa Fe in 1766 (Fig. 3.22 and Fig. 3.23). The houses of the town seem scattered at random, located close to the owners' fields to protect them from animals, and are more numerous south of the river in the Barrio de Analco than in the area near the plaza. The only concentration of buildings in the northern part of town was along San Francisco Street, which ran west from the church and *convento* along the bottom of the plaza until it met the road running northwest toward the settlement of Santa Cruz de la Cañada. Four roads ran out from the southern sector, two toward Pecos.

Fifty years before Urrutia's visit the *cabildo* (municipal council) had written to the viceroy protesting that the once orderly plan had been violated, reducing the city to a single street operable for processions, the "Calle Real de San Francisco." Important citizens, some of them captains in the garrison, had built houses which blocked off the other streets. The *cabildo* asked the viceroy to order the razing of these houses and the measuring of the streets with cords "so that the entrances and exits would be wide enough to permit the coming and going of the mounted soldiers, the flocks, the carts, and everything needed to expedite the commerce of this region."[36]

Santa Fe lacked the ordered streets and houses of the proper Spanish colonial regional capital and it also lacked people. In 1693 Diego de Vargas brought only seventy families of settlers with his one hundred soldiers and eighteen friars in the party of permanent reoccupation of New Mexico, and in 1695 forty-four

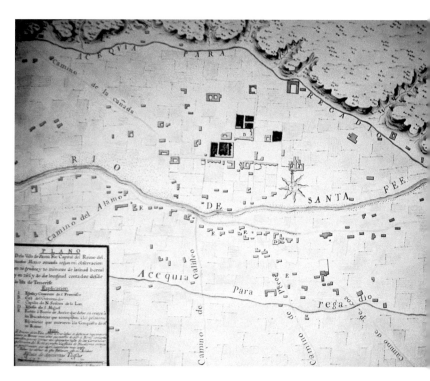

3.22 and 3.23. Plan of Santa Fe in 1766 by Joseph de Urrutia and a rendering of its central area in a painting by Wilson Hurley. The church and *convento* of San Francisco are on the right, the Governor's Palace is at the top of the plaza, and the chapel of Nuestra Señora de La Luz, La Castrense, at the bottom of the plaza, in the center. On Urrutia's map the church of San Miguel is below the river in the Barrio of Analco, which contains more houses than the central area, where building is concentrated below the plaza on San Francisco Street. Reproduced in David Grant Noble, ed., *Santa Fe: History of an Ancient City*, pp. 67 and 75.

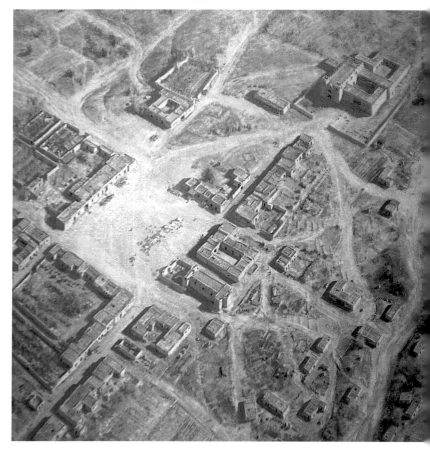

Chapter III

of the sixty families of "*espagñoles mexicanos*" resident in Santa Fe moved twenty-five miles north to found another *villa*, Santa Cruz de la Cañada. Forty-five additional families arrived to replenish the population later in 1695, but they found conditions so unpromising that they petitioned for an annual subsidy of 300 pesos until they could establish themselves as self-sustaining farmers.

Reports of the population of Santa Fe in the eighteenth century are conflicting, in part because some were limited to residents of the town itself and to citizens classified as Spaniards and some were not. It is clear that the growth in the city's population was slow until late in the century, and that the principal increase in New Mexico's population was not in Santa Fe but in the El Paso area and the areas surrounding the new *villas* of Santa Cruz and Albuquerque. In 1760 Bishop Tamarón reported that the capital had 379 families and 1285 people, that El Paso had 354 families and 2479 people, including Europeanized Indians and people of mixed blood, that Albuquerque had 270 families and 1814 people, and that Santa Cruz had 241 families and 1515 people. Santa Fe had the most families and the fewest people.

The census of 1790 provides more information about eighteenth-century Santa Fe than any other source. The town at that time had 2542 people and, unique in colonial New Mexico, there were about 100 more women than men. There were at least 564 families. The dominant occupation was farming, with 262 heads of households listed as farmers and another 60 as day laborers, working largely in agriculture. The occupation of many heads of households are not recorded, but there were 130 craftsmen, including 40 wood workers, 25 who operated the town's weaving shops, 18 carpenters, 13 shoemakers and leather workers, 12 blacksmiths, 9 muleteers, and 8 tailors. There was only one school teacher and only two who were engaged in trade, both natives of Chihuahua, one a merchant, the other a shopkeeper.

Apart from the governor, the officers of the garrison, and the Franciscan clergy, the upper class was made up of wealthy stock raisers who retained several servants, the most prominent of them members of the Ortiz family. The census reflects the eighteenth-century Mexican fascination with social mixing and the socially stratified society then in place. Probably the frontier society of New Mexico was less preoccupied with racial distinctions than the society of urban New Spain, but the census provides a breakdown of the society of Santa Fe by race as well as by gender and by occupation. Two-thirds of the population were classified as *españoles* even though only one person was born on the Iberian peninsula. Undoubtedly many of these "*españoles*" of Mexican or New Mexican birth who were accepted as members of Spanish society had some Indian and possibly African ancestors. The next largest racial classification at 15 percent was *color quebrado* (literally "of mixed color"), a term applied to those of mixed ancestry who were more acculturated than those listed as *mestizo*, 9 percent, or in other categories such as *mulato*, Indian, or *genízaro* (a detribalized Indian, usually taken as a captive or ransomed). There were in addition to those recorded in the census roughly ninety-five soldiers in the garrison, all of whom would probably have been classified as *españoles*.

Churches

Despite its status as capital of New Mexico, Santa Fe never had a church as impressive as those the Franciscans had constructed in pueblos such as Ácoma, Pecos, and Abó. Unlike St. Augustine's role in Florida, Santa Fe was not the center of Franciscan evangelism during the great period of New Mexican church building.

A sizable provisional church, described by Benavides as a *jacal* of mud-plastered poles, was erected about 1610. The "fine" parish church initiated by Benavides and dedicated to San Francisco

was not completed until 1639, and for the preceding eleven years the community was forced to use the Chapel of San Miguel in the Barrio of Analco, the quarter of the Indians. That chapel, constructed before 1628, was dismantled in 1640 by order of Governor Luis de Rosas. It was rebuilt, only to be destroyed again, along with the parish church, in the uprising of 1680.

Reconstruction was slow. Governor Vargas ordered the rebuilding of the burned but substantially surviving San Miguel, directing that the re-roofing and whitewashing of the walls and the repairing of its clerestory window be done "in a manner that shall be the quickest, easiest, briefest, and least laborious to the natives."[37] Despite the governor's order, the chapel was not rebuilt until 1710, two years before the total reconstruction of the parish church began. As an emergency measure Vargas ordered that a kiva in a patio of the *casas reales* be whitewashed and transformed by the addition of doors and an adobe altar, but the Franciscan *custodio* objected to celebrating Mass in a place of "idolatry and diabolical meetings and dances." Vargas responded that important cathedrals in Spain had been mosques of the Moors. A temporary church was also constructed on the edge of town.

Funds for the rebuilding of San Miguel were raised throughout New Mexico by Ensign Agustín Flores Vergara, whose name is memorialized on a *viga* of the choir loft. He hired a crew of fifteen workmen who apparently built upon the old walls, which had eroded to an average height of seven feet since Governor Vargas had attempted to have the church reconstructed. Twin towers, a transverse clerestory, and a crisply angled apse were features of this modest single-naved structure which has an interior length of seventy feet (Fig. 3.24). By 1818 the two towers had been replaced by what Bishop Juan Bautista Guevara described as "a little adobe tower without bells."[38] Repairs in 1830 may have included the construction of the massive tower of four adobe stages over the entrance, which was pic-

3.24. Interior of the church of San Miguel.

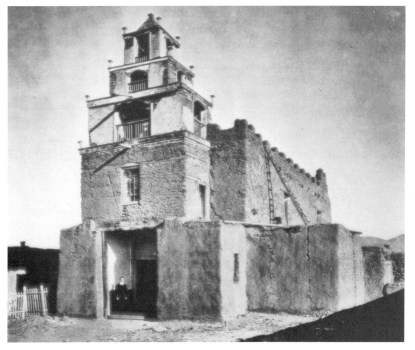

3.25. Church of San Miguel in the 1870s, photograph by Timothy O'Sullivan.

tured in photographs of the early 1870s (Fig. 3.25). The present awkward tower with oversized openings and flanked by steep stone buttresses resulted

Chapter III

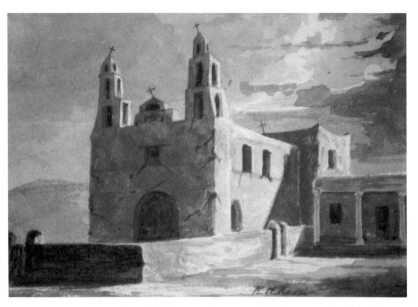

3.26. Parish church of Santa Fe in 1849, watercolor by Richard Kern.

from a series of renovations beginning in the 1880s and continuing until 1955.

The reconstruction of the parish church continued from 1712 until 1717 or 1718. The twin-towered church with a balcony stretched across its façade was in constant need of repairs and impressed visitors primarily with its size, measuring originally about 121 feet from entrance to rear wall. In 1776 Fray Francisco Atanasio Domínguez described its choir loft dismissively: "Its furnishing, or adornment, is the entire absence of any, for there is not even a bench for the singers. The floor is bare earth packed down like mud." He commented that the principal altar screen, though ungilded, was "reasonably ornamental as things go in this kingdom."[39] By 1797 erosion threatened the complete ruin of the church. Antonio José Ortiz, who also funded reconstruction of San Miguel, paid for repairs and for the construction of a cruciform chapel of San José which was added to the south transept to balance the chapel of Nuestra Señora de la Rosario ("*La Conquistadora*"), in the north. The repairs were insufficient and Ortiz undertook more substantial reconstruction which ultimately took six years.

In 1806 he wrote that after the work was nearly complete lightning struck, and because of the extensive damage he "had been obliged to tear it down again and enlarge it."[40] Ortiz contributed 5000 pesos to the rebuilding which enlarged the transept and added about twenty-two feet to the western end of the nave walls, incorporating the towers into the nave. A transverse clerestory apparently was not reinstalled. Shortly after the completion of the reconstruction the American army explorer Zebulon Pike was detained in Santa Fe. Pike wrote admiringly of the churches rising above the flat town, their steeples contrasting with the miserable appearance of the houses. Both Lt. J. W. Abert and Richard Kern pictured the parish church in 1846 with towers of three stages rising from the corners of a blocky façade and a structure containing a clock between them (Fig. 3.26). Early photographs show that the old building was transformed a final time before it disappeared behind the masonry walls of Bishop Jean Baptiste Lamy's Romanesque cathedral. After the American occupation the spindly upper stages of the towers were removed and the lower stages increased in height and modernized with Gothic arched openings and with sprightly fortresslike crenellations at the top. Similar crenellations enlivened the tops of the walls, as they did in early photographs of San Miguel.

The most refined of Santa Fe's churches was constructed for 8000 pesos by Governor Francisco Antonio del Valle on a lot he had purchased between houses of settlers on the south side of the plaza, facing his residence. Consecration was in May 1761. The structure, dedicated to Nuestra Señora de la Luz and commonly called La Castrense after a religious-military confraternity founded by the governor, served as a chapel for the soldiers of the garrison. Larger than San Miguel but considerably smaller than the parish church, La Castrense was set back from the plaza behind a *campo santo*. Towers framed the façade, which contained a stone medallion portraying Our Lady of Light rescuing a person from the gaping mouth of a devil. There was a transept, and the *vigas* and cor-

bels were notable for their decorative carving. An outstanding piece of church furniture was a painted altar screen carved of soft stone quarried about twenty miles from Santa Fe (Fig. 3.27).

The only stone reredos in a region where paint was customarily used to simulate stone, it was praised by Father Domínguez for resembling the façades of contemporary churches in Mexico City. The altarpiece does contain as columns blocky versions of the *estípites* fashionable in the capital of New Spain in the mid-eighteenth century, incorporating in its lower level just below each of the four crownlike capitals human faces on the three exposed sides. Beneath the capitals of the two *estípites* in the second level are human busts. The carvings of the four saints on the sides, and of the centrally placed figures of Santiago with sword in hand galloping over prostrate Moors, the Virgin of Balvanera emerging from a tree, and God the Father attired in a papal tiara, base their appeal more on the naïve charm of folk art than the complex sophistication of ornamentation in metropolitan Mexico.

La Castrense ceased to be used as a church when the government of republican Mexico stopped paying the salary of the military chaplain. It subsequently served as a United States military warehouse, a court of law, and a store. Bishop Lamy sold it to help fund his stone cathedral and it was subsequently demolished. The stone altar screen now ornaments John Gaw Meem's modern adobe church of Cristo Rey. The Mexican oil painting of the Virgin of the Light, which originally occupied the central position in the screen's lower level, has been replaced by the stone medallion of the virgin that once decorated the façade of La Castrense.

In approximately 1808 two more churches were built in Spanish Santa Fe, both outside the center of the city. Nuestra Señora de Guadalupe, now a center for the performing arts, contains a transept and formerly had one sturdy tower with multiple belfry stages beside its façade. El Rosario, its single nave now serving as transept and sanctuary for a larger

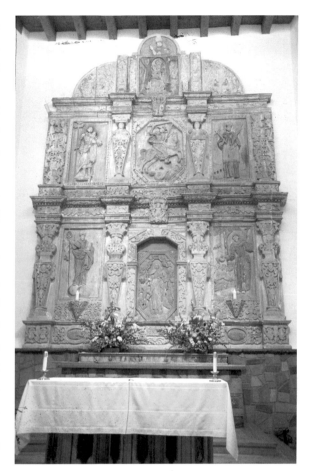

3.27. Stone altar screen from chapel of La Castrense.

twentieth-century addition, took its name from the Virgin of the Rosary, La Conquistadora, whose statue accompanied Governor Vargas on his campaign of reconquest. The Ortiz family, supporters of other ecclesiastical construction in Santa Fe, paid for this chapel and commissioned the *santero* Pedro Fresquis to paint an altar screen to frame the carving of La Conquistadora.

Civic Architecture

Visitors to Santa Fe from cities of central Mexico or the United States were unimpressed by its churches and even less by its civic architecture. Zebulon Pike compared the appearance of Santa Fe from a distance to a fleet of flatboats descending the Ohio River. But those who remained for extended periods came to appreciate the one-story adobe

Chapter III

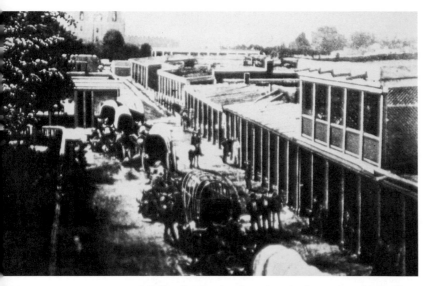

3.28. East San Francisco Street from the plaza to the parish church, photograph c. 1868. The plaza is on the left. The *portales* along the street and around the plaza provided protection from sun and rain. The church's towers, reduced to one belfry stage, were decorated by merlons. The balconied building on the right was the Spiegelberg store, which incorporated the La Castrense chapel. This photograph is reproduced in David Grant Noble, ed., *Santa Fe: History of an Ancient City*, p. 118.

structures. At the end of the first decade of American occupation the Pennsylvania lawyer, W. W. H. Davis, wrote that the thick adobe walls made Santa Fe's houses cooler in summer and warmer in winter than even the most substantial eastern structures of stone or brick. Davis explained to readers of *El*

3.29. Palace of the Governors in 1868, photograph reproduced in David Grant Noble, ed., *Santa Fe: History of an Ancient City*, p 129.

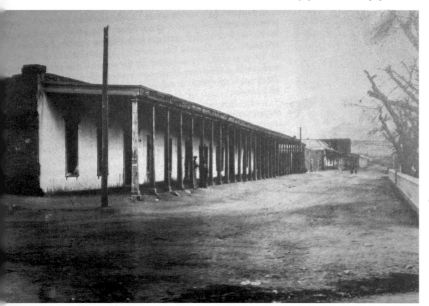

Gringo that the standard plan for sizable New Mexican houses "both in town and country, is in the form of a square, with a court-yard in the centre. A large door, called a zaguan, leads from the street into the patio or court-yard, into which the doors of the various rooms open. A portal . . . according to American understanding . . . a porch runs around this court, and serves as a sheltered communication between the different parts of the house."

Davis explained that similar *portales* ran along the fronts of the houses on the main streets, like colonnades in some cities of Europe. "They are of very rough workmanship, but are an ornament to the place, and a convenience to the inhabitants, as they afford a sheltered promenade around the town in a rainy season. A row of portales extends around the public square (Fig. 3.28). The plaza is the main thoroughfare, as well as the centre of business of the city, and fronting it are most of the stores and shops of the merchants and traders, and some of the public buildings. The public edifices in Santa Fe are few in number and of rude construction. The government palace, a long, low mud building extends the entire north side of the plaza."

Davis described the Governors' Palace of the middle 1850s, before any American alteration, as close to 350 feet in length and varying in width from 20 to 75 feet, in places where it projected to the rear. This many times reconstructed and reshaped building, the oldest European structure in the United States, had during Davis's time in Santa Fe "a portal or piazza in front . . . about fifteen feet wide, and . . . [running] the whole length of the building, the roof being supported by a row of unhewn pine logs" (Fig. 3.29).

At each end were small adobe projections, "extending a few feet in front of the main building." The one at the east corner was being used as the post office and the one at the west which had been used as the jail was "partly in ruins."[41]

The name *El Palacio Real* seems to have been given first to the *casas reales* by Diego de Vargas after

the reconquest. Seventeenth-century accounts of New Mexico are rare because of the general destruction of Spanish records in 1680. No plan of the palace is earlier than Urrutia's drawing of the city's layout in 1766. According to one account the pre-1680 *casas reales* were capacious enough to house more than a thousand people, "five thousand head of sheep and goats, four hundred horses and mules, and three hundred head of beef cattle, without crowding."[42] The palace reconstructed under the direction of Vargas and his successors probably roughly resembled that described by W. W. H. Davis. As early as 1708 it was decaying and a few years later the *cabildo* wrote that it would have collapsed but "for nine buttresses which . . . supported it on one side and the other" and "that only one lofty hall and a chamber remain [usable] together with a room that served as a chapel."[43] Repairs were made but in 1740 an entire wall collapsed and further repairs were completed in 1744.

The western third of the palace was demolished in 1866 to clear the way for Lincoln Avenue. The territorial authorities also rebuilt the structures to the rear, bringing them closer to the main building and reducing by half the inner patio. In 1878 the supports of the *portal*, or porch, were replaced by square posts of milled lumber and a white, wooden balustrade was added to Americanize the roofline.

The last reconstruction of the palace came as part of the conscious creation of a Santa Fe style, and the redesigned building appropriately housed the seminal New-Old Santa Fe exhibition of November 1912. Jesse Nusbaum started his redesign of the façade in 1909 with the intention of creating a monument to Spanish Santa Fe. He wished to remove all signs of the relentless Americanization that had virtually obliterated all traces of Spanish architecture in the city by the early twentieth century.

Like Sylvanus G. Morley in his earlier reconstruction of a modest Santa Fe house, Nusbaum created a perfectly symmetrical building with a

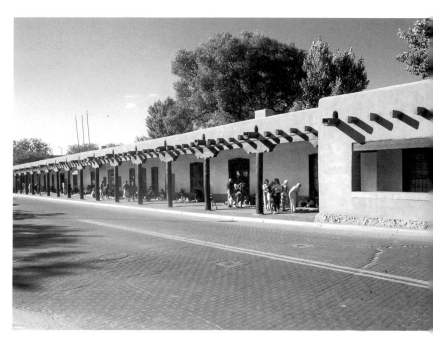

3.30. Palace of the Governors, reconstruction designed by Jesse Nusbaum.

monumental parapet above a line of protruding *vigas* and waterspouts (Fig. 3.30). Between end pavilions, suggestive of the former towers, he set fifteen roughly finished posts beneath huge *zapata* bracket capitals. The new-old Governor's Palace, as Chris Wilson has suggested in his provocative book *The Myth of Santa Fe*, is "a key monument in the development and popularization of a regional revival"[44] style.

El Paso

Juan de Oñate gave the name El Paso del Rio del Norte to the crossing as he passed over the river on his way northward a few days after he had formally taken possession of New Mexico in the name of King Philip II. Fray Alonso de Benavides recognized the importance of the El Paso region as a way station midway between the northernmost outposts of New Spain and the missions surrounding Santa Fe. He proposed the founding of a town, but no Europeans settled near El Paso for nearly sixty years after Oñate's passage. Two Franciscans congregated some Manso Indians and initiated a mission in

1656, but controversy between the procurator general of the order and the governor caused its abandonment. The permanent mission of Nuestra Señora de Guadalupe de los Mansos del Paso del Norte was established by Father García de San Francisco in 1659. The first buildings were "a little church of sticks and mud, and a straw-thatched convento."[45] The permanent church, the only surviving building of seventeenth-century New Mexico neither ruined nor significantly altered structurally, was begun in 1662 and completed in 1668. Timbers, cut in the Cloudcroft area of New Mexico, had been floated part of the way to El Paso in the Rio Grande.

The presence of the mission attracted a few settlers to the region, and a lieutenant governor was in residence in 1660. The scene changed dramatically twenty years later when Governor Otermín led nearly two thousand refugees to a camp twelve miles north of the mission and the El Paso area became all that remained of New Mexico. Three refugee camps were later set up south of the mission and by 1682 four new settlements were built, San Lorenzo, Senecú, Ysleta, and Socorro. All four, like Guadalupe del Paso, were on the west bank of the river until a shift of the river's channel in 1829 placed them within the present boundary of the United States.

El Paso was the capital of New Mexico and headquarters of the Franciscan *Custodia* until Governor Vargas led his expeditions of reconquest up the river in 1692 and 1693. A presidio was established in 1683 with twenty soldiers from Zacatecas and local volunteers. The dispersed settlements, ranging from Guadalupe del Paso to Socorro about fifteen miles to its south, were collectively elevated to the dignity of a *villa* and missions were established in the four new settlements which had as residents both Christian Indians and individuals classified as Spaniards.

During the long period of exile from their northern New Mexican homes many of the refugees left for less isolated settlements farther south. The exodus was increased by a rising of local Indians in 1684. In that year 1030 people were living in the El Paso area (little more than half the population of 1680), with 488 of the residents in Guadalupe del Paso and 354 in San Lorenzo. Probably only a quarter of the refugees from northern New Mexico remained in 1693, and many who did preferred to stay in the area rather than return with Governor Vargas's expedition of reconquest. The captain of the El Paso presidio had the civil authority of an *alcalde major* from 1692 until the 1760s when a lieutenant governor was again appointed. The Franciscan *custodio* sometimes resided in El Paso but more frequently in northern New Mexico.

El Paso was visited in the eighteenth century by a series of observers who provided substantial information regarding its population and development. On his tour of inspection of the northern presidios in 1726, Brigadier Pedro de Rivera noted "a sizeable town of Spaniards, mestizos, and mulattoes next to the presidio and two pueblos of Manso and Piro Indians administered by Franciscans."[46] He was the first outside observer to praise El Paso's vineyards for yielding grapes superior even to the celebrated ones of Parras, near Saltillo in Nueva Vizcaya. The irrigation ditches which carried water from the Rio Grande and relieved residents from concern during the long dry season also drew his interest.

In 1744 Fray Miguel de Mencheco reported that the population had reached 3130, triple that of 1692, and that of the total residents 1646 were Spaniards, nearly 1100 of them living in Guadalupe del Paso. The other communities in the area had become overwhelmingly Indian. Bishop Pedro Tamarón passed through in 1760 and placed the population at 4790, with 2479 Spanish, *gente de razón* (those capable of reasoning) residents of Guadalupe del Paso. The bishop found four priests in the area, two members of the secular clergy and two Franciscans. He appointed the Franciscan *custodio* vicar and ecclesiastical judge, replacing one of

the secular priests. Tamarón noted the fields of wheat and maize, the orchards of fruit trees, apples, pears, peaches, and figs, and estimated that there were 250,000 vines. The principal irrigation ditch seemed large enough to draw to the fields, orchards, and vineyards half the water of the Rio Grande, but the spring freshet was troublesome each year, washing away the irrigation ditches. The dam in the river was apt to be washed away or, if it was not, to increase the damage from the floods. A resident in 1773 described the dam as made of wattles because previous dams "built of stones, fagots, and stakes"[47] had to be demolished to avoid flooding the town. Although he never visited the El Paso area, Alexander von Humboldt provided a fuller account of the dam in his encyclopedic account of New Spain, the *Political Essay*. Humboldt echoed earlier praises of the agricultural products and compared the region to "the finest parts of Andalucia." He explained that during the "great swells of the Rio del Norte the strength of the current destroys this dam almost every year in the months of May and June." He praised the ingenuity of the inhabitants, who formed "baskets of stakes, connected together by branches of trees and filled with earth and stones" and used them to achieve a partial damming effect. "These cylinders of wickerwork (*cestones*)," he wrote, "are abandoned to the force of the current, which in its eddies disposes them at the place where the canal separates from the river."[48]

The first visual representation of El Paso, as of Santa Fe, was provided by Joseph de Urrutia in 1766 (Fig. 3.31). Urrutia's plan shows no concentrated urban development apart from the adobe presidio, organized around two courtyards, and its immediate neighbors the church and *convento* of Mission Nuestra Señora de Guadalupe. North and east of these structures are branches of the *acequia* and a wide spreading swath of irrigated fields, orchards, and vineyards. The houses are scattered in the fields themselves as well as along streets which radiate east from the presidio-mission complex through the fields. Even more than Santa Fe, El Paso exemplified the New Mexican fondness for decentralized living close to the agricultural fields and resistance to the ordered urban concentrations prescribed by the Spanish Ordinances. Urrutia showed the mission church facing east away from the presidio and with a forecourt, described by others as a garden. He placed the *convento* along the north side forming a cloister along the church's flank and extending half as far again to the rear. The most complete verbal description of these structures is a document recording their appearance in 1668 when the church was dedicated. Special praise was bestowed on the unusual and excellent ornamentation of the woodwork, on the wooden arch over the entrance to the chancel, and on the spacious choir loft. Several wooden statues were mentioned and a painting of Nuestra Señora de Guadalupe behind the main altar. At that time there was no altar screen. The nave measured just under a hundred feet in length and thirty-three feet in width. The transept was forty-five feet from end to end and twenty-eight feet across. The chancel, lit by a transverse clerestory,

3.31. Detail of a plan of El Paso del Norte, now Ciudad Juarez, by Joseph de Urrutia in 1766, showing the presidio, the church and *convento* of Mission Nuestra Señora de Guadalupe, and scattered fields and houses. The plans of Urrutia are reproduced in Max L. Moorhead, *The Presidio*, plates 1 to 21; the Plan of El Paso is plate 18.

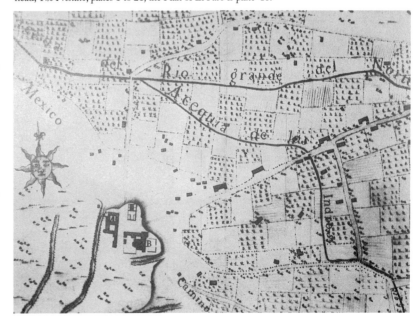

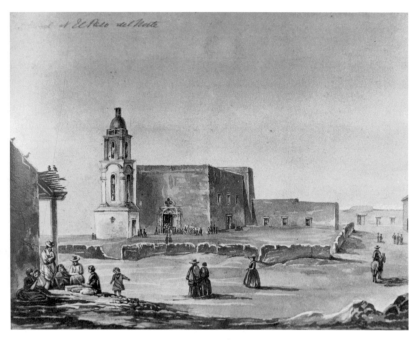

3.32. The church of Nuestra Señora de Guadalupe, c. 1851, drawing by John R. Bartlett, reproduced in Ron Tyler, *Visions of America*, fig. 105.

façade had acquired a central gabled decorative element at the top of its parapet and finials at its corners.

The interior was modernized in the twentieth century with stark white walls and wooden elements stained a handsome orange brown. The ornamental woodwork remains to suggest the excellence of the lost interiors of all other seventeenth-century New Mexican churches. The *vigas* and corbels are delicately carved and decorated. Above the *vigas* visible elements of roofing include diagonally placed poles and planks indented with carvings of circular ornaments set within diamonds. Particularly notable are the octagonal posts that support the choir loft (Fig. 3.33). They have square bases and modulate again into squares just below the handsome corbel capitals, which are decorated with stars set in circles.

was nearly square, twenty-one feet wide and twenty feet long.

The *convento* was praised for its porter's lodge, ample cloister, and seven cells, some with sub-cells to the rear, all "spacious, well lighted, and nicely finished off in wood." There were also a *sala de profundis* for meetings and services, a refectory, kitchen, and closets, "all so spacious and orderly that it would be pleasant to come and see them."[49] Unfortunately the buildings did not preserve their pristine appearance. In 1817 another bishop of Durango, Juan Bautista Ladrón, wrote that the church was dirtier than a pulque warehouse in Mexico City.

The document of 1668 does not describe the exterior of the church. The earliest pictures of the exterior date from the middle of the nineteenth century and are quite similar. One is based on a drawing by an artist associated with the International Boundary Commission, Augustus de Vaudricourt, and another, possibly also based on Vaudricourt's image, is by John Bartlett (Fig. 3.32). Since Vaudricourt's time the bell tower has lost in a rebuilding most of its ornamentation, including the dome and lantern which were its terminating feature. The

3.33. Interior of the church of Nuestra Señora de Guadalupe showing the carved post supporting the choir balcony. Also see Plate IV.

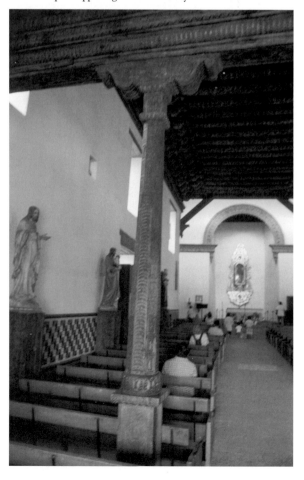

Las Trampas and Chimayó

The third and fourth *villas* of Spanish New Mexico were Santa Cruz de la Cañada founded in 1695 and Albuquerque founded in 1706. Both, like El Paso, were primarily farming communities, and both by the late 18th century had surpassed Santa Fe in population. In addition to its four *villas* for "*españoles mexicanos*," which were extended communities with modest populations, New Mexico had a large number of independent settlements, known as *ranchos* or *plazas*, consisting of a few families of farmers. Among these were two communities in the hills north of Santa Cruz, Las Trampas and Chimayó.

The valley in which Las Trampas was placed had been granted in 1712 to a formidable Indian fighter, Captain Sebastián Martín Serrano. But by mid-century, when it became apparent that a new fortified settlement was desirable to ward off Comanche raiders descending from the mountains to the east, he donated his land and Governor Tomás Vélez Cachupin arranged a royal grant of an additional forty-six thousand acres of land for grazing and wood cutting. The founding party of twelve families was drawn primarily from the Santa Fe presidio in 1751. The leader, Juan de Argüello, was seventy-four years old. He had resided in the capital for forty years. The settlers, who included his sons-in-law and a black man who had been a drummer boy when Diego de Vargas recaptured Santa Fe in 1693, were granted sufficient land for growing wheat on both sides of the River of Traps (*Las Trampas*) "with corresponding water, pastures and watering places, entrances and exits . . . to have, use, and cultivate for themselves, their children, heirs and successors, and to barter, sell, and dispose of the same." The grants were "free of all tax, tribute, mortgage, or other encumbrance."[50]

The village was constructed as a fortified plaza with the houses forming the perimeter of a square and probably only two narrow entrances. The horses and cattle could be protected within the enclosure during a raid. A defensive *torreón*, later used as a *morada* of the Penitente brotherhood, was built west of the plaza and north of the river. In the eighteenth century firearms were scarce in New Mexico, so the people of Las Trampas were forced to obtain arms from their potential enemies, the Comanches, trading knives, bridles, and grain for a pistol and five muskets.

In 1760 Bishop Pedro Tamarón granted the people a license to construct a lay chapel within their plaza. They had been dependent upon the church and friar at Picurís Pueblo nine miles away and reachable by a road threatened by Comanche raiders. The people of Las Trampas raised money for their church throughout New Mexico. At Picurís in 1776, when the church was virtually complete, ninety-eight-year-old Juan de Argüello asked the visiting friar Francisco Atanasio Domínguez for a donation. Domínguez wrote, "Since I had nothing, I gave him that with many thanks for his devotion." The visiting Franciscan had mixed feelings about the people of Las Trampas when he visited them. He was dismayed by their use of the Spanish language, as he was always by New Mexican Spanish, and by their racial makeup. Very few of them were "of good, or even moderately good blood." But ragged as they were in appearance, he wrote, "they are as festive as they are poor, and very merry." Domínguez has left us a characteristically meticulous description of the church of San José de Gracia, a remarkably large and ambitious structure for a community such as Las Trampas, which had grown to 63 families and 278 people. He listed its dimensions, "20 *varas* [about 56 feet] long from the door to the mouth of the transept, 7 wide, and 8 high up to the bed molding. The transept is 6 *varas* long, 15 wide, and more than 9 high because of the clerestory. The ascent to the sanctuary consists of five poor steps made of *vigas*, and its area is 4 *varas* square.

"There is a choir loft in the usual place. . . . There is a good window at each end of the transept,

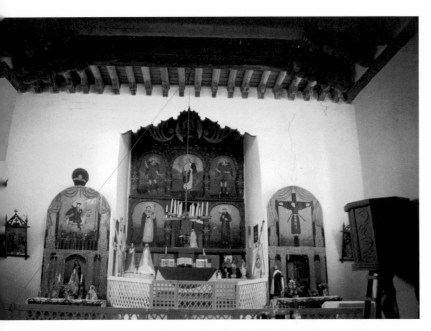

3.34. Interior of the church of San José de Gracia, Las Trampas, with the sanctuary lit by the transverse clerestory and paintings by José de Gracia González.

The chapel of Los Trampas was blessed and served periodically by Fray Andrés de Charamonte, the missionary at Picurís. He officiated at baptisms, marriages, funerals, and burials and at the annual feast of San José. The regular fee of six pesos for saying Mass covered the cost of an ample supply of wax candles, communion wine, and bread for the altar.

Significant additions to the ornamentation of the church were made after 1776. They range from the crude designs in color decorating the planking under the choir loft to five altar screens first recorded in an inventory of 1818. The paintings included Nuestra Señora de la Purísima Concepción, co-patroness of the church, and other figures behind the main altar. E. Boyd believed that these screens may have been painted by the first great New Mexican *santero*, Pedro Antonio Fresquis of nearby Las Truchas. They must have deteriorated gradually until they were repainted some time after 1862 in a Mexican folk style by José de Gracia González, an itinerant painter from Sonora who had worked in a church in Santa Fe and who later became a railroad construction worker in Colorado (Fig. 3.34). Striking among the images painted by Gonzalez, who repeated the subjects of the original painter, were the crucified San Felipe de Jesús with lances crossed behind him, and Santiago on a stiff white horse above the flanking altars in the transept. On the screens of the nave three bearded men of the Trinity are seated uncertainly upon a blue globe and Nuestra Señora del Carmen suspends a scapular toward souls in the flames of hell. An impressive large carved crucifix is now placed below the window at the east end of the transept.

and there are two more just like them on the Epistle side near the nave. There is a window-door to the balcony in the choir loft. The roof of the nave consists of twenty-five *vigas*, and the clerestory is on the one opposite the sanctuary. The transept is roofed by nineteen *vigas*, and the sanctuary by seven. All have multiple corbels as well as being wrought. The sanctuary has a false vaulted arch with multiple corbels."

At the time of Father Domínguez's visit, the altar was ornamented by a niche framed in wood and "painted and splattered with what they call *talco* [mica] here. . . . In this niche is a middle sized image in the round of Señor San José. There are many paper prints around the niche, and little candle sockets, like rulers used in school."

In his description of the façade of the church Domínguez mentioned two tower buttresses which "jut out from the front like those I mentioned in Santa Fe" and on them "no more than the beginning of towers." He noticed "toward the middle of one of them . . . a frame with a middle sized bell in it" and "a balcony almost like the one in Santa Fe over the door from one tower buttress to the other."[51]

The military ethnologist John Gregory Bourke visited Los Trampas and sketched the church in 1881 (Fig. 3.35). At that time the building had two towers with belfry stages and two balconies, one near the top of the façade above the window and a second, still existing, below the window and above the entrance. Just behind the right tower on the east

side of the nave was an additional structure not mentioned by Fray Domínguez in 1776. The other element now present, the addition to the west end of the transept, was not portrayed in 1881.

Bourke was interested to come across, in the room leading off the nave on the right, paraphernalia used by members of the Penitente brotherhood, a New Mexican version of the Third Order of St. Francis. The brotherhood had worshipped at particular altars in New Mexico churches until the mid-nineteenth century when their rites of flagellation had been condemned by Bishop José Antonio Zubiría of Durango and Bishop Lamy of Santa Fe. They then became a secret order and constructed their own *moradas*, but the room at Las Trampas was used by them well into the twentieth century.

Lt. Bourke was shocked to recognize in the semidarkness "a hideous statue, dressed in black, with a pallid face and monkish cowl, which held in its hands a bow and arrow drawn" to represent death. "The statue, thus hooded, armed and painted was seated on a wooden wagon. . . . [and] On Ash Wednesday, Good Friday, and other days of Lent, this ghastly reminder of life's brevity and uncertainty is hauled through the village by two of the most devoted Penitentes, who, to secure their important place in the procession, have to whip half the remaining repentant sinners in the valley."[52]

By the first decade of the twentieth century the church of San José was suffering from erosion, especially in the towers, the tops of the walls, and the critical area around the clerestory window. Some repair work was done in the early twenties, and in 1931 Father Peter Kuppers sought the advice of the Museum of New Mexico. Ultimately John Gaw Meem and B. A. Reuter, who had worked at Ácoma, came to Las Trampas. Meem found the interior still in reasonably good shape. His wooden crowns for the towers restored them to their appearance of 1900, after the loss of their upper stories (Fig. 3.36). Reuter directed the installation of a triple-layered felt and asphalt roof and a remodeled

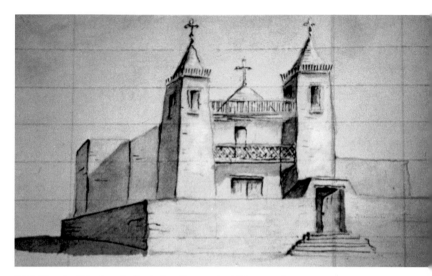

3.35. Church of San José de Gracia, Las Trampas, in 1881, watercolor by John G. Bourke, reproduced in John L. Kessell, *The Missions of New Mexico since 1776*, plate VII.

3.36. The church of San José de Gracia with Penitente *morada* on the right. Also see Plate V.

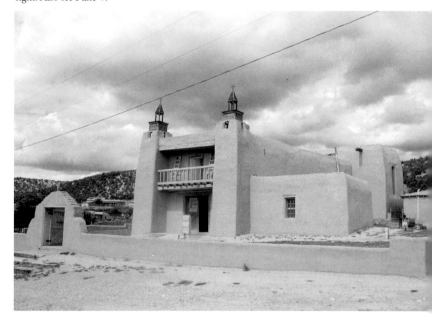

drainage system. Daniel T. Kelly of Santa Fe donated building materials from his wholesale firm and paid other expenses. The total cost was $1175.37.

In 1966 the church was threatened by a proposal to widen Highway 76 and to cut through the churchyard very close to the church. The parishioners were ready to sacrifice their old church to progress and economic development. The intervention of Nathaniel A. Owings, founding partner of

| Chapter III

3.37. Chimayó, Plaza del Cerro in the 1960s, photograph by Dick Kent.

the noted architectural firm of Skidmore, Owings and Merrill, was critical. Owings got the Secretary of the Interior, Stewart L. Udall, to write to the governor requesting a delay in the highway's construction. Bulldozers were stopped within two miles of Las Trampas. After Santa Fe preservationists formed the Las Trampas Foundation and secured National Historic Landmark Designation for the church, federal highway funds were frozen. Compromise was reached in June 1967; an alternate route was designed for the highway no wider than the old one and Owings donated $10,000 to the Las Trampas Foundation to pay for new roofing, replastering, and other repairs. Meem used a parishioner's old photograph in his design of replacements for the old wooden turrets at the top of the towers. In the end the people of Las Trampas were pleased. Owings particularly admired the work of the women plasterers. "The surface was almost as hard as glass with a texture like homemade bread crust, and the entirety so beautiful, so aesthetically satisfying, that the question of a cement surface was too ugly to consider."[53]

Chimayó

Settlers began occupying the Chimayó area, about halfway between Santa Cruz and Las Trampas, shortly after the reconquest. They displaced Indians who had briefly occupied the region after being ousted farther south by Diego de Vargas in 1695 to create space for the new *villa* of Santa Cruz. A priest was reported in the area by 1706 but no church was recorded on a map of 1779. The community centered on the still-existing defensive Plaza del Cerro, which was probably built in the 1740s, and is the only survivor of more than a hundred fortified settlements in New Mexico. Father Domínguez described Chimayó in 1776 as "a large settlement of many *ranchos*" on good lands and having "many more orchards than there are at *La Villa de la Cañada*."[54] There were two small mills and 71 families, 367 persons in all.

As recently as 1915 L. Bradford Prince described Chimayó as a remote pastoral place of sheep raisers and weavers, where the people were "cut off from the vices and frivolities of the world" and were "contented to live almost entirely on the products of their own valley." Money was "little needed where requirements for happiness are so few."[55] Now, on the high road to Taos with its weaving shops and popular restaurant, Chimayó is no longer isolated from the world.

The plaza, originally called San Buenaventura de Chimayó, was approximately square, enclosed on all sides by contiguous one-story adobe buildings without openings on the exterior (Fig. 3.37). There were only two narrow entrances, one at the middle of the north side, the other at the middle of the south. A *torréon*, now enclosed by a barn, is located a short distance to the south. The enclosed area, originally held in common by the settlers, is crossed by a curving *acequia*.

Most of the structures have been modernized and have gable or hipped roofs. Six buildings on the lower west side preserve much of their original appearance. One, identified only by a cross supported by a small, openwork wooden turret, is a chapel, the Oratorio de San Buenaventura, which is maintained by the prominent Ortega family of weavers (Fig. 3.38). The interior is simple, with a dirt floor and a single step up to the railed sanctuary and altar. A crude and pleasant altar screen, framed by a truncated H of spiraling wood painted to resemble a barber's pole, contains three painted figures and a central niche for a small carved *bulto*.

In November 1813 Bernardo Abeyta sought ecclesiastical permission to build a chapel for the residents of the Potrero section of Chimayó. He wished to "honor and venerate, with worthy worship, Our Lord and Redeemer in His Advocation of Esquipulas."[56] A carving replicating a miracle-working black Christ of the Cathedral of Esquipulas in extreme southeastern Guatamala had been revered in a shrine adjoining his house for three years previously. Approval was received from the Diocese of Durango in April 1815 and the Santuario de Esquipulas was probably completed in 1816. The site was sloping, requiring excavation for the front and much of the nave and the building of a platform and, ultimately, of substantial buttresses at the rear to support the apse end to prevent it from sliding down into the river. Although constructed midway through the second decade of the nineteenth century, the Santuario is a modest-sized adobe church with flanking towers and transverse clerestory, a type developed in New Mexico two centuries earlier (Fig. 3.39). In the 1920s the exterior appearance was greatly changed to protect the building from erosion. A sloping metal roof was placed over the flat earthen one covering the clerestory and a wooden gable was added to the façade between the towers. Probably at the same time, the towers were capped by what Marc Treib has called "folded wooden hats"[57] (Fig. 3.40).

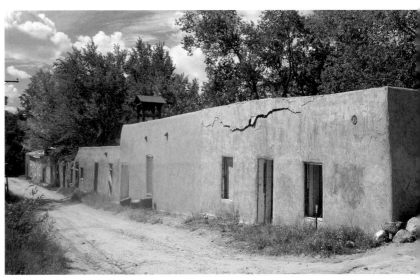

3.38. West range of Plaza del Cerro with the Ortega chapel, the Oratorio de San Buenaventura.

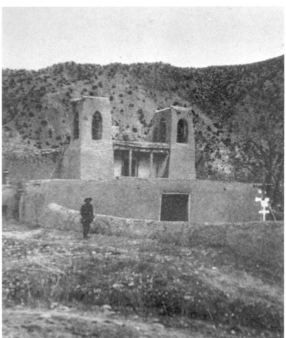

3.39. Chimayó, Santuario del Señor de Esquipulas in the early twentieth century, photograph from L. Bradford Prince, *Spanish Mission Churches of New Mexico*, p. 318.

3.40. Santuario del Señor de Esquipulas showing alterations of the 1920s.

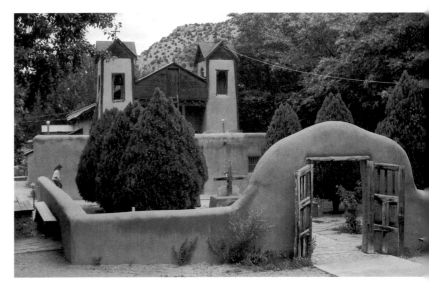

| Chapter III

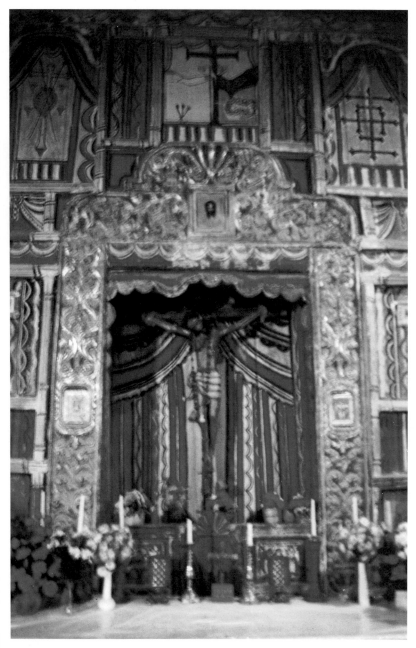

3.41. Chancel of the Santuario with altar screen attributed to Molleno.

One enters the Santuario from the walled *campo santo* into a narrow passage between rooms below the towers, which once contained carpets, blankets, and other woolen goods woven in the area, and both painted and carved images of saints which were bartered to visitors to support the religious activities. The interior is wider than it is high and widens slightly until the walls converge behind the railing of the sanctuary to form the polygonal apse.

View of the rear of the apse is blocked by an altar screen which fills the space behind the altar from wall to wall. E. Boyd believed that the screen, one of two listed in an inventory of 1818, was painted by the most abstract of New Mexican *santeros*, Molleno (Fig. 3.41). The screen, designed to frame religious ornaments Abeyta had purchased in Mexico, contains on its upper level simplified curtained images of the Five Wounds of Christ, the Franciscan emblem of arms holding a cross, and the cross of Jerusalem. Below, a black Christ on a cross, recessed and backed by boldly painted draperies, is flanked by emblems of the Eucharist, a sheaf of wheat, and a bunch of grapes.

One of the four screens standing in the nave, the one on the right nearest to the entrance, is also attributed to Molleno (Fig. 3.42). It is later, more broadly brushed and with simplified colors, probably painted after 1828 when an ecclesiastical visitor ordered the removal of all religious paintings on animal skins or crudely constructed wooden panels. Another screen in the nave, probably painted at about the same time, is attributed to José Rafael Aragón of Cordova.

A room to the left of the sanctuary contains a pit of sacred earth prized by pilgrims to the Santuario, among whom was the famous potter of San Ildefonso Pueblo, María Martínez. Small amounts of the earth, the New Mexican equivalent of the clay tablets of Esquipulas in Guatamala, are eaten to provide cures for, or protection against, paralysis, sore throat, rheumatism, and womanly difficulties with menstruation and childbirth. Many visitors to the Santuario are now curious tourists, but early in the century pious visitors were plentiful. According to the enthusiastic account of L. Bradford Prince they included "men, women and children . . . from Colorado on the north to Chihuahua and Sonora on the south . . . approaching . . . in carriages, in wagons, on horses, or burros, or on foot . . . all inspired with full faith in the super-natural remedial power that is here manifested."[58]

The Santuario passed from the ownership of Bernardo Abeyta to his daughter, Carmen Abeyta de Chavés, who resisted demands emanating from Bishop Lamy that it be turned over to the proper authorities of his diocese. Suspicious of Penitente practices in the area and of a cult of devouring dirt, Lamy and his clergy terminated religious services in the Santuario.

After the death of Carmen the church was willed to her daughter, but religious use and donations had fallen off and fiscal pressures brought the Santuario close to abandonment or exploitive misuse in the 1920s. Reports reached Santa Fe that the small statue of Santiago on horseback and the doors were for sale at curio dealers' shops. The Committee for the Preservation and Restoration of New Mexico Mission Churches was alerted but lacked the modest amount needed to purchase the building. Mary Austin, who was lecturing in the east, was informed and she aroused the interest of an anonymous Catholic alumnus of Yale who donated $6000. A deed dated October 15, 1929 conveyed "*un capilla titulada el Santuarió del Señor de Esquipulas*" to the archbishop of Santa Fe in trust for the church. Forty years later San José de Gracia at Las Trampas, which is the Santuario's neighbor to the north, would be rescued by Nathaniel A. Owings. Two irreplaceable religious structures were nearly lost but were preserved through the efforts of New Mexicans concerned for their state's Hispanic heritage, supported by timely actions of wealthy and sympathetic easterners.

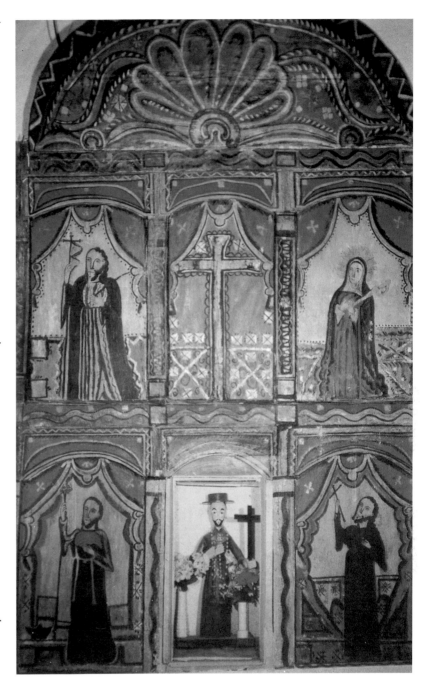

3.42. *Retablo* of the nave of the Santuario, attributed to Molleno.

CHAPTER IV

Texas

Almost a century passed after the arrival of Oñate's *entrada* in New Mexico before an attempt was made to settle Texas, despite visits to portions of the area before 1550 by Cabeza de Vaca and his companions and the major expeditions of Vázquez de Coronado and de Soto. Like Florida, Texas was settled to thwart a French threat. Texas originated in the fear for Spanish territories in America aroused by the Sieur de La Salle's expeditions down the Mississippi River and along the coast of the Gulf of Mexico in the 1680s. After the tenth Spanish search party finally located La Salle's abandoned colony and fort a few miles inland from Matagorda Bay on the Texas coast in 1689, the government of New Spain decided to establish an outpost along the upper Neches River in east Texas among Caddo-speaking Indians, the Hasinai confederation, whom the Spaniards called the Tejas and from whom the name of Texas was derived. The choice of the Hasinai, living in heavily wooded country four hundred miles distant from the nearest Spanish outpost and well inland from the coast threatened by the French, was based on enthusiastic secondhand reports of the Indians' openness to conversion and of their living in "towns with wooden houses," planting corn, beans, squash, and melons, and having a "civilization and government like the [central] Mexican Indians."[1]

Unlike New Mexico and Florida, Texas had no initial period of *adelantado* enterprise. It was shaped by decisions made by the viceroy in Mexico City rather than by the Council of the Indies and the king.

Of substantial initial importance was the decision to rely primarily on the relatively inexpensive efforts of the friars of the recently founded College for the Propagation of the Faith of Santa Cruz de Querétaro, rather than to construct a chain of fortified presidios. The *entrada* of 1690 led by Father Damián Massanet and Alonso de León, the discoverer of La Salle's settlement, included 110 soldiers with its four friars, but only three of the soldiers were permitted to remain lest undisciplined military behavior inhibit evangelism. Mission San Francisco de los Tejas was founded immediately, and Mission Santísimo Nombre de María, five miles to the east, a short time later. The Hasinai proved far less receptive to Christianity than the friars had hoped. They were unfriendly. Some were petty thieves; others stole horses and mules. Drought ruined the crops in 1692. Despite expeditions to strengthen the missions, separate decisions, in the viceregal capital and in the field, were made in 1693 to give up the frustrating effort, and for nearly a quarter of a century Texas was abandoned.

Resettlement resulted from a strange collaboration between a Querétaran friar, Francisco Hidalgo, eager to revive the missions and the French authorities in Louisiana eager to improve their colony's

financial condition by initiating potentially profitable trading with New Spain. Hidalgo provoked the Spanish reoccupation of Texas in 1713 by daringly writing to the governor of Louisiana, the Sieur de Cadillac, soliciting his help in reopening the missions. Cadillac dispatched an experienced Indian trader and linguist, Louis Juchereau de St. Denis, on an overland mission to the Spanish outposts on the Rio Grande. The trade goods of St. Denis were confiscated and he was sent for interrogation to Mexico City. As Hidalgo had anticipated, the appearance of a French trader on the Rio Grande caused the viceregal authorities to decide that Texas must be reoccupied to block French penetration of the area.

St. Denis disarmed the officials of the viceregal capital, married the granddaughter of the presidio commander on the Rio Grande, and returned to Texas in 1716 as guide and supply officer of an expedition headed by Domingo Ramón which included ten Franciscans, over thirty civilians, and eighteen soldiers, seven of whom brought their families, the first known to have entered Texas. The friars were equally divided between the College of Santa Cruz of Querétaro and the newer missionary College of Nuestra Señora de Guadalupe de Zacatecas; each college was represented by its president. At first the Hasinai received the Spaniards enthusiastically and, with the assistance of St. Denis, four missions were established in 1716, three of them by the Querétaran friars. But the Indians refused to congregate in villages at the missions and they remained faithful to their traditional religious beliefs and practices. Despite the Indian resistance to Christianization, two more missions of the Zacatecan College were founded further east among the Ais and the Adais Indians in 1617, and a presidio was founded at the western end of the mission chain on the Neches River, opposite Mission San Francisco de los Tejas. The chain extended approximately 150 miles and reached into present-day Louisiana, close to the newly fortified post of Natchitoches.

In 1718 Martín de Alarcón, appointed governor of Texas a year and half earlier, led another expedition into the province. He had been directed to create a post about halfway between the Rio Grande and east Texas in a place selected by Fray Antonio de San Buenaventura Olivares who, at odds with Alarcón, led a party of friars. Olivares, a member of the college at Querétaro, founded Mission San Antonio de Valero, the future Alamo, named to honor the current viceroy, the Marqués de Valero. Presidio San Antonio de Béxar was established by Alarcón nearby, and ten families recruited in northern Mexico built shelters and formed the nucleus of a civilian community which was immediately given the status of a *villa*. Alarcón's expedition moved on to east Texas and rescued the missions from near starvation. Some friars had been reduced to shooting crows from the trees to supplement their scanty food. This reviving of the missions in east Texas was short-lived. The outbreak of war between France and Spain led to an attack on one of the missions by seven armed Frenchmen. The ensuing fears resulted in the abandonment of all six missions and the presidio of east Texas.

The Marqués de San Miguel de Aguayo, a Spanish officer who had become by marriage the largest landholder in New Spain, was appointed governor of Coahuila and Texas in 1719 after promising to defeat the French and reestablish the settlements in east Texas at his own expense. He is reported to have spent over 103,000 pesos on his expedition which included about five hundred men, twenty-eight hundred horses, forty-eight hundred head of cattle, and sixty-four hundred sheep and goats. At San Antonio, a second mission, San José y San Miguel de Aguayo, staffed by the college in Zacatecas, was founded in early 1720. In east Texas the Marqués de Aguayo forced the French to withdraw to their post at Natchitoches and constructed nearby to oppose it the amply staffed presidio of Nuestra Señora del Pilar de los Adaes, which served as capital of Texas for half a century. He also recon-

stituted the six missions and relocated the old presidio. In addition, a mission and the presidio of Nuestra Señora de Loreto, which later would be twice relocated, were constructed on the vulnerable coast close to the site of La Salle's old settlement. When Aguayo returned in 1722 to Coahuila and retirement to private life, Texas was in the most promising condition of its existence under Spanish rule. There were four presidios with a garrison totaling nearly 270, ten missions including the six which had been hastily abandoned in 1719, and the beginnings of a permanent civilian settlement, the *villa* de Béxar, later named San Fernando de Béxar.

The retraction of presidios and economizing of royal expenditures for defense recommended by Brigadier Pedro de Rivera after his tour of inspection between 1724 and 1728 involved the abandonment of the Presidio de los Tejas at the western end of the east Texas chain of missions. That led to the removal of three Querétaran missions, ultimately to San Antonio. Short-lived expansion of Spanish Texas came in the middle of the eighteenth century. Three missions and a presidio were established northeast of present-day Austin on the San Gabriel River, a presidio and mission on the lower Trinity River northeast of Galveston Bay, and a presidio and mission among the Apaches in central Texas southeast of San Angelo. The San Sabá Mission to the Apaches was subsidized by one of the richest men in New Spain, the miner Pedro Romero de Terreros, who was subsequently created Conde de Regla. Despite the presence of a hundred soldiers nearby in the stone presidio of San Luis de Amarillas, San Sabá Mission was destroyed by Comanches and other Indians, who murdered Terreros's cousin, Fray Alonso Giraldo de Terreros, and Fray José de Santiesteban. No other missionaries were killed in Texas, but none of the other missions founded in mid-century were successful, and none lasted long. As enduring as the missions were ephemeral was the settlement in 1755 of Laredo on the Rio Grande, not part of Spanish Texas but of Nuevo Santander, colonized with great speed and skill by José de Escadón, Conde de Sierra Gorda.

The pressure of French Louisiana, which had caused Texas to be settled, was removed when the territory was ceded to Spain in 1762. Five years later the military inspection party of Field Marshal the Marqués de Rubí visited Texas. The easternmost presidio of Los Adaes, reported as early as 1737 to be decayed and eroded, more like a cattle pen than a fortress, was in a sorry state. The hexagonal enclosure with palisade and three bastions of pine poles was "badly constructed and in worse condition,"[2] with badly rotted timbers. It still housed the governor, but many of its soldiers were shoeless and only two muskets could be fired. Twenty-five families were housed in flimsy plank huts, and because of the scarcity of water the crops they raised in small clearings in the trees were insufficient to provision the presidio. The nearby mission had two friars but there were no Indians in residence.

The royal regulations of 1772, heavily influenced by Rubí's findings and recommendations, prescribed a withdrawal to an economical east-west line of presidios approximately along the 30th parallel. The presidios of San Antonio and La Bahía, then located at its third site in the Goliad area, were retained, but Los Adaes and the three remaining east Texas missions, together with the presidio and mission near Galveston Bay, were abandoned. The provincial capital was relocated in San Antonio, as were settlers from east Texas. Some of these civilians protested their removal to Viceroy Bucareli. Grateful for his sympathetic response, they named a community which they established on the Trinity River in his honor. After a few years existence it was abandoned and its inhabitants moved further east to found the permanent settlement of Nacogdoches.

Building in Texas

The materials and the techniques of construction of the buildings of Spanish Texas were more

varied than in New Mexico where *conventos* and churches were normally placed near preexisting Pueblo communities and were built with adaptations of their traditional building methods. The east Texas missions were placed in the territories of the Hasinai, Nazoni, Ais, and Adais Indians in hope of attracting potential converts. Their structures and those of the nearby presidios were made of wood, most plentiful in the region. The earliest structures were *jacales* with walls of vertical posts and the gaps between them filled with stone and plastered with mud. Timbers were also planted for defensive palisades and later carpenters fashioned walls of sawn planks.

In the San Antonio area, where wood was less readily available, adobe structures gradually replaced many of the original *jacales*. But in some instances stone was used almost immediately. Part of the *convento* of the first mission, San Antonio de Valero, the Alamo, had been completed in stone in the middle 1720s barely a half decade after its founding. A visitor, Fray Miguel Sevillano de Paredes, reported that although a *jacal* was being used for religious services, the friars "had always wanted to build a church entirely of stone with proper form and handsome appearance,"[3] but that they were delayed by the need to assemble suitable stone and to secure the services of a master mason.

Clearly the friars in the San Antonio area were much more ambitious architecturally than their contemporaries in conservative eighteenth-century New Mexico. They may have been able to oversee the construction of *conventos*, granaries, and flat-roofed churches themselves. But they depended on experienced master masons from Mexico when they wished to construct stone churches with European-type vaults and domes. Such masons were not easy to attract to what a friar called "these dangerous regions," and the protracted difficulties of Mission San Antonio in constructing a vaulted masonry church illustrates the difficulty.

Master mason *(maestro de albañil)* Antonio de Tello, a "Spaniard" from Zacatecas, arrived before 1741, but in late 1744, having almost certainly laid out the foundations and begun the stone walls of an ambitious church, he disappeared after being charged with murder of his lover's husband. Construction continued, without the oversight of a master mason, of a simplified church with a flat roof. Probably this building collapsed in 1750, possibly shattered by its falling tower. A few years later a visiting friar reported that the church, including a tower and the sacristy, had been finished but then had collapsed "because of the stupidity of the craftsman."[4] Reconstruction began about 1756 under the direction of *maestro* Gerónimo Ybarra, who retained de Tello's plan but modernized the façade with twisting baroque columns. Work stopped about 1759 with the walls half built. Another master mason, Estevan de el Oio (or Loyosa) was hired about 1765. He completed vaulting the ground floor rooms and the sanctuary and constructed four strong ribs of the crossing and two in the nave, but died in 1761. Six months later Dionicia Gonzales agreed to complete the façade as it was shown in the plan. But he never finished; all work on the church stopped in 1772 with the walls complete to the cornice level, but the upper façade, the vaulting of the nave and transept, and the dome were never initiated (Fig. 4.1).

4.1. Mission church of San Antonio de Valero, the Alamo, in 1847, watercolor by Edward Everett.

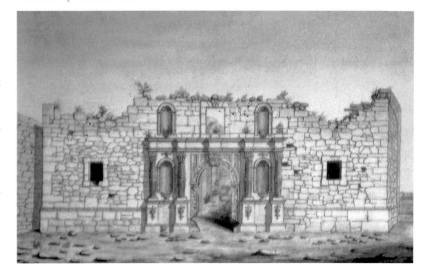

| Chpater IV

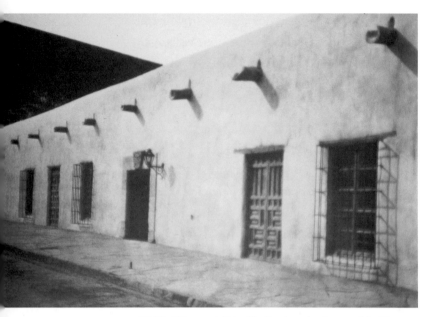

4.2. The "Governor's Palace" in San Antonio, photograph by Harvey Paterson.

Recently mural decorations in dry fresco depicting flowers and pomegranates in red, orange, and green geometric design have been discovered under many layers of whitewash in the sacristy.

The construction materials that were used in domestic structures in the San Antonio area followed the same pattern of change as the materials used in the mission churches. The friars and the Indian neophytes they attracted to the mission first sheltered themselves in *jacales* of brushwood. Ultimately these impermanent structures were replaced by buildings of adobe or of stone masonry. At Mission San Antonio a stone *convento* had been begun a few years after the mission was founded. By 1745 the *convento* had two stories with offices, refectory, and kitchen on the first floor and rooms for the friars above. At that time 311 Indians lived in adobe huts which were roofed with thatch and were arranged in two lengthy rows along the sides of the *acequia*. Eleven years later, when the Indian population was the largest recorded, 328, there were thirty neophytes' houses of adobe, twenty fronted by a stone arcade. Some Indians were still living in *jacales* but a number of permanent houses were under construction. A report of 1762 described the Indian houses as built of stone with arcades in front and arranged in seven rows. These houses were also described, confusingly, as built against the exterior wall of a rectangular compound. A careful report of 1789 confirms this last description. Fifteen or sixteen houses, with roofs of wood and mortar, were placed along the exterior wall of stone and adobe.

The first shelters in the *villa* of San Fernando were also *jacales*, and the type persisted into the nineteenth century. Structures of adobe followed. Some houses of stone were built in the 1720s, but as late as 1744 a former governor reported to the viceroy that there was no fortified presidio but only poorly formed houses making up a square plaza. In 1778 Fray Agustín Morfi described the town as consisting of "fifty-nine houses of stone and adobe and seventy-nine of wood, but all poorly built."[5] Houses were of one story, flat-roofed and rectangular, about fourteen feet deep and twenty to forty feet long, and divided into two or three rooms. A few stone houses such as the presidio commander's house, the "Governor's Palace" of 1742, and the Fernando de Veramendi house of almost a century later were more ambitious, although they were less extensive than some adobe residential complexes in New Mexico (Fig. 4.2). The commander's house contained one sizable *sala*, two smaller rooms, a kitchen, and two *zaguanes* (entry halls), but did not extend to the rear to enclose a patio on three or four sides. The Veramendi house had an at least partially enclosed patio with the kitchen to the rear.

San Antonio

Although the desire to contain French poaching in Spanish America along the Gulf of Mexico and in the lower Mississippi Valley led to a concentration of Spanish missionary activity in east Texas, the attractiveness of the San Antonio River valley was reported by both friars and secular officials. Domingo Ramón, on his way to reestablish the missions in east Texas in 1716, noted the external water

of the San Pedro Springs, capable of supplying a city. His clerical companion, Fray Isidro Félix de Espinosa, observed the desirability of the valley for missions and villages with its copious waters, which are "clear, crystal and sweet" filled with "multitudes of fish."[6] The reinforcing expedition of Martín de Alarcón was directed to assist Fray Antonio de San Buenaventura Olivares in founding Mission San Antonio de Valero and to establish a secular settlement. Alarcón remained in the area for ten days in late April and early May of 1718 before moving on to the east. He later wrote to Viceroy Valero of his establishing a presidio and the *villa* de Béxar with ten families and an adequate garrison of soldiers. The first crops of the settlement failed, some eaten by rodents, but during the first winter suitable places were found on both the river and San Pedro creek for diverting water, and *acequias* were begun for both the *villa* and the mission. Satisfactory crops of maize, beans, and other crops were subsequently harvested. In addition Alarcón had grapevines and fig trees planted and provided seeds for cantaloupes, pumpkins, and peppers. He also initiated the breeding of European-type animals—hogs, cattle, goats, and sheep—so that the *villa* was "supplied with the necessary implements, livestock, and munitions without lacking anything whatsoever."[7]

Father Olivares disdained the quality of the soldiers and settlers of San Antonio as "bad people," wholly beneath the sort he had advised the viceroy to specify for the expedition. Many were not married; few were of Spanish blood. Alarcón responded sharply that he lacked an apostolic college to recruit from and that the volunteers he could secure from northern Mexico were "Mulatoes, Lobos, Coyotes, and Mestizos," all of mixed blood, whom Olivares regarded as "people of the lowest order, whose customs are worse than the Indians."[8]

Despite Fray Olivares's contempt, the soldiers and settlers seem to have supported themselves as farmers, but the harsh conditions of early-eighteenth-century Texas caused some settlers to leave, and recruiting others was difficult. The Marqués de Aguayo increased the garrison to fifty-four in 1722; roughly twenty remained from the original Alarcón force. There were about two hundred residents in 1726, all but four being members of the fifty-four families of the garrison. During the next five years the balance of the population shifted as its garrison was reduced to ten; some of the retired soldiers stayed in the *villa* and the civilian population grew to at least twenty families.

A new *acequia* was constructed when the presidio was relocated in 1722. It was described as "capable of irrigating the two leagues of fertile land found within the angle formed by the San Pedro Creek and the San Antonio River, taking the water from the former for the benefit of the troops and settlers who might join them."[9] This *acequia* provided irrigated land south of the presidio for the agricultural fields and gardens of the settlers.

The earliest houses were almost entirely *jacales* with thatched roofs. They were vulnerable to fire. When sixteen houses and a granary were destroyed in a fire in 1721, the settlement was moved to a superior location and some houses of adobe and stone were begun. In 1727 Brigadier Rivera noted a few stone structures "built by Don Fernando Pérez de Almazán in 1726." He found the presidio without fortifications, with an unfinished chapel, and barracks for the soldiers were still of *jacal* construction of vertical logs and mud.

Conditions in San Antonio changed drastically with the arrival of fifty-five settlers from the Canary Islands on March 9, 1731. They were a fraction of the four hundred families which the royal government had intended to bring to Texas, but the viceroy, advised by Brigadier Rivera, recommended the discontinuance of recruitment of Canary Islanders because they were expensive to transport and ill-prepared for the harshness of life in Texas. Despite their incompetence in herding their own livestock and their inability to fire arms, the Canary Islanders regarded with old world disdain the

scruffy, multiracial original settlers and relished the special privileges awarded them by distant royal authorities who had overlooked the existence of those who had settled the *villa* thirteen years earlier.

In the absence of the governor, detailed instructions from the viceroy regarding the reception of the Canary Islanders were received by the captain of the presidio, Fernando Pérez de Almazán. He was ordered to provide provisions worth four *reales* to each new settler for a year until crops could be planted and harvested. The almost entirely illiterate *vecinos* of the newly constituted villa of San Fernando de Béxar were designated nobles, *hidalgos*, and a *cabildo*, a municipal government, was created from their group with appointments for life.

The viceroy, after soliciting conflicting advice from the Marqués de Aguayo and Brigadier Rivera, directed that the *villa* be located west of the presidio. However, Captain Almazán placed it directly to the east between the presidio and the river on the way to Mission San Antonio de Valero because the area to the west was without water from an *acequia* and was vulnerable to raiding Indians. In accordance with the royal Ordinances of Settlement the viceroy ordered the commander to "measure the land, lay off the streets, the town blocks, the main plaza, the site for the church, the house of the priest, the *casa real*, and the other buildings shown on the map which is sent with these instructions, to the end that, observing the measurements in feet and varas indicated in each direction for each block and street, and for the plaza, church, and *casa real*, he shall mark out these with a cord. . . . To distinguish every block from every other block, he shall place stakes in the four corners." Blocks were to be assigned to each of the fifteen families of Canary Islanders, "the blocks facing the plaza to the principal families," and the tent, awning, or "hut of twigs" of each family was to be placed in the center of each block.

The captain was also directed to confer with knowledgeable persons regarding land suitable for cultivation and to assign it in tracts equivalent to the number of house lots. These irrigable lands were specified for distribution "in just proportion to the first settlers." And, the order continued, "having reserved as much as he may think necessary for these families and for those who may come later, [the captain] shall set apart a sufficient amount for a commons (*ejido*), so that if the population increases, the people will have ample recreation grounds, and room for stock to graze without doing any damage.

"In addition to these commons, he shall lay off sufficient lands for pastures, on which to keep the work oxen, the horses, the stock for the slaughterhouses that may be built and for the other stock which by law the settlers are required to keep [initially ten ewes and a ram, ten female goats and a male, five sows and a boar, five mares and a stallion, and five cows and a bull]."

The viceroy's directions for the creation of this ideal community on the remote northern fringe of Spanish domains concluded with instructions regarding the houses: "In order that the dwellings may be beautiful they shall be of the same size and similar to each other with patios and corrals in which the horses and other work animals of the owners may be kept. The houses shall be adapted for defense, for cleanliness, and for the health of the inmates, and shall be built so that, as indicated on the map, the four winds, north, south, east, west, may enter the four angles or corners of the town and each of the houses, making them more healthful."[10]

After allowing the Canary Islanders nearly four months to recuperate from their taxing journey and to plant and harvest maize and other crops, Captain Almazán began the formal laying out of the *villa* on July 2. His procedures, which were reported in great detail to the viceroy, were concluded in five days. With the aid of a sundial and a 50-*vara* chain the plaza was laid out just east of the presidio, with the site for the church in the middle of the west side and the site for the *casa real* in the middle of the east.

Almazán reported that the plaza measured 200 *varas* in length and 133 1/3 varas in width, but subsequent maps show a smaller, approximately square plaza about 80 *varas* (222 feet) to a side. Streets 40 feet wide were marked by stakes. House lots adjoining the church and the *casa real* were measured to be 320 feet square and ordinary lots to be 240 feet square. Placing the *villa* east of the presidio forced Almazán to modify the viceroy's directives in regard to the commons and the pasture lands because of the limits of the local terrain. Upon completing his survey Almazán declared that one fifth of the pasture lands were given in perpetuity to the *villa* to support the expenses of the *cabildo* and of festivals and other public ceremonies.

The approximately fifteen families already living in San Antonio in the vicinity of the presidio were not assigned lots in the new town plaza. Excluded from the municipal government and from agricultural land which could be watered, the original settlers sought relief from the viceroy. Despite a sympathetic response in Mexico City to the original settlers' appeals, the Islanders stymied changes and remained firmly in control of San Antonio for more than a decade. Not till after the middle of the century did the passage of time and intermarriage bring about an integration of the two groups of settlers of Fernando de Béxar.

Like other Spanish communities within the present United States, San Antonio developed very slowly after its ambitious laying out (Fig. 4.3). The population increased gradually as some of the soldiers who retired remained in the *villa* and small numbers of immigrants arrived from Northern Mexico. Sites for the church and the *casa real* had been designated by Captain Almazán, but many years passed before they were built. Settlers attended religious services in a building of the presidio or in one of the mission churches, and not until 1738 did the community attempt to raise money for its own church. In a week, 642 pesos were collected, including 200 from the governor, 100 from the cap-

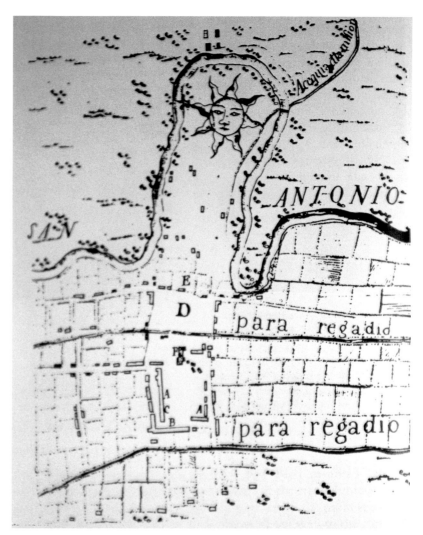

4.3. Detail of the Plan of San Antonio in 1767, Joseph de Urrutia. Two aquifers bring water to the town and one to "la mission," that is, Mission Concepción. At the top above the bend in the river is Mission San Antonio, the Alamo, which is misidentified as "Mission de san Joseph." Below the bend in the river are the two plazas surrounding the church, labeled F. At the center of the upper range of the "Plaza de la Villa," labeled D, is the "Casa Reales" for government. At the lower end of the other plaza are military structures, housing for soldiers, the guardhouse, and the "Casa del Capitan," the Governor's Palace. The few streets still reflect the original laying out of the town, being relatively straight and intersecting primarily at right angles. The plan is reproduced in Max L. Moorhead, *The Presidio*, plate 21.

tain of the presidio, 75 from the curate, and small amounts totaling 75 from the enlisted men. A cornerstone was laid on May 11 for a church probably designed by the master mason Antonio de Tello, but it was no more than half built in 1745, the year after de Tello fled San Antonio. The viceroy, petitioned to support the project, had approved a payment of 12,000 pesos in 1740, but the funds were not available until 1748 and the structure was not completed until 1755. It was described in 1777 by Fray Juan Agustín Morfi as spacious with a vaulted roof but

| Chapter IV

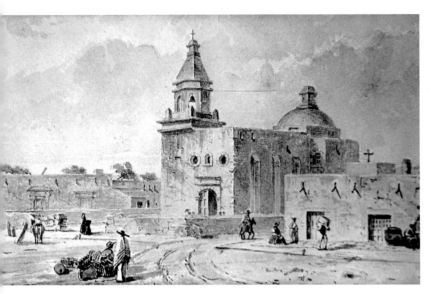

4.4. Main plaza and parish church in San Antonio in 1849, watercolor by Seth Eastman.

"so poorly constructed that it promises a short life."[11] Despite Fray Morfi's apprehensions, the church survived until its polygonal transept, its polygonal apse, and part of its nave were incorporated into a Gothic structure in the 1870s.

In November 2001 the architectural historian and practicing architect Eugene George was asked by those responsible for restoring the crossing area to examine the construction after the surface plaster had been stripped off to reveal the original work of the 1750s. George found the stone arches poorly built and the pendentives at the corners ill-joined. He believed that the artisans had attempted to shore up the shaky pendentive structures by applying by hand successive layers of very stiff plaster to form an octagon beneath the dome. He concluded that they did not know how to properly construct a pendentive-supported dome.

The parish church was under construction during the years in which Gerónimo Ybarra was completing the sturdily built church of Concepción Mission. It seems unlikely that in a small community like San Antonio Ybarra was uninvolved, in an advisory capacity at least, in the work on the church of the town. Yet how can his competence be reconciled with the inept construction of the area of the crossing and dome of that church? Possibly a less able mason in the town was employed to complete the church.

Prints, nineteenth-century photographs, and archeological excavations have extended our knowledge of the church beyond Fray Morfi's description (Fig. 4.4). It was barrel vaulted with walls of limestone rubble masonry finished with painted plaster. On the exterior the walls terminated in a plain parapet just under thirty-three feet high. A square bell tower at the southeast corner supported an octagonal belfry stage, roof, and a lantern. The structural integrity of the church, which concerned Father Morfi, was shored up by an array of at least eight buttresses—four on the north side, including a huge one which supported the north transept, and four along the south side.

Bids for the construction of a building for the cabildo and for the construction of a jail were solicited in 1740. The planned casa for the cabildo was to have been $33\frac{1}{2}$ feet long by $12\frac{1}{2}$ deep with a portico across the front and turrets for defense, but the structure was not completed for years because of inadequate funding. In 1749 the stone walls of the jail had reached the requisite height but had gaps in the masonry. Alberto López, a former soldier, was appointed to fill the holes and construct a temporary roof.

The population grew slowly but steadily, in part because of the lack of success in settling other areas of Texas. Estimated at 200 by Captain Almazán in 1726, it approximated 500 by 1750 and was reported by the cabildo as 860 in 1770. The addition of approximately 60 families of former residents of Los Adaes a few years later brought it close to 1,000 and by the 1790s that number had doubled. In the 1793 census three-fourths of the people of racially mixed San Antonio were classified as "Spaniards," a classification reflecting status in the community rather

than racial lineage. The prominent carpenter Pedro Huizar, a *mulato* born in Aguascalientes, rose after some fifteen years of residence to *espagñol* in 1793 and five years later gained the honorific title of *don*.

Subsistence farming was the principal occupation of San Antonio residents during the eighteenth century. The presidio was essential to the community, providing a market for crops, a store for the purchase of imported goods, and a place of employment for some. As late as 1783 the *cabildo* responded to an official request for a list of the local grocery stores by stating that at the moment there were none. "Most residents maintain themselves from their own fields and *ranchos*, and when there is some surplus to be sold, the amounts are too small to deserve much attention, and in any case the goods are usually exchanged for others because most *vecinos* are very poor, barely able to survive in the threat of Indian raids."[12]

The closing of the presidio of Los Adaes as the result of the ceding of Louisiana to Spain, and the recommendation of the Marqués de Rubí, made San Antonio the capital of Texas and the permanent residence of the governor. But except for causing a sudden expansion of the population, becoming the capital did not greatly change living conditions in San Antonio. The new arrivals were granted few civic privileges. Like the non–Canary Island settlers over forty years earlier, they were denied access to irrigable land and to social and political standing. Unlike the majority of older residents, they were not classified as *espagñoles* and they were hard pressed to support themselves. In the years after their arrival in 1773, eighteen were able to secure positions in the garrison but twenty-seven had to work as servants or day laborers and another twenty were employed in the missions performing tasks previously performed by Indian neophytes.

In founding communities like San Antonio, Spanish officials hoped to foster widespread breeding of livestock. After mid-century modest ranchos had been started in the San Antonio River valley. But as late as 1778 they were reported as having a total population of eighty-five, living in miserable huts and fearful of losing their lives to Indian raiders. But before the end of the decade cattle became Texas's first exportable commodity, driven in moderate-sized herds to the settlements on the Rio Grande and further south to Coahuila and to the annual trade fair at Saltillo. San Antonio became a distant supplier for the northern Mexican mining industry and, during the American Revolution, of Louisiana as well.

Mission Purísima Concepción

In the spring of 1731 Mission Nuestra Señora de la Purísima Concepción and two other east Texas missions administered by Franciscans of the College of Santa Cruz of Querétaro were relocated along the San Antonio River below the *villa* and the presidio. Mission Concepción had been located in 1716 near the village of the Hainai, a tribe of the Hasinai confederation of Caddo-speaking Indians whom the Spaniards called the *Tejas*. The effort to evangelize the Hasinai, once so promising, had been disappointing. Yet the friars of the three missions which were dependent for military support upon the Presidio de los Tejas had tried to prevent its closing by Viceroy Casafuerte upon the recommendation of Brigadier Rivera. Unsuccessful, they moved to the Barton Springs area near Austin for a brief stay and then on to San Antonio. Mission Concepción retained part of its name, dropping de los Ainais and adding de Acuña, the family name of the viceroy. The original east Texas mission, San Francisco de los Tejas, became San Francisco de la Espada, and Mission San José de los Nazonis became San Juan de Capistrano.

Upon relocation in the San Antonio area the friars of the three east Texas missions changed their method of evangelism and adopted that being used

in the two missions already in the area, San Antonio de Valero and San José y San Miguel de Aguayo. Rather than placing a mission close to an already existing community of Indians, the friars sought to congregate Indians of differing groups in a mission village. Gifts, food, European technology, and protection against hostile Indians were, in addition to the Christian message, inducements. According to Fray Isidro Félix de Espinosa, chronicler of the Querétaran college, nearly a thousand Indians of various Coahuiltecan tribes were brought to the three missions in 1731 after two recruiting trips of friars and soldiers.

Concepción Mission was located on the east bank of the river close to its junction with San Pedro Creek and about halfway between Mission San Antonio and Mission San José on the site of a previously abandoned mission. After temporary *jacal* shelters with thatched roofs were constructed, the layout of the permanent mission was marked off on the ground with a measuring cord following the standard plan worked out at the College of Querétaro. Originally the layout at Concepción and the other relocated missions was to be organized around an approximately square patio. Rooms along the north side were constructed beginning about 1733 at Concepción, but about five years later work was stopped and both the *convento* and church were redesigned. Work on the new structures began about 1740.

The report of Fray Francisco Xavier Ortiz, inspector of the College of Querétero, provides an account of the state of Mission Concepción in 1745. There were 207 Indians in residence, 176 already baptized and 31 under religious instruction. The complex was defended by a wall of stone and mortar. Inside were *jacales* for the Indians, three stone houses for soldiers, a two-story stone house for the friars with living quarters on the upper level, a large stone granary, and two churches. A sizable adobe hall with a flat earthen roof and, possibly, a New Mexican–type transverse clerestory, was in use and a new structure of cut stone was nearly half built. An *acequia* probably descending from a stone dam in the southern section of the loop of the river in central San Antonio irrigated a farm located west of the wall along the riverbank and passed through the mission compound. Thirty yoke of oxen were available for plowing and hauling, and a ranch some twenty-five or thirty miles to the east contained nine hundred cattle, three hundred sheep, and one hundred horses, according to an earlier report. The mission compound contained shops for carpentry, blacksmithing, and textile manufacture. The master mason Antonio de Tello had designed the stone church and the vaulted *convento* linked to it on the south and supervised their partial construction before he fled San Antonio late in 1744.

Father Ortiz returned on another tour of inspection in 1756 and found that the stone church had been completed (under the supervision of master mason Gerónimo Ybarra and sculptor Felipe de Santiago) and had been dedicated December 8, 1755, four days before the dedication of the San Antonio parish church. Some of the houses for Indians had been constructed of adobe bricks. Later these structures were replaced by twenty-four buildings with stone walls and flat earthen roofs supported by *vigas* arranged in rows along the north and south walls. Other changes noted by Father Ortiz and by subsequent visitors and residents included an orchard of fruit trees alongside the farm and surrounded by a stone wall. A one-story friary replaced the two-story one which had become dilapidated by 1756. The new vaulted friary adjoined the south tower of the stone church and was fronted by an arcaded corridor. Its rooms included a *portería*, two cells (one with an alcove and the other with a porch), a refectory, and a kitchen. Contiguous with the *convento* was a textile shop.

In 1773 Concepción and the other Texas missions of the College of Santa Cruz de Querétero

were turned over to the Franciscans of the College of Guadalupe de Zacatecas so that the Querétaran college could shift its evangelical efforts west to Sonora to replace the Jesuits, who had been exiled from New Spain in 1767. In preparation for the turnover the resident friar, Juan Joseph Sáenz de Gumiel, prepared a careful inventory of Mission Concepción in December 1772. At that time the mission population had declined from 247, the peak recorded in 1756, to 171. Seventy-five were Pajalache Indians, 48 were Mano de Perro, 18 Sanipao, 15 Toaraque, and the remainder were of unidentified tribal origins. By 1772 the mission had baptized 940 people, and had conducted 212 marriages and 740 burials.

The granary, located along the eastern wall behind the church, was fifty-six feet long and fourteen feet wide. It had been constructed of roughly cut stones and had a roof of earth, supported by *vigas* and boards. A masonry shop had been added to the other workshops. Within the walls of the mission, in addition to the twenty-four Indian houses, were a well, a chicken coop, a toilet, and separate corrals to protect the livestock and the horses from Indian raiders. Alongside the south arm of the transept was a sacristy furnished with three large painted and gilded cabinets, and above the sacristy was a cell with an alcove which was used as a lodging for guests and as a sickroom.

A document explaining a missionary's duties and revealing much about everyday life at a mission was probably written for his successor in 1787 or 1788 by Fray Joseph García, the next to last Franciscan in residence at Concepción. The missionary, the writer explained, "must have on hand medicines for the sick, hay for the animals, and a whip for the intractable. In his dealings with the Indians, he must be pleasant towards all, prudent, and a protector of their possessions. He must not give in to the rebellious, or to the arrogant. He must punish the wicked and be always jealous for the honor of God. Toward the sick, he must be charitable, long-suffering and patient, visiting them when they need it and see to it that they use the remedies he can obtain. Finally he is Padre and everything to the Indians, being all to all in order to win them all."

The writer ran through the missionary's duties during the season of planting and growing: "The irrigation ditches (*acequias*) are cleaned with water from the river . . . [and] the missionary will also see to it that the bridges and the dam are repaired when necessary. . . . When the ditches are cleared, the natives will mind the gaps in the fence around the field. . . . Others [may] begin to plow the land . . . or burn the cane which remained from the last harvest. Thus, the missionary sees to it that the field is tilled, so that in May, which is the best time of year, corn can be planted. . . . Others are busy preparing the soil for the planting of cotton, fruit, chile, the seedlings having already been prepared. The beans are planted in June. . . . He must also provide for irrigation in due time and for hoeing and weeding. . . . Formerly it was customary for the women to help the men, working like any farmhand. However this was stopped due to the disorder that resulted . . . the men did not do their own work fully because they were helping the women with theirs. Also, and this is more important, the women should be at home grinding grain and preparing meals for their husbands."

The writer conceded that women who were not ill or rearing or expecting a child could be brought into the fields to help bring in the harvest but counseled against allowing women to serve as mission cooks because "the employment of women could lead to disorder with single men in the kitchen."

Securing a regular supply of meat was another concern. "Every week the missionary must see to it that the supply of beef cattle is brought to be rationed for the sustenance of the Indians. . . . He must advise the foreman to bring the horses that are needed promptly so that with four to six cowboys he

Chapter IV

will go on Thursday and be back with the cattle on Saturday."

Supervision of textile manufacturing was another of the missionary's responsibilities. Boys were sent to the *acequia* to wash freshly sheared wool. Carefully selected corders worked on the wool and then it was given to children for making into thread. Uncorded wool was given to women who operated spinning wheels. Spun wool then was given to a weaver who made blankets.

Cotton was picked in September and children were given corded cotton to make thread on spinning wheels. A weaver, assisted by a boy, manufactured the cloth under the supervision of the missionary. Cloth was distributed to the men before the onset of winter cold. On the day for distribution the missionary "calls the men and, one by one, takes their measurement for the length of shirts and sleeves. Cutting the material thus, he gives them what is needed for pants (observing that if the Indian is fat, he is given narrow cloth for piecing), so that he may take it to his wife to sew for him."

Mission-spun clothes were provided for ordinary Indians. But "since distinctions are made among all people, the *majordomo*, his assistant, the governor, the *alcalde* and *fiscal* are given cloth from Puebla from which to make their white shirts and pants. This is ordered each year in the list of supplies. If the missionary wishes to favor some others with this material, he is free to do so." Shifts for women were, according to their preferences, made either of thick mission-spun cloth or material from Puebla. All received white undergarments made in Puebla.

Supervising the annual election of mission officials was a sometimes delicate task for the missionary. "He calls each one, beginning with the *mayordomo*, and asks him whom he wants for governor. . . . The same for *alcalde*. . . . But the missionary must keep in mind that it is the custom to alternate between the two nations, the Pajalaches and the Tacames. The former also include members of other nations. . . . For this reason it is necessary at times to remind some of the voters, who usually vote for a Tacame for governor, to alternate after his term is up."

When supplies arrived from Mexico annually, the missionary had to distribute to the Indians their proper share. "He has now calculated how many women and children there are and for them he designates a basket. In each, he puts three or four strings of beads (according to how many he has); a necklace, if there are any; one and a half, or one and three-fourths *varas* of ribbons; two and one half varas of straps; a rosary and a small brush, if there are any. Also, he has ready white underskirts or petticoats, as they call them here, and he should have the camisoles cut from Puebla cloth for those who use that. . . . Also, he has ready two pieces of flannel from which to cut the skirts. When all this is arranged, he calls the women and measures the skirt (or has another woman do this in his presence). . . . Some women are given shoes once or twice a year. The missionary must take care to order them from Saltillo. Should he wish to have one or the other dressed better than the others, either because she deserves it or for some other reason, he may do so. The same thing is done at the other missions. This also refers to the men and children."

After making prior calculations in his cell the missionary summoned the men on another day and "to each gives a hat, a large knife and shoes. . . . Spurs, bridles, saddles and other trappings, are not rationed because the missionary gives them out as needed to each according to the work he is doing. Regularly the supplies include woolen stockings and cotton socks. These items are not given to all, but to those the missionary selects, as is done for the women with griddles, kettles, copper water-pots, etc. The missionary takes care to determine the need, so as to avoid unnecessary selling and gambling to which some Indians are so prone."

Relatively few of the writer's explanations concerned religious matters. He did relate that "during the time of Easter duty, the Indians receive a chocolate bar for breakfast on the day they receive Holy Communion . . . [but] if the missionary should be unable to provide this the Indians are content with a sugar cane or half of one." Special attention was directed to the Indian boys. "In the past, the missionaries have kept the boys in the cell, inviting them when they have grown up a little, not only to have them work, nor employ them personally, but to educate them, civilize them and make them genuinely human. . . . The missionary takes care that they learn the catechism, are taught to serve Mass, to subdue their bad inclinations, correcting what is bad and showing them what is good." The importance of teaching the boys Spanish was also emphasized, "because of the facility it promotes both for the missionary to understand what they are saying and for the Indians to understand him."

Fiestas enlivened the mission year with exciting celebrations for the Indian neophytes. Corpus Christi and the Immaculate Conception were principal religious feasts and the conclusion of the harvest a secular holiday. On that day, "the Indians are accustomed to draw the last cart decorated with banners and ribbons and go to the majordomo, the governor, and *alcalde* and sing the 'Alabado' with accompanying music. This ends in the church. Then they go to the missionary's cell to enjoy a refreshment which is usually a bottle of wine.

"On Christmas Eve the Indians do the dance of the *Matachines* [a dance of Moorish origin in costumes and masks, carrying wands and rattles] and go on dancing at the entrance of the friary as long as the missionary allows it. . . . On Christmas Day they go and dance at the presidio, at the governor's house and other places. In some missions there were outfits in keeping with the spirit of the feast. . . . This dance is regularly performed also in the process of Corpus Christi instead of using giant figures.

"On the afternoon of the principal festivity of the mission it is customary to permit them to put a bull in the mission plaza and they amuse themselves with him. . . .

"Regarding the lawfulness of the dance called the *mitote* performed by the Indians, . . . they consider it evil [non-Christian] and . . . hide it from the missionary. The Indians have their superstitious practices, and for them this dance is like the *fandangos* and *saraos* among the Spaniards. . . . It is my conviction that when no superstition, no question of celebrating an enemy's death, or any sinful motive is present, the *mitote* is not unlawful when done for diversion, because among the Indians it is the same as the fandango among the Spaniards."[13]

This detailed account of the missionaries' lives and their nearly infinite responsibilities makes a modern secular reader sympathize with their benevolent paternalism. Totally alone in another world from their Spanish homes they were, at their best, prudent, patient, and seemingly tireless, endeavoring and sometimes succeeding, in Father García's words, to be "all in all in order to win them to all."

The Present Church

Notable for its four-square sturdiness, Concepción Mission church is nearly 250 years old, the oldest Christian structure of worship in Texas. This church and San Xavier del Bac in Arizona are the only Spanish vaulted structures in the United States which have endured without collapse. The second church on the site, it was begun about 1740 according to the design of Antonio de Tello, shortly after the parish church in the *villa* of San Fernando was initiated and probably before the beginning of the construction of the church of Mission San Antonio. Three vaulted churches of stone, probably from designs of de Tello, were under construction contemporaneously in the San Antonio area in the early 1740s.

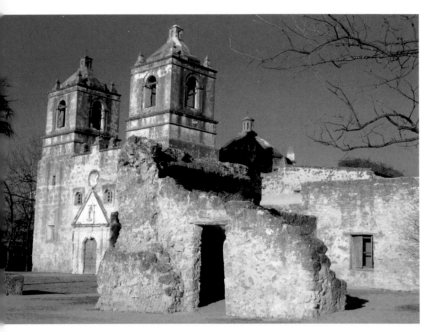

4.5. Mission Concepción, church and part of the *convento*. Also see Plate VI.

4.6. Mission Concepción, portal of the church.

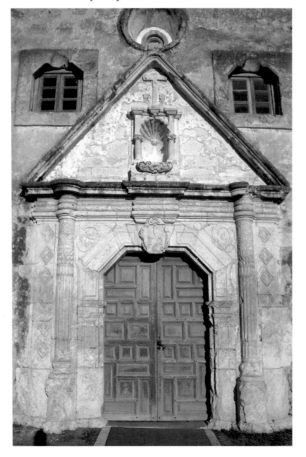

The design of the church of Concepción Mission, like the other stone churches of San Antonio, followed canons of geometrical proportions. Mardith Schuetz-Miller, who plans to publish a study of the geometric planning of Spanish colonial churches in the western United States, regards Concepción as the most sophisticated of all in its exemplification of geometric planning (Fig. 4.5).

The walls are forty-five inches thick, faced with roughly cut tufa limestone from a quarry a short distance to the west, set in lime mortar and filled with adobe and smaller stones. More carefully shaped stones were used for the corners of the towers and the arches of the windows and doors. The church was plastered on both its exterior and interior surfaces. The heavy low dome rests on an octagonal drum over the crossing and has a low octagonal lantern and four windows. At its corners are buttresses and merlons. Square towers are placed flush with the central façade to form a massive front wider than it is high. The solid cubic belfry stages are cut into on all four sides by modest arched openings and culminate in octagonal stone roofs topped by small squat lanterns.

The powerful front is punctured by seven symmetrically placed openings which provide light for the rooms in the towers and for the choir balcony. Ornamentation is concentrated in the odd-looking carved stone portal (Fig. 4.6). The handling of classical forms is free, resembling that in some sixteenth-century Mexican churches rather than eighteenth-century structures. The pediment is excessively steep, like the one at Tepotzlán, and the capitals of the flanking half-columns extend up into the entablature so as to recall the unfinished church at Cuilapán. More up-to-date is the faceted arch constituting half an octagon which frames the doorway. It is inscribed to the "Patroness" and princess of this mission and defends the doctrine of her purity, that is, of her Immaculate Conception. Over the arch is a loosely dangling Franciscan cord linking cartouches containing the five wounds of

Christ and the Franciscan emblem of an arm grasping the cross. Outside the half columns are superposed tiers of diamonds enclosing rosettes. Above the entablature in the center of the steeply sloping pediment is a columned niche covered by a scalloped arch and supporting a stone cross. Father Ortiz described the niche in 1756 as containing a statue of the Virgin of the Immaculate Conception. He also described painted decorations of the façade which have disappeared but were still visible in the nineteenth century. They covered the whole façade as well as enlivening the carved decorations around the portal. Prominent were representations of a red sun and a yellow crescent moon high on the central façade on either side of the circular window above the pediment. The flanking towers were fully colored. At their bases were bands of red three feet high. The bodies of the towers were painted with simulations of stones outlined in red and containing four-leafed rosettes in blue, also outlined in red. The stones at the corners of the towers were blue, edged with red, so that the overall effect suggested tile work. A band of alternating red and blue diamonds, or possibly diamonds and opals, marked the transition to the belfry stages which were decorated with painted pilasters with red bases, yellow shafts and flutes, and red and blue capitals. Chevrons of red and yellow with blue centers decorated the pyramidal roofs and may also have decorated the dome.

Above the window openings were bands painted alternatively gray, blue, and red to suggest flattened arches. At the top of the central façade were large intertwined letters MAR above AVE expressing the dedication of the mission to the Virgin Mother, Maria Ave. It is difficult to fully imagine the effect of the painted ornamentation upon the church of Concepción Mission. The liveliness must have transformed its somewhat stolid construction, particularly in the appearance of the façade.

Very little color appears in the smooth-ribbed barrel-vaulted interior at present, and little is recorded by visitors and residents in the eighteenth century. In 1890 William Corner described the interior as "massive but plain" with "walls, roof, and ceiling . . . newly white-washed"[14](Fig. 4.7). In 1756 the cruciform interior (in plan similar to that of the uncompleted church of San Antonio de Valero also laid out by Antonio de Tello) was described by Fray Ortiz as just over 83 feet long and $17\frac{1}{2}$ feet wide in the nave and $46\frac{1}{2}$ feet wide in the transept (Fig. 4.8). He described the vaulted ceiling of the choir balcony and mentioned a pulpit with a sounding board and a freestanding statue of Christ

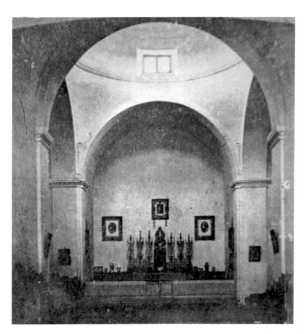

4.7. Mission Concepción, the interior of the church in the 1860s, photograph from San Antonio Light Collection.

4.8. Mission Concepción, plan, Historic American Buildings Survey.

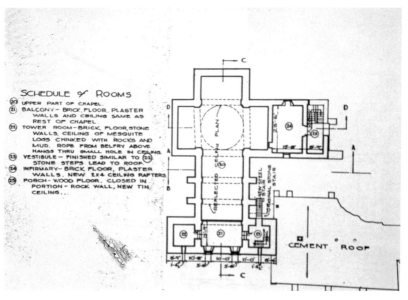

| Chapter IV

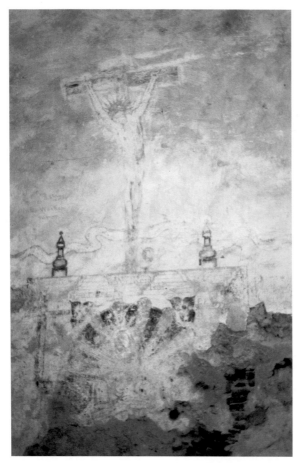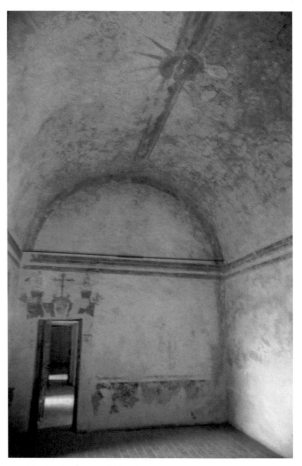

4.9. Mission Concepción, mural painting of the crucifixion and decorations in the baptistery.

4.10. Room in the *convento* of Mission Concepción with painted ornamentation in red, blue, and gold. At the center of the vault is a mustachioed sun with rotating spikes for rays. Also see Plate VII.

with a baldachin. Along the walls were paintings of the fourteen stations of the cross. There were three altars. Behind the main altar was a statue of Mary Immaculate with child in her arms nearly three feet high with a painted backdrop. One transept altar had a painting of Christ and various saints and the other had a painting of Nuestra Señora del Pilar.

In 1762 the resident friars contributed information to a report of Fray Mariano de los Dolores y Viana. They explained that the lower rooms in the towers contained chapels, one with an altar and statue of the Archangel Michael and the other with a baptismal font with a copper cover and silver shell. A powerful mural painting in the baptistery of Christ on the cross has recently been recovered through restoration (Fig. 4.9). Traces of paintings on the walls of the church were found in 1913 and may still survive under thick layers of plaster and paint.

The inventory of Fray Sáenz de Gumiel in 1772 described the barrel vault, which is divided by flat ribs into four bays in the nave, and is constructed of rubble masonry set in lime mortar. He also praised the good dome with a beautiful drum, impost, and cornice. In the four pendentives were painted images of San Francisco, San Buenaventura, San Antonio of Padua, and San Bernardino of Siena, all Franciscans.

Inside the entrance are rooms in the towers with flat wooden rather than vaulted ceilings. The choir balcony is supported by an arch and a vault. It had a lathe-turned railing. The vaulted sacristy had two doors, one leading to the church, the other to the *convento* (Fig. 4.10). Above the sacristy was a

high room, the office of the Father President of the Querétaran missions of Texas.

By 1794 the Indian population of Concepción had dropped to thirty-eight and the mission was secularized. The land was divided among those then in residence and some "Spaniards" began to join the Indians at the mission. In 1824 the College of Zacatecas closed the mission and transferred the church and other buildings to the pastor of San Fernando church. Subsequently the mission compound was used as a corral for hundreds of sheep and goats. In 1843 William Bollaert found "the church in pretty good order still," but "crowded with bats' nests and the floor of it covered in some places with excrement from these animals a foot thick, giving out no very pleasant odor."[15] The church was cleaned and used by United States troops in 1849, and ten years later the Brothers of Mercy received title to the church and restored it for religious use. In 1911 title for the mission buildings was transferred to the Bishop of San Antonio. Repairs to the roof and parapets of the church were completed by the WPA in the 1930s, and in the 1950s four rooms of the friary and its frontal arcaded corridor were cleared of debris and restored.

Mission San José y San Miguel de Aguayo

Mission San José was founded in 1720, the second in the San Antonio area, in spite of the protest of the friar resident at Mission San Antonio, Antonio de San Buenaventura y Olivares, who objected to another mission being located so close to his, fearing conflict between the Indians of the two establishments. The extension of the mission's name, "y San Miguel de Aguayo," honored the governor of Coahuila and Texas, the Marqués de Aguayo, who had authorized the founding.

One of the most remarkable of all Franciscan missionaries of Spanish America, the Venerable Antonio Margil de Jesús, was the founder. Father Margil, born in Valencia, was among the first recruits of Fray Antonio Linas, the founder of the missionary College of Santa Cruz de Querétaro. A prodigious walker, he spent thirteen years in missionary labor in Central America, ranging geographically from the Lacandon Indians of Chiapas to the feuding Terrabas and Ujambores of what is now southern Costa Rica and northern Panama. He survived food poisoned by Indians and a failed burning at the stake. He was the first guardian of the College of Guadalupe de Zacatecas and the leader of Zacatecan friars who founded three of the missions in east Texas. He established Mission San José when he was sixty-six years old, during the period after the east Texas Franciscans had retreated to San Antonio from the French threat in 1719 and before their return with the powerful expedition of the Marqués de Aguayo in 1721. Despite his formidable missionary energy, Fray Margil cultivated humility. He spoke of himself and signed himself "La Misma Nada," nothing itself, patterning his life after the abrogations of the Virgin whom he called "La Doña Nada," lady nothing.

San José Mission was first located east of the San Antonio River on "a slight elevation that is even and spacious"[16] and easily irrigable, a place less than four miles south of Mission San Antonio. The site was selected by Captain Juan Valdez with the concurrence of Father Margil and two other priests, three military officers, and the Indian chiefs who accompanied the founding party. This original site may be near that now occupied by Mission Concepción. When the mission was visited by the Marqués de Aguayo in late April 1721, there were already 227 Indians in residence. Later that year Father Margil returned to San José from east Texas for a brief period and worked on a dictionary of Indian languages. One of the two original resident friars, Fray Miguel Núñez de Haro, remained at San José for thirty-two years until his death in 1752.

Some time in the early or mid-1720s the mission was moved across the river to the west bank south of its original site. Father Marion A. Habig,

historian and author of *The Alamo Chain of Missions*, believed that its present location is the third, but recent investigations have questioned his belief. Early structures were *jacales*. No permanent stone structures are mentioned until after 1740. A church of stone with a flat earthen roof, a transept, and a tower with bells was first mentioned in 1744. It faced south and probably had a transverse clerestory like New Mexican churches. A mason named Nicolás Maldonado who worked in the San Antonio region in the 1720s may have had a role in this stone church or it may have been constructed by Indians under the direction of Father Núñez de Haro. A portion of its walls was incorporated into the back wall of the sanctuary of the present church, which faces west.

The first detailed description of Mission San José was included in a report of 1749 regarding missions of the College of Zacatecas written by Fray Ignacio Antonio Cyprión to the Franciscan commissary general of New Spain. The buildings in addition to the church—the friary with a cloister and *portería*, the granary, and the houses of the Indians—were all of stone with flat earthen roofs; later the roofs were described as being of wood plastered with cement. Mission San José, with over two hundred neophytes and a ranch with roughly two thousand head of cattle and a thousand sheep, had in the judgment of Father Ciprión made more progress, spiritually and temporally, than any Zacatecan mission in Texas or in any of the other regions of northeastern New Spain.

In 1758 Fray Ildefonso Joseph Marmolejo conducted Governor Jaciento Barrios y Jáuregui through the mission, and the governor provided the viceroy with an extensive report. The Indian population had reached 281, of whom 113 were capable of bearing arms. At this time the mission was being transformed into a virtual fortification. Indians mounted guard every night. The eighty-four strongly built Indian houses, placed along the periphery, had loopholes on the outside. Apaches and other Indians from the north were a recurring threat. The houses were of one room with a patio and kitchen with a fireplace to the rear and with flowing water from the *acequia*. They were furnished with a *metate* for grinding corn, a *comal* (a flat piece of iron for making tortillas), a water jar, another pot, a bed, and cupboards for storing food and clothes.

The stone *convento* had two stories but only one room above. The four rooms off the ground floor corridor were used as offices, a kitchen, and a friar's cell. Eight other rooms were mentioned in an inventory of 1755 but not identified as to nature or use. A stone building opposite the church housed the three military guards and like the Indian houses had a bathing pool. Between the church and the soldiers' quarters was the cemetery, which also served as a drill ground and was surrounded by a rubble fence with three entrances. The granary held four thousand baskets of corn and there were a smithy, a carpentry shop, a workshop for weaving, and a sugar mill for making syrup and bars of brown sugar.

At the mission's ranch, El Atascoso, over twenty-five miles to the south, there were almost thirty-five hundred sheep and fifteen hundred branded cattle, fewer than in 1749. Since that year Indian raiders had stolen or killed two thousand head.

In the thirty-eight years since 1720, 964 Indians had been baptized, 145 couples had been married, and 466 Indians had been buried. Governor Barrios was charmed by the Saturday services of rosary recitation and singing. "No one," he wrote "who has seen it can keep from weeping at the modesty, the composure, the religious fervor, the good voices, and the music of the Indians."[17]

Ten years later, in 1768, Mission San José was visited by Fray Gaspar José Solís from the College of Zacatecas. On March 19, the day after he arrived and the feast of San José, he and Governor Hugo O'Conor laid the first two stones of the present church. The resident missionary was Fray Pedro Ramírez de Arellano. The Indian population was at

its peak with 350 in residence, from eight different nations.

Father Solís described the mission compound as square, a little over two hundred yards on each side, with the stone Indian houses lining the sides forming defensive walls (Fig. 4.11). There were bastions at diagonal corners and entrances in each of the four sides. The houses were 14 to 16½ feet long and 11 feet from their defensive exterior walls to their entrances in the mission compound. A well within the compound produced "as large a flow of water as from a small river." This water irrigated the mission quadrangle and joined the irrigation ditch outside the walls. The *acequia*, which had many fish, irrigated a farm more than two and half miles long. The principal crops, corn, beans, lentils, sweet and Irish potatoes, sugar cane, cotton, and melons, supplied the mission and produced surplus to sell to the Texas presidios. A garden furnished varieties of vegetables and fruit, including some peaches weighing virtually a pound.

Father Solís praised the Indian workers and stressed the mission's self-sufficiency. "They are industrious . . . and very skillful in everything. They . . . [are the] muledrivers, stonemasons, cowherders, shepherds and in short do everything."[18] There was no mention of the military guard but an account of 110 Indians who were armed, 45 with guns and the others with bows and arrows, spears, and lances. The plain surrounding the mission had been cleared of trees and brush so that no cover was available for hostile Indians, and mounted sentinels patrolled in all directions to prevent any surprise attack. There is no record of any assault upon the mission itself. Raids were made on vulnerable outposts, but no party ever attacked the well-defended quadrangle.

The Present Church and Sacristy

Fray Juan Agustín Morfi, who arrived in San Antonio in 1777 as chaplain of Commandant General Teodoro de Croix of the Interior Provinces, left

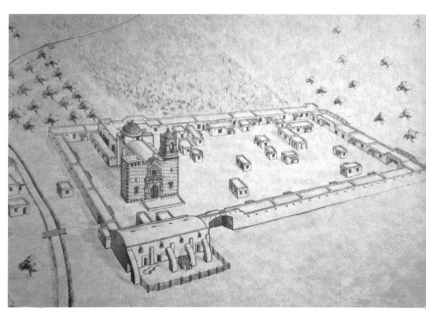

4.11. Bird's-eye view of Mission San José, drawing based on a model by H. L. Summerville, reproduced on the front cover of John W. Clark, Jr., *Mission San José y San Miguel de Aguayo: Archaeological Investigations*.

the first description of the nearly completed present church of San José Mission. At that time the resident Indian population had fallen to about 275, with about 25 more living at Rancho El Atascoso. Two more bastions had been added to the quadrangle so that a bastion defended each of the gates from above. Loopholes in the walls of the houses at the sides of the gates where particularly reliable Indians lived also provided defensive fire.

The *convento* had been expanded so that living quarters were provided above for missionaries and guests, and sufficient space below was available for offices. There was also "a large well-ordered kitchen, a comfortable refectory, and a pantry. There is an armory where the guns, bows and arrows, and the lances are kept. . . . In separate rooms are kept the ornaments and costumes with which the Indians clothe themselves for their dances." Spacious arcaded corridors fronted both stories and "the one on the second opens onto the flat roofs of the Indian quarters."

A handsome portal ornamented by a carved shell, winged angel heads and delicate rococo fronds gives access from the front of the lower friary arcade

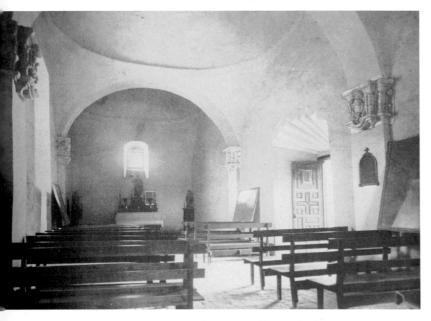

4.12. Interior of the sacristy of Mission San José, photograph by Harvey Paterson.

4.13. "Rose window" of the sacristy of Mission San José.

into the rear of the sacristy, which was located south of the church along the eastern two-thirds of the nave. Father Morfi described it as "cheerful [and] well-decorated, with a vaulted roof [and] good light" (Fig. 4.12). It has three domed bays separated by smooth arches marked at their springing by carved capitals. The tops of the doorways into the church and out to the friary are marked by powerful shells sculpted into the depth of the wall. The sacristy was completed before the church and housed the religious services of the mission during Father Morfi's visit while the main structure was being finished. Its exterior walls are of rough rubble limestone masonry, supported by three buttresses, and completed by an undulating parapet. The principal decorative feature is the animated frame of the celebrated "rose window," generally oval in shape but cut into by sharp angles and softened and enlivened by carved ornamentation of curving and counter-curving rococo fronds (Fig. 4.13). The material of the window and of the façade of the church and other decorative elements was of a denser type of limestone than the sandy variety of tufa, taken from the quarry near Concepción Mission, which was used for the walls of the sacristy and church. That stone was soft and porous when first lifted from the quarry but later hardened and united with the mortar to form a durable structure.

Father Morfi praised the nearly completed church and wrote in 1782 that "by now it had perhaps been completed," stating that it "would grace a large city as a parish church" (Fig. 4.14). And, although critical of some of the church's exuberant baroque decoration, he was sufficiently impressed to declare that "no one would have imagined there were so good artists in so desolate a place." He called San José "the first mission in America . . . in beauty, plan, and strength so that there is not a presidio along the entire frontier that can compare with it."[19]

Praise for the resident missionary, Pedro Ramírez de Arellano, concluded Father Morfi's account of San José, but he mentioned neither the

mason in charge nor the principal sculptor responsible for the carved ornamentation so remarkable in such a "desolate place." Ramírez served in Texas for at least thirty years, twenty-one of them at San José, from which he administered all the missions of Texas as Father President. He initiated the construction of the present church in or before 1768 and may have witnessed its completion before he died on the last day of September, 1781.

Mardith K. Schuetz-Miller has identified Antonio Salazar, an Indian mason from Zacatecas, as the probable designer and as director of construction of the church and sacristy. Salazar was recorded as living at the mission between 1779 and 1793. In 1786 he was listed as "*maestro de albañil*," master of stone masonry. Local tradition credits Pedro Huizar, a native of Aguascalientes, with the frame of the sacristy window, but he is recorded as a carpenter and that design is too sophisticated for an amateur sculptor. Huizar may have been the principal carpenter at San José.

The earlier flat-roofed stone church was demolished in the early 1760s. Part of the corridor of the *convento* was closed in to serve as a place of worship during the years of construction. Antonio Salazar may have been responsible for laying out the present church on the site of the former church, which had probably faced south, but there is no record of his activity in the early years of construction.

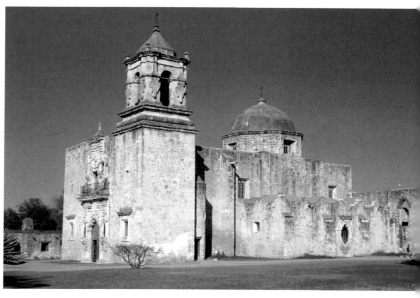

4.14. Church of Mission San José from the southwest, with the sacristy on the right.

The decision in the earlier 1760s to build a new church may have been influenced by the wish of the Zacatecan friars of San José to outdo the Querétaran friars, who had recently completed the vaulted and domed church of Concepción Mission. The new church at San José as originally planned was much larger than the church at Concepción and considerably more ambitious than what was ultimately constructed. It was to have been about thirty-nine feet longer and to have had transepts and two bell towers (Fig. 4.15). The reduction to a shorter, more economical design without transepts was made soon after Father Solís and Governor

4.15. Plan of Mission San José, Rexford G. Newcomb, *Spanish-Colonial Architecture in the United States*, plate 8.

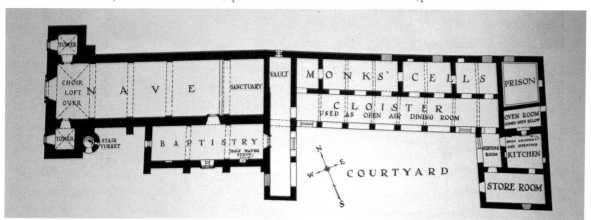

| Chapter IV

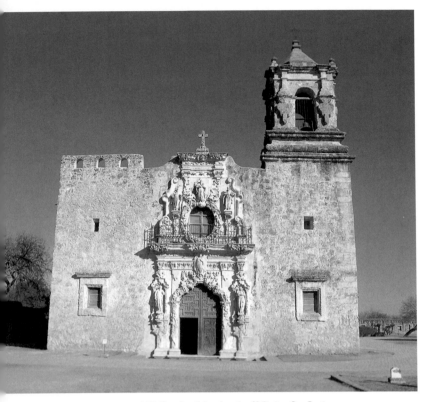

4.16. Façade of the church of Mission San José

Hugo O'Conor laid the cornerstones on March 19, 1768. The decision to eliminate the belfry stages of the northwest tower and to complete it with a parapet penetrated by three arched openings filled with mock cannons of wood to simulate a gun position was made late, sometime before the church was completed in 1781 or, more probably, in 1782 (Fig. 4.16).

The south tower has a tall belfry, ornamented by baroque lambrequin-like forms rather than classical pilasters, and capped by a pyramidal octagonal stone roof. A dome is supported by a tall octagonal drum carrying on alternating faces four glass windows. The dome of San José is a dominating form, unlike the conservatively built and relatively inconspicuous dome at Mission Concepción which had been constructed nearly thirty years earlier.

The most extraordinary feature of the church is the frontispiece projecting from the central façade (Fig. 4.17). It is comparable to the most assured of the freely composed high baroque church façades of central New Spain, such as those of the church of Lagos Moreno, the church of Guadalupe in Aguascalientes, and the Rosario Chapel of Santo Domingo in Querétaro. Carved possibly by Antonio Salazar, who was also a sculptor, this composition is freer than the "rose window," which surely had the same designer.

Flanking the portal, instead of traditional classical columns, are gently swaying statues of Saints Joaquín and Ana with the infant María. They are placed in freely suggested niches which are supported by pedestals covered by loosely flowing floral ornamentation. On the upper level the flanking figures, framed on their outer sides by stone uprights and inwardly undulating scrolls, are the friar saints, Francisco and Domingo. The central design flows upward in rococo fronds along the sides of the doorway into a triple arch, softened and partly concealed by densely curving fronds and small angel figures. Indenting the crest of the arch is a larger angel figure whose upthrust arms support the Virgin of Guadalupe, patroness of Mexico. From this vertical figure the eye follows a flowing shell form up over the balcony to an oval swirl of fronds, angels, and shells which leads around the central window to the topmost statue, San José holding the child, Jesús. Some tempering horizontal architectonic elements remain at the middle and the top of this design, but they are subordinate to the free upward flow of baroque and rococo forms. Iconographically the principal statues portray the Virgin as a child in her mother's arms and as wife and mother through her husband, José, and her child, Jesús.

Like the church of Concepción Mission, the church of San José was once decorated with colored patterns suggestive of tiles. Ernst Schuchard, an engineer employed by a San Antonio flour milling company, made a careful study in the 1930s of the colors of these churches. The principal colors used at San José, already hard to see in 1890, were red, yellow, and blue, probably made by pulverizing local stones and binding them with substances such as

goats' milk and cactus juice. The designs were laid out by rule and compass, with outlines cut into the plaster surface with a sharp tool.

Schuchard made colored drawings to suggest the original appearance of the churches of Concepción and San José. For the latter he portrayed the tower framed with alternating red and yellow squares, the red ones filled with four-petalled flowers. The expanse of plain wall on either side of the frontispiece was painted with an overall design dominated by four-lobed geometric frames containing stars; they were alternately red and blue, red frames and blue stars and blue frames and red stars. The spaces between the quatrefoil frames were filled with yellow crosses. The strong dome was highlighted by a pattern of painted zigzag stripes which suggested the tiled domes of central Mexico such as Francisco Antonio Guerrero y Torres's Chapel of the Well at Guadalupe. A model made by H. L. Summerville approximated the appearance of the brilliantly colored mission.

Inside the portal a vault supported a broad choir balcony which had a railing of turned wood and a music stand. Pilasters and broad flat arches divide the lofty barrel-vaulted interior into five bays. In the nave bay in front of the dome and in the sanctuary, penetrations lift the vault to create space for side windows. They and all other windows except that for the choir balcony originally had glass.

The vaults of both the church and sacristy were described as painted in 1785. Church furnishings included a carved stone holy water font, a pulpit with entry steps and a sounding board fixed to the wall by an iron clamp, and fourteen paintings of the stations of the cross set in carved and gilded oval frames. Two stone steps led up to the metal railing of the sanctuary. On one side were stairs to a wooden gallery which led to the *convento*. Beside the principal altar was a wooden throne, painted blue and adorned by thirteen gilded mirrors. Eighteen wall lamps were backed by other mirrors which reflected their flames. Adorning the principal altar

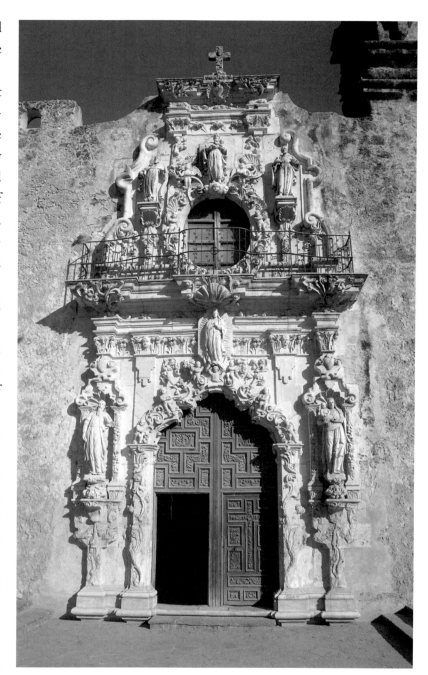

4.17. Frontispiece of the church of Mission San José. Also see Plate VIII.

was a niche in the rear wall containing a carved and gilded statue of San José and a gilded baldachin containing an image of the crucified Christ which was backed by another mirror. A second altar was probably placed against the north wall opposite the only decorative feature surviving in the restored church, the doorway to the sacristy with powerfully arching baroque cornice.

By the time the church was completed in 1781

119

| Chapter IV

or 1782, San José's Indian population had already begun to drop. But the decline was slower than in the other San Antonio missions. There were still 198 neophytes in 1789, and about that time a new flour mill was constructed on the *acequia* north of the quadrangle. But the Indian population was down to 106 in 1791, and San José, like the other still active missions, was partially secularized in 1794. The mission, like Concepción, continued to operate until 1824. During the next two decades, the period of the Texas War of Independence and the United States' war with Mexico, San José housed more soldiers than religious services. The sculpted façade was reported as undamaged by soldiers in 1841, but a decade later John R. Bartlett wrote that neighboring military companies found "the hands and features of the statues convenient marks for rifle and pistol shots" and were able to demonstrate "at the same time their skill in arms and their contempt for the Mexican belief." By that time the interior retained little to interest Bartlett. "The dampness has destroyed the frescoes upon the walls, and the altar has been stripped of its decorations."[20] But the structure was still pretty much intact. Seth Eastman sketched in 1849, and later painted, the church as viewed from the southwest, emphasizing the powerful forms of the tower and dome.

Bishop John M. Odin of Galveston persuaded Benedictines from St. Vincent's Abbey in Pennsylvania to move to San José in 1859, fearing that if no Catholics took it over the mission would fall into "the hands of the Protestants." The Benedictines remained almost a decade. Four years later in 1872 Holy Cross Fathers from Notre Dame took charge and remained until 1888. The Franciscans returned in 1931.

In 1868, the year the Benedictines left, part of the north wall which may have been partly undermined by treasure hunters collapsed in a December storm, bringing down part of the vault. Six years later the dome, which had been unsupported on one side, toppled to the floor, bringing most of the remaining vault with it, while Christmas Mass was being celebrated in the adjacent sacristy. Most of the north wall fell subsequently, and the desolate hulk of the church stood empty for more than half a century. The exterior of the spiral stair behind the southwest tower collapsed in 1903, leaving the hewn wooden steps scattered about, and in March of 1928, heavy rains caused the disintegration of a vertical slice of the tower.

Concern for preserving and restoring Mission San José grew gradually, stimulated by the careful study of the missions included by William Corner in his guidebook of 1890, *San Antonio de Béxar*. During the following decades modest acts of conservation were made. Debris was cleared from the ruined shell of the church, the portal was propped with poles to prevent the arch from falling, and cracks were filled in the façade. The sacristy was saved from further disintegration, furnished, and reopened for religious services. Major restoration of the church did not begin until after the shocking collapse of the south side of the bell tower in 1928. Within weeks Archbishop Arthur Drossaerts appointed a San Antonio architect, Atlee B. Ayres, as engineering consultant for restoration. Ayres designed an infrastructure of steel and concrete to support the tower's rebuilt outer walls, which were constructed of new and old blocks of limestone. The new pyramidal roof was at least two feet lower than the original and was later replaced.

Restoration of the rest of the church was delayed until 1933. Another San Antonio architect, Harvey P. Smith, who had restored the Governor's Palace and was responsible for rebuilding the vault of the granary and the Indian houses at San José, and a civil engineer, Jack Beretta, donated their services. In April 1934 the Federal Emergency Relief Administration allocated more than $77,000 for salaries and material for San José. Over three hundred people were employed, and the project was about half completed when the program was terminated the next January. After the WPA was created in May, San

José was allocated $30,000 and another $20,000 was secured from the Texas Centennial Commission.

Carlos E. Castañeda, the historian of Spanish Texas, provided Smith with photostats of eighteenth-century descriptions of San José, and Smith based the reconstruction on the fragments of the original vault which remained. But modern construction techniques were used. The rear wall was found to be unstable so it was demolished and rebuilt with a combination of reinforced concrete and newly quarried stone. Similar materials were used in the rebuilding of the north wall and the portion of the south wall closest to the fallen dome. Beretta reported that concrete arch rings were built to support the horizontal wooden joists from which were attached the "metal lath and plaster so placed as to have the identical appearance of the old stone arch [vault]." This technique was judged to distribute the weight evenly and to minimize the strain on what survived of the original walls. The restorers believed themselves justified in using reinforced concrete construction "since it would not be exposed."[21]

Despite the major reconstruction of the thirties, which was completed rapidly so that San José would seem fully restored for the Texas Centennial of 1936, problems remained. In December 1947 Archbishop Robert E. Lucey expressed his dismay at the state of San José despite his having tried for twelve months to initiate repair work. "Pieces of rock," he wrote in one letter, "are falling down from walls or from arches in the cloister." In another letter he reported that "a piece of stone weighing perhaps ten or twelve pounds has fallen from the stone frieze around the front door of San José. Throughout, the façade is absorbing water and is disintegrating." "It would be a great dishonor to all of us if when we come to die it would be said of us that we allowed the . . . most historic building in the United States to disintegrate and tumble down," Archbishop Lucey wrote in a third letter.[22]

A sculptor born and trained in Italy, Eraclito Lenardizzi, who had settled in Texas after fleeing the chaos in Mexico caused by the revolution in the years following 1910, was secured to repair the façade for $2,850, including the costs of the scaffolding, tools, and materials. In the contract of 1948 Lenardizzi specified that "at the top of the façade I will replace the missing cap and will rework the five foot frieze. Below the left cap, I will remove the inserted concrete slab and replace this with a new stone carved to conform with the intact portion. Below the stone, I will sculpture and replace the angel and the shell." Regarding the sculpted figures of the upper façade he wrote, "I will carve a new head for the center figure [San José] and arms and hands when needed for the side figures. I will clean all three of these figures. I will replace the destroyed portions of the angel and shell at the side of this group."[23] Some of the losses Lenarduzzi replaced were the results of nineteenth-century soldiers' shooting practice, others were a result of 175 years of weathering or of random vandalism. The principal statues flanking the portal required major work. The head and arms of Joaquín on the left had disappeared between 1876 and 1925. On the right the whole upper half of the statue of Ana with the child María was missing. A photograph of the façade in the 1870s and a photograph of a painting of the same period provided models. Lenardizzi's replacements lack the refinement and the graceful swing of the baroque originals, but they are compatible with them. Few of the visitors to San José realize that the sculptural ensemble of the façade fuses modern elements with the splendid eighteenth-century work.

Under Archbishop Lucey's direction the restoration of San José was completed in 1952. Final operations of his campaign ranged from rejointing the sacristy window to reinforcing the entire structure. Although additional repair of the statue of San Joaquin is now needed, Archbishop Lucey's determination not to allow the building to "disintegrate and tumble down" preserved a church exterior more admirable than any of Spanish North America except San Xavier del Bac near Tucson.

CHAPTER V

Louisiana

In the late afternoon of August 18, 1769, Irish-born Lt. General Alejandro O'Reilly limped, gimpy from an old wound, from his ship on the river to the Place d'Armes of New Orleans which was lined on three sides by two thousand Spanish soldiers and by French militia on the fourth. He lifted from the ground the keys to the city's gates placed at his feet by the French governor, Charles Philippe Aubry. Simultaneously, according to the general's aide-de-camp, Spanish flags were raised in various parts of the city, the bells of the town rang out, and a general salute was sounded by the muskets of the troops and by artillery in the Place and on the ships in the river. Louisiana had been ceded to Spain seven years earlier but decisive Spanish control was long delayed.

The cession is explained by the French desire to placate the Spanish, who had belatedly entered the disastrous Seven Years War on the side of the French in a Bourbon Family compact, and by the seeming uselessness of unproductive and costly Louisiana to France, which had recently lost Canada to the British. Louisiana had been settled at the end of the seventeenth century by an expedition led by a very able Canadian, Pierre Le Moyne, Sieur d'Iberville, after La Salle's descent of the Mississippi and subsequent failure to find the river's mouth from the Gulf. Iberville was the first European to find a way into the Mississippi, but at first French activity was concentrated along the Gulf in the areas of Biloxi and Mobile Bay.

New Orleans was not founded as the new capital of French Louisiana until 1718. The site on the east bank of the Mississippi was relatively high and at the Indian portage to Bayou St. Jean which led to Lake Ponchartrain. The water route across the lake to the settlements on the eastern Gulf was quicker and easier than the lower river. The dense canebrake on the site, split only by a path leading to the Bayou, was cut by Jean Baptiste Le Moyne, Sieur de Bienville, younger brother and companion of the founder of French Louisiana. The plan of the town, the present Vieux Carré, was drawn in 1721 by the Chief Engineer of the colony, Louis-Pierre Le Blond de la Tour, and laid out on the site by another military engineer, Adrien de Pauger. Placed by Pauger on the highest ground close to the river, the layout was a rectangular grid with an open plaza, the Place d'Armes, at the center of the frontal tier of blocks. The earliest plans have four blocks on either side of the plaza, but additional blocks were soon added at the ends creating a grid eleven blocks long and six deep, well suited to the site which was limited by low swampy land to the rear. The blocks, approximating squares, were divided into lots for twelve families. The overall scheme, more ordered

than those of the unevenly sited Quebec and Montreal, resembles the slightly earlier plan of Mobile and is very close to the general layout prescribed for coastal towns in the Spanish royal Ordinances of Settlement (Fig. 5.1).

The present symmetrical arrangement of Jackson Square was anticipated in the placing of the parish church, designed by Pauger, and flanking structures for priests and soldiers in the block facing the Place d'Armes. But Louisiana's halting development, typified by the shift from the direction of the faltering Company of the Indies back to unenthusiastic royal control in 1731, retarded the filling out of the ambitious urban layout. On his arrival in 1722 the Jesuit priest Pierre François Xavier de Charlevois found the town to consist of "a hundred huts placed without much order, . . . two or three houses that would not grace a French village and half a wretched warehouse," and to be a "wild and desert place that caves and trees still cover almost entirely."[1] For decades dense vegetation continued to fill the area of the plan a few blocks behind the church and almost to the river at the ends of the town.

A levee planned by Le Blond de la Tour and constructed by slaves extended along most of the river frontage by early 1724, but it was breached in a flood later that year and was not completed for several more years. Pauger's scheme for a drainage canal to Bayou St. Jean was rejected because of its cost. Instead, ineffective ditches were dug along both sides of all the streets; in wet seasons the ditches overflowed, filling the streets with water. Summers were unhealthy, with polluted water, dysentery, mosquitoes, malaria, and yellow fever. In

5.1. This French plan published in 1764, after Louisiana had been ceded to Spain, accords with the prescription of the Spanish royal Ordinances for cities located on water. The Place d'Armes, B, faces the river at the center. Bordering the inner side of the Place d'Armes is the church, flanked on the right by the convent of the Capuchins and on the left by the prison and the guardhouse. Five rectangular blocks are on one side of the Place and five on the other. The city is four blocks deep and eleven long. The plan is reproduced in John W. Reps, *The Making of Urban America*, fig. 40.

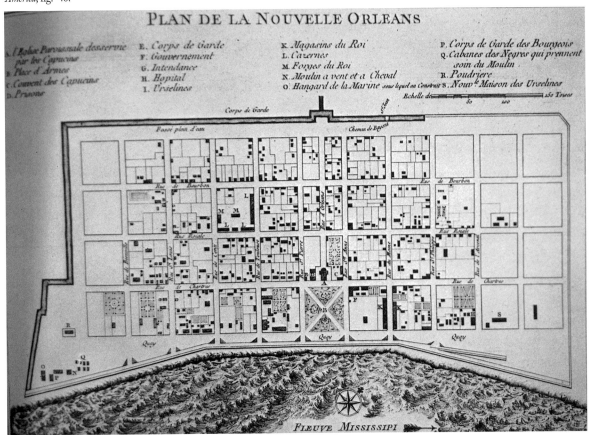

August 1723 deaths totaled eight and nine a day. That summer there were so many ill at one time that the capacity of the new two-building hospital, eighty, was exceeded and those unable to be admitted were placed in a storehouse then under construction.

An anonymous French report of New Orleans probably written a few years before the cession to Spain makes clear the attrition caused by the damp New Orleans climate in structures of wood: "The King's buildings . . . consist of a parochial church and a presbytère, a Government House and Intendance, two large barracks, a lodging for the Ursuline nuns, a hospital, a powder magazine and two warehouses.

"Almost all these buildings must be rebuilt. The church and the presbytère are falling in ruin and are no longer susceptible of repair. The Government House collapsed several years ago. The Intendance has been uninhabitable for a long time. The two barracks buildings have collapsed, the hospital is not worth much more but they are constructing a new one. Some years ago a new lodging was built for the Ursuline nuns [the only important building to survive from French New Orleans]. The corps de garde and the prison have also been renewed recently. The powder magazine is good enough, though low, of the two warehouses only one of them was reworked ten years ago; the other will soon need a similar repair."[2]

As the buildings of New Orleans decayed and were gradually replaced the town's population grew slowly. In 1724 there were fewer than 400 settlers; two years later there were 650 whites and 108 slaves, 80 of them black; by 1727 the white population reached 794 and there were 144 slaves, 130 of them black. Modest growth was stimulated by the Company of the Indies, which sought settlers outside France, particularly peasants from the Rhineland and German-speaking Switzerland. Attracting women to distant, impoverished Louisiana was difficult. Prostitutes and female convicts from the Salpêtrière penitentiary were transported in the early years. Later inducements were provided for honest peasant women and daughters of impoverished workers. In 1724 money for their trousseaux was given to 19 women, and it was customary to provide living expenses for women until they married. Population regressed during the first decade of restored royal control. In 1744 there were approximately 3,000 white civilians in all of Louisiana in addition to 800 soldiers and 2,000 slaves. Slow growth during the final French years brought the population to 5,595 whites, fewer than 2,000 of them in New Orleans, and 5,940 slaves in a census of 1766, the year the first Spanish governor, Antonio de Ulloa, arrived.

When the Spanish moved to occupy Louisiana in 1766, more than three years had elapsed since the Treaty of Fontainebleau had transferred Louisiana to Spain. The long delay troubled the French government, which had been petitioned by some residents of Louisiana to cancel the cession. The occupying force accompanying Antonio de Ulloa contained few more than a hundred persons, only eighty or ninety of them soldiers. Ulloa, a distinguished intellectual whose works on South America were translated into several languages and who concluded his naval career as a vice-admiral and chief of operations, was not by temperament a gifted political administrator, and the Spanish government failed to provide him with adequate military and fiscal support. Directed by his commission to treat Louisiana as a "separate colony" not subject like other Spanish territories to the Laws of the Indies, Ulloa, with royal approval, delayed taking formal possession of the colony and attempted to govern in collaboration with Charles Philippe Aubry, the military officer who had been the last French governor. Economic conditions, never certain in Louisiana, worsened when the Spanish government failed to provide adequate subsidies. Trade fell off and the threat of incorporation into the Spanish mercantile system dismayed influential merchants. Ulloa's requests for more troops,

more money, and the termination of the Superior Council, the French governing body, produced no effective response. In October 1768 a group of merchants led by the attorney general, Nicolas Chuvin de Lafrenière, with the probable support of the French Commissary General Denis-Nicolas Foucault, organized a rebellion bringing Acadian farmers and others into New Orleans to swell a protesting mob. The Superior Council then ordered Ulloa to leave Louisiana. He retreated to a ship in the river and soon left for Havana.

Dilatory in supporting Ulloa, the Spanish government determined to retake Louisiana with impressive force. Ulloa had had fewer than a hundred soldiers; less than ten months after his forced departure, General O'Reilly arrived with over two thousand. Following instructions, O'Reilly seized the civilian leaders of the revolt within three days of his arrival. They were tried according to Spanish law for treason and sedition, convicted largely on the testimony of French Governor Aubry and the Spanish officials who had remained in New Orleans, and sentenced by O'Reilly. Five were executed by firing squad, six received lesser sentences, and one died of disputed cause before the trial. Commissary General Foucault, as a French official, was exempted from trial but was imprisoned in the Bastille after he was shipped back to France. All other residents of Louisiana were granted amnesty by O'Reilly, who proclaimed officially that they had been misled by "the intrigues of ambitious, fanatical, and ill-intentioned people."

General O'Reilly remained in Louisiana less than seven months, but his energetic and decisive actions established the foundation for stable Spanish rule which lasted into the nineteenth century. He replaced the Superior Council with the regular Spanish form of urban government, a *cabildo*, and ordered the construction of a building for its meetings. Its earliest members were predominantly French planters who had been loyal to Spain. He replaced French law with the "Code O'Reilly" which drew from the Laws of the Indies and other Spanish codes and incorporated the French slave code of 1724. Concerned with relations with the Indians, he ordered that all Indian slaves be freed, and he brought to New Orleans chiefs from an area extending nearly two hundred miles away. The ceremonies of the gathering included the mutual smoking of ceremonial pipes and the presentation of medals portraying King Carlos III, and concluded with a parade displaying Spanish military might.

Personal inspection of a territory as vast as Louisiana, extending from the Mississippi to the Rockies, was impossible, but O'Reilly dispatched subordinates to posts as distant as St. Louis and traveled up the river beyond Baton Rouge as far as Point Coupée, visiting the Acadian region and the "German coast" on his way. Some military posts were closed and others were strengthened. Unneeded troops began to return to Havana within two months of their arrival.

Louisiana's economic health, always fragile, was a troubling problem. O'Reilly was expected to bring the colony into the Spanish mercantile system which limited trade to Spain and the Spanish colonies. He permitted trade with French Dominique (modern Haiti) and tried to create a market in Havana for Louisiana timber products. Spain was not a natural market; on the average one Spanish ship a year docked at New Orleans in the seven years following O'Reilly's arrival. He attempted to shut off the contraband trade with English West Florida and misjudged the prospects for legal trade within the Spanish world. His hopeful reduction of the royal subsidy initiated by Ulloa proved to be misguided. Louisiana required more not less support if trading was restricted to the Spanish world. Ultimately, because of its military importance during the American Revolution and the subsequent need to withstand American pressure, Louisiana received more support from the Spanish treasury than any other overseas dominion.

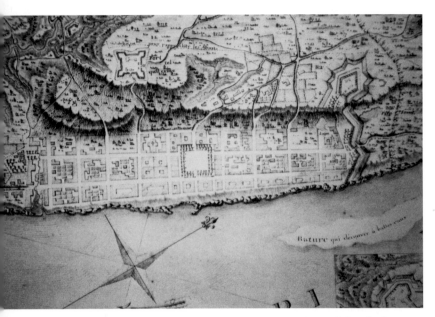

5.2. Detail of plan of St. Louis in 1796, George de Bois St. Lys, reproduced in John W. Reps, *The Making of Urban America*, fig. 45.

O'Reilly installed Colonel Luis de Unzaga as governor before he completed his own activities in Louisiana. A series of notably able military officers followed in that office until 1799. The most celebrated was Bernardo de Gálvez, the young nephew of the Minister of the Indies, José de Gálvez, who moved up the Mississippi and seized the English outposts on the east bank. Dangerous and skillful assaults on Mobile in 1780 and on Pensacola in 1781 brought the surrender of all West Florida.

Loosening limitations on trade and the development in the 1790s of larger scale agriculture in sugar and cotton brought relative prosperity. Upper Louisiana, governed by a military officer serving as lieutenant governor, remained thinly populated. Its capital, St. Louis, had been settled by a French company in 1764 after the cession of Louisiana to Spain. Placed on high ground above the Mississippi between an Indian village and the junction to the north of that river with the Missouri, the settlement was laid out similarly to New Orleans but with only three streets parallel to the river (Fig. 5.2). Vulnerable to the English and attacked by their Indian allies in 1780, St. Louis until the 1790s was more heavily fortified than New Orleans, with stone bastions at strategic points; one which was never completed had walls fifteen feet thick.

The population of Louisiana quadrupled in the Spanish period, increasing from no more than eleven thousand in 1766 to approximately thirty-two thousand in 1785, and rising rapidly in the succeeding years to close to fifty thousand when Louisiana was transferred to the United States in 1803. During the almost four decades of Spanish rule, settlers came from the Spanish-speaking world. At first a few came from Granada and Málaga and approximately two thousand from the Canary Islands. Catalans became important merchants and others came from Cuba and Mexico. Retired soldiers and officers and their families frequently remained in Louisiana. French-speaking immigration continued. There were additional Acadians from eastern Canada and other refugees from Haiti and from revolutionary France. Anglo-Americans and other English speakers also settled in Spanish Louisiana. In 1803 about half the white population of New Orleans was French speaking, a quarter Spanish speaking, and a quarter primarily English or German speaking.

Despite the imposition of Spanish laws and institutions and of Spanish as the official language, Louisiana remained predominantly French in culture. Spanish officials were tactfully respectful of established French customs and many, including three governors, married Creole wives. Only in architecture, because of the devastating fires in New Orleans, did Spanish culture lastingly imprint Louisiana.

Spanish New Orleans

Shortly after he arrived in 1769 General O'Reilly ordered that a census of New Orleans be taken. The population totaled approximately 3,190, including 1,902 free persons (31 of them black and 78 of mixed blood) 1,225 slaves, and 60 Indians. In 1785 nearly 5,000 were recorded and the population

in 1803 may have reached 10,000. At that time Santa Fe had no more than 4,000 residents, and the next largest Spanish towns in the present United States, San Antonio and St. Augustine, had about 1,500.

An English officer, Philip Pittman, has left us a description of New Orleans during the years of transition to Spanish control. Buildings were concentrated in the central portion of the four tiers of squares closest to the river, with the rear and sides of the town occupied by gardens, which also surrounded most of the houses. The orange trees provided a pleasant appearance and an "agreeable smell" in the spring. Pittman estimated the number of houses at seven or eight hundred. Construction was with heavy timber framing filled with bricks and covered by boards. Most houses had a single story for living, raised about eight feet to provide protection from flooding and space for storage in an above-ground cellar. Galleries normally surrounded the upstairs living area on two or four sides. The town was fortified by a palisade with a firing platform within and "a very trifling ditch without." Pittman considered the defenses valueless against a European assault, but useful perhaps in preventing communication at night between the slaves of the town and those of the countryside.

Like the anonymous French reporter of the 1750s, Pittman described the decayed state of many of the most important buildings. The church seemed "a very poor building . . . in so ruinous condition" that for some years divine service was conducted in one of the royal warehouses. The "handsome and commodious brick house" next to the church, formerly used by the Capuchin priests for their residence, "is totally deserted and gone to ruin, they now live on their plantation and in a hired house in town." The prison and guardhouse on the other side of the church were "very strong and good buildings" but the barracks which had lined the two sides of the Place d'Armes were "entirely destroyed."[3]

O'Reilly and his successors addressed the condition of the structures surrounding the Place d'Armes, renamed the Plaza de Armas. He ordered the construction of a new building, the Cabildo, flanking the church and adjoining the Corps de Garde, for the use of the new governing body. The designer was Luis Andry; the builder, Francois, or Francisco, Hery, had been born in France but was a long-time resident of New Orleans. The building was simple, with a large room for an audience hall and a smaller one for a waiting room. The construction was the usual timber and brick with wooden columns across the front of a gallery and a wooden railing fitted along the façade toward the plaza with flat balusters made of planks cut out in profile.

On the opposite side of the church O'Reilly had ordered a replacement for the two-story brick residence of the Capuchins which Philip Pittman had reported as uninhabitable. Luis Andry and Francois Hery were again called upon for a plan and for construction. The building had brick walls and a gallery across the front and was completed in 1772, but no descriptions or illustrations of its appearance have been found.

Adrien de Pauger's more than forty-year-old church was repaired and restored to use until the fire of 1788. Along both sides of the plaza rows of brick structures were erected on the sites once occupied by the old barracks. The land sold by the government was purchased by the entrepreneur and philanthropist Andrés Almonester y Roxas, who constructed buildings to rent with shops below and living quarters above.

A major construction project of the early 1790s was refortifying the city. By 1775 Governor Unzaga had written that the palisade, which incorporated six bastions, was constantly rotting because of the dampness of the soil. "It is kept up only by continual repair, to give the . . . false appearance of a fortified city and obliging the neighbors to come and go through its gates."[4] Governor Gálvez was troubled by the state of the fortifications but wrote that no one in Louisiana was capable of copying the old

Chapter V

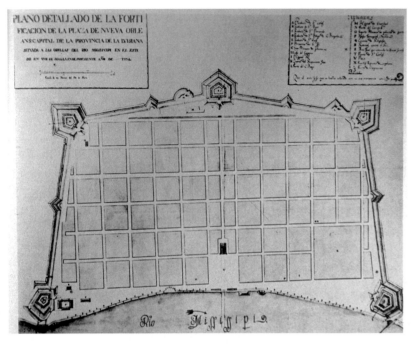

5.3. Spanish plan of New Orleans in 1794 showing Baron de Carondolet's fortifications, which were designed by Gilberto Guillemard. The plan is reproduced in Ernest F. Dibble and Earle W. Newton, eds., *Spain and Her Rivals on the Gulf Coast*, fig. 24.

French plans or devising new ones. In 1792 the governor, the Baron de Carondolet, fearful that the Americans would try to seize the Mississippi, asked a military officer, Gilberto Guillemard, who'd volunteered for engineering duty in Gálvez's Pensacola campaign, to design new defenses following the lines of the decayed French ones. The fullest description of Carondolet's fortifications was written in 1796 by a visiting French general, Victor Collot, whose access to them was limited because he was taken into custody and soon shipped to Philadelphia. The strongest elements were two forts at the extremities of the riverfront which commanded the river and the road (Fig. 5.3). Collot wrote that "their shape is that of a regular pentagon, with a parapet eighteen feet thick, coated with brick, with a ditch and a covered way," with living quarters, he implausibly asserted, for 150 men. Located in the Plaza de Armas was "a great battery, commanding the river with its guns, and crossing its fire with the two forts."[5] Three lesser fortifications were located at the rear of the city, one at each corner and one in the middle. Collot described the ditch which ran around the three land sides of the city in front of the bastions, earthworks, and palisade as forty feet wide, eight feet deep, and filled with at least three feet of water in all seasons.

Baron de Carondolet's other civic projects included a canal from the center of the city's rear wall to Bayou St. Jean, first proposed by Adrien de Pauger in the 1720s. The canal was dug in part to drain the streets, which in some places during the wet season were impassable even by carriages. Pedestrians could use wooden sidewalks but they were interrupted by the projecting steps of the houses, and at the ends of the blocks the planks laid at the street crossings were frequently muddy and sometimes broken. One historian, José Miguel Morales Folguera, lists 163 bridges within the city, as many as 16 on the Calle de San Felipe alone. Within less than a decade Carondolet's canal was of little help for drainage or transportation. It became so clogged with mud that it had to be reexcavated by slaves every year and much of the time was usable only by flat-bottomed boats.

Carondolet also had a promenade laid out on top of the levee, planted with orange trees to create an *alameda de naranjas*. Unhappily, the trees were killed by the friction of ropes used to tie boats. The city's safety and lighting also concerned Carondolet. He imposed a tax on the chimneys of the city's buildings and erected eighty street lamps and hired thirteen night watchmen.

New Orleans was a military town occupied by one battalion of troops in the early years after General O'Reilly's takeover. Another battalion was added during the period of Bernardo Gálvez's campaigns and a third in the final Spanish years to counter the American threat. At full strength they would have totaled eighteen hundred men. Religious and profane festivities were celebrated annually. In late winter Carnival was a precursor of Mardi Gras. An English visitor, Francis Baily, left a description of the

celebration of Corpus Christi on June 15, 1797. The associations of the city gathered under arms at the cathedral prepared to process through streets which had been ornamented with green boughs and bushes and strewn with gravel. Soldiers led the way, followed by priests wearing a variety of habits, carrying crosses and lighted tapers, and conveying the sacred host "which was carried on a kind of bier dressed round with flowers and trinkets, not unlike our Mayday garlands. After them came the bishop [Luis de Peñalver y Cárdenas, who had arrived two years earlier, the second prelate, the first of the new diocese of Louisiana and West Florida] walking in solemn state under a canopy supported by a half-dozen priests and scattering his . . . blessings . . . —close to the bishop followed the Baron de Carondolet . . . , together with his suite, and at the close . . . a party of horse and foot." The procession, accompanied by musical instruments, moved slowly, stopping at each corner to set down the host. "At the same time the houses on each side were lined with visitors who strewed flowers on the head of the venerable bishop as he went by, and kneeled to the host as it passed along." The procession circled through the streets back to the cathedral again, "which having entered, some little ceremony was performed, and the day left to be spent in mirth and merriment."[6]

Taverns were numerous. O'Reilly had licensed twelve taverns, six billiard halls, and one lemonade stand to dispense alcoholic drinks. By 1775 there were twenty-four taverns and close to a hundred by 1803. Particularly notorious were bawdy hangouts beyond the city gates which catered to a diverse clientele, free and slave, black, white, and red.

The Spanish had taken over three hospitals from the French. The Charity Hospital was destroyed by hurricanes and rebuilt by Andrés de Almonester, who also built a small hospital for lepers. An upper story was added to the Royal Hospital. A free school for boys, emphasizing the Spanish language, opened in 1772 with a director, three teachers, and close to 450 students. In 1778 there were eight private schools with about 400 students. Girls were educated in the Ursuline convent. There were places for 70 boarding students and about 100 day students were admitted from the city.

Hurricanes have always posed a threat to New Orleans. The city was severely damaged by storms in 1779, 1780, and 1793 and to a lesser extent by two in 1794. Calamitous fires were even more devastating. On Good Friday, March 21, 1788, a fire broke out a block from the river on Chartres Street close to the plaza in the house of the military treasurer, Vicente José Nuñez. Driven by a strong south wind the fire moved through the city consuming 80 percent of the city and 856 buildings. Among them, according to the dispatch of Governor Estevan Miro, "were the stores of all the merchants, and the dwellings of the principal inhabitants, the Cathedral, the residence of the Capuchins [the Presbytère], with the greater portion of their books, the Cabildo, the watch tower, and the arsenal with all its contents. Only 750 muskets were saved. The public prison was also burned down, and time was hardly left to save the lives of the unfortunate inmates."[7] Only the blocks along the river, which contained many of the important governmental structures, escaped. Another fire in 1794 consumed many of those, and 212 structures in all, constituting about a third of the city and probably being of even greater value than the structures lost in 1788. The whole area along the river from the block next to the plaza to the upstream end of town was destroyed. The two fires consumed roughly 90 percent of the city, sparing only the downstream section along the river. French New Orleans was virtually obliterated. Only a few important buildings escaped: at the downstream corner of the city the old and new buildings of the Royal Hospital, one used as a military barrack; nearby the still surviving Ursuline Convent; and just upstream of the plaza the Government House, which burned in a later fire in 1828.

Governor Miro acted decisively to ease the distress caused by the fire of 1788. On the morning after it had burned out, he issued a general order forbidding the raising of prices of provisions and sent express boats up and down the river with directions to planters to send their rice, corn, peas, cattle, and other foodstuffs to the city where they were distributed to the poor from the royal storehouse. Three vessels were sent to Philadelphia to purchase flour to avert the danger of famine. Some of the poorest were given bags of money by the governor himself.

Rebuilding after the fire of 1788 followed the regular methods, timber frames, filled with brick, faced with boards, and covered with wooden shingles. After the second great fire Baron de Carondolet's government passed laws requiring, for two-story houses, flat roofs of tile or brick and walls covered with at least an inch of "cement plaster." The depth of wooden houses, including the galleries, was limited to thirty feet, and they were required to have their fronts precisely facing the street. Much of the stucco was imported from Pensacola and tiles came from there and from Havana. Stipulations were even made regarding the seasons of the year and the phases of the moon best for cutting cypress for timbers resistant to decay. Although the regulations were not fully enforced, changes in building materials and methods of construction significantly altered the architecture of New Orleans.

The only surviving domestic structure from the massive rebuilding campaigns after the fires is known as "Madame John's Legacy" after a character in a story of the late-nineteenth-century New Orleans writer George Washington Cable (Fig. 5.4). Eleven days after the fire of 1788, Manuel Lanos, a Spanish officer, contracted with a local builder, Robert Jones, to construct a replacement for his house which had burned. The new house seems to have resembled its predecessor, which had been described as a pavilion raised on a brick wall. Materials were salvaged from the ruins. The living story is raised above the basement storage area and there are galleries, front and rear. The interior has no hallways. All six rooms open onto the galleries, providing welcome cross-ventilation. The walls are of timber, filled with brick, and originally were stuccoed on the front and rear. Boarding covered the sides. The exterior was painted white with dull green trim, and the shingle roof has a double pitch in front, with two dormers bringing light and air to the attic space, and one slope in the rear.

The Buildings of Almonester and Guillemard

The three principal public buildings erected by the Spaniards after the fires were admired for their overall appearance by the greatly gifted and outspoken architect Benjamin H. Latrobe, who spent several months in New Orleans in both 1819 and 1820 before his death there of yellow fever. The plaza seemed to him "infinitely superior to anything in our Atlantic cities as a water view of the city.... The whole side parallel with the river is occupied by the Cathedral in the center and two symmetrical buildings on each side. That to the west . . . contains the public offices and the council chamber of

5.4. "Madame John's Legacy," New Orleans.

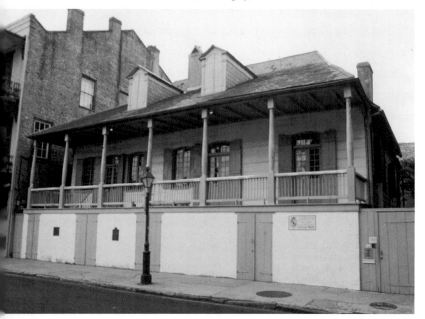

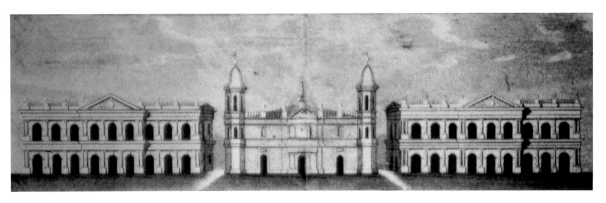

5.5. The buildings facing the Place d'Armes (Jackson Square) in 1815, detail of a drawing by Jacques Tanasee, reproduced in John W. Reps, *The Making of Urban America*, fig. 50.

the city. That on the east is called the Presbytery, being the property of the Church"[8] (Fig. 5.5).

The erection of these structures was made possible by Andrés Almonester y Roxas, who promised to rebuild the church and the residence of the Capuchins entirely at his own expense and who built the Cabildo building in the expectation of being eventually repaid by the city (Fig. 5.6). Almonester, a Spaniard from a village just east of Seville, had arrived in the entourage with General O'Reilly and had been appointed notary of the city, the army, and the treasury. He learned about property values and sales while acting as attorney of the city for a dozen years and moved into real estate, purchasing and building, and furnishing slave labor and building supplies. Rental revenue was his principal source of income as he became one of the richest persons in the city, the largest payer of Baron Carondolet's tax on chimneys. Much of his property seems to have escaped the fires.

Almonester was a great philanthropist who mightily irritated his peers by his behavior and by the transparency of his motives. Though he rebuilt the charity hospital in brick at a cost of over 100,000 pesos after it was demolished in the hurricanes of 1779 and 1780 and increased his substantial annual support during an epidemic after the fire of 1788, he threatened to expel a patient for failing to pay fifteen dollars a month. He founded another hospital for lepers on his own property outside the city and built a brick chapel for the Ursuline nuns, but was regarded by many with scornful amusement as they watched his consistent effort to use his charitable gifts to further his social advancement. One contemporary wrote that "the poor man is never satisfied, as soon as he obtains one thing, he lays claim to another."[9]

And advance he did. In 1791 Almonester, who had no military training, was, to the annoyance of aspiring captains, appointed colonel and commander of the New Orleans battalion of militia. Later the royal government intervened in local affairs with a *cédula* signed by the king admonishing the unfriendly Governor Carondolet to "distinguish, assist, and attend in a very special way the said Almonester in everything he may justly require . . . for he has endeared himself to my Royal Person,"[10] and ultimately, in a public ceremony in 1796, two years before his death, Almonester was created Knight of the Order of Carlos III.

Andrés de Almonester paid for and built the three monumental structures facing the plaza and the river, and Gilberto Guillemard designed them. Guillemard, who was also responsible for Governor Carondolet's fortifications, was born in northeastern France at Longwy, close to Belgium and Luxembourg. Arriving in New Orleans at a youthful age, he joined the militia organized by O'Reilly and served in the campaign of Gálvez. He was selected by Carondolet in 1796 as cartographer and surveyor of a commission to mark off the Spanish-American boundary "because he is well trained in mathematics and fortifications; and he is a man of wealth and honesty—qualities which are uncommon in the

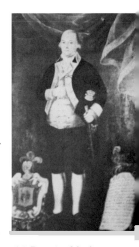

5.6. Portrait of Andrés Almonester y Roxas, as Knight of the Order of Carlos III.

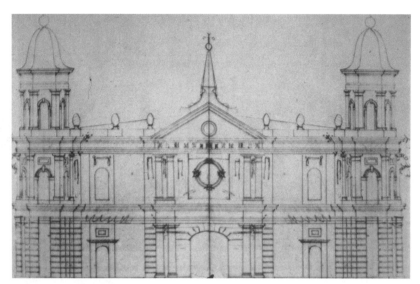

5.7. Façade of the Cathedral of St. Louis in New Orleans, based on a drawing by Benjamin H. Latrobe, 1819. The drawings Latrobe made of the cathedral and the Cabildo in New Orleans are reproduced in *The Journals of Benjamin Henry Latrobe, 1799–1820*, fig. 20 and p. 281.

Americas."[11] Subsequently Guillemard failed to secure the command in San Antonio and was living penniless in New Orleans in 1805, not having been paid for many months, before he left Louisiana.

At the meeting held the day after the fire, March 22, 1788, Almonester promised "to construct a new parish church of brick and wood, as large or larger than the one destroyed, and, nearby a house suitable for lodging the reverend father vicar, the priests' assistants and the sacristan"; and before June 3, 1789 he laid the first brick of the church according to Guillemard's plan. Meanwhile religious services were conducted on the gallery of the Government House and in other places in the city. According to Governor Miro, who was more sympathetic than his successor Carondolet, Almonester "had the ruins . . . demolished, the refuse cleared away, the site enclosed, and prepared to begin the actual work."[12] But disputes with members of the Cabildo, in which he played a leading role after paying for the office of Royal Ensign in 1790, and lack of action regarding his petition for a title of nobility caused an extended delay; as Miro reported, his "fervor" abated. On February 22, 1790, Almonester signed a contract with a master mason, Joseph Duquet, who agreed to put to work three workmen and one laborer. The "actual work" began on March 15, and by early August the five-foot-thick brick wall had reached a height of six feet all around the church and the brick columns of the interior had reached fifteen feet. A flood had breached the levee in front of Almonester's land and destroyed his large brick kiln, but Governor Miro provided substitute bricks from the wall of the old cemetery, hoping to prevent further delay. The uncompleted church was usable for an Easter service in 1793 and the official dedication was held at Christmas, 1794.

The church, the Cathedral of Saint Louis after Bishop Peñalver's arrival in 1795, was considerably larger than Pauger's. At more than 80 feet wide it was more than thrice the width of Pauger's, and at more than 120 feet long about twice its length. The central pedimented section, placed slightly in advance of the rest of the façade, loosely resembled Pauger's façade (Fig. 5.7). The flanking areas were plain except for the ornamentation surrounding the doors to the side aisles and the corresponding niches above. At the corners were three-stage hexagonal towers capped by segmented bell-shaped domes, possibly inspired by the bell crowns José Damián Ortiz de Castro designed for the Cathedral of Mexico. Superposed, paired three-quarter columns of brick supported the central pediment and were, according to Benjamin Latrobe, converted from the Tuscan order to "a sort of Doric" by triglyphs in the upper frieze. The tiled roof was flat, hidden by parapets at the top of the façade between the pediment and the towers.

The brick walls were built upon traditional New Orleans foundations, logs set in shallow trenches to provide stability in the soft, moist soil. The whole building was covered by white-painted stucco which soon discolored in the New Orleans climate. Latrobe, who regarded the cathedral as the least satisfactory esthetically of the three structures facing the plaza, was critical of the lack of alignment between the cornices of the towers and the pediment, and of the S-shaped iron clamps which were applied, unnecessarily he thought, to the exterior to

provide additional stability. In 1819, the year of his scathing criticism of the façade of the church, Latrobe won a competition for the design of a tall central tower with bell-shaped top which seemed to contemporaries particularly sensitive to the forms of the existing fabric.

Latrobe praised the sides of the church, with their four buttresses, and the rear for a "character of solidity which produces a pleasant effect on the eye of an artist." But he was no happier with the three-aisled interior, with its "massy brick and stuccoed columns" which supported architraves to divide the aisles, than he was with the slipshod detailing of the classical forms of the façade. There were altars at the ends of the side aisles and a semicircular arch over the entrance to the sanctuary which extended across the whole width of the nave (Fig. 5.8). The floor of the sanctuary was raised about two feet and the altar set back about ten. A gallery, raised about fifteen feet, surrounded the sanctuary and seemed to Latrobe to give that part of the interior "a tolerable effect."[13]

The cathedral, designed by Guillemard and on which Almonester expended almost 100,000 pesos, was a pleasant-looking structure despite its failure as a whole to please the discriminating classical eye of Latrobe. It lasted fifty-five years until 1849. Some portions of the foundations of the central tower and the front walls beneath the corner towers were incorporated in the present tall and architecturally incoherent structure, which was designed by J. N. B. de Pouilly and dedicated December 7, 1851.

The still-existing twin structures flanking the cathedral, the Cabildo and the Presbytère, replace earlier buildings consumed in the fire of 1788. By that time the buildings flanking the church had lost the symmetrical balance visible in a sketch of 1726 drawn by Jean Pierre Lassus. On the right was the residence of the Capuchins completed in 1772, and on the left were two structures, O'Reilly's Cabildo and a larger and sturdier building, the Corps de Garde of 1751. Behind them were the city jail and the living quarters for the jailer. Both the quarters

5.8. Aisle of the Cathedral of St. Louis, drawing by Benjamin H. Latrobe, 1819.

and the jail had been rebuilt after the fire of 1788 and were destroyed again in the fire of 1794. Nothing had been done about a building for the *cabildo*. That body met for a few years in the Government House and later in rooms rented from Andrés Almonester.

As after the earlier fire, the pressing need for a new jail was met relatively promptly. Then, at its meeting of January 16, 1795, the *cabildo* took up the question of replacing its own building. Governmental funding was not available, as it had not been in 1788. The minutes of the *cabildo* meeting indicate that Andrés Almonester volunteered to construct a building "following the same plan he is using in constructing the Presbytère." The plan of the Presbytère had been made in 1791 by Gilberto Guillemard, then Sgt. Major of the garrison. It was agreed that the Cabildo building would be appraised after completion and that its value would "be paid out of city funds in installments to Almonester without detriment to the city treasury nor causing delays in making other payments, whenever it is possible to do so." Finding this arrangement to their liking,

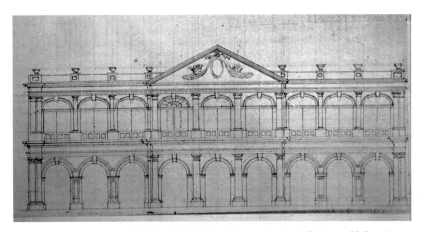

5.9. The Cabildo, New Orleans, drawing by Benjamin H. Latrobe, 1819.

Almonester's fellow members of the *cabildo* "duly" thanked him and "agreed to let . . . [him] proceed to reconstruct [the building] under the terms he . . . proposed, giving him sufficient authority to carry it out."[14]

Work began at some time before December 4, 1795. The minutes of the *cabildo* meeting of July 21, 1797, which described the first floor of the Presbytère as finished, state that "perhaps by the early part of next year the Cabildo building will be completed of brick from top to bottom. No doubt its cost will be over 30,000 pesos."[15] The *cabildo* agreed to pay city funds for a painted portrait of Andrés Almonester to be "placed in the chambers of the cabildo, with proper inscription concerning his deeds and liberality."[16] Gilberto de Guillemard, by that time promoted to Lt. Colonel and Commander of the New Orleans post, was awarded 200 pesos at the meeting of November 10, 1797, for making the plan and supervising the construction of the Cabildo building.

Almonester died after a short illness on April 25, 1798, and his forty-year-old widow soon demanded a partial payment and asked release from the contract to complete the virtually finished building. She also reneged on her husband's promise to complete the Presbytère, complaining that Almonester, who had spent approximately 300,000 pesos on philanthropic works, had excessively depleted his fortune, which had totaled over 420,000 pesos, and argued that what was left should be kept for his daughters. The daughter who survived childhood, Michaëla, married into a former Louisiana family ennobled by Napoleon and survived a murderous pistol assault by her money-obsessed father-in-law. She returned to New Orleans twice, the second time in 1849 as the Baroness Portalba, and replaced the buildings on the sides of the plaza, which had been constructed by her father and in part reconstructed by her mother, with long, tall, sharp-edged, gabled brick residential complexes, the Portalba Buildings.

Latrobe liked the detailing and execution of the Cabildo and the Presbytère, which was finally completed in 1813, little more than that of the cathedral, but he praised their "good proportions and strong relief." He admired the imposing effect of the façades from a distance, writing that "the deep recesses and bold dimensions of the Arches give . . . [them] a light as well as magnificent appearance." The Cabildo seemed "an excellent building for the Climate" with its wide arcade below and glazed gallery above, and "would be a good [structure] if judiciously warmed for one more northerly"[17] (Fig. 5.9).

The buildings were designed with two stories, marked at the top by central pediments flanked by balustrades ornamented by low urns, which masked flat roofs. The present third stories, with their mansard roofs and dormer windows, were designed by the New Orleans city surveyor, Louis Surgi, in 1847. The Cabildo has, and the Presbytère had, a lantern at the top of its roof (Fig. 5.10).

The original two-story façades of both buildings are divided into three sections with three arched bays each, those below half-circular and open, and those above segmented and glazed. The pedimented central section projects approximately a foot in front of the side sections and is ornamented

on both levels by half columns, Tuscan below and Ionic above. Pilasters decorate the upper stories of the sides, but the piers between the arches of the lower stories do not carry an architectural order except at the corners of the building where pilasters are doubled, both below and above. All these elements are stuccoed so that they resemble stone. Notable details include the iron railings with delicate, swinging scrolls which extend across the façade of the Cabildo below the glazed windows of the upper story and, on the side of the building, ornament the windows of the meeting chamber, the *sala capitular*. The finest decorative ironwork in New Orleans, the railings were made by a native of the Canary Islands, Marcelino Hernandez. Originally the pediment of the Cabildo was decorated by floral swags and an oval cartouche with the arms of Spain. This ornamentation was replaced in 1821 by a Roman sculptor, Pietro Cardelli, with according to his contract "an eagle, placed in the center of trophies of arms, flags, etc." all molded in plaster of Paris and "painted to simulate white marble."[18]

In designing the Cabildo, Guillemard was directed to incorporate into its lower floor the elements of the Corps de Garde of 1751 which had survived the fires. Thick brick walls, four square piers, and five arched windows constitute the left side of the structure, set behind Guillemard's frontal arcade and a groin-vaulted corridor. Baron Carondelet had insisted that a room on the lower floor forty-one feet across and sixty feet deep be always kept for the use of the guard. A room for the lighter of the city's lamps occupied the end nearest the cathedral. A graceful stone stairway survives near the center of the building with a balustrade of black walnut forming a pattern resembling the overlaid crosses of the British Union Jack.

The principal chamber of the upper story, entered from the gallery through a wall decorated by pediments and corbels made by Cristobel Le Prevost, is the *sala capitular*, the room in which the

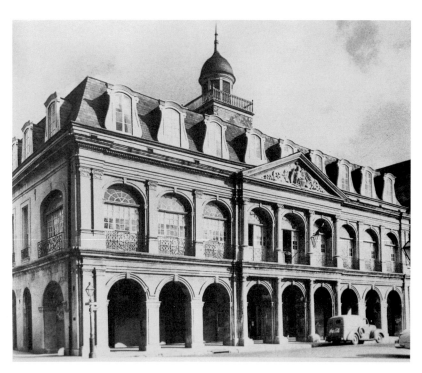

5.10. The Cabildo, New Orleans, after the addition of the mansard roof and the lantern in 1847, photograph by Wayne Andrews.

cabildo met. It occupies the area above the Corps de Garde and has been restored to its condition at the time of the signing of the document transferring Louisiana to the United States, 1803. Another large room at the other end of the gallery, nearest the cathedral, served as the office of the mayor of New Orleans between that year and 1853 while the Cabildo served as the city hall.

In the Presbytère, Guillemard may have incorporated elements of the earlier structure which had been finished in 1772. In a ground plan of 1801 the openings to the rooms off the lower corridor are not precisely aligned with the arches and piers of the façade except at the ends. The building was finally completed in 1813 by Claude Gurlie and Joseph Guillot, builders, for $34,000. In the contract the churchwardens demonstrated particular concern for the construction of the flat roof. Leaking was a problem in the Cabildo also. The specifications stated that "the roof will be solidly built to receive the terrace which must have as follows: a layer of

Chapter V

northern brick laid with good cement mortar, a coating of tar mixed with a bit of resin and covered with a layer of tiles, likewise laid with cement mortar."[19]

The building never served its nominal purpose as residence or rectory for the priests of the cathedral. A year after its completion it was fully rented for stores and apartments. The New Orleans city directory for 1822 listed sessions of the Supreme Court, the First District Court, the Parish Court, the Court of Probates, and the Court of Appeals as all being held in the building. In 1834 the entire structure was leased as a courthouse to the Orleans Parish Police Jury. It was bought by the city in 1853 and used as a courthouse until 1911.

The urban architecture of Spanish New Orleans was unique in the territory of the present United States. None of the other Spanish communities—neither St. Augustine, San Antonio, Santa Fe, nor the embryonic towns of California— possessed any structures comparable to the three buildings Andrés Almonester and Gilberto Guillemard had erected on the plaza of New Orleans.

It is our misfortune that we cannot see what Benjamin Latrobe saw in 1819. The cathedral has been demolished and the massing and proportions of the flanking structures, greatly admired by Latrobe, have been destroyed by the crude addition of third stories with mansard roofs and dormer windows. The subtlety of Guillemard's overall design has been lost. He incorporated remnants of earlier buildings into his Cabildo and Presbytère and created a whole in which the cathedral was the centerpiece framed by seemingly identical flanking structures. Measurements demonstrate that the Presbytère is a few feet wider than its apparent twin. Guillemard created the illusion of perfectly symmetrical balance by making the arches of the Presbytère a trifle wider than those of the Cabildo.

CHAPTER VI

Arizona

The regions previously considered in this book, Florida, New Mexico, Texas, and Louisiana, were distinct Spanish jurisdictions. Spanish Arizona was a small part of the colonial administrative unit of Sonora, the northern two-thirds of the present large Mexican state of Sonora with an extension north of the border. This largely desert area was crossed in the sixteenth century by the parties of Alvar Núñez Cabeza de Vaca and Fray Marcos de Niza, and the substantial force led by Francisco Vázquez de Coronado, but occupation by Spaniards was slow in spreading north.

The upper portion of Sonora, called the Pimería Alta by the Spaniards after its northern Pima occupants, who called themselves O'odham, was not inhabited by a European before the arrival of a South Tyrolean Jesuit missionary, Eusebio Francisco Kino, in 1687. Kino settled in the Pima village of Cosari, about a hundred miles south of the present border, which he renamed Dolores after a painting he had carried with him of Nuestra Señora de las Dolores (Our Lady of Sorrows) by the prominent Mexican painter Juan Correa. Father Kino had studied in the German University of Ingolstadt and was both a mathematician and cosmographer, expert in astronomy, surveying, and mapmaking. He had accompanied the governor of Sonora, Isidro Atondo y Antillón, in his abortive efforts to settle Baja California in the early 1680s, and he maintained a powerful interest in the Californias throughout the remainder of his life. After the California effort was suspended in 1686, he was directed to the Pimería Alta by his Jesuit superiors.

Kino was a man of great energy and great hopefulness, an eager evangelist, baptizer of close to four thousand Indians, and a tireless explorer. He laid the foundations for seven additional missions in Pima villages, including Guevavi and San Francisco Xavier del Bac in the Santa Cruz River valley south of Tucson, and set forth during his twenty-four years in the Pimería on more than forty expeditions, nine of them with the military officer Juan Mateo Manje.

As Kino's biographer Herbert E. Bolton wrote, "he made at least fourteen expeditions . . . into what is now called Arizona. . . . Six carried him to the Gila over five different routes. . . . Two of these expeditions carried him to Yuma and down the Colorado. Once he crossed that stream into California and finally reached its mouth."[1] His principal geographical discovery was that Baja California was a peninsula, not, as previously believed, an island, and that a land bridge existed from Sonora to the Californias. The names Baja and Alta California were proposed by Kino in a letter to Tirso González, head of the Jesuit order.

Kino's freewheeling style of evangelism made

some of his Jesuit superiors uncomfortable, and in late 1695 he was summoned to Mexico City by the Jesuit Provincial, ostensibly to confer with the viceroy but in actuality to remove him from missionary activity. Tirso González, an old acquaintance of Kino's who had risen to be Father General in Rome, wrote to the Mexican leaders of the order comparing Kino's methods to those of his great model San Francisco Xavier, the missionary to the Far East, and ordering his return to work among the Pimas. "The saints," wrote Father González, "use quite a different yardstick from that applied with such caution by ordinary mortals, for them the might of God has no limits."[2]

In addition to his evangelism and his exploring, Kino transformed life in the agricultural Pimería by introducing wheat and cattle, horses, and other livestock. Much of Kino's enthusiasm was conveyed eight years before his death in a letter to Viceroy Archbishop Juan de Ortega Montañez. He suggested the possibility of trade between upper and lower California by means of the Manila galleon, which annually brought far eastern goods from Manila to Mexico, and proposed the establishment, with modest initial outlay, of a town of three or four hundred at the critical site of the future Yuma outposts "on the banks of the bounteous and fertile Rio Colorado, close to the head of the Gulf of California. . . . And in time," Kino continued expansively, "an entrance could be made into the nearby country of the Moquis [the Hopis] and along the northern coast on to the regions known as Gran Quivíra . . ., and as far as Cape Mendocino [in northern California] . . . and following the northwestern and western coastline even as far as the territory close to Japan; or going northeast and east, one can reach regions above New Mexico, and thus establish a line of communication and trade with New France."[3]

After Kino's death in 1711 the missions of Pimería Alta experienced the limitations inherent in their situation, remote from Mexico City and dependent upon an uncertain Spanish government. For twenty years there was only one Jesuit in the whole Santa Cruz Valley, Agustín de Campos, who spent forty-three years in the Pimería Alta. Others came in the 1730s but they did not remain long.

Civilians were drawn to harsh, dry northern Sonora by the promise of mineral riches. The name Arizona is derived from Arizonac, a site south of the border where large chunks of raw silver were found on the surface of the ground in 1736. The settlement was abandoned in 1741. A sizable enduring civilian population developed in the Pimería Alta only after the founding of presidios on both sides of the border near mid-century. Soldiers had families, retired soldiers sometimes remained, and other settlers were drawn to the small clusters of Spaniards. Ranching was the common occupation.

Those who were classified as Spaniards, or *gente de razón* (those capable of reasoning), were usually of racially mixed blood. Father Ignaz Pfefferkorn, who served at the mission of Guevavi between 1761 and 1763 and published a two-volume description of Sonora in Cologne in 1794–1795, wrote that "besides the governor of Sonora, the officers of the Spanish garrisons, and a few merchants . . . there is hardly a true Spaniard in the province."[4]

There were continual troubles with the Indians. In 1751 a Pima chieftain, Luis Oacpicagigua, irritated by the Jesuits' disparaging comments, led a general uprising which killed two priests and more than a hundred settlers and Christian Indians. As a result new presidios were established in 1753 with garrisons of fifty men each at Altar in western Sonora and at Tubac in the southern Santa Cruz Valley across the river from a Pima village.

Little is known of the initial construction of the Tubac presidio. Two decades later, at Christmastime in 1766, it was sketched by Lt. Joseph de Urrutia, mapmaker to the party of inspection of the Marqués de Rubí (Fig. 6.1). In his map the presidio of Tubac consisted of a miscellaneous collection of adobe buildings on elevated ground. The largest structure,

U-shaped, served as guardhouse and residence of the captain. Close by was a chapel, "begun at the captain's expense," and a cluster of smaller buildings, living quarters for the soldiers. There were no fortifications. A short distance to the south was another cluster of small structures, houses of settlers. To the east between the river and an irrigation ditch were six tiers of cultivated fields, over sixty in all.

Rubí, who found most presidios and their officers shamefully ineffective, judged Tubac's captain, the younger Juan Bautista Anza, exceptional, "a complete officer" notable for "energy, valor, zeal, experience, and notable disinterestedness."[5] Contrary to the practices of most commanders of isolated frontier posts, Anza did not exploit his garrison for financial profit but, extraordinarily, sold supplies at the company store at or below the prices set in army regulations. Rubí appended to his report a list of sixty-two articles which Anza sold below the set prices. Most notable was the most expensive item, the soldier's protective leather jacket, or *cuera*, which was reduced in price at Tubac from 50 to 40 pesos. Marshal Rubí was also impressed by the military training of Anza's soldiers, judging them good marksmen and excellent mounted lancers.

A decade later Captain Anza led two remarkable expeditions overland to California, and he then served nine years as governor of New Mexico. He returned to Sonora in 1788, the last year of his life, as *Comandante de Armas* of the Interior Provinces.

Jesuit mission architecture in the Pimería Alta was no more ambitious than the buildings of the presidio at Tubac. Ignaz Pfefferkorn wrote that "the churches were built only of sun-dried adobe bricks" with ceilings which "were not arched but instead were flat, constructed with logs. In contrast to this simplicity of construction . . . [they] were decorated with beautiful altars, [carved] images, paintings, and other ornaments."[6] Church furnishings increased over the decades. Inventories of Guevavi and San Xavier del Bac in 1737 are extremely modest, listing only one painting for each church. An Indian artisan

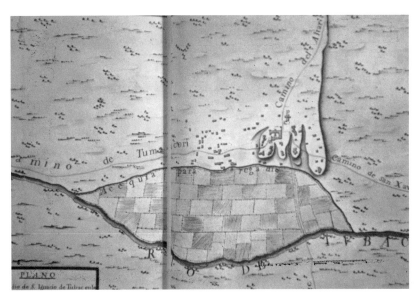

6.1. Detail of the map of the Presidio of Tubac in 1766, by Joseph de Urrutia, reproduced in Max L. Moorhead, *The Presidio*, plate 7.

from the Baja Pimería, Francisco, "El Pintor," is known to have worked for Father Kino.

After the devastation of the Pima revolt of 1751, the missions were able to do little more than, in John L. Kessell's description, hang on against increasing raids from the Apaches to the north and east. The removal in 1762 of Sobaípuri Indians from the eastern buffer zone along the San Pedro River, which was intended to strengthen the settlements in the Santa Cruz Valley, made those settlements even more vulnerable. The only missionary remaining in the valley in 1767, Father Custodio Ximeno of Guevavi, was escorted by a detachment of soldiers of the Altar presidio many miles to the southwest to Tubutama, the mission of the father rector, to be informed of the royal order expelling the Jesuit order from Spanish dominions.

Even before Father Ximeno was notified of his banishment, Manuel de Nájero, the Franciscan sub-commissary general for New Spain, met in Mexico City with the royal Visitor General José de Gálvez and Teodoro de Croix, nephew of the viceroy, to arrange for Franciscan replacements for the Jesuit missionaries. At this time the viceregal government made a determined effort to reform missionary practices and to terminate the communal paternalism

traditional in both the Jesuit and Franciscan orders. The Indians, the government believed, should be brought rapidly into the general society of New Spain and made productive tax-paying citizens. "Under no circumstances," wrote the viceroy, the Marqués de Croix, "are the Indians to be deprived of civil intercourse, communication, commerce, or residence with the Spaniards, no less the possession in individual and private domain of their property, goods, and fruits of their labors."[7] Despite grave misgivings about the new government policy, fifteen members of the College of Santa Cruz of Querétaro volunteered for duty in Sonora. Later the college would be relieved of its responsibilities in the northeast by the transfer of four missions in Texas to the College of Zacatecas, and two on the Rio Grande to the Franciscan province of Jalisco. The volunteers from the College of Santa Cruz stopped in Tepic, northwest of Guadalajara, to await passage from the nearby port of San Blas. They were lodged in a Franciscan hospice with thirty-two other missionaries, including Junípero Serra and the group from the College of San Fernando in Mexico City destined for Baja California, and still others from the College in Zacatecas directed to take over the Jesuit missions in the mountainous Tarahumara region.

Tumacácori

The first Franciscans in Arizona were Juan Crisóstoma Gil de Bernabé at Guevavi and Francisco Garcés at San Xavier del Bac, both later martyred. Within three years of his arrival in 1768, Father Gil shifted his mission headquarters a little more than ten miles up the Santa Cruz Valley to Tumacácori. Guevavi, which had an unhealthy site and a dwindling population, was reduced to a *visita*, like the nearby villages of Sonoita and Calabazas. Franciscans found missionary activities in Apache-threatened Arizona no easier than had the Jesuits. One of Gil's successors, Fray Bartolomé Ximenez, wrote, "As long as the government fails to provide more, prompt, active, and efficacious methods to contain the Apaches not only will the missions not be advanced . . . but . . . even what is already conquered will be lost. . . . All that will be said is, here was Troy, over there once stood a mission called Tumacácori."[8] By 1773 both Guevavi and Sonoita were abandoned and the government had dropped its effort to reform missionary procedures. The Franciscans, freed from the policies of reform, were allowed to keep their Indians segregated from Spanish soldiers and settlers, to regulate their labor, and to maintain discipline through punishments administered by Indian officers whom they appointed.

A document records the religious routine at Franciscan Tumacácori in 1772: "Every day at sunrise the bells are rung announcing mass. An old Indian commonly called the *mador* and two *fiscales* go through the whole village obliging the children and all unmarried persons to gather at the church to attend the Holy Sacrifice . . . in devotion and silence. When this is over, all recite with the Father missionary in Spanish the prayers and catechisms. In the evening at sunset this exercise is repeated before the door of the church. It is concluded with the praying of the rosary and the singing of the *Salve* or the *Alabado*.

"On Sundays . . . all men, women, and children are obliged to attend Mass with their meager clothing washed and everyone bathed and hair combed. On these days the Mass is sung, accompanied by harps, violins and with four or six male and female singers.

"During the Holy season of Lent, everyone is obliged to attend Mass daily and recite the prayers in Spanish. The Father explains to them the necessity, circumstances, and method of making a good confession, and every Sunday afternoon they are given a clear and substantial explanation of the Four Last Things [Death, Judgement, Heaven, and Hell]."[9]

Tumacácori, which had welcomed Father Kino in 1691, had been made a *visita* of Guevavi when its

neighbor three miles up the river, the presidio of Tubac, was established in 1753. A Jesuit headquartered at Guevavi, Francisco Xavier Paner (originally Bauer), had directed the construction of an adobe church with a *viga*-supported flat earthen roof and measuring approximately sixty by twenty feet. This modest church served the mission for half a century. In 1801 Fray Narciso Gutiérrez hired a stonemason to plan the construction of a new church of about twice its size. This new church, loosely modeled on the recently completed one of San Xavier del Bac, was to be constructed largely of adobe bricks but was to have a dome of fired bricks over its crossing and barrel vaults of fired bricks over its nave, transepts, sanctuary, and sacristy.

As Nicholas J. Bleser explained in his book *Tumacácori*, a bell tower supported by foundations nine feet thick was placed at the eastern end of the façade, helping to support the vaulted choir balcony, but the balancing bell tower planned at the opposite end was never built (Fig. 6.2).

The maestro and his work crew cost nine pesos a day in wages, and funds ran out after approximately a year when the foundations had been completed to a height of about two feet. In the remaining years before his death in 1820, Father Gutiérrez succeeded in having the walls constructed to a height of seven feet. Beyond that point a master mason was needed to construct the arches which would support the dome and the vaults. During the visitation in January 1821 of Bishop Bernardo del Espíritu Santo of Sonora, a contract was signed by the new missionary, Fray Juan Bautista Estelric, to secure funding for the completion of the church. Ignacio Pérez, an officer desirous of prospering in ranching, agreed to pay three pesos each for four thousand of the mission's herd of fifty-five hundred head of cattle. With his initial payment of 4,000 pesos, Father Estelric hired Maestro Félix Antonio Bustamente of Sombrerete, Zacatecas. At this time the plans of 1801 were scaled down to enable completion without exceeding the projected funding.

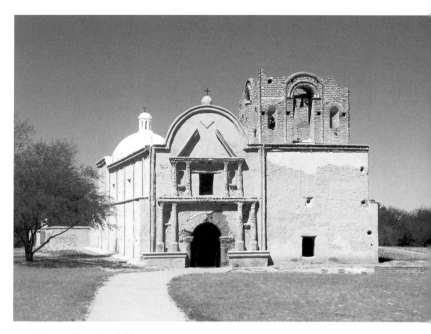

6.2. Church of San José de Tumacácori.

Within six months the transepts were closed off, the walls were carried up to fourteen feet, and a dome was built over the baptistery in the bell tower beside the façade. Payment for over 150 work days for Bustamente and his crew, which involved making seven thousand sun-dried adobe bricks and thirty-one hundred fired adobe bricks, making lime for mortar, and building scaffolding, required an additional 1,000 pesos beyond the initial payment, and Pérez stalled in paying the 8,000 pesos he owed. Disclosure of Father Estelric's mistress and purported children forced his departure from Tumacácori in 1822. His successor, Fray Ramón Liberos, extracted additional cash from Pérez and oversaw the near completion of the church after further reductions in its construction. A flat roof replaced the barrel vault intended for the nave, and the dome over the crossing was eliminated. As a result thinner upper walls were sufficient. The only exterior dome is over the sanctuary. One or more domes were intended for the upper stages of the uncompleted bell tower, and a dome was intended to cap the cylindrical mortuary chapel in the cemetery behind the church.

The church at Tumacácori survived essentially

as it had been finished until an Apache raid on Tubac in 1848. Two months before the raid, an American soldier was surprised to come across "a very large and fine church standing in the midst of a few common conical Indian huts, made of bushes, [and] thatched with grass." He discovered that the church was taken care of by the Pimas and that "no priest has been in attendance for many years, though all its images, pictures, figures remain unmolested, and in good keeping."[10] After the raid on Tubac the Tumacácori parishioners stripped their church of its paintings and *santos* and carried them to San Xavier del Bac, leaving the village deserted. The National Park Service took over the church from the Forest Service in 1916. After an initial reroofing, the policy has been preservation rather than restoration or speculative completion.

Tucson

The shift of the presidio of Tubac to Tucson in 1776 stemmed from the recommendations of the Marqués de Rubí and the resulting royal *Reglamento*, or Regulations, of 1772. Rubí had recommended locating the presidios in a line extending from west to east at approximately 120-mile intervals. The garrisons at Santa Fe and San Antonio, though well to the north, were retained in place because of their strategic importance; each was to constitute "a separate frontier." The *Reglamento* also specified that presidios, as had been only rarely true earlier, should be fortified places, and that "the exterior walls . . . [were] to be built first of adobes, with two small bastions in the angles; afterward on the interior wall . . . [were to] be built the chapel, the guardhouse, residences of the captain, officers and chaplain, and quarters for the soldiers and Indians."[11]

Lt. Colonel Hugo O'Conor, a younger cousin of Alejandro O'Reilly, who had served as provisional governor of Texas, was appointed *comandante inspector* to implement the *Reglamento*. In Sonora, O'Conor kept the presidio at Altar in place but moved three other presidios north. One, formerly at Fronteras, was placed just south of the border about sixteen miles east of present-day Douglas, Arizona; another, formerly at Terrenate, was put well within Arizona on the San Pedro River; and the presidio of Tubac was moved nearly fifty miles up the Santa Cruz River to a site opposite a recently relocated Pima village the Spaniards called San Agustín del Tucson, which was a *visita* of San Xavier del Bac. This was well north of the line recommended by Rubí, but O'Conor and Fray Francisco Garcés, the missionary at San Xavier del Bac, regarded it as strategically important for guarding the Gila River route to the Colorado and, ultimately, to California.

Colonel O'Conor, accompanied by Father Garcés, marked out the site in late August 1775 and reported that it provided "the requisite conditions of water, pasture, and wood," but the actual transfer of the garrison was delayed until 1776. Eleven years later Tubac was reopened with a garrison of Pima auxiliary troops, commanded by Spanish officers.

Three thousand pesos were allocated for the construction of new presidios, but construction in Tucson was slow because of inept leadership and fiscal incompetence. In the early years the soldiers slept in campaign tents. Captain Pedro de Allande y Saabedra, who assumed command in 1777, found that only two of the adobe perimeter walls (each three or four hundred feet long) had been constructed above foundation level and that even those two were only four or five feet high. Having no governmental funds, he had built at his own expense a temporary palisade of rough logs. Two years later an inspector, Colonel Rocque de Medina, reported that "the area of the presidio houses and *jacales* is fortified by a wide ditch roundabout and a palisade . . . and two ramparts on which cannon are emplaced. Some of the houses of citizens and soldiers are outside the palisade and are defended only by the artillery and the low works raised at one side."[12] In 1783, one year after a powerful Apache attack was

repulsed with minimal casualties to the garrison, another inspector commended Lt. José María Abate for "having at his own cost walled the Presidio on the very terms he offered."[13] We know that much of the labor was provided by Indians from the villages of San Agustín del Tucson and San Xavier del Bac.

When completed, the fortified presidio of Tucson was larger than average but considerably smaller than the immense enclosure which was completed in Santa Fe in 1791 (Fig. 6.3). It was approximately square with walls extending over six hundred feet on each side. The walls, partially excavated in 1954, were slightly more than three feet wide at the base, which consisted of three adobe bricks measuring four by twelve by eighteen inches set in adobe mortar. In height they reached at least ten feet, by one report sixteen.

Three other structures of Spanish Tucson are of particular interest. The earliest was a fortified structure in an Indian village, *El Pueblito*. In 1770 Captain Anza had promised a fort for protection against the Apaches to a group of Sobaípuri Indians who had fled Tucson to take refuge with relatives along the Gila River. By the next February an adobe fortification with lookout towers was completed. In the following year, 1772, Fray Francisco Garcés reported that a church was being constructed in the fortified village. He had reported to Captain Anza as early as 1768 that the Indians had "already built me a little hut among their own."[14] The church underway in 1772 was completed or replaced some time after 1797 under the direction of Fray Juan Bautista Llorens, who had overseen the completion of the church of San Xavier del Bac. By 1843 this *visita* church was in sorry shape. Rotten *vigas* had caused the roof to collapse and the adobe walls were badly cracked.

The third notable structure was also constructed under the direction of Father Llorens. An imposing two-story *convento* was built between 1797 and 1804. Abandoned when the Mexican government secularized San Xavier del Bac in 1828,

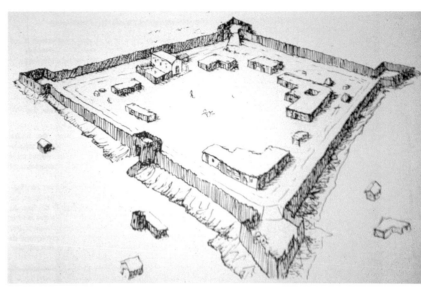

6.3. Tucson, the presidio in 1782, reconstruction drawing by Jack Williams, reproduced in Williams's "San Agustín del Tucson," *Smoke Signal* 47–48, p. 119.

6.4. Tucson, ruins of the *convento*, c. 1880, photograph reproduced in "San Agustín del Tucson," p. 127.

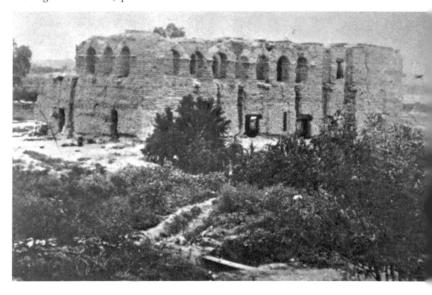

it stood derelict for decades. Substantial remains of the ruined structure are visible in a photograph from the 1880s (Fig. 6.4). It was eventually dismantled, adobe brick by adobe brick, ultimately to disappear under the Tucson city dump.

After it received the presidio, Tucson became the most important Spanish outpost in Arizona. Settlers left Tubac to join the community because they felt vulnerable to Apache attack after the garrison left. The Indian village, *El Pueblito*,

supplemented its dwindling Pima population with Papagos, Sobaipuris, and Western Apaches. In 1804 the presidio commandant, Captain José de Zúñiga, reported the total population of the area to be 1,015, including Spanish, Indian, and those of mixed bloods. There were three hundred Spaniards, thirty-seven of them civilian heads of families.

The principal occupations, apart from soldiering, were farming and ranching. Zúñiga wrote of the need for a tanner, a dresser of hides, a tailor, a weaver, a shoemaker and, even more important, a saddlemaker. Particularly needed were teachers of varied arts and trades. Zúñiga lamented the general lack of energy and industry among the settlers, complaining that "they barely allow the grape to mature before they are selling it."[15] The population continued to grow if not to greatly flourish. In 1819 there were sixty-two Spanish heads of families, making a civilian population of approximately three hundred in addition to the soldiers and their families.

In 1776 a new governmental structure was created for the northern regions of New Spain, extending from Texas to California. José de Gálvez had proposed such a reorganization as early as 1768 when he was Visitor General. After he was appointed Minister of the Indies by Carlos III, he was able to secure its approval. Teodoro de Croix, who had lived in New Spain when his uncle was viceroy, was chosen as the first *Comandante General de las Provincias Internas* (Commandant General of the Interior Provinces), with authority in the northern regions largely independent of the viceroy. The new commandancy was intended to grant authority for northern matters to a person close to the scene, authority which the distant viceroy, immersed in multiple responsibilities, could not effectively exert. Ultimately the new arrangement proved only marginally more effective than the former one, but Croix did his best to make the northern forces more efficient and more economical. He toured most of the interior provinces, except the Californias, and realigned presidios, in Arizona retaining Tucson but moving Terrenate back south of the border. He developed special companies of light troops, unencumbered with heavy leather jackets, lances, and shields, who were able to move rapidly in defending the line of presidios by intercepting Indians who had penetrated the line. Croix planned to conduct a massive assault on the Apaches but he was unable to secure the needed reinforcements because of the war against England during the American Revolution. Croix then shifted from a policy of force to one of strategic alliances, wooing the Comanches and other northern tribes who were traditionally hostile to the Apaches. Croix's successors continued many of his policies after his appointment as viceroy of Peru in 1783. With considerable success they adopted flexible tactics rather than a wholly military approach to Indian relationships.

But the years of Spanish dominion in America were limited. The most effective era of Spanish government of the eighteenth century came to its end in the 1780s. It was symbolized by the sudden deaths in Sonora of *Comandante General* Felipe de Neve in 1784 and of *Comandante de Armas* Juan Bautista Anza in 1788. It was marked in Spain by the deaths of Minister of the Indies José de Gálvez in 1787, and of King Carlos III in 1788.

San Xavier del Bac

In 1804 in response to a questionnaire regarding public works in his region, Captain José de Zúñiga described the church of San Xavier del Bac. "The entire structure," he wrote, "is of fired bricks and lime mortar. The ceiling is a series of domes. The interior is adorned with thirty-eight full-figure statues, plus three 'frame' statues dressed in cloth garments, and innumerable angels and seraphim. The façade is quite ornate, boasting two towers, one of which is unfinished." A conservative estimate of construction costs he thought "would be

40,000 pesos. . . . The reason for this ornate church at this last outpost of the frontier is not only to congregate the Christian Pimas of the San Xavier village, but also to attract by its sheer beauty the unconverted Papagos and Gila Pimas beyond the frontier." His account of the church was extended "because of the wonder that such an elaborate building could be constructed at all out here on the farthest frontier. Because of the consequent hazard involved, the salaries of the artisans had to be doubled."[16]

Bac, or Wa:k in the language of its Tohono O'odham people, the remote village that attracted such great architectural effort, was the most populous in the Pimería Alta and was related to other agricultural communities extending more than a dozen miles along a stretch of the Santa Cruz river in the present Tucson area. Maize, beans, melons, and cotton were grown in amply irrigated fields for generations before the first European arrival.

On his initial visit in 1692, Father Eusebio Kino, with the help of interpreters, used his cartographical skills to interest the Indians of Bac in Christianity, showing them on a "map of the world how the Spaniards and the faith had come by sea to Vera Cruz, and reached Pueblo, Mexico City, Guadalajara, Sinaloa, Sonora, and now to Nuestra Señora de las Dolores, in the lands of the Pimas." They could visit the church there, he told them, and hear its bells and see its images of the saints and also examine the "plentiful supplies, wheat, maize, and many cattle and horses,"[17] both things of the spirit and things of the flesh, or if they preferred they could question their relatives who had come with him to Bac about the splendors of Dolores.

Kino would visit Bac many times in the next few years. In early 1697 he brought to Bac, as he did to other villages where he intended to place missions, some cattle, sheep, goats, and a small drove of mares. He arrived later that year to celebrate the feast of San Francisco Xavier, his great model whom he made titular patron of Bac. His party slaughtered a few animals for food and were delighted to be served "bread fresh and very good, which they baked for us in the new oven which I had ordered." On one of his visits in 1699, Kino was accompanied not only by his regular companion on expeditions, Lt. Juan Mateo Manje, but also by two other Jesuits, Francisco Gonzalvo, a young priest who would later be the first resident missionary at Bac, and the Father Visitor Antonio Leal. Kino described their arrival at two hours after noon: "More than forty boys came forth to receive us with their crosses in their hands, and there were more than three hundred Indians drawn up in a line, just as in the pueblos of the ancient Christians. Afterward we counted more than a thousand souls. There was an earth-roofed adobe house [specially constructed for a missionary], cattle, sheep, and goats, wheat and maize, and sixty-six relay pack animals. . . . The fields and lands for sowing were so extensive and supplied with so many irrigation ditches running along the ground that the Father Visitor said they were sufficient for another city like Mexico."[18]

A particularly significant visit was in 1700, when Kino wrote to Father Leal requesting that he be replaced at Dolores and allowed to reside at San Xavier del Bac. Bac appealed to him as the gateway to the Gila and Colorado Rivers, to California and the expanses beyond to the north and west which offered territories to explore and souls to convert. "We began," Kino wrote, "the foundations of a very large and capacious church and house of San Xavier del Bac, all the many people digging for the foundations, others in hauling many and very good stones of *tezontle* from a little hill [perhaps Grotto Hill east of the present church] which was about a quarter of a league away. For the mortar for these foundations it was not necessary to haul water, because by means of the irrigation ditches we very easily conducted the water where we wished."[19]

Father Kino's great hope for San Xavier del Bac was not realized during the Jesuit years in Arizona. His promised relief never arrived in Dolores, and

6.5. Plan of the church of San Xavier del Bac, Rexford G. Newcomb, *Spanish-Colonial Architecture in the United States*, plate 47.

Father Gonzalvo, assigned to Bac, did not remain there long. The church Kino began enthusiastically was never finished, probably not ever being built above the foundations. Although some sort of mission structures were completed before 1737, Carlos Rojas, Father Visitor in 1748, wrote of "this mission, which has been truly unlucky, [which] contains very many people and is almost always without a priest."[20] Between 1756 and 1759 the puritanical Father Alonso Espinosa supervised the construction of a church of adobe bricks with mesquite *vigas* supporting its dirt roof; the *vigas* were later incorporated into the *convento*. Shortly before the expulsion of the last Jesuit missionary, José Neve, the inspection party of the Marqués de Rubí found a corporal and a small number of soldiers who had been detached from the Tubac presidio to defend San Xavier and its *visita* San Agustín de Tucson. "With this very small force," Rubí reported, "they defend themselves admirably against the Gila Apaches, whom they punish occasionally because they are the most warlike."[21]

The first Franciscan at San Xavier in 1768, Fray Francisco Garcés, was an ardent explorer who left his mission two months after he arrived and was away much more than he was in residence during his ten years as missionary at Bac. He shared the passion for exploration and the interest in the Colorado River country and California of his great Jesuit predecessor of over half a century earlier; but, as a country boy from Aragón, he also differed markedly from the university-bred Kino. Garcés accompanied Juan Bautista Anza on his expeditions to California, and Fray Pedro Font, the diarist of the second expedition, has left us a striking account of him. "Like the Indians he is impassive in everything. He sits with them in a circle, or at night around the fire, with his legs crossed. He will sit musing two or three hours or more, oblivious to all else, talking with much serenity and deliberation." He would eat the dirty and disagreeable food of the Indians "with great gusto. . . . In short God has created him . . . solely for the purpose of seeking out these unhappy, ignorant, and rustic people."[22] This unpretentious priest, completely at ease in Indian company, would be slaughtered in the Yuma uprising of 1781.

The remarkable present church of San Xavier del Bac was probably begun about 1781. The missionary in charge was Fray Juan Bautista Velderrain, or Belderrain, who had been born in northern Spain and had been tutored in the Pima language by Father Garcés. Other members of his family had also come to Arizona. His father had been the first commandant of the Tubac presidio; his sister married the second, Juan Bautista de Anza; and his brother had been the inept second-in-command of the Tucson presidio in its earliest years. Father Velderrain arrived at San Xavier in 1776 after having previously directed the building of a mission church in southern Sonora. In order to initiate construction at San Xavier he borrowed 7000 pesos from Antonio Hererros, who was willing to accept as collateral wheat crops of the mission which had not yet been planted, and who was never repaid. Father Velderrain died suddenly at Bac in 1790, after spitting blood. His successor, Fray Juan Bautista Llorens, oversaw the virtual completion of the church in 1797. In that year the church was described in careful detail by the Franciscan visitor Fray Francisco Iturralde. Father Llorens remained at Bac until 1814 or 1815 and, after the completion of San Xavier, oversaw the construction of the *visita* church and the impressive two-story *convento* in Tucson. His final building project was a chapel and residence for San Xavier's northern- and westernmost *visita*, Santa Ana de Cuiquiburitac, almost halfway to Phoenix from Tucson.

Ignacio Gaona was the master mason responsible for the design of San Xavier. He supervised its construction and was living in Bac or in Tucson's *El Pueblito* after its completion in 1801. He was then forty-seven years old. A few years later he moved south to Caborca to supervise the building of the

church of Nuestra Señora de la Concepción, which closely resembles San Xavier.

A substantial deposit of material for lime was discovered in the Bac area and, after at least a year of assembling stone and timber and making and firing many thousands of bricks, the work crew traced on the ground the outlines of the plan of the towers, nave, transept, sanctuary, and sacristy (Fig. 6.5). Three approximately square bays make up the nave, which measures almost 60 feet from the entry wall to the crossing. Three slightly larger square bays constitute the transept, making it more than 60 feet long. The square sacristy and the rectangular sanctuary at the end are slightly smaller. The church is sizable, measuring a little over 98 feet from the inside of the front wall to the end wall and over $21\frac{1}{2}$ feet across the nave. For the foundation, stones of varied sizes and shapes were set in lime mortar in trenches dug more than three feet deep.

The inner and outer faces of the walls are built of fired bricks measuring two by eight by twelve inches, and in between is a filling of stone rubble set in layers of lime mortar. The walls of the church are about three feet thick, those of the towers six. Broad brick arches, six in all and four of them at the crossing, support the domes and the choir balcony. Notches have been discovered high in the walls which provided support for the wooden scaffolding used in constructing the arches and the domes. Six of the eight brick domes are approximately oval, with semicircular ends and flat sides, because the spaces between the arches of the nave and in the ends of the transepts, which are used as chapels, are wider than they are deep. The domes of the nave are more than 30 feet and the circular dome over the crossing more than 52 feet above the floor. That central dome is supported by an octagonal drum pierced by multilinear baroque windows above the flat quasi pendentives. Four windows, set deep in the walls under shell-topped openings, light the nave. The brick surfaces of the domes, the arches, the walls, and the architectural ornamentation are

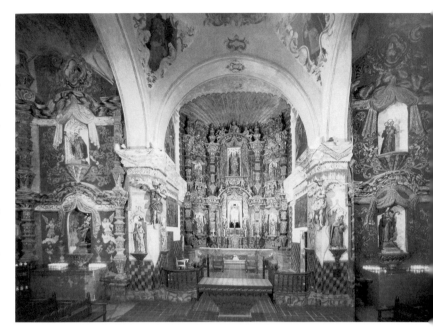

6.6. Interior of San Xavier del Bac facing the sanctuary, photograph by Jack Dykinga. Also see Plate IX.

6.7. Interior of San Xavier del Bac facing the choir balcony and the entrance, photograph by Jack Dykinga. Also see Plate X.

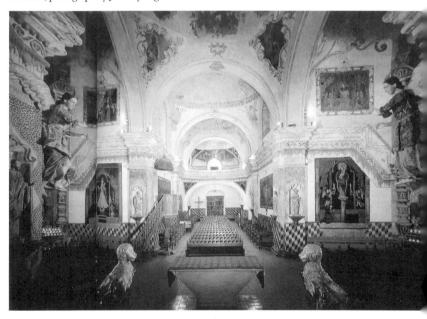

all covered with layers of lime plaster so that they appear to have been constructed of stone.

From the time of Captain Zúñiga and Fray Francisco Iturralde, who wrote shortly after San Xavier was completed, all descriptive accounts of the interior have stressed its overall ornateness (Fig. 6.6 and Fig. 6.7). In the 1980s Reyner Banham found almost all the ornamentation lacking in artistic cor-

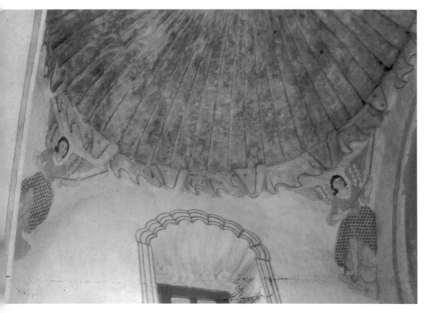

6.8. Vault of a bay of the nave, San Xavier del Bac.

rectness, but wrote that nevertheless "the whole effect is of brazen nonchalance, rather than provincial incompetence."[23] One particular delight is the painted cornice, ornamented above by a zigzag pattern of simulated marbling, and below by a frequently knotted Franciscan cord which trails suggestions of a fabric that dangles alternating tiny bells and pomegranates. It runs across the front of the choir balcony and along the walls of the nave, rounds the pilasters at the crossing, and then dives diagonally down the walls, slicing across the corners of pictures to run across the *retablos* in the transept chapels just below the level of their lower entablatures. It then slides vertically up the outer edges of the piers at the entrance to the sanctuary to reach cornice level for its journey along the side walls. At the rear of the church it is then drawn across the main *retablo* to drop, finally, along the sides of its central niche.

High above the nave bays, demurely dressed angels in the quasi pendentives appear to be pulling apart, like a curtain, the flounced lower edges of the canopy-like ribbed oval domes, as if to unveil heaven (Fig. 6.8). Lower down, solemn disciples and saints are set in sprightly niches cut into the pilasters. The niches are set in panels of pointillist splotches of blue against white. They are framed by writhing ropes of diamondback rattlesnakes, and at their tops blue moldings squiggle in tight curves and countercurves. Attached to the piers at the sanctuary are large, grave, winged angels and, placed beneath them farther back, are curiously proportioned, golden-headed and -maned lions who grin wide-mouthed across the sanctuary to each other (Fig. 6.7 and Fig. 6.9).

The five *retablos* are relatively ordinary in appearance, stiff country versions of the dazzling *estípite* style of sharply faceted columns dominant in metropolitan Mexico in the decades following the middle of the eighteenth century. They are very unusual in being constructed of brick with decorative elements of carved stucco instead of the normal material for building *retablos*, wood. The main *retablo* is set within a flattened shell, which originally had ribs painted alternately red and gold and scalloped recesses painted silver (Fig. 6.10). The *retablo*

6.9. Angel of pier of the crossing, San Xavier del Bac, photograph by John P. Schaefer.

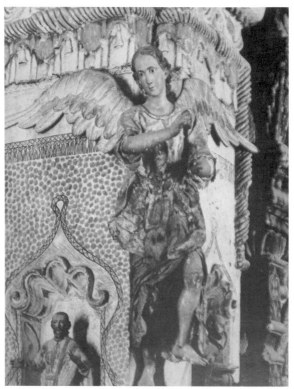

is gilded and enlivened by diverting folk images—small, angular, leggy angels sprawling about, and tiny horn-tooting angels in the capitals of the lower *estípites*.

At the apex is the solemn figure of God the Father holding the orb of the world with his left hand and blessing the world with his right. The other figures of the central axis are a black-bearded San Francisco Xavier, a frame statue (a carved head with clothes hung on a frame below the head) ordered from Mexico City by the Jesuit builder of the second church, Father Alonso Epinosa; and above San Francisco, surrounded by roses, a charming carved wooden image of Nuestra Señora de la Santísima Concepción, which was brought to San Xavier by the refugees from Tumacácori.

The side chapels have *retablos* on their inner side walls as well as on their rear walls and paintings on their outer side walls. These *retablos* simulate expensive materials with gold paint and marbling, lacking the gilding of the main *retablo*. Another of Father Espinosa's frame statues, Nuestra Señora de las Dolores, and a large black incised cross dominate the central axis of the rear *retablo* of the east chapel; the cross once bore a carving of the crucified body of Christ, and an arm from the carving is preserved in the church museum (Fig. 6.11). The principal features of the west side chapel include a Christ who lost his legs to Apaches at Tumacácori and has been recycled as the uncorrupted body of San Francisco Xavier. Directly above him are carvings of Christ crowned with thorns, the Ecce Homo, and a figure identified as San Francisco of Assisi with an iconographically puzzling gilded projection from the head.

The painted wooden statues, numbered by Captain Zúñiga at thirty-eight, are now diverse in style. The statues prominently set in the niches of the three *retablos* and in the niches hollowed from the pilasters of the nave and the piers of the crossing are varied in size and style, carved and ornamented by a variety of image makers. Some are from

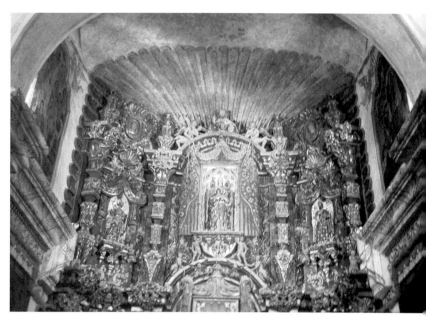

6.10. Main *retablo*, upper level, San Xavier del Bac.

6.11. *Retablo* of the east transept chapel of San Xavier del Bac with an incised cross, upper level center, photograph by Michael Freeman.

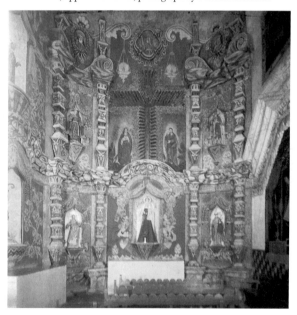

Tumacácori; most were among the thirty-eight enumerated by Captain Zúñiga in 1804.

The paintings on the walls of the church are even more remarkably varied. Large, stiff, almost academically correct paintings of the Last Supper and the Descent of the Holy Spirit to the Disciples at Pentecost face each other in the nave. Four paintings are on the side walls of the sanctuary and another, of the crucifixion, is on a wall of the sacristy.

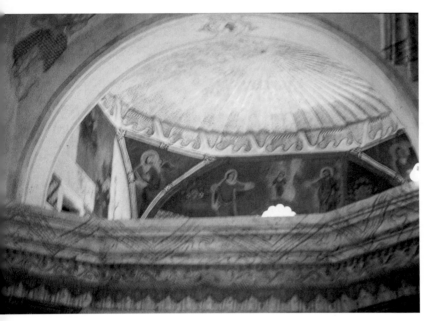

6.12. The choir balcony, San Xavier del Bac.

Four more paintings are on the outer walls of the transept chapels; the large lower ones, cut at their upper inner corners by the descending painted cornice, are lively folk images of manifestations of the Virgin. All these paintings were applied directly onto the walls but were given painted frames so that they seem to be oils on canvas. The decorations of the drum and the dome are the works of another painter, or painters. Striking and puzzling are four lightly sketched monochromatic winged figures high on the walls of the sanctuary above the upper paintings. Are they representations of devils or angels? These diverse paintings were produced by a team of unknown artisans. At least six and perhaps as many as ten different painters were employed in decorating the interior.

The auxiliary spaces of the church include square rooms in the towers. The one on the west is used as the baptistery and contains in its central font a covered copper basin preserved from the second church. The dado is an illusionistic painting of three-dimensional blocks in maroon and gold, like the dado of the nave which is now repainted a harsh red, gold, and blue. On an upper level between the towers is the virtually square choir balcony, well dec-

orated by another mural painter with representations of the evangelists in the quasi pendentives, and a fine canopy-like, ribbed, oval dome ornamented at its lower edge by the Franciscan cord and a scalloped pattern, like the domes of the nave but splattered by pointillist dabs of red (Fig. 6.12). The square sacristy, placed in the angle between the east end of the transept and the sanctuary, is a handsome room with an imposing mural painting of the crucifixion, like others in the church with painted frame to make it appear to be oil on canvas. The brick dome of the sacristy has lost almost all its stucco plaster and painted decoration.

The façade of San Xavier del Bac is divided into three approximately equal segments (Fig. 6.13). On the sides are the simple, now brilliantly white, masses of the towers, almost neoclassical in their simplicity, save for the swinging double volutes ornamenting the flying buttresses of their belfries and at midlevel the outer edges of the façade. The central frontispiece, once multicolored and now almost monochromatically brown, is a work of the

6.13. The façade of San Xavier del Bac. Also see Plate XI.

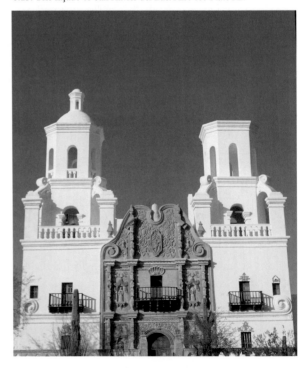

folk baroque. Both of its lower levels contain at their sides pairs of thin *estípites*, which enclose statues of female saints set in niches ornamented by flowing curtains. Over the central arched entrance is a balconied window crowned by a shell which admits light to the choir. Particularly striking features are the moldings, which run up the sides of the frontispiece as well as across the towers at midpoint and which terminate in broad scrolls (Fig. 6.14). The moldings at the outer edges of the frontispiece once had diagonal ornamentation. The two *estípites* which penetrate the third level of the façade terminate in diagonal, slightly curving slabs of entablature and in finials which jut above the free-flowing upper parapet. Outside these *estípites* are the broad scrolls which terminate the outer moldings. Their inner swirls support a mouse and a cat, and they seem to support leaning doglike lions. In the midst of the vegetative ornamentation in low relief at the center of the third level is the Franciscan emblem of cords, cross, and, nailed to it, the arms of Christ and San Francisco, which represent the union in charity and suffering of the Saint and his Divine Master. After swinging sharply up in curve and countercurve, the upper parapet dips sharply at its center to reveal the lower portion of what was once a large stone statue of San Francisco Xavier, patron of the church.

The church's side elevations are almost unbroken in their dazzling whiteness. The towers and the transept project substantially beyond the walls of the nave and the sanctuary. The two-story octagonal belfries, one of them incomplete, and the low central dome extend above the curves, scrolls, and finials of the sprightly roofline (Fig. 6.15).

San Xavier del Bac was without a priest for decades after secularization and the departure of the last Franciscan, Father Antonio González, in the mid-1830s. The buildings began to decay, the *convento*, which had been constructed partly from mesquite *vigas* and other remnants of Father Espinosa's adobe church, more rapidly than the brick church. The Papagos and Sobaípuris, who

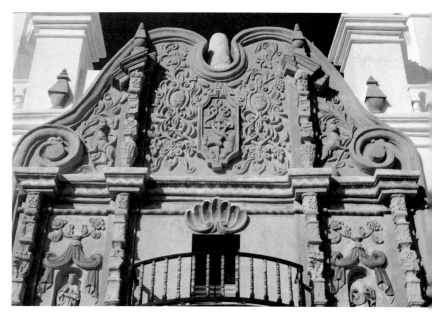

6.14. Upper level of the frontispiece, San Xavier del Bac.

6.15. West side of San Xavier del Bac.

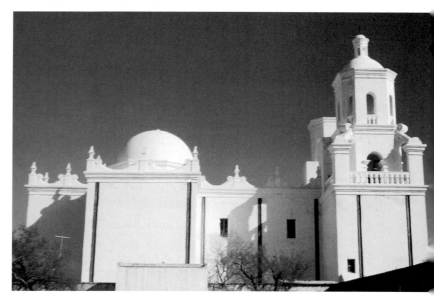

increasingly constituted the community, preserved church furnishings by using them in their homes.

Bac was on a much-traveled route to southern California in the forties, and the church of San Xavier startled those who came upon it standing in its village in the desert. The earliest reference to the church in English was made in December 1846 by Lt. Colonel Philip St. George Cooke, commander of the Mormon Battalion of General Stephen Kearny's Army of the West during the war against

Chapter VI

Mexico. The first visual rendering was by a soldier artist, Samuel Chamberlain, two years later. H. M. T. Powell made an excellent pencil sketch in 1849, and two months later Benjamin Hayes, later a judge in Los Angeles, included an extensive description of the church and its furnishings in his diary. In 1857 he noted that the church was "not what it was when I passed there in 1849, the church is becoming dilapidated."[24] An English physician, William A. Bell, who visited the church in late 1867 as a member of a surveying party for a transcontinental railroad, wrote the best of the early descriptions of San Xavier in English. "Grouped round it are the conical thatched huts of the Papagos, who seem to have taken shelter under the shadow of a great giant rising from their midst. Not a creature lives here but these Indians. . . . I wondered, as I looked at the strong sight, whether it might not be fairly represented as a Saxon village in the Twelfth Century— a number of huts clustered around a massive Norman church." Bell marveled at the construction of such a church by Indians, at their learning how to make "furnace-baked bricks" and at their building "the roof of brick arches, the moulding of the ornaments for the towers and decorations, and a thousand other arts necessary for the successful completion of such an undertaking."[25]

In 1853, as a result of the Gadsden Purchase, Bac became indisputably part of the United States, and subsequently San Xavier was added to Bishop Jean Baptiste Lamy's diocese of Santa Fe. Lamy's longtime companion and Vicar General, Father Joseph P. Machebeuf, later Bishop of Denver, visited the church twice in 1859 and initiated repairs which saved it from destruction. Under his direction the people of Bac applied a coat of mortar to the roof to prevent further damage from leakage in the domes. They also brought back to the church furnishings they had preserved in their houses, and Father Machebeuf was able to restore the church to religious use. He was delighted to discover that some of the villagers remembered the prayers and were able to sing at Mass.

Securing priests to remain at remote San Xavier was difficult. A Jesuit was briefly in residence in the 1860s and diocesan priests from Tucson made regular visits. In 1880, when he was Vicar General in Tucson, Jean Baptiste Salpointe, who later succeeded Lamy as Archbishop of Santa Fe, published a knowledgeable description of San Xavier. The Franciscans reestablished a priest in residence in 1913 and their current tenure now exceeds in years their original stay.

An earthquake had damaged the church in 1887, and in 1906 a building inspector had reported cracks in the dome and recommended covering it with copper. At that time, Bishop Henry Granjon of Tucson intervened to save and restore San Xavier. He clambered up the scaffolding in work clothes himself, had the exterior of the church plastered, and made extensive additions and alterations, substantially at his own expense. New buildings were built on the east range of the *convento* and two new entrances, one of them to the rear, the seven-arched Granjon's Gate. A new wall was constructed along the front of the church and the *convento*, and on the west side a new entrance was cut in the wall which surrounds the cemetery.

But the most remarkable of Bishop Granjon's changes was to have the whole complex painted white. Early photographs, beginning with those of Carleton E. Watkins of the 1870s, show the exterior apparently almost uniformly reddish brown in color like the frontispiece, and show the bricks of the unfinished east belfry unplastered. Bishop Granjon's paint crews transformed San Xavier into "the white dove of the desert." The present whiteness and the strong contrast of colors on the façade create an effect never intended by San Xavier's builders, whatever the original colors may have been. But as Reyner Banham has written, "the absolute, spectral whiteness . . . is emphatically not the wrong color

for San Xavier. It must be the most nearly perfect finish on any building in North America, and it prints on the retina of memory an image that will not go away."[26]

Preservation, not Granjon-style reconstruction, has been the concern in the subsequent work at Bac both in 1949 and more recently in preparation for the bicentennial celebration held in 1999. Funding was provided by the private *Patronato San Xavier*. Stabilization of the structure began in 1989 and restoration of the interior in 1992. An international team of conservators, recruited by Paul Schwartzbaum, chief curator of the Guggenheim Museum in New York, worked in Bac for three winter months each year. Four Tohono O'odham apprentices joined the team to learn their skills so that future restoration could be done by local people. Revival of the colors, expensive imported vermilion red and Prussian blue in addition to the local earth greens and reds, has been so complete that some visitors have assumed that the church was repainted. One surprising discovery was that the shepherd figure in the drum of the dome, believed to be Christ, the Good Shepherd, was female. What had seemed a beard was a woman's scarf. Interpretation is difficult; the Virgin as Good Shepherd seems an unlikely conception.

To bring such skill in conservation to a place as remote as Bac was remarkable, testimony to the knowledgeable loving care of Bernard L. Fontana, the resident Franciscan priests, and others in the region who support the Patronato San Xavier. Pride in the church and its restoration is evident in its reverential use by the people of Bac. The Spanish built other large and impressive churches in the United States, in San Antonio, in New Mexico, and in California, but only San Xavier survives substantially as it was originally created, preserved by a series of happy and timely interventions, and still treasured by its own people and by others from afar.

CHAPTER VII

California

The last of the Spanish provinces settled in North America was California. The coast as far north as the present Oregon border was explored as early as 1542–1543 by a small fleet initially led by Juan Rodríguez Cabrillo, who had been directed to sail on to China or to remain in California "if you find a good country where you can make a settlement."[1] The fleet landed in San Diego Bay and learned there of the arrival at the mouth of the Colorado River of a party from the expedition of Francisco Vázquez de Coronado. But Rodríguez Cabrillo died from complications resulting from breaking his upper arm; and sailing north after his death, the ships, repulsed by storms, were forced to return to New Spain. A second coastal exploration led by Sebastián Vizcaíno in 1602–1603 was dispatched because of fears for Spanish territories aroused by Sir Francis Drake's passage in 1579. Vizcaíno recommended an immediate settlement on a bay he named for the current viceroy, the Conde de Monterrey. But the succeeding viceroy, the Marqués de Montesclaros, abandoned the project, believing that a settlement would arouse foreign interest and that California would be protected by its remoteness.

Spanish settlement of Baja California began with the efforts of Governor Atondo y Antillón and Father Eusebio Kino between 1683 and 1685 and became permanent after the landing in 1697 of Kino's friend Father Juan María Salvatierra. The sixteen missions established by the Jesuits were not located in Indian towns. Rather the Indians were induced to congregate in *reducciones*, mission communities under Jesuit discipline where they were taught Catholic Christianity, the Spanish language, and some basic elements of European living. Ideally all the Indians would have been collected in the mission pueblos, but their numbers and the limitations of water and food supplies in the arid Baja forced a compromise. Many Indians were brought from their own villages to the missions for month-long periods of religious indoctrination, and priests from the missions made periodic visits to the villages. The system of *reducciones*, used by the Jesuits in Baja California and in regions with nomadic peoples by other orders, would later be adopted by the Franciscans in Alta California.

The belated Spanish settlement of upper California was the result of the vision and determination of José de Gálvez, who spent the years between 1765 and 1771 in New Spain as Visitor General for King Carlos III with powers that in some regards exceeded those of the viceroy. Gálvez, who was to be appointed Secretary of the Indies in 1776, believed that decisive action was necessary if Spain was to protect its northern Pacific coast from Russian fur hunters and English explorers seeking the North-

west Passage through the continent. "Certain foreign powers," he wrote to the king in 1768, "now have an opportunity and the most eager desire to establish some colony at the Port of Monterey."[2] Spanish interest in Monterey originated in Vizcaíno's recommendation and had been revived in Father Kino's aspirations for expansion to the northwest.

Shortly after Gálvez wrote to the king, he left Mexico City for Baja California intending to lead an expedition to Monterey. A missive from the viceroy, accompanying the letter of royal approval which was forwarded to him, prohibited his going to Monterey himself because he was needed in New Spain. As a result Gálvez was forced to find leaders for the expedition in Baja California. Captain Gaspar de Portolá, the governor who had supervised the expulsion of the Jesuits, was selected as overall commander, and Junípero Serra, president of the Franciscans of the missionary college of San Fernando in Mexico City (who had recently replaced the Jesuits), was the logical choice for religious leader. Gálvez led the overall planning of the settlement of California and immersed himself in details. He selected sites for three missions, in Monterey and San Diego, and in San Buenaventura halfway between. He determined that the travel would be by sea and by land, by two packet boats and by two parties marching north. He helped recondition one of the ships, helping apply tar derived from a cactus, and he packed the vestments and sacred vessels intended for the mission of San Buenaventura as Father Serra, more slowly, packed those for Monterey.

Junípero Serra was a fifty-five-year-old Mallorcan, a former professor of theology who had served almost a decade in a mission in the Sierra Gorda, a mountainous area in northeastern Mexico which was not evangelized until the mid-eighteenth century. An indomitable five-foot-two, he drove himself on marches of several hundred miles despite sometimes disabling varicose ulcers on his legs.

On July 1, 1769, Serra arrived in San Diego with the second and larger land party which had been led by Governor Portolá on a forty-six-day journey from its assembly point in Baja California. The land parties consisted primarily of soldiers and of Indians from the missions of Baja California. They found those who had preceded them by difficult sea passage, Portolá wrote to the viceroy, "immobilized and in so unhappy and deplorable state as moved my pity."[3] Fifty-one had died of scurvy and other illnesses.

Serra remained in San Diego to found a mission, but within two weeks Portolá pushed on to reach Monterey by land. He was accompanied by some sixty men, including two future commandants of Alta California, Captain Fernando de Rivera y Moncada, who had led the first land party to reach San Diego, and Lt. Pedro Fages. Two Franciscans and the military engineer Miguel Costansó, sometimes spelled Costanzo, also went along. Forced by coastal California's mountainous terrain to travel primarily inland through areas never before glimpsed by Europeans, they found their way to Monterey Bay but failed to recognize it as the extensive protected harbor praised by Vizcaíno. Pushing north in search of Vizcaíno's bay, they discovered the great bay of San Francisco without identifying its entrance, the Golden Gate. Discouraged, and finally reduced to eating their pack mules, Portolá's party returned to San Diego to find only twenty men remaining alive. The return of the ship *San Antonio* from Mexico with supplies averted the abandonment of Alta California. In June 1770 Portolá returned to Monterey Bay, which he belatedly recognized as the bay described by Vizcaíno. He established a presidio "to occupy the port and defend us from attacks of the Russians."[4] Having completed his assignment from Gálvez, Portolá returned by ship to Mexico to report.

Miguel Costansó, who had participated at San Blas in the planning session for California's occupation chaired by José de Gálvez, initiated the building of the presidio at Monterey of vertical logs and earth

and then returned to Mexico with Governor Portolá on the *San Antonio*. He wrote a lucid history of the settlement of California and acted as a consultant to successive viceroys on matters pertaining to the province. He had an impressive career in Mexico, where he rose to marshal in the Royal Corps of Engineers, providing advice on drainage and water supply for the capital, designing there important buildings such as the mint and the tobacco factory, and serving as professor of geometry in the Academy of San Carlos.

Junípero Serra, who had established the mission in San Diego in the summer of 1769 with, as Costansó wrote, "modest buildings surrounded by a palisade of trunks of trees,"[5] had sailed with Costansó to Monterey in the spring of 1770 and founded the mission there. The first church at Monterey was an arbor of branches, and the second a room in the presidio. The mission, named like the presidio San Carlos by José de Gálvez to honor both King Carlos III and Viceroy Carlos, the Marqués de Croix, was shifted to Carmel in August 1771. Earlier that summer Father Serra wrote to his former student and future biographer Fray Francisco Palóu, who had remained in Baja California, that the community in Monterey consisted of twelve friars who all had cells which constituted a *convento* attached to but distinct from the presidio.

Three years after the removal to Carmel, Serra wrote to Viceroy Antonio María Bucareli that in "looking over the whole sweep of our conquests" he had become convinced of the great importance of adding four more missions to the five already established (San Antonio de Padua, San Gabriel, and San Luis Obispo in addition to San Diego and San Carlos). "If placed at proper intervals—say every twenty-five leagues . . . they would form from San Diego to here stepping stones, so that every third day one might sleep in a village . . . and travel through all the country [would be] made easy, and a postal service might be established."[6] Such a grand scheme was impossible without adequate military protection, Serra continued, writing that "a mission must have at least ten leather-jacket soldiers and a muleteer" to drive the mules essential in carrying supplies. A chain of missions, carefully distributed geographically and adequately staffed with soldiers, could consolidate the Spanish conquest of California.

Despite his pride in the Spanish occupation of California, Junípero Serra was constantly at odds with the secular leaders. He used his influence in Mexico City to have Pedro Fages replaced as commandant and excommunicated his successor, Fernando Rivera y Moncada. The ablest of the Spanish governors, Felipe de Neve, wrote to Teodoro de Croix, *Comandante General de las Provincias Internas,* of Serra's "unspeakable artfulness" and his pretense of "obedience to an authority which he in reality eludes." At another time he described Serra as being "as wise as the serpent" if appearing "as harmless as the dove."[7]

The disputes arose from Serra's insistence on the separateness of the missions from secular life and secular authorities. Serra was eager for military support but would brook no directions from the military officers who served as governors and who were convinced that they partook of the *patronato real*, the royal power over the church, and who regarded missions as subsidized agencies of the state serving to civilize Indians and transform them into colonial citizens. Governor Neve, a man of the Enlightenment, disapproved of the missionaries' insistence on regulating the lives of their neophyte Indians, who he thought were treated "worse than slaves." In Neve's view the California missions should have been opened to Mexican-born settlers who would help Hispanicize the Indians. Neve founded civilian communities at San José and Los Angeles, to the annoyance of Serra, who believed that California should be a province of the Franciscans and their Indians, uncontaminated by the sex-hungry soldiers and loose-living settlers. Serra's

successor as president of the California missions, Fermín Francisco de Lasuén, was more tactful in dealing with secular authorities but equally adept in getting his way.

Throughout its three-quarters of a century of existence, Hispanic California was dependent on supplies sent by sea from the unsatisfactory port of San Blas. In the early years tools, liturgical supplies, and the foodstuffs necessary for survival came by ship—maize, wheat, beans, ham, chocolate, sugar, wine, and brandy. But contrary winds and currents made the passage difficult and uncertain. In 1772 fierce head winds prevented either of the scheduled transport ships from reaching Monterey. Daily rations for the Franciscans were reduced to half a pint of corn, twenty ounces of flour, and a little milk. As late as the spring of 1774 both the soldiers at Monterey and the missionaries at Carmel were weak from hunger.

Earlier that year Captain Juan Bautista de Anza had set out from his presidio of Tubac in present-day Arizona to realize Father Eusebio Kino's old dream, a land route to supply California. Accompanying Anza was the resolute explorer of San Xavier del Bac, Fray Francisco Garcés, and an Indian, Sebastián Tarabal, who had escaped from the recently founded mission of San Gabriel in the area which would become greater Los Angeles. The party crossed the Colorado River near the villages of the Yuma Indians but were turned back by the seemingly impassable dunes of the Colorado Desert. Returning to the river they made a second attempt and found a path which skirted the dunes and led eventually through the San Jacinto Mountains into the Los Angeles Basin. Anza's small party of thirty-one, including eight Indians, paused briefly at San Gabriel and then pushed on to Monterey. Anza then returned to Tubac, having traveled roughly two thousand miles in five months, and almost immediately set off on another fifteen-hundred-mile trip to Mexico City to report to Viceroy Bucareli.

The viceroy recommended Anza for promotion to Lt. Colonel and ordered him to return to California and to select a site on San Francisco Bay for a presidio. Anza's substantial second expedition included thirty soldiers and their families from Tubac, who would remain in California, and a few civilian settlers. Over half of the group were women and children. Anza set his pace accordingly. One woman died in childbirth, but three others and their newborn infants survived. Having left Tubac on October 23, 1775, with 240 people, he arrived at San Gabriel on January 4, 1776, with 242, doubling the Spanish presence in California.

Father Garcés had left the expedition at the Colorado River to prepare the Yuma Indians for missionary activity. Ever restless, he crossed the Mojave desert from the site of present-day Needles to San Gabriel and then moved some five hundred miles east to the Hopi villages in northeastern Arizona before returning to Yuma. Despite Garcés's persistent urging, nothing was done with the Yumas at the critical crossing for four years, until 1780. Then two villages protected by a few troops were established with Garcés and other priests in residence. By that time the Yumas had become less friendly, in part because of disappointment in their expectations of gifts from the Spaniards. The following year a party destined for California and led by Captain Fernando Rivera y Moncada stopped at the crossing, irritating the Yumas with demands for food, and damaging their fields with nearly a thousand hungry animals. On June 17, 1781, the Yumas turned on the Spaniards, beating Garcés and three other missionaries to death with war clubs and killing Rivera and the soldiers who'd remained behind with him. Over a hundred were killed, including thirty-seven soldiers, forty-three adult settlers, and twenty-one children. The Yuma crossing was never reopened by the Spaniards, and California settlement was handicapped by its total dependence upon the uncertainty of ships beating up the coast

against wind and current. Kino's dream of expansion along the Gila River and beyond, which had been revived by Garcés, was never realized.

The Missions

Fray Junípero Serra died in 1784 and was buried in the sanctuary of the old adobe church of Mission San Carlos in Carmel. His successor from the Basque region, Fermín Francisco de Lasuén, had served in the Sierra Gorda and in Baja California, not reaching Alta California until 1773. He served at San Gabriel, made an initial effort to found a mission at San Juan Capistrano, and served several difficult years at Mission San Diego. During Serra's fifteen years as president of the California missionaries, nine missions had been founded: San Diego, San Carlos, San Antonio de Padua, San Gabriel, and San Luis Obispo in the first four years (1769–1772); San Juan Capistrano, San Francisco, and Santa Clara in the years 1776 and 1777; and finally San Buenaventura, which, although it had been projected as an original mission by José de Gálvez, was delayed by the scarcity of available soldiers and not founded until 1782, two years before Serra's death. During the presidency of Fermín de Lasuén nine more missions were established, beginning with Santa Barbara in 1786 and concluding with San Luis Rey in 1798. The most architecturally impressive of California mission churches—San Carlos, San Gabriel, and the ruined stone church of San Juan Capistrano—were completed during Lasuén's tenure. Three more missions were added in the nineteenth century, the last and northernmost San Francisco Solano near Sonoma in 1823.

Father Serra and the other Franciscan missionaries of Alta California inherited two important things from the Jesuits who had preceded them in Baja California. One was fiscal support from the Pious Fund conceived by Eusebio Kino, Juan María Salvatierra, and Juan María Ugarte. The Jesuits had secured permission from the viceroy to solicit private funds to support missionary work in California after the royal government had decided in the late seventeenth century to expend no more of its limited resources on the effort. After the suppression of the Jesuit Order in 1767, the Spanish government assumed the role of trustee for the fund and subsequently the Mexican government continued to administer it for the support of the Franciscans.

Serra and his friars also followed the policy of congregation established by the Jesuits in Baja California and adopted by the College of San Fernando in the Sierra Gorda. In words echoing those of Father Juan Rogel, an early Jesuit in Florida, Father Pedro Pérez de Mezquía, the president of the College of San Fernando, had written that the Indians of the Sierra Gorda were to be induced to abandon their customary life of hunting for food in scattered bands and to gather about the missions to "live in community as was practiced in the beginning of the church." Essential to attracting the Indians was providing easy sustenance from mission crops and mission herds. Once under the supervision of the mission priests, the Indians could be indoctrinated in Christianity and compelled to attend daily prayers and Sunday Masses. Father Mezquía explained that the missionaries should "bring together each day at sunrise in the church at the sound of the bell all adult Indians, male and female, the pagans and the neophytes, without any exception. One of the fathers is to recite with them the prayers and text of Christian doctrine and to explain to them in Spanish the principal mysteries of religion."[8]

As the California missions developed, they became quasi-industrial as well as spiritual institutions, producing goods to supply nearby presidios and, ultimately, for export. In his introduction to his edition of the letters of Fray José Señan, a missionary who served at San Carlos and for many years at San Buenaventura, Lesley Bird Simpson summarized the "endless and apalling" duties of a missionary in such an industrial-spiritual enterprise. "He had to attend to everything; planting, culti-

vating, and harvesting the crops; breeding and slaughtering the cattle, sheep, and hogs, rendering out the prodigious quantities of tallow and lard and packing it in skins, which had to be manufactured for the purpose, making soap; shearing the sheep, carding and baling hemp and wool; weaving blankets; dressing hides and other pelts; marketing the mission produce through a lot of chiseling traders; and even keeping the account books.... All this in addition to his heavy spiritual duties; teaching the neophytes, baptizing, marrying, and burying them; nursing the sick, and chastising the naughty; staging festivals; preaching sermons and saying Mass we know not how many times a week."[9] The Indians provided the labor but the missionaries had to instruct them and oversee their work.

Many Indians did not fully appreciate either the heroic labors and sacrifices of the friars or the ordered, confined life of their missions, regulated by an unfamiliar bell time in a community numbering close to a thousand or more, in one case nearly three thousand. Many fled to resume their old, unregulated seminomadic life in bands of less than a hundred where the rhythms of daily life were not determined by mission bells or sundials. The friars did not regard Indians who had converted to Christianity as free to revert to paganism and attempted with detachments of soldiers to capture the deserters and to force them to return to Christian mission life.

California Indian women, who had less power in their societies than Pueblo women, found their life in the mission, with utensils for preparing and cooking food, ovens for baking, and looms for weaving, easier and in some ways preferable to their former nomadic life. Father Lasuén was impressed by their docility, writing in 1801 that the women "never object or show any dislike for the work we assign. They are not so much given to running away."[10] But the friars were uneasy with the sexuality of unmarried women. From the time the earliest missions were founded, separate buildings, *monjérios*, were constructed as living quarters for women from the age of eight or nine until they married, and for widows. The women were locked in for the night and lived a conventlike existence, instructed in Christianity and Spanish ways of living by instructors, *maestras*, who were often pious wives of soldiers or particularly well-trained Indian women.

As in all parts of America, exposure to disease-carrying Europeans, intensified in the confined life in the missions, was fatal to the majority of Indians. The traditional medicine of the California Indians, centered in sweat baths in underground chambers called *temescales*, followed by immersion in cold water, provided no protection against epidemics of mumps, measles, and smallpox or against dysentery and venereal diseases. The medicine of the friars was little more effective, although hospitals were constructed, in part to segregate those with contagious diseases.

The friars' concern for Indian mortality was expressed in reports to the College of San Fernando of the Commissary Prefect, Fray Mariano Payeras, in 1819 and 1820. The populous southern missions of San Gabriel, San Juan Capistrano, and San Luis Rey, he wrote in 1819, "have built chapels in their hospitals, in order to administer the sacraments to the sick more conveniently.... The majority of the Indians were dying exceedingly fast from dysentery and the *galico* [syphilis]." A year later he generalized, "The Indian population is declining. They live well in their free state but as soon as we reduce them to a Christian and community life they decline in health, they lose weight, sicken, and die. It particularly affects women. It is a sorrowful experience of 51 years that the Indians live poorly in the missions. Even when they remain healthy, the women lose fertility."[11] The Indian women were more reticent than their men in protesting against the regulated life of the mission, but their lives were comparably blighted by it.

The friars were torn between their growing awareness of the effect of mission life on Indian

mortality and their conviction that eternal life could be secured for the Indians only through conversion to Christ. Massive efforts were made to replenish mission populations with fresh contingents of neophytes, but populations began to decline long before the missions were secularized by the Mexican government in the years after 1834. Mission San Carlos, headquarters for the Franciscans, reached its maximum population as early as 1795, twenty-five years after it was founded and while its stone church was still under construction.

The Presidios

Presidios were regarded from the beginning as essential to the defense of California against Russian and other foreign threats. The presidios of San Diego and Monterey were founded in 1769 and 1770 coincidentally with their missions. The construction of a northern presidio on San Francisco Bay in 1776 resulted from orders from Viceroy Bucareli to Lt. Colonel Anza. A final presidio, midway between San Diego and Monterey, was founded at Santa Barbara in 1782, four years before the nearby mission. Ultimately California was divided into four military-civil districts with the presidio commanders acting as deputies of the governors.

Since the damp climate induced rot, the palisaded defensive wall and buildings of the headquarters presidio at Monterey were soon replaced by construction of adobe bricks. A letter from the commandant of Alta California, Pedro Fages, gives a very detailed account of the presidio's ongoing transition in 1773.

Three years later Lt. José Joaquín Moraga, who had been second in command of Juan Bautista de Anza's second expedition, led a party of "sixteen . . . soldiers, all married and with large families, seven colonists likewise married and with families, some workmen and servants of the foregoing, herdsmen, and muleteers driving the presidio cattle and the packtrain with provisions and utensils necessary for the journey"[12] from Monterey to the site on San Francisco Bay selected earlier by Juan Bautista de Anza. Moraga, who directed the construction of a presidio nearly twice the size of Monterey's original quadrangle, has left us a drawing of 1776 showing bastions at two opposite corners. This plan was adopted six years later at Santa Barbara by Governor Felipe de Neve and Lt. José Francisco Ortega. No representations of the first presidio, San Diego, before 1802 are known.

When Felipe de Neve arrived from Baja California in 1777 to become the first governor resident in Alta California, he found the three existing presidios indefensible. He had a fourth presidio placed at Santa Barbara, presumably more solidly constructed, and saw that the older presidios were rebuilt. He was able to write to Teodoro de Croix, *Comandante General de las Provincias Internas*, that defensive walls and bastions with stone foundations had been completed at Monterey enclosing an area more extensive than the original presidio.

After Neve's time in office, which concluded with his appointment in 1782 as Inspector General of the *Provincias Internas* followed by his appointment to succeed Teodoro de Croix as *Comandante General*, the presidios regressed. The adobe walls of the presidio of San Francisco had been rebuilt after they collapsed during the wet winter of 1778–1779, but Captain George Vancouver found only three walls standing in 1792. Vancouver explored the northwest coast of America for the British government again in 1793 and 1794. In 1794, the viceroy, the Marqués de Branciforte, probably disturbed by news of Vancouver's visits, asked Miguel de Costansó to consider the problem of the defense of California and to prepare a report. Costansó was not encouraging in regard to a military solution. The soldiers presently in California, he wrote, were fully occupied assisting the missionaries in "reducing the numerous pagans . . . to a centralized and Christian life," and an additional corps of troops would be

necessary to garrison and adequately defend the presidios. Forts of brick and mortar were essential but greatly expensive for the already stretched royal treasury. Even breastworks of earth faced with adobe for the entrances to the ports of San Diego, Monterey, and San Francisco would cost about 8,000 pesos each.

Instead of massive military expenditures, Costansó argued, "the first thing we should consider is populating the territory." The admirable missionary effort called for more presidios and more troops and was a limitless drain on the royal treasury. The Indians, Costansó wrote, should be instructed "in the arts which are demanded by society of *gente de razon* (as Europeans, Spaniards, Creoles, and the people of mixed blood are called . . .) provided they are hard working and useful." Navigation along the Pacific coast should be increased. "In these vast North American Coasts . . . the King does not possess a single vassal who is the owner or proprietor of one sloop . . . or . . . other type of coastal vessel." As long as maritime inactivity was allowed to persist, he argued, "the royal treasury will not receive any funds. . . . But if shipping is promoted and franchises are granted the demand for goods and merchandise from Europe and the nation will increase immediately. . . . The colonists of the Californias will be able to have a market for their materials and their manufactured goods. Fishing for sardines, salmon, and tuna . . . will be items of profit for them."

Costansó concluded by stating that his solution to the California problem, which was essentially capitalistic and would have incorporated the mission Indians in the world economy, would be "sufficient at this time to make these colonies flourish and to prepare to defend themselves and later to depend upon themselves."[13] In the twilight of Spanish sovereignty in North America, Costansó's recommendations recalled the buoyant expansiveness of Cortés and the other conquistadors of the sixteenth century and, more recently, of Father Kino and José de Gálvez. He anticipated the California which materialized after its conquest by troops of the United States just over half a century later.

Towns for Civilians

In a way more limited than Costansó's proposal, the presidios did provide the nuclei for civil settlements and civilian economic activity before the formal establishment of pueblos, as they had in San Antonio, Texas, and in other earlier Hispanic communities. Presidios were normally placed at a distance from the shore to minimize the potential effect of hostile ships' guns. Except in Monterey, a variety of modest shelters grew up around them from the time of their foundings. Seven settlers were included in the party which founded the San Francisco presidio and its nearby mission. Santa Barbara had in 1785, before the founding of its mission, 203 residents including 47 women. By 1827 when there were several hundred, a French visitor, Auguste Bernhard Duhaut-Cilly, reported around the fortress a scattering of "from sixty to eighty"[14] small houses. A similar village began to take form at Monterey in the Mexican period after 1822, becoming the nucleus of the present city.

In 1773 during his visit to Mexico City, Junípero Serra had suggested that settlers of "respectable Spanish families" be sent to California to reinforce his missions, and later that year, in instructions to the new *comandante* of Alta California, Captain Rivera y Moncada, Viceroy Bucareli expressed his concern for town building. The primary concern was for mission towns for Indians. "These little towns," he wrote, "may become great cities."[15] But he also specified that Spanish settlers should be given land in the towns and that they, like the Indians, should be required to live a civilized communal life and not allowed to live dispersed through the countryside.

After Governor Neve replaced Rivera y Moncada, he reported to Bucareli that two sites appro-

priate for pueblos had been identified, one in the north and one in the south, and asked him to recruit forty to sixty prospective settlers. Without delaying for a favorable response, he selected nine soldiers from the presidios of Monterey and San Francisco who had been farmers and five civilians who had arrived with Anza to settle the northern pueblo. He ordered Lt. José Moraga, who had founded the San Francisco presidio a year earlier, to lead them and their families, sixty-eight people in all, to a place on the Guadalupe River south of San Francisco Bay and a few miles northeast of the Santa Clara Mission. In November 1777 Moraga marked out the central plaza and distributed house lots for the town of San José de Guadalupe. "He measured off for each [settler] a piece of land for planting. . . . They also proceeded to build a dam to take water from the Guadalupe River . . . to irrigate the fields."[16]

The site selected by Moraga was low and was frequently flooded. Twenty years later, after many floodings, the pueblo was relocated more than a mile to the south on higher ground. Streets in the new layout were twenty-eight feet wide, and in 1798 the plaza contained an adobe town hall. Like other Spanish settlements in the United States, San José lacked the orderly arrangement prescribed in the Ordinances of Settlement. The streets were described as nonexistent or at best "irregular, every man having erected his house in a position most convenient to him."[17]

In 1781 a *reglamento* for California, which had been drafted by Neve in 1779, was approved by the viceregal and royal governments. Title Fourteen defined the purpose of the new civil settlements, to "encourage tilling, planting and stockraising, and in succession the other branches of industry, so that in the course of a few years their produce may suffice to supply the Post-Garrisons with victuals and horses . . . thus freeing the Royal Treasury from the forced costs which it is now under to meet these ends." Each settler was to be paid three and a half *reales* each year for the first two years and about half as much annually for three more. They were provided with rations, tools and livestock. The pueblo at large was to receive more animals, "one forge . . . six crowbars, six iron spades and the necessary tools for Carpentry and Wagon-making."[18]

San José did fulfill its intended purpose as an agricultural community. As early as 1781 the settlers produced enough grain to supply the two northern presidios. But population growth was modest, extremely slow at first, reaching only eighty in 1790, and then somewhat more than doubling in the next decade.

Neve corresponded with *Comandante General* Croix regarding a second, southern, pueblo, and in the spring of 1781 he went south to Mission San Gabriel to meet a party of settlers sent overland from Loreto in Baja California. He remained to oversee the founding of El Pueblo de la Reina de Los Angeles on a site he had selected in the valley of the Porciúncula River about ten miles southwest of San Gabriel.

The third civil settlement of Spanish California at the northern end of Monterey Bay was a particular project of a viceroy, the Marqués de Branciforte, who granted it the status of *villa* and for whom it was named. In 1796 Governor Diego de Borica and engineer Alberto de Córdoba chose the site and Córdoba drew a plan for a large plaza with a church at the center of one side. Borica rejected the plan because it included only the church and house lots and omitted sites for governmental buildings. Apparently a revised plan was approved, and in early 1797 Córdoba reported that he had completed his surveys and that a number of houses had been built.

As in the case of the pueblo of San José and Mission Santa Clara, the locating of Branciforte near Mission Santa Cruz drew protests from the Franciscans for encroaching on mission territory and led to extended legal haggling. The matter was again settled in favor of the civilian settlement, but the protracted dispute blunted growth. Although the houses were to be constructed at royal expense,

"houses of adobe, roofed with tile, and shuttered windows . . . [the cost] not to exceed 200 pesos,"[19] few were built. Six years after its foundation Branciforte had only twenty-five houses and just over a hundred people. Funding for the houses had not arrived from New Spain, and the best agricultural lands in the area were controlled by Mission Santa Cruz. Unlike San José and Los Angeles, which grew eventually into important cities, Branciforte withered despite its initial viceregal patronage. The few settlers moved off to more promising places.

The modest population of California and its racial makeup was revealed in the census of 1793. Only 32 European-born Spaniards were reported as residents, 28 of them Franciscans and the remainder officials and officers. Four hundred thirty-five were counted as Spaniards of American birth. Mulattoes totaled 183 and *castas* of mixed blood 418. The 3,234 mission Indians approximated three times the total for the four other categories.

Artisans

Essential to the notable architectural progress evident in California after 1791 was the arrival of trained artisans in the building trades from New Spain, primarily from the western region governed from Guadalajara. During the first twenty years California had been limited by its lack of craftsmen. Spanish regulations specified the presence of a carpenter and a blacksmith at each presidio, but in California the presidios had at best the services of visiting ships' carpenters and soldiers who had some experience in the crafts. Father Serra had brought three carpenters and three blacksmiths with him in 1774 when he returned from an extended stay in Mexico City, where he had made his college and viceregal officials aware of the needs of his friars. Some of these artisans remained, but others left after brief periods of contracted service. In 1787 Pedro Fages, who had returned to California as the successor to Governor Neve, wrote to the viceroy that his presidio at Monterey had neither a blacksmith nor a carpenter and proposed that artisans convicted of crimes be released from jail and exiled to California to serve the remainder of their sentences and to remain as settlers. At least three convict-artisans did arrive in California. Three years later Governor Fages requested fifty-one mechanics as well as teachers, millers, and a surveyor. The first four or five artisans assigned to teach their trades to Indian neophytes arrived in March 1791. Among them were the master stonecutter Manuel Esteban Ruiz and his two journeymen, Joaquín and Salvador Rivera. Nine more artisans, five of them in the construction trades, arrived the next year. They included master stonecutter Santiago Ruiz and his journeymen Manuel Doroteo and Pedro de Alcántara Ruiz, who were probably his sons, master carpenter José Antonio Ramírez, and master carpenter and millwright Cayetano López.

Because of the need and the difficulty in attracting artisans, pay in California was higher than in Mexico City. One master stonecutter, Manuel Esteban Ruiz, received eighteen reales a day and another, Santiago Ruiz, fourteen. Journeymen received between twelve and seven a day instead of the six or five they would have received in the capital of New Spain. Master carpenters received as much as eleven reales a day. Mardith K. Schuetz-Miller, our leading student of the Hispanic artisans of California and of the San Antonio area, has suggested that Manuel Ruiz received his strikingly high salary as an inducement to attract the other three members of the Ruiz family of masons.

Initially a dispute arose between the secular authorities and the Franciscans as to the place where the artisans would train the neophytes, the presidio or the mission. Father Lasuén was awarded the power to assign the artisans and in 1794 brought master mason Manuel Ruiz and journeyman Joacquín Rivera to Mission San Carlos. Manuel Ruiz had been directing the construction of the presidio chapel in Monterey, where he was replaced by San-

tiago Ruiz. All the artisans who arrived in 1791 and 1792 worked at Monterey or in nearby northern missions. By late 1795 Governor Diego de Borica reported to the viceroy that the training of neophytes had progressed sufficiently that Mission San Carlos had eight moderately trained Indian carpenters, eleven Indians working as stonecutters and masons, and two at blacksmithing. Earlier that year Borica, reversing the view of his predecessor that California had enough artisans, had requested fifteen more but only a few arrived, none of them masons. By 1797 only two masons remained, the others had completed the terms of their contracts and had returned to New Spain.

Construction in California

Building in California in the early years before the arrival of any artisans had rapidly evolved from temporary work using plastered vertical and forked branches and pine palisades to more durable construction with walls of adobe bricks covered by flat roofs of brush and dirt supported by projecting horizontal *vigas*. These roofs were later replaced by thatched roofs supported by wooden frames, which were superior in keeping out the rain in winter but were extremely vulnerable to fire. Adobe-making was easy and particularly desirable in the south where timber was scarce. Fray Estevan Tapis of Mission Santa Barbara explained that the local soil was soft and that water was readily available. "Nine men will make three hundred and sixty adobes a day, which is forty for each one. . . . Those who work at this task never labor after eleven o'clock in the morning, and never on Saturday, nor many times on Friday, because during the first days of the week they have accomplished the task . . . and are then free."[20]

More permanent construction materials, tile for roofs and burned bricks for chimneys and architectural ornamentation, came into use after the early years. The present church of Mission San Buenaventura, begun about 1793, was the only structure of Spanish California to be built entirely of fired bricks. The use of roof tiles, which began at Mission San Antonio de Padua in 1776, became widespread in other missions and now seems an essential element of the California Hispanic style although tar was commonly used for the roofs of houses. In tile-making the clay mud was sometimes trampled in pits by horses and mules and was laid out on flat boards and then shaped on half-round tapering molds of roughened wood. The tiles were next dried in the sun, like adobe bricks, and finally were baked in small kilns. Flat tiles, *ladrillos*, were used for floors, and sometimes for chimneys and for the lanterns of domes.

Construction in stone became possible only after the arrival of the skilled stonemasons from New Spain. Buildings with walls of carefully cut stones and of *mampostería*, unshaped rubble stone set in mortar of lime and even of mud, were constructed. But stone construction was unusual. Only four mission churches—San Carlos of Carmel, San Gabriel, Santa Barbara, and the ruined church of San Juan Capistrano—and the chapel of the presidio of Monterey were constructed of stone. And of these only San Gabriel and San Juan Capistrano had vaults completely of stone. After the earthquake of 1812, which destroyed the stone church at Capistrano, construction in California became less architecturally ambitious. Even the stone church of Santa Barbara and the great church of Mission San Luis Rey had roofing of timber and tile.

Decoration

Normally walls of structures in California, even *jacales* of branches, were plastered and covered with whitewash both outside and in. The whitewash provided a base for painted decoration. Dry fresco, painting on whitewash or on dry plaster with water-soluble colors, was widely used in California on both inside and outside walls. A notable instance of a

painted exterior was the now lost façade of Mission Santa Clara, painted in the Mexican period in 1835 by Agustín Dávila, with giant paired columns at the sides and a niche over the entrance.

Decoration of California church interiors differed from the virtually unchanging folk tradition of New Mexico. In the nineteenth century, neoclassical motifs, fashionable in metropolitan New Spain, began to replace the older baroque ornamentation. Artisans were varied, ranging from the missionary Fray Estevan Tapis, who decorated the 1794 church of Santa Barbara, to itinerants such as Agustín Dávila, who worked at San José as well as Santa Clara, and from Thomas Doak, an American sailor who executed Father Tapis's designs at San Juan Bautista, to residents such as the Barcelona-born Estebán Munras, who stenciled charming neoclassical designs to the interior of San Miguel, the only California mission church to survive with its decoration virtually unaltered (Fig. 7.1).

Indian artists were employed widely as decorators. They are reported to have done all the work at San Buenaventura. The painter Juan Pacífico was employed there and at nearby Santa Barbara. Friars oversaw the painting and were intent on having European types of ornamentation. At San Antonio de Pala, a branch chapel (*asistencia*) of Mission San Luis Rey which was decorated by its Indians, there were a few traces of Indian motifs. More extensive indications of Indian taste were evident at Mission San Fernando before it was destroyed in an earthquake. San Fernando originally owned a remarkable series of paintings of the Stations of the Cross which are now on display at Mission San Gabriel.

These paintings, probably painted in 1806 and 1807 for the third church of San Fernando which was dedicated in November 1806, seem to have been the work of Juan Antonio, who was known as "El Indio de la Via Crucis." They were painted on sailcloth stitched together to make canvases measuring fifty-two inches wide and thirty-two inches high. Some have been trimmed at the edges because the

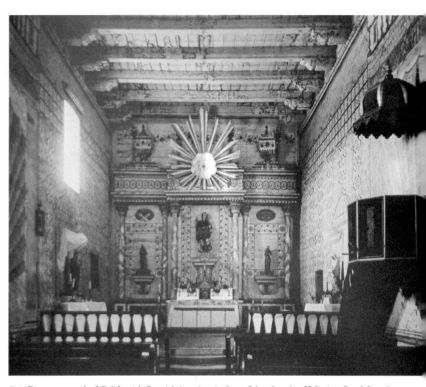

7.1. Best preserved of California's Spanish interiors is that of the church of Mission San Miguel Arcángel decorated by Estebán Munras, largely with designs taken from pattern books. The wall behind the pulpit and that opposite it are painted with stylized shell forms framed by pilasters. Above are representations of classical cornices and of balustrades. Flanking the sanctuary are domed tabernacles behind the statues and alternative strips of geometrically ordered floral decoration. The *retablo* is dominated at the top by a sunburst emanating from the divine eye in a triangle, representative of the Trinity, similar to that in the great seal of the United States and appearing on the back of a dollar bill; to its sides are florally ornamented vases. The six sprightly columns below have two-tiered blue and red capitols and blue fluting above and below swirling patterns of marblization. Photograph by Adam C. Vroman.

canvases had been damaged before they were discovered on their old stretchers in the belfry of the Plaza Church in Los Angeles. They were then mounted on boards and sent to Chicago in 1893 for display at the World's Columbian Exposition. The fourteen episodes were probably loosely based on a series of prints illustrating the Way of the Cross, possibly contained in a book in the mission library. A few of the stylized, flattened scenes show traces of sources composed in correct three-dimensional perspective.

Much of the charm of the paintings is in their bold naiveté. The organization of several is around a giant cross placed parallel to the picture plane and sloping slightly upward from the bent shoulders of Christ. The stupid and brutal soldiers wear exotic, wonderfully decorated Middle Eastern headgear. Diverse background figures, one blowing a trumpet,

Chapter VII

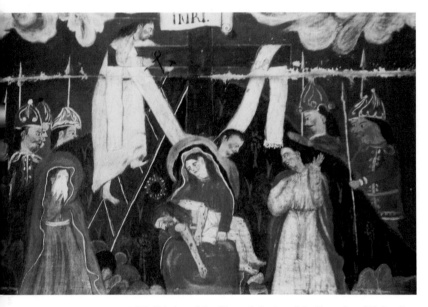

7.2. Painting of the thirteenth Station of the Cross, from Mission San Fernando Rey, now on display at Mission San Gabriel. Also see Plate XII.

7.3. Plan of the Monterey presidio, c. 1771, generally similar in arrangement to the later description of Pedro Fages. In this plan, on the upper right, the chapel then in use, A, is located below the southwest bastion; in addition, a new chapel, B, is to the left of the bastion. Reproduced in John W. Reps, *Cities of the American West*, fig. 4.2.

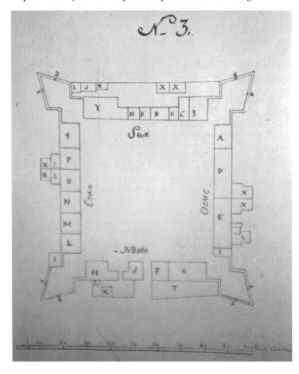

places at one side Pilate against a white background, jaunty on a tilting chair, and at the other side, Christ being lashed, meekly tied to a curious white pillar suggestive of a chess piece. The sequence culminates in the twelfth, thirteenth and fourteenth scenes. The twelfth, "Jesus Dies on the Cross," portrays Jesus between the two thieves who are tied to their crosses. The Marys and John face us at the base of Christ's cross, and the sun and a crescent moon frown in the upper corners of the canvas. The Marys and John are also in the foreground of the thirteenth, "The Body of Jesus Is Removed from the Cross," the Virgin cradling her blood-stained, angular, diminutive son (Fig. 7.2). To the sides are spear-bearing soldiers with sprightly decorated hats, and above, a white-garbed figure poised precariously on a tilting ladder pulls nails from the cross which is draped in a long white clerical vestment. Strangest and most powerful is the final station, "Jesus Is Laid in the Sepulchre." At the sides are tiny, sleeping, in one case seemingly dead, soldiers. At the center is a huge white box set in powerfully incorrect perspective against limitless blackness. Faintly traced and not initially legible is a rendering of Christ's body on the lid of the box, a ghostly echo of the recumbent figures on medieval tombs.

Monterey and Mission San Carlos Borromeo of Carmel

The Presidio

Monterey, which had been identified in 1602 by Sebastián Vizcaíno as a promising place for settlement, remained the seat of government from its belated settlement in 1770 until the end of the Spanish period. Gaspar de Portolá established the presidio on June 3, 1770, after leading a second expedition by land from San Diego. He had been joined by Junípero Serra and Miguel Costansó who arrived on the ship *El Príncipe*. Costansó selected a site for the presidio on elevated land some hundreds

are mounted on black and white horses with odd, abstract faces, some suggestive of cubist renderings.

The emotional power of the paintings comes from the artist's empathy with the suffering Christ. The first station, identified as "Casa de Pilato,"

of yards back from the beach at the southern end of Monterey Bay, close to the midpoint of a large cove which was protected from the open Pacific by the Point of Pines. He measured and marked out the foundations on the ground and supervised the construction of warehouses to protect the supplies, arms, and powder of the presidio. After little more than a month in Monterey, Costansó left by ship for New Spain with Governor Portolá. An unsigned plan of the presidio of the early 1770s in the Archive of the Indies in Seville was probably drawn by him (Fig. 7.3). More formidable in appearance than what was actually built, it shows a square enclosure with walls approximating 140 feet in length, pointed angular bastions at the four corners, and buildings lining the interior walls.

Father Serra slept on the ship at first and said Mass in an arbor of branches on the beach. On the last day of June, he wrote that he was "busy building a small cabin of wood for my abode, which at the same time has to be used as a storehouse . . . for everything the boat brought for the church and our living quarters, and for our provisions, and as a church when we say mass."[21] A few days later he explained that "the men from the ship got the church ready—the middle part of the storehouse."[22] A fuller account is provided in Palóu's *Life of Fray Junípero Serra*. "Adjoining the presidio they built a chapel of palings to serve as a temporary church, and living quarters with their respective rooms or compartments for the use of the fathers, and the necessary workshops."[23] Both establishments were surrounded by a stockade for their protection. The plan of the early 1770s shows both an "actual" and a new chapel, modest-sized buildings close to the southwest bastion.

A soldier, Mariano Carrillo, described the building of the presidio in a letter of December 21, 1772. There being no workers but sailors and soldiers, the soldiers were set to work as "woodsmen and muleteers." "After having unloaded *El Príncipe* we started . . . on the construction of the presidio, laboring from sunrise to sundown, without any rest during the day, except the time we spent for our meals. . . . The amount of work at cutting timber was set as follows: fifty logs of from three to four *varas* [nearly nine to nearly twelve feet] in length, if of good width, if they were thin sixty must be cut daily. The work of those who transported the logs depended on the distance they had to carry them. In everything else, however, a day's task was rigidly set so that no one had any spare time during the day." *Comandante* Fages set the soldiers to work at other tasks than cutting and hauling timber. He had "some of us mixing clay for adobes, others making them, some carrying mud in carts to plaster huts, others doing the plastering, some sawing boards and others making lime kilns."[24]

Father Serra was not encouraged by the response of the natives to his mission attached to the presidio. He wrote that they had initially been frightened away by "the many volleys of artillery and muskets fired by the soldiers."[25] A year later Serra, after describing to Fray Francisco Palóu (who had remained in Baja California) a new *convento* built of adobe with cells "plastered and whitewashed with lime" and fitted with doors and locks, wrote that the community of twelve friars were to leave Monterey for a site a few miles south at the other end of the peninsula near the Carmel River. "It will give us some peace of mind," he wrote, "though I doubt it."[26]

Pedro Fages's letter to Viceroy Bucareli provided a detailed description of the presidio two years later. Adobe construction was replacing the log palisades because Monterey's "humidity . . . tends to rot and destroy wood." The front wall had been rebuilt in adobe bricks supported by a stone foundation, but the other three walls were still of pine logs plastered with lime. The northwest bastion nearest the point, which had a sentry box, had been rebuilt in adobe and like the corner bastions (which were still of wood) had two embrasures for bronze campaign cannons.

The religious significance of the presidio, origi-

nally a presidio-mission, was proclaimed by a cross at the center of the interior quadrangle rising nearly 20 feet above a domed substructure. The south range of the interior, farthest away from the bay, was given to religious structures, the church and the quarters of the friars, all reconstructed in adobe. The church, approximately 28 feet long and 19½ feet wide, had a flat earthen roof supported by twenty hewn *vigas* and a layer of cane. Alongside was an adobe tower nearly 17 feet square and fully 42 feet high with two upper stages for bells. Both church and tower were plastered with lime within and without. The ambitious tower endured less than twenty years.

Two long structures of pine palings along the west wall served as barracks for the Catalonian volunteers and for the regular leather-jacket soldiers. Six rooms of pine palings along the east wall were used by mail carriers, as shops for blacksmithing and carpentry, as a place of storage for the gear of the muleteers, and as dwellings for servants and for Indians who wished to sleep in the presidio. The primarily adobe buildings along the entrance front facing the bay included the guardhouse next to the single entrance, the commandant's quarters, a prison, storehouses, and a store for the display and sale of clothes to "the dependents of this establishment."[27]

When Governor Felipe de Neve arrived to reside in Monterey four years later in 1777, he was disturbed by the condition the presidio had reached. It was, he wrote, "entirely open and without any other defense than the troops."[28] With characteristic energy he restored and expanded the presidio to about twice its original size. The walls and bastions were of stone, he wrote to Teodoro de Croix in the summer of 1778, nearly twelve feet high and almost four feet thick, and they enclosed ten adobe houses and a barracks more than ninety feet long which was not quite completed. By walls of stone Neve apparently meant walls constructed of a mixture of stone and adobe.

Neve's buildings had roofs of thatch, better at shedding rain than flat earthen roofs; and in August 1789, a presidio gun answering a visiting vessel's salute gave off a spark which set the thatch afire and burned about half the presidio, including four warehouses, the governor's residence, and the houses of the officers and of eleven of the soldiers. Pedro Fages, who returned to California as Neve's successor, initiated the rebuilding of the presidio and the construction of the surviving stone chapel. In the years after 1791, masons from New Spain were available in Monterey. The workers who had begun the presidio in 1770 had been soldiers and sailors. In the 1790s Indians were the primary work force. Gentiles, or unconverted Indians, from villages near San José, and neophytes from Mission San Antonio de Padua were employed between the spring of 1791 and the final months of 1793 when the chapel was being completed. In the latter year the cost of Indian labor constituted 399 pesos of the total of 400 expended on the chapel. Indian workers were sent by their headmen and escorted by soldiers. They came in groups ranging from five to twenty, depending on the size of their villages, and remained at the presidio for several weeks before being replaced by another contingent of workers.

A concern for the defense of the landing place on the beach led to the placing of a battery with several cannon on hilly ground a mile or so west of the presidio, but the battery seemed to visiting English Captain George Vancouver vulnerable to attack.

By the early 1780s the garrison of the presidio was set at 52 soldiers with six detached to each of the three nearby missions, San Carlos in Carmel, San Antonio de Padua, and San Luis Obispo, and four to the pueblo of San José. After 1796 the total force was increased to approximately 110, but those in Monterey continued to live within the walls of the presidio. Retired soldiers were not allowed to build houses or farm near the presidio until after Mexican independence from Spain. Some of the visitors in the 1790s were surprised at the absence of civilian settlers and the need for the soldiers to perform "the

few most necessary mechanical employments . . . in an indifferent manner."[29] By 1827 houses were scattered over the area stretching from the vicinity of the presidio to the high ground to the west. At that time little remained of the presidio's adobe exterior walls, and the buildings of the interior plaza were disintegrating. The last house of the governor, built in the early 1790s, survived to be photographed in dilapidated condition about 1900, and the stone chapel remains today in altered condition.

The Presidio Chapel

Two early chapels are recorded in the plan attributed to Miguel Costansó. Both were probably constructed of vertical timbers. A third chapel of adobe, which was completed before Father Serra moved the mission to Carmel in 1771, endured until 1791 when it was portrayed in the middle of the south side of the plaza covered with a thatched roof. Pedro Fages, who remained in charge at Monterey after he resigned the governorship until the fall of 1791, put the Mexican stonemasons who had arrived in March, Manuel Esteban Ruiz and his journeyman Joaquín Rivera, to work designing and constructing a new chapel in stone. Work apparently began at the rear and progressed rapidly. A seemingly complete rear wall is visible in a sketch of the presidio probably made by José Cordero, an artist with the fleet of Alejandro Malaspina which visited Monterey in September.

The chapel was single naved; the present transept was added in 1858. Its tile roof was supported by timbers and did not reach to the full height of the façade. That height was originally matched by the *espadaña* tower for bells at the left. The present tiled pyramid at the top of the tower was a later addition.

Work on the chapel was suspended in the spring of 1792 by order of the viceroy, the Conde de Revillagigedo. A design signed by Manuel Ruiz, now in the Archivo General de la Nación, had been sent to Mexico City for approval. The viceroy, sharing the neoclassical taste which had swept the capital in the previous decade, was disturbed by the intricacy of Ruiz's baroque design and sent it to the professor of architecture in the new Academy of San Carlos, Antonio Gonzáles Velásquez, for simplification and ordering. Velásquez's drawing which altered Ruiz's façade has been lost, but in his accompanying letter he explained that he had made only minor changes to the relatively classical lower story, but had simplified the upper levels as much as he could while maintaining proper portions with Ruiz's design. The viceroy authorized resumption of construction on April 7, specifying that Velásquez's design was to be followed.

The change deprived California, and the United States, of a spirited baroque façade, naïve in some aspects but much more interesting than the tame exercise in neoclassicism which was built (Fig. 7.4 and Fig. 7.5). At the center of Ruiz's composition, instead of the present broad window with a flattened arch and the suggestion of a pediment pasted on the bare wall above it, a tall window was related dynamically to the topmost niche above it by upwardly surging baroque forms. At the outer edges

7.4. Monterey presidio chapel, design for the façade, Manuel Ruiz, reproduced in Mardith K. Schuetz-Miller, *Building and Builders in Hispanic California, 1769–1850*, p. 163.

7.5. Monterey presidio chapel in 1847, drawing by W. R. Hutton, reproduced in *California 1847–1852: Drawings by William Rich Hutton*.

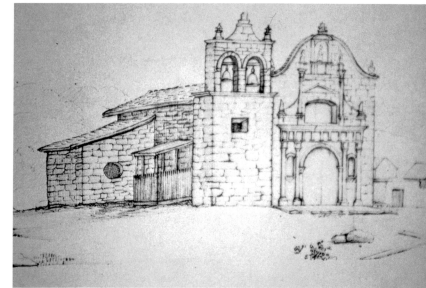

169

of the façade Ruiz had placed swirling, curving, and countercurving scrolls above obelisk-decorated pilasters which extended up to the level of the top of his window. The present second stage of the design seems lifeless with its stunted central forms and large expanses of bare wall. Ruiz's upper silhouette, enlivened with scrolls and angles, was replaced by limp scroll moldings which rise curving to the level of the top of the upper niche, which contains a shell-crowned Virgin of Guadalupe.

A few unexpected baroque details enliven the façade, some possibly finished before Velásquez's design was received. Incised elements ornament the pilasters and vegetative ornamentation fills the spandrels above the portal arch. The surprising upper niche has, in addition to its lively curving shell, scrolls at the outer bottom edges of its pilasters, and below, a rippling molding and a dynamic form containing the date 1794.

Manuel Ruiz and Joaquín Rivera remained at work on the chapel until November 1792 when they were called by Father Lasuén to Carmel to begin the stone church there. They were replaced by master mason Santiago Ruiz, possibly Manuel's brother, and Salvador Rivera and Pedro de Alcántara Ruiz. Manuel may have continued some overall supervision on visits from Carmel, but day-to-day construction was directed by Santiago. After another year Velásquez's façade was nearing completion and the roofing had begun. The church was dedicated in 1794.

Mission San Carlos de Borromeo of Carmel

Father Serra must have decided to remove the San Carlos Mission from the Monterey presidio almost immediately. Approval was sent from Mexico City by Viceroy de Croix in November 1770, but the small community of friars and converted Indians did not move until the final days of 1771. The site alongside the Carmel River in view of the Pacific had been inspected by Serra in the previous July, and he had moved there in early August to live in a brush shelter. He supervised the construction and often acted as an ordinary workman. For some weeks before his arrival, three sailors and four Indians had been at work cutting logs and preparing timber. According to Serra's biographer, Fray Francisco Palóu, the first permanent construction he ordered was "a large cross. This he blessed and raised, with the aid of soldiers and servants, fixing it in the center of the area selected for the mission . . . next to the cabin where he lived and the other cabin which served temporarily in place of a church."[30] The earliest mission buildings were described in a letter Serra wrote to the Father Guardian of the College of San Fernando, Fray Rafael Verger, in August 1772. "The principal building has a flat roof made of clay and dirt. The walls are made of stout limbs of pine trees, stripped off and well trimmed, the spaces between filled with stones, rubble or branches and stuccoed all over both inside and out." The building about 140 feet long and 43 feet wide was divided into six rooms—three cells, a reception room, an office, and a storehouse and granary. One of the cells was used as a church "until . . . a separate church with a sacristy can be built, in a place selected for the purpose." The other buildings were a guardhouse with a separate kitchen for the military detachment, a general kitchen for the mission, and "another building divided into three parts, the largest for the new Christian girls, another for chickens, and a third for no particular use."[31]

The flat earthen roofs and walls of pine limbs were gradually replaced. As Serra reported in the last year of his life, 1784, the original roofs had been constructed of earth "to minimize fire danger, but no matter what we did they always leaked like sieves and between that and the humidity everything would rot. So we decided to build of adobe and . . . today all the buildings are of that material."[32] By that time an adobe church 110 feet long and 22 feet wide had replaced two earlier churches walled with

pine palings. Its thatched roof extended beyond the front wall to form a covered porch. The principal interior decoration was a painting of the Virgin of Sorrows seated at the foot of the cross holding the dead Christ.

There were also adobe replacements of the two principal buildings Serra had described twelve years earlier, a three-room residence for the friars and a structure which served three functions: as a *monjério* for unmarried women, as a storeroom, and in its center section, "whitewashed and clean"[33] with barred windows, as a guest chamber which was to be subdivided into two rooms. A guardhouse was not mentioned but there was a granary, as well as work spaces for a blacksmith and a carpenter, and for women who ground grain and made cheese. There were also living quarters of secular residents, a hen house, a storage area for five carts, and corrals of palings, needing repair, for horses and cattle.

In the same year, 1784, Serra had written to the priest who would succeed him at Mission San Carlos and as president of the California Missions, Fermín de Lasuén, of the importance of finding a way to manufacture tiles in order to eliminate the difficulties with leaking or fire-prone roofs. Yet not for another six years, fourteen years after tile-making was initiated at the nearby mission of San Antonio de Padua, did roofing in tile begin at Mission San Carlos. In 1791, sketches made by artists of the Malaspina expedition show one tile-roofed building, the others with thatch. A drawing probably made in 1794 by John Sykes of the Vancouver expedition shows three tile roofs and the partially built walls of a new stone church, including the base of the larger southern tower and an arch of the entrance behind it (Fig. 7.6 and Fig. 7.7).

In late November 1792 Father Lasuén had been notified that the viceroy had granted him authority to assign the artisans from Mexico to train Indian apprentices. Within a month he summoned the most gifted of the artisans, Manuel Ruiz and his journeyman, from work on the presidio chapel to

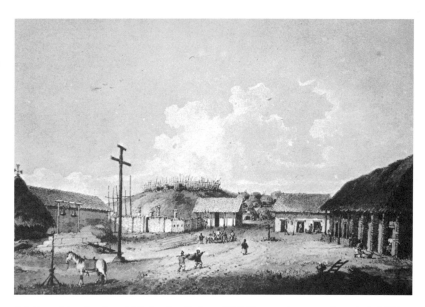

7.6. Carmel, interior view of Mission San Carlos, c. 1794. The prominent cross is on the left. Tile has replaced thatch for roofing of three of the buildings. The stone church, in the left background, is under construction. On the high ground behind are a pen for animals and huts for the Indians. Watercolor by William Alexander based on a drawing by John Sykes, reproduced in Jeanne Van Nostrand, *A Pictorial and Narrative History of Monterey*, plate 8.

7.7. Mission San Carlos, view from the rear in 1837. A shed and a pen for animals had been added to the rear of the church, and the back range of dwellings had already lost much of its roof. Engraving by Cyrille P. T. Laplace based on a drawing by François Edmond Pâris, reproduced in Jeanne Van Nostrand, *A Pictorial and Narrative History of Monterey*, plate 25.

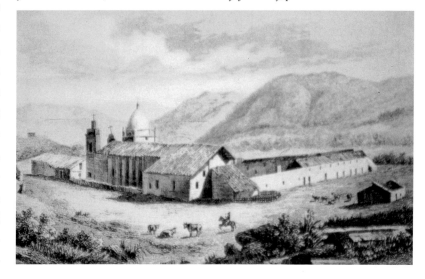

Carmel to construct what was probably the first stone church of the California missions. No building materials had been assembled and heavy rains had begun so that laying the cornerstone was delayed until July 7, 1793. By December of 1794, about the time of Vancouver's third visit, Lasuén wrote that the church was about half finished. Vancouver, in a passage which confusingly seems to refer to his 1792 visit, described the stone used at

Chapter VII

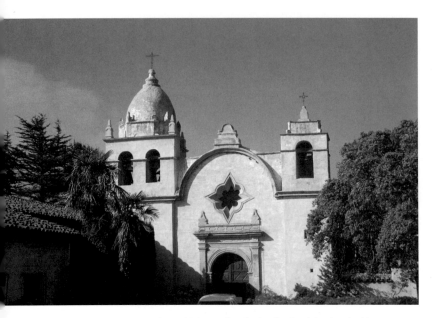

7.8. Carmel, Mission San Carlos, façade of the church. Also see Plate XIII.

Carmel, which resembled in some regards the stone used for the Castillo de San Marcos in St. Augustine and Concepción and San José Missions in San Antonio. Vancouver said it "appeared to be of a very tender friable nature, scarcely more hard than indurated clay but . . . on its being exposed to air, it soon becomes hardened. . . . It is of a light straw color, and presents a rich and elegant appearance in proportion to the labour that is bestowed upon it. It is found in abundance at no great depth from the surface of the earth; the quarries are easily worked."[34]

Father Lasuén was delighted with his master mason, finding in him "all the qualities one could ask for in one who furthered the king's pious objectives"[35] in advancing Spanish America. But Lasuén was concerned that the stone church would not be completed within the four years of Ruiz's contract. He asked both Governor Borica, at the end of 1794, and Viceroy Branciforte, in November 1795, to extend it. "Many oxen and wagons," he wrote to the viceroy, "have been employed on [the church]. Much iron has gone into it, and much labor too." But it was not far enough advanced to be completed in June 1796 when the contract expired. "It could be completed by that date in '97."[36] The viceroy granted the extension and the church was dedicated in September 1797.

The church of San Carlos designed by Manuel Ruiz was single-naved encompassing an interior space larger than any subsequent California mission church except the stone church of San Juan Capistrano and the churches of Mission San Luis Rey and Mission Santa Barbara. Its 150 feet of interior length made it as long as San Esteban of Ácoma, the longest Spanish church in New Mexico. Subordinate structures flank the nave—a baptistery under the south tower, a chapel also on the south side, and a sacristy on the other side at the rear.

Unrestrained at Carmel by the neoclassical taste of the viceregal capital, Ruiz created a simple baroque façade asymmetrically flanked by towers differing in height, width, and design (Fig. 7.8). The larger, on the south, has two arched openings for bells on its front and at its top, above an octagonal stage, a very unusual steep oval dome. The lesser tower on the north has a single opening for a bell and at its top an odd, stepped pyramidal form bearing a cross. The central façade had a sedate architectural frame surrounding its arched portal, but above it an irregular four-pointed star window and at the center of its framing upper arch another unusual baroque form which, like the other crowning elements of the façade, supported a cross. The star window echoes those recently designed for the Chapel of the Well at the shrine of the Virgin of Guadalupe by the last great baroque architect of Mexico, Francisco Antonio Guerrero y Torres.

The façade of the church of San Carlos is the most impressive of California mission façades, but the most remarkable feature of the building is its interior construction (Fig. 7.9). Ruiz designed walls which tapered inward from the level of the bottom of the windows. On either side three evenly spaced piers supported stone ribs which carried their graceful curves up into soaring arches. Originally the arches supported the roof timbers and defined a pattern for a series of intermediate wooden arches

which sustained a high wooden ceiling. There were two other arches, a flattened one near the entrance supporting the choir balcony and, at the other end of the church, an arch in the chancel in front of the rear wall. A remarkable feature was a ribbed Gothic vault over the baptistery (Fig. 7.10).

Reports of the mission in the early years of the nineteenth century record two important alterations after Manuel Ruiz returned to Mexico. The report of 1801 stated that the walls of the church had been raised one *vara*, nearly a yard, in height and that the resulting strain required a buttress to be added to correct a bulge of four fingers breadth in the front wall. There is not a buttress against that wall and it is possible that the reporting friar meant the rear wall, which has at its center a sizable buttress. Raising the wall would have required raising the level of the interior cornice and interior piers and a rebuilding of the stone ribs. Thirteen years later in 1814, the mission reported a necessary reconstruction of the ceiling involving removal of the wooden vault because it threatened to collapse. The timber crossbeams visible in early photographs must have been inserted at that time, creating a low ceiling of flat planks.

After secularization in the 1830s Mission San Carlos began to decay. In 1837 a French visitor, Abel Du Petit-Thouars, found it still occupied by its last missionary, Father José María del Real, and two or three Indian families. The church still contained the portable organ presented to Fray Lasuén by Captain Vancouver, and the chapel had some paintings, one hanging at an angle from one of its corners. Four years later New England–born Thomas Jefferson Farnham rode with a group from Monterey and found everything "forsaken and undesirable." He described the mission's buildings as "built around a square area of half an acre," with the "Indian houses with their ruined walls, scalloped tile roofs, clay floors, and unglazed windows" filling the east, south, and west sides and on the north "the church, the cells and dining hall of the padres"[37] (Fig. 7.8). By the 1850s Mass was being celebrated

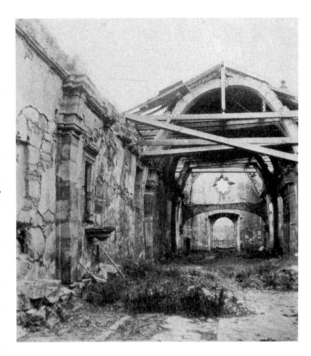

7.9. Interior of the church of Mission San Carlos facing the entrance, about 1880, photograph by Clarence Brown.

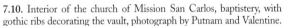

7.10. Interior of the church of Mission San Carlos, baptistery, with gothic ribs decorating the vault, photograph by Putnam and Valentine.

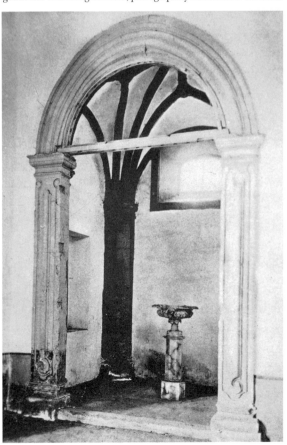

Chapter VII

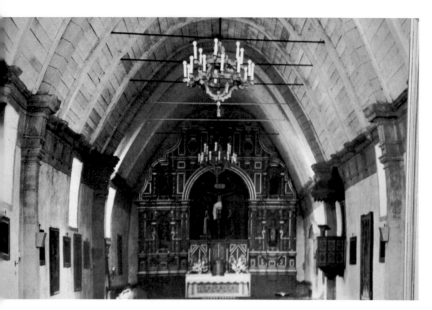

7.11. Present interior of the church of Mission San Carlos, photograph by John S. Weir.

in the sacristy because of fear for the main roof. A collapse occurred on San Carlos's Day, November 4, 1852. There were traces of fresco and inscriptions from the Bible remaining on the walls in 1857 and painted wooden statues of saints which had, like the façade of San José in San Antonio, been used as targets and were "riddled with bullets."[38] William H. Brewer, a Yale-educated geologist, rode into the church in 1861 and found the frescoes and inscriptions "mostly obliterated." "Cattle had free access to all parts, the broken font, finely carved in stone, lay in a corner; broken columns were strewn around where the altar was and a very large owl flew frightened from its nest over the high altar." Brewer dismounted, tied his mule to a broken pillar, and "climbed over the rubbish to the altar" and passed into the sacristy where he found "a dead pig . . . beneath the finely carved font for holy water." The old mission garden had become a barley field but many pear trees had survived to be "full of young fruit. Roses bloomed luxuriantly in the deserted places, and geraniums flourished as rank *weeds*. So," noted Brewer, "have passed away former wealth and power in this new country."[39]

Conservation of the church concerned Father Angelo Canova, who became pastor in Monterey in 1863 and said mass at Carmel annually on San Carlos's Day. He reroofed the sacristy for forty dollars in 1777. Helen Hunt Jackson visited Carmel in 1880 and later wrote that "it is a disgrace to both the Catholic Church and the State of California that this grand old ruin, with its sacred sepulchres [of fathers Junípero Serra and Juan Crespí] should be left to crumble away."[40] Father Canova organized a solicitation of funds from people such as Bishop Mora of Los Angeles and Mrs. Leland Stanford for restoration to celebrate in 1884 the centennial of Junípero Serra's death. A tall gabled roof was installed which climbed to a peak seventeen feet higher than the rounded arch at the top of Manuel Ruiz's façade. That arch was used as a model for a wooden vault over the sanctuary, but Father Canova's carpenters built a ceiling over the nave which differed from the original one. Wooden arches replaced the former stone ones, and instead of following the high curve of the central façade, they lifted steeply at their sides and then flattened over the central nave to support a ceiling of flat planks.

Restoration to a form approximating the church's original interior was the work of Harry Downie in 1936. A San Francisco boy, Downie was first summoned to Carmel in 1931 by Monsignor (later Bishop) Philip Scher of Monterey to mend some of the old statues. He remained for the rest of his life training himself in construction work and is buried outside the church's north wall. Downie collected old photographs and made copies of the mission's reports and inventories. He once remarked to a journalist, "You have to do it the way it was done, putting in all the crooked walls and inaccuracies. You can't have any ideas of your own [or] you'll fizzle. . . . A square corner or a straight line—neither looked good to a Spaniard."[41] After rebuilding the friars' residence, now the museum, Downie removed Father Canova's awkwardly placed high gable and roof and stripped "the church down to its original walls. The hardest job," he stated, "was to locate the exact angle of the original

tile roof. Once I got that right, I constructed the supporting arches and installed them."⁴² Downie's roof has restored the church's exterior to a form closely resembling its original appearance.

Restoration of the interior was more difficult. Downie's interior is relatively bare (Fig. 7.11). It lacks the former wall paintings and inscriptions, and very few statues have survived. The unique inward-leaning cornice still crowns the wall. A wooden pulpit has replaced the old stone one, but the portals to the baptistery, sacristy, and chapel have survived, the last a flowing multicurved and multiangled baroque design. Re-creation of the stone arches and the wooden vault was difficult. Downie believed that he had found the old form in marks left on a wall in the choir balcony. But his parabolic arches are considerably steeper than those visible in old photographs and seem less successful in carrying out the graceful curve initiated by the inward lean of the piers and wall. Downie's large painted and gilded *retablo*, which virtually fills the end wall of the sanctuary, was loosely based on the surviving one in Mission Dolores in San Francisco. It obscures the effect of the old arch and, like the vault, diminishes the sense of space of the old interior. This criticism may seem severe. Harry Downie worked with loving carefulness. His restored church is the most impressive of all the major reconstructions in California with the possible exception of San Luis Rey.

Mission San Gabriel and the Pueblo of Los Angeles

The attractiveness of the Los Angeles basin was first recorded in the diary of Fray Juan Crespí in early August 1769 when he accompanied the party of Governor Portolá in the initial search for Monterey. "After traveling about a league and a half through a pass between low hills, we entered a spacious valley, well grown with cottonwoods and alders, among which ran a beautiful river from the north-northwest. . . . Toward the north-northeast there is another river bed which forms a spacious watercourse, but we found it dry. This unites with that of the river, giving a clear indication of great floods in the rainy season, for we saw that it had many trunks of trees on the banks. We halted not very far from the river, which we named the Porciúncula. Here we felt three consecutive earthquakes. . . . The plain where the river runs is very extensive. It has good land for planting all kinds of grain and seeds, and is the most suitable site of all we have for a mission."⁴³

Mission San Gabriel

The fourth of the California missions was San Gabriel, founded soon after Mission San Antonio de Padua in the late summer of 1771 and named El Misión del Santo Príncipe el Arcángel San Gabriel de los Temblores (of the Tremors). Father Serra had selected a site in what is now Orange County but missed the founding because he was not notified of the arrival of the founding friars. They decided against settling in the place he had chosen and moved on to a place not far from the present mission. The initial structures were made of stakes and were surrounded by a stockade for defense. Father Palóu wrote that "the pagans themselves cut and dragged the greater part of the lumber for the construction; they helped in building the small houses."⁴⁴ But the enthusiastic welcome of the natives was short-lived. A soldier sexually assaulted the wife of an Indian ruler, and in the ensuing fracas that Indian was killed and his head impaled on a lance. As a result the natives wanted nothing to do with Spanish soldiers or Spanish missionaries. Indian fear and anger softened in time. The son of the slain leader was among the first children baptized at San Gabriel, and seventy-three neophytes were baptized by the end of the second year. The founding missionaries, Ángel Somera and Pedro Benito Cambón, had been replaced in 1772 by Antonio Cruzado and Antonio Paterna.

Chapter VII

The mission received the first of Juan Bautista Anza's overland expeditions from Sonora in March 1774, and had moved to its present site a few miles from the San Gabriel Mountains when the large second expedition arrived in early January 1776. Fray Pedro Font, diarist of that expedition, described the setting as level and unobstructed, having "the most beautiful qualities, with plentiful water and very fine lands." He noted the ample supply of oak and other timber and the fact that no lime had been discovered by the time of his arrival. Some construction was of adobe but most was of palisades and rushes and subject to fire. The principal building, a long shed of palisades, served "as a habitation for the Fathers, and for a granary and everything [else]."[45] There was another palisaded structure used as a church, a building for the guard of eight soldiers, and a cluster of rush huts where the converted Indians lived.

Father Font described the daily routine at San Gabriel: "At sunrise, Mass is regularly said, and at it, or even if it is not said, they assemble all the Indians. The father recites with all of them the *Doctrina Christiana*, which is concluded with the singing of the *Alabado*. . . . The Fathers sing it, although they may not have very good voices, since uniformity is best. Then they go to breakfast of *atole* [corn meal mush sometimes containing tortillas]. . . . Before they eat they make the sign of the cross and sing the *Bendito*. Afterward they go to work, at whatever they can do, the Fathers encouraging them and teaching them to work by their example. At noon they eat their *pozole* [stew of meat, grain, corn, and beans] which is made in community for all. Thereafter they work again for a while. At sunset all return to recite the *Doctrina* and conclude it by singing the *Alabado*."[46]

Reciting Christian doctrine was done in Spanish as directed by the first Mexican church council in order that the Indians should be induced to speak Spanish and because all Indian languages were regarded as barbarous and lacking in terms needed for theological explication. The recitation was rigidly fixed. A summary of doctrine distilled by a Father Catani was repeated without any variation being permitted.

The friars came to understand that the Indians needed some relief from their regimented life as Christian neophytes. Dances, formerly essential in Indian communal life, were allowed in the missions although the friars exercised some supervision. The Indians' traditional sweat baths were, after initial disapproval, also tolerated in the missions. On some occasions behavior got out of hand. In 1779 the missionaries of San Gabriel were embarrassed to report that an Indian *alcalde*, Nicolás, "provided women for as many soldiers as wanted them."[47] Soldiers spread syphilis, which gradually decimated mission populations. By 1814 the missionaries of San Gabriel reported sorrowfully in response to a questionnaire from the Franciscan Order that "many children at birth already manifest the only patrimony their parents give them. Hence it is that of every four children born, three die in their first and second year while those who survive do not reach the age of twenty-five. If the government does not provide doctors and medicine, California will be exhausted of its Indian inhabitants."[48]

Little is recorded of building activities at San Gabriel between Father Font's visit and the beginning of construction of the present church almost twenty years later. In the intervening period large-scale construction in adobe began and the rate of conversions increased and agricultural production accelerated. Font had described the spring-fed irrigation *acequia* running between the dwelling of the fathers and the huts of the Indians; the *acequia*, he wrote, "dominates all the fields near the mission site rendering them apt for planting grain."[49] He estimated neophyte numbers at five hundred, more than doubling the actual number of just under two hundred.

As early as 1777, San Gabriel was able to donate to the struggling original mission of San

Diego modest quantities of grain for sowing and for cooking and substantial amounts of onions, garlic, tomatoes, and chile for eating. In 1787 wheat, corn, and beans were supplied to soldiers. By 1783 there were 1800 sheep, 1000 goats, 900 head of cattle, 140 horses, 140 pigs, and 36 mules. The Christian Indian population reached 800 in 1784, and by 1790 San Gabriel was second only to Mission San Antonio de Padua in neophyte numbers and by far the most productive mission in agriculture.

The accumulation of livestock and the expansion of the planting of grain, vegetables, and fruit increased steadily during the residence of Father Antonio Cruzado, who died at San Gabriel in October 1804 after more than thirty-two years of service, and continued during the time of Father José María Zalvidea, who arrived in 1806 and remained until 1827. In the year following Zalvidea's departure San Gabriel had 42,145 livestock, including 26,300 head of cattle, 13,500 sheep, and 2,035 horses. Six years later, at the time of secularization in 1834, the mission had nine orchards with 2,333 fruit trees, among them oranges, citrons, limes, apples, peaches, pomegranates, and figs. There were 163,578 grapevines in four vineyards totaling 170 acres and including the Viña Madre, the oldest at San Gabriel and largest in California. A year earlier the Father President, Narciso Durán, had replied to an inquiry from Governor José Figueroa praising the wine of San Gabriel as the best made in any mission and describing its two reds, one "dry but very good for the table" and the other sweet and less pleasant, and two whites, one fermented apart from the skins of the pressed grapes and the other "fermented with a quantity of grape brandy. These two make a most delicious drink for the dessert. The wine from the pure grape juice is for the altar; the other for any use whatever."[50]

A mill for grinding grain and a mill for making olive oil were begun in 1820. San Gabriel established twenty-four ranchos at varying distances from the mission to raise the livestock away from its close-in fields, gardens, orchards, and vineyards. Mission land comprised roughly a million and a half acres and extended more than seventy miles to the east and southeast past the present cities of Redlands and Riverside as far as Beaumont. The most important of the *ranchos* were La Puente, Santa Ana or Santa Anita, and San Bernardino.

An account of life at San Gabriel in the 1820s and early '30s was given to one of Hubert Howe Bancroft's historians in 1877 by Eulália Pérez de Guillan. Mrs. Pérez, approximately one hundred years old at the time, had been born in Loreto in Baja California and had moved to San Diego with her soldier husband. She survived the earthquake of 1812 which destroyed most of the stone church of San Juan Capistrano, and was a widow with a family to support when she was called to San Gabriel about 1821 by Fray José Bernardo Sánchez, younger colleague of Father Zalvidea. Winner of a cooking contest judged by six secular males, Mrs. Pérez taught her skills to Indian women. Appointed housekeeper of the mission, she was responsible for distributing daily rations to the heads of Indian households and to the kitchen of the missionaries. She doled out material for clothing for women, both married and unmarried, and for children. She also saw to the cutting and making of the outfits for the mission's cowboys.

Mrs. Pérez summarized the diverse manufacturing of San Gabriel: "At the mission coarse cloth, serapes, blankets were woven and saddles, bridles, boots, shoes and similar things were made. There was a soap house, and a big carpenter shop as well as a small one. . . . Wine and oil, bricks and adobe bricks were also made. Chocolate was manufactured from cocoa, . . . and sweets were made. Many of these sweets made by my own hands were sent to Spain by Father Sánchez.

"There was a teacher in every department, an instructed Indian who was Christianized. A white man headed the looms, but when the Indians were finally sufficiently skillful he withdrew."

In addition to the shops mentioned by Mrs. Pérez, San Gabriel had forges for making metal implements such as knives, locks, and plows. The products of the wood-working shops included wheels, carts, and yokes for oxen.

The tactfulness of the two missionaries in dealing with the Indians drew Mrs. Pérez's praise, but she also described the punishments meted out to maintain discipline. Minor offenses were punished with time in the stocks or in confinement, but "when a misdemeanor was serious the delinquent was taken to the guard, where they tied him to a pipe or post and gave him twenty-five or more lashes, depending on his crime. Sometimes they put them in head-stocks, other times they passed a musket from one leg to another and fastened it there, and also tied their hands. That punishment, called 'The Law of Bayona,' was very painful."

Another feature of mission life was the housing of the unmarried—at San Gabriel of both women and men, although the usual practice was to confine only the women. Mrs. Pérez described the practice at San Gabriel: "They brought girls from the ages of seven, eight or nine years to the *monjério*, and they were brought up there. They were under the care of a mother in the *monjério*, an Indian. During the time I was at the mission this matron was named Polonia—they called her 'Mother Superior.' The [Indian] *alcalde* was in charge of the unmarried men's division. Every night both divisions were locked up; the keys were delivered to me and I handed them over to the missionaries. . . .

"If any girl was missing at admission time, they looked for her the following day and brought her to the *monjério*. Her mother, if she had one, was brought in and punished for having detained her, and the girl was locked up for having been careless in not coming in punctually."[51]

Father Zalvidea, the driving force behind the planting of the great vineyard and other agricultural enterprises at San Gabriel, was a strange and complex person. He regularly scourged himself and wore beneath his robe ropes of horsehair around his waist and legs, above the knees, to mortify him with discomfort. One visitor testified that "the padre experienced religious exaltations and sometimes twitched as he attempted to drive away the devil, but otherwise he was of a sane mind. . . . One could take advice from him about any matter."[52] The eccentricity characteristic of his years at San Gabriel worsened after his retirement in 1827, first to San Juan Capistrano and then to San Luis Rey. In his last months he allowed no one to stay with him at night and was found bloody with self-inflicted wounds in the mornings.

In 1776 Fray Pedro Font had described the first buildings of the mission on its new site as primarily wooden-walled and roofed with rushes. A report of 1783, describing the construction since 1775, mentioned a sizable new church approximately 100 feet in length and with walls built of two layers of adobe. The roof was layered. Pine *vigas* supported caning of oak on which earth was spread and, on the top, rushes. In 1783 a quadrangle about 140 feet on each side had been completed and, the friars wrote, a second "will be finished shortly."[53] In 1789 the existing roofs of the mission were replaced with new ones of tile. No accounts of building activities are available between 1792 and March 11, 1795, when Father Lasuén wrote in his Biennial Report that San Gabriel was constructing a church of stone and mortar with the walls then at half the intended height. Two years later he reported that the church was still being built and in early 1799 that it was "finished to the top of the vaults excepting the one over the choir."[54] By February 25, 1801 he was able to write that "all the vaults have already been enclosed" but he had to add that "they have developed cracks. And the question now is whether it will be necessary to demolish and rebuild them or, given the circumstances, to replace them with wooden beams."[55] The worst apprehensions proved unfounded, at least temporarily, and in early 1803 Lasuén wrote, "The church of San Gabriel is now

about to be whitewashed and painted for it appears not to be in great danger and the cracks which were discovered in the vaults are repaired."[56]

But in 1805, after the church had been consecrated and opened for regular use, Lasuén's successor as Father President, Estevan Tapis, wrote: "In consequence of a violent earthquake, new cracks have been discovered in the concrete vaulted roof. For this reason, in the judgement of an intelligent mason, they will have to take it down and substitute in its place for security's sake a roof of timber and tiles. This will be done under the direction of said mason, when the floods have passed away."[57]

Clearly masons, not priests, were in charge of constructing the stone church of San Gabriel. None are named in the friars' accounts. Mardith K. Schuetz-Miller has identified the probable mason, Miguel Blanco, an Indian master who was born at Mission San Ignacio in Baja California and is recorded as a resident in the San Gabriel–Los Angeles area between 1794 and 1804. A neophyte of San Gabriel, known only as Remigio, may have acted as assistant mason.

The church of San Gabriel was probably the second stone church begun in California. It is unlikely it was begun before July 1793 when the church of Mission San Carlos was started. Under construction for approximately six years, the San Gabriel church could not have been completed before late 1799, more than two years after Father Lasuén's church at Carmel. Also single naved, San Gabriel was about eight feet shorter and somewhat narrower than San Carlos.

The structure and the interior appearance differed. Both churches had a choir balcony inside the entrance, that at San Gabriel supported by wooden beams shaped and marbleized to imitate a stone arch. At San Carlos the interior is divided into four sections by the three evenly spaced structural stone piers and arches. The narrower interior of San Gabriel is divided into seven half-square bays by tall pilasters which once supported the transverse arches

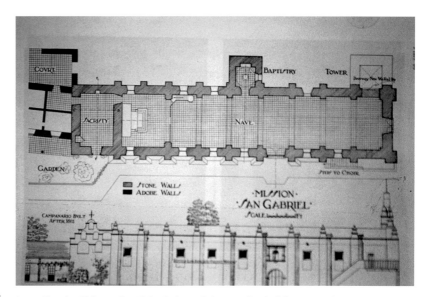

7.12. Church of Mission San Gabriel, plan and elevation, Rexford G. Newcomb, *Spanish-Colonial Architecture in the United States*, plate 66.

of a stone vault. The square sanctuary adds the equivalent of two more bays (Fig. 7.12). Gothicized in the nineteenth century, the interior was altered somewhat for the better in the 1930s. The sacristy at San Carlos was placed outside the main structure at the north side of the sanctuary; a chapel was placed on the south side, and the baptistery was placed under the south tower. At San Gabriel the sacristy is placed in line with the nave and sanctuary to extend the long thin rectangular layout by another bay and to increase the building's overall exterior length to just over 172 feet. The sacristy's barrel vault, 18 feet above its floor, is, however, set at right angles to the church. The baptistery of San Gabriel is placed outside the north wall, close to its middle, and is entered from the fifth bay. Ten feet square, it is covered by a half-circular dome and contains at its center on a stone base the original hammered-copper font.

The walls of San Gabriel are four and a half feet thick and are built of stone up to a level just above the originally small rectangular windows. Fired brick was used above that level and stucco applied to disguise the change in material. The most expressive feature of the exterior is the ten tall, sturdy buttresses which line the long south wall and culminate

| Chapter VII

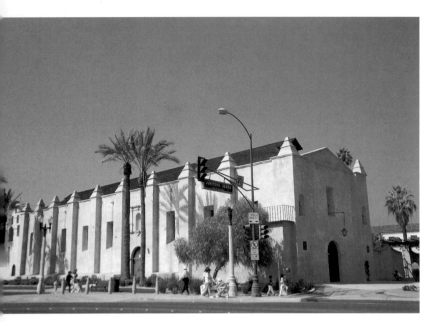

7.13. Mission San Gabriel.

above its top in pyramidal caps interrupted by horizontal moldings (Fig. 7.13). They correspond with the pilasters of the interior. The south side is suggestive in its appearance of the sides of churches of sixteenth-century Mexico such as Tepeaca, Huejotzingo, and Actopan, and some believe of the Great Mosque of Cordova.

Father Tapis mentioned in his report of 1805 the "concrete vaulted roof"[58] which had been irreparably damaged in the earthquake of 1803, but neither he nor Father Lasuén described its con-

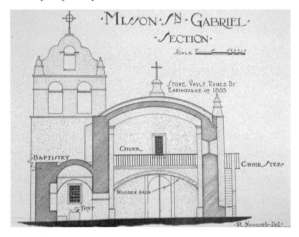

7.14. Reconstruction, Mission San Gabriel, cross section facing entrance, Rexford G. Newcomb, *Old Mission Churches and Historic Houses of California*, p. 86.

struction. In 1925 Rexford Newcomb carefully studied the material evidence available in the existing church and concluded convincingly that the vault had been low and segmental, with great lateral thrust and much more vulnerable to an earthquake than the surviving semicircular barrel vault of the sacristy. Newcomb based his reconstruction of the vault on the segmental curve of the top of the west wall of the church above the adjoining sacristy (Fig. 7.14). He was convinced that it survived from the original church and that its upper profile was that of the vault. He also concluded that the vault was supported by segmental cross ribs, which rose from the pilasters of the interior and were sustained by the corresponding buttresses of the exterior.

San Gabriel originally had a bell tower at its northeast corner, entered through an arched opening beneath the choir which has been walled up. It was ruined in the earthquake of 1812 and a part of its rear wall was converted into a buttress. Newcomb suggested that it had two lower stories and an open belfry above. The present *campanario*, which extends the south wall to the west, was constructed on top of what had been the parapet of the sacristy during a general rebuilding of the church begun in 1827 (Fig. 7.15). Originally it had five symmetrically placed openings. The present pleasing irregularity resulted from enlarging one opening for a huge new bell and adding an opening at the right end of the middle tier. Two of the bells were cast by Paul Ruelas in Mexico City in 1795 and two in Massachusetts by George H. Holbrook in 1828. The great bell on the lower left is dated 1830.

In 1828, a year or two after artists with the expedition of Captain William Beechey portrayed Mission San Carlos, a representative of a German-owned firm in Mexico City specializing in hides and tallow made a sketch of Mission San Gabriel. Ferdinand Deppe later transformed his sketch into a painting in oil which is now in the archive of Mission Santa Barbara (Fig. 7.16). He portrayed the belfry with five regularly placed openings and next

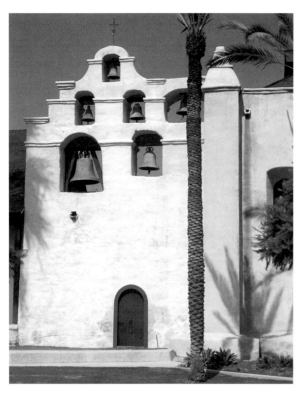

7.15. *Campanario*, Mission San Gabriel.

to it a whitewashed quadrangle, with a red tile roof supported by the posts of a corridor extending across its long front. What may be a guardhouse is next, close to a *zanja* bringing water from Lake Wilson. On the other side of the irrigation ditch are three rows of residences for Indians, one behind the other, the first containing eleven doorways to separate living quarters. A religious procession is emerging from the church, soldiers are firing a cannon at a corner of the quadrangle, and two *vaqueros* are engaged with a steer. In the foreground at the right an elaborately costumed figure, probably the famous *mayordomo* Claudio López stands with Indians, and at the left a figure in brown Franciscan habit and cowl, probably Padre Sánchez, is conversing with a person dressed in nautical white trousers, probably Ferdinand Deppe himself.

Los Angeles

Water has always been essential to Los Angeles, and its presence determined the city's location. Soon after he arrived at Monterey as governor, Felipe de Neve wrote to Viceroy Bucareli on June 7, 1777, informing him of places in California sufficiently watered to support agriculture and outlining for him some of the ideas he would incorporate into his *Reglamento* for the province two years later. Neve noted, in addition to the site on the Guadalupe River where he would soon place the pueblo of San José, the abundant waters of the San Gabriel River, and "three leagues from [Mission San Gabriel] . . . the Porciúncula [the present Los Angeles] River with much water easy to take on either bank and beautiful lands where it all could be used." He stressed the value of agricultural settlements for supplying produce to the presidios, thereby reducing the expenses to the royal treasury, and continued, "I have no better advice to submit but that your Excellency . . . order the recruiting of 40 or 60 field workers and experienced farmers to people the said localities . . . dividing them into two groups to go to the Santa Clara River [for San José] and the Porciúncula."[59] Neve did his own initial recruiting in Alta California for San José, but recruitment for El Pueblo de la Reina de Los Angeles was difficult. Lt. Colonel Anza had attracted 240 settlers in Sonora in 1775, but four years later Captain Rivera y Moncada was unable to enlist 24 even though he extended his recruiting effort farther south into Sinaloa and on toward Guadalajara. He secured 59 soldiers for the presidios but only 16 settlers, 12 of

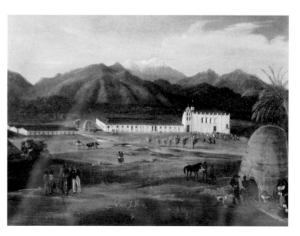

7.16. Mission San Gabriel in 1828, painting by Ferdinand Deppe, 1832. Also see Plate XIV.

7.17. Los Angeles, layout of house and field lots, 1793, drawn by José Argüelo, from the Bancroft Library, reproduced in John W. Reps, *Cities of the American West*, fig. 4.11.

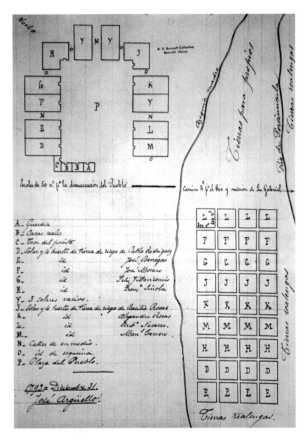

whom arrived with their families in different groups at San Gabriel from June until August of 1781. One settler dropped out at San Gabriel, but the others may have been supplemented by four soldiers of the escort and their families.

Felipe de Neve had arrived at San Gabriel from Monterey in the late spring to welcome his settlers, and he sent the first four and their families to the selected site in June. Shortly after the final group, who had been delayed by infection with smallpox, arrived under the leadership of Lt. José de Zúñiga, Neve issued specific instructions for settlement of the new pueblo on August 26. Like the instructions half a century earlier of Viceroy Casafuerte for the settlement of San Antonio, Neve's closely followed the Ordinances of Settlement of the Laws of the Indies. Town lots 55 by 110 feet were located on three sides of a plaza 208 by 277 feet. Main streets would run out from the center of the sides and two additional streets would run out from the corners. The plaza would be oriented so that the corners would face the cardinal directions in order to minimize vulnerability to strong winds, and one side was reserved for the *casas reales* and other public buildings and for the church. A plan in the Bancroft Library signed José Argüello and dated 1793 shows the plaza with twelve house lots and an orderly array of thirty-six agricultural tracts, four identified for each of nine named householders (Fig. 7.17). Three house lots, two at the north end and one close to the middle of the east side, are labeled vacant. The agricultural tracts were chosen by lot and were 550 feet square. They were located between the Rio Porciúncula and the *Acequia Madre* so that each settler's two outer tracts could easily be irrigated in accordance with Neve's instructions that two of the four be irrigable. Land beyond the tracts was labeled *tierras realengas*, royal land. Neve had written that land not apportioned to the original settlers should be reserved for future comers and also for common municipal purposes.

By October 29 the governor was able to write to Teodoro de Croix, *Comandante General de las Provincias Internas*, that the settlers were well along in developing the site. They had finished the principal irrigation ditch and "are continuing building their houses and also corrals for their stock," which had not yet been distributed, "because they are concentrating their efforts on finishing the pueblo and when it is finished they will begin to plow the fields for the sowing of wheat." Neve had to acknowledge that only eleven settlers had arrived "and of these eight alone are of any use."[60]

The families of the settlers brought the numbers to twenty-three adults and twenty-one children. The only European-born Spaniard was worthless, a bigamist and an escapee from the law. Most of the others were American-born farmers, laborers, and mine workers of mixed blood. Eight of the twenty-three adults were Indians and ten were

at least partly African in lineage. None could read or write.

The first houses were *jacales*, but by 1784 a report described the buildings as houses of adobe, a small public building, and an adobe chapel under construction. A dam of willow poles and woven twigs was constructed in the river to divert water into the *Acequia madre*, and lesser ditches were dug to distribute the water more widely. Ultimately, settlers could draw water for their agricultural tracts for periods of twelve hours for a fixed payment regardless of the amount used. Those living at a distance from the ditches were supplied by carriers. The minimum charge was the equivalent of about fifty cents a week for a daily bucket of water.

Not until after five years could title to house lots and agricultural plots be officially conveyed to the settlers. By that time they were expected to have repaid from their produce the advances made by the royal treasury in money, rations, livestock, clothing, seeds, and tools for farming. Town government evolved into a Castilian-type *cabildo* with elected *alcalde* (somewhat similar to a mayor), two *regidores* (administrative judges), and a public attorney, but at first the governor appointed a *comisionado* to supervise the *cabildo* because he questioned the political competence of the settlers.

The growth of the population of Los Angeles remained modest throughout the Spanish period, and California's Spanish population, like that of Texas, never exceeded one-tenth of New Mexico's. By 1791, ten years after the Pueblo's foundation, there were in Los Angeles 139 people, 29 houses of adobe, a chapel, a guardhouse, granaries and a structure for government, all surrounded by an adobe wall. The census of 1790 had counted 1,096 horses, 39 mares, 528 sheep, and 4 burros in the municipal herds. With Mission San Gabriel, Los Angeles was the largest center of population in California. There were 1,027 neophyte Christians at San Gabriel; the pueblo reported its population to include: 73 "Spanish," 30 *mestizos* (part Spanish, part Indian), 22 *mulatos*, 7 Indians, and one European. Six artisans were recorded, a mason, a tailor, two shoemakers, a blacksmith, and a master mechanic, but no carpenter.

Private ranching in the Los Angeles area began in 1784 with grants by Governor Fages to three retired military men. The crown retained title, as it always did unless settlers journeyed to a distant *audiencia* to secure clear title, but the ranchers had exclusive use of the land at their own expense if they built a house and raised at least two thousand head of cattle. Grants stopped between 1785 and 1795. Then ten new grants were made and they continued with some regularity throughout the remainder of the Spanish period, proliferating again between 1819 and 1821. More than half the *ranchos* in California were in the Los Angeles vicinity, and herds of sheep, cattle, horses, and mules rapidly multiplied.

Friars from San Gabriel said mass in the town's adobe chapel and settlers attended mass in the mission. Father Serra had lost his enthusiasm for towns and settlers, in part because he saw them as competitors of the mission in the sale of agricultural products. Yet relations with San Gabriel, and after 1797 with Mission San Fernando Rey, were generally congenial. A dispute developed in 1810 when the friars constructed a dam upstream to water what they called a small field. They were conciliatory to the protesting settlers, offering to stop their irrigation "if it proves to inflict the least damage on the people of Los Angeles by diminishing the water."[61]

Recurring flooding as well as the scarcity of water in dry years troubled the people of Los Angeles. Ten days of rain in 1815 produced a torrent which shifted the course of the river closer to the pueblo, destroyed several houses, damaged half the town, and flooded the plaza to a depth of several inches, ruining the foundations of the church which was under construction. A later protracted deluge in 1825 returned the river to its present bed. The flood

of 1815 led to a relocation of the plaza to higher ground under the directions of Governor Pablo Vicente de Solá. The new plaza was located largely on what had been common land, but some houses had to be demolished.

The Plaza Church

The small adobe chapel constructed at the southwest corner of the original plaza in the 1780s was in decrepit condition in 1810 and seemed to the people of Los Angeles in need of replacement. A new church was authorized in 1811, but not until three years later did a friar from San Gabriel, Luis Gil y Taboada, bless and lay the cornerstone. The foundations were washed away in the flood of 1815. Three more years elapsed before the plaza was relocated in early 1818. Later that year Governor Solá reported that the citizens had begun a new church. The impoverished community could not have completed the construction without the fiscal support of the friars. Fray Mariano Payeras, leader of the Franciscans in California, assembled the wealthiest residents of the community and the ranchers of the area and promised to supplement the funds they could contribute. In response to his appeal, the southern missions donated in 1819 seven barrels of brandy which were sold to the presidios for a sum calculated as $575.81. "The most insurmountable difficulty I always thought," he wrote, "was to secure the requisite architect and artisans of every type, who could erect a decent temple, but all this was overcome by the well-known charity of the Missionary Fathers of San Luis Rey. . . . they fixed the wages of the neophyte laborers, including the master carpenters and laborers, at one *real* a day, besides board, and in part payment they accepted cattle at a favorable price."[62] José Antonio Ramírez, a native of the Guadalajara area who had recently designed and supervised the construction of the church of San Luis Rey and had previously worked at San Carlos, Santa Barbara, and San Juan Capistrano, was secured as architect after some initial resistance of the Angelenos to a salary of six *reales* a day in addition to board and a barrel of wine every three months.

In 1821 work was suspended when the walls had reached the top of the windows because only fifty dollars remained in the building fund and two thousand was needed to complete construction. Father Payeras wrote another letter to the missions, soliciting support as far north as San Francisco in the form of carpenters, sawyers, money, cattle, tallow, pack mules, brandy, and "even cloth from the looms."[63] Substantial herds of cattle were sent from missions as far away as San Miguel, San Luis Obispo, and Purísima Concepción, and the missions from Santa Barbara south sent one or more barrels of brandy, except San Diego which sent two barrels of white wine. Work was resumed in early 1822 and the church was dedicated on December 8.

The walls were of adobe and the flat roof was covered with tar from the La Brea deposits. The length was modest, only a little over eighty feet, but there were projecting transepts and a low external baptistery. The culminating feature of the façade was a curving gable which rose high above the roof, but it was less baroque than the multicurved gable Ramírez had designed for the church of San Luis Rey (Fig. 7.18). Like that gable it probably contained a niche for a statue at its top. To the left of the façade was a *campanario* wall, related to those at San Gabriel and San Diego, which was pierced with

7.18. Los Angeles, Plaza Church before 1860, drawing from Title Insurance Trust Co.

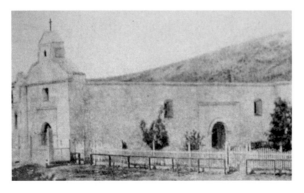

openings for bells, three below and one above. The church is visible in drawings of Los Angeles of the 1840s and '50s; H. M. T. Powell provided a front view from a distance. The church is more clearly rendered in views from the rear by William Rich Hutton and Henry Miller (Fig. 7.19). Rains damaged the structure in 1860, and in January 1861 a newspaper reported that "the front of the old church, attacked through the leaking roof, disintegrated, swayed and finally gave way, filling the neighboring street with impassable heaps."[64]

The church was rebuilt with a brick façade that terminates in a triangular pediment. Further reconstruction in 1869 added a gabled roof of shingles, later replaced with tiles, and remodeled the *campanario*, filling its bell openings and replacing the upper one with a round window to match one which had been placed in the pediment of the façade. The height was increased by adding at the top an open wooden belfry stage. The church was extended to the rear in 1912–1913, and at that time the *campanario* acquired its present upper wall with three openings for bells. The construction of a new larger church to the rear in 1965 led to the removal of the addition and a restoration intended "to retain, reinforce and make safe the original mission church."[65] Unfortunately, because of the many alterations, nothing short of total reconstruction could have restored the appearance of the façade designed by José Antonio Ramírez.

Gradually increasing prosperity came to Los Angeles after Mexico achieved independence from Spain. California was opened to foreign ships, including those from the United States, and trade in hides and tallow developed. American and British merchants settled in Los Angeles, which in 1835 officially became a city and, briefly, the capital of California. The Spanish population of the Los Angeles district listed in the 1836 census was 603 men, 421 women, and 651 children. The French traveler Eugene Duflot de Mofras described the town as situated "on a vast plain covered with trees,

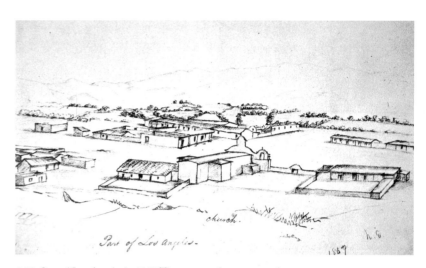

7.19. Central Los Angeles in 1847. The one-story houses are modest, the streets few, and the plaza ill-defined. The church, seen from the rear, has a flat tar roof behind its projecting frontal gable and a *campanario* on the side. Drawing by W. R. Hutton.

olive groves, orchards, and extensive vineyards." He explained that the community had profited from the Mexican government's secularization of the neighboring missions and that its people owned "over 80,000 cattle, 25,000 horses and 10,000 sheep. Vineyards yield 600 barrels of wine and an equal amount of brandy."[66] Duflot de Mofras attributed the relatively paltry production of grain to the indolent habits of the inhabitants who used and exploited Indian farm workers living in a village close to town.

Houses continued to be modest, and Los Angeles never attained the ordered form prescribed in Governor Neve's instructions. The plaza was an irregular quadrilateral, converted into its present rounded form in 1870, and no more than two or three streets ran from it to the west and one to the east. Harris Newmark described the houses of 1853, the year he arrived, six years after the American occupation. "Conventionality prescribed no limit as to the number of rooms, one adobe frequently having a sitting-room, a dining room, a kitchen and as many bedrooms as were required, but there were few, if any, 'frills' for the mere sake of style. Most adobes were but one story in height; although there were a few two-story houses; and it is my recollec-

tion that in such cases, the second story was reached from the outside. Everything about an adobe was emblematic of hospitality: the doors heavy and often apparently home-made, were wide and the windows were deep. . . . There were few curtains or blinds, wooden shutters, an inch thick . . . were generally used instead. . . . The porches, also spoken of as verandas and rather wide, were supported by equidistant perpendicular posts. . . . The *roofs* which . . . proved as necessary to preserve the adobe as to afford protection from the semi-tropical sun, were generally covered with asphalt and were usually flat to keep the tar from running off."[67] Annually when the season of winter rains approached, there was a great scramble to secure the services of Vicente Salsido, the only man in town who repaired roofs.

The plaza remained the center of business and social life and Los Angeles remained a distinctly Hispanic community for more than a decade after American occupation. Newmark described the Corpus Christi processions of the 1850s: "Notable families such as the Del Valles, the Oliveras, the Lugos and the Picos erected before their residences temporary altars, decorated with silks, satins, laces and even costly jewelry. The procession would start from the church after the four o'clock service, and proceed around the plaza from altar to altar. Then the boys and girls, carrying banners and flowers, and robed or dressed in white, paused for formal worship, the progress through the square, small as the plaza was, . . . taking a couple of hours. Each succeeding year the procession became more resplendent and inclusive." In one procession, "twelve men, with twelve great burning candles, represented the apostles."[68]

SAN JUAN CAPISTRANO AND SAN LUIS REY

Mission San Juan Capistrano, founded in 1776 by Fray Junípero Serra, and Mission San Luis Rey, founded in 1798 by Fray Fermín de Lasuén, complete the chain of missions between Los Angeles and San Diego. These, with San Gabriel, were the most prosperous of all the missions and both were notable for the architecture of their churches.

Mission San Juan Capistrano

Informed by Junípero Serra in 1775 of his intention to found a mission on San Francisco Bay and "another under the name of San Juan Capistrano between San Diego and San Gabriel, for which the Fathers Fermín de Lasuén and Gregorio Amúrrio have been appointed,"[69] Viceroy Bucareli expressed his pleasure and added that "as the Missions increase and the neophytes grow in number, the land will produce copious harvests for their maintenance."[70] But progress was not as easy as the viceroy anticipated. Soon after Father Lasuén offered the first mass in late October in an arbor beside a large cross, news arrived that Indians had burned Mission San Diego and killed one of its missionaries. San Juan Capistrano was abandoned, its two bells buried, and its two friars departed to the shelter of the presidio of San Diego. Fermín de Lasuén was subsequently assigned to the difficult post of Mission San Diego, where he remained until he was appointed Father President after Serra's death.

Exactly a year later Mission San Juan Capistrano was refounded by Fathers Serra, Amúrrio, and Pablo Mugártegui, who was chosen to replace Lasuén. The large cross remained and the bells were exhumed. The first chapel and other structures, constructed of branches and roofed with thatch, were soon replaced with buildings of adobe.

The church, known popularly as "Serra's church" because of the Father President's use of it on visits, was reported as completed before December 1778. Located on the east side of the quadrangle, it is the only church remaining which was used by the founder of the California missions. At some time in the 1780s, it was extended to twice its length to accommodate the increasing number of neophytes

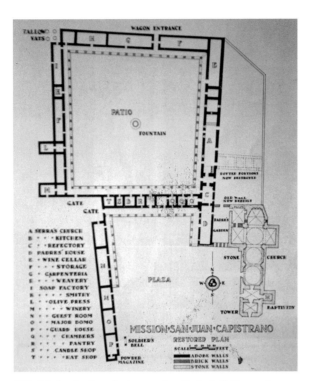

7.20. Mission San Juan Capistrano, plan, Rexford G. Newcomb, *Spanish-Colonial Architecture in the United States*, plate 61.

in residence. At that time the walls of the older section were raised to the level of the new higher walls.

Each side of the mission quadrangle now contains sixteen restored arches which support red tile roofs extending over the corridors (Fig. 7.20). The arches are uneven in breadth so that the sides are uneven in length and no corner forms a right angle. The buildings other than the church which surround the quadrangle on the east, north, and west sides contain large rooms which served utilitarian purposes, providing storage spaces and rooms for weaving, smithing, carpentry, and for the processing of olives and grapes. The refectory was at the southeast corner, and adjoining it and extending south from the quadrangle was the residence of the friars. Opposite the residence at some distance to the west, a building approximately as long as one of the sides of the quadrangle contained the guardhouse of the soldiers, the residence of the mission's *mayordomo* and ample quarters for the mission's guests. These buildings and the subsequently constructed stone church formed a U-shaped forecourt south of the quadrangle.

The Stone Church

By late 1796 the stone church of San Carlos in Carmel was nearing completion, and that of San Gabriel had been under construction for at least two years. There were more than a thousand Indians living in Mission San Juan Capistrano, more than those in San Carlos although less than in San Gabriel. About two-thirds of the Indians were adults required to attend Sunday mass. The enlarged adobe church was no longer adequate, and the missionaries, Vicente Fuster and Juan Norberto de Santiago, decided to construct the most architecturally ambitious of California's mission churches. They initiated building in February and laid the cornerstone on March 2, 1797.

The exact form, plan, and dimensions of the church are impossible to determine because of its ruined condition and the limited description available. Fathers Fuster and Santiago reported on the last day of December 1797 that the planned interior length was 53 *varas*, approximately 146 feet, and that the sacristy had been outlined to measure approximately 28 by 19 feet. Seven years later the resident friars wrote that the church was enclosed by five domes, three along the central axis and one at each side of the transept. The annual report after the earthquake of 1812 explained that "the tower tottered twice. At the second shock it fell on the portal and bore it down, causing the concrete roof to cave in as far as the transept."[71]

Rexford Newcomb believed that the tower was frontal, standing before the narthex, but the studies in the 1930s of the Historic American Buildings Survey set the tower on the east side of the narthex and placed the baptistery within it. The measurements of the Survey suggest that the dimensions of this first Latin cross church in California differed from those planned in 1797 and that the layout con-

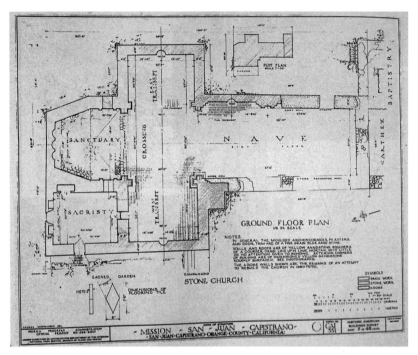

7.21. Mission San Juan Capistrano, plan of the stone church, Historic American Buildings Survey.

tained notable irregularities (Fig. 7.21). The interior length of the church proper was approximately 133 feet, with the narthex in front adding about 25 feet, making the overall length approximately 158 feet. The transept was wider (at 75 feet) than the relatively short nave was long (67 feet), and was irregularly laid out, slightly wider at its west end than its east, and extending two and a half feet more beyond the outer wall of the nave on the west than on the east.

One full bay of the east wall of the nave has sur-

7.22. Remains of the stone church of San Juan Capistrano, c. 1880, photograph by Carleton E. Watkins.

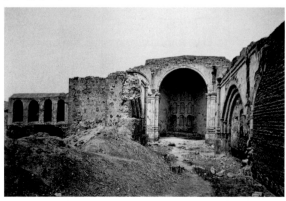

vived so that its form can be perceived (Fig. 7.22). The bays were separated by pilasters which supported transverse ribs. In each bay three layers of cut-stone arches were set into the wall to frame niches containing statues or, more probably, large wooden *retablos*. The transverse ribs provided support for the shallow domes which were constructed with rough stones set in a thick layer of concrete, like some of the domes constructed by Indians under the direction of friars in sixteenth-century Mexico. Newcomb believed that the dome over the front bay of the nave was oval rather than circular in order to cover a bay which was longer than the surviving bay which led into the transept.

The height from the floor to the domes, approximately 53 feet, exceeded the height of the oval roof domes of San Xavier del Bac and of the vaults of San José in San Antonio by more than 17 feet. It exceeded the interior height of the crossing dome at San Xavier by several feet and equalled that of the crossing dome at San José. The polygonal sanctuary is covered by a surviving groined vault, and its rear wall contains nine niches placed in tiers of three to hold statues or *retablos* to ornament the altar. The sacristy has a dome lower than the other five. The floor was made of flat tiles laid in a chevron pattern. The height of the tower has been estimated at 120 feet, more than twice the height of the domes of the roof.

The church was constructed of two different stones, a yellow sandstone roughly cut from a quarry about six miles to the northwest and set in mortar for the walls, and a softer, finer bluish gray sandstone used for framing doorways and for building pilasters, cornices, and arches. The work of quarrying and of construction was done by neophyte workers who transported large stones in lumbering *carretas* (two-wheeled carts) pulled by oxen and small ones in nets slung over their backs.

Unlike California's two earlier stone churches, this church was begun before the friars secured a master mason. The irregularities of the plan prob-

ably resulted from the lack of a trained mason. It was apparent that without one, work could not continue once the walls reached the level of the arches which would support the vaulting, and Fathers Fuster and Santiago grew increasingly anxious. Nearly two years after the laying of the cornerstone, Governor José Joaquín Arrillaga wrote to the viceroy explaining that they had been unable to get even a passably competent artisan but that he had written to a man in Los Alamos, Sonora, who had located a master mason farther south in Culiacán who had finally arrived after traveling five months. *Maestro de albañil* Isidro Aguilar was at Mission San Juan before late January, 1799.

Two years later Father President Lasuén informed the College of San Fernando and the viceroy that work on the church, which had begun four years before in 1797, was progressing steadily if slowly. In November 1800 a minor earthquake had caused some cracks in the walls and necessitated some reconstruction. The elderly Father Fuster had died that year and was replaced by Father José Faura. In the same year a side altar screen had arrived from Mexico.

The death of Isidro Aguilar, probably in early 1803, was a great setback. Work slowed and the friars sought a replacement. None is recorded. They may have continued construction, following Aguilar's design without additional expert guidance. By the end of 1805 the church was nearing completion. On September 7, 1806, it was officially consecrated and dedicated to the "Solemnity of the Purification of Mary Most Holy" by Father President Estevan Tapis, in the presence of Governor Arrillaga and officers from the presidios of San Diego and Santa Barbara, missionaries from San Gabriel, San Luis Rey and Santa Barbara, and many neophytes from nearby missions.

After more than nine years of construction, the church was used for six years and three months before it was destroyed in the earthquake of December 8, 1812. During the thinly attended first mass on the Feast of the *Purísima Concepción* of the Virgin, quaking of the earth brought down the tower and caused the roof of the nave to collapse. The friars reported that "40 Indians, 38 adults and two children, were buried beneath the ruins."[72] Eulalia Pérez, later housekeeper at San Gabriel, was at mass that terrible morning. Sixty-five years later she recalled that as the tower tottered she, "dashed through the sacristy, and in the doorway people knocked me down and stepped over me. I was pregnant and could not move."[73] "The disaster," the missionaries explained, "has left us without a church because its gaps and cracks make it unserviceable, and because the walls of the fallen part remain high, we dare not work and are in constant fear."[74]

Despite the apprehensions of the missionaries, the transept and its domes survived substantially intact for at least another thirty-eight years. An 1850 sketch by H. M. T. Powell shows a lantern over the remainder of the dome above the crossing and indeterminate forms over the ends of the transepts. Nothing remains of the front of the church, but thick walls of the nave still reach their original height (Fig. 7.23). Henry Miller's drawing of 1856 is in some regards confusing, but it clearly

7.23. The remains of the stone church of San Juan Capistrano in 1850. H. M. T. Powell's drawing shows the walls of the nave, the transept ends with domes above them, and part of a higher dome over the crossing still supporting a lantern. The drawings of H. M. T. Powell are reproduced in *The Santa Fe Trail to California, 1849–1852: The Journal and Drawings of H. M. T. Powell*.

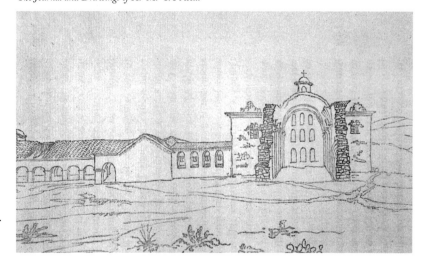

shows grass growing above the roofs of the transept ends. In the following decade an ill-advised effort to supplement the stone ruins with adobe construction led to the dynamiting of the damaged domes.

The adobe buildings of the quadrangle were still standing behind their stone arcades in the 1850s, although the wooden supporting structures of their red tile roofs had begun to rot. Decay was gradual, as Carleton Watkins's photograph of the mid-1870s shows, but by 1897 little remained but the old adobe church. Tiles had been stripped from the buildings to roof new houses constructed in the neighborhood. Preservation of what had survived became a priority for Charles F. Lummis and the Landmarks Club, which took a lease on the mission property in 1896. Lummis later reviewed the club's accomplishments in his magazine *Out West*, explaining that "the first work of the Club was done at that gem of all the missions, San Juan Capistrano. . . . The Club has re-roofed with tiles, 387 feet in length the principal buildings—including the *old adobe church which Serra himself founded*—with a total roof area of 9,640 square feet. It has re-roofed with gravel and asphalt—as they were originally—an area of 5,250 square feet of corridors. . . . It has also rebuilt serious breeches in adobe walls, and tied in, with iron rods, some walls that were about to fall outward, has buttressed the crumbling stone pilasters which support all that is left of the great stone church . . .; has removed about 400 tons of debris from fallen walls and roofs . . .; and has in general brought order out of the wreck."[75]

Father St. John O'Sullivan, pastor in charge of the mission from 1910 until his death in 1933, worked steadily with limited means to extend the restoration begun by the Landmarks Club. He repaired buildings and laid out and planted gardens.

Mission San Luis Rey

The final mission founded in the eighteenth century and the last of nine founded by Fermín de Lasuén, San Luis Rey became the largest and most successful California mission. Fray Domingo Rivas, who in early June 1798 arrived at the site of the new mission between San Juan Capistrano and San Diego with the *comandante* of the presidio in San Diego, left an account of the founding. They came upon three friars, one of whom was "a venerable old man seated on a bundle of blankets. It was the Reverend Father *Presidente* . . . Fermín Francisco de Lasuén. . . . With him were fathers Juan de Santiago and Antonio Peyri. He was giving directions for completing that very evening the church and the dwelling for the religious. The shortness of the time it took to construct the two rooms indicates of what material they must have been built [branches and brush]. . . . They are perfectly described by saying that they were . . . like a lodge in a garden of cucumbers. . . . The Father *Presidente* remained there [after the formal celebration of the founding] about three or four days more, selecting together with Father Antonio Peyri the places where grain might be planted, where the [permanent] church could be erected, and where the dwelling of the Fathers and other necessary quarters of the Mission should be built."[76]

For the establishment of the mission, Father Peyrí and his associate, Father José Faura, had only "some pickaxes, a dozen plowshares, half a dozen crowbars, some blankets, a quantity of flannel and two dozen bolts of cloth with which to clothe the naked Indians."[77] Yet San Luis succeeded seemingly almost without effort. As early as June 20, Father Lasuén wrote to Governor Borica: "Here everyone is wondering at the marvels God has wrought. Already there are seventy-seven baptized and twenty-three catechumens. Large numbers are not admitted to instruction for it is impossible to maintain them in the customary manner . . . and more especially because it is difficult to transport food for so many. . . . Since the day when we first took possession here, the large *pozole* cauldron, has been filled three times a day, twice with *atole*, and once with

pozole, and so it goes without stopping. We have thirty neophytes [to assist us,] fifteen from each of the missions San Juan Capistrano and San Diego and they are good workers. There are twenty yoke of oxen, eighteen equipped for present needs. Good corrals have been made for the cattle and sheep and all the preparations have been made for an additional one for the horses. To protect everything a palisade is being built, and without much trouble. . . . Yesterday when it was a bit late, they began to make adobes, and by five o'clock they had made more than five hundred."[78] By July 12, Father Lasuén reported that 6,000 adobes had been made, and six days later 8,002. At the end of the year, the missionaries reported to Lasuén that all the needed adobes had been made and that their residence and the residences of the soldiers and of the corporal of the guard had been completed with roofs of thatch and earth, and that the *monjério* and another building were nearly finished and would soon be roofed.

At that time there were 203 Indians in residence. Their numbers rose steadily, passing 1,000 in 1807 and reaching 1,866 in 1815 and 2,756 in 1825. The peak year was 1831 with 2,819, shortly before secularization. The mission's herds also increased steadily from 162 head of cattle, 600 sheep, 28 horses, and 10 mules in 1798 to 3,000 head of cattle, 6,400 sheep, 276 horses, and 28 mules in 1804. These numbers approximately tripled in the next eleven years, and in the peak year of 1828 there were 25,754 head of cattle, 28,913 sheep, 1,232 goats, 295 pigs, 2,226 horses, and 34 mules for a total of 58,764 animals, most of whom were pastured at some of the mission's more than twenty outlying *ranchos*. Large *ranchos* such as Las Flores, Temécula, and Santa Margarita, which also had extensive agricultural fields and a large orchard, had sizable Indian communities and chapels which were visited periodically by a friar. Other cattle ranches included Las Pulgas, San Jacinto, San Juan, and San Mateo. Sheep ranches included Agua Hedionda, Buena Vista, Pamuza, and San Marcos. The still-existing San Antonio de Pala near a stream in the hills to the east of the mission had fields for wheat, corn, and beans, a vineyard, and orchards for fruit and olive trees, as well as an Indian community, granaries, and a chapel.

Agricultural production on the land of Mission San Luis Rey was limited by the scarcity of water much of the year, and it varied with the annual changes in the rainfall. Drought in some years was severe enough to cause deaths of livestock. In 1822 Fray Mariano Payeras reported to the new government of Mexico that water had been sought up to thirty miles from the mission, "for the purpose of irrigating but irrigable places are few, and for the principal crops we depend on the rains, which in some seasons are scarce enough." Five years later Fray Antonio Peyri reported that there was little water continually available to the mission. A stream originating in the Sierra Madre which ran in one arroyo brought plenty of water during the rainy season from October or November until April or May, but then "it is again lost in the sand." Some water was extracted from a marsh by forcing it to the surface in some way with earth hauled to the site. "By means of two dams the water was then collected so that it sufficed for the assembled Indians and for irrigating a garden. This is the only water on which we can depend."[79]

The mission's two gardens for fruits and vegetables were described by a French traveler, Auguste Bernard Duhaut-Cilly, who visited San Luis Rey in 1827. The broad stairs to the lower garden located in a deep depression in front of the mission reminded Duhaut-Cilly, because of their arrangement, numbers, and dimensions, of the stairs of the *orangerie* at Versailles. "At the bottom of the stairs," he wrote, "are two fine basins of stucco for washing; one of them is a pool where the Indian women bathe every morning, the other is used every Saturday for washing clothes. Some of the water is afterward distributed into the garden, where many channels maintain a permanent moisture and cool-

Chapter VII

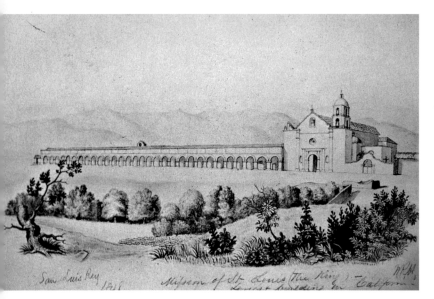

7.24. Mission San Luis Rey in 1848. W. R. Hutton's drawing shows the immensely long arcade of thirty-two arches before the front range of the great quadrangle. In the foreground below the trees was the sunken garden.

ness. The second garden, situated in a higher place, can be watered only by mechanical means: a chain pump, worked by two men, is used twice a day." Duhaut-Cilly believed that "these gardens produce the best olives, and the best wine in all California,"[80] and he testified that he still had some of the wine seven years later.

The *ranchería*, or Indian village, began about two hundred yards north of the mission buildings and spread over an extensive area. Unlike the regularly placed, tile-roofed adobe houses of San Gabriel and most other missions, these dwellings were scattered and of various shapes, many of them conical and all built of reeds. The missionaries of San Luis Rey believed that European-style housing contributed to the mortality of the Indians and allowed them to construct the type of houses they were used to living in.

The Present Church and Father Peyri's Quadrangle

Father Antonio Peyri remained at Mission San Luis Rey for thirty-four years and was primarily responsible for its long-continued construction. José Antonio Ramírez, later architect of the Plaza Church in Los Angeles, was of critical assistance in the design and construction of the large church which was built between 1811 and 1815 after it became apparent that the second church, which had been built in 1802 in an effort to accommodate a thousand Indians in an adobe structure approximately 138 feet long and 19 wide, was no longer adequate. The plan was formulated in 1811 and the foundations marked out and constructed. During 1812 the walls were built up to the cornice level.

In the following year, while material for more work on the church was assembled, extensive construction was under way elsewhere in the mission. By that time the buildings around the quadrangle, which measured in the interior nearly 300 feet on the long sides and 280 on the short ones, dwarfing the one at San Juan Capistrano, had been completed. In 1813 the front corridor of the mission was added with its arcade of thirty-two arches and immense length, extending approximately 460 feet from the new church on the east to the end of a new wing which projected beyond the quadrangle to the west (Fig. 7.24). In addition the arches of the arcades of the interior of the quadrangle had been built to approximately half their intended height. There were twenty-three arches on the longer sides, twenty-one on the shorter. The design and construction of the mission buildings at San Luis Rey were the finest in California. The arches of the long front were not high, no more than thirteen feet, but a parapet and a latticed balustrade of brick raised the overall height to twenty feet. Duhart-Cilly praised the proportions, writing that they created both grace and nobility.

The quadrangle was the center of the mission's life as well as of its architectural layout. Alfred Robinson, a visitor in 1829, wrote that "the interior is divided into apartments for the missionary, and majordomos, storehouses, workshops, hospitals,

rooms for unmarried males and females." He continued with an account of the uses of structures beyond the quadrangle. "Near at hand is a range of buildings tenanted by families of the superintendents. There is also a guardhouse [in front], where were stationed some ten or a dozen soldiers, and in the rear spacious granaries stored with an abundance of wheat, corn, beans, peas, etc. also large enclosures for wagons, carts, and implements of agriculture." Robinson wrote that "in the interior of the square might be seen the various trades at work" and offended the Franciscan historian Zephyrin Engelhardt by comparing the scene "to some of the working departments of our state prisons."[81]

A fountain at the center of the quadrangle supplied water for the mission's use. On feast days the enclosure constituted a stage for games and dances. Duhaut-Cilly described the fiesta staged to celebrate the Feast of San Antonio, June 13, 1827, which was also the twenty-ninth anniversary of the founding of the mission. Volleys of rifle-fire and fireworks provided the prelude on the eve of the opening day, and an early morning high mass in the church inaugurated the festivities. Interest then shifted to the quadrangle, where crowds of Indians watched from the roof terraces behind the balustrades. Bullfights lasting several hours featured the skill of horsemen in teasing and wearing down a bull. Then the bull was released into the open country and pursued by the horsemen, who seized its tail and pulled it upside down. Another game which displayed horsemanship featured the snatching from horseback of a cock buried up to its neck in the ground and the brutal combat of the riders to grab away and retain what soon became the feathery and bloody remnants of the cock. Purely Indian games included efforts to toss four-foot-long sticks through a spinning three-inch ring of willow, and a game resembling field hockey played by both sexes in large groups. The married women defeated the single women on June 13. The festivities were marred by a girl's skull-smashing fall over the balustrade. They were concluded by a rhythmic torchlight dance of men clad in head feathers, shirts, and breechclouts, accompanied by a chorus and orchestra of old men, women, and children whose music Duhaut-Cilly found "plaintive and wild."[82]

Pablo Tac, one of the Indian boys Father Peyri took with him when he left the mission and for whom he secured admission to the missionary College of the Propagation of the Faith in Rome, recalled life in the mission before he died in 1841. He wrote that the "father is like a king. He has his pages, *alcaldes*, *mayordomos*, musicians, soldiers, gardens, *ranchos*, livestock, horses by the thousands." Yet he was abstemious, "drinks little, he who knows the customs of the neophytes does not wish to give any wine to any of them but sells it to the English or Anglo-Americans, not for money but for clothing for the neophytes, linen for the church, hats, muskets, plates, coffee, tea, sugar and other things." Tac listed the products of the mission as "butter, tallow, hides, chamois, leather, bear skins, [red] wine, white wine, brandy, [olive] oil, maize, wheat, beans and also bull horns which the English take by the thousand to Boston."[82]

Trade in hides was large in scale in all the southern missions, and was most spectacular at Mission San Juan Capistrano, where hides were dropped from cliffs 280 feet above the boats on the beach at low tide. Richard Henry Dana described the process in 1839. "Down this height we pitched the hides, throwing them as far out in the air as we could; and as they were all large, stiff and doubled like the cover of a book, the wind took them, and swayed them about, plunging and rising in the air, like a kite when it has broken its string."[84]

Construction of the new church resumed in 1814 and was rapid. By the end of the year the church was close to completion, and it was dedicated on the Feast of San Francisco, October 4, 1815. A little more than two years later, Father Peyri wrote

Chapter VII

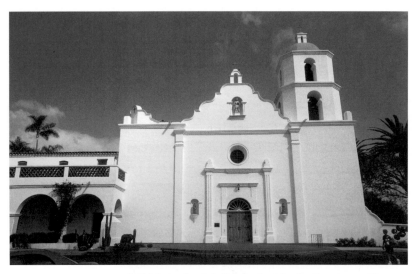

7.25. Mission San Luis Rey, façade of the church, and part of the arcade of the restored quadrangle. Also see Plate XV.

7.26. Interior of the church of Mission San Luis Rey, photograph by Will Connell.

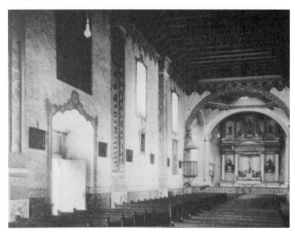

that rain had come through the roof and formed a lake. "With the assistance of maestro Salvador repairs are under way; but good masons do not know how to place the tiles." Eventually the roof was made watertight, and the adornment of the interior of the church continued into the 1820s. In its original form the church's crossing was not covered by the later wooden dome and lantern. Peyri wrote on the last day of 1829 that all parts of the church were handsomely adorned for worship and that "a graceful dome was built; this supported a small cupola sustained by eight columns. This little cupola, or lantern, was formed of 144 panes of glass."[85]

Of the California mission churches, San Luis Rey most resembled in plan its northern neighbor, the stone church of San Juan Capistrano, which was still standing when San Luis Rey was conceived. They were the only Latin cross churches in California and had comparable dimensions. A vaulted roof was never considered at San Luis. Most of the walls were built of adobe bricks, with large fired bricks, measuring about ten by six by two inches, used for the façade, the tower, the arches, and the corners.

The façade is asymmetrical (Fig. 7.25). The larger eastern tower supports a simple, graceful two-story octagonal belfry crowned with an octagonal dome and a square lantern. The slightly narrower western tower supports near its outer corner a triangular parapet softened by a baroque multicurved and multiangled upper molding. The central frontispiece, now rather stiffly restored, was crowned by a flowing gable of similar design. The cornice below the gable is set slightly below the cornices of the flanking towers to avoid a strong horizontal accent high on the façade. The portal, its framing entablature, and the pilasters placed at the inner edges of the towers are straightforwardly neoclassical. A small round window is located at the center of the façade between the portal and a niche in the flowing gable above.

The interior has a choir balcony over the entrance, and side altars at the ends of the transepts as well as the principal altar in the sanctuary. The altar screens are neoclassical, primarily white and gold, but the principal one has a flowing baroque curve in its upper molding. They were probably designed and constructed by José Antonio Ramírez about 1820. An earlier main altar screen was flat, ornamented by stenciled fronds painted on wide wooden boards. The nave is lit on both sides by three rectangular windows and accented along the walls by four tall pilasters (Fig. 7.26). Doors, leading on the left to Father Peyri's private garden with its three fountains and on the right to the chapel in the cemetery, are located in the middle of the sides. Shorter pilasters support the stuccoed and painted

brick arches which sustain an octagonal wooden dome over the crossing. It is wholly within the roof but rises above the nave, the horizontal *vigas* of which were hidden behind a painted ceiling of canvas. Mural paintings were noted by nineteenth-century visitors, and much ornamentation, now repainted more than once, has survived. Loosely flowing patterns of marbleized blue decorate the pilasters and arches. The walls are crowned by a marbleized cornice and a strong frieze of red lambrequins suspended at two levels. Frames of floral garlands surround the windows and the doorways to the garden.

The baptistery is in the western tower, and at the other end of the church, auxiliary spaces flank the sanctuary, one of them the sacristy (Fig. 7.27). A notable adjunct to the church is the San Francisco Chapel in the cemetery to the east (Fig. 7.28). It is octagonal with a projecting rectangular sanctuary opposite the entrance from the church. The dome, which has been restored after its collapse in the second half of the nineteenth century, was constructed of fired bricks. It was divided into eight segments by painted ribs. The wall segments are articulated by half columns and painted arches and unified by a marbleized cornice and a double lambrechin frieze similar to that of the church.

San Antonio de Pala

Separated from Mission San Luis Rey by twenty-five miles and located in a valley where the San Luis River cuts into the hills to the east is the chapel of San Antonio de Pala, the only *asistencia* chapel remaining in California. San Luis Rey had as many as five other such chapels located in Indian villages too distant to permit attendance at religious services at the mission. Perhaps twenty or more *asistencia* chapels were associated with the other missions. All were visited periodically by a friar from the home mission. San Antonio de Pala was founded by Father Peyri in 1816. He remained in the village,

except for brief visits to Mission San Luis Rey, for more than a year to oversee the construction of the chapel and its initial operations. He returned in 1818 when the chapel was enlarged into a narrow rectangle of over 106 feet of interior length, with a sacristy behind the sanctuary. Its tile roof was supported by a frame of rough timbers, and its walls acquired crude but powerful decorations painted by an Indian in red, black, and green. The side and rear walls were covered by arches swinging from column to column and containing unusual circular and triangular forms. The sanctuary contained five simulated niches before which statues were placed, one on each of the side walls and three on the main wall. The niche above the altar was hollowed from the wall to hold the statue and was painted to suggest a niche like that over the doorway from Father Peyri's garden into the church at San Luis Rey (Fig. 7.29).

The painted decorations survived with little damage into the first years of the twentieth century despite gradual disintegration of the tile roof and decay of the front end of the church. The Landmarks Club directed a campaign of restoration which enlisted as workers many of the Indians who had been relocated on a reservation in the Pala Valley after they had been expelled from their ancestral homes in Warner's Ranch in San Diego County. Charles F. Lummis reported in the July 1903 issue of *Out West* that the reconstruction had included a complete reroofing of the chapel and a rebuilding of the front (including four piers which had supported an overhanging roof).

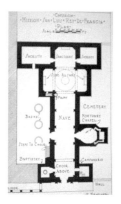

7.27. Plan of the church of Mission San Luis Rey, Rexford G. Newcomb, *Old Mission Churches and Historic Houses of California*, p. 129.

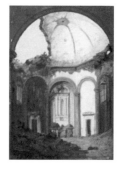

7.28. Mission San Luis Rey, San Francisco Chapel in 1870, painting by Lemuel Wiles.

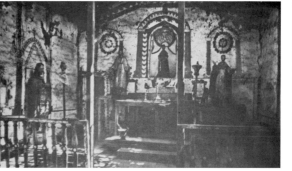

7.29. Chapel of San Antonio de Pala, interior in the 1890s, before alteration by the Landmarks Club and subsequent repainting, photograph in George Wharton James, *Picturesque Pala*, before p. 27.

In the interior the rebuilders removed "the ugly posts from the center" and created a completely open nave by constructing roof trusses, adding the "tension members which the original builders had failed to supply."[86] Soon after the rebuilding a priest assigned to the chapel whitewashed the walls and obliterated the decorations, to the great dismay of the Indian congregation. They were not easily placated and he was soon replaced by a more sympathetic cleric. An additional grievous loss to Pala was the free-standing *campanario* which collapsed when its adobe base was eroded by a storm in January 1916 that dropped approximately a foot of rain on Pala in twenty-four hours. The new priest raised funds, and the *campanario* with its two openings for bells was rebuilt on a concrete base using as much of the old materials as was salvageable. The walls of the church were later repainted in red, blue, and gold, following very loosely the original designs. The result is disappointing, resembling an interior decorator's work more than that of the original Indian painter. Such restorations are deplorably common in California.

Mission San Luis Ray after 1831

After almost thirty-three years of uninterrupted development, drastic change came suddenly to Mission San Luis Rey in mid-December 1831. Narciso Durán, head of the California missions, informed Father Peyri that he had considered journeying to Mexico to defend the missions from their enemies but had decided that it would be better if Peyri went in his stead. He suggested that Peyri turn his mission over to another friar and go to Mexico City and "represent to the College [of San Fernando] and to the supreme government our intolerable oppression, the peril from our cruel enemies, and our inability to continue in the service of the missions owing to our old age [he was fifty-five and Peyri was sixty-two], our physical maladies, and exhaustion. You will urge that secular priests be sent hither to take over the missions from us, and that we be given our passports in order to return to the College, . . . or to Europe."[87]

Peyri, probably sharing his superior's discouragement, turned San Luis Rey over to Fray Antonio Ánzar, who had been assisting him. To the shocked dismay of his 2,700 neophytes, Father Peyri sailed from San Diego January 17, 1821, on a ship carrying to Mexico former Governor Manuel Victoria, who had been ousted in a coup. Peyri was allowed to return to his native Catalonia. He found ecclesiastical conditions unencouraging there and would have returned to California had his health permitted. It is thought he died in 1834 or 1835.

The disaster that Father Durán had anticipated gradually overtook Mission San Luis Rey. By 1835, following secularization, lay administrators had taken control and the friars became resident tenants. The last at Mission San Luis Rey was Fray José María Zalvidea, for twenty-one years missionary at San Gabriel, who died in 1846. During the following year the mission was visited by the invading Army of the West of Stephen Watts Kearny. Major W. H. Emory, topographical engineer and western explorer, found the mission deserted, offering "no resting place for the weary and hungry" but still impressive. "The building is one that for magnitude, convenience, and durability of architecture would do honor to any country."[88] In 1852 John R. Bartlett, commissioner of the boundary survey subsequent to the Mexican War, praised the garden beside the church with its fruit and ornamental trees but reported that the lower garden's "acequias had been neglected, and the dams and embankments washed away, and the beautiful gardens and shady walks . . . overflowed [by] a swamp filled with rushes and rank weeds."[89] The mission was substantially intact except for the northwest corner of the quadrangle where the roof had fallen in.

As late as 1865 Henry Miller found all thirty-two arches of the front range still in place, but in the 1870s Carleton E. Watkins was able to photograph only six which remained standing, those closest to

the church. Father Joseph J. O'Keefe, who arrived at Mission San Luis Rey in 1893 to join Franciscans who had fled from secularism in Mexico, explained that "the houses were unroofed for tiles and rafters; the beautiful arches were blown down with powder to get the brick; doors and windows were appropriated." He found "no roofs on any part of San Luis Rey except the church and even that was gone in large part."90

Father O'Keefe led an extended campaign to save the church and restore part of the other mission buildings. The roof over the nave was still in place, so O'Keefe walled off the damaged transept and sanctuary and installed an altar in front of the partition for the rededication of the church on May 12, 1893. Later he constructed a new wooden-beam ceiling, rebuilt the crossing with a dome which protruded above the roof, and built living quarters in a portion of the old quadrangle. Subsequent priests modified Father O'Keefe's utilitarian approach. Father Peter Wallischeck carefully restored the chapel in the cemetery beside the church which Father O'Keefe had walled off from the nave, and Franciscans under the leadership of Fray Ferdinand Ortiz restored much of the interior painting and stencilwork, rebuilt the choir balcony, and removed Father O'Keefe's dome, replacing it with one within the roof "as it was first built."91 At present the church interior approximates that completed about 1829, and a two-story seminary building with a twelve-arch arcade and inner courtyard, together with a one-story arcaded structure which extends it to the rear and to the east, provides some sense of Antonio Peyri's great quadrangle.

Santa Barbara

Villages of the Chumash Indians were visited along the shore of the Santa Barbara Channel by the earliest naval explorers of Alta California, Juan Rodríguez Cabrillo in 1542 and Sebastian Vizcaíno in 1603. In planning the occupation of California, José de Gálvez had specified that a mission named for San Buenaventura be founded in the Santa Barbara area midway between San Diego and Monterey. As the initial Portolá expedition came out to the coast after passing through the San Fernando Valley around the Santa Monica Mountains, Miguel Costansó recorded the sighting of "a real town, the most populous and best arranged we had seen up to that time. We counted as many as thirty large and capacious houses spherical in form, well-built [of poles] and thatched with grass. We judged . . . that there could not be less than five hundred souls in the town." Costansó also admired the building skills of these pleasant-appearing natives whom he found well-disposed toward the Spaniards, alert and agile. Their skill was most apparent "in the construction of their canoes made of good pine boards, well joined and caulked and pleasing in form. They handle them with equal skill and three or four men go to sea in them to fish, as they will hold eight or ten men. They use long double-bladed paddles with indescribable agility and swiftness." Costansó praised all their workmanship and found it particularly admirable because "to work the wood and stone they have no other tools than those of flint."92

Fray Junípero Serra was eager to establish the mission conceived by José de Gálvez among the Chumash, the most numerous and most technologically advanced of California Indians, but its founding was delayed for twelve years after the establishment of the presidio and mission in Monterey. The Chumash soon dropped their welcoming friendliness toward Europeans, and in occupying the area along the channel where the road was pressed by the mountains almost into the Pacific, they were a potential threat to the continued existence of Monterey and the other Spanish outposts in the north. They numbered at least eight thousand, possibly twice that number, and inhabited at least twenty-eight villages. As early as 1772 they had threatened an expedition headed by Lt. Pedro Fages and

Junípero Serra, and in 1775 they intimidated a packtrain led by Fermín de Lasuén. As *comandante* of Alta California, Fages withheld the essential military support for missions among the Chumash, believing that he could not spare the needed troops.

On his trip north as the first governor resident in Alta California, Felipe de Neve carefully examined the channel coast after he had located a well-watered site for the pueblo of Los Angeles. His report to Viceroy Bucareli shortly after his arrival in Monterey in 1777 recommended Spanish occupation of that coast with a presidio and three missions. Neve's instructions to Lt. José Francisco Ortega, who was to establish the presidio, stressed the need to construct a defensive palisade before any permanent building was undertaken, and the importance of courtesy, gifts, and expressions of respect in dealing with the local Indian rulers. Lt. Ortega had been a member of a land expedition to San Diego in 1769. He had gone on the search for Monterey Bay and had been the first to explore the site of San Francisco. A favorite of Junípero Serra, he had been recommended by him to become *comandante* of Alta California.

The establishment of the projected posts along the Santa Barbara Channel was postponed until the final year of Neve's governorship. Preparations had been completed and the personnel gathered at Mission San Gabriel in the fall of 1781, but making adobe bricks, essential in the channel area because of the scarcity of timber, was not feasible during the rainy season. The expedition set out on March 26, 1782, and reached a site near the Santa Clara River at the southern end of the channel on March 31. There, close to the village whose Indians had greatly impressed Miguel Costansó in 1769, the Mission San Buenaventura was finally founded with provisions and equipment which had been stored at San Gabriel.

The Presidio

In mid-April Governor Neve arrived, after delaying to confer with Pedro Fages regarding the massacre at Yuma, and joined Lt. Ortega and Father Serra in founding the presidio of Santa Barbara near the midpoint of the channel on an elevated site nearly a mile from the shore. An inlet, or *laguna*, provided a protected landing, and nearby was a substantial Chumash village ruled by Yanunali, who also had authority over another dozen villages. Yanunali's friendship was essential in securing Chumash construction workers, who were paid in food and clothing. Father Serra wrote that in a chapel of brush "decorated as best the circumstances permitted" he "blessed water, and with it dedicated the area to God our Lord"[93] on April 21. With the help of the Chumash workers, a palisaded enclosure approximately eighty yards square had been constructed and adobe buildings built for a storehouse, guardhouse, and barracks for the soldiers by June 6. Neve had assembled for Lt. Ortega a force consisting of three sergeants, two corporals, and sixty-two cavalrymen. Of these a sergeant and fourteen soldiers were to be detached to form a guard for each of the neighboring missions. The garrison later numbered in the middle and upper fifties.

The Santa Barbara presidio was the fourth and last established in Alta California. Its military and civil jurisdiction, second only to Monterey's, extended from the northern border of the channel area as far south as the pueblo of Los Angeles and included ultimately the missions of Purísima Concepción, Santa Inés, Santa Barbara, San Buenaventura, and San Fernando Rey.

More permanent buildings were under construction in 1785 when sixty-one timbers for roofing were brought by ship from the north. Twenty thousand adobes had been made by mid-1787. A plan of 1788 sent by the second *comandante*, Lt. Felipe de Goycoechea, to Governor Pedro Fages shows the presidio as it would be after completion of construction then under way. The quadrangle is nearly square, with its ranges of buildings set in from an adobe perimeter wall which was "ready to be started." Living quarters for the garrison

lined two of the sides "with roofs of rafters, wattles and good tile." The corners of the presidio, in accord with the Ordinances of Development, were oriented to the cardinal directions. The main entrance and the chapel, which was surrounded by the quarters of the *comandante* and the chaplain, faced each other from the midpoints of opposing sides. The chapel, about forty-five feet in length and nineteen in width, was "lined with mortar and whitewashed—its roof of beams and finished planks and good tile, and adorned with painting."[94]

A year after Felipe de Goycoechea's plan was sent to Pedro Fages, a fire spread from a straw roof and consumed much of the presidio, apparently including the chapel. Rebuilding commenced almost immediately, and three sides of the outer wall and much of the quadrangle were completed by the end of 1790. Three years later everything was finished except the new chapel. In 1794 a shortage of funds limited work on the chapel and allowed only the most essential repairs to the presidio. The viceroy ruled that the treasury of the naval establishment would no longer pay the salaries of eight ship's boys and other naval personnel for work in construction, apparently limiting the work force to soldiers and hired Indians. The chapel was finally completed and dedicated in 1797. It suffered some damage in a storm in 1806. Repairs probably began immediately, but on December 21, 1812, an earthquake made it unusable. Rebuilding was completed in March 1813. The reconstructed chapel was a simple gabled structure, larger than its predecessor, somewhat over one hundred feet in length with walls about twenty feet high.

In Santa Barbara, unlike Monterey, retired soldiers and other settlers were permitted to build in the vicinity of the presidio and the nucleus of the future city of Santa Barbara gradually developed. Captain George Vancouver, who visited Santa Barbara for several days in November 1793, found it "far more civilized than any of the other Spanish establishments. . . . The building appeared to be regular and well-constructed, the walls clean and white, and the roofs of the houses covered with a bright red tile. The presidio excels all the others in neatness, cleanliness, and other small though essential comforts."[95]

The population grew slowly. Non-Indians totaled approximately 200 in 1791 and 370 in 1800. Duhaut-Cilly reported in 1827 that around the presidio were grouped sixty to eighty houses without any particular order, most of them modest adobes containing one or two rooms. In that year a commodious U-shaped house with a dozen rooms was nearing completion for José Antonio de la Guerra y Noriega, long-time *comandante* of the presidio and prosperous trader.

The presidio of Santa Barbara was never used as a defensive fortress. Its soldiers were all cavalrymen. Although it had two brass cannon in 1793, there was only one and a few lighter iron pieces in 1798, and there were no regularly trained artillery men to fire them. None of the additional infantrymen and artillerymen sent as reinforcements to California in 1796 were assigned to Santa Barbara. A plan of the presidio of 1802 shows no defensive bastions and shows the reconstructed larger chapel protruding several feet beyond the rear wall (Fig. 7.30).

Most of the presidio disintegrated before the chapel, which was preserved for worship until a parish church was built in 1854, but one of the

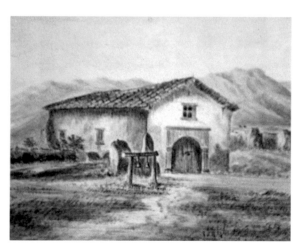

7.30. Santa Barbara presidio chapel in 1855, painting by J. N. Alden.

living quarters for soldiers' families in the southwest range survived in altered form and is now known as "El Cuartel," and the foundations of a noncommissioned officers' quarters were incorporated into the "Caneda Adobe." The stone foundations of the remainder of the quadrangle were buried under the city until 1967 when the footings of the chapel were located. Subsequently sections of all four sides of the quadrangle were excavated and surveyed. The Santa Barbara Trust for Historic Preservation operates the Royal Presidio of Santa Barbara Historic Park and is gradually rebuilding the presidio, following the Felipe de Goycoechea plan of 1788 and documented modifications made before 1800. The first reconstructions were the Padre's Quarters and the adjoining noncommissioned officers' quarters. The chapel was rebuilt and rededicated on the Feast of Guadalupe, December 12, 1985, the one hundred and eighty-eighth anniversary of the original dedication in 1797. Care has been taken to make the restoration as authentic as possible. The adobes have been made by hand, the timbers shaped by adzes and lashed in place by rawhide, the hardware made by a Mexican blacksmith, and the tiles made by an Indian tribe. The chapel's interior, painted by an expert on Spanish decoration in California, Norman Neuerburg, is lavish but was limited to motifs used at the end of the eighteenth century.

Mission Santa Barbara

Fray Junípero Serra expected to be able to establish Mission Santa Barbara in 1782 at the time that the presidio was founded. He named it in the registers he prepared "The Mission and Presidio of Santa Barbara." But after waiting three weeks, he was informed by Governor Neve that the founding would be impossible. The cause of the difficulty became clear after he left for Monterey. Neve's *Reglamento* for the government of California contained provision for the filling in of the chain of missions and its extension into the interior, but it also provided for a drastic reformation of mission procedures. Staffing was reduced to one missionary per mission, and missionaries were to be stripped of their temporal authority over Indians and their property. No longer would they operate as benevolent despots, absolute rulers of their neophyte disciples, virtually independent of civil authority. Henceforth they were to devote themselves entirely to the spiritual needs of the Indians, who would continue to reside in their own villages. Mission villages, mission fields, and mission herds would gradually be abolished, and subsequent to the founding of Mission San Buenaventura tools for their construction and operation would no longer be furnished by the government.

After the College of San Fernando learned of the new provisions for missionary operations, it informed the royal officials that the three Franciscans scheduled for duty in California had refused to serve. No missionaries came until 1786 when the Father Guardian of the college informed Father President Fermín de Lasuén on April 1 that, at the request of Viceroy Matias de Gálvez, he was sending six new missionaries and that Mission Santa Barbara was to be founded. The Franciscans had held their ground and the government backed off. A royal *cédula* of May 20, 1782, had under pressure from the Franciscans revoked the provisions of Neve's *Reglamento*, which had established the new methods the friars found offensive.

Mission Santa Barbara was placed at the top of an extended slope more than a mile northeast of the presidio. Fermín de Lasuén, Fray Antonio Paterna, and Fray Cristóbal Oramus founded it in 1786, informally on December 4 and formally after the arrival of Governor Pedro Fages on December 16. Construction was delayed until early spring because of the wetness of the winter, but the mission was ready for occupation by May 21, 1787. As in certain other missions there were three phases of construction: first of palisades of wood, then of bricks of adobe, and finally of blocks of sandstone. The ear-

liest structures of vertical timbers plastered with mud, and with flat roofs of thatch, were gradually replaced by ones of adobe. The initial adobe structure was four-roomed, built in late 1787 but not roofed until after the winter rains. In 1788 the original church of palisaded walls was enlarged by an addition which was part adobe and roofed with tile. A new adobe church, which was approximately 83 feet long and 17 wide, replaced it in 1789. Fray Antonio Paterna planned a larger, more carefully built, and permanent adobe church but died in February 1793 before it was finished. The church, 124 feet long and at least 25 feet wide in its nave, was dedicated March 19, 1794. Its plan was unusual, with three chapels lining each side of the nave more than half the distance from the front to the sanctuary. The church was roofed with tile and plastered with lime inside and out. Adhesion of the lime plaster to the walls was enhanced by pressing fragments of stone and tile into the adobe mortar while it was still wet and by gouging grooves into the walls. Fray Estevan Tapis, who succeeded Father Paterna and oversaw completion of the church, painted decorations on the walls, concentrating on those of the sanctuary. The original portico, constructed of tiles and mortar, was replaced by a more impressive one in 1811.

Indian labor, under the direction of the friars, continued on diverse building projects almost without ceasing during the dry months until the stone church was completed in 1820. For over thirty years work continued, as Edith Buckland Webb described it, "of making adobes and tiles, of felling trees and hauling logs, or dragging them by ox-team from the canyons, of sowing and hewing them into shape for use. . . . [There were] years of gathering limestone and seashells and preparing lime, of gathering and carrying stones for foundations and later for walls, for reservoirs, for the mill, the jail and the [fourth] church. Year after year of adding a few buildings here and a few buildings there until an almost complete community was established."[94]

The front range of the main quadrangle, which still runs southwest from the façade of the stone church, took twenty-six years to complete. A row of rooms for living quarters for the friars, for a refectory and a kitchen, and for other purposes was constructed in 1790. Another row of rooms adjoining this one in front was begun in 1795, and the following year a corridor 126 feet long was added. It had a flat tile roof supported by pillars of tile and lime mortar. Nothing more was done until 1809 when the adobe walls were replaced by ones of masonry and the back row was given a gabled roof of tile. In 1812 the front corridor acquired its present extended arcade. Finally in 1816 an upper story was added, with a parapet above the arcade consisting of triangular and arched forms. The space above the parapet was open, covered by the large gabled tile roof which sheltered both the outer and upper rows of rooms (Fig. 7.31).

Fray Estevan Tapis also oversaw the completion of the main quadrangle. The unmarried women's quarters, the *monjério*, was at the rear of the range alongside the church, and close to it in the rear range was the room for weaving. The rooms opposite the church range originally contained living quarters for soldiers and granaries, which extended to the rear to form part of a second quadrangle which was used primarily for workshops. The ranges of the main quadrangle were provided with corridors on their inner sides with tile roofs supported by piers of tile and mortar. Corridors also fronted the patio side of the weavery, the house of

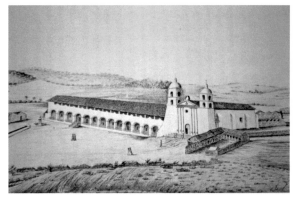

7.31. Mission Santa Barbara in 1856. Henry Miller's drawing shows the open space beneath the tile roof over the arcade in front of the *convento*. At the left are the fountain and *lavandería* and the end of one of the rows of Indian houses. Henry Miller's drawings of missions are reproduced in *Account of a Tour of the California Missions*.

the *mayordomo,* and the adjoining tannery, and one side of four houses built for soldiers of the guard in 1806.

In November 1793 when Captain Vancouver's party visited Santa Barbara, the Indians of the mission were still living in a traditional village. Archibald Menzies, botanist of the expedition, wrote that adjoining the mission was a "crowded village containing 500 to 600 Indians, converts to Christianity, who still lived in conical huts thatched with bulrushes like the other natives of the country, but clothed and maintained by the fathers."[97] Five years later the friars began an orderly mission village to the southwest of the quadrangle with 19 adobe houses, 18 feet by 11, plastered with lime mortar outside, whitewashed within, and roofed with tiles. Thirty-one more houses were built in 1800 and the same number in 1801. The houses were placed in rows with narrow streets between. Another row of 31 was built in 1802, and a wall of adobe eight feet high was constructed to protect the houses on three sides. Even more houses were added in the following years, 48 in 1803 and 37 in 1804. Of these 197 neophyte houses, 183 were still in use in 1834 when they were recorded in the inventory made upon secularization.

The Water Supply

Governor Fages had expressed concern for Santa Barbara's water supply in a letter to the viceroy just after the mission was founded, writing of the inadequacy of water for the irrigation of the fields which they "must begin to cultivate in spite of the lack of sufficient water."[98] The friars' report of 1796 reiterated the governor's concern: "We are dependent on rain, because the running water of the mission is not abundant. The dearth of it is greater in the months of July, August, and September, as repeatedly in the year 1794 the water stopped flowing a quarter of a league from the mission, though through much effort and work it was made to run to the mission. The harvests are small considering the amount of grain planted, because at a certain time of year the rains would regularly fail."[99]

Ten years later a comprehensive campaign to bring water to the mission was initiated. In 1806 a reservoir of stone and mortar was constructed, 110 feet square and about 7 feet deep, probably under direction of the mason Miguel Blanco. A dam was built the following year in the hills a mile and a half north of the mission on a branch of Pedregosa Creek, and an *acequia* was constructed to bring the water down the slope to the reservoir (Fig. 7.32). In 1808 the still-existing double-basin fountain which stands in an octagonal pool and the *lavandería*, a trough for washing over 72 feet long, were built in front of the mission's extended arcade not far from the village of neophyte houses Fig. 7.33). These probably were designed by José Antonio Ramírez, the master carpenter who learned the craft of masonry in California and would later design the church of San Luis Rey, the Plaza Church in Los Angeles, and probably the present church of Santa Barbara. A spout for water entering the *lavandería* in the form of a bear and a lion at its lower end was carved by a Chumash artisan, Paciano, who also made plank canoes and who worked steadily and happily nipping from his gourd of *aguardiente.* Later the water system was extended to include another dam and another reservoir, a water-powered gristmill, and aqueducts set in walls to bring water to the fields, orchards, and gardens, to the tannery, and to provide toilet facilities to the *monjério* and the jail.

In 1827 Duhaut-Cilly found Fray Antonio Ripoll wholly engrossed in "a water mill he was having built at the foot of a hill to the right of the mission." The French visitor was intrigued by the hydro-engineering which caused the water to fall about "twenty feet upon the buckets of the wheel. [But] the fall was not perpendicular but at a pitch of about 35 degrees and the wheel instead of being vertical was horizontal, it was a full circle upon whose

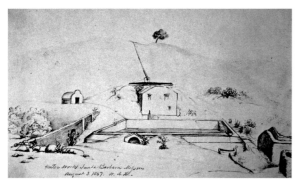

7.32. Part of the water system of Mission Santa Barbara in 1847. W. R. Hutton's drawing shows the water coming down the channel from the hill toward the gristmill. The settling basis is on the left and the larger of the two reservoirs near the front.

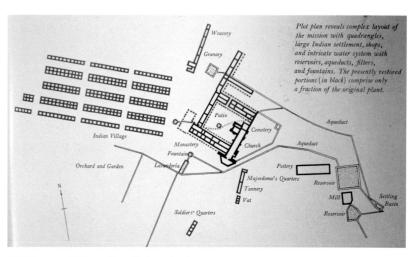

7.33. Layout of Mission Santa Barbara showing how water was brought to the quadrangle, to the fountain and *lavandería* and the rows of Indian houses, and to the orchard and garden, from *The California Missions*, Sunset Books, p 186.

plane were disposed like spokes, objects like large slightly concave spoons, which receive, one after another, the force of the water and thus impart movement."[100] Horizontal waterwheels without gear mechanism were common in Hispanic New Mexico.

Father Ripoll's mill did not last long. After an 1840 visit, T. J. Farnham provided a comprehensive description of Santa Barbara's water system. He described the bringing of the water "around the brow of a green hill, in an open stone aqueduct, to a square reservoir of beautiful masonry. Below, and adjoining this, are the ruins of the Padres' grist mill. Nothing is left of its interior structure but the large ridgepole. Near the aqueduct which carries the water into the reservoir of the mills, stands a small stone edifice ten feet in length by six in width. This is the bath [the filtering plant]. . . . Below the ruins of the grist-mill is another tank one hundred and twenty feet square . . . constructed like the one above. In this was collected water for the fountains, irrigating the grounds below, and for the propulsion of different kinds of machinery. Below the mission was the tan-yard, to which water was carried by an aqueduct, built on top of a stone wall, from four to six feet high."[101]

The Stone Church

The friars explained in their annual report on the final day of 1812 that "in the terrible earthquakes of December 21st and the days following, the mission was considerably damaged, necessitating a careful inspection and more or less repaired." Of particular concern was the condition of the church, which they were convinced should be replaced by a new structure once permission was obtained from the government "because when one compares the labor necessary to repair it with the work required for a new edifice, the difference will be small. Also when we consider the little satisfaction which the repaired walls give against the security which new and thick ones of mortar and stone on a solid foundation would provide, the reason for choosing that latter will far outweigh the former."[102]

Permission to construct a new church was not immediate. In their annual report for 1813 the resident friars stated in reference to the remainder of the mission that "all that was damaged by the earthquake has been repaired,"[103] but no reference was made to the new church until it was completed in 1820. In June 1815 Fray Antonio Ripoll, who had been at Mission Purísima Concepción at the northern end of the channel, joined Fray Francisco Suñer at Santa Barbara. Suñer's health deteriorated in 1816 so that Ripoll took over the major responsibility for the construction of the church, which began in 1815. He wrote to the governor on May 9,

| Chapter VII

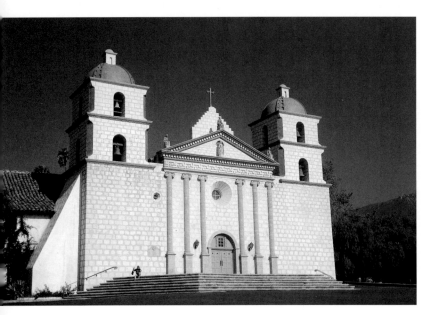

7.34. Mission Santa Barbara, rebuilt façade of the church.

1817, requesting iron tools and implements, and on August 5 asked permission to accept the offer of an American ship's captain, James Wilcox, to bring to the mission beams which had been cut in 1816 on the channel islands.

The designer of the church is not mentioned in surviving documents of Santa Barbara. In 1827 Duhaut-Cilly identified the "very skillful man" who worked with Father Peyri at San Luis Rey as one who "had previously aided in the construction at Mission Santa Barbara," and stated that "the hand of the same artist"[104] was recognizable in the buildings of the two missions. José Antonio Ramírez was recorded as the designer of San Luis Rey and probably designed the present church of Santa Barbara as well. These two churches and San Buenaventura, where Ramírez also worked, have towers with two belfry stages, the only ones of Hispanic California. Duhaut-Cilly may have confused the chronological relationship between the churches of San Luis Rey and Santa Barbara. Ramírez is known to have worked at Santa Barbara earlier, between 1800 and 1803, and in 1808 and 1811.

Construction continued from 1815 until 1820, when the church was dedicated on September 10, but nothing of the work was recorded in the mission's annual reports until the report for the year of its dedication. Then Fathers Suñer and Ripoll wrote: "[The church] is of hewn stone and mortar. The walls of solid sandstone and nearly six feet thick (two *varas*) are strengthened by stone buttresses. The massive tower of the same material has two stories and holds six bells."[105] Three of the bells were stationary and had to be struck by hand. The other three swung on a yoke.

The friars continued: "The statue of the patroness, Santa Barbara, was placed in a niche in the façade, which appears to be supported by six columns, and in the corners of the triangle [of the pediment] were placed the Three Virtues, Faith, Hope, and Charity, these four figures are of carved stone and painted in oil."[106]

A stone vault seems never to have been considered at Santa Barbara. The sandstone walls, more than five feet thick, and the heavy buttresses were designed to withstand earthquakes rather than to support vaulting. Originally the church, like San Luis Rey and San Buenaventura, had only one tower with belfry stages. The annual report of 1831, signed by Father Antonio Jimeno, who would remain at Santa Barbara until 1859, stated "a new tower has been added"[107] without indicating whether it was on the west or the east. If the first tower was on the east corner of the church, the original arrangement of forms would have resembled San Luis Rey. The second tower soon collapsed and was reconstructed in 1833. Father Thaddeus Kreye, who directed the rebuilding of the 1950s and hoped to write an architectural history of Mission Santa Barbara, came to believe that the tower which fell was the western one and that its failure was due to insufficient compensation for the weakness caused by the construction of its internal stair. What is certain is that the tower which collapsed was rebuilt with special care and that the west tower has a massive buttress on its west side. It suffered less damage than the east one in the devastating earthquake of 1925.

The towers, like the rest of the façade, reflect

the influence of neoclassicism (Fig. 7.34). Santa Barbara, the last of the major California mission churches, is unique in strongly showing the influence of neoclassical taste. The bases of the towers are fused with the central façade to form a simple, broad block. The belfry stages are rectangular with their wide sides flush with the façade. Their solid blockiness is only slightly softened by chamfering at their four corners. Strong simple horizontal moldings mark the top of the lower façade and the tops of both belfry stages.

The most remarkable feature of the façade is its central frontispiece, a pedimented temple front motif derived from a design found by Father Ripoll or Father Suñer in an edition of Vitruvius published in Madrid in 1787 which was available in the mission library. José Antonio Ramírez transformed Plate X, an image of a Roman temple with four free-standing Ionic columns, into a delightful folk design. The free-standing four-column portico became a pattern of six brick half-columns set upon high bases applied decoratively upon the block of the façade. The half-columns were spread apart at the center to provide space for the arched portal and, well above it, the round cavity in the wall of the façade which brought light to the deeply set window opening to the choir balcony (Fig. 7.35). The volutes of the capitals and the carved ornamentation of the Greek key frieze are flatter and more ornamental than orthodox classical designs, and the divided triads of half-columns harmonize pleasantly with the broad bulk of the façade providing it with a crisp linear accent. The curious stepped gable supporting a cross, which rises behind the pediment to add to the verticality of the central façade, is not mentioned in the early descriptions of the church but seems to have been an original feature.

The front of the church of Mission Santa Barbara differs interestingly from that of San Luis Rey, completed five years earlier and also associated with José Antonio Ramírez. There the style seems primarily late baroque, not neoclassical. The façade

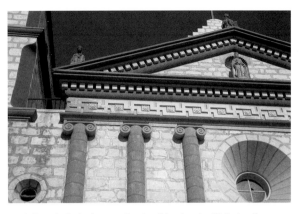

7.35. Detail of rebuilt upper façade of the church of Mission Santa Barbara. Also see Plate XVI.

with its single tower is more vertical than Santa Barbara. The belfry stages of the tower are octagonal rather than square and appear less blocky and more graceful. The central façade is set slightly back from the tower bases and rises to form a flowing baroque gable rather than a sharp-edged classical pediment.

The rectangular interior of Santa Barbara, measuring just over 162 feet in length, is almost 40 feet longer than its adobe predecessor and slightly wider. The frontal pair of that church's six flanking chapels were retained and the others eliminated. An early account attributed by Zephyrin Engelhardt to Father Ripoll provides a fuller description of the interior than the annual report of 1820. "[It is] neatly finished: the walls are plastered, the columns [actually pilasters] and cornices are frescoed [marbleized]; the ceiling is lathed, hard finished, ornamented with designs from Vitruvius [winged flame and thunderbolt motifs which are in the middle of the ceiling, and which now support chandeliers] cut from cedar and painted. The floor of red cement, made from lime and oil, is hard and finely polished. The altars are neatly ornamented with crucifixes and statues of wood. Over the high altar, on a bracket in the wall, stands a statue of Santa Barbara. On each side of Santa Barbara are paintings on the canvas altar screen of San Joaquín and of Santa Ana. Directly under these on brackets are the statues in wood of the Blessed Virgin and of San José. Small wooden statues of Santo Domingo and of San

Francisco may be seen on each side of the high altar on pillars"[108] (Fig. 7.36 and Fig. 7.37).

The church has continued in use without interruption and, unlike the other major California mission churches, never suffered drastic alteration. Secularization of Mission Santa Barbara was decreed by the Mexican government in 1834 but revoked a year later because parish priests were not yet available to replace the Franciscans. William Hartness, the English-born Mexican Inspector of Missions, appointed Fray Narcíso Durán administrator of Santa Barbara in 1839. At that time there were still 246 neophytes. The herds, which had totaled 16,598 in 1814, were reduced to 1,770 head of cattle, 2,250 sheep, 609 horses, 34 mules, and 22 goats. The 1840s were a period of rapid and seemingly calamitous change. The mission served as the residence and parish church and quasi cathedral for a series of three bishops who lived for brief periods in Santa Barbara. The first was Bishop Francisco García Diego y Moreno, who arrived in 1842. The mission was sold to Nicholas A. Den for 7500 pesos in 1846, and the Indians were liberated and given small plots of land. Later that year the American flag was raised by Commodore Robert F. Stockton and the mission was briefly occupied by troops of John C. Frémont.

The second bishop, Joseph S. Alemany, arrived on Christmas, 1850. An apostolic college was founded by the Franciscans at Santa Barbara in 1854 and moved from the mission into the former Den house in the town. The third bishop, Tadeo Amat, having found the mission an inconvenient residence, swapped it in 1856 with the Franciscans for the college building, the reconstructed Den house.

On their return to the mission with their new college, the friars found only the front range suitable for living quarters and soon built a second story over the half of the range closest to the church. About a decade later the upper story was extended to the end of the range. Modest-sized rectangular windows were placed in the new upper wall above the piers of the arcade, and the old tile roof was replaced by a new one of wooden shingles with five dormers and a double pitch in its slope. Santa Barbara in its transition from Indian mission to parish church was described after a visit in 1861 by the Yale geologist William H. Brewer. He rode out to the Good Friday services and was surprised to find the church so darkened by thick curtains at the windows that "the many candles at the altar did not light up the obscurity." He noticed that "a number of Indian women were kneeling before a shrine; one would lead off with the prayers and all join in the responses. Their pensive voices, the darkened interior, the pictures and the images seen in the dim light, the tapers on the altar, the echoes of their voices, the only sounds breaking the stillness, produced an effect . . . most touching to the imaginations of the worshippers." On the following day the curtains were gone and Brewer was impressed by the music, "the best I have heard in California. It began with an instrumental *gallopade* (I think from *Norma*), decidedly lively and undevotional in its effect and associations. But the other parts were more appropriate. As the priests chanted the long lists of saints in order, the response, Ora pro nobis by the audience . . . and the choir very pretty indeed. . . .

"Not the least interesting to me were the costumes. Standing, kneeling, sitting over the floor were people of many races. Here is a genuine American, in that aisle kneels a genuine Irishman, his wife by his side; near him some Germans; in the short pew by the wall I recognize some acquaintances, French Catholics, also an Italian. But the majority of the congregation is Spanish Californians. Black eyes twinkle beneath the shawls drawn over the heads of the females, and glossy hair peeps out also. Here is a group of Indians, the women nearly conforming to the Spanish dress, only their calico dresses are of even brighter colors—all are dressed in holiday clothes. Here is a man with a Parisian rig; there one with the regular Mexican costume, buttons down the sides of his pants, beside him an

Indian with fancy moccasins and gay leggings; behind me in the vestibule, looking on with curiosity are two Chinamen. No place but California can produce such groups."[109]

In the ensuing decades small changes were made in the church. The old pulpit was removed, never to be replaced, and new altars were installed. A wooden floor was built over the cement one and a new altar rail and steps replaced the originals. Additional paintings and works of art were brought from Mexico by Fray José María Romo. Work was needed on the exterior. New rafters had to be installed and the old tiles replaced on the roof. Plaster flaked off the adobe walls and the masonry piers and arches.

The church has continued to be used as a parish church for people in the neighboring area, at first informally and by canonical designation after 1928, but changes came in regard to the status of the mission. Fiscal difficulties caused the closing of the apostolic college in 1885 and the mission became a friary of the eastern American province of the Franciscan order. Thirty years later the Province of Santa Barbara was established and the mission became its seminary. It had functioned as a seminary earlier under Bishop García Diego and during the period of the apostolic college.

More extensive changes in the buildings began in 1897 when the partially ruined west range of the quadrangle, which had not been altered since 1800, was taken down and replaced by a two-and-a-half-story school building. Only a few sections of the old adobe walls were retained. Substantial modifications were made in the church interior after 1911. The sanctuary was extended forward and its floor raised. The original cloth altar screen was partly repainted and a tall elaborate Italianate altar was installed. A new plank ceiling was constructed and painted to resemble the original (Fig. 7.37).

Still more extensive changes followed the severe earthquake of June 29, 1925. The upper façade and both towers of the church were badly damaged, and

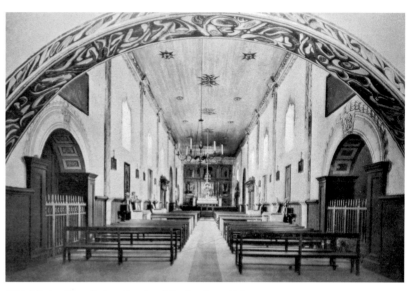

7.36. Mission Santa Barbara, interior of the church, c. 1905, photograph by George Wharton James.

the second-story wall of the front range above the arcade of the adjoining building was left leaning dangerously outward. Although the friars decided to restore the mission rather than reconstruct it, massive rebuilding was necessary. The whole upper story of the front range had to be taken down. Reconstruction was in reinforced concrete which was plastered and supported by forty-six columns sunk into the ground through the walls of the lower story. The east tower had to be totally rebuilt and the four buttresses along the wall behind it had to be strengthened and reanchored to the wall. Extensive strengthening of all four walls was also undertaken. They were pierced in twenty-four places and tied together with steel rods, plates and turnbuckles. The sections of a massive concrete lintel poured at the top of the wall were fused into a single unit by fifteen steel beams. The roofs of both the church and the front range had to be removed, rotting and twisted rafters replaced, and the tiles put back in place.

The interior was given extensive refurbishing and redecoration. New altars of concrete were installed and tile was laid on the floor of the sanctuary, the steps to the communion rail, and the platforms of the altars. Paintings done by the neophytes,

| Chapter VII

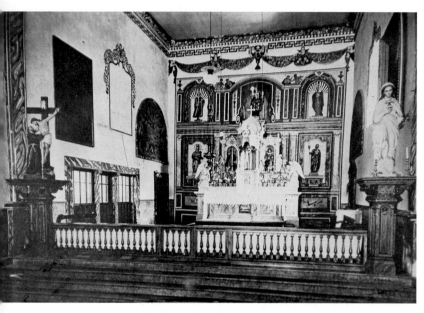

7.37. Mission Santa Barbara, interior, sanctuary, about 1911, photograph in Kurt Baer, *Painting and Sculpture at Mission Santa Barbara*, fig. 23.

such as the running borders of fruit and flowers, were repainted and the entire decorative ensemble was made more sophisticated and less primitive. The most striking change was the replacement of the painted altar screen of the 1820s with a new wooden one with four pairs of Ionic columns; it is somewhat suggestive of the surviving altar screen of Mission San Miguel but is more elaborately tasteful with little of that screen's naïve charm. The new wooden screen uses the statue of Santa Barbara, which had been placed high against the center of the earlier painted screen, but locates it beneath a powerful crucifix. The flanking painted images of Saints Joaquín and Ana in the upper tier have been replaced by statues of the Virgin of the Immaculate Conception and San José, which had been placed below them; the excellent small statues of San Francisco and Santa Domingo have been retained in their original places in the lowest tier.

Total reconstruction of the front of the church seemed necessary twenty-five years later. Dismaying cracks had appeared in the façade and the towers. An analysis of the condition of the structure was made by Ross Montgomery of Los Angeles, architect of the rebuilding after 1925, and a chemist and a structural engineer, and they recommended reconstructing the front so that the church would no longer be threatened with disintegration. Fray Thaddeus Kreye, who had training in engineering, oversaw the work which entailed removing both towers and the entire façade. New footings were constructed with 136 cubic yards of concrete and 16 tons of steel. The core of the upper structure was a Rocklite aggregate judged to be "peculiarly free from deteriorating effects." The outer walls were of reinforced concrete faced with four-inch-thick blocks of limestone quarried in Santa Barbara County. Great pains were taken to duplicate the appearance of the original sandstone masonry, and few contemporary visitors are aware that the church front they see at Santa Barbara is a mid-twentieth-century simulation of an 1820 building.

CHAPTER VIII

Hispanic Architecture in the United States after 1846

Loving, often meticulous, reconstruction and restoration of surviving and partially surviving Spanish buildings, such as the mission churches of Santa Barbara, San Luis Rey, San Carlos of Carmel, San Xavier del Bac, San Esteban of Ácoma Pueblo, and San José of San Antonio, as well as the governors' palaces of Santa Fe and San Antonio, exemplify the modern American attitude toward relics of the Hispanic past. At the middle of the nineteenth century when the United States took over close to a hundred abandoned and already decaying Spanish missionary churches, the attitude was different. A few travelers, including the future Los Angeles judge Benjamin J. Hayes, Major W. H. Emory, the boundary commissioner John R. Bartlett, and the draftsmen H. M. T. Powell and William Rich Hutton admired the remarkable buildings which they saw isolated and unused. But more characteristic of Protestant Americans were the soldiers who used the saints of the façade of Mission San José for target practice, demonstrating, as Bartlett wrote, both their marksmanship and their contempt for Mexican Catholicism. Little was done for decades to arrest the decay as missions were used as barracks, as stables, and as quarries for building materials.

Sympathetic interest in the Spanish past was late in developing in the United States because of persisting anti-Catholicism, and because of lingering memories of historic English and American rivalries with Spain and appetites for Spanish territory. The black legend of the cruelty of Catholic Spain was nurtured by powerful myths associated with the defeat of the famous armada sent against England by Philip II, some years earlier the tactful husband of an English Queen, and the celebrated massacre at the mission of San Antonio de Valero, renamed the Alamo, by the Mexican general and president Antonio López de Santa Anna. The U.S.-Mexican War inflamed anti-Hispanic feelings in the United States and they persisted into the twentieth century, revived by unfounded accusations regarding the explosion of the battleship *Maine*, and the ensuing Spanish-American War which stripped Spain of the few American remnants of what had been the most enduring of European empires.

In the 1880s evidence of an affectionate, nostalgic feeling toward a lost Spanish past became apparent in many parts of the United States. The celebration of the 333rd anniversary of the founding of Santa Fe in 1883 elicited Walt Whitman's well-known letter welcoming Spanish contributions to a future composite national identity no longer limited to English sources. Interest in the Spanish life and architecture appeared strikingly from Florida to California. Henry N. Flagler, closest of John D.

Chapter VIII

Rockefeller's associates in Standard Oil and pioneer developer of Florida as a resort for wealthy northerners, was inspired with an awareness of the state's Spanish legacy by a Ponce de León celebration in 1885 and soon commissioned sumptuous hotels in St. Augustine loosely based on Spanish prototypes. For California, Helen Hunt Jackson created a romantic past of gentle Spaniards and Indians in her very popular novel *Ramona*. Senator Leland Stanford felt the importance of the state's Hispanic tradition in mandating missionlike quadrangles in the planning of his new university.

Particularly influential was Charles Fletcher Lummis, not long dropped out from Harvard, who reported in weekly dispatches his long walk from Chillicothe, Ohio, to the newsroom of the *Los Angeles Times*. Permanently transformed by his imaginative sense of the Southwest, Lummis devoted the remainder of his life to celebrating a romantic region settled by Pueblo Indians and kindly Spanish missionaries. He directed the Landmarks Club, active in preserving crumbling missions. In historical writing the great achievement of the 1880s was the more than a dozen thick volumes issued by Hubert Howe Bancroft and his associates recounting the history of Spanish North and Central America, comprising a third of his massive history of the West.

The interest in the Spanish past evident in the 1880s developed slowly in the next decade. Daniel H. Burnham, architectural consultant for the celebrated World's Columbian Exposition of 1893 in Chicago, specified that the buildings representing the states of the West and Southwest be of the mission style. California's building, designed by A. Page Brown, reflected the state's missions, notably Santa Barbara and San Luis Obispo. Texas and Colorado erected structures suggestive of Spanish architecture, and Florida was represented by a one-fifth-scale model of the venerable fortress of San Marcos in St. Augustine.

A major undertaking in history was the decision in 1896 of Woodbury Lowery to abandon a legal career to devote the rest of his life to a multivolume history, *The Spanish Settlements within the Present Limits of the United States*. He lived to complete a general account of the years 1513 to 1561 and a volume on Florida between 1562 and 1574. In 1901 Herbert E. Bolton, librarian of Hubert Bancroft's great library after he sold it to the University of California, began a long scholarly life exploring episodes of the Spanish past and inspiring generations of students, over a hundred of them doctoral ones, to share his enthusiasm and his historical labors.

The momentum of the interest in things Spanish gradually gathered force, related in some instances to the Arts and Crafts Movement, and dependent on the growing romantic interest in an imagined Hispanic past. A spare minimalist version of mission architecture appeared in buildings of Irving J. Gill of San Diego as early as 1907. But in 1911 New York architect Bertram G. Goodhue was given responsibility for the overall design of San Diego's Panama-California Exposition. Goodhue had provided drawings for the pioneer North American study, *Spanish Colonial Architecture of Mexico*, by Sylvester Baxter, and when the exposition opened in 1915 his dominating and widely influential California Building was based upon the eye-catching eighteenth-century churches he and Baxter had admired in Mexico.

The Santa Fe style came into being between 1912 and 1917, nurtured by an alliance between the recently founded Museum of New Mexico–School of American Archeology and local interests concerned with stimulating tourism and reversing the city's protracted economic decline. In 1912 an archeologist of the school, Sylvanus Morley, later one of the influential Maya scholars of his generation, provided a precursor of the style in the restoration and modification of the Roque-Lobato house for his residence, making it more monumental and emphasizing its formal symmetry. That year a "New-Old Santa Fe" exhibit was held in the Palace

of the Governors, including a model and a drawing of differing proposals for an imaginative monumental reconstruction of the palace façade designed by the museum's staff photographer, Jesse Nusbaum. Sylvanus Morley twice wrote definitions of the New-Old Santa Fe style, and he cautioned entrants in a 1913 competition for the design of a model house against following the California Mission style because "nothing can retard the development of the Santa Fe style more than to confuse it" with California work.

The local architectural firm Rapp, Rapp and Hendrickson supplied an influential example of the approved style in the New Mexico Building of the Panama-California Exposition of 1915. It was based on the Ácoma Pueblo mission complex, with decorative details drawn from the San Felipe Pueblo church. The design was given permanent form in the Fine Arts Museum in Santa Fe (1916) with the addition of a side elevation based on the façade of the church of Laguna Pueblo. An additional element of the mature Santa Fe style appeared in the Pueblo-like terraced forms in the Rapp firm's School for the Deaf (1917).

Although Henry Flagler's St. Augustine hotels, designed by Carrere and Hastings, were the first monumental American structures to reflect Spanish influence, the rapid spread of Spanish revival architecture in Florida began twenty years later with the arrival of Addison Mizener in Palm Beach in 1918. Mizener's Everglades Club of that year started the vogue. Many large Spanish-style houses in Palm Beach built for rich vacationers followed rapidly, and in 1925 the Mizener Development Corporation inaugurated the new planned community of Boca Raton. Coral Gables, begun a year earlier, was another Florida community notable for Spanish-style structures.

The new Spanish architecture continued to spread in California, appeared in Texas, and rapidly expanded beyond the limits of Spanish settlement in the United States. Citizens of Santa Barbara voted to reconstruct their urban center in Spanish style after the earthquake of 1925. George Washington Smith's designs in Santa Barbara are notable for their restrained finesse, and Julia Morgan's San Simeon for William Randolph Hearst is notable for glamorous showiness. A striking instance of the growing appeal of Spanish ornamentation was its use in two of the earliest examples of a new architectural form, the shopping center: Country Club Plaza in Kansas City (1923) and Highland Park Village in the Dallas area (1930).

A retrospective and comparative summary account of Spanish urban construction and architecture in the present United States may be a useful conclusion to this book. Spanish building began with the settlement in 1526 of San Miguel de Gualdape on the coast of Georgia. The continuous presence of Hispanic patterns of living started in 1565 in St. Augustine and lasted until after the occupation of Santa Fe and Los Angeles by American troops in 1846, a period more than half a century longer than that between the signing of the Declaration of Independence in 1776 and the present.

Spanish towns were normally laid out systematically according to the Ordinances of Settlement incorporated into the Laws of the Indies, but only St. Augustine grew into an ordered urban layout surrounding a plaza facing the water as prescribed for coastal communities. Other Spanish settlements such as Santa Fe, San Antonio, and Los Angeles were carefully and ambitiously laid out around their central plazas according to the provisions of the Ordinances for inland towns but developed slowly in loose and disorderly ways. In New Orleans the Spanish inherited from half a century of French occupation an urban organization remarkably similar to that prescribed in the Ordinances for waterside settlements.

The great distances of the towns of Texas, New

Chapter VIII

Mexico, and California from central Mexico inhibited growth in their populations. Relatively few secular Spaniards were attracted to areas on the remote northern frontier of New Spain which had few obvious natural resources and limited supplies of water. The poverty and general ineffectiveness of the Spanish monarchy in the seventeenth and early eighteenth centuries restricted its ability to foster growth. Most Spaniards who ventured to the western provinces were missionaries or soldiers. The families of soldiers and of former soldiers who remained after their term of service was completed constituted a substantial component of the population of the towns of the western provinces.

The materials and methods of construction in Spanish North America varied widely from region to region. In Florida, close to Caribbean settlements like Havana and subject to the Council of the Indies rather than the viceroy of New Spain, the use of concrete for roofs began early and stone was used in the late seventeenth century for the Castillo de San Marcos and in the eighteenth century for houses in St. Augustine. In remote New Mexico, more than fifteen hundred difficult land miles from Mexico City, the friars adapted the materials and construction methods of the Indian pueblos to the building of the mission churches and *conventos* and the houses, churches, and civic buildings of the towns. Using structures akin to native ones may have eased the placing of missions in the pueblos, and hardly any artisans trained in European methods of construction were available in seventeenth-century New Mexico. In contrast, the most significant structures in Florida were designed and built under the direction of military engineers, generally available in the Caribbean region. Florida was the only Spanish province which was forced to defend itself continually against raids and invasions of other European powers—England and, on one occasion, France.

In eighteenth-century Texas the friars hired master masons from Mexico to design and direct the construction of vaulted and domed stone churches. Masons were also essential in the building in Arizona of the churches of Tumacácori and San Xavier del Bac. The building of major churches in California was also directed by masons: San Carlos in Carmel, San Gabriel in the Los Angeles area, the largely destroyed stone church of San Juan Capistrano, and the surviving partially reconstructed churches of the missions of San Luis Rey and Santa Barbara. The most impressive urban ensemble of Spanish North America and, at the time, of all North America was the cathedral and its flanking structures constructed facing the plaza of New Orleans after the disastrous fires of 1788 and 1794. They were built of brick, stuccoed to resemble stone, and were designed by Gilberto Guillemard, who learned engineering and architectural skills on the campaigns of Bernardo de Gálvez against Pensacola and other British territories during the American Revolution.

The remains of Spanish building in the United States constitute a heritage certainly comparable in quality to the surviving structures of the English colonies. They are increasingly appreciated, as Walt Whitman prophetically wrote in 1883, as increasingly "America, from its many far back sources . . . identifies its own."

PLATES

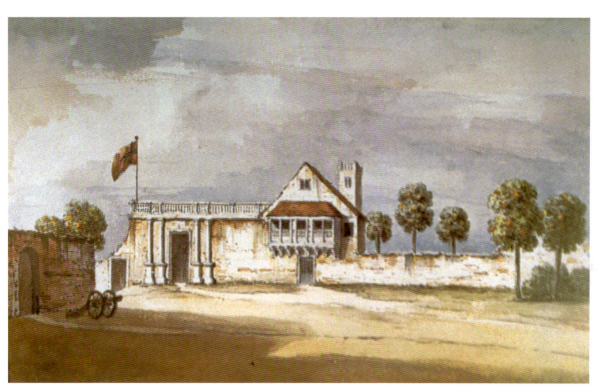

Plate I. Governor's house, St. Augustine, drawing 1764, British Library, reproduced in Elsbeth K. Gordon, *Florida's Colonial Architectural Heritage*, plate B. Also see Fig. 2.8.

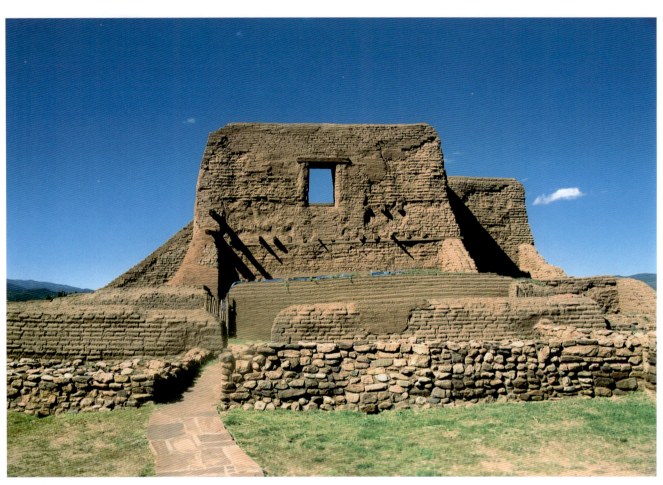

Plate II. Remains of the eighteenth-century church at Pecos. Also see Fig. 3.8.

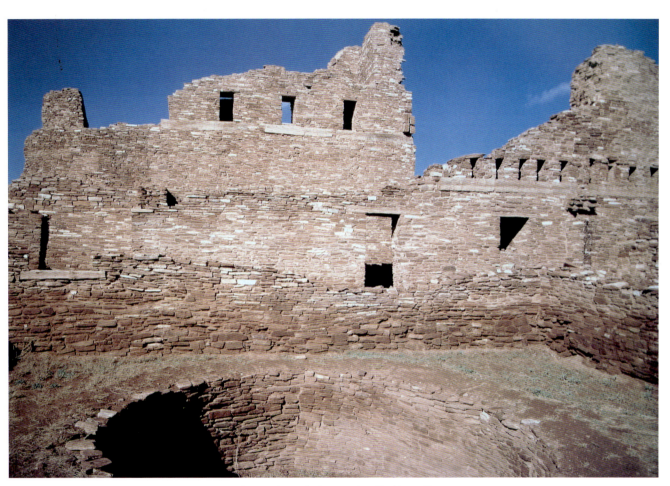

Plate III. San Gregorio at Abó from the east, photograph by David Wakely. Also see Plate III. Also see Fig. 3.13.

Plate IV. Interior of the church of Nuestra Señora de Guadalupe showing the carved post supporting the choir balcony. Also see Fig. 3.33.

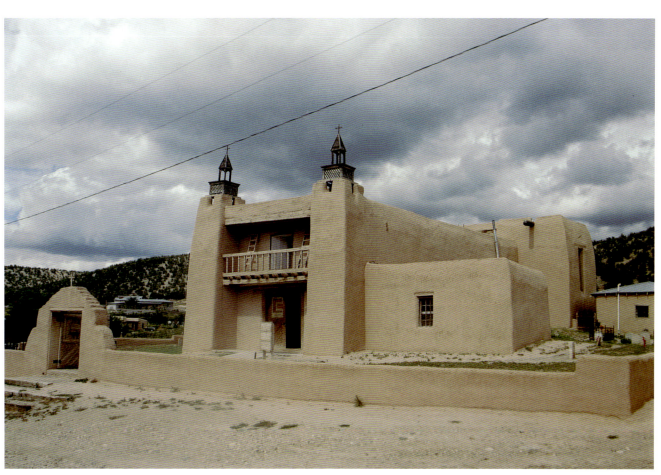
Plate V. The church of San José de Gracia with Penitente *morada* on the right. Also see Fig. 3.36.

| Plates

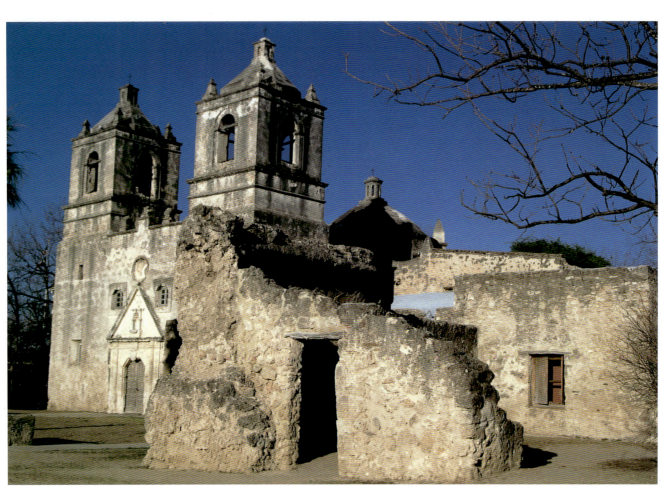

Plate VI. Mission Concepción, church and part of the *convento*. Also see Fig. 4.5.

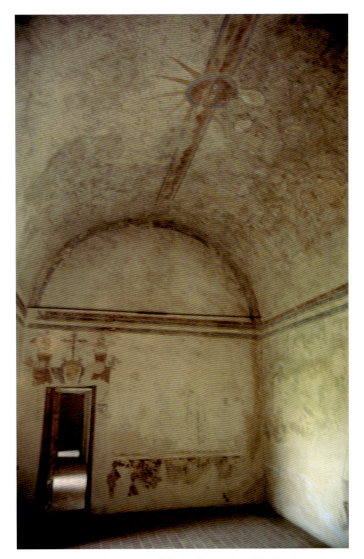

Plate VII. Room in the *convento* of Mission Concepción with painted ornamentation in red, blue, and gold. At the center of the vault is a mustachioed sun with rotating spikes for rays. Also see Fig. 4.10.

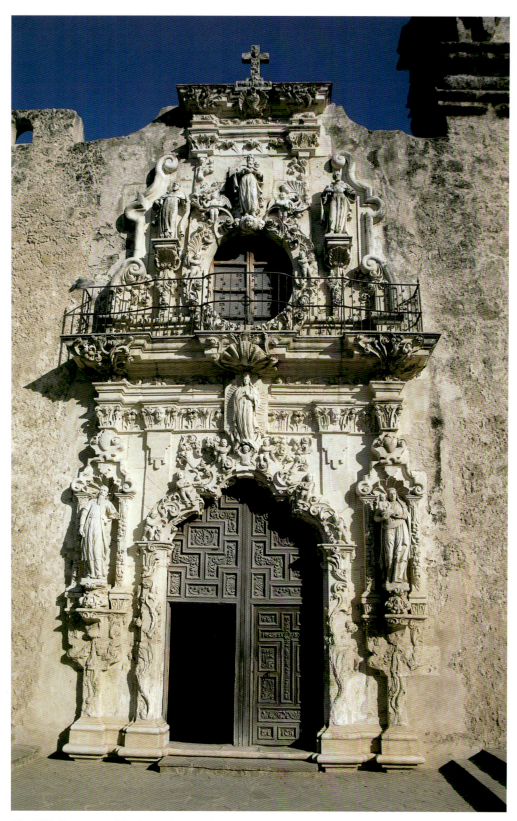

Plate VIII. Frontispiece of the church of Mission San José. Also see Fig. 4.17.

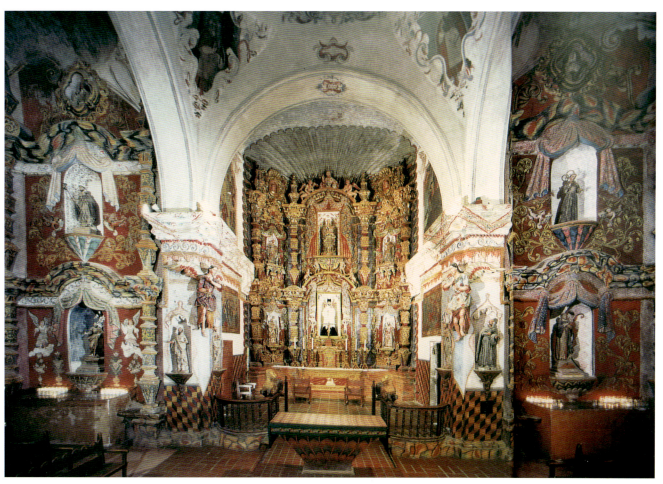

Plate IX. Interior of San Xavier del Bac facing the sanctuary, photograph by Jack Dykinga. Also see Fig. 6.6.

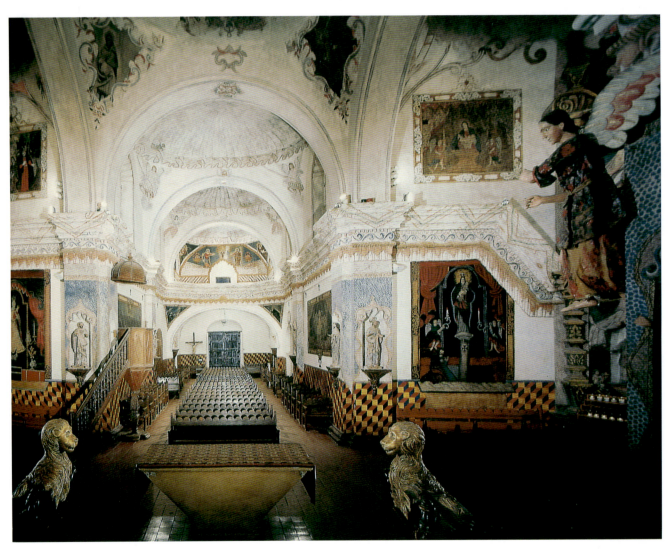

Plate X. Interior of San Xavier del Bac facing the choir balcony and the entrance, photograph by Jack Dykinga. Also see Fig. 6.7.

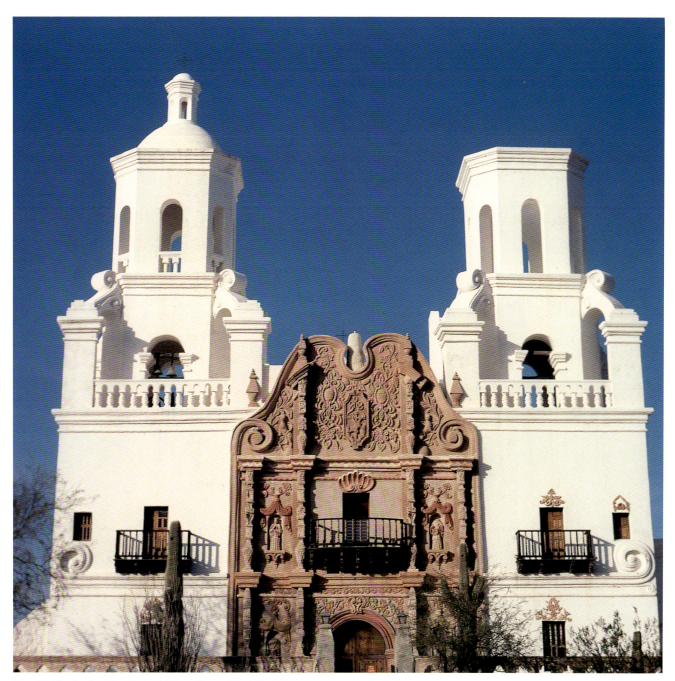
Plate XI. The façade of San Xavier del Bac. Also see Fig. 6.13.

| Plates

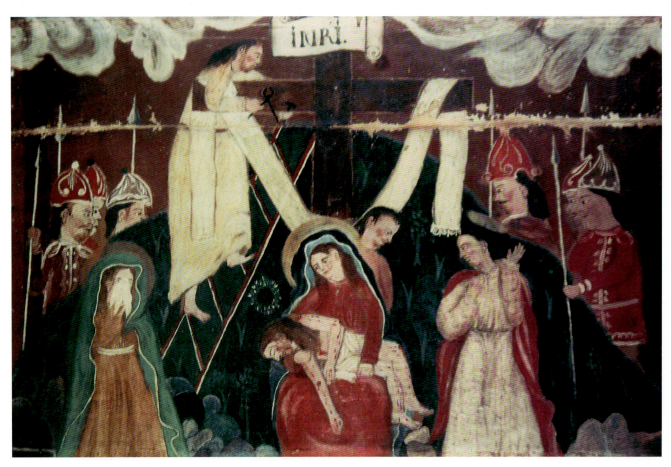

Plate XII. Painting of the thirteenth Station of the Cross, from Mission San Fernando Rey, now on display at Mission San Gabriel. Also see 7.2.

PLATES

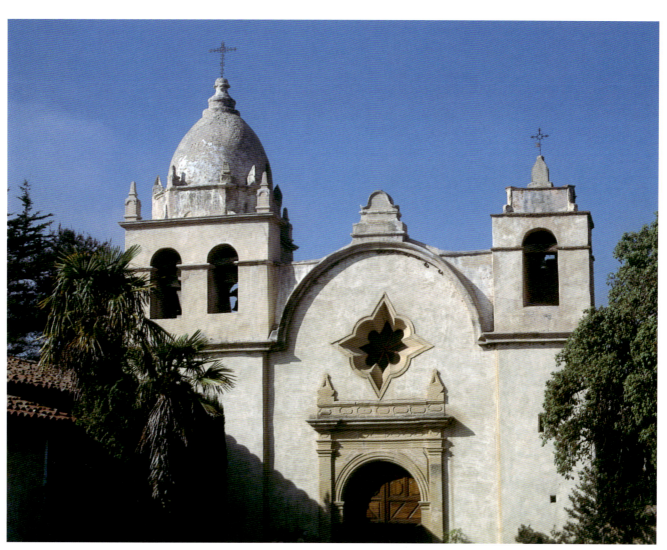

Plate XIII. Carmel, Mission San Carlos, façade of the church. Also see 7.8.

| Plates

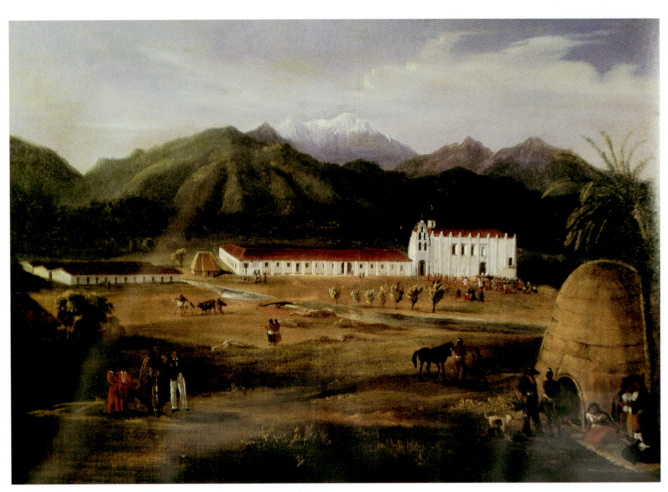

Plate XIV. Mission San Gabriel in 1828, painting by Ferdinand Deppe, 1832. Also see 7.16.

PLATES

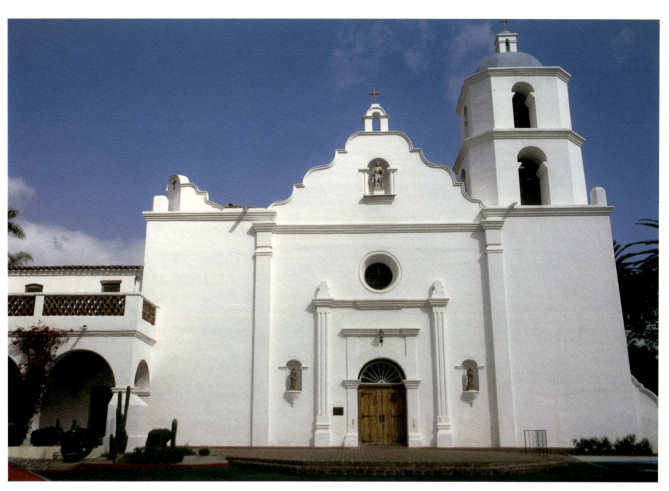

Plate XV. Mission San Luis Rey, façade of the church, and part of the arcade of the restored quadrangle. Also see 7.25.

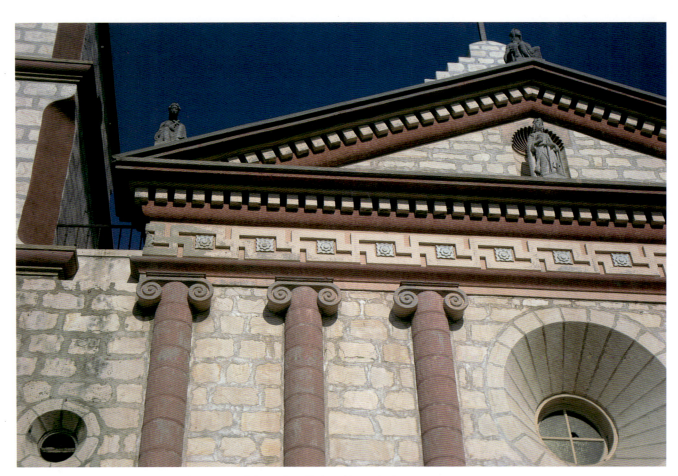

Plate XVI. Detail of rebuilt upper façade of the church of Mission Santa Barbara. Also see 7.35.

Notes

Chapter I

Spanish Settlement and Construction in North America

1. *The Complete Poetry and Prose of Walt Whitman*, ed. Cowley, 2:402–403.
2. Crouch, Garr, and Mondigo, *Spanish City Planning in North America*, 6–19.

Chapter II

Florida

1. Lyon, ed., *Pedro Menéndez de Avilés*, 80.
2. Ibid., 170.
3. Ibid., 532.
4. Ibid., 361.
5. Connor, ed., *Colonial Records of Spanish Florida* 2:283.
6. Manucy, *Sixteenth Century St. Augustine*, 41.
7. Bushnell, *Situado and Sabana*, 88.
8. Bushnell, "Sacramental Imperative," 485.
9. Lyon, ed., *Pedro Menéndez de Avilés*, 82.
10. Gannon, *The Cross in the Sand*, 78.
11. Manucy, *Sixteenth Century St. Augustine*, 51.
12. Bushnell, *The King's Coffer*, 11.
13. Deagan, ed., *America's Ancient City*, 564–569.
14. Bigges, *Sir Francis Drake's West Indian Voyage*, 45, and Chatelain, *The Defenses of Spanish Florida*, 53–54, map 3.
15. Connor, "The Nine Old Wooden Forts of St. Augustine," 171–172.
16. Chatelain, *The Defenses of Spanish Florida*, map 4, and Manucy, *Sixteenth Century St. Augustine*, 42–49.
17. Lowery, *The Lowery Collection*, 270.
18. Waterbury, ed., *The Oldest City*, 79.
19. Gannon, *The Cross in the Sand*, 33–34.
20. Geiger, *The Franciscan Conquest of Florida*, 90.
21. Bushnell, "Sacramental Imperative," 479.
22. Axtell, *The Indians' New South*, 28.
23. Alonso de Jesús, "Fray Francisco Alonso de Jesús Memorial, 1630," 101.
24. Pareja, *Francisco Pareja's 1613 Confesionario*, 10–15.
25. Bushnell, *Situado and Sabana*, 156.
26. Hann, "Summary Guide to the Spanish Florida Missions," 485.
27. Díaz Vara Calderón, *A 17th Century Letter*, 13.
28. Hann, *Apalachee*, 140–141.
29. Leonard, *The Spanish Approach to Pensacola, 1689–1693*, 153.
30. Ibid., 182.
31. Ibid., 193.
32. Manucy, "The Founding of Pensacola—Reasons and Reality," 239.
33. Rowland, Sanders, and Galloway, *Mississippi Provincial Archives: French Dominion, 1729–1763* 3:26.
34. Gordon, "Journal of an Officer who Traveled in America and the West Indies, 1764–1765," in *Travels in the American Colonies*, 381–382.
35. *The Travels of William Bartram*, 332.
36. José de Gálvez to Bernardo de Gálvez August 29, 1779, quoted by Abbey, "Spanish Projects for the Recuperation of the Floridas during the American Revolution," 274.
37. Robin, *Voyage to Louisiana*, 3.

Chapter III

New Mexico

1. Hammond and Rey, eds., *Don Juan Oñate: Colonizer of New Mexico* 1:315, 335.
2. Ellis, *San Gabriel del Yunge*, 14.
3. Ordinance 36, in Crouch, Garr, and Mondigo, *Spanish City Planning in North America*, 9.
4. Benavides, *A Harvest of Reluctant Souls*, 43.
5. Ibid., 43.
6. Domínguez, *Missions of New Mexico, 1776*, 34.
7. Davis, *El Gringo*, 177.
8. Domínguez, *Missions of New Mexico, 1776*, 55.
9. Minge, "The Last Will and Testament of Don Severino Martínez," 39.
10. Kessell, *Kiva, Cross, and Crown*, 239.
11. Hammond and Rey, eds., *Obregon's History*, 335.
12. Kessell, *Kiva, Cross, and Crown*, 122–123.
13. Vetancurt, *Teatro Mexicano* 3:277.
14. Hayes, *The Four Churches of Pecos*, front cover.

15. Lummis, *The Land of Poco Tiempo*, 296–297.
16. Ivey, *In the Midst of a Loneliness*, 59.
17. Ibid., 87.
18. Carleton, *Diary of an Expedition*, 26.
19. Murphy, *Salinas Pueblo Missions*, 54.
20. Carleton, *Diary of an Expedition*, 37.
21. Murphy, *Salinas Pueblo Missions*, 59.
22. "Relación del Suceso," *Narratives of the Coronado Expedition*, ed. Hammond, 288.
23. Antonio Espejo, "Account of the Journey to the Provinces and Settlements of New Mexico," in Bolton, ed., *Spanish Exploration of the Southwest, 1542–1706*, 182–184.
24. Benavides, *A Harvest of Reluctant Souls*, 33.
25. Scholes and Adams, "Inventories of Church Furnishings in Some of the New Mexican Missions, 1672," 34–35.
26. Espinosa, ed., *The First Expedition of Vargas into New Mexico*, 194.
27. Tamarón, *Bishop Tamarón's Visitation of New Mexico, 1760*, 189.
28. Domínguez, *Missions of New Mexico, 1776*, 189–193.
29. Ibid., 254–256.
30. Chauvenet, *John Gaw Meem*, 30–31.
31. Kessell, *The Missions of New Mexico since 1776*, 200.
32. Reuter, "Restoration of Acoma Mission," 79–80.
33. Hammond and Rey, eds., *Don Juan Oñate: Colonizer of New Mexico, 1595–1628* 2:1087.
34. Ibid., 1087–1091.
35. Benavides, *Revised Memorial of 1634*, 68.
36. Twitchell, *Old Santa Fe*, 51, note 1224.
37. Kubler, *The Rebuilding of San Miguel at Santa Fe in 1710*, 9.
38. Treib, *Sanctuaries of Spanish New Mexico*, 82.
39. Domínguez, *Missions of New Mexico, 1776*, 13–15.
40. Treib, *Sanctuaries of Spanish New Mexico*, 91.
41. Davis, *El Gringo*, 164–166, 169.
42. Ellis, *The Historic Palace of the Governors*, (unpaged) c.13.
43. Report of the Cabildo in 1716, in Twitchell, *Old Santa Fe*, 59.
44. Wilson, *The Myth of Santa Fe*, 127.
45. Fray Garcia de San Francisco y Zuñiga, quoted in Sonnichsen, *Pass of the North*, 22.
46. Timmons, *El Paso*, 35.
47. Simmons, "Spanish Irrigation Practices in New Mexico," 143.
48. Humboldt, *Political Essay on the Kingdom of New Spain*, 271.
49. Fray Salvador Guerra, in Scholes, trans. and ed., "Documents for the History of the New Mexican Missions in the Seventeenth Century," 195–199.
50. Twitchell, ed., *The Spanish Archives of New Mexico* 1:289–293.
51. Domínguez, *Missions of New Mexico, 1776*, 99–101.
52. Bourke, "Bourke on the Southwest," *New Mexico Historical Review* 11 (1936): 272–273.
53. Owings, "Las Trampas: A Past Resurrected," 34.
54. Domínguez, *Missions of New Mexico, 1776*, 83.
55. Prince, *Spanish Mission Churches of New Mexico*, 316.
56. Borhegyi, "The Miraculous Shrines of Our Lord of Esquipulas," 92.
57. Treib, *Sanctuaries of Spanish New Mexico*, 166.
58. Prince, *Spanish Mission Churches of New Mexico*, 317.

Chapter IV

Texas

1. Weber, *The Spanish Frontier in North America*, 153.
2. Rubí's *Diary*, in Jackson, ed., *Imaginary Kingdom*, 129.
3. Benoist and Flores, eds., *The Spanish Missionary Heritage of the United States*, 185.
4. Schuetz, "Professional Artisans in the Hispanic Southwest," 20.
5. Morfi, *History of Texas* 1:92.
6. Espinosa, "Ramon's Expedition: Espinosa's Diary of 1716," 346.
7. De la Teja, *San Antonio de Béxar*, 18.
8. Céliz, *Diary of the Alarcón Expedition into Texas, 1718–1719*, 86–87.
9. De la Teja, *San Antonio de Béxar*, 32.
10. Spell, trans. and ed., "The Grant and First Survey of the City of San Antonio," 75–77.
11. Morfi, *History of Texas* 1:92.
12. De la Teja, *San Antonio de Béxar*, 134.
13. Leutenegger, trans. and ed., "Selections from Guidelines for a Texas Mission," in *Archaeology of the Spanish Missions of Texas*, ed. Fox, 75–121.
14. Corner, *San Antonio de Béxar*, 16.
15. *William Bollaert's Texas*, 231.
16. "Report of Captain Juan Valdez, March 13, 1730," in Leutenegger, trans., *The San José Papers* 1:32–33.
17. Ibid., 133.
18. Solis, "Diary of Fray Gaspar José de Solis," 50–51.
19. Morfi, *History of Texas* 1:95–98.
20. Bartlett, *Personal Narrative of Explorations and Incidents* 1:43.
21. Harvey Smith Jr., "Thirty Years Service: Harvey Smith and the Restoration of the San Antonio Missions, 1934–1964," in Cruz, ed., *Proceedings of the 1984 and 1985 San Antonio Missions Research Conferences*, 64–67.
22. Letters to Father Roy Rihn in December 1947 and January 1948, in Cruz, ed., *Proceedings of the 1984 and 1985 San Antonio Missions Research Conferences*, 33.
23. Cruz, ed., *Proceedings of the 1984 and 1985 San Antonio Missions Research Conferences*, 27.

Chapter V

Louisiana

1. Charlevois, A Journal of a Voyage to North America, 275.
2. Wilson, *Vieux Carré New Orleans*, 37.

3. Pittman, *The Present State of European Settlements on the Mississippi*.
4. Wilson, *Vieux Carré New Orleans*, 44.
5. Gayarré, *History of Louisiana* 2:381.
6. Baily, *Journal of a Tour in the Unsettled Parts of North America*, 174.
7. Gayarré, *History of Louisiana* 3:203.
8. *The Journals of Benjamin Henry Latrobe 1799–1820* 3:172–173.
9. Wilson, "Almonester: Philanthropist and Builder," 299.
10. Ibid., 297.
11. Holmes, "Some French Engineers in Spanish Louisiana," 125.
12. Kinnaird, *Spain in the Mississippi Valley, 1765–1794*, 371.
13. *The Journals of Benjamin Henry Latrobe 1799–1820* 3:255.
14. Wilson and Huber, *The Cabildo on Jackson Square*, 28.
15. Ibid., 31.
16. Wilson, "Almonester: Philanthropist and Builder," 311.
17. *The Journals of Benjamin Henry Latrobe 1799–1820* 3:256.
18. Wilson and Huber, *The Cabildo on Jackson Square*, 59–60.
19. Wilson and Huber, *The Presbytère on Jackson Square*, 35.

Chapter VI

Arizona

1. Bolton, *The Padre on Horseback*, 53.
2. Burrus, *Kino and the Cartography of Northwestern New Spain*, 8.
3. Burrus, *Kino's Plan for the Development of Pimeria Alta, Arizona and Upper California*, 32–33.
4. Pfefferkorn, *Sonora: A Description of the Province*, 284.
5. Kessell, *Mission of Sorrows*, 174.
6. Pfefferkorn, *Sonora: A Description of the Province*, 272.
7. Kessell, *Friars, Soldiers and Reformers*, 17.
8. Ibid., 77–78.
9. Ibid., 69–70.
10. Ibid., 307.
11. Gerald, *Spanish Presidios*, 14.
12. Dobyns, *Spanish Colonial Tucson*, 60.
13. Ibid., 61.
14. Sonnichsen, *Tucson*, 14.
15. Ibid., 26.
16. Schaefer, Chin, and McCarty, *Bac: Where the Waters Gather*.
17. Burrus, *Kino and the Cartography of Northwestern New Spain*.
18. *Kino's Historical Memoir of Pimeria Alta* 1:174, 205.
19. Ibid., 235–236.
20. Fontana, "Biography of a Desert Church," 6.
21. Donahue, "The Unlucky Jesuit Mission of Bac, 1732–1767," 136.
22. *Font's Complete Diary*, 121.
23. Banham, *Scenes in America Deserta*, 175.
24. *Pioneer Notes from the Diaries of Judge Benjamin Hayes*, 162.
25. Bell, *New Tracks in North America*, 334–335.
26. Banham, *Scenes in America Deserta*, 174–175.

Chapter VII

California

1. Kelsey, *Juan Rodríguez Cabrillo*, 110.
2. Richman, *California Under Spain and Mexico*, Appendix A, 505–506.
3. Weber, *The Spanish Frontier in North America*, 244.
4. Ibid., 246.
5. *The Discovery of San Francisco Bay: The Portolá Expedition of 1769–1770: The Diary of Miguel Costansó*, 196.
6. *The Writings of Junípero Serra* 2:143.
7. Beilharz, *Felipe de Neve*, 133.
8. *Palóu's Life of Fray Junípero Serra*, 26–27.
9. Simpson, Introduction to *The Letters of José Señan O.F.M.*, 111.
10. *The Writings of Fermín Francisco de Lasuén* 2:213.
11. Monroy, *Thrown Among Strangers*, 84–85.
12. Reps, *Cities of the American West*, 89, 93.
13. "Costansó's 1794 Report on Strengthening New California's Presidios," 225–226, 228–229.
14. Duhaut-Cilly, *A Voyage to California*, 78.
15. Bancroft and collaborators, *History of California* 1:216.
16. Reps, *Cities of the American West*, 97.
17. Ibid., 97.
18. Ibid., 98.
19. Ibid., 102.
20. Webb, *Indian Life at the Old Missions*, 106.
21. Letter to Sister Antonia Valladoid, in *The Writings of Junípero Serra* 1:181.
22. Letter to José de Gálvez, in *The Writings of Junípero Serra* 1:187.
23. *Palóu's Life of Fray Junípero Serra*, 93.
24. Howard, *The Archaeology of the Royal Presidio of Monterey*, 53–54.
25. *Palóu's Life of Fray Junípero Serra*, 93–94.
26. *The Writings of Junípero Serra* 1:237.
27. Fages, "A Description of California's Principal Presidio, Monterey, in 1773," 328–334.
28. Beilharz, *Felipe de Neve*, 80.
29. Vancouver, *Vancouver in California 1792–1794* 1:85.
30. *Palóu's Life of Fray Junípero Serra*, 116.
31. *The Writings of Junípero Serra* 1:255, 257.
32. Ibid. 4:273.
33. Ibid., 275.
34. Vancouver, *Vancouver in California* 1:65.
35. *The Writings of Fermín Francisco de Lasuén* 1:323.
36. Ibid., 360.
37. Farnham, *Life, Adventures and Travels in California*, 100.
38. Miller, *Account of a Tour of the California Missions*, 15.
39. Brewer, *Up and Down California in 1860–1864*, 106–107.
40. Jackson, *Glimpses of California and the Missions*, 133–134.
41. Temple, *The Carmel Mission*, 133–134.

42. "Sir Harry of Carmel," in Weber, ed., *Father of the Missions*, 103.
43. Crespi, diaries, in Bolton, *Fray Juan Crespi*, 146–147.
44. *Palóu's Life of Fray Junípero Serra*, 119.
45. *Font's Complete Diary*, 175–178.
46. Ibid., 179–180.
47. The Writings of Junípero Serra, 3:415.
48. Engelhardt, *San Gabriel Mission and the Beginnings of Los Angeles*, 104.
49. *Font's Complete Diary*, 177.
50. Webb, *Indian Life at the Old Missions*, 222
51. Pérez, "An Old Woman and Her Recollections," 81–82.
52. Augustin Janssens, quoted in Geiger, *Franciscan Missionaries in Hispanic California*, 268.
53. Weber, *Pride of the Missions*, 18.
54. *The Writings of Fermín Francisco de Lasuén* 2:387.
55. Ibid., 389.
56. Ibid., 391.
57. Engelhardt, *San Gabriel Mission and the Beginnings of Los Angeles*, 73.
58. Ibid., p. 73.
59. Bynum, "Governor Don Felipe de Neve," 58–59.
60. Rios-Bustamente and Castillo, *An Illustrated History of Mexican Los Angeles, 1781–1985*, 36.
61. Caughey, *Los Angeles: Biography of a City*, 79.
62. Engelhardt, *San Gabriel Mission and the Beginnings of Los Angeles*, 127.
63. Ibid., 129.
64. Owen, "The Church by the Plaza," 25.
65. Ibid., 193.
66. Duflot de Mofras, *Travels on the Pacific Coast*, 184, 186.
67. Newmark, *Sixty Years in Southern California, 1853–1913*, 113–114.
68. Ibid., 102.
69. Engelhardt, *San Juan Capistrano Mission*, 3.
70. Ibid., 4.
71. Ibid., 53.
72. Ibid., 53.
73. Pérez, "An Old Woman and Her Recollections," 74–75.
74. Engelhardt, *San Juan Capistrano Mission*, 84.
75. Ibid., Appendix G, 247–251.
76. Weber, *King of the Missions*, 4.
77. Ibid., 5.
78. *The Writings of Fermín Francisco de Lasuén* 2:86–87.
79. Engelhardt, *San Luis Rey Mission*, 41.
80. Duhaut-Cilly, *A Voyage to California*, 117.
81. Robinson, *Life in California*, 25.
82. Duhaut-Cilly, *A Voyage to California*, 123.
83. Tac, "Conversion of the San Luiseños of Alta California," 100.
84. Dana, *Two Years Before the Mast*, 174.
85. Engelhardt, *San Luis Rey Mission*, 35–36.
86. James, *Picturesque Pala*, 42–43.
87. Engelhardt, *San Luis Rey Mission*, 78.
88. Emory, *Narrative of a Military Tour*, 66, 70.
89. Bartlett, *Personal Narrative of Explorations and Incidents* 2:91.
90. Weber, *King of the Missions*, 101.
91. Ibid., 179.
92. Costansó, *The Discovery of San Francisco Bay*, 33.
93. Weber, *Queen of the Missions*, 28.
94. Whitehead, "Alta California's Four Fortresses," 84–85.
95. Vancouver, *Vancouver in California* 2:149.
96. Webb, *Indian Life at the Old Missions*, 121.
97. Menzies, "Journal of the Vancouver Expedition," 318–319.
98. Engelhardt, *Santa Barbara Mission*, 57–58.
99. Ibid., 65.
100. Duhaut-Cilly, *A Voyage to California*, 87.
101. Farnham, *Life, Adventures and Travels in California*, 110.
102. Geiger, *Mission Santa Barbara*, 43.
103. Ibid., 43.
104. Duhaut-Cilly, *A Voyage to California*, 116.
105. Engelhardt, *Santa Barbara Mission*, 111.
106. Engenhoff, ed., *Fabricas*, 167.
107. Geiger, *Mission Santa Barbara*, 49.
108. Engelhardt, *Santa Barbara Mission*, 113.
109. Brewer, *Up and Down California in 1860–1864*, 69–70.

Glossary

Acequia, ditch carrying water from a stream for irrigation.
Adelantado, title, along with specified privileges granted to a person initiating the settlement of a region.
Aguardiente, strong alcoholic drink.
Alabado, hymn sung in praise of the consecrated host.
Alcalde, political official, sometimes with powers like those of a mayor.
Alcalde major, district governor.
Alguacil, town constable.
Apse, enlargement of the altar end of a church, rectilinear, polygonal, or semicircular.
Asistencia, church or chapel visited periodically by friars from a mission.
Atole, gruel made of corn flour.
Audiencia, a high court and council to a viceroy or captain general.

Baldachin, an ornamental canopy over an altar.
Bujio, large circular communal Indian lodge.
Bulto, carved wooden statue.
Buttress, element, usually vertical, placed outside a wall to support it.

Caballeria, building lot for a prominent person, approximately 200 by 100 feet.
Cabildo, municipal council.
Camino Real, highway.
Campanario, wall with openings to hang bells
Camposanto, cemetery.
Canal, projection to drain water off a roof and away from the wall.
Carreta, cart, usually two-wheeled.
Casas reales, the buildings of the vice-regal government.
Cédula, royal decree.
Chancel, the space in a church reserved for officiating clergy.
Convento, religious establishment, in particular the residence of friars.
Corbel, timber projecting from a wall to support a viga or beam.
Corinthian, the most elaborate of the classical orders of architecture, with a capital decorated by stylized icanthus leaves.
Cornice, the horizontal element, usually molded or carved and projecting, which crowns a façade, a wall, or an entablature.
Cuera, cavalryman's coat of arrowproof leather.

Custodia, a subdivision of a Franciscan province.
Custodio, the head of a *custodia*.

Doctrina, religious establishment for converted Indians, often having subordinate *asistencias*.
Doric, the oldest of the classical orders of architecture with a simple capital.
Drum, a wall, cylindrical or polygonal, which supports a dome.

Ejido, municipally owned agricultural land.
Encomendero, person granted specified goods or produce from one or more Indian communities.
Encomienda, the place or places granted to an *encomendero*.
Entablature, the horizontal section above classical columns or pilasters, consisting of architrave, frieze, and cornice.
Entrada, formal entry, usually armed, into a new territory.
Espadaña, wall belfry, usually at the top of a façade.
Estípite, baroque or mannerist column or pilaster consisting of a base, an inverted obelisk, and other sharp-edged elements.

Fanega, unit of dry measure, approximately 1.5 bushels.
Fiscal, lay assistant to a parish priest or legal counsel to an *audiencia*.

Hidalgo, Spanish gentleman or minor noble.
Horno, oven or kiln.

Ionic, classical order of architecture with curving volutes on the capital.

Jacal, a building with walls constructed of vertical timbers plastered with mud, stones, or sticks.

Kiva, a Pueblo Indian chamber used for religious and other purposes, usually circular and wholly or partially underground.

Ladrillo, tile or brick.
Lavandería, wash basin.

Mampostería, rubble masonry.
Manta, woven material used as a cloak or blanket.
Merlon, solid, vertical, decorative, often pyramidal element in a parapet between gaps or at the base of a dome or tower.

Glossary

Metate, concave slab or stone for grinding corn.
Mestizo, person of both Spanish and Indian ancestry.
Mirador, belvedere, building, or upper floor of a building providing a view.
Mitote, an Indian dance.
Monjério, quarters in a mission for unmarried women.
Morada, building used for religious services and for eating and dressing by the Penetente cult.

Nave, the central longitudinal part of a church.

Obraje, workshop for making textiles.
Oidor, judge, member of an *audiencia*.

Patronato Real, rights and privileges of the Spanish crown in ecclesiastical matters, especially to name clerical officials.
Pediment, a low pitched gable formed by the sloping roofs of a classical temple.
Pendentive, a spherical triangle forming a transition from a squared area to a drum or dome.
Peonaria, building lot for an ordinary person, approximately 100 by 50 feet.
Pesta, plague, epidemic.
Pilaster, flattened column attached to a wall.
Portal, doorway, entrance, or covered walkway along a street or the sides of a plaza or courtyard, supported by posts.
Portería, entrance to a friary.
Pozole, dish of boiled barley and beans.
Pueblo, town.

Ranchería, small settlement.
Rancho, small estate used primarily for ranching.
Real, royal, or coin worth one-eighth of a silver peso.
Refectory, room where meals are served.
Regidor, councilman, an ordinary member of a *cabildo* or town council.

Reglamento, official regulation.
Repartimiento, work party of Indians assigned to a project for a specified period of time, such as two weeks.
Retablo, a decorative altar screen, in New Mexico a painting on a wooden panel or on metal.

Sala, large, important room, or court of justice.
Sanctuary, the chancel, the part of the church containing the altar and reserved for the clergy.
Santero, an itinerant maker of religious images, carved or painted.

Torreón, fortified tower.
Transept, interior space of a church at right angles to the nave.
Transverse clerestory, translucent strip at the juncture of the roof of the nave and the higher roof of the rear of a church which brings light into the sanctuary.
Tuscan order, classical order similar to but simpler than the Doric.

Vaquero, herdsman, cowboy.
Vara, measure equal to 33.6 inches.
Vecino, resident of a town.
Villa, corporate residential community more important than a *pueblo* and less important than a *ciudad*.
Visita, a church or chapel visited periodically by friars from a mission.

Wattle and daub, framework of poles and interwoven twigs smeared over with clay or mud for walls.

Zaguan, covered entrance way.
Zanja, ditch carrying water from a stream for irrigation.

Bibliography

General Works

Bartlett, John R. *Personal Narrative of Explorations and Incidents.* 2 vols. New York, 1854.

Benoist, Howard, and Maria Carolina Flores, eds. *The Spanish Missionary Heritage of the United States.* San Antonio, 1991.

Bolton, Herbert E. "The Mission as a Frontier Institution." In *Bolton and the Borderlands*, ed. John F. Bannon. Norman, 1964.

———. *The Spanish Borderlands.* New Haven, 1921.

———. ed. *Spanish Exploration of the Southwest, 1542–1706.* New York, 1930.

Bringas de Manzaneda y Encinas, Diego. *Friar Bringas Reports to the King: Methods of Indoctrination on the Frontier of New Spain*, trans. and ed. Donald S. Matson and Bernard L. Fontana. Tucson, 1977.

Brinckerhoff, Sidney B., and Odie B. Faulk, eds. and trans. *Lancers for the King: A Study of the Frontier Military System of Northern New Spain.* Phoenix, 1965.

Crouch, Dora P., Daniel J. Garr, and Axel I. Mundigo. *Spanish City Planning in North America.* Cambridge, 1982.

Cruz, Gilbert R. *Let There Be Towns: Spanish Municipal Origins in the American Southwest, 1610–1810.* College Station, 1988.

Drain, Thomas A. *A Sense of Mission: Historic Churches of the Southwest.* San Francisco, 1994.

Emory, W. H. *Notes of a Military Reconnaissance.* Washington, 1848.

Fireman, Janet R. *The Spanish Royal Corps of Engineers in the Western Borderlands.* Glendale, 1977.

Font, Pedro. *Font's Complete Diary.* Vol. 4 of *Anza's California Expeditions,* ed. and trans. Herbert E. Bolton. Berkeley, 1930.

Fontana, Bernard L. *Entrada: The Legacy of Spain and Mexico in the United States.* Tucson, 1994.

Garr, Daniel J., ed. *Hispanic Urban Planning in North America.* Spanish Borderlands Sourcebooks 27. New York and London, 1991.

Gerhard, Peter. *The Northern Frontier of New Spain.* Princeton, 1982.

Hall, Douglas K. *Frontier Spirit: Early Churches of the Southwest.* New York, 1990.

Jones, Oakah L., Jr. *Los Paisanos: Spanish Settlers on the Northern Frontier of New Spain.* Norman, 1979.

Kennedy, Roger G. *Mission.* Boston, New York, 1993.

Kubler, George. "Two Modes of Franciscan Architecture: New Mexico and California." *Gazette des Beaux Arts*, 6th Series 23 (1943): 39–48.

Lummis, Charles F. *The Land of Poco Tiempo.* New York, 1893.

McAlister, Lyle. "The Reorganization of the Army of New Spain, 1763–1766." *Hispanic American Historical Review* 33 (1953): 1–32.

Moorhead, Max L. *The Presidio: Bastion of the Spanish Borderlands.* Norman, 1979.

Navarro Garcia, Luis. "The North of New Spain as a Political Problem in the Eighteenth Century," trans. Beth Gard and David J. Weber. In *New Spain's Far Northern Frontier*, ed. David J. Weber, 201–215. Albuquerque, 1979.

Naylor, Thomas H., and others, eds. *Presidio and Militia on the Northern Frontier of New Spain.* Vol. 1, *1570–1700.* Vol. 2 pt. 1, *The Californias and Sinaloa Sonora, 1700–1765.* Vol. 2 pt. 2, *The Central Corridor and the Texas Corridor, 1700–1765.* Tucson, 1986, 1997.

Newcomb, Rexford G. *Spanish-Colonial Architecture in the United States.* New York, 1937.

Nuttall, Zelia, trans. and ed. "Royal Ordinances Concerning the Laying Out of New Towns." *Hispanic American Historical Review* 4–5 (1921, 1922): 743–753, 249–254.

Park, Joseph F. "Spanish Indian Policy in Northern Mexico, 1765–1810." *Arizona and the West* 4 (1962): 325–344.

Reps, John W. *Cities of the American West.* Princeton, 1979.

———. *The Making of Urban America: A History of City Planning in the United States.* Princeton, 1965.

Schuetz-Miller, Mardith K. "[The Architecture of] The Spanish Borderlands." In *Encyclopedia of the North American Colonies*, vol. 3. New York, 1993.

———. "Survival of Early Christian Symbolism in Monastic Churches of New Spain and Visions of the Millennial Kingdom." *Journal of the Southwest* 42 (2000): 763–800.

Thomas, Alfred B., ed. *Forgotten Frontiers: A Study of the Spanish Indian Policy of Don Juan Bautista Anza.* Norman, 1932.

Thomas, David H., ed. *Columbian Consequences*, vols. 1 and 3. Washington, 1989, 1991.

Tyler, Ron. *Visions of America.* New York, 1983.

Velazquez, María del Carmen, ed. *La Frontera Norte y La Experiencia Colonial.* Mexico City, 1982.

Vecsey, Christopher. *On the Padres' Trail*. Notre Dame, 1996.

Vigil, Ralph. "The Hispanic Heritage and the Borderlands." *Journal of San Diego History* 19, no. 3 (1973): 32–39.

Weber, David J. *The Mexican Frontier, 1821–1846*. Albuquerque, 1982.

———. *The Spanish Frontier in North America*. New Haven, 1992.

———, ed. *The Idea of Spanish Borderlands*. Spanish Borderlands Sourcebooks 1. New York and London, 1991.

———, ed. *New Spain's Far Northern Frontier*. Albuquerque, 1979.

Weddle, Robert S. *Changing Tides: Twilight and Dawn on the Spanish Sea, 1763–1803*. College Station, 1995.

———. *The French Thorn: Rival Explorers in the Spanish Sea, 1682–1762*. College Station, 1991.

———. *Spanish Sea: The Gulf of Mexico in North American Discovery, 1500–1685*. College Station, 1985.

Whitaker, Arthur P. *The Spanish-American Frontier, 1783–1795*. Boston, New York, 1927.

Whitman, Walt. *The Complete Poetry and Prose of Walt Whitman*, ed. Malcolm Cowley. 2 vols. New York, 1948.

Florida

Abbey, Kathryn T. "The Spanish Projects for the Recuperation of the Floridas during the American Revolution." *Hispanic American Historical Review* 9 (1929): 265–285.

Alonso de Jesús, Francisco. "Fray Francisco Alonso de Jesús, Memorial 1630," trans. and ed. John H. Hann. *The Americas* 50 (1993): 85–105.

Arana, Luis. "Fortifications of Spanish Florida, 1565–1763." *Courier*, special issue (October 1991): 26–30.

Arana, Luis, and Albert Manucy. *The Building of the Castillo de San Marcos*. Eastern National Park and Monument Association, 1977.

Arnade, Charles W. "The Architecture of Spanish St. Augustine." *The Americas* 18 (1961): 149–175.

———. "The Failure of Spanish Florida." *The Americas* 16 (1960): 271–281.

———. *Florida on Trial, 1593–1602*. Coral Gables, 1959.

———. *The Siege of St. Augustine in 1702*. Gainesville, 1959.

Axtell, James. *The Indians' New South*. Baton Rouge and London, 1997.

Barrientos, Bartolomé. *Pedro Menéndez de Avilés*, trans. Anthony Kerrigan. Gainesville, 1965.

Bartram, John. *Diary of a Journey Through the Carolinas, Georgia and Florida. Transactions of the American Philosophical Society* 33. Philadelphia, 1942.

Bartram, William. *The Travels of William Bartram*, ed. Mark Van Doren. New York, 1928.

Bense, Judith A., ed. *Archaeology of Colonial Pensacola*. Gainesville, 1999.

Bigges, Walter. *Sir Francis Drake's West Indian Voyage*. London, 1589.

Boyd, Mark F., trans. and ed., with Hale G. Smith and John W. Griffin. *Here They Once Stood: The Tragic End of the Apalachee Missions*. Gainesville, 1951.

Bushnell, Amy T. *The King's Coffer: Proprietors of the Spanish Florida Treasury, 1565–1702*. Gainesville, 1981.

———. "Ruling the Republic of Indians in Seventeenth Century Florida." In *Powhatan's Mantle: Indians in the Colonial Southeast*, ed. Peter H. Wood, Gregory A. Wasekov, and M. Thomas Hatley, 134–150. Lincoln, 1989.

———. "The Sacramental Imperative: Catholic Ritual and Indian Sedentism in the Provinces of Florida." In *Columbian Consequences* 2, ed. David H. Thomas, 475-490. Washington, 1990.

———. *Situado and Sabana: Spain's Support System for Presidio and Mission Provinces of Florida*. Anthropological Papers of the American Museum of Natural History 74. New York, 1994.

Chatelain, Verne E. *The Defenses of Spanish Florida, 1565–1763*. Washington, 1941.

Coker, William S. "Pensacola, 1786–1783." In *The New History of Florida*, ed. Michael V. Gannon, 117-133. Gainesville, 1996.

———. "Pensacola, 1786–1821." In *Archaeology of Colonial Pensacola*, ed. Judith A. Bense, 5-60. Gainesville, 1999.

Coker, William S., and Susan R. Parker. "The Second Spanish Period in the Two Floridas." In *The New History of Florida*, ed. Michael V. Gannon, 150-166. Gainesville, 1996.

Coleman, James C., and Irene Coleman. *Guardians on the Gulf*. Pensacola, 1982.

Connor, Jeanette T., trans. and ed. *Colonial Records of Spanish Florida, 1570–1577*. 2 vols. Deland, 1925.

———. "The Nine Old Wooden Forts of St. Augustine." *Florida Historical Quarterly* 4 (1926): 102–111, 170–180.

Covington, James W. "Drake Destroys St. Augustine." *Florida Historical Quarterly* 44 (1965): 81–93.

Deagan, Kathleen, ed. *America's Ancient City: Spanish St. Augustine, 1565–1763*. Spanish Borderlands Sourcebooks 25. New York and London, 1991.

———. "Saint Augustine: The First Urban Enclave in the United States." *North American Archaeological* 3 (1982): 183–206.

———, ed. *Spanish St. Augustine*. New York, 1983.

Deagan, Kathleen, and Darcie MacMahon. *Fort Mose*. Gainesville, 1995.

Dewhurst, William. *The History of St. Augustine*. New York, 1881.

Díaz Vara Calderón, Gabriel. *A 17th Century Letter of Bishop Gabriel Díaz Vara Calderón*, trans. and ed. Lucy L. Wenhold. Smithsonian Miscellaneous Collections 95, no. 16. Washington, 1936.

Dickinson, Jonathan. *Jonathan Dickinson's Journal*, ed. Evangelina W. Andrews and Charles M. Andrews. New Haven and London, 1945.

Faye, Sidney. "The Spanish and British Fortifications of Pensacola." *Pensacola Historical Society Quarterly* 6 (1992): 151–293.

Fairbanks, George R. *The History and Antiquities of the City of St. Augustine.* Gainesville, 1975.

Gannon, Michael V. *The Cross in the Sand: The Early Catholic Church in Florida, 1513–1970.* Gainesville, 1965.

———, ed. *The New History of Florida.* Gainesville, 1996.

Geiger, Maynard J. *Biographical Dictionary of the Franciscans in Spanish Florida and Cuba. Franciscan Studies* 21. Peterson, 1940.

———. *The Franciscan Conquest of Florida, 1573–1618.* Washington, 1937.

Gordon, Lord Adam. "Journal of an Officer Who Traveled in America and the West Indies 1764–1765." In *Travels in the American Colonies*, ed. Newton D. Mereness, 367–453. New York, 1916.

Gordon, Elsbeth K. *Florida's Colonial Architectural Heritage.* Gainesville, 2002.

Griffin, W. B. "Spanish Pensacola, 1700–1763." *Florida Historical Quarterly* 37 (1959): 242–262.

Hann, John H. *Apalachee.* Gainesville, 1988.

———. "Summary Guide to the Spanish Florida Missions and Visitas." *The Americas* 46 (1990): 417–514.

Hann, John H., and Bonnie G. McEwan. *The Apalachee Indians and Mission San Luis.* Gainesville, 1998.

Hoffman, Paul E. *A New Andalucia and the Way to the Orient.* Baton Rouge and London, 1990.

———. "Lucas Vázquez de Ayllon's Discovery and Colony." In *The Forgotten Centuries: Indians and Europeans in the American South, 1521–1704*, ed. Charles Hudson and Carmen Chaves Tesser. Athens, 1994.

———. *The Spanish Crown and the Defense of the Caribbean, 1535–1585.* Baton Rouge and London, 1980.

Keeler, Mary F. *Sir Francis Drake's West Indian Journey.* London, 1981.

Leonard, Irving A. *The Spanish Approach to Pensacola 1689–1693.* Albuquerque, 1939.

———. "The Spanish Re-Exploration of the Gulf of Mexico in 1686." *Mississippi Valley Historical Review* 22 (1936): 547–557.

Lewis, Clifford M., and Albert J. Loomis. *The Spanish Jesuit Mission in Virginia, 1570–1572.* Chapel Hill, 1953.

Lopez de Mendoza Grajales, Francisco. "Memoir of the Happy Result and Prosperous Voyage of Pedro Menéndez de Avilés," trans. Charles E. Bennett. In *Laudonniere and Fort Caroline.* Gainesville, 1964.

Lowery, Woodbury. *The Lowery Collection: A Descriptive List of the Maps of the Spanish Possessions within the Present Limits of the United States, 1502–1820*, ed. Philip L. Phillips. Washington, 1912.

———. *The Spanish Settlements within the Present Limits of the United States.* 2 vols. New York, 1901, 1905.

Lyon, Eugene. *The Enterprise of Florida: Pedro Menéndez de Avilés and the Spanish Conquest of 1565–1568.* Gainesville, 1983.

———, ed. *Pedro Menéndez de Avilés. Spanish Borderlands Sourcebooks* 24. New York and London, 1991.

———. "Pedro Menéndez's Strategic Plan for the Florida Peninsula." *Florida Historical Quarterly* 67 (1988): 1–14.

———. "St. Augustine in 1580: The Living Community." *El Escribano* 14 (1977): 20–33.

———. *Santa Elena: A Brief History of the Colony, 1566–1587.* Institute of Archaeology and Anthropology, University of South Carolina, Research Manuscript Series 193. Columbia, 1984.

Manucy, Albert. "The Founding of Pensacola—Reason and Reality." *Florida Historical Quarterly* 37 (1959): 223–241.

———. *The Houses of St. Augustine, 1565–1821.* Gainesville, 1992.

———. *Menéndez: Pedro Menéndez de Avilés, Captain General of the Ocean Sea.* St Augustine, 1983.

———. *Sixteenth Century St. Augustine: The People and Their Homes.* Gainesville, 1997.

Matter, Robert A. "Mission Life in Seventeenth Century Florida." *Catholic Historical Review* 67 (1981): 401–420.

McAlister, L. N. "Pensacola During the Second Spanish Period." *Florida Historical Quarterly* 37 (1954): 281–327.

McEwan, Bonnie. *The Spanish Missions of La Florida.* Gainesville, 1993.

McGovern, James R., ed. *Colonial Pensacola.* Pensacola, 1972.

Milanich, Jerald T. "Franciscan Missions and Native Peoples in Spanish Florida." In *The Forgotten Centuries: Indians and Europeans in the American South, 1521-1704*, ed. Charles Hudson and Carmen Chaves Tesser, 276–303. Athens, 1994.

Newton, Earle W. *Historic Architecture of Pensacola.* Pensacola, 1969.

Pareja, Francisco. *Francisco Pareja's 1613 Confesionario*, ed. Jerald T. Milanich. Tallahassee, 1972.

Parry, John H., and Robert G. Keith, eds. *New Iberian World.* 5 vols. New York, 1984.

Priestly, Herbert I. *The Luna Papers.* 2 vols. Deland, 1928.

Quinn, David B. *Explorers and Colonies: America 1500–1625.* London, 1990.

———, ed. *New American World.* 5 vols. New York, 1979.

Robin, C. C. *Voyage to Louisiana.* New Orleans, 1966.

Rowland, Dunbar, A. G. Sanders, and Patricia K. Galloway, eds. *Mississippi Provincial Archives: French Dominion, 1729–1763.* 5 vols. Jackson, 1927–1984.

Sauer, Carl D. *Sixteenth Century North America.* Berkeley, 1971.

Saunders, Rebecca. "Ideal and Innovation: Spanish Mission Architecture in the Southeast." In *Columbian Consequences* 2, ed. David H. Thomas. Washington and London, 1990.

Sluiter, Engel. *The Florida Situado: Quantifying the First Eighty Years, 1571–1651.* Gainesville, 1985.

Solis de Merás, Gonzalo. *Pedro Menéndez de Avilés*, trans. Jeanette T. Connor. Gainesville, 1964.

South, Stanley. "Santa Elena: Threshold of Conquest." In *The Recovery of Meaning*, ed. Mark P. Leone and Parker B. Potter, Jr., 27–71. Washington and London, 1988.

Spellman, Charles W. [and Michael V. Gannon]. "The Golden Age of the Florida Missions, 1632–1674." *Catholic Historical Review* 51 (1965): 354–372.

Te Paske, John, Jr. *The Governorship of Spanish Florida*. Durham, 1964.

Thomas, David H. *The Archaeology of Mission Santa Catalina de Guale* 1. *Search and Discovery*. Anthropological Papers of the American Museum of Natural History 63, pt. 2. New York, 1987.

———. Introduction to *The Archaeology of Mission Santa Catalina de Guale* 2. *Biocultural Interpretations*, ed. Clark S. Larsen. Anthropological Papers of the American Museum of Natural History 68. New York, 1990.

———. *Saint Catherine's: An Island in Time*. Atlanta, 1988.

———. "Saints and Soldiers at Santa Catalina." In *The Recovery of Meaning*, ed. Mark P. Leone and Parker B. Potter, Jr., 73–140. Washington and London, 1988.

———. "The Spanish Missions of La Florida: An Overview." In *Columbian Consequences* 2:357–397. Washington, 1990.

———, ed. *The Anthropology of St. Catherine's Island* 1. *Natural and Cultural History*. Anthropological Papers of the American Museum of Natural History 55, pt. 2. New York, 1978.

———, ed. *Columbian Consequences* 2: *Archaeological and Historical Perspectives on the Spanish Borderlands East*. Washington and London, 1990.

Waterbury, Jean P., ed. *The Oldest City*. St. Augustine, 1983.

Wilson, Samuel Jr. "Gulf Coast Architecture." In *Spain and Her Rivals on the Gulf Coast*, ed. Earle W. Newton and Ernest F. Dibble. Pensacola, 1977.

NEW MEXICO

Adams, Eleanor B. "The Chapel and Cofradia of Our Lady of Light in Santa Fe." *New Mexico Historical Review* 22 (1947): 327–341.

Aragón, Janie L. "The People of Santa Fé." *Aztlan* 7 (1976): 391–413.

Bandelier, Adolf F. *The Southwestern Journals of Adolph F. Bandelier, 1880–1882*, ed. Charles H. Lange and Carroll L. Riley. Albuquerque, 1966.

———. "A Visit to the Aboriginal Ruins in the Valley of the Rio Pecos." *Papers of the Archaeological Institute of America, American Series* 1, pt. 2, 37–135.

Benavides, Alonso de. Benavides' Memorial of 1630, trans. Peter P. Forrestal, ed. Cyprian J. Lynch. Washington, 1954.

———. *Fray Alonso de Benavides' Revised Memorial of 1634*, trans. and ed. Frederick W. Hodge, George P. Hammond, and Agapito Rey. Albuquerque, 1945.

———. *A Harvest of Reluctant Souls: The Memorial of Fray Alonso de Benavides, 1630*, trans. and ed. Baker H. Morrow. Niwot, Colorado, 1996.

Borhegyi, Stephen F. "The Miraculous Shrine of Our Lord of Esquipulas in Guatemala and Chimayo, New Mexico." *El Palacio* 60 (1953): 83–111.

Bourke, John Gregory. "Bourke on the Southwest," journal entries, ed. Lansing B. Bloom. *New Mexico Historical Review* 8 (1933): 1–30; 9 (1934): 33–74, 159–183, 273–289, 374–430; 10 (1935): 1–35, 271–322; 11 (1936): 77–122, 188–207, 217–282; 12 (1937): 41–77, 337–379; 13 (1938): 192–238.

Boyd, E. *The Literature of Santos*. Dallas, 1950.

———. *The New Mexican Santero*. Santa Fe, 1969.

———. *Popular Arts of New Mexico*. Santa Fe, 1974.

Broughton, William H. "The History of Seventeenth-Century New Mexico: Is It Time for New Interpretations?" *New Mexico Historical Review* 68 (1993): 3–12.

Bunting, Bainbridge. *Early Architecture of New Mexico*. Albuquerque, 1976

Carleton, James H. *Diary of an Expedition to the Ruins of Abó, Quarra and Gran Quivera in New Mexico in 1853*. Santa Fe, 1965.

Chávez, Angelico. "Nuestra Señora del Rosario, La Conquistadora." *New Mexico Historical Review* 23 (1948): 94–128, 177–216.

Chauvenet, Beatrice. *John Gaw Meem: Pioneer in Historic Preservation*. Santa Fe, 1985.

Davis, W. W. H. *El Gringo*. New York, 1857.

Domínguez, Atanasio. *Missions of New Mexico, 1776: A Description by Fray Atanasio Domínguez*, trans. and ed. Eleanor B. Adams and Angelico Chávez. Albuquerque, 1956.

Dozier, Edward P. *The Pueblo Indians of North America*. New York, 1970.

Ellis, Bruce T. *Bishop Lamy's Santa Fe Cathedral*. Albuquerque, 1985.

———. *The Historic Palace of the Governors*. Santa Fe, 1968.

Ellis, Florence H. *San Gabriel del Yunge*. Santa Fe, 1989.

Espejo, Antonio. "Account of the Journey to the Provinces and Settlements of New Mexico." In *Spanish Exploration of the Southwest, 1542–1706*, ed. Herbert E. Bolton, 182–184. New York, 1930.

Espinosa, J. Manuel, ed. *The First Expedition of Vargas into New Mexico, 1692*. Albuquerque, 1940.

Gritzner, Charles F. "Hispanic Grist Mills in New Mexico." *Annals of the Association of American Geographers* 64 (1974): 514–524.

———. "Log Housing in New Mexico." *Pioneer America* 3 (1971): 54–62.

Gutiérrez, Ramón A. *When Jesus Came, the Corn Mothers Went Away: Marriage, Sexuality, and Power in New Mexico, 1500–1846*. Stanford, 1991.

Hackett, C. W., ed. *Historical Documents Relating to New Mexico*. 3 vols. Washington, 1923–1937.

Hammond, George P. *Don Juan Oñate and the Founding of New Mexico*. Santa Fe, 1927.

———, ed. *Narratives of the Coronado Expedition*. Albuquerque, 1940.

Hammond, George P., and Agapito Rey, trans. and eds. *Don Juan Oñate: Colonizer of New Mexico, 1595–1628*. 2 vols. Albuquerque, 1953.

———, trans. and eds. *Obregón's History of 16th Century Explorations in Western America.* Los Angeles, 1928.

Hayes, Alden C. *The Four Churches of Pecos.* Albuquerque, 1974.

Hewett, Edgar L., and Reginald G. Fisher. *Mission Monuments of New Mexico.* Albuquerque, 1943.

Hughes, Anne E. *The Beginnings of Spanish Settlement in the El Paso District.* Berkeley, 1914.

Humboldt, Alexander von. *Political Essay on the Kingdom of New Spain.* London, 1822.

Ivey, James E. "The Greatest Misfortune of All." *Journal of the Southwest* 36 (1994): 76–100.

———. *In the Midst of a Loneliness: The Architectural History of the Salinas Missions.* Southwest Cultural Resources Center, Professional Paper 15. Santa Fe, 1990.

Kelly, Henry W. "Franciscan Missions of New Mexico, 1740–1760." *New Mexico Historical Review* 15–16 (1940, 1941): 345–368, 41–69, 148–183.

Kessell, John L. *Kiva, Cross and Crown: The Pecos Indians and New Mexico, 1540–1840.* Washington, 1979.

———. *The Missions of New Mexico since 1776.* Albuquerque, 1980.

Kessell, John L., and Rick Hendricks, eds. *The Spanish Missions of New Mexico.* 2 vols. Spanish Borderlands Sourcebooks 17, 18. New York and London, 1991.

Kubler, George. *The Rebuilding of San Miguel at Santa Fe in 1710.* Colorado Springs, 1939.

———. *The Religious Architecture of New Mexico.* Colorado Springs, 1940.

Loomis, Sylvia G. *Old Santa Fe Today.* Santa Fe, 1966.

Magoffin, Susan. *Down the Santa Fe Trail and into Mexico*, ed. Stella M. Drum. Lincoln, 1982.

Minge, Ward A. *Acoma: Pueblo in the Sky.* Albuquerque, 1976.

———. "The Last Will and Testament of Don Severino Martínez." *New Mexico Historical Quarterly* 33 (1963): 33–56.

Montgomery, Ross, Watson Smith, and John O. Brew. *Franciscan Awatovi: The Excavation and Conjectural Reconstruction of a 17th-Century Spanish Mission Establishment at a Hopi Indian Town.* Papers of the Peabody Museum 36, report 3. Cambridge, 1949.

Moorhead, Max L. "Rebuilding the Presidio of Santa Fe, 1789–1791." *New Mexico Historical Review* 69 (1974): 123–142.

Morfi, Juan Augustín de. "Geographical Description of New Mexico, 1782." In Alfred B. Thomas, ed., *Forgotten Frontiers.* Norman, 1932.

Morley, Sylvanus G. "Santa Fe Architecture." *Old Santa Fe* 2 (1914–1915): 273–301.

Murphy, Dan. *Salinas Pueblo Missions.* Tucson, 1993.

Nabokov, Peter. *Architecture of Acoma Pueblo: The Historic American Building Survey Project.* Santa Fe, 1986.

Noble, David G., ed. *Santa Fe: History of an Ancient City.* Santa Fe, 1989.

———. *Pueblos, Villages, Forts and Trails.* Albuquerque, 1994.

Obregón, Baltazar de. *Obregón's History of 16th Century Explorations in Western America,* trans. and ed. George P. Hammond and Agapito Rey. Los Angeles, 1928.

Owings, Nathaniel A. "Las Trampas: A Past Resurrected." *New Mexico Magazine* 48 (July-August 1970): 30–35.

Pérez de Villagrá, Gaspar. *History of New Mexico,* trans. and ed. Miguel Encinias, Alfred Rodriguez, and Joseph P. Sanchez. Albuquerque, 1992.

Pike, Zebulon M. *The Journals of Zebulon Montgomery Pike*, ed. Donald Jackson. 2 vols. Norman, 1966.

Prince, L. Bradford. *Spanish Mission Churches of New Mexico.* Cedar Rapids, 1915.

Reuter, B. A. "Restoration of Acoma Mission." *El Palacio* 22 (1927): 79–87.

Riley, L. A. II. "Repairs to the Old Mission at Acoma." *El Palacio* 18 (1925): 2–9.

Scholes, France V. *Church and State in New Mexico, 1610–1630.* Albuquerque, 1942.

———. "The Supply Service of the New Mexico Missions in the Seventeenth Century." *New Mexico Historical Review* 5 (1930): 93–115, 186–210, 386–404.

———, trans. and ed. "Documents for the History of the New Mexican Missions in the Seventeenth Century." *New Mexico Historical Review* 4 (1929): 45–58, 195–201.

Scholes, France V., and Eleanor B. Adams. "Inventories of Church Furnishings in Some of the New Mexico Missions, 1672." *University of New Mexico Historical Publications* 4 (1952): 29–38.

Scholes, France V., and Lansing B. Bloom. "Friar Personnel and Mission Chronology, 1598–1629." *New Mexico Historical Review* 19 (1944): 319–336; 20 (1945): 58–82.

Sedgwick, Mrs. William T. [Mary K. R.]. *Acoma, The Sky City.* Cambridge, 1927.

Simmons, Marc. *The Last Conquistador: Juan de Oñate and the Settling of the Far Southwest.* Norman, 1991.

———. "Settlement Patterns and Village Plans in Colonial New Mexico." *Journal of the West* 8 (1969): 7–21.

———. *Spanish Government in New Mexico.* Albuquerque, 1968.

———. "Spanish Irrigation Practices in New Mexico." *New Mexico Historical Review* 47 (1972): 135–150.

Sonnichsen, C. L. *Pass of the North.* El Paso, 1968.

Tamarón y Romeral. *Bishop Tamarón's Visitation of New Mexico, 1760,* ed. Eleanor B. Adams. Albuquerque, 1954.

Timmons, W. H. *El Paso: A Borderlands History.* El Paso, 1990.

Toulouse, Joseph H. *The Mission of San Gregorio de Abó.* Monographs of the School of American Research 13. Santa Fe and Albuquerque, 1949.

Treib, Marc. *Sanctuaries of Spanish New Mexico.* Berkeley, 1993.

Twitchell, Ralph E. *Old Santa Fe.* Chicago, 1925.

———. *The Spanish Archives of New Mexico.* 2 vols. Cedar Rapids, 1914.

Vargas, Diego de. *Blood of the Boulders: The Journals of don Diego de Vargas, New Mexico, 1694–97,* ed. John L. Kessell, Rick Hendricks, and Meredith D. Dodge. Albuquerque, 1998.

———. *By Force of Arms: The Journals of don Diego de Vargas, New Mexico, 1691–93*, ed. John L. Kessell, Rick Hendricks, and others. Albuquerque, 1992.

———. *Letters from the New World: Selected Correspondence of don Diego de Vargas to His Family, 1675–1706*, ed. John L. Kessell, Rick Hendricks, and Meredith D. Dodge. Albuquerque, 1992.

———. *To the Royal Crown Restored: The Journals of don Diego de Vargas, New Mexico, 1692–94*, ed. John L. Kessell, Rick Hendricks, and Meredith D. Dodge. Albuquerque, 1995.

Vetancurt, Agustín de. *Teatro Mexicano*. 3 vols. Madrid, 1961.

Weber, David J. *On the Edge of Empire: The Taos Hacienda of los Martínez*. Santa Fe, 1996.

Where Cultures Meet: Remembering San Gabriel del Yunge Oweenge. Papers from the October 20, 1984 conference held at San Juan Pueblo, New Mexico. Santa Fe, 1987.

Whiffen, Marcus. "The Manzano Missions." *Architectural Review* 133 (1963): 219–221.

White, Leslie A. *The Acoma Indians. United States Bureau of American Ethnology Annual Report* 47 (1929–1930). Washington, 1932.

Wilson, Chris. *The Myth of Santa Fe*. Albuquerque, 1997.

Wilson, John P. *Quarai: State Monument*. Santa Fe, 1977.

Wroth, William. *Christian Images in Hispanic New Mexico*. Colorado Springs, 1982.

———. "The Flowering and Decline of the New Mexican Santero, 1789–1900." In *New Spain's Far Northern Frontier*, ed. David J. Weber. Albuquerque, 1979.

———. *Images of Power, Images of Mercy*. Norman, 1991.

Texas

Ahlborn, Richard. *The San Antonio Missions: Edward Everett and the American Occupation, 1847*. Fort Worth, 1985.

Bollaert, William. *William Bollaert's Texas*, ed. W. Eugene Hallon and Ruth L. Butler. Norman, 1956.

Bolton, Herbert E. *Texas in the Middle Eighteenth Century. University of California Publications in History* 3. Berkeley, 1915.

Brooks, Charles M., Jr. *Texas Missions: Their Romance and Architecture*. Dallas, 1936.

Buckley, Eleanor. "The Aguayo Expedition into Texas and Louisiana, 1719–1722." *Southwestern Historical Quarterly* 15 (1911): 1–65.

Castañeda, Carlos E. *Our Catholic Heritage in Texas, 1519–1936*. 7 vols. Austin, 1936–1958.

Céliz, Francisco. *Diary of the Alarcón Expedition into Texas, 1718–1719*. Los Angeles, 1935.

Chabot, Frederick C. *San Antonio and its Beginnings, 1691–1731*. San Antonio, 1931.

Clark, John W., Jr. *Mission San José y San Miguel de Aguayo: Archaeological Investigations, December 1974. Office of the State Archaeologist Reports* 29. Austin, 1978.

Corner, William. *San Antonio de Béxar: A Guide and History*. San Antonio, 1890.

Cruz, Gilbert R., ed. *Proceedings of the 1984 and 1985 San Antonio Missions Research Conferences*. San Antonio, 1985.

De Long, David G., ed. *Historic Buildings: Texas*. 2 vols. New York, 1979.

De la Teja, Jesús F. *San Antonio de Béxar: A Community on New Spain's Northern Frontier*. Albuquerque, 1995.

Espinosa, Félix Isidro de. "Ramón's Expedition: Espinosa's Diary of 1716," trans. and ed. Gabriel Tous. *Mid-America* 12 (1930): 339–361.

Fox, Anne E., ed. *Archaeology of the Spanish Missions of Texas. Spanish Borderlands Sourcebooks* 21. New York and London, 1991.

Gómez, Arthur R., ed. *Documentary Evidence for the Spanish Missions of Texas. Spanish Borderlands Sourcebooks* 22. New York and London, 1991.

Guerra, Mary Ann N. *The Missions of San Antonio*. San Antonio, 1982.

Habig, Marion A. *The Alamo Chain of Missions*. Chicago, 1968.

———. *The Alamo Mission: San Antonio de Valero, 1718–1793*. Chicago, 1977.

———. "Mission San José y San Miguel de Aguayo, 1720–1824." *Southwestern Historical Quarterly* 71 (1968): 503–516.

———. *San Antonio's Mission San José*. San Antonio, 1968.

Hackett, Charles W. "The Marqués of San Miguel de Aguayo and His Recovery of Texas from the French, 1719–1723." *Southwestern Historical Quarterly* 49 (1945): 193–214.

Jackson, Jack, ed. (annotated by William C. Foster). *Imaginary Kingdom: Texas as Seen by the Rivera and Rubí Military Expeditions, 1727 and 1767*. Austin, 1995.

Lafora, Nicolás de. *The Frontiers of New Spain: Nicolás de Lafora's Description*, ed. Lawrence Kinnaird. Berkeley, 1958.

Leutenegger, Benedict, trans. "Two Franciscan Documents on Early San Antonio, Texas." *The Americas* 25 (1968): 191–205.

———, trans. and ed. (revised by Sister Carmelita Corso and Sister Margaret R. Warberton). "Selections from Guidelines for a Texas Mission: Instructions for the Missionary of Mission Concepción in San Antonio, Texas." In *Archaeology of the Spanish Missions of Texas*, ed. Anne E. Fox, 75–121. New York and London, 1991..

———, trans. (annotated by Marion A. Habig). *The San José Papers, Primary Sources for the History of Mission San José y San Miguel de Aguayo: Part 1, 1719–1791; Part 2, 1791–1809; Part 3, 1810–1824*. San Antonio, 1978, 1983, and 1990.

———, trans. (with biographical dictionary by Marion A. Habig). *Zacatecan Missionaries in Texas 1716–1824. Office of the State Archaeologist Reports* 23. Austin, 1973.

López, José Francisco. "Report on the San Antonio Missions in 1792," trans. Benedict Leutenegger, ed. Marion A. Habig. *Southwestern Historical Quarterly* 77 (1973–1974): 486–498.

———. *The Texas Missions in 1785,* trans. J. Aubrey Dabbs. *Preliminary Studies, Texas Catholic Historical Society* 3 no. 6. Austin, 1940.

Margil, Antonio. *Nothingness Itself: Selected Writings of Ven. Fr. Antonio Margil,* trans. Benedict Leutenegger. Chicago, 1979.

Morfi, Juan A. *History of Texas, 1673–1779,* trans. and ed. Carlos E. Castañeda. 2 vols. Albuquerque, 1935.

O'Connor, Kathryn S. *The Presidio La Bahía del Espíritu Santo de Zuñiga, 1721–1846.* Austin, 1966.

Ortega y Gasca, Felipe de, ed. *Contemporary Perspectives of the Old Spanish Missions of San Antonio.* San Antonio, 1979.

Pages, Monsieur de. *Travels Round the World.* London, 1791.

Poyo, Gerald E., and Gilberto Hinojosa, eds. *Tejano Origins in Eighteenth Century San Antonio.* Austin, 1991.

Quirarte, Jacinto. *The Art and Architecture of the Texas Missions.* Austin, 2002.

Ramón, Domingo. *Captain Domingo Ramón's Diary of His Expedition into Texas in 1716,* trans. Paul E. Fork. *Preliminary Studies, Texas Catholic Historical Society* 2, no. 5. Austin, 1933.

Robinson, Willard R., and Jean M. Robinson. *Reflections of Faith: Houses of Worship in the Lone Star State.* Waco, 1994.

Schuetz, Mardith K. "Professional Artisans in the Hispanic Southwest: The Churches of San Antonio, Texas." *The Americas* 40 (1983): 17–71.

Scurlock, Dan, and Daniel E. Fox. *Archeological Investigation of Mission Concepción, San Antonio, Texas.* Austin, 1977.

Solis, Gaspar José de. "Diary of Fray Gaspar José de Solis," trans. by Margaret K. Kress. *Southwestern Historical Quarterly* 35 (1931): 30–71.

———. "Report on Mission San José in 1768." In *The San José Papers, Primary Sources for the History of Mission San José y San Miguel de Aguayo: Part 1, 1719–1791,* trans. Benedict Leutenegger. San Antonio, 1978.

Spell, Lota M., trans. and ed. "The Grant and First Survey of the City of San Antonio." *Southwestern Historical Quarterly* 16 (1962): 73–89.

Tinkle, Lon, and others. *Six Missions of Texas.* Waco, 1965.

Tjarks, Alicia V. "Comparative Demographic Analysis of Texas, 1777–1993." *Southwestern Historical Quarterly* 77 (1974): 291–338.

Weddle Robert S. *San Juan Bautista: Gateway to Spanish Texas.* Austin, 1968.

———. *The San Sabá Mission: Spanish Pivot in Texas.* Austin, 1964.

Louisiana

Adams, Edwin A. *Louisiana: A Narrative History.* Baton Rouge, 1965.

An Account of Louisiana, 1803. Old South Leaflets 5, no. 105. Boston, n.d.

Baily, Francis. *Journal of a Tour in Unsettled Parts of North America: The Spanish Dominions,* ed. Jack D. L. Holmes. Carbondale and Edwardsville, 1969.

Baudier, Roger. *A Historical Sketch of the St. Louis Cathedral of New Orleans, the First Ursuline Convent and the Mortuary Chapel.* New Orleans, 1935.

Berguin-Duvallon. *Travels in Louisiana and the Floridas in the Year 1802,* trans. John Davis. New York, 1806.

Bouligny, Francisco. *Louisiana in 1776,* ed. and trans. Gilbert C. Din. New Orleans, 1977.

Burson, Caroline M. *The Stewardship of Don Esteban Miró.* New Orleans, 1940.

Charlevois, Pierre Francois Xavier de. *A Journal of a Voyage to North America.* London, 1761.

Collot, Victor. *A Journey in North America,* trans. J. Christian Bay. Florence, 1924.

Cowan, Walter G., and others. *New Orleans, Yesterday and Today: A Guide to the City.* Baton Rouge and London, 1983.

Din, Gilbert C., and John E. Harkins. *The New Orleans Cabildo, Colonial Louisiana's First City Government, 1769–1803.* Baton Rouge and London, 1996.

Ellicott, Andrew. *The Journal of Andrew Ellicott.* Philadelphia, 1803.

French, B. B. *Historical Memoirs of Louisiana.* New York, 1853.

Gayarré, Charles. *History of Louisiana.* 3 vols. New York, 1854.

Giraud, Marcel. *A History of French Louisiana.* Vol. 1, *The Reign of Louis XIV,* trans. Joseph C. Lambert. Vol. 2, *Years of Transition,* trans. Brian Pearce. Vol. 5, *The Company of the Indies,* trans. Brian Pearce. Baton Rouge and London, 1974, 1993, and 1991. Originally published as *Histoire de la Louisiane Francaise* (Paris, 1953–).

Holmes, Jack D. L. "Andrés Almonester y Roxas: Saint or Scoundrel." *Louisiana Studies* 7 (1968): 47–64.

———. "Some French Engineers in Spanish Louisiana." In *The French in the Mississippi Valley, 1762–1802,* ed. John F. McDermott. Urbana, 1965.

Huber, Leonard. *Landmarks of New Orleans.* New Orleans, 1991.

———. *New Orleans: A Pictorial History.* New York, 1971.

Huber, Leonard, and Samuel Wilson, Jr. *The Basilica on Jackson Square and its Predecessors.* New Orleans, 1965.

King, Grace. *Creole Families of New Orleans.* New York, 1921.

Kinnaird, Lawrence, ed. *Spain in the Mississippi Valley 1765–1794, Annual Report of the American Historical Association,* 1945, vol. 2. Washington, 1946.

Latrobe, Benjamin H. *The Journals of Benjamin Henry Latrobe, 1799–1820,* ed. Edward C. Carter II, John C. Van Horne, and Lee W. Formwalt. Vol. 3 of Series 1 of *The Papers of Benjamin Henry Latrobe.* New Haven and London, 1980.

———. *Latrobe's View of America, 1795–1820,* ed. Edward C. Carter II, John C. Van Horne, and Charles E. Brownell. Series 3 of *The Papers of Benjamin Henry Latrobe.* New Haven and London, 1985.

McDermott, John F. *The Spanish in the Mississippi Valley, 1762–1802.* Urbana, 1965.

Moore, John P. *The Revolt in Louisiana: The Spanish Occupation, 1766–1770.* Baton Rouge, 1976.

Morales Folguera, José Miguel. *Arquitectura y Urbanismo Hispano Americano en Luisiana y Florida Occidental.* Malaga, 1987.

Pittman, Philip. *The Present State of European Settlements on the Mississippi.* London, 1771.

Poesch, Jessie, and Barbara S. Bacot. *Louisiana Buildings 1720–1940: The Historic American Buildings Survey.* (Baton Rouge and London, 1997).

Pope, John. *A Tour Through the Western Territories of the United States of North America: The Spanish Dominions.* Richmond, 1792.

Renshaw, Henry. "Jackson Square." *Louisiana Historical Quarterly* 2 (1919): 38–46.

Robertson, James A. *Louisiana Under the Rule of Spain, France and the United States 1785–1807.* Cleveland, 1911.

Robin, C. C. *Voyage to Louisiana*, trans. Stuart O. Landry, Jr. New Orleans, 1966.

Rojas, Lauro A. de, and Walter Pritchard. "The Great Fire of 1788 in New Orleans." *Louisiana Historical Quarterly* 20 (1937): 578–589.

Stoddard, Amos. *Sketches, Historical and Descriptive of New Orleans.* Philadelphia, 1812.

Taylor, Joe Gray. *Louisiana: A Bicentennial History.* New York, 1976.

Texada, David K. *Alejandro O'Reilly and the New Orleans Rebels.* Lafayette, 1970.

Vela, Christina. *Intimate Enemies: The Two Worlds of Baroness de Pontalba.* Baton Rouge and London, 1997.

Wilson, Samuel, Jr. "Almonester: Philanthropist and Builder in New Orleans." In John F. McDermott, ed., *The Spanish in the Mississippi Valley, 1762–1804,* 183–271. Urbana, 1974.

———. *The Architecture of Colonial Louisiana.* Lafayette, 1987.

———. *Vieux Carré New Orleans: Its Plan, Its Growth, Its Architecture.* New Orleans, 1968.

Wilson, Samuel, Jr., and Leonard V. Huber. *The Cabildo on Jackson Square.* New Orleans, 1970.

———. *The Presbytère on Jackson Square.* New Orleans, 1981.

Wood, Minter. "Life in New Orleans in the Spanish Period." *Louisiana Historical Quarterly* 22 (1939): 642–709.

Arizona

Ahlborn, Richard C. *The Sculpted Saints of a Borderland Mission.* Tucson, 1974.

Baldonado, Louis R. "Mission San José de Tumacácori and San Xavier del Bac in 1774." *Kiva* 24 (1959): 21–24.

Banham, Rayner. *Scenes in America Deserta.* Layton and Salt Lake City, 1982.

Bell, William A. *New Tracks in North America.* London, 1869–70.

Bleser, Nicholas J. *Tumacácori.* Tucson, 1989.

Bolton, Herbert E. *The Padre on Horseback.* San Francisco, 1932.

———. *Rim of Christendom: A Biography of Eusebio Francisco Kino.* New York, 1936.

Brinckerhoff, Sidney B. "The Last Years of Spanish Arizona 1786–1821." *Arizona and the West* 9 (1967): 5–20.

Burrus, Ernest J. *Kino and Manje, Explorers of Sonora and Arizona.* Rome and St. Louis, 1971.

———. *Kino and the Cartography of Northwestern New Spain.* Tucson, 1965.

———. *Kino's Plan for the Development of Pimería Alta, Arizona and Upper California.* Tucson, 1961.

Couts, Cave J. *Hopah, California: The Journal of Cave Johnson Couts*, ed. Henry F. Dobyns. Tucson, 1961.

Dobyns, Henry F. *Spanish Colonial Tucson.* Tucson, 1976.

Donohue, J. Augustine. "The Unlucky Jesuit Mission of Bac 1732–1767." *Arizona and the West* 2 (1960): 127–139.

Duell, Prent. *Mission Architecture, Exemplified in San Xavier del Bac.* Tucson, 1919.

Eckhart, George B., and James S. Griffith. *Temples in the Wilderness: Spanish Churches in Northern Sonora.* Tucson, 1975.

Fontana, Bernard L. "Biography of a Desert Church: The Story of Mission San Xavier del Bac." *Smoke Signal* 3 (1961): 2–24.

Garcés, Francisco. *On the Trail of a Spanish Pioneer: The Diary and Itinerary of Francisco Garcés*, trans. and ed. Elliott Coues. 2 vols. New York, 1900.

Gerald, Rex E. *Spanish Presidios of the Late Eighteenth Century in Northern New Spain.* Santa Fe, 1968.

Goss, Robert C. "The Churches of San Xavier, Arizona and Caborca, Sonora: A Comparative Analysis." *Kiva* 40 (1975): 165–179.

———. "The Problems of Erecting the Main Dome and Roof Vaults of San Xavier del Bac." *Kiva* 37 (1972): 117–127.

Hall, Alice J. "New Face for a Desert Mission." *National Geographic* 188, no. 6 (December 1995): 53–59.

Hammond, George P. "Pimería Alta After Kino's Time." *New Mexico Historical Review* 4 (1929): 220–238.

Hayes, Benjamin I. *Pioneer Notes from the Diaries of Judge Benjamin Hayes.* Los Angeles, 1929.

Hinton, Richard J. *The Handbook of Arizona.* San Francisco, 1878.

Howlett, W. J. *The Life of the Right Reverend Joseph P. Machebeuf D.D.* Pueblo, 1908.

Kessell, John L. *Friars, Soldiers and Reformers: Hispanic Arizona and the Sonora Frontier, 1767–1856.* Tucson, 1976.

———. *Mission of Sorrows: Jesuit Guevavi and the Pimas, 1691–1767.* Tucson, 1970.

Kino, Eusebio. *Kino's Historical Memoir of Pimería Alta*, trans. and ed. Herbert E. Bolton. 2 vols. Berkeley, 1919.

McCarty, Kieron. *A Spanish Frontier in the Enlightened Age: Franciscan Beginnings in Sonora and Arizona, 1767–1779.* Washington, 1981.

Newhall, Nancy, with photographs by Ansel Adams. *Mission San Xavier del Bac.* San Francisco, 1954.

Officer, James E. *Hispanic Arizona, 1536–1856.* Tucson, 1987.

Officer, James E., Mardith K. Schuetz-Miller, and Bernard L. Fontana, eds. *The Pimería Alta: Missions and More.* Tucson, 1996.

Pfefferkorn, Ignaz. *Sonora: A Description of the Province*, trans. Theodore Trentlein. Tucson, 1989.

Polzer, Charles W. *Kino Guide II*. Tucson, 1982.

Salpointe, Jean B. *A Brief Sketch of the Mission San Xavier del Bac*. Tucson, 1880.

Schaefer, John P., Celestine Chin, and Kieron McCarty. *Bac: Where the Waters Gather*. Mission San Xavier del Bac, c. 1977.

Smith, Fay J., John L. Kessell, and Francis J. Fox. *Father Kino in Arizona*. Phoenix, 1966.

Sonnichsen, C. L. *Tucson, the Life and Times of an American City*. Norman, 1982.

Walker, Kathleen. *San Xavier: The Spirit Endures*. Phoenix, 1998.

Williams, Jack S. "San Agustín del Tucson: A Vanished Mission Community of the Pimería Alta." *Smoke Signal* 47–48 (1986): 113–121.

CALIFORNIA

Archibald, Robert. *The Economic Aspects of the California Missions*. Washington, 1978.

Baer, Kurt. "California Indian Art." *The Americas* 16 (1959): 23–44.

———. *Painting and Sculpture at Mission Santa Barbara*. Washington, 1955.

———. *The Treasures of Santa Ines*. Fresno, 1956.

Bancroft, Herbert H., and collaborators. *History of California*. 7 vols. San Francisco, 1884–1890.

Barker, Leo R., and Julia G Costello, eds. *The Archaeology of Alta California. Spanish Borderlands Sourcebooks* 15. New York and London, 1991.

Beilharz, Edwin A. *Felipe de Neve*. San Francisco, 1971.

Berger, John A. *The Franciscan Missions of California*. New York, 1941.

Brewer, William H. *Up and Down California in 1860–1864*, ed. Francis P. Farquar. New Haven, 1930.

Bynum, Lindley. "Governor Don Felipe de Neve." *Historical Society of Southern California, Annual Publications* 15 (1931): 57–68.

Campbell, Leon G. "The Spanish Presidio in Alta California during the Mission Period." *Journal of the West* 16 (1977): 63–77).

Caughey, John W., and La Rae Caughey, eds. *Los Angeles: Biography of a City*. Berkeley, 1976.

Cesar, Julio. "Recollections of My Youth at Mission San Luis Rey." *Touring Topics* 22 (November 1930): 42–43.

Chapman, Charles E. *The Founding of Spanish California*. New York, 1916.

———. *A History of California: The Spanish Period*. New York, 1921.

Connell, Will. *The Missions of California*. New York, 1941.

Costansó, Miguel. "Costansó's 1794 Report on Strengthening New California's Presidios," trans. Manuel P. Servin. *California Historical Society Quarterly* 49 (1970): 221–232.

———. *The Discovery of San Francisco Bay: The Portola Expedition of 1769–1770: The Diary of Miguel Costansó*, ed. by Peter Browning. Lafayette, California, 1992.

Costello, Julia G., ed. *Documentary Evidence for the Spanish Missions of Alta California. Spanish Borderlands Sourcebooks* 14. New York and London, 1991.

Costo, Rupert, and Jeanette H. Costo, eds. *The Missions of California: A Legacy of Genocide*. San Francisco, 1987.

Crespi, Juan, diaries. In Herbert E. Bolton, *Fray Juan Crespi*. Berkeley, 1927.

Crosby, Henry W. *Antiqua California*. Albuquerque, 1994.

Cutter, Donald C. *California in 1792: The Spanish Naval Visit*. Norman, 1990.

———. *Malaspina in California*. San Francisco, 1960.

———. "Malaspina's Grand Expedition." *El Palacio* 82, no. 4 (1976): 28–41.

Dana, Richard H. *Two Years Before the Mast*. New York, 1840.

Davis, William H. *Seventy-Five Years in California*, ed. Harold A. Small. San Francisco, 1967.

Duflot de Mofras, Eugene. *Duflot de Mofras' Travels on the Pacific Coast*, trans., ed., and annotated by Marguerite E. Wilbur. Santa Ana, 1937.

Duhaut-Cilly, Auguste Bernard. *A Voyage to California, the Sandwich Islands and Around the World in the Years 1826–1829*, trans. and ed. August Frugé and Neal Harlow. Berkeley, 1999.

Dunne, Peter M. *Black Robes in Lower California*. Berkeley, 1952.

Emory, W. H. *Narrative of a Military Tour*. Washington, 1847.

Engelhardt, Zephyrin. *Mission San Carlos Borromeo*. Santa Barbara, 1934.

———. *Missions and Missionaries of California*. 5 vols. San Francisco, 1908–1916.

———. *San Gabriel Mission and the Beginnings of Los Angeles*. San Gabriel, 1927.

———. *San Juan Capistrano Mission*. Los Angeles, 1922.

———. *San Luis Rey Mission*. San Francisco, 1921.

———. *Santa Barbara Mission*. San Francisco, 1923.

Engenhoff, Elizabeth L., ed. *Fabricas: A Collection of Pictures and Statements on the Mineral Materials Used in Building in California prior to 1850*. Supplement to the *California Journal of Mines and Geology*. San Francisco, 1952.

Fages, Pedro. "A Description of California's Principal Presidio, Monterey, in 1773," trans. and ed. Maynard Geiger. *Southern California Quarterly* 49 (1967): 327–336.

———. *A Historical, Political and Natural Description of California*, trans. Herbert I. Priestly. Berkeley and London, 1937.

Farnham, J. T. *Life, Adventures and Travels in California*. New York, 1857.

Fireman, Janet R., and Manuel P. Servin. "Miguel Costansó: California's Forgotten Founder." *California Historical Society Quarterly* 49 (1970): 3–19.

Ford, Henry C. *An Artist Records the California Missions*, ed. Norman Neuerburg. San Francisco, 1989.

Garr, Daniel J. "A Rare and Desolate Land: Population and Race in Hispanic California." *Western Historical Quarterly* 6 (1975): 133–148.

Geiger, Maynard. "The Building of Mission San Gabriel: 1771–1828." *Southern California Quarterly* 50 (1968): 33–42.

———. *Calendar of Documents in the Santa Barbara Mission Archives*. Washington, 1947.

———. *Franciscan Missionaries in Hispanic California, 1769–1848*. San Marino, 1969.

———. *The Life and Times of Fray Junípero Serra, O.F.M.* 2 vols. Washington, 1959.

———. *Mission Santa Barbara, 1782–1965*. Santa Barbara, 1965.

Guest, Francis F. *Fermín Francisco de Lasuén*. Washington, 1973.

Hawley, Walter A. *Early Days of Santa Barbara*. Santa Barbara, 1910.

Historic American Buildings, California, with introduction by David G. DeLong. 4 vols. New York, 1980.

Howard, Don. *The Archaeology of the Royal Presidio of Monterey*. Carmel, 1978.

Hutton, William R. *California 1847–1852: Drawings by William Rich Hutton*. San Marino, 1942.

———. *Glances at California 1847–1853: Diaries and Letters of William Rich Hutton*, with a memoir and notes by Willard O. Waters. San Marino, 1942.

Jackson, Helen Hunt. *Glimpses of California and the Missions*. Boston, 1903.

James, George W. *In and Out of the Old Missions*. Boston, 1905.

———. *Picturesque Pala*. Pasadena, 1916.

Kelsey, Harry. *Juan Rodríguez Cabrillo*. San Marino, 1986.

———. "The Mission Buildings of San Juan Capistrano: A Tentative Chronology." *Southern California Quarterly* 69 (1987): 1–32.

———. "A New Look at the Founding of Old Los Angeles." *California Historical Society Quarterly* 55 (1976): 326–339.

Kirker, Harold. *California's Architectural Frontier*. Santa Barbara, 1973.

Langellier, John P., and Katherine M. Peterson. "Lances and Leather Jackets: Presidial Forces in Spanish Alta California, 1769–1821." *Journal of the West* 20 (1981): 3–11.

Lapérouse, Jean F. de G. *The First French Expedition to California, Lapérouse in 1786*, trans. and annotated by Charles N. Rudkin. Los Angeles, 1959.

Lasuén, Fermín Francisco de. *Writings* of Fermín Francisco de Lasuén, ed. and trans. Finbar Kennealy. 2 vols. Washington, 1965.

Layne, J. Gregg. "Annals of Los Angeles." *California Historical Quarterly* 13 (1934): 195–234, 301–354.

Menzies, Archibald. "Journal of the Vancouver Expedition." *California Historical Society Quarterly* 2 (1923–24): 267–340.

Miller, Henry. *Account of a Tour of the California Missions*. San Francisco, 1952.

Monroy, Douglas. *Thrown Among Strangers: The Making of Mexican Culture in Frontier California*. Berkeley, 1990.

Neuerburg, Norman. *The Decoration of the California Missions*. Santa Barbara, 1987.

———. "Painting in the California Missions." *American Art Review* 4 (1977): 72–88.

Neve, Felipe de. *Reglemento para el gobierno de la Provincia de Californias*, trans. John E. Johnson. 2 vols. San Francisco, 1929.

Newcomb, Rexford G. *Franciscan Mission Architecture of California*. New York, 1916.

———. *Old Mission Churches and Historic Houses of California*. Philadelphia, 1925.

Newmark, Harris. *Sixty Years in Southern California 1853–1913*, ed. by Maurice and Marco R. Newmark. New York, 1916.

Oak, Henry L. *A Visit to the Missions of Southern California in February and March 1874*, ed. Ruth F. Axe, Edwin H. Carpenter, and Norman Neuerburg. Los Angeles, 1981.

Owen, J. Thomas. "The Church by the Plaza." *Historical Society of Southern California Quarterly* 42 (1960): 5–28, 186–204.

Palóu, Francisco. *Palóu's Life of Fray Junípero Serra*, trans. and ed. Maynard J. Geiger. Washington, 1955.

Pelzel, Thomas O. "The San Gabriel Stations of the Cross from an Art-Historical Perspective." *Journal of California Anthropology* 3 (1976): 101–119.

Pérez, Eulalia. "An Old Woman and Her Recollections." In *Three Memories of Mexican California*. Berkeley, 1968.

Phillips, George H. "Indian Paintings from San Fernando: An Historical Interpretation." *The Journal of California Anthropology* 3 (1976): 96–114.

Pico, Pio. *Don Pio Pico's Historical Narrative*, trans. Arthur P. Botello, ed. Martin Cola and Henry Welcome. Glendale, 1973.

Powell, H. M. T. *The Santa Fe Trail to California, 1849–1852: The Journal and Drawings of H. M. T. Powell*, ed. Douglas S. Watson. San Francisco, 1931.

Priestly, Herbert J. *José de Gálvez, Visitor General of New Spain, 1765–1771*. Berkeley, 1916.

Richman, Irving B. *California Under Spain and Mexico, 1535–1847*. Boston and New York, 1911.

Rios-Bustamente, Antonio and Pedro Castillo. *An Illustrated History of Mexican Los Angeles 1781–1985*. Los Angeles, 1986.

Robinson, Alfred. *Life in California*. New York, 1846.

Schuetz-Miller, Mardith K. *Building and Builders in Hispanic California, 1769-1850*. Tucson, 1994.

Serra, Junípero. *The Writings of Junípero Serra*, ed. Tibesar Antonine. 4 vols. Washington, 1955–1966.

Servin, Manuel P. "California's Hispanic Heritage: A View into the Spanish Myth." *The Journal of San Diego History* 19, 1973): 1–9.

Simpson, Lesley R. Introduction to *The Letters of José Señan O.F.M.* San Francisco, 1962.

Smith, Frances R. *The Architectural History of Mission San Carlos Borromeo*. Berkeley, 1921.

Soto, Anthony. "Mission San Luis Rey: Excavations of the Sunken Garden." *Kiva* 26 (1961): 34–43.

Sunset editors. *The California Missions.* Menlo Park, 1979.

Tac, Pablo. "Conversions of the San Luiseños of Alta California," trans. and ed. Minna and Gordon Howes. *The Americas* 9 (1952): 92–106.

Temple, Sydney. *The Carmel Mission from Founding to Rebuilding.* Santa Cruz, 1980.

Truman, Benjamin C. *Observations of Benjamin Cummings Truman on El Camino Real*, ed. Francis J. Weber. Los Angeles, 1978.

Vancouver, George. *Vancouver in California, 1792–1794*, ed. and annotated by Marguerite E. Wilbur. 3 vols. Los Angeles, 1953–1954.

Van Nostrand, Jeanne. *A Pictorial and Narrative History of Monterey.* San Francisco, 1968.

Vischer, Edward. *Missions of Upper California.* San Francisco, 1872.

———. *Edward Vischer's Drawings of California Missions, 1861–1878*, with biography by Jeanne Van Nostrand. San Francisco, 1982.

Watson, Douglas S., and Thomas W. Temple II, trans. and eds. *The Spanish Occupation of California: Plan for Establishment of Government, Junta or Council Held at San Blas, May 16, 1768.* San Francisco, 1934.

Webb, Edith B. *Indian Life at the Old Missions.* Los Angeles, 1952.

———. "Pigments Used by California Mission Indians." *The Americas* 2 (1945): 137–150.

Weber, Francis J. *Father of the Missions: A Documentary History of San Carlos Borromeo.* Hong Kong, c. 1982.

———. *King of the Missions: A Documentary History of San Luis Rey de Francis.* Hong Kong, c. 1980.

———. *Nuestra Señora de Los Angeles, The Old Plaza Church: A Documentary History.* Hong Kong, c. 1980.

———. *Pride of the Missions: A Documentary History of San Gabriel Mission.* Hong Kong, c. 1978.

———. *Queen of the Missions: A Documentary History of Santa Barbara.* Los Angeles, 1979.

Whitehead, Richard S. "Alta California's Four Fortresses." *Southern California Quarterly* 65 (1983): 67–94.

Winthur, Oscar O. *The Story of San José: California's First Pueblo, 1777–1869.* San Francisco, 1935.

Index

Note: *While this index includes general headings for churches, missions, and ranches, names of specific churches, missions, and ranches are listed by their name rather than under the kind of facility, e.g., "Agua Hedionda rancho" rather than "Rancho Agua Hedionda."*

Abate, José María, 143
Abert, J. W., 82
Abeyta, Bernardo, 93–95
Abó Pueblo (NM), 51, 61, 65–72, 80
Academy of San Carlos, 169
Acadians, 125, 126
Acapulco (Mexico), 6
Acequias. See Irrigation
Acevedo, Francisco de, 51, 66, 67, 70
Ácoma Pueblo (NM), 61, 211; church at, 54, 56, 72–77, 80, 172, 209; Oñate at, 47, 72–73
Actopan (Mexico), 180
Adais Indians, 97, 99
Adams, John Quincy, 14, 45
Adelantados: definition of, 2, 3; instructions for, 11–12; lack of, in Texas, 96. *See also names of specific adelantados*
Adobe: as construction material, 2, 163, in Arizona, 9, 138–39, 141–43, 146, in California, 9, 160, 163, 164, 167–71, 176, 178, 183–86, 190–92, 194, 198–202, in Florida, 15, 18, in New Mexico, 9, 47, 51, 54, 57, 58, 60–62, 73, 74, 76, 81, 83, 84, 87, 92, 93, in Texas, 8, 99–101; benefits of using, 84; bricks of, 8, 51, 58, 61, 106, 139, 141, 143, 146, 160, 164, 167, 198, 200–201; "coursed," 47; fortifications made of, 6; making, 51; Moors' influence on Spanish, 51, 57, 58; as perishable, 9, 52, 78; puddling technique with, 8, 51
African Americans (free), 21, 27, 29, 44. *See also* Slaves
Agriculture: in Arizona, 138, 144, 145; in California, 158–59, 162–63, 176–78, 182, 185, 191–92, 196; in Florida, 15, 20, 23, 33, 35–37, 39, 41; in Louisiana, 126; missionaries' contributions to Indians', 138; missionaries' insistence on, for migratory Indians, 31, 32; of missions as supporting presidios, 115, 158, 162, 177, 181; in New Mexico, 49, 70, 72, 80, 86–87, 89; Spanish dependence on Indians', 13, 15, 36, 37, 40, 49, 72; in Texas, 96, 101, 105, 107, 115; in town plans, 8. *See also* Fruits; Irrigation; Livestock; Ranching
Agua Hedionda rancho (CA), 191
Aguayo, Marqués de San Miguel de, 2–3, 97–98, 101, 102, 113
Aguilar, Isidro, 189
Aguilar, Nicolás de, 70
Ais Indians, 97, 99
Alabama, 45
Alamo (formerly, San Antonio de Valero mission, TX), 97, 99–102, 106, 111, 113, 209
The Alamo Chain of Missions (Habig), 114
Alarcón, Martín de, 5, 97, 101
Alberti, Leon Battista, 7
Albuquerque (NM), 80, 89
Alcántara Ruiz, Pedro de, 163, 170
Alemany, Joseph S., 206
Allande y Saabedra, Pedro de, 142

Almazán, Fernando Pérez de, 101–4
Almonester, Michaëla, 134
Almonester y Roxas, Andrés, 2, 127, 129, 131–34, 136
Alta California. *See* California
Altamirano, Juan de las Cabezas de, 32, 36
Altar (Sonora), 138, 139, 142
Altar screens (*retablos*): in Arizona, 148–49; in California, 175, 188, 189, 194, 205, 207, 208; in Florida, 35; importing of, from Mexico, 49, 69; in New Mexico, 49, 55–56, 67, 73, 76, 82, 83, 90, 93, 94
Amat, Tadeo, 206
Amelia Island (FL), 35–37
American Revolution, 125, 144, 212
Amúrrio, Gregorio, 186
Analco Barrio (Santa Fe), 77, 78–79, 81
Anastasia Island (FL), 15, 19–22, 25–27, 30
"Andrés" (Indian stonecutter), 28
Antonelli, Juan Bautista, 6, 26
Antonio, Juan ("El Indio de la Via Crucis"), 165–66
Anza, Juan Bautista de: and California settlements, 160, 162, 181; death of, 144; and El Pueblito, 143; as New Mexico governor, 57–58, 63; overland expeditions of, to California, 3, 57, 146, 157, 176; and Santa Fe presidio, 78–79; and Tubac presidio, 139
Ánzar, Antonio, 196
Apache Indians: in Florida prisons, 31; Pueblo Indians' trade with, 60, 62; raids by, 69, 70, 72, 114, 139, 140, 142–43, 146, 149; in Spanish missions, 144; Spanish presidios and missions among, 98
Apalachee Indians, 28, 33, 34, 37–39
Apalachicola (FL), 34
Aqueducts and reservoirs, 202–3
Aragón, José Rafael, 94
Archaeology: of New Mexican churches, 54, 61, 65, 66–69; of San Gabriel Pueblo, 47; of San Luis de Talimali, 37–39; of Santa Catalina de Guale mission, 35, 37; of Santa Elena, 15
Argüello, José, 182
Argüello, Juan de, 89
Arizona, 137–53; agriculture in, 138, 144, 145; churches in, 1, 9, 50, 54–56, 74, 77, 80–83, 109, 121, 140–53, 188, 209, 212; construction materials in, 9, 51, 138–39, 141–43, 146, 147, 152; missionaries and missions in, 3, 4, 137–53; population of, 144; presidios in, 138–39, 141–44, 146, 157; Spanish architectural remains in, 1–2, 142, 152–53; Spanish explorers in, 46, 137. *See also specific places in*
Army of the West, 62, 151, 196
Arredondo, Antonio de, 6, 28–29
Arrillaga, José Joaquín, 189
Arriola, Andrés de, 41, 42
Artisans (craftsmen; masons; painters): in Arizona, 139, 141,

246

145–47, 150, 212; in California, 21, 163–66, 168–74, 179, 183–85, 188–89, 194, 200, 203–5; from Cuba, 27; in Florida, 26–28; Indians as, 28, 55–56, 76, 139, 163–66, 171, 179, 200, 202; "Laguna Santero" as, 55–56, 76; in Louisiana, 132; in New Mexico, 50–51, 54, 55–56, 76, 80, 90, 94, 212; from New Spain, 9, 55–56, 99, 117, 141, 163–64, 168–74, 184, 212; in Texas, 99, 106, 114, 116–17, 212
Arts and Crafts Movement, 210
Atondo y Antillón, Isidro, 137, 154
Aubrey, Charles Philippe, 122, 124, 125
Audiencias, 4
Audry, Luis, 127
Austin (TX), 98, 105
Austin, Mary, 95
Awatovi (AZ), 54, 74
Axtell, James, 33–34
Ayres, Atlee B., 120
Aztecs, 9

Bac (AZ), 143, 145, 153. *See also* San Xavier del Bac
Bahama Channel, 9, 11
Baily, Francis, 128–29
Baja California: artisans from, 179; missionaries in, 4, 137, 140, 154–55, 158; Spanish attempts to settle, 137, 154, 162
Balconies (galleries): on New Mexican churches, 53, 74, 82, 90; in New Orleans, 127. *See also* Choir lofts; *Portales*
Bancroft, Hubert Howe, 177, 210
Bancroft Library, 182, 210
Bandelier, Adolf F., 70
Banham, Reyner, 147–48, 152–53
Baroque elements: in Arizona churches, 55, 147, 151; in California churches, 169–70, 172, 175, 194, 205; in New Mexico, 55, 56; in St. Augustine church, 24; in Texas churches, 118, 121
Barreiro, Francisco Alvarez, 5
Barrio de Analco (Santa Fe), 77, 78–79, 81
Barrios y Jáuregui, Jaciento, 114
Barrota, Juan Enríquez, 40, 41
Bartlett, John R., 88, 120, 196, 209
Bartram, John, 19, 43
Bastions (in fortifications), 6, 38, 43, 79, 98, 115, 126, 142, 160, 167
Baton Rouge (LA), 44
Baxter, Sylvester, 210
Bayou St. Jean (LA), 122, 123, 128
Beaumont (CA), 177
Beechey, William, 180
Belderrain, Juan Bautista, 146
Bell, William A., 152
Bells: in California churches, 180, 186; in New Mexico churches, 53, 74; of St. Augustine church, 24
Benavides, Alonso de: on El Paso, 85; on Franciscans' work, 48, 50, 51; at Las Humanas, 70; on Pueblo Indians, 54, 60, 73; on San José de Guisewa, 64; on Santa Fe, 77, 80
Benedictines, 120
Beretta, Jack, 120–21
Bernal, Juan, 71
Bernard del Espíritu Santo, 141
Béxar villa (TX). *See* San Fernando de Béxar (TX)
Bienville, Jean Baptiste Le Moyne, Sieur de, 41, 42, 122
Biloxi (MS), 122
Blanco, Miguel, 179, 202
Bleser, NIcholas J., 141

Blockhouses. *See* Fortifications
Bloom, Lansing B., 65
Boazio, Baptista, 7, 16
Boca Raton (FL), 211
Bollaert, William, 113
Bolton, Herbert E., 137, 210
Bonaparte, Napoleon, 134
Borica, Diego de, 162, 164, 172, 190
Bourke, John Gregory, 90–91
Boyd, E., 90, 94
Branciforte (CA), 162–63
Branciforte, Marqués de, 160, 162, 172
Brew, John O., 54
Brewer, William H., 174, 206
Brick (fired): in Arizona, 141, 144, 147, 152; in California, 164, 179, 185, 194, 195; in Florida, 45; in Louisiana, 127, 130, 132, 212; as roofing material, 136, 152
British Museum, 22
Brothers of Mercy, 113
Brown, A. Page, 210
Brozas y Garay, Pedro, 6, 30
Brush. *See Jacales*
Bucareli, Antonio María, 98, 156, 157, 160, 161, 167, 181, 186, 198
Buena Vista rancho (CA), 191
Building traditions. *See* Construction techniques; *Specific construction materials*
Bujio (Florida Indians' communal house), 37–39
Bultos. *See* Statues
Burnham, Daniel H., 210
Bushnell, Amy, 37
Bustamente, Félix Antonio, 141
Buttresses: of Arizona churches, 150; of California churches, 173, 179, 180, 204, 207; of Louisiana churches, 133; of New Mexico churches, 52, 53, 66, 69, 74, 81, 90, 93; of New Mexico governor's palace, 85; of Texas churches, 104, 110, 116

Cabeza de Vaca, Alvar Núñez, 46, 96, 137
Cabildo: in Los Angeles, 183; in New Orleans, 2, 5, 125, 127, 129, 130–31, 133–36; in San Antonio, 102, 104, 105; in Santa Fe, 77, 79, 85
Cable, George Washington, 130
Cabrillo, Juan Rodríguez, 154, 197
Cadillac, Antoine de la Mothe, Sieur de, 97
Calabazas (AZ), 140
California (Alta California), 154–208; agriculture in, 158–59, 162–63, 176–78, 182, 185, 191–92, 196; bishops over, 5; churches in, 153, 162, 164–81, 183–208, 212; construction materials in, 9, 155–56, 160, 163–64, 167–72, 174–76, 178–79, 183–92, 194, 195, 197–202, 204; missions and missionaries in, 3, 4, 154–65, 167, 169–81, 184, 186–95, 197, 198, 200, 206–7; population of, 162–63; presidios in, 3, 9, 155–57, 160–64, 166–69, 181, 186, 198–200; reasons for Spanish settlement of, 9, 154–55, 160–61; Spain's subsidizing of settlements in, 158, 181, 199, 200; Spanish architectural influence on, 209–11; Spanish architectural remains in, 2, 10, 165, 186, 195, 197, 200, 209; Spanish colonial policy in, 4; Spanish exploration of, 3, 57, 146, 154–58, 176; Spanish overland expeditions to, 3, 137, 139, 146, 157–58. *See also* Baja California; *Specific places in*
California Hispanic style, 164
California Mission style, 211

Cambón, Pedro Benito, 175
Camino Real, 47, 57, 78
Campanarios. *See* Bells; Towers
Campos, Augustín de, 138
Campo santo. *See* Cemeteries
Canary Islanders, 23, 101–3, 126, 135
Canova, Angelo, 174
Caoacooche (Indian chief), 30
Capuchin fathers, 127, 129, 131, 133
Cardelli, Pietro, 135
Carleton, James H., 69, 71
Carlisle Indian School (PA), 31
Carlos II (king of Spain), 40
Carlos III (king of Spain), 3, 4, 144, 154–56
Carmel (CA), 156–58, 170–75. *See also* San Carlos de Borromeo mission
Carmel River, 170
Carnegie Institution, 25
Carolina: Florida attacks by, 5, 17–22, 24, 28, 33; founding of, 27; revolutionaries from, 30. *See also* South Carolina
Carondolet, Baron de, 128–32, 135
Carrere and Hastings (architects), 211
Carrillo, Mariano, 167
Cartagena (Colombia), 6
Cartographers (map makers): Costansó as, 3; de la Puenta as, 33; Guillemard as, 131; Kino as, 137, 145; Mestas as, 17, 20; military engineers as, 5, 6, 33; Sigüenza as, 2, 40–41; Urrutia as, 138
Casafuerte, Marqués de, 105, 182
Castañeda, Carlos E., 121
Castelló, Pablo, 6, 33
Castillo de San Marcos (St. Augustine, FL), 25–31; attacks on, 5, 39; name of, 31; plans for, 6, 27–28; as remnant of Spanish architecture, 1, 10, 210; salaries of soldiers at, 20; stone used for construction of, 6, 8, 14, 27–28, 172, 212
Catalonia (Spain), 126, 196
Cathedral of Esquipulas (Guatemala), 93, 94
Cathedral of Saint Louis (New Orleans), 2, 5, 132–33, 136
Catholicism: Aztecs' conversion to, 9; Indian conversions to, 9; opposition to, in United States, 1, 209; Spanish king's role in, 4, 17, 48, 156. *See also* Missionaries
Cattle. *See* Livestock
Cemeteries (*campo santo*): at Ácoma Pueblo, 74; at Chimayó, 94; at Santa Catalina mission, 37; in Santa Fe, 82; in Texas, 114
Cendoya, Manuel de, 27, 28
Census (U.S.) of 1790, 80, 183
Chaco Canyon, 52, 64
Chamberlain, Samuel, 152
Charamonte, Andrés de, 90
Charleston (SC), 6, 21
Charlevois, Pierre François Xavier de, 123
Chatelain, Verne E., 25
Chavés, Carmen Abeyta, 95
Cheyenne Indians, 31
"Chicora," 14
Chihuahua (Mexico), 47
Chimayó (NM), 58, 89, 92–95
Chimneys, 19, 164
Choir lofts: in Arizona churches, 141, 147, 150; in California churches, 173, 179, 194, 197, 205; in New Mexico churches, 53, 71, 74–75, 81, 82, 87–89; in Texas churches, 110–12, 119
Chumash Indians, 197–98, 202

Churches: in Arizona, 1, 9, 50, 55–56, 77, 80–83, 109, 121, 141–53, 188, 209, 212; in California, 153, 162, 164–81, 183–208, 212; construction techniques for, 8, 17, 50–56, 68, 74, 212; in Florida, 14, 16, 17, 22, 24, 34–35, 37–39, 42, 212; in Indian pueblos, 1, 47, 49–56, 60–77, 99, 211; location of, in town plans, 7–8; in Louisiana, 122, 123, 127, 130–34, 136; in New Mexico, 47–56, 60–77, 80–83, 86–92, 153, 165, 211, 212; Pueblo Revolt's destruction of, 54, 60–62, 77–78; re-use of ruins of, 17, 24, 70, 143, 151; in Texas, 106, 109–14, 116–21, 153, 212; uniformity of appearance of, 8. *See also* Altar screens; Artisans; Balconies; Bells; Buttresses; Cemeteries; Corbels; Domes; Facades; Missions; Molding; Murals; Statues; Towers; Vaulted church ceilings
"Cíbola," 46
Ciudad Juárez (Mexico), 48, 50; Spanish architectural remains in, 54–56
Class. *See* Social class
Clerestories. *See* Windows
Clothing: importing of, from Mexico, 49; making of, in missions, 108, 177; social class and, 21; variety of, in California churches, 206–7
College for the Propagation of the Faith of San Fernando (Mexico City), 4, 140, 155, 158–59, 170, 189, 196, 200
College for the Propagation of the Faith of Santa Cruz de Querétaro, 3, 4, 96–98, 105–7, 113, 117, 140
College for the Propagation of the Faith of Nuestra Señora de Guadalupe de Zacatecas, 4, 97, 107, 113, 114, 117, 140
Collot, Victor, 128
Colorado, 210
Colorado River, 3, 142, 145, 154, 157
Comanche Indians: and Anza, 3, 58, 63; and Croix, 144; in Florida prisons, 31; as threat to New Mexican Spanish settlements, 89; as threat to Pueblo Indians, 58, 62–63; as threat to Texas missions, 98
Committee for the Reconstruction and Preservation of New Mexico Mission Churches, 76, 95
Commons (in town plans), 8
Company of the Indies, 123
Concepción mission. *See* Nuestra Señora de la Purísima Concepción mission
Concrete (as roofing material), 29–30, 180, 212
Congregation for the Propagation of the Faith (Rome), 4
Construction techniques: in contemporary Texas, 121; in Florida, 8, 17, 217; Hispanic, 1; Indian, 8, 50–57, 212; involving re-use of church ruins, 17, 24, 70, 143, 151; from Spain, 51, 52. *See also* Adobe; Brick (fired); Roofing materials; Stone; Wood
Convento(s) (friaries): in Arizona, 143, 146, 151; in California, 167; in Florida, 32–33, 35, 37–39; Indian servitude at, 73; in New Mexico, 50–51, 56, 61–62, 64, 68, 70, 75, 76, 86–88, 99, 212; in Texas, 99, 100, 106, 114, 115
Convento de San Francisco (St. Augustine, FL), 32–33
Convento of San Francisco (Mexico City), 4
Convento of the Immaculate Conception (St. Augustine, FL). *See* Convento de San Francisco (St. Augustine, FL)
Cooke, Philip St. George, 151
Coquina stone, 8, 19, 24, 27–29, 33
Coral Gables (FL), 211
Corbels and lintels: in Louisiana, 135; in New Mexico, 52, 54, 58, 62, 67, 70, 74, 82–83, 85, 88, 90
Córcoles y Martínez, Francisco de, 36
Cordero, José, 169
Cordero, Juan, 34

Córdoba, Alberto de, 162
Corner, William, 111, 120
Cornerstone Community Partnerships, 76
Coronado, Francisco. *See* Vázquez de Coronado, Francisco
Corpa, Pedro de, 32
Corps de Garde (New Orleans), 134, 135
Correa, Juan, 137
Cortés, Feringan, 42
Cortés, Hernán, 46, 161
Cosari (Pima village in AZ), 137
Costansó, Miguel, 3, 155–56, 160–61, 166–67, 169, 197, 198
Cotilla, Juan de, 6
Cotton manufacture, 108
Council of Castile (Spain), 3
Council of the Indies (Spain): and Florida, 27, 39–41, 212; jurisdiction of, 3–4; and New Mexico, 48; and Texas, 96. *See also* Laws of the Indies
Country Club Plaza (Kansas City), 211
Craftsmen. *See* Artisans
Creek Indians, 39, 41
Crespí, Juan, 174, 175
Cristo Rey church (Santa Fe), 83
Croix, Marqués de (Viceroy Carlos), 140, 144, 156, 170
Croix, Teodoro de, 115, 139, 144, 156, 160, 162, 168, 182
Cruzado, Antonio, 175, 177
Cuarac or Cuara. *See* Quarai Pueblo
Cuba (or Havana): bishop of, as responsible for Florida, 5; and Florida, 18, 23, 37, 42; fortifications in, 6; and Louisiana, 125, 126, 130; O'Reilly's role in, 2; slavery in, 17, 26
Cuilapán (Mexico), 110
Cyprión, Antonio, 114

Dallas (TX), 211
Dana, Richard Henry, 193
Dances. *See* Festivities
Dancy, Francis L., 30
Dávila, Agustín, 165
Davis, W. W. H., 57, 84–85
Daza, Ignacio, 6, 27–28
Deegan, Kathleen, 17, 18, 25
De la Chica, Juan Gutiérrez, 68
De La Puente (cartographer), 33
De la Rocque, Mariana, 6, 24, 30
De Leche Pueblo (FL). *See* Nombre de Dios mission (FL)
Del Valle, Francisco Antonio, 82
Del Valle family (Los Angeles), 186
Den, Nicholas A., 206
Deppe, Ferdinand, 180–81
De Soto, Hernando, 2, 11, 37, 96
Díaz Vara Calderón, Gabriel, 32–34, 38
Diego y Moreno, Francisco García, 206, 207
Dios, Juan de, 60
Diseases, 9, 31, 36, 159, 176
Dixon (NM), 58
Doak, Thomas, 165
Doctrinas. *See* Missions
Dolores (AZ), 137, 145
Dolores mission (San Francisco, CA), 158, 175
Domes (in churches): in Arizona, 9, 144, 147, 150, 152, 153; in California, 172, 187–89, 194, 195, 197; in Louisiana, 132; in New Mexico, 50; in Texas, 99, 104, 110, 112, 117, 118, 120, 212
Domestic architecture. *See* Houses

Domínguez, Francisco Atanasio, 55, 57, 82, 83; on Ácoma Pueblo, 74–75; on Chimayó, 92; and Las Trampas church, 89–91
Doroteo, Manuel, 163
Douglas (AZ), 142
Downie, Harry, 174–75
Drake, Francis, 6, 7, 13, 15–16, 25, 26, 154
Drossaerts, Arthur, 120
Drought: at Las Humanas, 71–72; at San Luis Rey mission, 191
Duflot de Mofras, Eugene, 185
Duhaut-Cilly, Bernhard, 161, 191–93, 199, 202–4
Du Petit-Thouars, Abel, 173
Duquet, Joseph, 132
Durán, Narciso, 177, 196, 206
Durnford, Elias, 42–43

Earthquakes: and San Carlos mission, 187; and San Fernando mission, 165; and San Gabriel mission, 9, 175, 179, 180; and San Juan Capistrano mission, 9, 164, 177, 189; and Santa Barbara mission, 199, 203, 204, 207, 211; and San Xavier del Bac mission, 152
Eastman, Seth, 120
East Texas: abandonment of presidios and missions in, 5; missions and presidios in, 2–3. *See also* Texas
Ecclesiastical architecture. *See* Churches
El Atascoso ranch (TX), 114, 115
El Cerro de Chimayó (NM), 58, 92–93. *See also* Chimayó (NM)
"El Cuartel" (Santa Barbara, CA), 200
El Misión del Santo Príncipe el Arcángel San Gabriel de los Tremblores, 175. *See also* San Gabriel mission (CA)
El Paso 47, 49, 50, 80, 85–88
El Príncipe (ship), 167
El Pueblito (AZ), 143–44, 146
El Pueblo de la Reina de Los Angeles, 181. *See also* Los Angeles (CA)
El Rosario church (Santa Fe), 83
Emory, W. H., 196, 209
Encomederos, 61–62
Engelhardt, Zephyrin, 193, 205
Engineers. *See* Military engineers
England: Americans' national origin as based in, 1, 2, 212; attacks on St. Augustine by, 6, 7, 13, 15–22, 24–26, 28, 33, 212; claims of, to North America, 9, 27, 44, 154–55, 209; Florida's manufactured goods from, 23; Florida's transfer to, 6, 14, 18–19, 30, 42–44; Havana's capture by, 2; and Indians against Spanish in Florida, 5, 20, 36, 42; land grants from, 3; as St. Augustine owner, 6, 14, 18–19, 22–23, 30, 42; surrender of West Florida to Spain by, 126. *See also* American Revolution; Seven Years War; Spanish Armada; *Specific colonies of and explorers from*
Escadón, José de, 98
Escobedo, Alonso, 33
Espejo, Antonio de, 72
Espinosa, Alonso, 146, 149, 151
Espinosa, Isidro Félix de, 101, 106
Estelric, Juan Bautista, 141
Everglades Club (FL), 211
Excommunication, 49
Explorers (Spanish), 2, 3, 5, 7, 11; in Arizona, 3, 137–40, 145–46; in California, 2, 3, 101, 137, 154, 211; in Florida, 2, 3, 5, 7, 11, 14, 25, 37, 39–41; killing of, by Indians, 3, 146,

249

157, 198; in New Mexico, 3, 46–47, 60, 70, 72; in Texas, 3, 96, 97, 154, 211

Facades (of churches), 9, 35; in Arizona, 144, 150–52; in California, 165, 172, 184–85, 194, 204, 205, 208; in Florida, 24; in Louisiana, 133; in New Mexico, 53, 67, 82, 83, 88, 211; in Texas, 111, 118, 120
Fages, Pedro, 155, 156, 160, 163, 167–69, 183, 197–200, 202
Farnham, Thomas Jefferson, 173, 203
Faura, José, 189, 190
Federal Emergency Relief Administration, 120
Festivities (dances): in California, 176, 186, 193; missionaries' concern about Indian, 32, 38, 39, 48–49, 71, 97, 109, 176; in New Orleans, 128–29
Field, Matthew C., 63
Fiestas. *See* Festivities
Figueroa, José, 177
Fine Arts Museum (Santa Fe), 211
Fireplaces, 57. *See also* Chimneys
Fires: at Ácoma Pueblo, 72; at Florida fortifications, 6, 15; in Monterey presidio, 168; in New Orleans, 126, 127, 129–30, 133, 212; in Pecos Pueblo, 59; in Quarai, 69–70; in St. Augustine, 16, 17, 22, 24, 25, 32; in Santa Barbara presidio, 199
Flagler, Henry, 24–25, 209–11
Floods, 183–84
Florencia family (Florida), 37
Florida (*La Florida*), 11–45; agriculture in, 15, 20, 23, 33, 35–37, 39, 41; churches in, 14, 16–17, 22, 24, 34–35, 37–39, 42, 212; construction materials in, 6, 8, 14–19, 21–29, 32–35, 38, 40, 42, 44–45, 172, 212; construction techniques in, 8, 212; England's ownership of, 6, 14, 18–19; extent of, under Spain, 2, 9–11, 13–14; first European legal code established in, 14–15; fortifications in, 1, 5–10, 12–15, 20, 25–31, 37–42, 44–45, 172, 210, 212; France and Spain's contention for, 2, 11–12, 14, 25, 39, 40–41, 96, 212; Menéndez as *adelantado* of, 11–12, 40; missionaries in, 4, 12–14, 31–39; missions in, 20, 31–39; reasons for Spanish settlement of, 9; Spain's subsidizing of settlements in, 12–14, 17, 18, 20; Spanish architectural influence on, 209–11; Spanish architectural remains in, 1, 9–10, 17, 19, 23–24, 45, 212; Spanish colonial policy in, 3–5, 11–12, 45, 46; as Spanish province, 4, 14, 30; strategic importance of, to Spain, 2, 9, 11, 14, 19; United States' ownership of, 14, 24, 30, 45. *See also* St. Augustine; West Florida
Font, Pedro, 146, 176, 178
Fontana, Bernard L., 153
Fonte, Francisco, 65, 66, 69
Fort Caroline (now Jacksonville, FL), 12, 25
Fort George, 43, 44. *See also* San Miguel de Penzacola
Fort Marion, 30–31. *See also* Castillo de San Marcos
Fort Matanzas (FL), 21, 31
Fort Mose and pueblo (FL), 21, 29
Fort Picolata (FL), 21, 28
Fort St. Marks (FL), 30. *See also* Castillo de San Marcos
Fort San Carlos de Austría (Pensacola Bay), 41, 42, 45
Fort San Carlos de Barancas (Pensacola), 45
Fort San Francisco de Pupo (FL), 28
Fort San Mateo (now Jacksonville, FL), 12, 14, 25
Fort Santa Anastasia (FL). *See* Anastasia Island
Fortifications (blockhouses; garrisons): in Florida, 6, 7, 12–15, 20, 25–31, 37–42, 44–45; houses' double role as, 57–59, 102; in Louisiana, 126, 127–28; in New Mexico, 78, 89, 92–93; Rubí's recommendations concerning, 142; in Texas, 114, 115.

See also Bastions; Palisades; Powder magazines; Presidios; *Names of specific forts and presidios*
Foucault, Denis-Nicolas, 125
Four Churches of Pecos (Hayes), 61
France: claims of, to North America, 2, 9, 11–12, 14, 96, 97, 100, 113, 122, 209; as Louisiana's owner, 10, 39, 98, 122–24, 211; people from, in Louisiana, 126; people from, in St. Augustine, 23; and Spain's claims to Florida, 2, 11–12, 14, 25, 39, 40–41, 96, 212; Spain's "family compact" with, 42, 43, 122; war of, with Spain, 10, 97. *See also* Seven Years War
Franciscans: in Arizona, 139–43, 146–53; in California, 3, 154–63, 165, 167, 169–71, 175, 184, 186, 190, 197–98, 200, 206–7; fleeing secularism in Mexico, 197; in Florida, 4, 14, 31–39; in New Mexico, 46, 48–50, 60, 62, 65–66, 69–75, 80, 85–86; in Texas, 97–121. *See also* College of Nuestra Señora de Guadalupe de Zacatecas; Querétero College; San Fernando College; *Names of specific Franciscans*
Francisco "El Pintor" (artisan), 139
Francisco Xavier (saint), 138, 145
Francke, Jaime, 6, 41
Frazer, Walter B., 25
Frémont, John C., 206
French Dominique (Haiti), 125
French Quarter (New Orleans), 2, 5, 126–36, 212
Frescoes. *See* Murals
Fresquis, Pedro Antonio, 83, 90
Friaries. *See* Convento(s)
Fronteras (Mexico), 142
Fruits: in California, 174, 177, 191, 196; in Florida, 22, 23; in Louisiana, 127; in New Mexico, 86–87, 92; in Texas, 101, 106
Fuentes, Francisco de, 36
Fuster, Vicente, 187, 189

Gadsden Purchase, 152
Galistea Pueblo (NM), 62
Galleries. *See* Balconies
Galve, Conde de, 40, 41
Galveston Bay (TX), 98
Galvez, Bernardo de: as governor of Louisiana, 43–44, 126, 127–28, 131; and Guillemard, 5, 212
Galvez, José de, 3, 43, 126, 144, 161; and California, 154–56, 158, 197; and expulsion of Jesuits from New World, 4, 139
Gálvez, Matias de, 200
Gaona, Ignacio, 146–47
Garcés, Francisco, 3, 140, 142, 143, 157–58
García, Joseph, 107–9
Garrisons. *See* Fortifications
George, Eugene, 51, 104
Georgia: Guale missions in, 31, 34–37; as site of first Spanish settlement, 7, 211; as threat to Florida, 5, 21, 28, 29
Germany, 23
Geronimo (Apache Indian), 31
Gila Apache Indians, 146
Gila Pima Indians, 145
Gila River, 3, 142, 145, 158
Gil de Bernabé, Juan Crisóstoma, 140
Gill, Irving J., 210
Gil y Taboada, Luis, 184
Glass: in California churches, 194; lack of, in early Florida, 19; lack of, in early New Mexico, 53, 57; in Texas churches, 119
Goliad (TX), 1, 98
Gómez de Engraba, Juan, 39

Gómez Robeledo, Francisco, 61–62
Gonzáles, Antonio, 151
Gonzales, Dionicia, 99
González, Tirso, 137–38
Gonzalvo, Francisco, 145–46
Goodhue, Bertram G., 210
Gordon, Adam, 43
Gothic elements (in California churches), 172
Governors' residences: in California, 169; in Florida, 16, 19, 22–23, 42, 43; in Santa Fe, 6–7, 58, 77, 78–79, 84–85, 209, 210–11; in Texas, 1, 100, 102, 105, 120, 209; in town plans, 8
Goya, Francisco José de, 78
Goycoochea, Felipe de, 198–200
Gracia Gonzáles, José de, 90
Granada (Spain), 126
Granjon, Henry, 152
Gran Quivera (Las Humanas) Pueblo (NM), 65, 70–72, 138
Greece, 23
El Gringo (Davis), 57, 84
Gritzner, Charles F., 57
Guadalajara (Mexico), 4
Guadalupe (Mexico), 119
Guadalupe River (CA), 162, 181
Guale Indians, 13, 14, 28; missions for, 32–37
Guatemala, 93, 94
Guerra y Noriega, José Antonio de la, 199
Guerrero y Torres, Francisco Antonio, 119
Guevara, Juan Bautista, 81
Guevavi mission (AZ), 137–40
Guillemard, Gilberto, 5, 128, 131–36, 212
Guillot, Joseph, 135
Gurlie, Claude, 135
Gutiérrez, Narciso, 141
Guzman, Nuño de, 3

Habig, Marion A., 113–14
Hainai Indians, 105
Haiti, 125, 126
Hampton Institute (VA), 31
Hann, John H., 1
Hartness, William, 206
Hasinai (Tejas) Indians, 96–97, 99, 105
Havana. *See* Cuba
Hayes, Alden C., 61
Hayes, Benjamin J., 152, 209
Hearst, William Randolph, 211
Hererros, Antonio, 146
Hernandez, Marcelino, 135
Hery, François or Francisco, 127
Hidalgo, Francisco, 96–97
Hides, 62. *See also* Leather; Murals
Hiester, H. T., 62
Highland Park Village (Dallas), 211
Historia de la Nuevo México, 1610 (Pérez de Villagrá), 72
Historic American Building Survey, 187
Hita, Manuel de, 24
Hita Salazar, Pablo de, 27
Holbrook, George H., 180
Holy Cross Fathers, 120
Hopi Indians, 46, 50, 54, 74
Horruytiner, Pedro Benedit, 37, 39
Horses: in Florida, 21

Hospitals: in California missions, 159; in New Orleans, 124, 129, 131; in St. Augustine, 22, 24
Households (Spanish), 20–21
Houses (domestic architecture): in California, 2, 183, 185–86, 192, 197, 199, 202; in Florida, 1, 17–23, 37–39, 44, 212; Indian, in Arizona, 152; Indian, in California, 192, 197, 202; Indian, in Florida, 37–39; Indian, in Texas, 96, 100, 106, 115; in Louisiana, 130; in New Mexico, 47–48, 57–59, 70, 84; similarity of, to presidios, 7; in South Carolina, 15; in Texas, 96, 100–102, 106, 115; uniformity in appearance of, 8, 102. *See also* Construction techniques; Governors' residences; Housing lots; Missions
Housing lots: in California, 162, 182; in Florida, 18; in Santa Fe, 77; in Texas, 103; variation in, according to social class, 8, 18
Huejotzingo (Mexico), 180
Huizar, Pedro, 105, 117
Humboldt, Alexander von, 87
Hurricanes. *See* Storms
Hutton, William Rich, 185, 209

d'Iberville, Pierre Le Moyne, Sieur, 40, 122
Indians: as aligning with English against Spanish in Florida, 5, 20, 36, 42; as artisans, 28, 55–56, 76, 139, 163–66, 171, 179, 200, 202; attempts by missionaries, to take away culture of, 31, 32, 38, 39, 48–49, 71, 81, 97, 105–9, 158–59, 176; Catholic evangelism directed to, 7, 12, 14, 20, 31–39, 46, 48–50, 60, 72–74, 85–86, 96–97, 99, 137–53, 156–60, 167, 176, 190–91; churches in pueblos of, 1, 47, 49–56, 60–77, 99, 211; differences between, in Spanish American and New Spain, 9, 32; discipline of, in missions, 5, 9, 32, 36, 72–74, 107, 140, 154, 156, 158, 159, 178, 200; diseases afflicting, 9, 31, 36, 159, 176; efforts to reform missionaries' treatment of, 3, 33, 34, 139–40, 200; intertribal warfare by, 39, 42, 143, 144; killing of explorers by, 3, 146, 157, 198; killing of missionaries by, 4, 32, 38, 49, 70, 73, 98, 138, 146, 157, 186, 198; labor of, for restoration work, 76, 153, 195–96, 200; labor of, for Spanish missionaries and soldiers, 8, 16, 27, 28, 36–39, 49, 50, 61, 68, 70, 74, 81, 115, 140, 143, 152, 159, 165, 168, 170, 175–77, 188, 191, 198, 199, 201; languages of, 33, 34, 36, 113, 146, 176; liberation of, from missions, 206; missionaries' efforts to congregate various tribes in mission villages, 31, 32, 97, 106, 154, 158, 159, 200; mortality rate of, under Spanish, 9, 16, 31, 49, 71, 159–60, 192; population decline of, in missions, 9, 34, 36, 37, 62, 63, 70, 107, 113, 114–15, 120, 159–60, 176, 192, 206; population of, in Florida, 20, 38; population of, in New Mexico, 65; as prisoners in forts, 30–31; raids by, 45, 57–58, 69–70, 72, 89, 98, 105, 107, 114, 115, 139, 140, 142–44, 146, 149; resistance by, 6, 15, 25, 31, 32, 34, 38–39, 72–73, 77–78, 86, 96, 97, 138, 139, 146, 159, 186, 197, 198; segregation of mission, from soldiers and settlers, 140, 158, 170–71, 178, 191, 201, 202; as slaves, 39, 62, 125; as soldiers in Spanish presidios, 142; Spanish dependence on agriculture of, 13, 15, 36, 37, 40, 49, 72; Spanish towns located near villages of, 7, 14–15, 20, 25, 34–35, 37–38, 137; treatment of, by Spanish explorers, 11, 47, 72–73; treatment of, by Spanish soldiers, 31, 32, 96, 156, 175, 176; villages of, in Arizona, 137, 143, 145, 153, in California, 192, 195, 197, 200, 202, in St. Augustine, 14, 15, 20, 37. *See also* Missionaries; Pueblo Revolt of 1680; Trade; Wages; *Specific Indian tribes*
"El Indio de la Via Crucis," 165–66
Inquisition (Holy Office of), 49, 62, 69

251

| INDEX

International Boundary Commission, 88, 131
In the Midst of a Loneliness (Ivey), 66
Ironwork (in New Orleans), 135
Irrigation (*acequias*): in Arizona, 139, 145; in California, 162, 176, 181–83, 191, 196, 202–3; in New Mexico, 72, 77, 86–87, 92; in Texas, 100–102, 106, 107, 114, 115
Italy, 23
Iturralde, Francisco, 146, 147
Ivey, James E., 66–69

Jacales: in Arizona, 9, 142; in California, 9, 164, 183, 198; in New Mexico, 47, 57, 60, 80; in Texas, 9, 99–101, 106, 114
Jackson, Andrew, 45
Jackson, Helen Hunt, 174, 210
Jackson Square (New Orleans). *See* New Orleans: Place d'Armes
Jacksonville (FL), 12, 24, 37
Japelo Island, 36, 37
Javier, Francisco, 62
Jesuit(s): in Arizona, 137–41, 145–46, 152; in California, 154–55, 158; expulsion of, from New World, 4, 107, 139–40, 155, 158; in Florida, 4, 12–14, 31, 34; Kino as, 2, 3, 137–40, 145–46; in New Orleans, 123
Jesús, Francisco Alonso de, 34
Jimeno, Antonio, 204
Jones, Robert, 130
Juana Inéz de la Cruz, 2
Juanillo (Guale Indian chief), 32–34
Juárez, Andrés, 51, 60, 61

Kansas, 46, 47, 60, 211
Kansas City (MO), 211
Kearny, Stephen Watts, 62, 151, 196
Kelly, Daniel T., 91
Kern, Richard, 82
Kessell, John L., 59, 61, 74, 139
Kino, Eusebio Francisco, 2, 137–40, 145–46, 154–55, 157–58, 160
Kiowa Indians, 31
Kiva, Cross, and Crown (Kessell), 59
Kivas: in churches, 73, 81; in conventos, 66, 68; in pueblos, 70–73, 75, 78
Kreye, Thaddeus, 204, 208
Kubler, George, 50, 52, 64
Kuppers, Peter, 91

La Bahía presidio (TX), 98
Lacandon Indians (Chiapas), 113
La Castrensa (Santa Fe church). *See* Nuestra Señora de la Luz, La Castrense, church
Ladrón, Juan Bautista, 88
La Florida. *See* Florida
La Florida (Escobedo), 33
Lafora, Nicolás de, 5
Lafrenière, Nicolas Chuvin de, 125
Laguna Pueblo, 75–76; San José church in, 55, 211
"Laguna Santero," 55–56, 76
Lake Ponchartrain, 122
Lamy, Jean Baptiste, 58, 82, 83, 91, 95, 152
Landmarks Club, 190, 195, 210
The Land of Poco Tiempo (Lummis), 64

Lanos, Manuel, 130
La Puente rancho (CA), 177
La Purísima Mission (CA), 184, 198, 203. *See also* Nuestra Señora de la Purísima Concepción mission and church (TX); Quarai Pueblo
Laredo (TX), 98
La Salle, René Robert Cavelier, Sieur de, 9, 40, 41, 96, 98, 122
Las Flores rancho (CA), 191
Las Humanas (Gran Quivera) Pueblo (NM), 65, 70–72, 138
Las Pulgas rancho (CA), 191
Lassus, Jean Pierre, 133
Las Trampas Foundation, 92
Las Trampas rancho (NM), 55, 58, 89–92, 95
Las Truchas (NM), 90
Lasuén, Fermín Francisco de, 157–59, 163, 170–73, 178–80, 189–91, 198, 200
Latrobe, Benjamin H., 130–34, 136
Law (first European code of, in North America), 14–15. *See also* Laws of the Indies; *Reglamentos*
"Law of Bayona," 178
Laws of the Indies, 7, 77, 124, 125, 211. *See also* Ordinances for the Discovery, New Settlement, and Pacification of the Indies
Leal, Antonio, 145
Leather (hides): eating of, 71–72; manufacture of products made of, 59, 159; trade in, 185, 193. *See also* Hides; Murals
Le Blond de la Tour, Louis-Pierre, 122, 123
Lenardizzi, Eraclito, 121
Lentz, Hans, 61, 121
León, Alonso de, 96
Le Prevost, Cristobel, 135
Letrado, Francisco de, 70
Leturrondo, Alonso de, 17
Liberos, Ramón, 141
Life of Fray Junípero Serra (Palóu), 156, 167, 170, 175
Limestone: in Florida, 18; in New Mexico, 71; in Texas, 110, 116
Linas, Antonio, 113
Livestock: abandoned missions used for, 113, 174, 209; in Arizona, 138, 144, 145; in California, 158–59, 162, 177, 183–85, 191, 200, 206; in Florida, 12, 20, 32, 37, 44; in New Mexico, 49, 59, 72, 85; in Texas, 97, 101, 102, 105–8, 114; and Yuma rebellion, 157. *See also* Leather; Ranching
Llorens, Juan Bautista, 143, 146
López, Alberto, 104
López, Cayetano, 163
López, Claudio, 181
López de Mendizabal, Bernardo, 62, 71
López de Mendoza Grajales, Francisco, 17
Loreto (Baja California), 2, 162, 177
Los Adaes presidio (now LA), 3, 97, 98, 104, 105
Los Angeles (CA), 175–76, 181–84; founder of, 3, 156, 162–63, 198; historic religious paintings discovered in, 165; Plaza Church in, 165, 184–86, 192, 202; population of, 182–83, 185; Spanish architectural remains in, 2, 10; town plan for, 7, 182–83, 211; U.S. occupation of, 211. *See also* San Gabriel mission
Los Angeles Times, 210
Los Dolores y Viana, Mariano de, 112
Louisiana, 122–36; agriculture in, 126; churches in, 122, 123, 127, 130–34, 136; construction materials in, 124, 127, 130, 132, 212; French control of, 42, 98; population of, 126; Spain's subsidizing of settlements in, 124, 125; Spanish abandonment of presidios and missions in, 5; Spanish architec-

tural remains in, 2, 5, 126–36, 212; Spanish control of, 2, 43, 98, 105, 122, 124–36; Spanish control of, transferred to France, 10; trade of, with New Spain, 96–97; United States' control of, 10, 44, 126, 135. *See also* New Orleans (LA); St. Louis (MO); *Specific places in*
Lowery, Woodbury, 210
Lucey, Robert E., 121
Lugo family (Los Angeles), 186
Lummis, Charles Fletcher, 64, 190, 195, 210
Luna y Arellano, Tristán de, 11, 39–40

Machebeuf, Joseph P., 152
"Madame John's Legacy" (New Orleans house), 130
Maine (ship), 209
Málaga (Spain), 126
Malaspina, Alejandro, 169, 171
Maldonado, Nicolás, 114
Manchac (LA), 44
Manje, Juan Mateo, 137, 145
Mano de Perro Indians, 107
Manso Indians, 85
Manucy, Albert, 16, 17–18, 20, 25, 26
Manufacturing: at Martínez Hacienda, 59; at missions, 158–59, 177–78, 193
Map makers. *See* Cartographers
Margil de Jesús, Antonio, 3, 113
Mariana (Spanish queen regent), 27, 33
Marion, Francis, 30
Markets: in St. Augustine, 20; in San Antonio, 105; in Santa Fe, 58. *See also* Trade
Marmolejo, Ildefonso Joseph, 114
Márques Cabrera, Juan, 36
Martínez, Antonio José (later, Padre Martínez), 58
Martínez, María, 94
Martínez, Severino, 58–59
Martínez Hacienda (Taos, NM), 58–59
Masons. *See* Artisans
Massanet, Damián, 96
Matagorda Bay, 96
Matheos, Antonio, 39
McEwan, Bonnie G., 39
Meem, John Gaw, 76, 83, 91, 92
Men: role of Indian, in church construction, 48, 51. *See also* Polygamy
Menchaco, Miguel de, 86
Méndez de Canzo, Gonzalo, 14, 16, 17
Mendoza, Antonio de, 46
Menéndez de Avilés, Bartolomé, 14–15
Menéndez de Avilés, Pedro: achievements of, 2, 25; missionaries associated with, 31; secular priests accompanying, 4, 17; settlements founded by, 7, 11–14, 25, 34, 37; settlers associated with, 5, 16–17; social class of, 20
Menéndez Marqués, Francisco, 22
Menéndez Marqués, Pedro, 13, 15–16, 18
Menzies, Archibald, 202
Merriam, John C., 25
Mesa Verde (CO), 52
Mestas, Hernando de, 17, 20, 26
Mexican War, 120, 151–52; United States' seizure of Mexican lands after, 10, 196, 209, 211
Mexico: as administrator of Pious Fund, 158; architecture in, 54–56, 118, 180; California missions' dependence on supplies from, 155, 157–58; importing of religious items from, 49, 69, 73, 74, 149, 189; independence of, from Spain, 10, 168, 185; Louisiana emigrants from, 126; secularization under, 10, 83, 160, 197; Texas missions as dependent on supplies from, 108. *See also* Mexican War; New Spain; *Specific Mexican cities, people, and institutions*
Mexico City: artisans in, 74; as artistic influence on New Mexico, 55–56, 83; as home of viceroy of New Spain, 4, 46, 48, 69, 73, 96, 157; Kino summoned to, 138; San Fernando College in, 4, 140, 155, 158, 159, 189, 196, 200
Mezquía, Pedro Pérez de, 158
Military engineers: Costansó as, 3, 155–56; in Florida, 26, 27–28, 212; in New Orleans, 5, 122–23, 128, 131–36, 212; roles of, in Spanish North America, 5–6
Miller, Henry, 185, 189–90, 196
Mills: in California, 177, 202–3; in New Mexico, 57, 59, 92; in Texas, 120
Minorca, 23
Miranda, Antonio, 73
Miranda, Hernando de, 15
Miro, Estevan, 129–30, 132
"La Misma Nada," 3, 113
Missionaries: and agriculture, 31, 32, 49, 115, 138, 158, 162–63, 177, 181, 183, 186, 191–92, 196; in Arizona, 1–2, 137–53; attempts to take away Indians' culture by, 31, 32, 38, 39, 48–49, 71, 81, 97, 105–9, 158–59, 176; in California, 2, 3, 154–63, 165, 167, 169–71, 175, 184, 186, 190, 197, 198, 200, 206–7; competition between soldiers and, 36, 156–57; construction tools for, 50; difficulties for, 31, 75; disputes between civil authorities and, 4, 36, 38–39, 49, 69, 86, 156–57, 162, 163–64, 200; duties associated with, 107–9, 140, 158–59, 176, 193; efforts to reform, 3, 33, 34, 139–40, 200; expenses associated with, 48, 50; in Florida, 1, 12, 14, 20, 27, 31–39; goals of, 4, 39; killing of, by Indians, 4, 32, 38, 49, 70, 73, 98, 138, 146, 157, 186, 198; as less expensive than soldiers, 9, 96; and mission discipline, 5, 9, 32, 36, 72–74, 107, 140, 154, 156, 158, 159, 178, 200; in New Mexico, 46, 48–56, 60–75, 79, 86; papal authorization for, 4; powers of, 49, 69, 200; royal funding for, 4–5, 9, 10, 12–14, 17, 18, 20, 48, 50, 124, 125, 158, 181, 199, 200, 212; as settlers, 212; soldiers' roles with, 5, 31, 38–39, 46, 70–73, 212; termination of, under Mexican secularization, 10, 83, 160, 197; in Texas, 1, 4, 96–97, 105–15. *See also* Convento(s); Franciscans; Indians; Jesuit(s); Missions; *Monjérios*; Priests (secular); *Names of specific missionaries and missions*
Missionary Fathers of San Luis Rey, 184
Missions (*doctrinas*): abandonment of, 5, 196, 209; agriculture of, as supporting presidios, 115, 158, 162, 177, 181; in Arizona, 137–42; in Baja California, 154; in California, 155–60, 163–65, 170–81, 186–95; construction of, 201; in Florida, 20, 31–39; as industrial institutions, 158–59, 177–78, 193; as less expensive than presidios, 9, 96; in New Mexico, 49–50, 57, 85–86; secularization of, 10, 113, 120, 143, 151, 160, 185, 191, 196, 202, 206; in Texas, 1–3, 5, 96–121. *See also* Agriculture; Livestock; Ranching; *Names of specific missions*
Mississippi River, 40, 44, 96, 122, 126, 128
Mizener, Addison, 211
Mizener Development Corporation, 211
Mobile (AL): Apalachee Indian refugees in, 39; fort at, 44; French rule over, 39, 40, 122; layout of, 123; Spanish campaigns against, 5, 126
Moldings: in Arizona churches, 151, 152; in California churches, 170, 194, 205; in New Mexico churches, 54
Molleno (New Mexican santero), 94

Monjérios, 159, 170–71, 178, 191, 201, 202
Monterey (CA), 3, 157, 182; churches in, 156, 164, 169–70; missions associated with, 155, 156, 160, 164, 170–75, 197; presidios in, 155–56, 160–64, 166–70, 197; Spanish exploration of, 154, 175, 198
Monterrey (New Spain), 5
Monterrey, Conde de, 154
Montesclaros, Marqués de, 154
Montezuma (Aztec ruler), 46
Montgomery, Ross, 208
Montiano, Manuel de (governor), 29
Montreal (Canada), 123
Moore, James: attacks on St. Augustine by, 17–22, 24, 28, 33; attacks on Santa Catalina mission by, 37; and San Luis de Talimali, 39
Moors, 51, 57, 58, 81
Mora, Francis (Los Angeles bishop), 174
Moraga, José Joaquín, 160, 162
Moral, Alonso, 38
Morales Folguera, José Miguel, 128
Morfi, Juan Agustín, 100, 103–4, 115–16
Morgan, Julia, 211
Morley, Sylvanus G., 85, 210–11
Moundbuilding Indians, 37
Mugártegui, Pablo, 186
Municipal governments (Spanish): in Florida, 14–15; in New Mexico, 77, 84–85. *See also* Cabildo; Governor's residences
Munras, Estebán, 165
Murals (frescoes; paintings): in California churches, 164–66, 174, 175, 195–97, 199–201, 207–8; in New Mexico churches, 54–55, 65, 67; in Texas churches, 100, 111, 112, 118–20. *See also* Altar screens
Museum of New Mexico, 62, 91, 210
The Myth of Santa Fe (Wilson), 85

Nacogdoches (TX), 98
Nájero, Manuel de, 139
Nambé mission (NM), 57
Narváez, Panfilo de, 37
Natchez (MS), 44
Natchitoches (LA), 97
National Historic Landmark Designation, 92
National Park Service, 31, 142
Nazoni Indians, 99
Neches River (TX), 96, 97
Neoclassical elements: in California churches, 165, 205; in Castillo de San Marcos, 30; in St. Augustine church, 24
Neuerburg, Norman, 200
Neve, Felipe de (governor), 3, 160, 163; death of, 144; and Los Angeles, 7, 181–82, 185; on Monterey presidio, 168; presidios report by, 6, 198, 200; on Serra, 156
Neve, José (missionary), 146
Newcomb, Rexford, 180, 187, 188
Newmark, Harris, 185–86
New Mexico, 46–95; agriculture in, 49, 70, 72, 80, 86–87, 89; bishops over, 5; churches in, 47–56, 59–77, 80–83, 86–92, 153, 165, 211, 212; construction materials in, 8, 47, 51, 212; houses, 56–59; missions and missionaries in, 4, 46, 48–56, 60–75, 79, 86; in Panama-California Exposition, 211; presidios in, 6–7, 78–79, 86, 87, 89; reconquest of, 49–50; search for riches in, 46–47; Spanish architectural influence on, 210–11; Spanish architectural remains in, 1, 50, 56, 58–59, 68, 70, 84, 86, 91–92, 95, 209; Spanish civic architecture in, 77–85; Spanish colonial policy in, 3, 4; Spanish ecclesiastical architecture in, 50–56, 64–72, 80–95; Spanish settlement of, 3, 10, 46–50, 57–59, 85–86. *See also* Pueblo Indians; *Specific places in*
New-Old Santa Fe exhibition (1912), 85, 210–11
New Orleans (LA), 122–36; Almonester in, 2, 127, 129, 131–34, 136; Cabildo in, 2, 5, 125, 127, 129, 130–31, 133–36; churches in, 2, 5, 122, 123, 127, 130–34, 136; French architectural remains in, 123; hospitals in, 124, 129, 131; languages spoken in, 126; layout of, 122–23, 211; O'Reilly in, 2, 122; Place d'Armes in (Jackson Square), 122, 123, 127, 128, 130–31, 136, 211, 212; population of, 124, 126–27; Portalba Buildings in, 134; Presbytère in, 5, 129, 131, 133–36, 212; Spanish architectural remains in, 2, 5, 126–36, 212; Ursuline convent in, 124, 129, 131
New Orleans Picayune, 63
New Smyrna (FL), 23
New Spain: artisans from, 9, 55–56, 99, 117, 141, 163–64, 168–74, 184, 212; new governmental structure for northern regions, 144; and New Mexico, 46–48; and Texas, 96, 103; treasure of, 9, 11; viceroy's role in, 4. *See also* Mexico
Niza, Marcos de, 46, 137
Nombre de Dios mission (FL), 20, 21, 24, 28, 31, 33, 37
Norfolk (VA), 21
North Carolina. *See* Carolina
Nuestra Señora de Guadalupe (Ciudad Juarez, formerly Spanish El Paso), 54–56, 86, 87
Nuestra Señora de Guadalupe (Santa Fe), 83
Nuestra Señora de la Concepción (Caborca), 147
Nuestra Señora de la Luz, La Castrense, church (Santa Fe, NM), 55, 82–83
Nuestra Señora de la Purísima Concepción mission and church (San Antonio, TX), 104, 105–13, 172
Nuestra Señora de la Purísima Concepción de Quarai church. *See* Quarai Pueblo
Nuestra Señora de la Rosario church (Santa Fe), 82
Nuestra Señora de Loreto presidio (TX), 98
Nuestra Señora de los Angeles de Porciúncula church (Pecos, NM), 60
Nuestra Señora del Pilar de los Adaes presidio (now in LA, formerly in Spanish Texas), 3, 97, 98, 104, 105
Nuñez, Vicente José, 129
Núñez de Haro, Miguel, 113–14
Nusbaum, Jesse, 85, 211

Oacpicagigua, Luis, 138
O'Conor, Hugo, 114, 118, 142
Odin, John M., 120
Oglethorpe, James, 21, 29
Oio, Estevan del, 99
O'Keefe, Joseph J., 197
O'Keeffe, Georgia, 52
Okhe Pueblo (NM), 47
Olivares, Antonio de San Buenaventura, 97, 101, 113
Olivera family (Los Angeles), 186
Olmos, Alonso de, 20
Oñate, Cristóbal, 3, 46
Oñate, Juan de, 3, 70; as *adelantado*, 46–47, 60, 65, 72, 77, 85, 96; missionaries associated with, 46, 48–50; settlers associated with, 5
Onís, Luis de, 45
O'odham. *See* Pima Indians
Oramus, Cristóbal, 200

Oratorio de San Buenaventura (Chimayó), 93
Ordinances for the Discovery, New Settlement, and Pacification of the Indies: and Florida towns' layout, 16, 18, 35, 211; and Los Angeles' layout, 182, 211; and New Mexico towns' layout, 77, 79, 87, 211; and New Orleans' layout, 123, 211; and San Antonio's layout, 102, 211; and San José's layout, 162; and Santa Barbara presidio's layout, 199; town layout recommended by, 7, 8, 211
O'Reilly, Alejandro, 2, 78, 122, 125–29, 131, 133, 142
Ormsby, Lawrence, 61
Ortega, José Francisco, 160, 198
Ortega, Pedro de, 60
Ortega family (Chimayó), 93
Ortega Montañez, Juan de, 138
Ortiz, Antonio José, 82
Ortiz, Ferdinand, 197
Ortiz, Francisco Xavier, 106, 110
Ortiz, Pedro Zambrano, 60
Ortiz de Castro, José Damián, 132
Ortiz family (of Santa Fe), 80, 82, 83
Osceola (Seminole Indian chief), 30
O'Sullivan, St. John, 190
Osuna, Duke of, 78
Otermín, Antonio, 62, 77–78, 86
Out West magazine, 190, 195
Owings, Nathaniel A., 91–92, 95

Paciano (Chumash artisan), 202
Pacífico, Juan, 165
Paintings. *See* Altar screens; Murals
Pajalache Indians, 107, 108
Pala. *See* San Antonio de Pala church (CA)
Palisades (in fortifications), 6, 28, 38, 127, 142, 167, 176, 191, 198, 200
Palm Beach (FL), 211
Palmer, John, 21, 28
Palóu, Francisco, 156, 167, 170, 175
Pamuza rancho (CA), 191
Panama, 4
Panama-California Exposition (1915), 210, 211
Paner (Bauer), Francisco Xavier, 141
Panton, Leslie and Company (firm), 44
Panton, William, 44
Papago Indians, 144, 145, 151, 152
Pareja, Francisco, 33, 36
Parris Island (SC), 7, 12–15
Paterna, Antonio, 175, 200–201
Patronage (in Spanish society), 20–21
Patronato Real de Indias, 4
Patronato San Xavier, 153
Pauger, Adrien de, 122–23, 127, 128, 132
Payeras, Mariano, 159, 184, 191
Pecos Pueblo (NM), 51, 53, 59–63, 66, 69, 70, 73, 74, 77, 80
Peñalver y Cárdenas, Luis de, 129, 132
Penitente brotherhood, 70, 89, 91, 95, 178
Pensacola (FL), 39–45; Canary Islanders in, 23; diversity of people in, 44; English control of, 6, 10, 41, 42–45; founding of, 14, 39–40; French control of, 42; layout of, 40; Sigüenza in, 2; Spanish architectural remains in, 45; Spanish campaigns against, 5, 44, 126, 212; Spanish fortifications on, 6, 10, 41, 42, 45; stucco from, 130; United States' attacks on, 45
Peralta, Pedro de, 48, 77
Perea, Estevan de, 69, 73

Pérez, Ignacio, 141
Pérez de Guillan, Eulália, 177–78, 189
Pérez de Villagrá, Gaspar, 72
Peru, 9
Peyri, Antonio, 190–97, 204
Pez, Andrés de, 40
Pfefferkorn, Ignaz, 138, 139
Philip II (king of Spain), 2, 6; and Florida, 11–12, 15, 24, 26, 39, 40; and New Mexico, 46, 48, 85; ordinances of, regarding town layout, 7; and Spanish Armada, 209. *See also* Ordinances for the Discovery, New Settlement, and Pacification of the Indies
Philippines, 4
Pico family (Los Angeles), 186
Picurís Pueblo (NM), 89, 90
Pike, Zebulon, 82, 83
Pima Indians (Tohono O'odham), 137–38, 142, 144, 145, 153
Pinkley, Jean M., 61
Piño, Ignacio del, 74, 75
Pious Fund, 158
Piro Indians, 86
Pittmann, Philip, 127
Place d'Armes (New Orleans). *See* New Orleans: Place d'Armes
Playdon, Dennis, 76
Plaza(s): at Chimayó, 58, 92–93; in Indian missions in Florida, 35–36; in Indian pueblos in New Mexico, 47, 50, 70; in Las Trampas, 89; in Los Angeles, 162, 182, 183–86, 211; in New Orleans, 122, 123, 127, 128, 130–31, 212; in Pensacola, 40; in St. Augustine, 16, 20, 22, 211; in San José, 162; in Santa Fe, 77–79, 82, 84, 211; in Texas, 100, 102–3, 211; in town plans, 7, 211
Plaza Church (Los Angeles, CA), 165, 184–86, 192, 202
Plaza de Armas (New Orleans). *See* New Orleans: Place d'Armes
Point of Pines (CA), 167
Point Sigüenza (Santa Rosa Island), 42, 45
Political Essay (Humboldt), 87
Polygamy, 32
Ponce de León, Juan, 2, 11, 210
Porciúncula River (now the Los Angeles River, CA), 162, 175, 181, 182
Portalba Buildings (New Orleans), 134
Portales: in New Mexico buildings, 58, 59, 84–85; in Texas buildings, 115
Portolá, Gaspar de, 3, 155–56, 166, 167, 175, 197
Pouilly, J. N. B. de, 133
Powder magazines: in Florida, 18, 24, 27, 44; in Louisiana, 124; in New Mexico, 78
Powell, H. M. T., 152, 185, 189
Pratt, Richard, 31
Predregosa Creek (CA), 202
Presbytère (New Orleans). *See* New Orleans: Presbytère in
Presidio de los Tejas (TX), 98, 105
Presidios: in Arizona, 138–39, 141, 142–44, 146, 157; in California, 3, 9, 155, 157, 160–64, 166–69, 181, 186, 198–200; chaplains of, 4; duties of soldiers in, 5; in Florida, 1, 5, 6, 8–10, 14, 20, 25–31, 39, 42, 172, 210, 212; missions as less expensive than, 9, 96; missions' support for, 115, 158, 162, 177, 181; in New Mexico, 6–7, 78–79, 86, 87, 89; Rivera's inspection of, 5, 6, 86, 98, 101, 102, 181–82; Rubí's inspection of, 5, 6, 78, 98, 105, 138–39, 142, 146; in Texas, 1, 5–7, 9, 97, 98, 115; Urrutia's drawings of, 5, 6, 78, 79, 85, 87, 138–39. *See also* Fortifications; Soldiers
Priests (secular): roles of, in northern New Spain, 4–5

Prince, L. Bradford, 92, 94
Protestantism, 1, 209
Province of Santa Elena de la Florida, 4. *See also* Florida
Province of Santo Evangelico, 4. *See also* New Mexico
Puebla (Mexico), 54, 107
Pueblo Indians: churches in pueblos of, 1, 47, 49–56, 60–77, 99, 211; construction techniques of, 8, 47–48, 50, 52–56, 212; governing of, under Spanish, 50; housing of, like fortifications, 58; and Spanish explorers, 46, 47. *See also* Pueblo Revolt of 1680; *Specific pueblos and Indian tribes*
Pueblo Revolt of 1680: churches destroyed in, 54, 60–62, 77–78; as driving Spanish out of New Mexico, 1, 49, 64, 78; loss of documents in, 51, 85; missionaries killed in, 73
Purísima Concepción mission. *See* La Purísima mission (CA); Nuestra Señora de la Purísima Concepción mission and church (TX); Quarai Pueblo

Quarai Pueblo (also known as Nuestra Señora de la Purísima Concepción (NM)), 64–66, 68–71, 73
Quarries. *See* Stone
Quebec (Canada), 123
Querétaro College for the Propagation of the Faith, 3, 4, 96–98, 105–7, 113, 117, 140
"Quivera," 46, 47, 60

Ramírez, José Antonio, 163, 185, 192, 194, 202, 204, 205
Ramírez, Juan, 73
Ramírez de Arellano, Pedro, 114, 116–17
Ramón, Domingo, 97, 100–101
Ramona (Jackson), 210
Ranching: in California, 177, 183, 191, 195; in Texas, 114, 115. *See also* Livestock
Rancho de Taos church (Taos, NM), 52, 53
Ransom, Andrew, 28
Rapp, Rapp and Hendrickson (architects), 211
Real, José María del, 173
Rebolledo, Diego de, 27, 36, 39
Redlands (CA), 177
Redoban, Pedro de, 5
Reducciones, 154
Reglamentos: of *1772*, 142; of *1779*, 181, 200; of *1781*, 162
Reina, Jordán de la, 40
Reinoso, Alonso, 31
Religious architecture. *See* Churches; Missions
The Religious Architecture of New Mexico (Kubler), 50
Repartimiento system, 16, 28, 36, 39
Reredos, 55
Reservoirs and aqueducts, 202–3
Retablos. *See* Altar screens
Reuter, B. A., 76, 91
Revillagigedo, Conde de, 169
Ribault, Jacques, 12, 14
Riches. *See* Silver
Riley, Lewis, 76
Rio Grande, 86–87
Ripoll, Antonio, 202–5
Rivas, Domingo, 190
Rivera, Joaquín, 163, 169, 170
Rivera, Pedro de, 5, 6, 86, 98, 101, 102, 181–82
Rivera, Salvador, 163, 170
Rivera y Moncado, Fernando de, 155–57, 161
Riverside (CA), 177

Roanoke Island (NC), 6
Robin, C. C., 44
Robinson, Alfred, 192–93
Rockefeller, John D., 210
Rococo elements (in Texas churches), 116, 118
Rocque, Mariano de la, 6, 24, 30
Rocque de Medina (colonel), 142
Rodríguez Cabrillo, Juan, 154, 197
Rogel, Juan, 31, 158
Rojas, Carlos, 146
Romanesque elements (of Santa Fe church), 82
Romero de Terreros, Pedro, 98
Romo, José María, 207
Roofing materials: asphalt, 76; brick, 136, 152; concrete, 29–30, 180, 212; earthen, 168, 170, 171, 178, 191; tar, 2, 136, 164, 184, 186; thatch, 8, 18, 19, 32, 38, 40, 42, 43, 100, 101, 106, 164, 168, 171, 178, 186, 191, 197, 201, 202; tile, 2, 163, 164, 171, 178, 179, 185, 187, 190, 194, 195, 199–202, 207; tile, as component of California Hispanic style, 164; and *vigas*, 52, 76; wood shingles as, 19, 21, 43, 130, 185, 206
Roque-Lobato house (Santa Fe), 210
Rosas, Luis, 81
"Rose" windows, 116, 118
Royal Presidio of Santa Barbara Historic Park (CA), 200
Rubí, Marqués de, 5, 6, 78, 98, 105, 138–39, 142, 146
Ruelas, Paul, 180
Ruiz, Manuel Esteban, 163, 169–74
Ruiz, Santiago, 163–64, 170
Ruiz de Olana, Pedro, 6, 29
Russia, 9, 154–55, 160
Ruy, Pedro, 35

Sáenz de Gumiel, Juan Joseph, 107, 112
St. Augustine (FL): British attacks on, 6, 7, 13, 15–22, 24–26, 28, 33, 212; churches in, 14, 16, 17, 22, 24; City Gate in, 24; England's ownership of, 6, 14, 18–19, 22–23, 30, 42; founding of, 7, 12, 14; hospitals in, 22, 24; as Indian market town, 37; Indian village at, 14, 15, 20, 37; layout of, 16, 17–18, 21–22, 211; missionaries in, 31; occupations in, 20; pirate raids on, 27; population of, 16, 20, 21, 127; racial and national diversity of, 20, 21, 23; secular priests in, 4, 12, 17; siting of, 15; Spanish architectural influence in, 210, 211; Spanish architectural remains in, 1, 9–10, 17, 19, 23–24, 212; Spanish ownership of, 2, 9–11, 13–14, 19, 23, 40, 211. *See also* Castillo de San Marcos; Convento de San Francisco
St. Augustine Historical Society, 31
St. Augustine Preservation Society, 25
St. Catherine's Island, 32, 34–37
St. Denis, Louis Juchereau de, 97
St. Louis (MO), 2, 125, 126
Salazar, Antonio, 117, 118
Salazar, Hita, 17
Salinas salt bed missions (NM), 65–72
Salpointe, Jean Baptiste, 152
Salsido, Vicente, 186
Salvador (artisan), 194
Salvador, George, 76
Salvatierra, Juan María, 154, 158
San Agustín de Tucson, 142, 143, 146. *See also* Tucson (AZ)
San Angelo (TX), 98
San Antonio (ship), 155–56
San Antonio (TX), 100–105; baroque architectural elements in, 55; cabildo in, 102, 104, 105; churches in, 103–4, 111; con-

struction materials in, 99, 101; houses in, 100–102; missions in, 3, 97–102, 105–21, 172, 174, 188, 209; population of, 101–5, 127; presidio in, 3, 6, 7, 97, 98, 101, 105, 142; Spanish architectural remains in, 1, 10, 109, 209; as Spanish provincial capital, 98, 105

San Antonio de Béxar (Corner), 120
San Antonio de Béxar presidio (San Antonio, TX), 97
San Antonio del Embudo (Dixon, NM), 58
San Antonio de Padua mission (CA), 156, 158, 164, 168, 171, 175, 177
San Antonio de Pala church (CA), 165, 191, 195–96
San Antonio de Valero mission (later, the Alamo), 97, 99–102, 106, 111, 113, 209
San Antonio River, 101
San Bernardino rancho (CA), 177
San Bernardo de Aguatubi church (Awatovi, AZ), 54
San Blas (Mexico), 140, 157
San Buenaventura mission (CA), 155, 158, 164, 165, 197, 198, 200, 204
San Buenaventura y Texada, Francisco de, 17, 22
San Carlos de Borromeo mission (Carmel, CA): artisans at, 163–64, 184, 212; church at, 170–75, 179, 187, 209; drawings of, 180; as Franciscan headquarters, 160; Serra buried at, 158, 174; soldiers at, 168, 180, 187
San Carlos presidio (CA), 156
Sánchez, Hernán, 74, 75
Sánchez, José Bernardo, 177
Sánchez, Padre, 181
Sanctuario de Esquipulas (Chimayó), 93–95
San Diego (CA): missions in, 2, 155, 156, 158, 160, 184; Panama-California Exposition in, 210, 211; presidio at, 160–61, 177, 186, 189; Spanish architectural remains in, 2; Spanish exploration of, 154, 166
San Diego mission (CA), 2, 155, 156, 158, 160, 184
Sandstone: in California, 188, 200–201, 204; in New Mexico, 61, 66
San Esteban church (Ácoma Pueblo, NM), 54, 56, 73–77, 80, 172, 209
San Felipe Pueblo church (NM), 211
San Fernando College (Mexico City), 4, 140, 155, 158, 159, 170, 189, 196, 200
San Fernando de Béxar (TX), 98, 100, 102, 103, 113. *See also* San Antonio (TX)
San Fernando mission (CA), 165, 198
San Francisco (CA), 3, 155, 198; mission in, 158, 175, 186; presidio in, 157, 160–62
San Francisco de la Espada mission (formerly San Francisco de los Tejas mission, TX), 96, 97, 105
San Francisco Solano (CA), 158
San Gabriel (CA), 3
San Gabriel mission (Los Angeles, CA), 175–81, 183, 189, 196; artisans who worked on, 212; in chain of missions, 156, 186; churches of, 9, 159, 176–81; construction of, 164, 175–81, 184, 187, 198; founding of, 157, 175; Neve at, 162, 182; paintings at, 165; Serra at, 158
San Gabriel Pueblo (NM), 47–48
San Gabriel River, 98, 181
San Gregorio church (Abó, NM), 66–68
San Ignacio mission (Baja California), 179
San Ildefonso Pueblo, 94
Sanipao Indians, 107
San Jacinto rancho (CA), 191
San José (CA), 3, 156, 161–63, 165, 168, 181

San José church (Laguna Pueblo), 55, 211
San José de Gracia church (Las Trampas, NM), 89–92, 95
San José de Giusewa (near Jémez Springs, NM), 64–67
San José de los Nazionis mission (TX), 105
San José del Vado (NM), 63
San José y San Miguel de Aguayo mission (San Antonio, TX), 3, 97–102, 105–6, 109, 113–21, 172, 174, 188, 209
San Juan (Puerto Rico), 6
San Juan Bautista (CA), 165
San Juan Capistrano mission (CA), 178; artisans at, 184, 212; in chain of missions, 159; church at, 172, 187–90, 192; earthquake destruction of, 9, 164, 177, 189; founding of, 158, 186; San Luis Rey compared to, 194; trade at, 193
San Juan de Capistrano mission (TX), 105
San Juan de los Caballeros Pueblo (Okhe Pueblo, NM), 47, 73
San Juan rancho (CA), 191
San Lorenzo (NM), 86
San Luis de Amarillas presidio (TX), 98
San Luis de Talimali mission (FL), 37–39
San Luis Obispo mission (CA), 156, 158, 168, 184, 210
San Luis Potosí (Mexico), 46
San Luis Rey mission (CA), 190–97; artisans at, 165, 184, 203, 204; in chain of missions, 158, 159; church at, 164, 172, 192–97, 205; founding of, 186; missionaries at, 178, 189; restoration of, 175, 209, 212
San Marcos Castillo (St. Augustine, FL). *See* Castillo de San Marcos
San Marcos de Apalachee (FL), 21, 37, 39
San Marcos rancho (CA), 191
San Mateo rancho (CA), 191
San Miguel, Andrés de, 17–18
San Miguel, Francisco de, 60
San Miguel church (CA), 165, 184, 208
San Miguel church (Santa Fe, NM), 56, 77, 81, 82
San Miguel de Gualdape town (GA), 7, 211
San Miguel de Penzacola presidio (Pensacola Bay), 42
San Miguel Pueblo (NM), 63
San Pedro Springs (near San Antonio, TX), 101, 106
San Sabá mission (TX), 98
San Sabá presidio (TX), 6
San Sebastian de Yaoconos (Indian village in Florida), 20
San Simeon estate (CA), 211
Santa Ana de Cuiquiburitac *visita* (AZ), 146
Santa Ana (or Anita) rancho (CA), 177
Santa Anna, Antonio López de, 209
Santa Barbara (CA), 180; churches in, 165, 202–9, 212; Franciscan apostolic college at, 206–7; Indian labor at, 164; mission at, 158, 160, 172, 184, 197–209; presidio at, 160, 161, 189, 198–200; secularization of mission at, 206; Spanish architectural influence on, 210, 211; Spanish architectural remains in, 2, 203–8, 212
Santa Barbara Trust for Historic Preservation, 200
Santa Catalina de Guale mission (FL), 32, 34–37
Santa Clara mission (CA), 158, 162–63, 165
Santa Cruz de la Cañada (NM), 79, 80, 89
Santa Cruz mission (CA), 162–63
Santa Elena (on Parris Island, SC): as capital of *La Florida*, 7, 12–15, 40; construction materials at, 18; description of settlement at, 15–17, 25, 34; missionaries in, 31
Santa Fe (NM), 77–85; anniversary celebrations of, 1, 209; cabildo in, 77, 79, 85; churches in, 1, 50, 55–56, 77, 80–83; founding of, 77; houses in, 57, 58; plaza in, 77–79, 82, 84, 211; population of, 79–80, 127; *portales* in, 58; presidio at,

78–79, 89, 142, 143; priests from, 63; Pueblo Revolt in, 62; Spanish explorers near, 47; town plans for, 6–7, 78–79; U.S. occupation of, 211. *See also* Santa Fe style
Santa Fe style, 85, 210–11
Santa Inés mission (CA), 198
Santa Margarita rancho (CA), 191
Santander, Diego de, 70, 71
Santa Rosa Island (Pensacola Bay), 42, 45
Santeros, 55–56, 76, 83, 90, 94. *See also* Artisans
Santiago, Felipe de, 106
Santiago, Juan Norberto de, 187, 189, 190
Santiesteban, José de, 98
Santísimo Nombre de María mission (TX), 96
Santos, Domingo, 36
San Xavier del Bac mission (AZ), 144–53; church of, 1, 9, 109, 121, 141, 143–53, 188, 209, 212; founder of, 3, 137; furnishings of, 139, 142, 147–52; Indian village at (Bac), 143, 145, 153; preservation of, 152–53; secularization of, 143, 151; white color of, 152–53
Save America's Treasures Project, 76
Scher, Philip, 174
School for the Deaf (NM), 211
Schools: for the deaf, 211; for missionary training, 3–4, 96–98, 105–7, 113, 114, 117, 140, 155, 158–59, 170, 189, 196, 200; in missions, 70; in New Orleans, 129; in Santa Fe, 80
Schuchard, Ernst, 118–19
Schuetz-Miller, Mardith, 51, 53, 110, 117, 163, 179
Schuster, Fridolin, 76
Schwartzbaum, Paul, 153
Secularization: under Mexico, 10, 83, 160, 197; of missions, 10, 113, 120, 160, 185, 191, 196, 202, 206
Sedaño, Antonio, 34
Seloy (Indian chief), 14, 15, 20, 25, 37
Seminole Indians, 30
Señan, José, 158
Senecú (NM), 86
Serra, Junípero, 2, 140; and California, 3, 155–58, 161, 163, 165, 167, 169, 170–71, 175, 186, 190, 197, 198, 200; disputes of, with civil authorities over reform, 3, 4, 156–57, 200; sepulchre of, 158, 174; and settlers, 183; training of, 4
Serrano, Sebastián Martín, 89
Settlements (Spanish): first, in northern New Spain, 2, 7; in Florida, 7, 11–16, 25, 34, 37; justification for, 9, 40; length of time Spain was involved in U.S., 2; located near Indian villages, 7, 14–15, 20, 25, 34–35, 37–38, 137; in New Mexico, 3, 10, 46–50, 57–59, 85–86; pressures on, 9–10; reasons for, in California, 9, 154–55, 160–61; reasons for, in Texas, 9, 96; Spain's subsidizing of, 9–10, 12–14, 17, 18, 20, 124, 125, 158, 181, 199, 200. *See also* England; France; Indians; Spain; United States; *Specific places*
Seven Years War, 42, 43, 122
Sevillano de Paredes, Miguel, 99
Shapiro, Gary, 39
Sigüenza y Góngora, Carlos, 2, 40–41
Silva Nieto, Francisco Manuel de, 73
Silver: hopes for, in Arizona, 138; hopes for, in New Mexico, 46–47; Mexican mines for, 12, 46, 47
Simpson, Lesley Bird, 158–59
Sixteenth Century St. Augustine (Manucy), 17–18
Skidmore, Owings and Merrill (architectural firm), 92
Slaves (African American): as construction workers in Florida, 16–17, 28; as craftsmen, 26; in Louisiana, 123–27; in Spanish households, 20. *See also* African Americans (free)

Slaves (Indian): in Florida, 39; in Louisiana, 125; in New Mexico, 62
Smith, George Washington, 211
Smith, Harvey P., 120–21
Sobaípuri Indians, 139, 143, 144, 147
Social class: and house furnishings, 15; and housing variations, 8, 20; among Indians, 33, 48; and mission clothing, 108; in St. Augustine, 20; in Santa Fe, 80; Spanish disregard of, among Indians, 36, 39, 175; terms for people of high, 104–5
Socorro (NM), 86
Solá, Pablo Vicente de, 184
Solano, Juan Joseph, 21–22
Soldiers: American, as defacing historic Spanish architecture, 120, 121, 174, 209; in Arizona, 138, 144, 146; behavior of, as undercutting missionaries' efforts, 31, 32, 96, 156, 175, 176; in California, 3, 9, 155, 157, 160–64, 166–69, 181, 186, 198–200; competition between missionaries and, 36, 156–57; in Florida, 11, 14, 16, 20, 21, 25, 27, 34, 36–38; Indians as, in Spanish presidios, 142; in Louisiana, 124, 127–29; missionaries as less expensive than, 9, 96; in New Mexico, 46–48, 71–73, 78–80, 86; salaries for, 20; in Spanish North America, 5, 6, 9, 212; in Texas, 96, 97, 101, 106. *See also* Fortifications; Presidios
Solís, Gaspar José, 114–15, 117
Somera, Ángel, 175
Sonoita (AZ), 140
Sonora (Mexico), 4, 5; Arizona as northern part of, 2, 137
Soto, Hernando de, 2, 11, 37, 96
South Carolina: French settlements in, 11, 12, 14; Spanish settlements in, 7, 12–15. *See also* Carolina
Spain, 2; architectural remains of, in Arizona, 1–2, 142, 152–53, in California, 2, 10, 165, 186, 195, 197, 200, 209, in Florida, 1, 9–10, 17, 19, 23–24, 45, 212, in Louisiana, 2, 5, 126–36, 212, in New Mexico, 1, 50, 56, 58–59, 68, 70, 84, 86, 91–92, 95, 209, in Texas, 1, 10, 209, in United States, 1–10, 209–12; colonial policy of, 3–5, 11–12, 45, 46, 77; explorers from, 2, 3, 5, 7, 11, 14, 25, 37, 39–41, 46–47, 60, 70, 72, 96, 97, 101, 137–40, 145–46, 154, 211; France's competition of, for Florida, 2, 11–12, 14, 25, 39, 40–41, 96, 212; France's "family compact" with, 42, 43, 122; king of, as head of church and state, 4, 17, 48, 156; length of time involved in U.S. settlement by, 2; as Louisiana's owner, 2, 43, 98, 105, 122, 124–36; Moorish influence on, 51, 57, 58, 81; poverty of, in 17th and 18th century, 212; and Spanish-American War, 209; subsidizing of settlements by, 9, 10, in California, 158, 181, 199, 200, in Florida, 12–14, 17, 18, 20, in Louisiana, 124, 125; war of, with France, 10, 97. *See also* Council of the Indies; Laws of the Indies; Mexico; New Spain; Spanish Armada; *Names of kings, explorers, missionaries, and soldiers from*
"Spaniards" (as term reflecting social class), 104–5
Spanish-American War, 209
Spanish Armada, 1, 13, 209
Spanish Colonial Architecture of Mexico (Baxter), 210
Spanish Royal Corps of Engineers, 5
Spanish St. Augustine (Deegan), 17, 18
The Spanish Settlements within the Present Limits of the United States (Lowery), 210
Spanoqui, Comendador Tiburcio, 26
Standard Oil Company, 210
Stanford, Leland, 210
Stanford, Mrs. Leland, 174
Stanford University (CA), 210
Stanley, John Mix, 62

Stations of the Cross paintings, 165–66
Statues (and *bultos*), 35; in Arizona churches, 144, 148–49, 152; in California churches, 174, 175, 188, 195, 204, 205–6, 208; importing of, from Mexico, 49; in New Mexico churches, 49, 54–56, 75, 87, 90, 91, 93; in Texas churches, 111, 118, 120, 121
Stockton, Robert F., 206
Stone: as construction material in Arizona, 147, in California, 9, 163–64, 168–72, 174–75, 178, 179, 187–90, 197, 200–202, 204, in Florida, 6, 8, 14, 17, 18–19, 21, 22, 24, 26–29, 33, 172, 212, in New Mexico, 51, 52, 58, 61, 64–73, in Texas, 9, 98–101, 104, 106, 107, 109–10, 112, 114, 116, 212; in New Mexico reredos, 55, 83; relative lack of, in New Mexico churches, 50; use of, in fortifications, 6, 8, 14, 27–28, 172, 212. *See also* Coquina stone; Domes; Limestone; Sandstone; Stucco; Vaulted church ceilings
Stonecutters: *See* Artisans
Storms: in Florida, 16, 17, 40, 42, 44; in New Orleans, 129, 131
Strand, Paul, 52
Streets: in El Paso, NM, 87; in Los Angeles, 182; in Pensacola, 43; in St. Augustine, 16, 22; in San José, 162; in Santa Fe, 79; in town plans, 7, 8, 102
Stucco, 130, 132, 135, 148, 179, 191, 212
Summerville, H. L., 119
Suñer, Francisco, 203–5
Surgi, Louis, 134
Switzerland, 23
Sykes, John, 171

Tabby (construction material), 8, 15, 18–19
Tac, Pablo, 193
Tacame Indians, 108
Tallahassee (FL), 24, 33, 37
Talmus Hadjo (Indian chief), 30
Talpa (NM), 58
Tamarón y Romeral, Pedro, 74, 78, 80, 86–87, 89
Taos Pueblo (NM), 61. *See also* Rancho de Taos
Tapis, Estevan, 164, 165, 179, 180, 189, 201
Tar (as roofing material), 2, 136, 164, 184, 186
Tarabal, Sebastián, 157
Taxation, 49
Teatro Mexicano (Vetancurt), 60–61
Tejas Indians, 96, 105
Tello, Antonio de, 99, 103, 106, 109, 111
Temécula rancho (CA), 191
The Ten Books of Architecture (Vitruvius), 7
Tepeaca (Mexico), 180
Tepic (Mexico), 140
Tepotzlán (Mexico), 110
Terrabas Indians (Central America), 113
Terrenate (Mexico), 142, 144
Terreros, Alonso Giraldo de, 98
Texas, 1, 96–121; agriculture in, 96, 101, 105, 107, 115; churches in, 106, 109–14, 116–21, 153, 212; construction techniques and materials in, 8–9, 98–101, 104, 106, 107, 109–10, 112, 114, 116, 212; French claims to, 2, 96, 97, 100, 113; missions and missionaries in, 1–5, 96–121; naming of, 96; presidios in, 1, 5–7, 9, 97, 98, 115; reasons for Spanish settlement of, 9, 96; as ruled by viceroy in Mexico City, 96; Spanish architectural influence in, 210, 211; Spanish architectural remains in, 1, 10, 109, 209; War of Independence in, 120. *See also* East Texas; *Specific places in*
Texas Centennial Commission, 121

Thatch (as roofing material), 8; in California, 164, 168, 171, 178, 186, 191, 197, 201, 202; in Florida, 18, 19, 32, 38, 40, 42, 43; in Texas, 100, 101, 106
Third Order of St. Francis, 91. *See also* Penitente brotherhood
Thomas, David Hurst, 35
Tile roofs, 2, 163, 164, 171, 178, 179, 185, 187, 190, 194, 195, 199–202, 207; and California Hispanic style, 164
Timbers. *See Vigas*; Wood
Timucuan Indians, 14, 28, 32–34, 36, 39
Toaraque Indians, 107
Tohono O'odham people. *See* Pima Indians
Tolomato Pueblo (FL), 21
Tolosa Cortés Montezuma, Isabel, 46
Torreones (in domestic architecture): in New Mexico, 58, 62–63, 78–79, 89, 92. *See also* Towers (church)
Toulouse, Joseph H., 67
Towers (church): in Arizona churches, 144, 150–52; in California churches, 168, 172, 180, 184–85, 187–89, 194, 196, 204, 205, 207, 208; in Louisiana churches, 132; in New Mexico churches, 53, 62, 64–65, 69, 74, 76, 81–83, 88, 90–93; in St. Augustine, 17; in Texas churches, 99, 104, 110, 112, 119, 120. *See also Torreones*
Town plans: regulations for laying out of, 7–8, 211. *See also* Housing lots; Municipal governments; Ordinances for the Discovery, New Settlement, and Pacification of the Indies; Plaza(s); Settlements; Streets; *Specific towns*
Trade: in California, 161, 185, 193; between French and Spanish in North America, 41, 96–97; Indian, 37, 39, 60; with Indians, 44, 59, 62, 70, 89; Kino's suggestions for, 138; in Louisiana, 124–25; in New Mexico, 59, 80; in San Antonio, 105. *See also* Markets
Treaty of Fontainebleau, 124
Treib, Marc, 93
Trinity River, 98
Tubac presidio (AZ), 3, 138, 141–43, 146, 157
Tubutama mission, 139
Tucson (AZ): baroque architectural elements in, 55, 148, 151; presidio in, 142–44, 146. *See also* San Xavier del Bac
Tufa. *See* Limestone
Tumacácori (Bleser), 141
Tumacácori mission (AZ), 1, 140–42, 149, 212
Turnbull, Andrew, 23

Ubeda, Luis de, 60
Udall, Stewart L., 92
Ugarte, Juan María, 158
Ujambore Indians (Central America), 113
Ulloa, Antonio de, 124–25
United States: anti-Catholic/anti-Hispanic sentiments in, 1, 209–11; Arizona added to, 152; Army of the West of, 62, 151, 196; California's conquest by, 161, 185, 186, 196, 206; Florida's goods from, 23; Florida's ownership by, 14, 24, 30, 45; Hispanic territories owned by, 209; Louisiana as part of, 10, 44, 126, 135; New Mexico's occupation by, 50; oldest European structure in, 84; soldiers from, as defacing historic Spanish architecture, 120, 121, 174, 209; Spanish influence on, 1–10, 209–12. *See also* American Revolution; Census; Mexican War; Spanish-American War; *Specific states*
U.S. Corps of Engineers, 30
Unzaga, Luis de, 126, 127
Urban design. *See* Town plans
Urban III (pope), 70

Urrutia, Joseph de, 5, 6, 78, 79, 85, 87, 138
Ursuline convent (New Orleans), 124, 129, 131
Uzeda, Juan de, 36

Vaez, Augustín, 34
Valdez, Juan, 113
Valero, Marqués de, 97, 101
Vancouver, George, 160, 168, 171–73, 199, 202
Vargas, Diego de: at Ácoma Pueblo, 73, 74; displacement of Indians by, 92; reconquest of New Mexico by, 49–50, 62, 86; in Santa Fe, 78, 79, 81, 83, 84–85, 89
Vaudricourt, Augustus de, 88
Vaulted church ceilings: in Arizona, 109, 141; in California, 9, 172, 175, 178–80, 188, 189; lack of, in New Mexico, 50; in Texas, 99, 104, 106, 109, 111, 112, 117, 119–21, 212
Vázquez de Ayllón, Lucas, 7, 14
Vázquez de Coronado, Francisco, 2, 39, 46, 47, 60, 72, 96, 137, 154
Velasco, Diego de, 20
Velasco, Fernando de, 62
Velasco, Luis de, II, 39–40, 46, 48
Velásquez, Antonio Gonzáles, 169–70
Velderrain, Juan Bautista, 146
Vélez Cachupin, Tomás, 62, 89
Venezuela, 4
Ventura (Indian chief), 36
Vera Cruz (Mexico), 6
Veramendi, Fernando de, 100
Verboom, Marqués de, 5
Vergara, Agustín Flores, 81
Verger, Rafael, 170
Vetancurt, Agustín de, 60–61
Victoria, Manuel, 196
Vigas: in Arizona architecture, 141, 143, 146, 151; in California architecture, 164, 178; construction techniques employing, 52; in New Mexico architecture, 52–54, 57, 62, 69, 73, 74, 76, 82–83, 85, 88–90; obtaining, 74; in Texas architecture, 106. *See also* Wood
Villafáne, Angel, 40
Viña Madre (San Gabriel's vineyard), 177
Visitas: in Arizona, 140, 142, 143, 146; definition of, 33; in Florida, 33; in New Mexico, 70, 75
Vitruvius, 7, 205
Vizcaíno, Sebastián, 154–55, 166, 197

Wages: for artisans building San Xavier del Bac church, 145; for artisans in California, 163; for Indian workers, 39, 168, 184; for Spanish soldiers, 20; for workers building Castillo de San Marcos, 28; for workers building Tumacácori church, 141
Wallischeck, Peter, 197
Warner's Ranch (CA), 195
War of 1812, 45
War of the Quadruple Alliance, 42
Water: at California missions, 191, 193, 194, 202–3; cutting off supply of, 77, 78; limited amounts of, in Spanish territories, 212; methods for obtaining and saving, in New Mexico, 70, 72, 74; as resource for all, 77; in Texas, 100–101. *See also* Drought; Irrigation; Wells
Waterwheels, 202–3
Watkins, Carleton E., 152, 190, 196
Wattle and daub construction (in Florida), 18, 20, 34, 35, 38, 57
Wauchope, Alejandro, 42

Webb, Edith Buckland, 201
Wells: for New Mexico houses, 59; in St. Augustine, 18, 22, 23; in Texas, 115
Western Apache Indians, 144
West Florida: maps of, 2; Pensacola as capital of, 42–44; surrender of, by England, 126; trade in, 44, 125. *See also* Pensacola
Whitman, Walt, 1, 209, 212
Wilcox, James, 204
Wilson, Carl, 85
Windows (or clerestories): in Arizona churches, 147, 151; in California churches, 169, 172, 194, 205; in Louisiana buildings, 135; in New Mexico churches, 50, 52–53, 62, 67, 69, 81, 89–91, 93; in New Mexico houses, 57, 59; in Spanish Florida houses, 19; in Texas churches, 110, 116, 118, 119. *See also* Glass
Winter, W. J., 25
Witkind, William B., 61
Women (woman): mistaken for Christ, 153; Indian, and Spanish men, 41, 96, 156, 175, 176; Indian, as adobe makers, 47, 48, 51, 77; Indian, as agricultural workers, 107; Indian, in missions, 159–60, 170, 171, 176–78, 191, 206–7; Indian customs regarding, 32; in Louisiana, 124; Spanish, in North America, 41–42, 157, 177–78; as whitewashers, plasterers, and floor finishers, 57, 92
Wood (timber): in adobe structures in New Mexico, 8, 48, 58, 70, 84–86, 88; as construction material in Arizona, 139, 142, 147, in California, 155–56, 160, 164, 167–70, 175, 176, 178, 179, 186, 190, 195, 197, 198–200–201, in Florida, 8, 15–19, 21–23, 25–27, 32–35, 38, 40, 42, 44, in Louisiana, 124, 127, 130, 132, in Texas, 9, 96, 98–100; dams of, 87; fortifications of, 6, 7, 18, 25; New Mexico structures of, 57; as perishable, 9, 167, 190; shingles of, as roofing material, 19, 21, 43, 130, 185, 206; for sidewalks, 128; in stone structures in New Mexico, 67. *See also Jacales; Vigas*; Wattle and daub construction
Wool manufacture, 59, 108, 159, 177
World's Columbian Exposition (Chicago), 165, 210
World's Monuments Watch (2002), 76
WPA, 25, 113, 120–21

Ximenez, Bartolomé, 140
Ximeno, Custodio, 139

Yamasee-Apalachino Indians, 42
Yanunali (Chumash Indian chief), 198
Ybarra, Gerónimo, 99, 104, 107
Ybarra, Pedro de, 26, 35
Ysleta (NM), 86
Yuma (AZ), 138
Yuma Indians, 3, 146, 157, 198

Zacatecas (Mexico): founders of, 3, 46; silver mines in, 12, 46, 47; soldiers from, in New Mexico, 86. *See also* College of Nuestra Señora de Guadalupe de Zacatecas
Zaldívar, Juan de, 72
Zaldívar, Vicente de, 72–73
Zalvidea, José María, 177, 178, 196
Zapatas, 58. *See also* Corbels
Zárate Salmerón, Jerónimo de, 73
Zeinos, Diego de, 62
Zubiría, José Antonio, 91
Zúñiga, José de, 144–45, 147, 149, 182
Zuñi Pueblo (NM), 46, 70, 76